Power and Difference

Gender in Island Southeast Asia

Sponsored by the Joint Committee
on Southeast Asia of the American
Council of Learned Societies and
the Social Science Research Council

Power and Difference

Gender in Island Southeast Asia

Edited by
Jane Monnig Atkinson and
Shelly Errington

Stanford University Press
Stanford, California 1990

Stanford University Press
Stanford, California
© 1990 by the Board of Trustees of the
Leland Stanford Junior University
Printed in the United States of America

CIP data appear at the end of the book

In memory of Shelly Rosaldo

Preface

This volume honors the memory of Michelle Zimbalist Rosaldo, who, in her short life, pioneered new and important developments in cultural anthropology, feminist scholarship, and island Southeast Asian ethnography. The Social Science Research Council conference that led to this volume was initially conceived by Shelly Rosaldo the year before her tragic death on October 11, 1981. Thanks to the efforts of David Szanton of the Social Science Research Council and the members of the Joint Committee on Southeast Asia, plans for the proposed conference continued after her death and a revised call for papers was issued by Shelly Errington. The conference, titled "The Cultural Construction of Gender in Island Southeast Asia," was held in December 1983 in Princeton, New Jersey. It brought together scholars with diverse interests in cultural analysis, feminist scholarship, and island Southeast Asia. In like fashion, this volume is designed to draw together a similarly diverse readership.

Feminists who chance upon this volume may well ask, "Why island Southeast Asia?" By the same token, area specialists may ask, "Why gender?" Culturally, gender does not stand out as an overarching or dominant theme throughout most of the archipelago that comprises the modern nations of Indonesia, Malaysia, and the Philippines. Hierarchy is typically encoded here not by gender but by rank, birth order, and spiritual potency. In scant evidence are sexual antagonism, misogyny, and similar social practices that mark gender relations in many other parts of the world. It is worth noting that the two major world religions with the greatest influence in the region are Islam and Roman Catholicism, conventionally associated in the West with less benign systems of gender relations. As Michelle Rosaldo noted in her original prospectus for this conference, the concerns of Anglo-American femi-

nism with equality and civil rights may seem curiously out of place in Southeast Asia, "where women are said, traditionally, to have enjoyed a relatively 'high status' (enjoying economic opportunities; suffering few legal restrictions or damning stereotypes; participating in cultures where the sexes are construed in terms of complementarity and balance rather than differential worth)." Likewise, constructions of "womanhood" as a unitary and essential category are also undeveloped or only now developing in response to such transnational processes as film, advertising, and tourism (see Rodgers, Blanc-Szanton, this volume).

Our response then, to the feminist who asks, "Why island Southeast Asia?" is that Western feminism, in its current efforts to reconsider and transcend perspectives rooted in Euro-American history and culture, should look to cultural worlds in which the rules are different. Before analogies to the conditions of women in the West are sought, local constructions of gender relations demand understanding on their own terms. Whether in what Errington calls the "Centrist Archipelago" (including the Malay Peninsula, Borneo, Sulawesi, the Philippine islands, Java, and in a distinctive way, Bali), where relative age and spiritual powers would seem to eclipse gender as principles of social hierarchy, or in the dualistically inclined islands of Eastern Indonesia and parts of Sumatra, where oppositions of male and female are rejoined in cosmic synthesis, this region of the world offers feminists a bracing and insightful reorientation.

And for the area specialist who asks, "Why gender?" one might recall Clifford Geertz's observation about common sense: what we most take for granted may be what is most in need of explanation. Until recently, it seems fair to say, no social division seemed more fundamental, more essential to Western thinking than an opposition between the sexes. In her theoretical overview, Shelly Errington offers a reconsideration of the interplay between biology, society, and culture in the construction of gender. Given the inextricable nature of this interplay, questions about what has produced the present-day patterns of gender symbolism and gender relations in the archipelago should be valuable not only for the study of gender but also for our understandings of other dimensions of island Southeast Asian cultures.

Indeed, essays in this volume demonstrate how focusing on gender can illuminate the general workings of social and cultural systems of the area and beyond. For example, James Boon demonstrates how thinking about gender can solve some seemingly intractable puzzles in island Southeast Asian kinship and marriage, with implications for the Indo-European world as well. Jane Atkinson and Anna Tsing shed light on the political workings of relatively egalitarian social orders. In keeping with Michelle Rosaldo's attention to the social use of language, Ward Keeler and Joel Kuipers offer elegant analyses of speech styles across genres and social contexts. Janet Hoskins makes a valuable contribution to studies of Eastern Indonesian thought and ritual with an examination of the cultural construction of potency in Kodi. In his reconsideration of the nature/culture opposition, Valerio Valeri recasts important questions of analysis for feminists and structuralists alike. A number of the papers focus on the changing nature of gender relations in the region in response to colonialism, nationalism, neocolonialism, and the world economic system. Barbara Hatley explores how a popular theatrical form responds to social transformations in contemporary Java. Susan Rodgers explores how Batak images of women operate in the expression of ethnic relations in the context of a modern nation-state. Likewise, Aihwa Ong and Cristina Blanc-Szanton focus on dynamic historical transformations of gender symbolism and gender relations wrought by massive changes in the political economy of the region. And in her theoretical introduction, Shelly Errington poses new ways to conceptualize gender, power, and the body in culturally specific but comparative ways.

By focusing on the construction of gender in island Southeast Asia, then, this volume should reveal new dimensions of gender to feminist readers and offer new perspectives on the region to area specialists. Further, the range of approaches exhibited in the volume demonstrates both the breadth and the tensions within interpretive anthropology today. The initial formulation of the conference by Michelle Rosaldo and Shelly Errington's "Call for Papers" both focused the theme on the "cultural construction of gender in island Southeast Asia." This phrase can be read in two ways. It can refer to gender as a set or system of symbolic forms, already con-

structed. Alternatively, it can refer to the process through which cultural categories are created and used. On the one hand, gender can be regarded as various systems deriving from a common fund of symbolic forms that are played out in different permutations across these many islands. On the other, it can be viewed as diverse resources that take on new forms and meanings through the actions of women and men in the context not only of local communities but of wider political, economic, and ideological structures as well. How one reads the phrase depends certainly on one's theoretical orientation and analytical predilections. Much discussion at the conference centered on differences between structural-symbolic analyses of constructed categories of gender and practice-oriented approaches to the ongoing production of gender relations through social action. This discussion, as well as subsequent developments in anthropology that attempt to reconcile these approaches, has had a clear influence on the final shape of this collection. The result is a tribute to Michelle Rosaldo's sensitivity to cultural expression and to her concern for an anthropology that neither mistakes cultural imagery for the fullness of human experience nor treats symbolic forms as mere tools of individual action and agency.

Several forms of institutional support have assisted in the preparation of this volume. The Social Science Research Council has sponsored this project from its inception to its final publication. We are deeply indebted to the Council, to David Szanton, and to members of the Joint Committee on Southeast Asia for their commitment and encouragement. The conference was also supported by the Ford Foundation and in part by the John D. and Catherine T. MacArthur Foundation. Both editors worked on this volume during their respective fellowship years at the Center for Advanced Study in the Behavioral Sciences at Stanford. Jane Atkinson was supported in part by National Science Foundation grant #BNS 84-11738; Shelly Errington by National Science Foundation grant #BNS 87-00864. We acknowledge this assistance with gratitude.

We also wish to thank Donna Haraway, David Schneider, Bradd Shore, and Marilyn Strathern, who in their role as discussants at the Princeton conference helped us to find our common ground and sharpen our theoretical differences. We also thank Muriel Bell

and John Feneron of Stanford University Press, for patiently shepherding the volume to press; Sherry Wert for her sensitive and sensible copy-editing; an anonymous reader for Stanford Press who went to extraordinary lengths to provide each contributor with substantial, insightful, and generous commentary; Bonnie Goldstein for research and clerical assistance to Shelly Errington; Anne McCauley and Robert McKinley for their participation in the original conference; and Harold Conklin for his helpful suggestions.

Our deepest thanks go to the contributors for their intellectual energy and adventurousness, for their receptivity to critical feedback, their diligent and inspired revisions, and their patience during the long years it has taken to bring this book to press. We hope they will be pleased with the results.

J.M.A.
S.E.

Contents

Contributors

Jane Monnig Atkinson, Associate Professor of Anthropology, Lewis and Clark College

Cristina Blanc-Szanton, Research Associate, Southern Asian Institute, Columbia University

James A. Boon, Professor of Anthropology, Princeton University

Shelly Errington, Associate Professor of Anthropology, University of California, Santa Cruz

Barbara Hatley, Lecturer, Department of Indonesian and Chinese Studies, Monash University

Janet Hoskins, Assistant Professor of Anthropology, University of Southern California

Ward Keeler, Assistant Professor of Anthropology, University of Texas

Joel C. Kuipers, Assistant Professor of Anthropology, George Washington University

Aihwa Ong, Assistant Professor of Anthropology, University of California, Berkeley

Susan Rodgers, Associate Professor of Anthropology, Holy Cross College

Anna Lowenhaupt Tsing, Assistant Professor of Anthropology, University of California, Santa Cruz

Valerio Valeri, Professor of Anthropology, University of Chicago

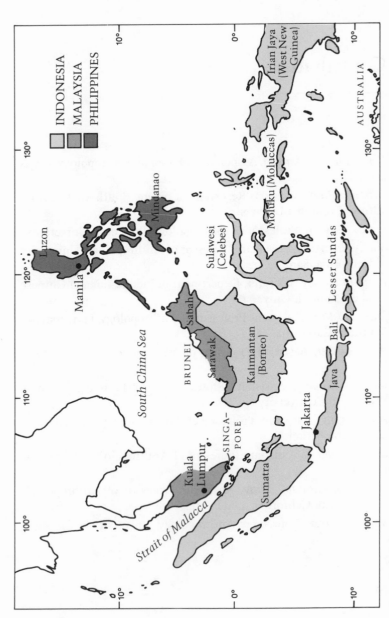

Countries and major islands and island groups of island Southeast Asia

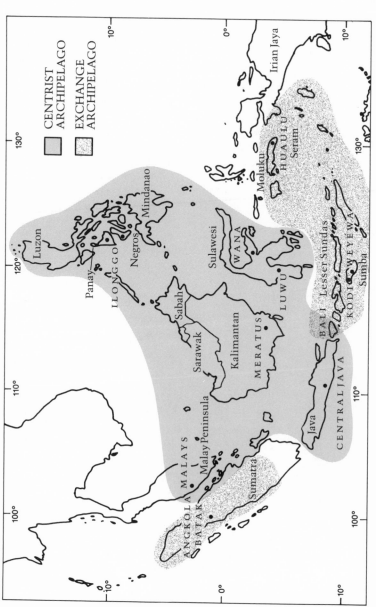

Location of case studies within the Centrist Archipelago and the Exchange Archipelago

Power and Difference

Gender in Island Southeast Asia

Recasting Sex, Gender, and Power

A Theoretical and Regional Overview

Shelly Errington

"Southeast Asia has long been identified as an area where women enjoy high status. From Burma to the islands of Indonesia and the Philippines this alleged high status is accentuated by the contrasting male dominance characteristic of traditional Indian and Chinese societies," Penny van Esterik wrote in the introduction to a collection on women of Southeast Asia (1982a:1). Leaving aside for a moment the difficulties in defining what "high status" might mean cross-culturally, it is nonetheless true that Western observers of many of the societies in both mainland Southeast Asia (Burma, Thailand, Cambodia, Laos, and Vietnam) and island Southeast Asia (the area to which this collection is devoted—Malaysia, Indonesia, and the Philippines, plus Brunei and Singapore) have been struck by the complementarity of men's and women's work and the relative lack of ritual or economic differentiation between men and women there.

The sorts of things said about Bali can stand as an example of the sorts of things that have been said about Southeast Asia generally. Jane Belo, writing in the 1930's and 1940's, emphasized the complementarity of the sexes in Bali: "The most important point is the complementariness of the sexes, male and female together

making up an entity, completing each other. Like the Chinese yin and yang, the theme male and female (*loeh moewani*) is endlessly repeated and recurrent in every context from the description of the gods to the terms for a carpenter's joining" (Belo 1949:14). Moreover, Belo goes on to say, in many areas of life, the distinction between the sexes is irrelevant: in some circumstances, daughters can substitute for sons, or husbands for wives. When a child is born, "no special point is made as to whether the infant is male or female"; and in the very young and very old, "the difference in sex is of no consequence." As Belo saw it, "only for purposes of mating is it felt necessary to keep the two sexes distinct. During the years of young courtship there is rather more emphasis on the difference between male and female" (ibid.: 14–15). In sum, she emphasizes the substitutability of female for male, and concludes that "male and female together, as an entity, is an idea which runs through the whole culture. If a woman acts, she acts as the representative of this entity, not as a female attempting to usurp a male role nor as a matriarch who tends to put the male in a position of subordination" (ibid.: 16–17).

Writing several decades later, Clifford Geertz comments on Bali in a similar vein. He writes that "sexual differentiation is culturally extremely played down in Bali and most activities, formal and informal, involve the participation of men and women on equal ground, commonly as linked couples. From religion, to politics, to economics, to kinship, to dress, Bali is a rather 'unisex' society, a fact both its customs and its symbolism clearly express. Even in contexts where women do not in fact play much of a role—music, painting, certain agricultural activities—their absence, which is only relative in any case, is more a mere matter of fact than socially enforced" (C. Geertz 1973a: 417–18 n. 4).

The tenor of Belo's and Geertz's remarks about gender in Bali— emphasizing the complementary of the sexes or, alternatively, the downplaying of differences between them—is common in Western commentary about gender relations in the area, insofar as gender is a topic of comment at all. For as striking as the alleged high status of women in the area is the paucity of sustained scholarly attention to them. In the study cited above, Esterik continues by asking, "when we look to Southeast Asia for documentation on

women, what do we find? A delightfully refreshing cliché about the high status of women in this part of the world and very little else" (1982a: 1). Few collections focusing on women of the area even exist. Of those, most span several wide geographical-cultural areas (such as all of South and Southeast Asia), and most concentrate on economic and development issues.[1] None relates the topic of "women" to contemporary feminist and anthropological theory. None approaches the topic as the issue of "gender" (as contrasted to "women"), that is, as a cultural system of practices and symbols implicating both women and men.

Even so, it is worth noting that these collections all characterize Southeast Asia as an area in which men and women enjoy equally many economic privileges and freedoms. Barbara Ward (1963a), contrasting Southeast Asian women's roles and privileges with those of women in South Asia (especially India and Pakistan), attributes the greater equality of women and men in Southeast Asia in large part to what she calls the "family structure" predominant in a good part of Southeast Asia, namely "bilateral kinship." Several ideas are usually compounded within the idea of "bilateral" or "cognatic" kinship; the term is usually applied when, in a given society, a child is considered equally related to both its parents, when kinship terminology is the same when applied to relatives on both parents' "sides" (a Euro-American way of thinking about it) of the family, and when the most important social grouping of which a person is a part comprises relatives from both parents' "sides." This way of conceptualizing and organizing social relations is indeed widespread in Southeast Asia, although there are notable exceptions there that do not conform to all or any of the criteria mentioned above (mainly societies in Sumatra and Eastern Indonesia). It is also true that in many parts of Southeast Asia women inherit wealth and noble titles (if the society has them) equally with their brothers, and maintain control over their wealth even after marriage. Moreover, the exchanges of wealth at marriage throughout the area tend either to be reciprocal between bride's and groom's families (thus requiring expenditure on the part of each) or to cost the groom's side more than the bride's in the form of "bridewealth," services or valuables rendered by the groom or groom's family to the bride and her family. As a conse-

quence, throughout most of Southeast Asia female children are not a greater financial burden on their parents than male children when they marry—in contrast, for example, to the case in much of India, where the necessity of providing a daughter with a dowry makes the wedding of female children a financial burden on their parents. Commentators on Southeast Asia often remark that the births of male and female children are equally valued.

Another reason that Westerners tend to view women throughout Southeast Asia as having "high status" is that women are usually the ones who deal with money and control family finances, and often become traders. Instead of doling out spending money to their wives, men tend to receive it from their wives. Traditional wet-rice agricultural requirements and the division of labor in harvesting and rice-hulling also gave poor women considerable scope for earning cash or being paid in kind, although mechanized harvesters and hullers have reduced the ability of poorer women and men to earn (cf. Stoler 1977). Throughout the area, there is a customary distinction between men's and women's tasks and labor, but Robinson's comment on Soroako, South Sulawesi, can be generalized to other societies of the area: "In the peasant economy it seemed a way of organising tasks, and did not entail a means of one group appropriating surplus from another" (Robinson 1988: 71). Moreover, in many of these societies either spouse will substitute for an absent husband or wife in the event that he or she is unable to perform some task; and when a couple divorces, husband and wife split evenly what was acquired during their time together. Thus women's financial circumstances in this part of the world appear relatively favorable, at least if contrasted with women's circumstances in much of India and China.

Perhaps the relative economic equality of men and women and the paucity of symbolic expressions of gender differences explain why the issue of gender in this area of the world has excited so little attention. As Atkinson has pointed out, "How one studies the significance of sex differences in a system that minimizes them is far more difficult than cases where clitoridectomy, foot binding, and homosexual fellatio fairly scream out for ethnographic investigation" (Atkinson 1982: 257). Because feminist theories about gender tend to be formulated for and from societies

where male-female difference is highly marked, we may be miss-
ing issues germane to the topic when we glance casually at the
"high status of women" in an area where the treatment of women
seems relatively benign.

Actually, it could be that differences between men and women
are not socially visible to us because they are not marked in ways
we easily recognize. I am not arguing that the differences between
men and women are, in fact, highly marked socially in island
Southeast Asia; actually, I think they are not—if they are con-
trasted with differences in certain other parts of the world rather
than taken on their own terms. But within the societies them-
selves, subtle differences may be important as gender markers but
may go unnoticed by observers. A minor case in point: both men
and women wear sarongs in Bali, but they tie them slightly differ-
ently; to us, the difference is small, but to the Balinese it may
speak a world of difference.

A second reason we may have difficulty grasping the meanings
and import of gender difference in island Southeast Asia is that we
tend to assume that "power" and "status" are cross-culturally rec-
ognizable. We in Euro-America tend to identify power with eco-
nomic control and coercive force: any status or prestige not linked
to it we tend to conceptualize as empty prestige, mere symbolism.
We also tend to identify "power" with activity, forcefulness, get-
ting things done, instrumentality, and effectiveness brought about
through calculation of means to achieve goals. The prevalent view
in many parts of island Southeast Asia, however, is that to exert
force, to make explicit commands, or to engage in direct activity—
in other words, to exert "power" in a Western sense—reveals a
lack of spiritual power and effective potency, and consequently di-
minishes prestige.

A Javanese notion of "power" is exemplified and emblematized
by the contrast between the shadow-puppet figures of Arjuna, a
Javanese culture-hero, and the *raksasa* ('monster') he fights. (See
the illustration on page 6.) Arjuna is small and fragile-looking,
with downcast eyes and delicate features. The monster is large,
bulbous, loud, forceful, and direct—not unlike (in Javanese eyes)
many of the loud, raucous Westerners who have recently invaded
their island. Yet in a battle, the delicate Arjuna need only flick his

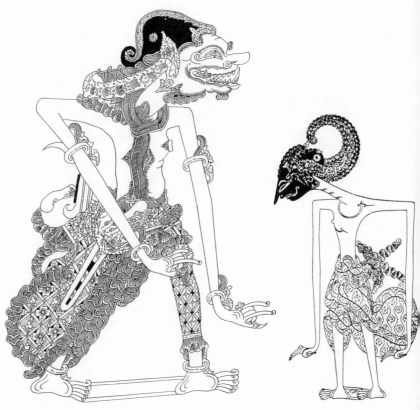

The delicate but spiritually powerful Arjuna (right) confronts the monster Cakil. (Drawing by Hardjowirogo, in the possession of Benedict Anderson; used with permission.)

wrist for the gross and forceful monster to fall, defeated. Not just incidentally, very high-status noble men and others regarded as "powerful" in Javanese eyes (such as puppeteers and spiritual leaders), who may be graceful and slight of build, sometimes strike Westerners as effeminate.

The relevance of all this for the study of gender is that women in many of these societies are assumed to be more calculating, instrumental, and direct than men, and their very control of prac-

tical matters and money, their economic "power," may be the opposite of the kind of "power" or spiritual potency that brings the greatest prestige; it may assure them of lower rather than higher prestige. This is not to say that women in Southeast Asia would be better off in any sense without economic autonomy and control over the products of their labor; nonetheless, to pull out of context their economic and instrumental power and to designate it as the most important factor in high prestige is to create an optical illusion based on the importation of Eurocentric ideas about the relations of power and prestige.

Our views of gender in other cultures may also be informed and misinformed by what Connell distinguishes as "categorical theory" (1987: 54–61)—perhaps better termed merely "categorical thinking." "Categorical theorists" use terms like "sexual stratification," "sex class," and "the [universal] patriarchy," he writes. This sort of thinking, Connell points out, takes the categories of the two sexes for granted, stressing conflict of interests between them; but it is not very helpful for showing how these interests are constituted or how the sexes construct themselves. I would add that in hierarchical societies of Southeast Asia, it is very clear that women who are of high status by birth outrank men who are of low status by birth, whether by material or symbolic criteria; moreover, in many societies, among them quite a few in island Southeast Asia, a woman acting in the capacity of sister is quite different for social purposes from a woman acting in the capacity of wife. In either case, it is difficult to conceptualize "the" status of women in such a society, or to imagine what their collective interests might be in relation to the opposing category, men.

More examples could be given, but the point is that, at best, no simple content or criterion of high status or low can measure the status and power of women cross-culturally. At worst, our most unconscious common-sense ideas about "power," and with it "status," may have to be turned inside out if we are to understand the relations between men and women in some parts of the world. Although the social and economic equality of women in island Southeast Asia is certainly impressive, terms like "equality" and "power" barely begin to tell the story of how differences be-

tween men and women, and the powers to which each has access and may exercise, are understood and constituted there.

This book is about men and women in island Southeast Asia. Although far from homogeneous in their theoretical approaches, the editors and the contributors are all concerned with gender as a cultural system of meaning pertaining to the differences and similarities between men and women as they are lived and interpreted in particular contexts; and all of them are concerned with the relevance of those gender meanings for the differential access that men and women have to local sources and emblems of power and prestige. These island Southeast Asian cases therefore provide us with materials useful for recasting and reexamining some of the theoretical issues that currently most concern feminists and others interested in culture and power. Key texts in the conversation concerning the nature of men, women, and power to which this book contributes include the collections edited by Michelle Rosaldo and Louise Lamphere (1974), Rayna Reiter (1975), Sherry Ortner and Harriet Whitehead (1981a), and Jane Collier and Sylvia Yanagisako (1987). The last two collections are immediately relevant to the formulation of issues in this volume. Ortner and Whitehead proposed the idea that societies have "prestige systems," which are especially salient for gender constructions. That idea is very useful in conceptualizing the issue of status in island Southeast Asia, and Jane Atkinson and I have made use of it in our introductions to individual papers. Collier and Yanagisako raised the importance of coming to terms with the relation between "sex" and "gender," an issue I address at length in the first part of this introduction.

A variety of concerns have emerged in this conversation and in the related ones conducted within other strands of feminist thought.

The debate has been characterized over the course of the last twenty years or so by a gradual movement from universal questions raised and universal categories and arguments proposed to answer them, to a greater interest in formulating general or universal questions in ways that can be answered by examining particular contexts. For instance, "Is the [presumably universal] divi-

sion of labor between men and women the first class struggle?" has been transformed for Marxists into something like "How do race, class, and gender intersect to affect the welfare of women in such-and-such a society and historical period?" And "Why is the status of women low everywhere?" has been transformed into something like "What is the dominant prestige system of such-and-such a society, and how does gender difference fit into it?"[2]

One of the most recent and most productive transformations of universals into context-dependent particulars concerns the status of the very categories "man" and "woman." To speak of the statuses of "men" and "women" as though they could be discerned globally, for instance, as early phases of this debate did, not only assumes that "status" is measurable cross-culturally but also presupposes that the species falls into two natural categories, "men" and "women," without any cultural "work" or interpretation to construct those categories. Several lines of questioning have eroded an earlier unself-conscious acceptance of these categories.

One line of questioning is voiced by feminists outside Euro-America who have objected that white middle-class Euro-American feminists' assumptions about women's "nature," interests, and goals did not relate to their own aspirations or local struggles. These objections have led to considerably more self-reflexivity among American feminists about the forms that status and power take in different cultural settings. Implicitly, they have also brought about an awareness that "woman" is not necessarily a universal category, and that the sorts of persons identified as women are constructed culturally.

Another source of the erosion of the idea of males and females as self-evident "natural" entities, unconstructed by history except in superficial ways, is the work of Michel Foucault. Foucault's insistence that bodies are "historical" (e.g. Foucault 1975, 1979, 1980) has prompted an explosion of interest in bodies (medical, criminal, and gendered) as constructed artifacts. This expanding literature, predominantly in literary and historical studies, has regrettably been largely ignored in discussions about sex and gender in a feminist theory in the social sciences.

A third line of questioning that has eroded or at least challenged the idea of "woman" as a cross-cultural constant has emerged

in the debates about the resurgent biologistic and determinist explanations for the social differences between men and women. The specter that haunts feminism is biological determinism, and a version of it has been raised recently by proponents of sociobiology. Partly in order to counter some of the explanations for differences in the social roles and occupations of men and women proffered by those proponents, some feminist commentators reject the naturalness of the categories "male" and "female." To reject "male" and "female" as natural categories, however, seems to leave unresolved the issue of the relation between men and women as socially constructed beings and their physiological functions and anatomical attributes, the relations of "gender" to "sex."[3] This rejection flies in the face of a common-sense belief that the species "naturally" falls into male and female categories, necessary for reproduction, and it seems to deny the fact that human bodies' genitals, everywhere and nearly always, conform to one of two major types in our species.

The time seems ripe both for recasting the relations of sex and gender and for relating that new formulation of what it means to be a gendered person to the idea of prestige and power systems. The first of these projects, recasting the relations between sex and gender, which recalls issues posed by Collier and Yanagisako (1987), requires a theory of the body in relation to cultural meanings. In the first part of this introduction ("Body and Person"), I propose a view of the relation between culture and the body, between "gender" and "sex," that takes both into account without making one seem more basic or causally prior to the shape and meaning of the other and thereby avoids making one of them appear as secondary or a mere reflection of the other.

The second of these projects, relating gendered bodies/persons to "prestige systems," relevant to issues posed by Ortner and Whitehead (1981a), requires, I believe, both the first project (recasting the concept of gendered bodies) and also a way of thinking about the local, culturally specific ways that "power" and prestige are construed and enacted socially. In "Body and Person" I will only touch on the issue of power, but it is central to my consideration of the organization of societies in island Southeast Asia. Hence some of the ideas proposed in the first project of recasting

the "person" are worked out in much greater ethnographic detail in the introduction's second part ("Island Southeast Asia"), which also provides cultural and geographical background about the area. The general tack I take in approaching these topics is cultural, emphasizing meaning; and I put the concept of the "person" at the center of the analysis.

Body and Person

Some Assertions About the Body

Although the ways humans are embodied (as opposed to, say, the way wasps are embodied) make human culture possible, few cultural anthropologists begin with the fact that humans have bodies or with the ways our human embodiment enables, constrains, and informs human activities. Curiously enough, however, in popular discourse whenever the topic of women or of differences between men and women comes up, "biology" suddenly becomes an issue. That is probably because we in the Anglo-American world tend to think of "gender" as the social construction and elaboration of the bedrock biological "facts" of sexual difference. Thus to raise the topic of gender is ipso facto to raise the topic of sex, and therefore of the importance of biology.

Sex researchers, biologists, and physicians tend to study "sex" as though it were a biological phenomenon, whereas historians, anthropologists, and feminist theorists often take "gender" as their subject, investigating it as a social and historical phenomenon. Partly because of the pervasive emphasis on sex, and therefore on biology, in discussions of gender, I will sketch here my formulation of the relations between "biology" and "culture," embodiment and human interpretation and activity, before recasting "sex" and "gender."

The most basic and obvious importance of embodiment for culture and vice versa is that we are born biologically unfinished and require human culture in order to develop into humans. (See C. Geertz 1973b for a classic formulation of this interactive approach to bodies and culture.) Human genetic potentials set the

parameters of the bodies we have: we have big brains, opposable thumbs, upright posture; we cannot live without air; we can talk. Humans, like other living creatures, need appropriate environments in which to become humans. No one would say that an acorn, to turn into an oak, did not need earth, nutrients, and water; yet some of the more extreme biological determinists write as though people emerge full-formed from genes, like Athena from the head of Zeus, without going through any stages of development. The environment we humans need to develop into humans is composed not only of physical substances and conditions like food, water, and warmth, but also of human companionship and culture, from mother's milk to people who talk to us. Humans who do not have humans to talk to do not learn to talk, regardless of their genetic potential to talk; the few examples of "wild" children are stunted and pathetic creatures (cf. Curtiss 1977; Lane 1976; Shattuck 1980). From the time the fetus forms, the human body and the physiocultural environment in which it exists are in a state of continuous interaction. "Nature versus nurture" or "genes versus environment" are therefore spurious and highly misleading phrases; they emblematize an erroneous way of thinking about human embodiment.

It follows from the specifically human ways that we are embodied that our potentials are general, and consequently largely without content. Take the fact that we must eat, a fact neither trivial nor debatable. The same is true for koala bears: they must eat. But koala bears are adapted to eat nothing but eucalyptus leaves. Their bodies impose upon them a constraint that is also a command: not just "Eat!" but "Eat eucalyptus leaves!" Humans are also obliged to eat, but the universal command ("Eat!") is fulfilled by a content particular to a particular environment, culture, and system of meaning. What items count as food, on what occasions they are eaten, how they are prepared, their articulation with the culture's aesthetic and ethical systems, the part eating plays in the larger economic and symbolic context—all are culturally and historically contingent.[4] In other words, our human embodiment provides us with a set of human "potentials," both constraints and possibilities: for example, we cannot fly, we cannot go without sleep, we are upright, we reproduce sexually, we must eat. The

forms and constraints of embodiment for the conduct of human life are not trivial in any sense, and all humans have approximately the same sorts of bodies. But only a few of the specific characteristics of any particular person's body—eye color, skin color, hair texture—are coded directly from genes, relatively impervious to environment. Height, weight, posture, what prompts the person's adrenaline to flow—those are shaped through the cultural environment, not solely by genes.

It follows that the human body cannot play the part of fundamental cause or ultimate authority in an analysis of cultural social beings. As Clifford Geertz put it, "What [the co-evolution of human bodies and the capacity for culture] means is that culture, rather than being added on, so to speak, to a finished or virtually finished animal, was ingredient, and centrally ingredient, in the production of that animal itself" (C. Geertz 1973b: 47). Our embodiment is a nontrivial and universal human attribute, but it does not form a bedrock of ahistorical, acultural "nature" on which culture is draped by history as an afterthought, like a collection of variegated clothing of many lands drying on the rocks. A case in point is adrenaline. Adrenaline is part of the body, is "physical," not "cultural." It emerges into the bloodstream of a person who is very frightened or very elated. Yet what causes fright and elation depends partly on the culture in which a person finds himself or herself, and partly on the person's own self-restraint and training. Something similar could be said about bodily characteristics that are molded into and manifest themselves as "gender" characteristics in a particular culture. Most humans have XX or XY chromosomes; XX and XY chromosomes help to trigger certain developmental processes in the body, and these result in a predominance of estrogen in some bodies and testosterone in others. Does a lot of testosterone in a body cause the person to be aggressive? Well, some cultures glorify aggression, and some cultures value its restraint. In each sort of culture, some men and some women manage to restrain their aggression, some do not. Testosterone may provide a predisposition toward aggression, but it does not *cause* aggression any more than artistic talent causes a person to paint illusionistic pictures in oils; both require training and encouragement and constraint. The bodies we have and the cultures in which we live con-

tinuously interact: human embodiment makes culture possible, and conversely human bodies are cultural artifacts, formed within human cultures.

In sum, human bodies and the cultures in which they grow cannot be separated conceptually without seriously misconstruing the nature of each. We are not stratified into a biological base and a cultural superstructure; what we do know about human bodies and culture is that the two are not layered. Culture does not lie on the surface of the anatomical and physiological base as a decoration, the way icing lies on a cake. If human social life were compared to a cake, we would better say that "biological givens" are analogous to flour, eggs, and sugar, and the socializing process of human interaction "cooks" them into their final form: cake. There can be no cake without its raw ingredients, and culture's raw ingredients are a capacity for language, mammalian sexual reproduction, opposable thumbs, and the rest of it; but by the same token, these would be merely sugar, eggs, and flour—not a cake but the potential for a cake—without the cooking process of human interaction and culture.

Our human form of embodiment, which includes a large brain with a large cerebrum (where language and voluntary functions are located), constructs us in such a way that we constantly engage ourselves in interpreting our worlds, our environments, and, not the least of it, our bodies. We are constructed in such a way that we cannot *not* make an effort to make sense of things, and one of the most obvious things that we humans think about and use culturally is our bodies. Human bodies provide us with attributes— uprightness, dark skins, light skins, penises, vaginas, brown, blue, or green eyes, to name a few—which may well be put to social use, interpreted as signs that tell us who we are and what we are doing on this earth. The list of our attributes is endless, and particular cultures make sense of some of them, ignore others, and invent others. The sense made of bodies is far from universal.[5]

Two points must be made, then, about biology and culture: bodies and cultures interact and form each other; and interpretations of the nature and functions and capacities of the body differ in different cultures. The question of how the body/person is constituted beyond the universal potentials it shares with all other

humans is unanswerable without reference to the cultures and material circumstances the bodies/persons formed in. Human cultures "dictate" human bodies, as well as vice versa. From this point on I will take it for granted that the body is not a one-way cause of anything. It exists, but it does not provide its own interpretation or dictate the activities (including "gender roles," character, or temperament) that humans will engage in or ought to engage in. The fact that bodies with their sexual apparatuses really exist does not keep them from being historical and cultural artifacts as well.

The question we can and ought to ask of the body is not what it is naturally like outside or before culture: that question is meaningless. What we *can* reasonably ask is, What meanings are human bodies asked to bear in particular cultures and historical periods? One of the most important sets of meanings bodies are asked to bear in any given culture is the culture's gender ideology, its mythologies of the person with special reference to men and women. (I use the term "mythology" here as Barthes [1972] does; he defines the activity of "mythologizing" as making that which is cultural and historical appear to be natural.) I turn now to sketch an approach to unpacking and unraveling a culture's sex/gender system.

A Model for the Study of the Person

A useful way to begin the examination of any society's myths of gender is to look at local notions of the "person," that is, of what people in a particular culture think it is to be human. For the purposes of studying power and difference, especially gender difference, cross-culturally, I suggest that the study of the "person" can usefully be divided into three areas of focus.

The first area concerns local ideas about the body, focusing on the analogues of what we call anatomy. The first aspect of the anatomy analogue consists of its hidden dimensions, such as the internal structure of the body or person, including its souls, its organization, and the energies that move it. I would count the function of the heart in the circulation of blood, for instance, as an "internal" aspect of anatomy, for it is not visible to casual inspection and is so far from common-sense understandings about the body

that it had to be discovered by Harvey in 1628. Other hidden aspects are chromosomes and hormones. Obviously, not all cultural systems construe hidden anatomy this way. Another example of an internal anatomy analogue is the belief in Luwu, South Sulawesi, that humans have a life-energy called *sumange'* attached at the navel. Although Luwu people see evidences of sumange', they do not see sumange' itself; it remains a hidden aspect of their local anatomy (cf. Errington 1983).

The second aspect of anatomy concerns the surfaces of the body visible to inspection, such as hair, eye, and skin color, genitalia, and height. Visible attributes of the body can be interpreted as meaningful signs in a given culture. These signs point in two directions: inward toward the hidden interior anatomy analogue of the person, and outward toward demeanor and activities. Probably in all cultures visible body signs point in both directions. Skin color, for instance, is a visible sign that may in certain cultures and times be believed to index deeper hidden characteristics of the person, anatomical or moral or both. Genitals are also visible signs in our own culture, which are believed to index deep elements of hidden anatomy, invisible to casual inspection: chromosomes and hormones. The body's visible signs also point outward, toward behavior and social expectations. In some societies a person's skin color leads to behavioral expectations about the person's innate capacities and appropriate demeanor. Similarly, the presence or assumed presence of a certain type of genitals on a body is read as signs by other members of the society that the person with them will behave in certain ways. Such expectations are likely to be heavily moralized, because classifications of members of a society into separate categories using visible bodily attributes as their signs and justifications are likely to be moral categories, not merely reflections of the society's members' ideas about the statistical probability that people with such-and-such attributes will act in certain ways. The social order, as Durkheim pointed out, is a moral order, and people's bodies are used by it both as raw material to be molded and as evidence of its correspondence to the way things really are.

The visible attributes that human bodies display are infinite in number, and any of them may or may not be used as the signs of a

social category. Even if some visible attributes of human bodies seem so obvious that they cannot be ignored and *require* interpretation by a society's members (genitals would seem to be such an attribute), what those visible attributes become signs *of* can be highly variable cross-culturally: the hidden presumed interior organization of the person the signs are thought to indicate is by no means shared by all human groups, and the behavioral expectations they prompt are also highly variable cross-culturally.

Indeed, where do the visible aspects of the body end and demeanor and behavior begin? In Java and much of the rest of island Southeast Asia, bodily behaviors—one's posture and demeanor, the tone of one's voice—are constantly attended to and read as signs of inner moral states.[6] Thus the first area of focus I propose for the study of the person shades into the second, the person's behavior and social attributes exhibiting identity: how a person goes about demonstrating convincingly that he or she is a proper person in that society. In any given society, any number of bodily attributes may figure into the way categories of persons are constituted, and may be used in assigning infants to those categories. But regardless of how inherent the person's attributes, including genitalia, are considered to be, they require social enactment to be convincing. Having genitals of a particular sort, for instance, is not by itself enough to make a person into a proper member of the category the person has been assigned to at birth or aspires to belong to whose visible sign is that sort of genitals. (An early and well-known study on this topic is Garfinkel's 1967 account of the transsexual Agnes, which showed how much work Agnes had to do in order to maintain a female identity.)

Incidentally, it would be interesting to see how closely people in a particular society think that their own demeanors and behaviors are linked to attributes in the first area of focus, the body, and how closely they think they ought to be linked. It seems clear, for instance, that some societies designate certain activities as "male," others as "female," but do not prevent people with nonmale genitals from doing "male" activities and vice versa, even if statistically the vast majority of the people who engage in each type of activity have the genitals that correspond to the categories' respective names. Similarly, it is possible for cultural systems to concep-

tualize the structure of the universe as gendered, or its cosmic energies as gendered, without concomitantly assuming that people with men's and women's bodies must divide their activities along gendered lines that correspond to male and female cosmic divisions. For instance, many Eastern Indonesian societies, in which dualisms of every sort pervade ritual and everyday life, typically had two chiefs, an "inner" dignified chief called "Mother," and an "outer" active chief called "Father"; but men usually filled both positions. In other words, a rhetoric of gender could be used to describe or characterize "male" and "female" cosmic energies, roles, activities, or functions in a particular society, but without a presumption that they either reflect or are anchored in physical differences between men and women, or that the sexed bodies of individual men and women are required to fulfill or enact those activities or roles. The ties between physical sex and ideas about gender and gendered energies may be much looser than we usually imagine to be the case.

The third area of focus concerns the access that persons of different sorts or categories constitutive of their social identities have to power. In very hierarchical societies, the most salient differences between people with respect to power might well be high- and low-status birth; in others it might be dark skin and light; in yet others it might be a person's social classification as a man or a woman or as a third or even fourth category, such as a *berdache* among Plains Indians, or a *bissu* in South Sulawesi, or as any one of several categories in America (e.g., transsexual, transvestite, or homosexual). Particular social classifications of people, such as by skin color, genitals, or generation, have different valences in different societies. The apparently "same" sets of categories (for instance, black and white, or male and female) have different moral force in various societies, and a society's most fundamental classifications of people articulate with each other in varying ways. The categories of greatest interest here are those with differential relevance for their members' access to power.

Finally, I would argue that ideas about what power is and how prestige should be attained vary greatly cross-culturally, and that local ways of gaining power and prestige both affect and are affected by local ideas concerning the constitution of the person.

"Sex" as the Gender System of the West

A sketch of the myth of the "person" along the lines proposed above in contemporary Euro-America might look something like this.

The way a society conceptually divides up the person is apparent in the sorts of curers it has and what it thinks those curers can cure. Euro-American culture has two major categories of curers: doctors of the "body" and doctors of the "soul" or "psyche." This culture's understanding of the "person" postulates a physical realm called "anatomy" or "biology," which is regarded as subject to mechanical and physical laws of operation—a realm called "objective," believed to be outside culture and history, a natural rather than a human construct. That realm is regarded as quite distinct from the realm called "subjective," which includes a complex of ideas and words such as "spirit," "mind," "meaning," "culture," etc. The two realms correspond to a host of pairs that line up: nature—culture, mechanism—consciousness, body—mind.

In this culture, the visible signs on an infant's body are used at birth to classify the infant, assigning it to one of two mutually exclusive and exhaustive categories, "male" and "female." Although it is recognized that some infants have ambiguous genitals, no allowance is made for a third category in hospital sex-assignment at birth (cf. Kessler and McKenna 1978), and, as Garfinkel puts it, "from the standpoint of an adult member of our society, the perceived environment of 'normally sexed persons' is populated by two sexes and only two sexes, 'male' and 'female'" (Garfinkel 1967: 122–23; and see his seven generalizations in subsequent pages).

The infant's genitals at birth are regarded as indexical signs (thus "natural") of two other components of what is called the "sexual" identity of the person. On the one hand, infant genitals are seen as signs of more hidden interior differences called "chromosomes." It is known in this culture that most human sex chromosomes fall into one of two major types, XX or XY. It is also known that many humans have incomplete or broken or extra chromosomes in their bodies; nevertheless, in accord with this culture's social classification of persons into two mutually ex-

clusive and exhaustive categories, no provision is made for a third or multiple types of sexed beings with nonstandard chromosome sets. (So, for instance, Olympic athletes who claim to be women but do not have perfect XX chromosomes are classified as men.) On the other hand, genitals are also seen as signs of future sexuality: it is assumed that they will develop at puberty into adult "sex organs." At maturity, these organs are also viewed as signs of further interior, hidden fluid substances called "hormones." It is known that all bodies have many "hormones," and it is known that the amounts of various hormones in any given body fluctuate; nevertheless, it is assumed that people in each of the two mutually exclusive and exhaustive categories have amounts of hormones congruent with the category to which the person has been assigned.

In one respect, the genitals stand as signs of inner hidden substances and fluids that are classed as part of "nature" or the "objective" realm of the "body." In another respect, the social import of these genitals is that they stand as signs of reproductive capacity. The physical union of persons with complementary genitals is believed in this culture to be linked to conception, which eventually leads to parturition and therefore is the key symbol denoting the physical reproduction of persons. Such a belief is widespread throughout humankind, but it has particular force in this society because it is widely believed that the two mutually exclusive and exhaustive categories of people exist *in order to* reproduce. Many believe also that any use of the genitals for purposes other than reproduction is an abuse and misuse of them. This view is probably based ultimately on some of the culture's sacred books, which continue to exert a powerful influence on social policy and everyday practices. It was long held in this culture that to spill fluids from the genitals outside the body of a person with complementary genitals was immoral and harmful. Consequently some of the society's religious sects disapprove of people with complementary genitals mating with no intent to reproduce. The physical union of people with similar genitals, which will not result in offspring, is considered by many people in this culture to be even more immoral, contrary to "nature," which (the feeling and argument go) dictates that male and female were created in

order to reproduce. The logic of all this is that genitals in this culture, and the male and female bodies attached to them, are deeply associated with ideas about the reproduction of the species. One of the several consequences is that genitals are widely felt to be signs of what the attached person's sexual preference ought to be.

Genitals, then, along with invisible body fluids and substances of which they are believed to be signs, are classed in this culture as part of the "natural," "objective" realm, and humans are assumed to be "naturally" divided into two categories without the help of cultural ideas or social institutions—and the main *raison d'être* of those two categories is generally believed, whether by religious persons or by secular evolutionary biologists, to be reproduction. I will call this the taxonomy of Sex, with a capital "S." By "Sex" I mean not just the fact that human genitals both at infancy and at maturity do indeed tend to exist in two major genital types. By "Sex" I mean to include the whole complex of beliefs about genitals as signs of deeper substances and fluids and about the functions and appropriate uses of genitals; the assignment of the body into the category of the "natural" (itself a culturally constructed category); and the cultural division of all human bodies into two mutually exclusive and exhaustive Sex categories.

In this culture, people's genitals are usually covered; so, even though the genitals are the sign of Sex, which is an important aspect of personal identity in this culture, they cannot be used in most circumstances of casual inspection to infer another person's Sex. The person's behavior, dress, and other social attributes are themselves read as signs of genital-class membership. Dress and demeanor ("culture") *ought* in this culture to act as an indexical sign of inner body ("nature"), and when they sometimes do not, people are disturbed. For instance, men who have an urge to "cross-dress" wonder whether they are less than full men; and men who cross-dress in public can make a profession of it as drag queens or "transvestites." Other attributes and behaviors of people in the two Sex categories—such as their scores on math tests, their numerical frequency in various occupations and professions, and so on—are widely regarded as stemming directly from, as reflecting, in fact, their respective "natural" Sexual differences. Once again, many studies have shown that these behavioral and social differ-

ences between men and women are not produced by "natural" Sex
differences between them. Nonetheless, the resistance in this cul-
ture to a social analysis of social phenomena is very strong, and
educated people are not averse to attributing virtually all differ-
ences between men and women to some "natural" difference be-
tween the Sexes.

Exhibiting one's membership in one of the two major Sex cate-
gories actually requires effort. Writing about contemporary Amer-
ica, the sociologists Candace West and Don H. Zimmerman distin-
guish between "sex," "sex category," and "gender." Sex, they state,
is "a determination made through the application of socially agreed
upon biological criteria for classifying persons as females or males"
(1987: 127). By "sex category," they mean the "sex to which a per-
son is assigned by social processes" (in Euro-America, usually at or
near birth, and usually determined by infant genitalia). By "gen-
der," they mean the enactment of "sex categories." One of their
points is that people are not simply assigned to a sex category and
thereafter hold it as a sinecure, but rather that a person's gender
must continually be affirmed and expressed in social practice, an
activity they call "doing gender."

An attractive feature of this schematization is that by suggest-
ing that sex (what I call Sex) is a social determination rather than a
natural given, West and Zimmerman point to the mythical status
of Sex in contemporary America. Another virtue is that, although
they maintain an analytical distinction between these three lev-
els, the authors view them as related: the specific way of "doing
gender" may differ in different contexts, yet all are enactments of
Sex categories, which in turn are based on the mythical categori-
zation Sex, which is thought to be an aspect of "nature."

Access to (locally defined) power is one of the most salient as-
pects of "doing gender" in America, for when women "do gender"
in a way appropriate for females, they reveal themselves as non-
powerful. In this respect, Nancy Henley's book *Body Politics* (1977),
again about contemporary America, can be read as a kind of hand-
book on the enactment of power, through body stance and de-
meanor as well as other realms of behavior, and the consequences
of particular enactments for the demonstration of and therefore

access to interpersonal power—in Henley's eyes relevant especially to gender, race, and class.

More implications of this culture's classifications of the Sexes into mutually exclusive and exhaustive categories (admitting no easy ambiguity or third term) can be teased out. For instance, because of this system of classification and because a person's membership in one of the two categories is believed to be so closely linked to the person's body, this culture has a business in altering the genitals of people who want to cross categories. It is not enough to simply act or dress in ways appropriate to the other category, as it is in some other cultures. Moreover, because ideas about the constitution of Sex are believed to be unitary, natural, and unarguable, yet in fact involve multiple criteria and attributes, people who do not exhibit congruence in all criteria for determining a person's Sex (i.e., chromosomes, hormones, dress, sexual preference, and others) can be viewed as anomalous. People who cross-dress, people who occasionally or always mate with people who have genitals similar to their own, people who act in ways stereotypically attributed to the opposite Sex, and people who enter occupations largely filled by people of the opposite Sex, are widely viewed as "unnatural," even perverse.

Apparently to deal with the fact that the criteria for determining Sex are not always congruent in all members of the population, this culture has invented another term, "gender," to designate social categories that are related to or based on Sex classes. Although Sex is regarded as natural and biological and gender as socially constructed, it is nonetheless true that "gender" is usually regarded as an elaboration of Sexual difference (with all that implies in this culture as to Sexual reproduction, mating preference, etc.), as Collier and Yanagisako have pointed out (1987). To illustrate: Most people in this culture would probably maintain that there are only two Sexes; but the number of genders could be debated. Are people who mate with others with similar genitals a third gender? If so, are there two sub-genders, or perhaps even three: one for people with one set of genitals who mate with those with a similar set, one for people with the opposite set who mate with those with a set similar to theirs, and one for people who mate with those of

both similar and complementary genitals? What gender are people who cross-dress yet prefer to mate with people with complementary genitals? The absurdity of these questions simply serves to point out that there are two genders, which reflect two Sexes—not three genders, or five. The idea of gender is not usually detached from the idea that it reflects the two Sex categories.

The difference between the Sexes is part of a larger mythic structure, the distinction between nature and culture. One of the important uses to which the nature–culture contrast has been put is, rather paradoxically, to "mythologize" (in Barthes's [1972] sense) differences—differences between races, ethnic groups, classes, Sexes, Europeans and non-Europeans.

One can read nineteenth-century social evolutionism as an effort to "mythologize" the differences between colonizer and colonized by locating them as steps in evolutionary stages. Or one can read the eugenics movement in America in the early part of the twentieth century as an effort to "mythologize" the visible differences in income, I.Q., and the like between blacks and whites, criminals and law-abiding citizens, lower classes and upper, the sane and the insane, immigrants and natives, by locating them in inherited characteristics (cf. Gould 1981; Kevles 1985). These particular forms of "mythologizing," of making differences appear to have a cause in something suprahistorical and supracultural, have now largely lost credibility in mainstream scientific inquiry. The abuse of genetic theories in Hitler's Germany discredited the Euro-American eugenics movements, which in the 1920's had been part of mainstream science, and even silenced discussion of hereditary characteristics of social classes and of "ethnic groups" or "populations" (cf. Jenks 1987; Kevles 1985). The decolonization of the world after World War II indirectly but emphatically ended the rhetoric of race as the explanation for the alleged inferiority of the colonized. In short, world events diminished the legitimacy of a rhetoric of bodily or genetic difference to explain differences between social classes, populations, ethnic groups, or "races" in mainstream scientific research, if not in popular discourse.

Curiously enough, however, the rhetoric within which the differences between men and women are discussed remains largely biological. If anything, the effort to locate the cause of differences

in behavior and in social and economic statuses between men and women within biological (Sex) differences has hardly abated, and may even have increased. Such leaps to biologistic explanatory modes would not be tolerated in the scientific mainstream if they were used to explain differences in performance between "races" or classes. But in scientific, popular, and even some forms of feminist imagination, Sex remains the biological, hence "real," base, which culture merely elaborates and reflects.

Another way that relations between men and women commonly are mapped onto the nature–culture divide is the assertion that women are in some way closer to nature, men to culture. Implicit in this strategy is the claim that male and female differences are essential and ahistorical, even if the details are worked out in the media available at a particular point in history. Several serious works by feminists have been written in this vein.[7] Although some of those authors do not actually write that Woman's essential nature is different from Man's, and might indeed want to distance themselves from that position, much in those books suggests that interpretation. An essentializing stance of the sort suggested, if not explicitly made, in those books—and certainly taken up with no qualifications by many feminists citing and quoting them—does not constitute an escape from gender stereotypes prevalent in the West: quite the contrary. To "discover" that women are nurturant, loving, intuitive, and irrational, while men are abstract and logical, does not tell us something new and different about men and women, as Judith Shapiro (1988) has pointed out, but rather reinvents Western stereotypes with an elaborate apparatus of "science," just as studies based on such premises tell us what we already (think we) know.

A curious feature of assertions about the "Nature" of "Man" and "Woman" is that they often imply or even claim a moral. If Woman is more nurturant, etc., and Man is more aggressive, etc., then women and men should be more like what they already really are: i.e., women ought to strive to be virtuously nurturant and soft, while men ought to be competitive and in control; or women should rear children while men fight wars. On the face of it, the moral corollary is silly: why should we strive to be more like what we are? But, of course, the popular interest in reading

about differences between men and women, just as was once the
motive for locating differences between the so-called "races" or
between social classes, is often to rank those differences in order
to judge their moral and social import. And the conclusion often
reached is that it is more moral for men and women to strive to
maintain these "natural" differences than it is for them to engage
in practices contrary to them, which are seen as merely cultural
and historical, epiphenomenal, and even contrary to "nature." It is
probably no accident that many antifeminists, as well as some
feminists, postulate an essential and natural male and female "na-
ture," albeit for different ends.

Essentialist stances strike me as parallel to nineteenth-century
efforts to understand the essential nature of "savages." Like that
ploy, the stance that essentializes Woman—regardless of what
evaluation of her is proposed—has a double edge: if, for example,
Woman is more nuturant, closer to "nature" than Man, more
right-brained and intuitive (as some claim), how can it not also be
the case that these very capacities make girls poor at math? Rac-
ism and romanticism, like praise and blame, are each other's flip
sides. To assert that Man and Woman each has an essential, ahis-
torical "nature" seems both incorrect and a political mistake.

Sex, sex, and Gender

I propose here that we distinguish between Sex, sex, and gender.
By "Sex," I mean a particular construct of human bodies, one
prevalent in Euro-America, whose major features I have outlined
above. By "sex," I mean to point to human bodies, but I do not
want to give it much content or I will begin unintentionally to re-
invent Sex. I can clarify the problem with an analogue. Historians
use the term "history" both to denote events that occurred in the
past and to designate writings of a particular genre known as "his-
tory." As long as they believed that historical writings were small-
scale descriptive models of events in the past that corresponded
mimetically to the structure of those events, using the two terms
for the two different things did not worry them. Hayden White's
Metahistory (1973), which argued that historical writings come in
a variety of rhetorical modes, did not actually question whether

events occurred in the past ("history"), but it did throw into question the mimetic correspondence of historical writings to those events. Many historians were disturbed, accusing White of believing that events did not happen, or that there is no difference between history and fiction. That was not the point. Analogously, I am not arguing that humans do not have bodies or that those bodies are not sexed, just as no one argues that events did not occur; but we have no way of characterizing those bodies except in culturally specific terms, any more than one can write about past events without casting them into some genre, some rhetorical mode. I have no good neutral alternative to the terms "bodies" and "embodiment" and "sex" for the materials of which we are made, but by differentiating between sex and Sex I mean to point to something that exists but has no meaning outside the way it is construed within specific cultures and historical periods.

By "gender" or "gender system," I mean what different cultures make of sex. (There are many other cultural constructions of differences, of course; skin color, for instance, might feature prominently in the social construction of significant differences, and socially and politically significant categories of people can be socially constructed completely without the use of members' bodily attributes to distinguish them.) Thus Sex is the gender system of the West, because Sex is the most predominant and pervasive sense made of sex in this culture and era. Behavior, dress, and other social constructs tend to be regarded as elaborations on the basic "facts" of Sex, which are in turn seen as indistinguishable from sex.

The distinction between sex and Sex will seem spurious to some: for what can possibly be meant by sex except Sex? Collier and Yanagisako, following Schneider's ideas on kinship, have argued something along that line in their edited collection *Gender and Kinship* (1987). Their argument is that gender is virtually always construed as a reflection of sex differences, and that sex differences in this era and culture are viewed as being "about" reproduction; similarly, the anthropological topic of kinship has long been predicated on the idea of natural biological reproductive processes, which are viewed as precultural. Collier and Yanagisako therefore see the two topics as linked, and ask the reason for the

persistence of ideas about the "natural" in these two realms when we anthropologists tend to regard a wide range of other realms as socially constructed. "The answer Schneider has proposed," they write, "is that our theory of kinship is simultaneously a folk theory of biological reproduction" (Collier and Yanagisako 1987:31). They suggest that the same folk theory of biological reproduction informs our ideas about sex; and they argue that the study of gender as cultural systems is therefore hampered by the pervasive "conviction that the biological difference in the roles of women and men in sexual reproduction lies at the core of the cultural organization of gender [which] persists in comparative analyses" (ibid: 32).

Collier and Yanagisako well understand that the word "sex" is not neutral. It usually denotes a particular understanding and social construct of the body, one that is culturally and historically specific (the one that I call Sex). They consequently want to avoid linking the study of gender to the concept of sex in any way, because they believe that any mention of sex carries a load of culture-specific meanings, such as the idea that women's bodies are specialized to reproduce, that biology has its own imperatives, that male and female constitute a natural dichotomous set, and so on.

In the terms I am using now and have sketched in previous sections, Collier and Yanagisako collapse sex, one of the many features of human bodies, and Sex, a particular cultural construction of human bodies. As a result, they are unable to imagine what sex could look like if it did not look like Sex, and understandably hesitate to use the term, proposing instead that the study of gender should proceed without it. In other words, because our ideas about gender are linked to our ideas about sex, and those ideas about sex are deeply enmeshed in ideas about reproduction, it seems impossible to the authors to acknowledge the existence of sex because to do so would contaminate the study of gender with assumptions about male and female roles in sexual reproduction and biological determinisms of various sorts (ibid.: 15 and 32). They propose, therefore, to dissociate the study of gender from sex, and, presumably, to study only cultural constructions.

The problem with their solution is that it is rather difficult to imagine what the topic of "gender" would refer to if it had no relation to sex. As Collier and Yanagisako themselves say, "It is impossible, of course, to know what gender or kinship would mean if they are to be entirely disconnected from sex and biological reproduction" (ibid.: 34).

Let us do a thought experiment, imagining what "gender" would look like not only without Sex but without sex. I think there are two possibilities. One is that, echoing its Latin root, "gender" would mean simply "class" or "distinction" or "genre." This is one of the ways the term has been used in linguistics. (See Shapiro 1989 on this use of "gender.") It could encompass any distinctions made in social life, from young to old and black to white, and none of those distinctions need be dualistic ones. So, men in different age-grade societies could be said to exhibit "gender" distinctions, if "gender" were used as equivalent to "classification." This possibility is not likely to appeal to most feminists, who are usually interested in women in some form, not in just any culturally constructed distinctions.

A second possibility for dissociating gender from sex is to restrict the word "gender" to any dualistic distinctions with organizing prominence that are made in a society, on the view that men and women form a contrastive pair rather than a continuum. Following this program, we would call any socially acknowledged differences between night and day, black and white, alive and dead, right and left, and so on, "gender" differences. Two objections to this solution come to mind. One of them I just mentioned: most feminists are more interested in women, or in the culturally constructed contrasts and similarities between women and men, than they are in the culturally constructed contrasts between night and day or earth and sky. As students of "gender," we ought to identify a starting point that will likely lead us to women and men more often than to up and down or right and left. The second objection is that this solution reifies "male" and "female" as a dichotomous distinction, allowing no third term or, for that matter, other ways of configuring the relations between classes of people, such as thinking of male and female as the poles of a continuum, or think-

ing of men and women as basically the same sorts of beings. The dualism solution thereby reproduces what I called Sex rather than dissolves it.

This thought experiment reveals, I think, that dissociating sex and gender completely is not likely to clarify matters. It would not only cause considerable confusion about what "gender" might possibly mean; it also tends ultimately to perpetuate the distinction between "idealism" and "materialism," and the endless and fruitless debate between the proponents of each. It perpetuates it because dissociating sex and gender and then studying only one half of the pair, gender, is analogous to asserting that culture is the superorganic, and, by implication, that cultures transcend the fact that people have bodies, and that analyses of human activities and symbols need never refer to human embodiment or to practice. That sort of thinking prompts outraged cries of "Idealist!" and "Let us begin with the fact that Man must eat!" from commentators who fancy themselves practical materialists.

What is required is to socialize the body rather than to deny its existence. I have tried to sketch a possible rapprochement between culture and embodiment in the preceding sections by using the term "gender" to mean the cultural elaboration and context of meaning through which sex is construed in a society. By "sex" I do not mean to imply any of the thousand things that are implied by the construct of sexual difference that I have called Sex, such as that semen impregnates women, or that women are "specialized" for reproduction (as some have claimed), or that people with different genitals have different hormones, or that the different sexes usually have or ought to have a particular sexual preference.

If by Sex I mean a cultural construction, a gender construct, what do I mean by sex, which I have carefully not defined except to say that it has something to do with the body? How will we know that Sex and other gender constructs refer to sex rather than to stereoscopic vision or opposable thumbs or any other bodily attributes?

The likeliest point of linkage is probably the genitals, because (unlike, for instance, chromosomes) they are on the surface of the body and therefore are accessible as signs to all cultures; and because the vast majority of infant bodies exhibit them in one of two

major configurations. Genitals do not provide us with meanings that are constant cross-culturally: as I pointed out, as signs they point inward to anatomy analogues that are not shared cross-culturally; and they point outward to behavior that is not uniform cross-culturally. But they provide a reasonable starting point for identifying a topic that emerges in some form in all cultures.

The Body as a System of Signs

Viewing the body as a system of signs in no way denies its existence as a physical entity, and consequently does not perpetuate the endless idealist-materialist debate. Quite the contrary, the fact that bodies really do exist and have genitals adds considerably to the symbolic power that cultural understandings of genitals and their meanings have for people. Here the work of Lévi-Strauss, especially in *The Savage Mind* (1962), is useful. Lévi-Strauss claims that "la pensée sauvage," untutored or undomesticated or unself-reflexive thought, uses the concrete, perceivable attributes of the world in order to make sense of the world through taxonomies based on contrastive oppositions. (Note, however, that it is impossible to know a priori which attributes of things in the world will be chosen to build up taxonomies of contrastive oppositions. Note, too, that all unreflexive thought is "sauvage," undomesticated, if it does not question its own assumptions, most particularly, for our purposes, the category of Sex.)

The analogy with anatomical differences in human bodies is this: just as a plant species has infinite attributes—smell, shape, color, etc.—so, too, human bodies have infinite attributes—smell, height, skin color, hand shape, protrusions, orifices, hair shape, eye color, etc. Any of these attributes can be used for the basis of classificatory schemes, or, to push the point a little further than Lévi-Strauss, can be used as evidence of the truth of classifications already made. By the same token, any of these attributes can be ignored or downplayed. Skin color and eye shape, say, can be used to make classes called "races." But "race" is a social classification, not a biologically produced "natural" category—even though some people do in fact have lighter skin, and some have darker. Like skin color and eye shape, body attributes such as genitals, lacta-

tion, ejaculation, bodily protrusions like breasts and so forth, may figure in classifications. But which of these attributes will be used, how many categories will be formed, what their significance will be, and how the bodies that come to occupy the classes are related to other aspects of social life and other socially significant local categories of people, can all be pursued as empirical questions in particular societies. They do not emerge from the attributes themselves.

Drawing on Lévi-Strauss's *Totemism* (1963b), Judith Shapiro has written an exceptionally useful piece on this topic called "Gender Totemism" (1988). "According to Lévi-Strauss," she points out, "the world of animal and plant species, which in some ways resembled one another and in other respects differed, offered a particularly suitable model for representing relationships among human groups" (Shapiro 1988: 3). To understand "totemism," Lévi-Strauss argued, we must stop asking what the relationship, functional or utilitarian or even symbolic, is between a group and its totem-animal (a question that implicitly conceptualizes the natural world in terms of its "real" functional or utilitarian qualities) and must instead ask about the ways in which the signs (the totems) are locally imagined to be related to each other.

Shapiro uses Lévi-Strauss's insight to reformulate the oppositional distinction between "male" and "female," viewing this opposition as occurring at the level of signs rather than as derived from or produced by the attributes of bodies. She writes:

Following the logic of Lévi-Strauss's argument, we can say that the biological opposition between female and male, like the array of animal species, provides a powerful natural model for representing differences between social groups and oppositions between culturally significant categories. In terms of Lévi-Straussian structuralism, with its particular emphasis on binary opposition, sex is, in fact, especially suited to this structural symbolic work. Binarism aside, however, the main point is to shift focus from the properties of groups to the nexus of relationships. Instead of focusing on the characteristics of women as a group or men as a group ("What do members of the Bear Clan have in common?" "How are members of the Bear Clan like bears?"), the issue becomes one of seeing how a series of categorical oppositions, including the one between female and male, map onto and construct each other. (Ibid.: 3)

For Lévi-Strauss or Shapiro, the fact that differences among hu-
man bodies, or among animal and plant species, "really" exist is
no hindrance to these attributes being used for cultural purposes;
on the contrary, the real existence of these attributes makes them
all the more powerful when they are construed as significant dif-
ferences within systems of signs. People can point to them as em-
pirical proof that the categories they articulate are real, based on
natural differences, not the product of human consciousness. This
is what Lévi-Strauss means by undomesticated thought, and this
is why the sciences of the concrete are so powerfully convincing.
The evidence is in front of your eyes.

Shapiro's use of Lévi-Strauss and my sketch of Sex differences
are different approaches to showing that Sex, like any gender sys-
tem, is a mythic structure. We cannot escape mythic structures
because nothing speaks for itself, nothing carries its own meaning,
and further, humans are constructed so as not to be able not to in-
terpret. We have no choice about participating in meaning sys-
tems. But Sex is not the only way to sort out human bodies, not
the only way to make sense of sex. One can easily imagine differ-
ent cultural classifications and rationales for gender categories,
different scenarios that equally take into account the evidence our
bodies provide.

A cultural system could have a category for infants with ambig-
uous genitals at birth, or whose genitals do not develop at puberty.
In such a case, the classes into which people's bodies were mapped
would, like our Sex categories, have specific reference to genitals,
but would invent three classes rather than our two. Or a culture
could imagine that people are "male" or "female" only during the
sexually productive phases of their lives, and that prepubescent
boys and girls and postmenopausal women are socially gender-
neutral. Thus the gender classes into which a person's body fell
would be temporally inflected with reference to the person's life-
time. Then again, some societies regard an infant's social classifi-
cation with respect to its genitals more as a potential than as a fait
accompli at birth or even puberty, and it requires social effort—for
instance, the infusion of male substances—to make little boys
into men (e.g., in highlands New Guinea; cf. Herdt 1987).

However classifications may be articulated with respect to body attributes, in no society, even our own, do a person's body characteristics (skin color, genital accoutrements, age, etc.) suffice to make that person into a socially adequate member of a particular class. Cultural classifications, including Western Sex, exist not just as thought, as ideas about what it is to be human, but also as practices. Societies do not merely imagine classifications: they also require their members to enact those classifications, which are moral, not merely statistical, categories.

When this society, for instance, classifies its members' bodies into two Sex categories, it also requires its members to enact those categories in ways that are both convincing and socially acceptable; in West and Zimmerman's phrase (1987), Euro-American society requires its members to "do gender." "Doing gender" is viewed as the "natural" expression of Sex. Many societies, however, emphasize the enacting or "doing" of a social classification as much as or more than they emphasize the congenital basis upon which a person may have been put into that class in the first place. So, for instance, a society may categorize its infants into two main classes tentatively on the basis of genitals, thus socially instituting a distinction analogous to our "men" and "women," "male" and "female," and it may insist that its members enact this dual classification. Yet "doing" these two major classes may turn out to be distributed over a wide variety of activities and signs: men and women may work at different tasks, speak in different styles or with different vocabularies, dress in different clothing (or tie their similar clothing around themselves with different knots), move with different gestures. A person with male genitals at birth who enacts the behavior of women might be classed as a woman, or as a third classification that corresponds perfectly to neither of the dominant ones and whose members are all adults. People's genitals may constitute a starting point for their social classification, but they are not necessarily definitive. Most societies do not have the technological capability, it is true, to change a person's genitals from one type to another; but it is also true that many would consider it unnecessary.

Classifications (based on skin color, or genitals, or relative age,

or whatever) into which human bodies may be put by particular cultures coexist within the cultures' broader notions of what it is to be a person. If we think for a moment of genitals as one of the (several) differences humans bodies may exhibit, it will be clear that it is entirely reasonable and in accord with the facts of our embodiment to emphasize either differences or similarities between male and female bodies.

Some cultures insist that men and women are profoundly different sorts of beings who draw on different sorts of cosmic energies and are constituted in very different ways anatomically and psychologically. These cultures may think of the distinction between men and women as the most profound and significant difference that human life offers up, worthy of elaboration and contemplation in every sphere of activity and thought, from strict divisions of labor, to separate men's and women's religious cults, curing rites, and birth ceremonies, to separate language styles or highly gender-inflected languages. Many New Guinea peoples apparently interpret human nature this way (cf. Strathern 1987a, 1987b), as do some of the societies of the circum-Mediterranean area (cf. Abu-Lughod 1986 and its references). In some of these societies, the difference between male and female bodies is taken as a fundamental emblem of difference in general; it may be the most fundamental distinction among human beings, the difference that informs and forms all other distinctions and that must be acknowledged or accommodated by other classes of difference.

Other human cultures downplay the differences between male and female bodies and between men and women as social persons, and these interpretations are also plausible. All humans, after all, share a great deal of common anatomy: upright posture, stereoscopic vision, opposable thumbs. A culture, then, can conceptualize all human bodies and human "persons" as very similar to each other, barely inflected by anatomical difference and functioning. Quite a few societies in island Southeast Asia apparently take this view, and the lack of emphasis on differences between men and women in many aspects of life may be one of the reasons that so little attention has been paid to the topic of "gender" in this region: at first glance it presents us with a blank rather than with a

subject. Following Atkinson (1982), I suggested earlier that this apparent blank begins to explain why the subject of gender in Southeast Asia has largely been ignored.

The body is a malleable vehicle of meaning. The issue is not what bodies are "really" like without culture, or what sex is "really" like without gendered constructions of it, nor whether bodies are important in or to culture (they are), but what meanings bodies are asked to bear in particular cultures and historical periods. The work of Mary Douglas (1966) is of course pioneering on this topic; but Douglas's suggestive formulation contains almost no account of the gendered body and almost none of the politics informing particular constructs of the body in a given society. Shapiro's approach to gender (1986, mentioned above) is structuralist, concerned primarily with categories and classifications as sets of oppositional elements. But once we ask about cultural constructs of the body and gender classifications, we can ask political questions about them. Shapiro goes on to ask, for instance (although she does not answer at length), what cultural and ideological "work" is done by gender totemism in the contemporary West, and inquires how some strands of feminist research themselves feed into and replicate this gender totemism. Social historians, inspired by Foucault, have gone much further than most anthropologists and feminist theorists in the project of understanding the body, including the gendered body, as systems of meaning and ideological constructs linked to the exercise of power. (See, for instance, Gallagher and Laquer 1986; Representations 17 [1987; special issue]; Foucault 1975, 1979, 1980.)

Understanding the body as a cultural construct does not *replace* understanding the body as a material entity that inhabits the world, eats, engages in passionate encounters, and participates in a thousand practical activities. Quite the contrary: gendered bodies, as signs and as tokens within systems of signs, are all the more potent as signs for being put to daily practical uses. At the most abstract and contentless level, these signs obey universal commands, as it were (Eat! Reproduce! Classify! Interpret!)—commands that human body-persons cannot *not* obey, for humans are both enabled and constrained to obey them by their specifically human

embodiment. That something is a sign does not mean that we must abandon examining its material presence and its ideological work.

Bradd Shore has addressed the practical uses and "motivation" (distance from arbitrariness) of powerful signs at length in a piece called "Totem as Practically Reason: Food for Thought" (1986). To paraphrase very briefly and radically simplify the gist of his argument, animals are both good to eat *and* good to think, not just one or the other. Not only is there no contradiction between the two; their deliciousness helps to motivate their power as signs.

Similarities and distinctions between men and women, like similarities and distinctions between totemic animals, are good to think; their bodies and activities provide rich material for classification and interpretation, which are basic human activities. And the myriad activities that gendered human bodies engage in, from sexual activity and lactation to being isolated in menstrual huts and participating in marriage exchanges, are, like eating totemic animals, satisfyingly "good" in practical, material terms, which, because we are human and condemned to interpret, cannot be dissociated from symbolic-meaningful terms. To emphasize the cultural constructs and symbolism of the gendered body is not to remove it from politics and practicality but to enmesh it within them.

The papers in this volume concern gendered bodies and gendered persons in island Southeast Asia, and how they are mapped onto and into ideological and political systems that constrain and enable the activities of men and women and what it means to be men, women, and third or other classifications of people there. I turn now to sketch some background relevant to gender systems in island Southeast Asia.

Island Southeast Asia

As a region, island Southeast Asia is ecologically and culturally diverse and historically almost dizzyingly complex. The societies lying within it range from the fairly egalitarian hunters and gath-

erers and slash-and-burn horticulturalists of the mountainous rainforests, to the vast hierarchical "Indic States" of Java and Bali that engaged in wet-rice agriculture, to the symbolically dualistic societies practicing a variety of modes of subsistence of northern Sumatra and the Lesser Sundas. Wave after wave of traders, bearers of religious ideas, and colonial powers have swept over the area, flooding (so to speak) some areas, trickling into others, and stopping short before reaching others. Hindu and Buddhist ideas and trade "indicized" Java, Bali, the Malay peninsula, and the lowland parts of South Sulawesi well before the first millennium A.D., but did not spread (a few vocabulary items aside) into most of the Lesser Sundas and the Philippine islands. Bali remains "Hindu-Buddhist," as they say in Indonesia, but subsequently Islam became well established in northern Sumatra, the Malay peninsula, and throughout Java by the fifteenth century. Indonesia remains very diverse in its religions: a statistical majority profess Islam (although the type of Islam practiced there tends to be quite different from the Middle Eastern and North African varieties); Bali remains Hindu; many Indonesians have become Christians, most within the twentieth century and almost all of them in its second half; and not all peoples adhere to a world religion, but practice their local ones. In Malaysia, by contrast, to be "Malay" is to be Muslim, but a large number of people of Chinese descent live there, and almost none practice Islam. The Philippines is overwhelmingly Christian, mainly Roman Catholic, with a significant Muslim population in its southern islands. Different colonial powers colonized the three major nation-states of this area. By the mid-nineteenth century, the British were firmly ensconced in what was to become Malaysia, while the Dutch were in control of what would become Indonesia. The Spanish had been in the Philippine islands for many centuries, but were replaced by the Americans at the turn of this century. Along with the rest of Asia, these formerly colonized regions became independent nation-states after World War II.

In spite of the tremendous diversity of every sort within this region, certain common themes concerning gender, the "person," power, and the constitution of significant difference emerge from a reading of the history and anthropology of this area. I will try to cast these themes along the lines I suggested for a model of the

study of the "person": the anatomy analogue (both invisible interior and visible signs), deference and demeanor and how to "do gender," and the relevance of and access by these constructed identities to local notions of power.

The analogue of anatomy has not been much studied in island Southeast Asia, at least as it pertains to gender. In this volume, Atkinson discusses the Wana, a hill people of Central Sulawesi, who view male and female anatomy as nearly identical, and I have argued (1989: ch. 1) that Luwu "internal" anatomy similarly is viewed as identical for male and female and high and low. I have the impression that in a good part of island Southeast Asia, the part I call the "Centrist Archipelago" (see 1989: Part III; map on p. xvii, this volume; and below), male and female are viewed as basically the same sorts of beings, that is, ones whose souls and functioning are very similar or are parallel. In this part of island Southeast Asia gender differences tend to be downplayed in ritual, economics, and dress; kinship terminology and practice tend to be bilateral; and male and female are viewed as complementary or even identical beings in many respects.

A second area of island Southeast Asia, which I term the "Exchange Archipelago," consisting of Eastern Indonesia (the Lesser Sundas) and parts of Sumatra, promotes a different sort of gender ideology. The social organization of these societies is very complex, but the gist of it is that the entire system of marital exchanges they practice is predicated on the distinction between male and female, and the fact that women must leave their natal Houses (social groupings) in order to marry men who are not their "brothers." These societies construct their symbolic forms in terms of paired oppositions—right and left, sky and earth, inside and outside, etc. One need not be a Durkheimian to find it understandable that the "anatomy" of male and female is likely to be construed differently there than in the Centrist Archipelago, and that Male–Female forms a prominent symbolic pair there. Hoskins (this volume) mentions in passing that male and female in Kodi, Sumba (in the Exchange Archipelago), are each believed to have two souls, but the "male" soul becomes more developed among men, the "female" one, among women. This is suggestive, but

anatomy analogues, especially gendered ones, are a neglected topic in the Exchange Archipelago as well as the Centrist.

The second area to focus upon consists of demeanor, behavior, and activities: how people show that they are convincing members of the category they are assigned to or choose to join. The papers in this volume are rich sources of information on this topic. One of the issues that several take up is precisely why, when male and female "persons" are not viewed as so radically different, nonetheless women's political prominence and prestige tends to be less than men's and their speech tends to be regarded as less potent.

The third area of focus is the access that constructed gendered identities have to power, as it is locally imagined. This is a topic of special interest with respect to island Southeast Asia because differential male–female access to power tends to be located, in local theory, not at the level of the "person"'s intrinsic gendered characteristics or anatomy analogue, but in practices. Island Southeast Asians tend not to be biological reductionists: they usually do not claim that women, because they are anatomically women, are weak or ineffective. Rather, they are probabilists: they point out that women and men are basically the same, but because of the activities women engage in or fail to do, they tend not to become prominent and powerful. Thus, as Atkinson puts it, a Wana woman who becomes a powerful shaman has not broken the rules but beaten the odds. The why's and wherefore's of women's "statistical" relative lack of power and prestige form the problematic of a number of papers in this collection.

I want to turn now to local island Southeast Asian notions of power, an explication of which will help to illuminate ideas about the person, the background of cultural assumptions, and the broad outlines of the cultural topography of the area. I begin below by outlining the idea of power in island Southeast Asia, then argue that an original source of power splits, in myth, into two types of difference: hierarchical, coded by age, and complementary, coded by gender. I finish by explicating the symbolism of gender in the marriage systems of the two areas I call the "Centrist Archipelago" and the "Exchange Archipelago."

Power

We in Euro-America now take for granted that "power" names a secular relation between people. Many other humans live or historically lived with very different notions about power and effectiveness—from the healing powers of water at Lourdes, France, to an Islamic *barakat*, to the blessings given to those who make *puja* in an Indian temple, to the Chinese Mandate of Heaven. Such ideas about cosmic powers continue to inform the healing rites and religious ceremonies of many societies in the world. Before the mainly nineteenth-century adoption of the idea of the secular nation-state as the model for conceptualizing and organizing polities in Europe, and its subsequent virtually universal adoption throughout the rest of the world by the second half of the twentieth century (cf. Anderson 1972, 1983; Gellner 1983), notions based on nonsecular ideas about the nature of power—such as the notion of intrinsic connections between cosmic powers and human life—informed the exercise of statecraft in perhaps most of the world's major polities. In those polities, "state" or "political" power was organized around the acquisition or demonstration by state dignitaries of suprahuman powers, powers that were believed to link human society with natural and cosmic energies.

The kingdoms of Central Java in what is now Indonesia were such societies, and the classic work on this subject is Benedict Anderson's "The Idea of Power in Javanese Culture" (1972). In it, Anderson notes that political power became an explicit problem for Western thinkers only in the period of secularization in Europe after the Renaissance and Reformation, when kingships waned and the secular polities that would eventually become nation-states arose. "The contemporary concept of power," he writes, "arose historically from the need to interpret politics in a secular world." In Europe since the sixteenth or seventeenth century, "power" has named an abstract relation between people: it is not something that actually "exists." In traditional Javanese political thought, by contrast, "power" is "concrete," more like a substance or an energy:

This is the first and central premise of Javanese political thought. Power exists, independent of its possible users. It is not a theoretical postulate

but an existential reality. Power is that intangible, mysterious, and divine energy which animates the universe. It is manifested in every aspect of the natural world, in stones, trees, clouds, and fire, but is expressed quintessentially in the central mystery of life, the process of generation and regeneration. In Javanese traditional thinking there is no sharp division between organic and inorganic matter, for everything is sustained by the same invisible power. This conception of the entire cosmos being suffused by a formless, constantly creative energy provides the basic link between the "animism" of the Javanese villages, and the high metaphysical pantheism of the urban centers. (Anderson 1972:7)

Anderson points out that this notion of "power," which I will henceforth call "potency" or "spiritual potency" for the sake of clarity, presents very different political problems for people who want to acquire it and interpret it than does the idea of power as an abstract relation. His article details some of the ideas and practices of politics in the precolonial Javanese Indic State, and some of their relevance to the practice of politics in the contemporary Indonesian nation-state.

There is no denying a very general understanding throughout island Southeast Asia that the world that humans inhabit—the visible, palpable, tastable, audible world—is intersected and permeated by a realm called in Indonesian the *alam ghaib*, the invisible or spirit realm. One of the most important implications of this understanding for our purposes is that "the central problem raised by this conception of [potency], by contrast with the Western tradition of political theory, is not the exercise of [potency] but its accumulation" (Anderson 1972:8). O. W. Wolters (1982) has suggested that tapping such powers and emerging as a leader with an entourage is a very ancient Southeast Asian form of politics and political structures. He calls the leaders "men of prowess," and points out that their follower-worshippers believed that care of the leader, and the potency he embodied, would bring them prosperity and fertility. It seems that a good part of the indigenous politics and symbolic forms of this area have as their intention to tap the energy and effectiveness of this invisible realm, from the seances of shamans in remote mountain settlements, to the trance-dances of lowland peoples, to the asceticism and meditation of the indicized hierarchical courts of Java and elsewhere.

Potency is invisible. It cannot be known directly. It can be known only by its signs. Consequently, people of island Southeast Asia tend to be expert "readers" of the world and its events and inhabitants. This world, the tangible world, stands as a system of signs that can be read as traces of potency. The signs of potency in persons include large amounts of wealth and substantial numbers of followers. These are regarded not as *causes* of a person's prestige but as the signs or by-products of his or her potency.

Potency is unitary; it is a single substance or energy. In the epistemology of sign-reading implied by this fact, potency's unity implies duality, because a center, to be known or "read" as a center, requires a periphery. The periphery around a potent center consists of its entourage or audience, which both signifies and bears witness to the presence of potency. In relatively hierarchical societies, the "audience" of followers may be quite stable, as the descendants of a high-noble follower today become the followers of the high noble's descendants tomorrow. In relatively "level" societies (those with very little hierarchy or stratification), the "audience" of followers literally may be an audience, an ad hoc grouping of people gathered to listen to or benefit from the presence of a person who strives to be a leader. So, Tsing (this volume) describes an aspiring dispute-settler among the very level Meratus of Kalimantan who spends the better part of the day gathering an audience so that his authority may be witnessed—so that he thus will have authority. Atkinson (1989) describes the audiences of shamans among the level Wana of Central Sulawesi, who are necessary to validate the shamans' potency. Potent Wana shamans are known to be such because they develop followings. To attract an audience is to act "politically."

Yet a striking aspect of the demonstration of potency in these situations is that it is divorced from power as it is usually understood in the West, and (in the most level societies) it is completely divorced from force. Those who aspire to demonstrate potency must persuade others to listen to them or be cured by them; the material gain may be negligible, the gain in influence in other contexts, uncertain. The prestige of having potency is its own reward.

It follows that the performing arts tend to be far more important throughout island Southeast Asia than are any silent plastic

or visual arts. Dance, trance-dance, public curing rites through spirit possession, shadow-puppet theater, public chanting of sacred texts—these are the characteristic and best-known expressive forms of island Southeast Asia. It is no accident that these performances attract audiences, that the performers (puppeteers, dancers, chanters . . .) are regarded as capable of performing because they are spiritually potent, and that the degree of the performers' spiritual potency tends to be judged by the size of the audience they attract. The potency of the refined Javanese master-puppeteer (*dalang*) and of the shaman-healer in an isolated hill tribe alike are judged in good measure by how large an audience the performance attracts.

This sort of cultural understanding and assumption, I think, lies behind Clifford Geertz's statement (1980:13) that power (in a Western sense) served pomp in nineteenth-century Bali, rather than pomp serving power. Power—wealth and influence and the control of the means of force—was mobilized in these hierarchical states in order to hold ceremonies ("pomp"), for those ceremonies indicated the degree of the center's potency. Of course, a gloriously successful ceremony, in turn, increased the influence of the center, allowing it ultimately to hold yet more glorious ceremonies, and more of them. (Actually, pomp and power were in a circular reciprocal relation rather than a causal one in which one was logically or socially prior.) Attracting audiences is crucial to the demonstration of potency, and therefore to the exercise of "power," such as it is, in both large hierarchical polities and smaller, more level polities. Individuals who aspire to tap potency and gain prestige must attract audiences.

The center and the periphery it requires and implies structure the shape of "space" and movement in this part of the world. A center is still; its periphery is active. An observer looking at any two items can "read" which one is more central and which one is more peripheral, by observing which moves less and which moves more. Moreover, since potency is invisible and impalpable (part of the alam ghaib rather than the tangible and active human world), the item that is more tangible, more coarse, more brutal, more forceful, is ipso facto the more peripheral.

People in the former Indic State in which I did fieldwork, Luwu

of South Sulawesi (a polity similar in kind, though on a lesser scale, to those of Central Java and Bali), express the relation of the two aspects of potency with a saying, "the *keris* is in the hands of the few, the axe is in the hands of the many." A keris is a sword of particular design, inherited and (formerly) carried only by nobles. It can be used in battle, but its virtue as a weapon lies in its animating potent spirit and the potency of the one who bears it. Unlike ordinary knives and swords, a keris has a sheath. The sheath shields its keris from the careless glance of the many, but it also protects the impotent many from the stinging *moso* of the keris. (*Moso* means 'sting.' Moso is the bite of a snake, the sharpness of a keris, the authority of a noble.) An axe, by contrast, is a crude tool used for practical matters like chopping wood and sago. Appropriately enough, kerises are inherited and formerly were not bought and sold, whereas axes can be made or bought by anyone. Thus kerises are noncirculating valuables, metaphorically immobile, like their possessors, whereas axes circulate through barter or money, hence metaphorically move around, like their possessors. And kerises, like their possessors and like impalpable potency, have little practical utility (a keris is useless for chopping wood), whereas the reverse is true for an axe. So the keris functions metonymically to exemplify noble potency, authority, and immobility, while the axe exemplifies brute force, the material basis of life, activity, practicality, utility, and movement. The contrast reveals the disjunction between what Euro-Americans call "prestige" or "dignity" and what we call "power": the former is empty and "merely symbolic" in our view, whereas "power" is active and practical, has a goal and goes after it. But dignity and "power" are not disjunctive in Luwu and in other hierarchical island Southeast Asian polities and former polities; they express the two necessary aspects of unitary potency.

In the more level societies of what I call the Centrist Archipelago as well, potency has a dual figuration, but it is less obvious. These societies are called level, egalitarian, or nonhierarchical precisely because they have no mechanisms or institution for transferring prestige or potency (such as noble titles or "noble" blood) from one generation to its descendants. No one in these level societies, therefore, is believed to be born already potent, as

high nobles are in the former Indic States of the area. Thus the politics of the accumulation and demonstration of potency in these level societies differ from those of the Indic States. In the level societies, the collection of potency tends to be open to everyone, and prestige is, as a consequence, "achieved." ("Everyone" includes women, in both Indic States and hill tribes. But, for reasons that will become clearer in the papers in this volume, women tend to be less successful collectors of potency than men.) People in these smaller societies typically look outside their own societies to find and acquire potency: to the forest, source of spirit familiars; to the coastal towns on the periphery of Indic States, where they may go to acquire wealth and amulets; and/or to the invisible realm of spirits, accessible by trance. Potent humans in those societies (such as shamans and dispute-settlers) tend to be seen as vehicles and lodging places for potency rather than as sources of potency intrinsic to their bodies (in the way high nobles of hierarchical states fancy it), for potency's source is located outside themselves and their societies, in the potent lowlands or spirit-filled forests. These mountain people have the reputation (in the more hierarchical societies) of being rather direct and unrefined. Indeed, the leaders in these more level societies are active, direct, and forceful: they are orators who persuade and harangue, or shamans who collect invisible allies and undertake spirit quests, or warriors who gather followers and go fight. Their behavior contrasts radically with the "still, unmoving center" aspirations of the centers of hierarchical polities, where total immobility and muteness may be read as an expression of potency.

Significantly enough, in some parts of island Southeast Asia, potency is conceptualized as intrinsically dual. The Lesser Sundas, the string of islands lying to the east of Bali, is known as "Eastern Indonesia," and it is known for its pervasive dualism in virtually every aspect of its ritual and social life: its houses are split into inner and outer spaces, the distinction between right and left is prominent in many contexts, its oratory consists of paired couplets, and so on. Many of these societies were also structured politically as diarchies, in which power was shared by two chiefs, both of them usually male. The inner, more dignified, more spiritually potent chief, often called the "Female" or "Mother" of the polity, had

as a counterpart the more outer, less dignified, more active orator chief, often called the "Male" or "Father" of the polity. The fact that these societies represented potency to themselves as dual, as split into two aspects of nearly (though not quite) equal stature, itself indexes the fact that in those societies potency was never fully captured by an entity that could claim symbolic hegemony, as happened in the Indic States. (Indeed, these Eastern Indonesian societies institutionalized potency in ways that mitigated the chances for or made impossible potency's hegemonic accumulation.) In Luwu and other Indic States of the area, potency was more spread out, less compressed: center and periphery formed an infinite range of gradations. Even so, the center-obsessed Indic States and the more dualistic Eastern Indonesian diarchical structures and symbols of potency were analogous. In Luwu, for instance, the Opu Pa'Bicara (the Lord Orator) stood as the active, speaking periphery of the still center defined by the ruler. Analogously, the active "male" chief stood as the active speaking periphery of the still, quiet, dignified inner "female" chief in Eastern Indonesia.

Difference

The configurations of potency in these societies are various, as I have sketched above; but whatever forms it takes, in many origin myths potency originated from an ancestral unitary source; then, in these myths, some event caused its unity to fracture, and fracture means difference.

The fracture of ancestral potency created difference of two kinds: hierarchy and complementarity. Hierarchy in this part of the world is expressed and coded as difference in age or seniority. Seniors—those who are older by absolute age or by generation or by birth order within a generation—are superior to juniors because they are closer to the ancestral source than juniors are. Complementarity in this part of the world is expressed and coded as difference in sex, in male and female; but the icon and paradigm of sex difference is not husband and wife but brother and sister, the pair into which, in origin myths throughout the area, the original unitary source of potency split. Both types of difference are evident in and expressed by ideas about generational layer and the relation-

ships between people that are evident in the kinship terminology
and the understandings that lie behind it that prevail in this area.

The ancestral source of potency fractured. Moving through
duration, it can be measured as generations. Generations in this
part of the world are linguistically construed in kinship termi-
nology as generational layers. These generational layers are com-
posed of "siblings." So, for instance, in many of these societies, a
person's first cousin is regarded as a "sibling," just a little more
distant than one's full sibling; a second cousin is a "sibling" just a
little more distant than a first cousin. The logic is often quite
straightforward: full siblings share a common "source" (their par-
ents) in the generation above themselves; more distant "siblings"
(such as first cousins) share a common source (their grandparents)
two generations above themselves, hence are a little more distant
both from their common source and from each other. The same
sibling logic applies to a person's parents' generational layer, in
which a person's parents' brothers and sisters as well as their first
cousins and cousins to the nth degree are called and viewed as
aunts and uncles. Similarly, not just the children of one's siblings,
but the children of one's more distant "siblings" (what we call
cousins) become one's nephews and nieces.[8]

In sum, this way of understanding relationships encodes two
types of difference. One is the difference in seniority. Senior gen-
erational layers are supposed to be superior in authority to junior
ones. Within generational layers, the birth order of the children in
a sibling set is important; in some places, such as Bali, children are
given names according to their birth order. The other is the differ-
ence in sex, which, paradigmatically, is the complementary differ-
ence between brother and sister. Throughout the area, brothers
and sisters are allies and are supposed to be mutually helpful and
have long-lasting bonds of affection. So strong is this bond that it
is a paradigm and model for the husband-wife bond. It is probably
significant that in many Indonesian societies, a respectful and af-
fectionate way for a wife to address her husband is "older sibling."

Seniority. Generational layer, what we could call symbolic age,
is the dimension of difference that, elaborated, becomes the di-
mension of prestige, authority, and hierarchy in this area. Many
societies of island Southeast Asia (such as the hunter-gatherer

bands of the area and some of the dry-rice horticulturalists) are, of course, fairly "level," in the sense that their members conceptualize themselves as all peers in prestige, and no attributes of prestige can be inherited. But even these societies have a nascent prestige and authority structure based on generational seniority: people of senior generational layers are supposed to protect and advise those who are younger, while those who are younger are supposed to respect and obey those who are senior. (The generational layerings of kinship terminology make one's generational layer very clear.) Seniority becomes authority within a generational layer, as well: among a set of full siblings, children stand to each other as "elder sibling" or "younger sibling."

In more hierarchical societies of the area, the generational layers are overlaid, but not displaced, by institutionalized structures of inheritable prestige. But it is striking that terms of respect and titles in these societies often suggest seniority, age, or closeness to the ancestral source. For instance, the Buginese term *toma-toa* and the Javanese *wong tuo*, each meaning literally "old person," denote a person who is a generational layer or two senior to the speaker, a person who is respected, a noble person, or a spiritually potent person. Such terms, roughly translatable as "respected elder," are used as pervasively in the Centrist Archipelago as the term "Big Man" is in New Guinea to name a leader or noble. Then, too, Opu and Ampo are noble titles in South Sulawesi and Central Java, respectively, and cognates of those titles as terms of respect are common throughout island Southeast Asia. In much of Eastern Indonesia, with its multiple Houses (social groupings relevant to marriage), elder Houses are superior to younger Houses, the former ritually encompassing the latter.

Island Southeast Asian peoples speak languages of the Austronesian group, which is largely gender-neutral. For one thing, there is nothing analogous to marking with articles or endings the "gender" of nouns that have no sex, the way the French and Spanish do. For another, the term for "human" or "person" is unmarked as to gender. In Indonesian, for instance, the word for a human is *orang*, and it has to be modified to show gender: *orang perempuan* (female person) or *orang laki-laki* (male person). Sibling terms are usually not gender-marked, either. At most, some of

these languages may have terms meaning "my same-sex sibling" and "my opposite-sex sibling," a distinction relative to the speaker rather than to an absolute classification. Pronomial systems, too, are generally unmarked for gender. And habits of speech also support the genderless texture of the language. Throughout much of the area, people ask not "How many brothers and sisters do you have?" but "How many older siblings and younger siblings do you have?" This generally genderless speech provides, as it were, a smooth ground, against which the terms and distinctions based on age or seniority stand out noticeably.

In sum, hierarchical difference and difference in authority tend to be cast, coded, and elaborated as the distinction between senior and junior entities. To this difference, the distinction between male and female bodies is nearly irrelevant.

Complementarity. The syllable *pu* or *fu*, widely used throughout Oceania, is often associated with clusters of meanings concerning ancestors, sources, origin points, bases, and roots. In many of these societies, ancestors are regarded as the "roots" or the "base" from which later people have grown, like plants. Junior people who share a common ancestor are often described as shoots or leaves stemming from a single base.

In Luwu, for instance, people say that full siblings have a common source or root. (The word is *apongeng* or *apuongeng*, from the root-syllable *pu*, whose cognates include *punnana* 'owner'; *puang* 'lord'; and *opu*, a noble title.) The sibling cluster is described as a 'clump' (*rapu*). Coconut palms, banana trees, and bamboo also are said to form rapu. The common root of a clump of growing stems is hidden from view; but, people of Luwu point out, that should not deceive us into imagining that a clump consists of many separate plants. Rather, those stems are simply the visible evidence of a single root, a single source. Full siblings are the same plant, the visible evidence of the same ancestral root, and ideally they ought to act in perfect accord—supporting each other monetarily and politically. Indeed, siblings tend to look at each other as allies. That is especially true of opposite-sex siblings, who are complements rather than competitors. (It is less true of same-sex siblings, especially men.)

The brother-sister pair often features in origin myths through-
out Malayo-Polynesia. The two marry, have a child, and then,
having discovered they are brother and sister and have therefore
committed incest, must part. Or, they wish to marry, but, being
brother and sister, are not allowed to do so, and each seeks a
spouse explicitly as a substitute for the prohibited sibling. Or, in
other variations, they are "married" when they enter the world,
for they are born as opposite-sex twins; but, as they are gods, their
relationship is all right. The variations are many, but they all fea-
ture an ancestral brother-sister pair whose sexual relationship or
lack of it, and their eventual parting, is equivalent to the original
fracture of unity that brings about the world's events and begins
human history.

Fusion. Sometimes unitary wholes never fracture in the first
place, or they exhibit the fusion of difference, or complementarity,
and as a result are especially potent. Boon (this volume) addresses
this theme, suggesting that opposite-sex twins have such an im-
portant symbolic place in the most hierarchical House societies of
the area because they represent the fusion of two kinds of differ-
ence, age and sex. Twins collapse difference in two ways: where
normally two age slots would be expected for two people, twins
are two people who occupy one age slot; where normally one age
slot would result in only one sex, opposite-sex twins are people of
one age slot who have two sexes. And Hoskins (this volume) ad-
dresses the same theme in her paper on the Eastern Indonesian
Kodi, whose deities, with their male-female dual names, represent
the fusion of male-female difference into undifferentiated whole-
ness. "The fusion of male and female attributes among deities,"
writes Hoskins, "symbolizes their concentration of power, whereas
in human beings a parallel fusion of gender characteristics is in-
appropriate and even dangerous." At the level of gods, male and
female are fused into one; but in merely *human* practice, men and
women must be separated for the purpose of exchange between
Houses. Indeed, an old theme in Southeast Asian scholarship is
that the higher an entity's status, the more fusion, or undifferen-
tiation, it can appropriately exhibit—so that marriage between
full siblings in Bali (a union appropriate only for deities), Clifford

Geertz has remarked, is not so much a "sin" as a status mistake. Deities and the highest-status humans are closer to the unitary ancestral source; therefore more unity, less differentiation, is appropriate for them.

At first glance, twinship and double-gendered deities do not seem relevant to institutionalized transvestism in theater and court, which was well known throughout island Southeast Asia in various forms. Several papers in this collection mention gender-switching, homosexuality, and transvestism. Male transvestites, who also sometimes practiced homosexual sex, had a ritual function in several of the Indic States. In South Sulawesi, for instance, the *bissu* (consisting of male transvestites and old women) were the guardians of the royal regalia or ornaments (cf. Hamonic 1987). Chabot's information about the rationale for this institution, obtained from the Makassarese assistant to the government linguist for South Sulawesi in 1948, is as follows:

According to the description of the ritual, performed at the inauguration of the new head of the bissu (Puang Matoa), one of them leads the new head to the ornament of Segeri, a plow, and at this point he makes an announcement the significance of which the assistant reproduced as follows: "It is neither known of the person who is here brought to the sacred object and who touches it, nor of the object, who is the man and who is the woman. If the sacred object is a man, then this person is a woman, and vice versa." (Chabot [1950] 1960: 209)

If this information is accurate, it represents once more the desirability of producing perfect unity by reuniting opposites, forming an undifferentiated unitary whole, a theme that runs through much of social and symbolic life of the area.

In sum, the ancestral source fractures and splits, creating two sorts of difference: hierarchical and complementary. Hierarchical difference has as its metaphorical and often literal basis the elaboration of seniority versus youth; layers of "siblings," elder and younger "siblings," respected elders, and so forth, figure prominently in the images and terms of hierarchical difference. Complementary difference is often imaged and elaborated as the contrast between brother and sister, which stands as the icon of male-

female difference generally. Hierarchical differences tend to be a graded ladder of distinctions, infinitely expandable: one thinks of the difference in Javanese speech between *alus* ('refined') and *kasar* ('direct, crude') with the infinite gradations of *madyo* in-between; and the same is true for alus and kasar behavior, or the stair-step spacing of elder siblings and their younger siblings, or the infinitely expandable social distance between the ruler of a kingdom at its center and the lowest slave of a slave at the social periphery, or the elder-brother House, a ritual center for its younger-brother Houses in Eastern Indonesia, each of which (except the last and lowest) is elder-brother House to its own junior Houses. (For extensive accounts of each of these types of graded differences, see Keeler 1975 on speech levels; H. Geertz 1961 on the family; Reid 1983 on slavery; Traube 1986 and McKinnon 1983 on Eastern Indonesian Houses.) The examples could be multiplied indefinitely, because the principle of graded difference exists throughout island Southeast Asia, and is elaborated in a thousand different media.

Complementary differences tend to be coded as contrastive opposites, often expressed as brother and sister or male and female. In some Indonesian societies, a pair of anything (say, of shoes) is called *laki-bini*, male and female. The rationale of calling a pair "male and female" is obviously not to differentiate one from the other (as in the way we may speak of the parts of a plug as "male" and "female") but to assert that together they form a whole.

Marriage Systems

The complementarity of difference (whether of male and female or even of high and low), and even the effort to eradicate difference through conflation of opposites into unities, form powerful cultural themes in the ritual and ceremonial life of island Southeast Asia, and these themes are expressed in many noticeable ways in everyday sensibilities and psychology.

Two major variations in the idea of unity and its differentiation into brothers and sisters, men and women, exist in island Southeast Asia. These two variations are expressed in and partially constructed by two major variations in the marriage-cum-political

systems of the region. I call those two major variations respectively the "Centrist Archipelago" and the "Exchange Archipelago" (see Figure 2; and see S. Errington 1987, 1989: pt. 3). Neither term is in general use; I introduce them here for the sake of convenience. (The word "archipelago" is something of a misnomer in both cases, but since these terms name conceptual spaces rather than geographical ones, it will do.)

Societies of the Centrist Archipelago are found for the most part on the swath of islands on the rim of mainland Southeast Asia: the Malay peninsula, Kalimantan (Borneo), Java, Sulawesi, Mindanao, the Visayas, Luzon, and other Philippine islands. The Centrist Archipelago includes the former Indic States of Java and Bali, about which Boon, Hatley, and Keeler have written in this volume, and it includes a number of shifting agriculturalist and hunter-gatherers (in Sulawesi and Kalimantan [Borneo]), about which Atkinson and Tsing have written in this volume. Ong's paper here, about factory workers in Malaysia, and Blanc-Szanton's, about changing gender images and ideologies in the Philippines, also concern people of the Centrist Archipelago; these papers are concerned with the changes of gender ideology with the advent of colonialism and global capitalism.

I call these societies "centrist" because they are preoccupied with unity and view fracture and divisiveness as either the result or the cause, or both, of personal illness, community misfortune, or political failure. Thus, Indic States represented themselves historically with images that stressed oneness: as mountains, stable and round; as umbrellas, round and shading; as banyan trees, rooted, protecting, and overarching. Smaller societies of hunter-gatherers and horticulturalists, for instance the Wana of Sulawesi (see Atkinson 1989 and this volume), also emphasize the internal unity of the village as the way to combat illness. Societies of the Centrist Archipelago, too, regard men and women as very much the same sort of creature, descended from a common ancestral source. A question for a number of the papers in this volume that concern Centrist Archipelago societies is how, despite notions about the similarity or even near identity of male and female (as among the Wana), women tend to be systematically disadvantaged in the effort to achieve prestige. The answers given are various, but

they tend to emphasize practice rather than stated rules; women are not prohibited from becoming shamans, meditating, or being highly respected, but their life circumstances and everyday tasks are such that they are disadvantaged. Thus, in Atkinson's phrase, a woman who becomes a shaman in Wana has not broken the rules but beaten the odds.

The second area or set of variations in marriage system and gender relations is well known geographically: its most famous exemplars lie in the lesser Sundas, also known as "Eastern Indonesia," but several can be found as well in Sumatra. Many of these "Exchange Archipelago" societies, like many of the Centrist Archipelago, consider themselves to be descended from a single ancestral origin point that fractured long ago. But unlike Centrist societies here, Exchange Archipelago societies tend to represent themselves as irremediably fractured into pairs. Their self-representations emphasize not unbroken wholes but rather matched pairs. Especially in Eastern Indonesia, symbolic, ritual, and social life is shot through with dualisms at every level. Politically, for instance, many of these societies had diarchies prior to Indonesian independence, which split inner, ritual, and dignified authority from outer, instrumental, and active authority. Socially, these societies consist of "Houses" (a term used to denote both a physical structure and a ritually defined corporate group), each of which is related to other Houses as a wife-giver House or a wife-taker House. Linguistically, these societies' ceremonial languages make much use of paired couplets and parallelism in ritual language. The distinctions between right and left, male and female, heaven and earth, black and white, are used prominently in a variety of media from house forms to funeral ceremonies. (See, e.g., Adams 1969; Cunningham 1964; Fox 1971, 1974, 1980a; McKinnon 1983; Traube 1986; Valeri 1980.) Papers by Hoskins, Kuipers, and Valeri in this collection address issues of gender in Eastern Indonesia, and Susan Rodgers has written in this volume about the Angkola Batak of Sumatra, whose marriage systems and myths of the "person" are very similar in principle to Eastern Indonesian ones, emphasizing the duality of the genders and other dualisms. For those interested in this subject, Rodgers's paper also includes a brief and exceptionally lucid account of "exchange" marriage systems, known

in anthropological literature as "asymmetric alliance systems," which are typical of the Exchange Archipelago.

Like other symbolic forms of the area, gender ideologies of the Exchange Archipelago stress complementary difference rather than unity or sameness, even though much of ritual and symbolic life there strives to achieve a form of unity; but the union of forever distinct opposites, which will eventually have to be fractured, once more, into twos, is as close as can be gotten to it. The reasons for this are complex, but have to do with the way that difference is institutionalized through the practices of exchange there. When the authors of papers in this volume ask themselves how the complementarity of the sexes has relevance to the access each side has to spiritual potency and prestige, the answers they give tend to stress the relations of exchange, which both institutionalizes fracture and also circulates women, rather than men, from House to House.

In spite of the structural and institutional differences between these two areas of island Southeast Asia, it is sometimes striking how close the gender ideologies of the two areas are; the difference between men's and women's speech in Java (as represented in Keeler's paper, this volume), for instance, which counts as a former Indic State of the Centrist Archipelago, is very similar in principle to the difference in men's and women's speech in Weyéwa (as represented in Kuipers's paper, this volume), which is a dualistic society of Eastern Indonesia. Examples like these serve to illustrate what Boon argues in his paper on Bali in this volume. Although Bali, like Java, is classed as a former Indic State, Boon suggests that Bali combines both the centrism of Indic States and the dualism of Eastern Indonesia, and he argues that the two systems are transformations of each other. His paper stands, therefore, as a pivotal point in the middle of this collection.

Some Final Comments

After clarifying some assumptions concerning the relations between the human body and the cultural milieu in which it grows, I proposed a model for the study of the "person" consisting of three

areas of focus: the anatomy analogue, demeanor and social attri-
butes related to demonstrating identity, and finally the relevance
of socially constituted identities to access to power and prestige in
a given society. I suggested that these areas of focus could provide
a useful starting point for cross-cultural research on the person,
and I then proceeded to sketch the "person," following my model,
first for the contemporary dominant-culture United States and
second for island Southeast Asia. In the section on the United
States, however, I emphasized the body and the relations between
"sex" and "gender," whereas in the section on island Southeast
Asia I explicated local ideas of power and prestige, mentioning the
anatomy analogue there only in passing. These different emphases
are explainable in part because of the state of research in each of
these areas of the world: very little has been done on the anatomy
analogue in island Southeast Asia, but too much to review here
has been done on the relations of identity (race, ethnicity, and gen-
der) to power in the United States.

But the reasons for my skewed emphasis run deeper than that.
In popular discourse in contemporary America a great many expla-
nations concerning the shape and import of social life are either
biologized (attributed to bodily and often inherited differences
among peoples) or psychologized (attributed to individual differ-
ences), and quite often—especially in popular writing on sex/
gender research, and sometimes in the research itself—the two
categories coincide. Furthermore, contemporary commentators
who write about sex and gender cross-culturally quite commonly
assert that cultures can merely distort or superimpose a cultural
veneer on the "natural, biological differences" between male and
female. They thereby take "our" way of tieing gender differences
closely to bodily differences as the scientific way to imagine things,
but also as the "natural" way, since they take these views to be an
iconic model of what is real. It seems to me, therefore, that if we
want to understand gender constructions in the United States, we
must first discuss and understand local concepts of the body. In
island Southeast Asia, by contrast, speculations about the reasons
for differences between people (men and women, high and low, Jav-
anese and non-Javanese, etc.) seldom put anatomy or physiology at
the center.

I have asserted in this essay that "gender" is not construed as a direct reflection of male/female anatomical and physiological differences in much of island Southeast Asia or, I would hazard, in many other parts of the world (the story in each would certainly be quite complex, requiring at least an account of the local anatomy analogue). We might therefore ask ourselves why sex/gender is so heavily biologized in popular discourse in the contemporary United States.

Recent studies in the history of science give us some clues about the biologization of gender and the invention of Sex. Londa Schiebinger and others (see Schiebinger 1989 and its bibliography) have recently argued that in Europe the study of human anatomy was cast or construed as gendered only at the end of the eighteenth century. At that time, the illustration of the gendered skeleton made its debut—a nice illustration that the local anatomy analogue may have relevance for local ideas about gender difference (ibid: ch. 7). Such shifts in the focus of scientific explanations both prefigured and laid the groundwork for the scientific racism and scientific sexism for which the nineteenth century has now become famous, most accessibly in the work of Stephen Jay Gould; some aspects continue to be promulgated in this century.

In island Southeast Asia, differences between people, including men and women, are often attributed to the activities the people in question engage in or the spiritual power they exhibit or fail to exhibit. If we want to understand gender there, we cannot begin with gendered bodies but must understand local ideas of power and prestige; the next step (which many of the papers in this volume illustrate) is to ask how people defined as male, female, or something else are mapped onto, as it were, the prestige and power systems.

How Gender Makes a Difference in Wana Society

Jane Monnig Atkinson

Atkinson's paper on the Wana of Central Sulawesi, Indonesia, is conceived in part as a dialogue with Michelle Rosaldo's work on Ilongot gender. Like the Ilongot of Northern Luzon and the Meratus of Kalimantan treated by Tsing in this volume, the Wana live in small unstratified settlements with a subsistence economy based on swidden rice cultivation, hunting, and foraging. Political organization in these societies is minimal. Although certain individuals may be respected for their contacts with spirits, their knowledge of customary law, their oratory, or their valor, leadership relies on persuasion, not coercion.

Whether gender relations are hierarchical in societies with minimal hierarchy of other sorts has been a subject of debate for feminist scholars. Marxist feminists like Leacock (1978) and Sacks (1979) have argued that gender equality has existed in simple societies in the precapitalist past. Others, like M. Rosaldo (1974, 1980), Ortner and Whitehead (1981b), and Collier and Rosaldo (1981), have maintained that even in the simplest societies some form of gender asymmetry has been present. The Wana, Meratus, and Ilongot by no means represent pristine primitive societies untouched by history or wider political systems. Thus they cannot resolve debates about gender equality in early times. But they do serve as examples of societies with relatively egalitarian social orders in which gender—understated in many contexts—does make a difference when it comes to asserting political claims in public ways.

A pattern evident not only in Atkinson's essay but in a number of other essays in this volume as well shows that gender typically serves as a "difference that makes a difference," principally in relation to spiritual potency. Spiritual potency is culturally the sine qua non for political power and authority in the archipelago (cf. Anderson 1972; Wolters 1982). In contrast to Eastern Indonesian societies (cf. Hoskins, Kuipers, Valeri, this volume), where male and female difference becomes grist for the mill of other pervasive dualisms, male-female difference is downplayed in Wana cultural imagery about the "person" but is evident in political practice.

Atkinson's analysis shows a strong emphasis in Wana culture on human "sameness" little inflected by male-female difference, a pattern found elsewhere in the Centrist Archipelago. The Wana carry this emphasis to an extreme by asserting the identity rather than the complementarity of women's and men's roles in human procreation. The Wana case as well as others treated in this volume suggest that more anthropological attention should be paid to nondichotomous constructions of gender that stress continuities rather than contrasts between maleness and femaleness.

Feminist scholars have found it more compelling and perhaps easier to dwell on the dichotomization of gender and the devaluation of women than to unravel the intricacies of gender in a culture that downplays it (Atkinson 1982). My aim in this paper is to explore cultural expressions of gender among an Indonesian hill population for whom human "sameness" rather than gender difference is a dominant idiom. In addition to exploring gender constructions of a sort that is underrepresented in the literature, this paper has two aims. First, it develops a comparison to Michelle Rosaldo's writings on the Ilongot, which are both theoretically and ethnographically germane to the Wana case. Second, it reconsiders an early effort by Rosaldo and Atkinson (1975) to compare the contours of gender systems in island Southeast Asia.

The Wana people are swidden cultivators who inhabit the rugged mountainous interior of the eastern arm of Central Sulawesi. While they share with other peoples of the archipelago a strong respect for age and spiritual potency, and while they hold in awe the holders of rank in the successive coastal regimes (headed by raja, colonialists, and now national administrators) that—from a

distance—have claimed authority over them, Wana represent the relatively egalitarian end of the Indonesian political spectrum. Thus the construction of gender in Wana society has bearing on debates about gender equality in simple societies.

To portray the Wana as an example of primordial primitive egalitarianism would be a grievous distortion of what is known of Wana history. In the latter half of the last century, nascent chiefdoms emerged in the Wana region in response to wider political developments in the area (see Atkinson 1989, ch. 15). For approximately two generations, Wana knew a three-tiered ranking system composed of chiefly families, commoners, and debt slaves, although the degree to which this system actually operated across the Wana region is not clear. With the arrival of the Dutch in the first decade of the twentieth century, this system, along with whatever degree of regional integration had been achieved, collapsed, and leadership reverted to the local level.

In recent times, Wana have generally met Morton Fried's (1967: 33) criterion for an egalitarian social order, "one in which there are as many positions of prestige in any given age-sex grade as there are persons capable of filling them." Fried's definition, of course, begs the question of equality between women and men, the possibility of which, past and future, has been a subject of heated debate in feminist circles. Marxist-feminists for whom gender ideology devolves primarily from relations of production make the point that a gendered division of labor does not in itself constitute a form of inequality (e.g. Leacock 1978; Sacks 1979). They tend to read evidence of male privilege in small-scale noncentralized societies as a function of either ethnographic bias or debilitating culture contact. Others—and I include myself here—argue that inequalities in political authority, the acknowledged right to assert control over key aspects of community life, are integrated, but not coterminous with economic relations. In the Wana case, gender inequality emerges principally in political contexts at the community level and beyond, and is more discernible in political practice than in the cultural representations that practice invokes (see Tsing, this volume). While not discounting the impact of economic factors such as long-distance trade on Wana gender relations, I think the gender asymmetries of Wana political dynamics

are not reducible to exploitative economic relations (see Atkinson 1989). Whatever their derivation and the effect of interaction with more stratified populations in the region, these asymmetries are long standing and conform to a pattern found widely across social formations in the Archipelago whereby men have privileged access to prestigious resources of a spiritual and political nature.

Rosaldo's Readings of Ilongot Gender

To provide a context for my analysis of Wana constructions of gender, it will be useful to review Rosaldo's Ilongot work and to note in particular some important shifts in her understanding of Ilongot gender. Rosaldo's first field stay among the Ilongot, from 1967 to 1969, predated the resurgence of feminism in the United States. Upon her return from the Philippines, she was caught up in the radical questioning of self and society that feminism provoked. Spurred by the women's movement, her initial concern was with the subordination of women not only in her own society but cross-culturally as well. Thinking back on her Ilongot fieldwork, she concluded that Ilongot society, in comparison to most societies elsewhere, exhibited a strong measure of equality between women and men. It seemed to her that Ilongot headhunting alone served to mark "men as special," though she played down its impact by noting that headhunting was not mandatory, that it was valued only in moderation, and that it did not serve as a basis for male political hierarchy (Rosaldo 1974:40).

In 1974, Rosaldo returned to the field prepared to reevaluate Ilongot society in terms of a feminist framework. During that time, Rosaldo refined her word-oriented style of cultural analysis by seeking overarching systems of coherence in discourse. *Knowledge and Passion* (1980) is the result of her reanalysis of Ilongot sex roles in light of her feminism and a maturing approach to cultural analysis. Sensitive to feminist criticism of the fact that she centered her monograph on men's headhunting, Rosaldo sought to explain why "women figure minimally in [her] account" (1980:232). While women as social actors may have different interests in the system, Ilongot ideology, she claimed, with its emphasis on the

"equality and 'sameness'" of human relations, does not bifurcate cultural experience into separate male and female realms, except through the institution of headhunting. Whereas she had previously defined headhunting in terms of what it did not do—i.e., create political hierarchy—she now recognized headhunting as a key to Ilongot social reproduction, as the means through which egalitarian cohorts of adult men established themselves as the knowledgeable guardians of Ilongot society. By focusing on headhunting, Rosaldo claims to have zeroed in on the one difference that, in Bateson's fine phrase, makes a difference in the Ilongot gender system. The point is that in other contexts, Ilongot notions of human "sameness" override gender as a system of differences.

From Northern Luzon to Central Sulawesi

Rosaldo's work on Ilongot gender bears directly on the analysis I shall develop here. Not only are the Wana and the Ilongot—both populations of upland swidden farmers with traditions of magic, oratory, and warfare—similar, but like Rosaldo's work, my analysis relies heavily on examination of everyday conversation and exploratory discussions with people on the subject of gender. In contrast to the Ilongot, however, Wana are more inclined to explain their world with reference to a mythologized past and an elaborately envisioned spirit world. Thus, unlike Rosaldo, I have a more highly embellished ideological dimension to analyze as well. The contemporary Wana counterpart to Ilongot headhunting is shamanship, a male-controlled institution with major significance for Wana social reproduction. I shall not use shamanship as my primary lens for viewing Wana constructions of gender since I do that elsewhere (Atkinson 1989). Instead I shall show how Wana notions of gender shift across cultural domains to become a difference that makes a difference primarily when issues of community authority are at stake.

The configurations of Wana gender bear strong resemblances to the Ilongot case. Wana underscore the fundamental likeness of the sexes and the complementary nature of their work. And like

the Ilongot, Wana prize experience that lies beyond the everyday events of their farming communities. What Ortner and Whitehead (1981b) would deem the prestige structures of Wana society— shamanship, legal expertise, agricultural magic, and millenarian prophesy—are rooted in powerful forms of knowledge that derive from sources spatially or temporally removed from Wana communities.

But Wana constructions of gender differ from the Ilongot constructions in two important ways. The first is an emphasis upon biological reproduction. In a 1975 article, Rosaldo and Atkinson attempted to construct a general framework for analyzing cultural representations of gender. Using Southeast Asian materials, we concentrated upon the symbolic associations drawn among the life-giving and life-taking activities of farming, childbearing, hunting, and warfare. An analysis of Ilongot magic spells suggested strong associations between farming and hunting and between hunting and warfare. By contrast, Ilongot women's farming and childbearing were only weakly associated. Other forms of cultural evidence hinted that headhunting was symbolically deemed antithetical to farming and childbirth, and that childbirth and hunting were weakly opposed as well. The evidence suggested that Ilongot magic underscored the similarities of women's and men's subsistence activities and downplayed the differences between women's role in physiological reproduction and men's acts of physical destruction. We concluded that by stressing positively the parallels between women's and men's subsistence activities and minimizing women's childbearing, Ilongot, as read through their spells, seem to say that women and men are the same, but men, by taking heads, are somehow "more so."

Our initial hunch in 1975, inspired by Ortner's influential 1974 article, was that a cultural emphasis upon childbearing would accentuate the differences between the sexes. Now intriguingly, the Wana represent a case in which sexual reproduction is a cultural preoccupation. But instead of highlighting the physiological differences between women and men, Wana notions of procreation appear to deny gender differences and to assert an identity between men's and women's reproductive roles. Needless to say, such an as-

sertion violates our own cultural common sense of which anatomi-
cal differences between women and men are "the bottom line." In
the terms of Rosaldo and Atkinson's model, both Wana women
and Wana men are represented as life-givers with identical, not
opposing and complementary, roles in procreation. Although, in
contrast to the Ilongot, Wana emphasize procreation, they do so
in ways that follow the contours of the Ilongot case by assert-
ing fundamental identity between women and men as productive
members of a community while glorifying stereotypically male
achievements in realms beyond that community.

Wana representations of gender differ from those of the Ilongot
in another significant way. For the Ilongot, women and men share
the same basic humanity, but through headhunting, men (up until
the early 1970's) could achieve a form of transcendence not avail-
able to women. The Wana region was pacified in the first decade of
this century. Before that time, headhunting was an important in-
stitution in Central Sulawesi. But from all accounts, it appears
that in the regional game of headhunting, the Wana were quite
often the heads. As portrayed by my companions, pacification did
not spell the end to a former age of manhood and glory, but instead
came as a welcome relief. The historical accuracy of these recent
perceptions cannot be debated here. My point is that unlike some
other pacified swidden peoples for whom a warrior tradition is
fundamental to notions of masculinity (cf. Metcalf 1982), Wana
manhood in contemporary times is not heavily burdened by war-
rior bravado.[1] And shamanship, legal authority, and the leadership
of community rice-farming—keys to Wana social reproduction—
are not so explicitly defined as male achievements. But as I shall
examine later, while the links between gender and power are
subtle, the exercise of authority in Wana communities is a princi-
pally male prerogative.

In constructing this paper as a commentary on Rosaldo's writ-
ings on gender, I have emphasized the textual quality of Wana im-
ages of gender. But in treating cultural representations, I have not
assumed a priori the existence of an overarching or uniform gen-
der system in Wana society. Instead, I have attended to disconti-
nuities as well as continuities across social contexts and cultural

domains and approached Wana talk about gender not as a dis-
embodied set of definitive cultural statements, but rather as poly-
logues among cultural actors.

Wana phrase gender relations quite differently in reference to
daily activities, procreation, and prestige. In terms of daily work,
women and men are paired with reference to their different but
parallel activities. In talk about sexual procreation, Wana mask
anatomical distinctions to emphasize the identity of women and
men. But in reference to power and authority, men have an edge
that is represented physiologically by their penises; characterwise
by their bravery; and experientially with reference to their travels
to distant realms. This edge is mitigated physiologically by no-
tions of women's alleged anatomical completeness; characterwise
by the sense that while men are generally braver than women,
Wana as a people are quite cowardly; and experientially by the fact
that access to exogenous forms of power is not limited to those
who travel long distances. Subsequent discussion will show how
these systemic properties of Wana talk about gender operate in so-
cial life. As this analysis will establish, Wana social values are not
explicitly about gender. Instead, to borrow Ortner and Whitehead's
(1981b) felicitous term, gender distinctions seem "inveigled" by a
structure of social values that on the surface downplays them.

Gender and Community Life

Wana communities share some affinities with Collier and Ro-
saldo's (1981) model of "brideservice societies," societies in which
men achieve wives by proving themselves to their parents-in-law
with gifts of meat. Most of Collier and Rosaldo's examples came
from foraging societies, but they included simple horticulturalists
as well and used the Ilongot as a primary example. In such sys-
tems, marriage appears to be a point in the life cycle at which the
differences between man and woman, husband and wife, are most
sharply drawn in cultural terms. By contrast, as the parents of a
bride, the interests of a woman and a man appear to be conjoined.

But Wana marriage procedures represent a "low budget" version
of the marriage payment systems of their Muslim coastal neigh-
bors, for whom marriage is an occasion for exchanges of heirloom
objects and other forms of wealth. What is more, generation over-

shadows gender as the theme of Wana weddings, which are occasions for the *tau bose tu'a* ('great old people') to unite their *ananya* ('children'). Both the groom's and the bride's side present payment, although the groom's payment may be somewhat larger in some areas, because, people say, it is easier for men to acquire the goods with which to pay. To have one side pay all is to suggest that one side has bought total rights over the child of the other. The items constituting the marriage payment—typically, brass trays, china plates, and cloth—are then divided among the elders who officiate at the marriage. These elders are said to "hold the mat of the world" for the couple, a reference to the name of the central marriage payment. This gives them the right to counsel and discipline the pair. Thus marriage payments do not constitute a transfer of rights in a woman's (or a man's) sexuality or labor, but instead constitute an assertion of authority by older kin over the couple whose union they formalize.

The conjugal relationship is central to Wana social structure. Wana communities are made up of households, each containing one or more productive units typically comprised of a married couple and their dependents, both old and young. Such a unit goes by the name of 'woman' (*tina*) or 'hearth' (*rapu*). There is no single lexeme for a nuclear family. Adults with children are referred to by some variation of the phrase *sira sana* ('they together with children'). It is assumed that people marry, and with rare exception they do. People tell of Guma Langi ('Sheath of the Sky'), who intercepts the souls of unmarried people and hammers them into broad-bladed weeding knives called *pansuu*. Their souls return to earth to live another life and marry, while their ghosts turn into ants that pinch people.

Terms for "spouse"—the blunt word *rongo* or 'fuck' and the more polite *bela* or 'friend'—are not gender-marked. Less intimately and more comfortably, people refer to spouses—their own and others'—as the 'mother' or 'father of one's children' (*indo nu ana, apa nu ana*). Teknonyms are a mark of adulthood. Childless people commonly take their title from a niece or nephew.

The centrality of the conjugal couple in Wana life is evident in everyday life and underscored ritually in a number of contexts. Typically, likeness, not difference, between husband and wife is

expressed. A comparison can be drawn to Metcalf's (1982) study of death rites among the Berawan, a swidden population of northern Borneo. In both the Wana and Berawan cases, mourning rites for widows and widowers are identical, with one notable exception. A Wana, male or female, who would observe full traditional mourning for a spouse dons a white shirt and headband made from the same stuff that serves as bindings on the corpse.[2] During the period of mourning, the spouse watches over the betel bag of the deceased, then carries it out to the "small house" built at the grave site. As in the Berawan case, however, men appropriately express their grief through displays of anger; women, by contrast, wail. And men's greater mobility and capacity for violence once offered them another outlet for their grief. I was told that in the past a man could *mantau kamawo nraya,* 'carry out his grief,' by killing someone. As an act of mourning, he would don a white headscarf to wear until he had fulfilled his vow to take a life. At that moment, he would transfer the scarf to his victim to signal the completion of his resolution. The parallels to the Ilongot case are obvious (R. Rosaldo 1980a, 1984). Wana I knew did not lament the passing of this option. But after a death some brave individuals undertake a similarly dangerous quest by keeping vigil over graves and enticing the fiercesome spirits who gather there to become spirit familiars.

The conjugal relationship is about work. Both young and old, male and female, stressed industriousness and a capacity for hard labor as attributes of an ideal spouse. The emphasis on industry goes for both sexes. In explaining why a wife would be jealous of her husband's lover, one woman explained that to seduce an unmarried woman, a married man disparages his own wife. He tells his lover that his wife is lazy, weak, and will not work for his mother. He proceeds to praise his would-be lover for her strength and industry. In this way, a man's adultery is an insult to his wife's worth as a producer and as a considerate daughter-in-law. Similarly, women will divorce men who are shiftless workers. Wana talk about marriage brings out the point that both spouses are expected to be hard-working contributors to their productive unit.

One might note a contrast to Collier and Rosaldo's (1981) model of brideservice societies in which marriage is represented as an ex-

change of men's hunting abilities for women's sexual favors, and a wife's adultery impugns her husband's manhood. Collier and Rosaldo do not explore what a man's adultery implies. My sense is that for the Wana, adultery by either party says the same thing about the injured spouse—he or she is lacking as a cooperative producer and a desirable mate. Just as proper marriages are more the design of wise elders than the achievement of brave men, so too they represent the joint productive efforts of women and men, not a trade of meat for sex.

The work of a conjugal unit is divided into gendered tasks.[3] Men clear brush, fell trees, and burn plots for planting; women are primarily responsible for planting, weeding, and harvesting, although the last of these three tasks is in fact one in which both sexes freely participate. In addition, men hunt and both sexes forage for riverine and forest foods. Men build houses and granaries; women make items like mats, baskets, and clothing. And, importantly, men travel long distances to coastal markets to trade Wana products like rice, resin, and in some areas rattan, for cloth, salt, and metal implements.[4]

Wana conceptualize women's and men's work differently from the Ilongot, though the division of labor by gender in the two societies is basically the same. Ilongot regard rice as women's contribution to subsistence and game as men's. Wana consider rice to be the product of the couple in whose field it is grown and in whose granary it is stored. Wana men profess none of the ignorance or detachment from rice growing that M. Rosaldo (1980:103) reports for Ilongot men. Several reasons may be cited for the difference. First, hunting at the time of my fieldwork seemed less central in Wana life than it was during the Rosaldos' first field stay among the Ilongot.[5] In contrast to Ilongot, Wana lack guns and do not trade meat for store goods. Second, during my fieldwork, rice was the major item of Wana trade at coastal markets. (This is a recent development. Up until the 1960's, wild resin or damar was of central importance in external trade.) Rice is, as one old man put it, the 'source of seeking goods' (pu'u mpoliwu). Given frequent shortages of rice in the area, people with large rice harvests attract large followings of dependents who exchange labor and trade goods for food during hard times. And finally, with the highly irregular

rain patterns of eastern Central Sulawesi, Wana men spend a good deal more time than Ilongot men do in secondary clearing of fields. At the time of my fieldwork, there appeared to be a generational gap in men's hunting knowledge and experience. Most of the young men in the area where I worked were not hunters; older men were. In the Ilongot case too, hunters were not at their prime until middle age (R. Rosaldo 1980a: 143). But in the Wana communities I knew best, young married men were hardly trying.

Though not as central as in Ilongot culture, the image of "man the hunter" is certainly salient for Wana. And while the image of men and women as cooperative farmers is dominant, there is also a notion of men as providers of meat for women, especially for pregnant women and new mothers. For example, two women laughed when a young father in need of meat for his wife harvested for another man to obtain some birds that the latter had trapped. Women spoke of their embarrassment at going to wait for divisions of meat at the house of another woman's husband. Doing so is particularly embarrassing, they noted, when one is pregnant and looking like a "bundle tied on backwards."

A variety of folk tales, magical procedures, and health concerns suggest an opposition between hunting and children. For instance, the presence of a great hunter can provoke crying and stomach pains in a baby. To prevent such trauma, a visiting hunter may be asked to touch the navel of a small child, a request that publicly underscores the reputation of the visitor. More important is the idea that fine hunters know powerful magic that can cause their children to die. Spirit owners of game give over their animals to hunters in return for special offerings of betel; if the spirits feel slighted, they may demand their fair "share" from the hunter by killing his children. Hunters can even use their hunting magic to kill themselves. Whereas most deaths are attributed either to fate, to sorcery, or to malicious spirits, the deaths of men in their prime are frequently regarded as suicides invited by offerings to personal hunting spirits. Thus, in contrast to others who are younger, older, or female, these men are seen not as victims, but as controllers of their own destinies.

The antithesis of children and hunting relates to an important opposition in Wana culture between the human settlement and

the wilderness beyond it. Whereas women tend to be 'settled' (rodo), men go off to distant places from which come both danger and power. The following popular story illustrates the perils of such ventures. A hunter went off in search of meat for his pregnant wife. She waited, but he did not return. As he hunted, he made small gardens to provide him with food. Finally, the woman sent her child in search of his father. The man sent the child home with meat for his wife, but would not return himself. Eventually, he grew a long snout and hair all over his body, and turned into a demon known as Asu Ose, 'the charging dog,' whose frightening bark can be heard in the forest.

This story may be compared to another oft-told tale about the origin of another dangerous spirit, a tale that begins with a man leaving his pregnant wife either to hunt or to seek goods at the coast. Upon his return, the man approached the house at twilight and saw his wife holding a newborn. As he drew closer, he realized that her fingernails were long, her eyes bulged and shining, and her back hollow. It was not his wife, but her ghost, the dangerous spirit of a woman who has died in childbirth.

Both stories depict the origins of vicious spirits from the dangerous activities of women and men. Both hunting and childbearing involve chancy matters of life and death. One is commonly read by structuralist scholars as a purposeful act of cultural agency, the other as a passive response to species demands. It could of course be countered that hunting, like parturition, is a behavior humans share with other animals—note the transformation of the hunter into a dog in the Asu Ose story—and that women and men in many cultures, including Wana, are thought capable through their knowledge and action of directing the outcome of parturition. Indeed, although an analytic distinction of cultural and natural processes has value in anthropological interpretation (see Valeri, this volume), the proper use of this distinction is problematic. Why should we assume that whenever hunting and childbirth are paired in symbolism and narrative, the issue of purposeful agency versus species passivity is both central and settled in advance? Does this pairing invariably imply an asymmetrical valuation of these activities and, by implication, of the women and men with which each one is primarily identified? Just as Lévi-Strauss (1963b)

long ago argued that elements in myth should not be decoded in isolation, but rather in terms of the relations that obtain among them, so too symbolic relations cannot be deciphered according to a fixed and invariant code, but require analysis within their narrative and cultural contexts.

Like many comparable societies, Wana associate the most valued forms of cultural knowledge with distance from their own settlements. These forms of knowledge operate to organize, integrate, and transform people and their activities. Through powerful magic and spirit allies from the forest, shamans sustain the health and lives of their patients. In the past, victorious headhunters were credited with enhancing the fertility of rice fields. And through negotiations with leaders from afar, local leaders insure peace and prosperity for their neighbors. Thus, distinctive and prestigious forms of purposeful agency exercised elsewhere transcend and allegedly govern ordinary settlement life. But rather than elevating men's purposeful actions in the forest over women's biologically bound fate of bearing babies in the settlement, this particular pair of stories can be read as a brief against such gender asymmetry. In a society where men's greater political authority is culturally linked to their greater physical mobility, these stories offer a counter-claim by illuminating the common powers and dangers shared by emblematically male and female activities. The transformations of both characters are pregnancy-related. The men in both stories are in search of provisions for their wives in childbed. And the stories portray identical fates for a father and a mother in their respective projects gone wrong. Both lose their agency and identity to forces beyond mortal control. In a culture where special power is typically a function of distance from human communities, the stories underscore that comparably ferocious and powerful demons can have their origin within a human settlement as well as beyond it. The significance of this point can be seen in a woman's report that her shaman husband tried to frighten her one evening by claiming he heard the cry of the ghost of a woman who had died in childbirth close by the house. She retorted that she was not afraid because "the origin of that spirit is with us women." Citing familiarity with spirit origins is a form of

"one-upsmanship" among claimants to special power in Wana society. Why childbearing should be invoked in such contests of power calls for some investigation.

Gender and Procreation

Conjugal pairs are about sex and reproduction as well as about subsistence activities. For the Wana, sexual pleasure is sought and valued apart from procreation. The origin of sexual intercourse is told in a Garden of Eden-like story minus all implications of sin and divine disapproval. As the story goes, the Owner (*Pue*) created a man and put him down on earth. Later he heard the fellow screaming. He sent his emissary, *kuasa mpue*, to investigate. The man was screaming, it was learned, because his penis was hard and painful. So the Owner made a woman and placed her on earth. But the screaming persisted. Once again, the emissary was dispatched, only to find that the couple did not know how to relieve the pain. So the kuasa mpue taught them how to have sex. It was quiet then, so quiet that the Owner sent his emissary yet again to find out if the two were dead. No, it was reported, simply happy.

It is assumed that young unmarried people have sex. "It's their rice," one elder told me. No one minds, so long as they keep their activities discreet (cf. Geddes [1957] 1961:59–73). But if an affair becomes blatant, if a pregnancy is involved, or if an unmarried person is known to have sex with a married person, then the matter is subject to legal negotiation, the aim of which is to sort all parties concerned into monogamous or polygynous conjugal units. Extramarital sex has dangerous consequences for both parties to a marriage. They are inevitably plagued with what is called a *kuse* or 'monkey,' an expression that identifies a dangerous condition and its spirit agent, a monkey-like creature that holds in its grip innocent and guilty party alike. Constriction is a feature of the illnesses that result. Particularly feared is the effect of such constriction in childbirth—the retention of either the baby or the placenta, or both, in the mother's womb. Women often seek preventive spells for kuse before delivery to protect themselves, they'll say, from their husbands' reluctance to confess infidelities. No doubt, some cover for their own indiscretions as well.

A puzzle in analyzing Wana notions of sexuality and reproduction is an apparent contradiction between the cultural importance placed on procreation and what can best be called an ambivalence about childbearing in Wana life. As will be seen, procreation is phrased as the central and most powerful mystery in Wana thought. But in fact, people, especially women, seemed preoccupied with avoiding it. Contraceptive magic and techniques abound. As for magic to promote conception, it is used maliciously to make unwilling or unsuspecting couples conceive. A variety of stock reasons to avoid pregnancy are given. Having children interrupts work. Cleaning up children's excrement is a nuisance. And for women's part, the threat of death in childbirth is of paramount concern. (As one friend called out to me in a late stage of labor, "Aba [our reciprocal nickname], this is what kills women!") But although pregnancies in general are regarded ambivalently, and frequent pregnancies are a source of dismay, refusing to have children is regarded as a grave "sin," that is, a violation of the bonds between parent and child. Indeed, the reasons for having children are phrased primarily in the negative. For example, a couple that dies childless "leaves no trace and has no meaning"; a person without children may die alone and be eaten by the household dogs. Institutionalized incentives like perpetuating a lineage, insuring a constituency, or breeding successors to property or office are absent in Wana society. In terms of the life cycle, small children are thought to inhibit a couple's economic productivity; adolescent children are regarded as an asset since they increase household productivity through their work; but after children marry and "seek their own fortunes" as members of separate production units, parents are "no longer happy." Although adult children may live in the same community as their parents and are expected to show respect and concern for their parents and parents-in-law by helping them occasionally with farm work, their interests are separate (unless or until a widowed parent joins their household). It was apparent to me that adult children could be a political asset to their elders, but this aspect of parenthood was not played up in talk about parenthood. Thus the puzzle remains—why a heavy preoccupation with procreation in a society where childbearing is not an unequivocal social good?

The thematic concern with procreation in Wana culture cannot be reduced to institutional dimensions of Wana society, but derives instead, I think, from ideological considerations of gender and from the cultural constitution of power in Wana life. Reinforcement may come as well from traditions of Islamic religious thought, prevalent at the coasts that border the Wana region. This is suggested by claims to the effect that the source of procreative fluid, termed 'the seat of white blood' (*patunda nu raa buya*), is the *hakiki nu agama* ('the truth of religion') and that the navel cord and placenta represent the *kamula jadi* ('the beginning of creation or being').

The Wana word *pu'u* can be translated as 'source,' 'origin,' 'base,' or 'foundation,' and perhaps as 'reason' or 'cause.' Wana ontology and epistemology concern themselves not with superficial reality, but with the underlying "sources" from which the significance of outward appearance and events derives. Something that lacks a pu'u is groundless and consequently meaningless. People and peoples have origins (*tau sampu'u* are people who derive from the same place or stock); forms of powerful knowledge have origins (the spirit "owners" from whom they originally came); serious illnesses have origins (in the acts of human or spirit agents); human actions may have underlying motivations. And cosmologically and historically, Wana see their homeland as the point of origin from which power, knowledge, wealth, and all peoples and religions dispersed.

To be pregnant and to give birth is called *mpu'u*. These processes are not regarded as exclusively female ones. Indeed, rather than conceptualizing male and female roles in procreation as complementary, Wana ideologically assert their identity. Two explanations might be suggested. One is that recognizing differentiated functions of women and men in sexual reproduction would be inconsistent with a cultural emphasis on unitary points of origin. Another is that in terms of Wana sexual politics, men cannot leave anything as ontologically powerful as childbearing to women. Both of these explanations will be considered later. But first, the details of the case.

As Wana tell it, men used to be the ones to give birth. Men suffered terribly in childbed. They'd stamp their feet in rage, tear

down the rafters, and after all their suffering, they'd deliver mea-
sly, unviable little infants—smaller than tadpoles, and rather like
ants. Then a woman said to a man (some say, to her brother), let
me take that over, I have a 'pocket' (*salembu*) for it. The word
salembu refers to the fold in a woman's sarong and metaphori-
cally, I'm told, suggests her womb. In another version, a man left
his child with a woman while he went to attend a legal debate. He
came back to find the child amusing itself at the woman's breast
and unwilling to come back to him. He told the woman that from
here on out she should have the children, that it was more "appro-
priate." As a consequence, women are now the ones to give birth
and to nurse small children. And by implication, legal authority
is a male domain, somehow incompatible with childbearing and
tending.

But although women bear children, men are pregnant first.
A man carries the child for seven days then puts it into a woman.
Sterility is attributed by some to men, not to women. If a man is a
tau ri ana or 'a person with children,' and his wife doesn't abort, a
couple will have a child. Some say woman is fertile at all times,
whereas a man is fertile only seven days a month.

In the past, men menstruated. One story describes men engaged
in legal proceedings with bamboo tubes hanging down through the
floor slats to catch their menstrual blood. Some people say that
today all men menstruate. Others say only some do. Men's men-
strual blood is said to be *raa buya*, 'white blood.' (I'm unclear how
literally this is identified with semen.) "White blood," for the
Wana, who were on the peripheries of Islamic coastal sultanates,
connotes *baraka*, the supernatural power of *raja*. Raa buya is said
to be the liquid in which *manusia*, 'humanity,' is suspended. It
solidifies in the womb as a fetus. Regarding the creation of the
fetus, there is a diversity of opinion. According to some people,
men alone carry the substance that becomes humanity. By this ac-
count, women's wombs are simply "empty nests" waiting to re-
ceive embryos. But other evidence, direct and indirect, having
to do with the special nature of menstrual blood, suggests that
women too contribute to the creation of a child. And at the other
extreme, I was told that 'humanity' (manusia) is already present

in the woman and men simply carry the water that "arrives at the nest."

The point of this discussion is, first, to underscore the power Wana attribute to the procreative process, and second, to show how the participation of men and women in the process is conceptualized not as complementary, but as identical. Both sexes menstruate, both become pregnant, and both are the "source" of humanity. The identity of male and female reproductive processes is accentuated in a variety of ways. For example, some men are said to give birth even today. What they deliver sound suspiciously like kidney or bladder stones, but these offspring are regarded as powerful talismans with magical uses in rice magic and healing. Both sexes are susceptible to the symptoms of pregnancy, such as a condition of thinness called *mayo*. And although I never witnessed it myself, I have heard two men describe how they suckled children at their breasts. In one case, the death of his wife left the man with an unweaned child who craved the breast. In the other case, the birth of a sibling necessitated weaning a first child, and the boy's father comforted his son with his own nipple.

In their theories of procreation, then, Wana largely downplay reproductive differences between women and men. This is consistent with their conceptions of the nonreproductive aspects of people's bodies and souls. In their highly developed and very complex notions of illness and etiology, women and men appear not as dichotomous or complementary human forms, but rather as the same kind of being, susceptible to the same kinds of threats to their well-being. There is no sexual difference in the constitution of the person as a concatenation of soul parts whose centrifugal tendencies must be curbed through shamanic intervention. Although there are certain conditions of illness that would seem sex-specific, generally they are not. For example, Pontiana, the Wana version of a pan-Indonesian demon that afflicts women in menstruation and childbirth, also attacks boys at superincision (about which more in a moment) and causes genital pains and incontinence of bladder and bowel for both sexes. *Kapuwau* is a condition brought on by spirits who are attracted by the 'smell' (*wau*) of blood. It plagues newborn children, and women at childbirth and

menstruation, but it is a problem as well for boys at superincision and for persons of both sexes who experience heavy bleeding. The same name and the same medicines are applied to prolapsed wombs and rectums—thus people of both sexes can suffer this ailment. Similarly, diagnoses of impotence and its cures apply to both women and men.

Among the most intriguing parallels in male and female anatomy derives from a male genital operation that in another culture might well exaggerate the differences between women and men (see Valeri, this volume). Some time before puberty, most Wana boys undergo a brief and rather casually performed operation on their foreskins. The procedure is done in the houseyard in the full view of anyone who cares to watch. A small stick is placed between the foreskin and the glans, and the foreskin is slit vertically, then folded back to expose the glans. The "real name" of the operation is *sui*, 'to slit.' I was told that a euphemism is used because the spirit owner of pigs, whose pets are not so cut, takes offense at the name. The fact that slit bamboo is used in pig traps seems to be involved here too. The preferred term is *ponte*, which means 'to hatch,' an expression that plays on the fact that male testicles are called *gura*, a word consciously likened to the word for egg, *gura'u*. The euphemistic substitution seems to switch the association from hunting to birth, and from wild animals to domesticated chickens, a common metaphor for children and community members. Reasons given for the operation include the notions that women find unincised penises distasteful and that a man who is afraid of a tiny knife is not prepared to handle a big one (i.e., to do men's work). Some say too that penile incision promotes the growth of young boys. The similarity to the Islamic *sunnat* is openly acknowledged, and Wana term circumcision *ponte* as well.

Superincision does underscore the difference between males and females. The fact that young boys must confront a knife in order to make themselves brave and attractive to women implicitly differentiates males and females in Wana society. But the operation also establishes an identity between the sexes, namely, bleeding as a prelude to maturity. Children of both sexes are told to observe a variety of prohibitions lest boys bleed heavily when

they are incised and girls bleed heavily at menstruation and child-birth. These include prohibitions on betel chewing (only casually observed), stepping over betel spit, rinsing betel spit with water, and drinking coffee.[6] Another reason given for why children should avoid betel nuts is that they hasten the deaths of their parents by such precocious demonstrations of maturity—an example once again of generation eclipsing gender. Superincision for the Wana then emphasizes an identity in the physical nature of boys and girls, and at the same time suggests a link between the penis and bravery, an association to be investigated in a moment.

Gender and Power

No doubt one who favors explaining cultural themes in terms of psychodynamics would find the preceding account replete with evidence for a massive case of womb envy on the part of Wana men. Unqualified as I am to analyze Wana psyches, however, I would stress that Wana ideas of procreation are quite consistent with a cultural emphasis upon unitary origins that does not permit dichotomous creative principles, and with an assumption that women and men are fundamentally the same sort of beings who are differentiated primarily through their activities, not in their fundamental nature. Rather than opposing women as life-givers and men as life-takers, or downplaying women's life-giving as Ilongot do, Wana identify both women and men as life-givers. Asserting a fundamental likeness between the sexes, however, Wana culture celebrates powers removed by space and time from human settle-ments and defines access to these powers in a manner befitting men's, not women's, activities. Achievement of these powers rep-resents control over processes of life and death in the Wana world. Thus, for the Wana, as for the Ilongot, there is an arena beyond the community in which some individuals can reach the fullest expression of human achievement. Although not phrased cate-gorically in gendered terms, it is in this arena that gender is a dif-ference that makes a difference.

Wana are preoccupied with powerful knowledge, epitomized in magical spells (do'a) that derive from hidden spirit realms that lie beyond the ordinary social world. Like similar societies in the area, Wana pursue the powers of the wild that lie far beyond their

swidden communities. At the same time, other forms of exogenous powers have impressed themselves upon Wana consciousness in recent centuries, in particular the power of the state, meaning here both the traditional *negara* and more recent colonial and national institutions. Although men and women may be the same sort of beings going about their tasks in Wana communities, men gain something extra by travelling farther in the realms of both the wilderness and the state.

In their encounters with far-off dangers, men protect themselves with the magical powers of substances associated with birth. Infants' cauls, clots of blood clenched in a newborn's fist, and even aborted fetuses are prized as powerful talismans. People listen to catch the sound a child utters with its first breath—the kind of magic that can cause guns to fire water instead of bullets. One shaman I know dug up a stillborn child and danced it up and down until it revealed magic to him. A woman of my acquaintance was said to possess a stillborn child that was dried by the light of the moon until it turned into a white stone, the size of a small betel nut. Such items possess special power through their association with the womb. The use of womb-related magic is great. Along with other forms of magic used to ward off danger from sorcery and violent attack, it is commonly called *sangka sangka langkai* or *pake pake langkai*, 'men's accoutrements.' This is not to say that women may not possess it, but the association of womb-related magic with men is said to come from the fact that men travel farther and require protection against the violence and sorcery of strangers.[7] What is more, men travel in multiethnic and heavily Islamic areas where such knowledge is both prized and necessary. The suggestion is that men, because they travel far, have special uses to which they can put the powerful substances and knowledge associated with the source of human life. This fact does not alter the notion that women and men are identically involved in biological reproduction; it only suggests that men have a distant arena in which the powers of procreation have added significance.

The magical power Wana attribute to reproductive substances derives not from a Melanesian-like notion of men's control of contaminating female materials, nor from principles of cosmic du-

alism such as one finds in the mythologies of the ancient Near East and China. Instead, it is based on the power that comes from unitary points of origin and generational priority. Reproductive substances are the ultimate defense against sorcery and violence because a source cannot be defeated by its offspring. A child who would curse its parents' genitals is overcome by "sin." Magic from the womb cannot be conquered because, it is said, "one's mother cannot be defeated." It is this allusion to the priority of the source, and not a notion of female pollution, that explains the death of a man at the hands of a woman who prepared her murder weapon by wiping it with her menstrual blood.

The power of reproductive magic has a part in Wana sexual politics. No matter how well protected against malign magic one is, one is vulnerable to sorcery by a member of the other sex. Men have an advantage though, because they, who are supposed to travel further and have more need for sorcery and its antidotes, can assume that most women are not their equals in dangerous magic. In fact, there are notable exceptions, but by and large, the stereotype holds. Men use sorcery as a threat in courtship. Young women and their families are careful in dealings with suitors who may vent their rage at rejection through sorcery. And shamans both enhance their reputations and create anxieties for women of childbearing age by claiming to undo contraceptive magic and move fetuses from womb to womb.

Gender as Difference

Although no gender distinction is made regarding the spiritual configuration of a person, and differences in reproductive functions are played down, two aspects of anatomy are significantly gender-marked. I'll start with what might strike us as the odder of the two. As Wana physiology has it, women possess "enough" ribs, but men are missing two. Whereas women have a complete set, nine on a side, men have only eight on a side. For this reason, it is said, men strap on a knife.

The number of ribs a person possesses has significance in Wana mortuary ritual. Legend says that the inventor of present practice confined a man and a woman each in a separate room. The man

had a musical instrument called a *du'e;* the woman had a flute. By
the sound of the instruments, it could be determined if they were
still alive. In eight days the man died. In nine days the woman
died. The woman survived a day longer, it is said, because she had
a piece of coconut, such as one would use for oiling one's hair,
tucked in the fold of her sarong.[8] As a consequence, funeral rites
for a man take sixteen days, double the number of days it took for
the man to die and equaling the count of his ribs. Funeral rites for
a woman last eighteen days, once again in line with the experi-
ment and the rib count. The symbolism involved here is complex.
Eight and nine are inauspicious numbers that follow the aus-
picious count from one to seven that spells out a full life in other
Wana rituals. The days of a funeral observance are counted off on a
blade of house thatch with paired leaves representing the ribs of
the dead. And finally, death is in a sense a journey—as it is else-
where in the archipelago (cf. Metcalf 1982)—and women, being
less strong than men and more encumbered by children, are slower
to travel on both mundane and spirit paths. By the same token, girl
babies are said to be a month longer in the womb than boy babies.[9]

Given the presence of both Islam and Christianity in the region,
there may well be a connection between the Wana reckoning of
ribs and the Genesis account of Eve's creation from Adam's rib.
But the Wana rendition is significantly different from a common
Euro-American one, for its message is not that women are men's
helpmates or dependents, but that women are anatomically com-
plete whereas men are lacking. Far from attributing a castration
complex to women, Wana find it necessary for men to compensate
for their physical deficiency. The rib tale would explain men's
character as a function of their anatomical inadequacy. Missing a
rib on each side, a man straps on another long, hard object, to wit
(or to whet), a knife.

Not all references to gender differences are so sexually oblique
as the rib story. Manhood is linked more directly to male genitals
in a complex association of men, sexuality, independence, mobil-
ity, spirit realms, and the sources of power in the Wana world. *Ne'e
yau ngkalio, ma'i tute lampu* is a continual refrain in Wana com-
munities: 'don't go out alone, a feral cat will come [to get you].'
The world beyond the settlement is populated by all sorts of spir-

its, some malicious by nature, others easily provoked by human misconduct. Venturing forth alone in the forest is a dangerous business that only the very brave will casually undertake. Just as it is fraught with danger, so too the world beyond the settlement is the site of the most valued resource in Wana life, powerful spirit knowledge. Success in any and all endeavors in Wana experience is predicated upon such knowledge from exogenous sources. Shamanship, though, is the Wana activity that relies most directly upon personal contact with hidden spirit realms. When asked who can become a shaman, Wana answer anyone—anyone, that is, with a lucky 'palm line' (ua mpale) and the courage to pursue spirit contacts. It is quite evident from the overwhelming predominance of men in the shamanic ranks that men, not women, are likely to be so fortunate. To that observation, Wana in my experience, to a man and woman, reply that men tend to be braver in their pursuit of spirit knowledge.

A simple functionalist explanation would note that shamanic resources happen to be located in the site of typically male activity. Since spirits are more likely to be encountered in the forests that men frequent, it's no wonder that more men are shamans. And given that women are typically preoccupied with settlement-bound tasks, it is obvious that they don't get around as much and consequently do not enter the shamanic line of work as often as their male compatriots do. Such an explanation is decidedly in line with Wana reasoning on the subject. There is no rule that categorically excludes women from the ranks of shamans—and indeed my notes are full of stories of women shamans of other times and places, as well as firsthand accounts of girls and women seeking shamanic skills. But in implicit and subtle ways, gendered notions of appropriateness dictate who will move easily into the conventional role of shaman and who, if she can beat the odds, will carve a niche for herself as a distinctive sort of mediator between human and spirit realms.

"Don't go out alone, a feral cat will come." A feral cat is a euphemism for a liver-eating demon. The paradox is that a demon is precisely the sort of creature a person in search of spirit powers wants to meet. A clue to the association between men and the wild came to me one day when Mpaa, a strong and handsome

young bachelor, went off to the woods. Someone asked who his companion was. "He has no companion. He's a man, he has a companion," came the answer. The joke was explained to me: as a male, he had his genitals to keep him company. But what about women? They have genitals too. Yes, I was told, "but a man's genitals are hard and brave; a woman's genitals are cowardly and flat." This answer masked a more complete set of associations. A man's genitals, in this phrasing, are called his *bebela*—a word commonly applied to a shaman's spirit familiars. Women are told not to venture alone in the forest or a *measa* or 'demon' will come. Measa are spirits that become spirit familiars. *Tute lampu* or 'feral cat' is a euphemism for both demons and genitals. The pun here is that off in the woods on her own, a woman may meet a demon of one sort or another. If not assaulted by a liver-eating demon, she may be raped. Logically, a lone man in the forest who encountered a woman would be meeting a "demon" as well—the pun works for both male and female genitals. But the criterion of bravery is at work here. So too is men's greater access to trade goods. Whereas a woman is supposed to avoid seduction lest she be forced to pay a legal fine, a man, I'm told, would be embarrassed to resist a woman's sexual overture, lest it appear that he could not pay a legal fine for adultery.[10]

Stereotypes aside, adolescents of both sexes venture forth into the forest ostensibly in search of spirit familiars. Young men meet both teasing and approval as they seek to emulate the masculine ideal of brave young shamans-to-be. Young girls may meet with something else as well—intimations of rape. One widower joked that he was going to go out and wait for two young teenage girls who had taken to roaming the forest. A young mother, convulsed with laughter, declared that she too would go out in search of spirits in the forest. Her husband tauntingly responded that he'd hide in the dark and, in the manner of a spirit addressing a vigilant, would ask her what she wanted. "The old medicine" was the appropriate answer, namely, his penis. And one young father in a serious tone told his wife's young cousin that if he caught her alone in the forest he would rape her. After all, he noted, she was not his parent-in-law, that is, someone whose person he had to respect.

When she sniffed that *that* was not what she was seeking in the forest, he told her that her wishes were no matter. All of this suggests the inappropriateness of women venturing alone into the forest, the site of men's activities and the source of powerful spirit resources.

Whereas they downplay dimorphism in procreation, Wana freely associate bravery with those who possess male genitals. At one point during my fieldwork, rumors of a millenarian movement were causing a considerable stir in the community where I worked. Apa Mene, the shaman with whom I lived, was deeply concerned. His wife, Indo Lina, was flippant and scornful of the dire predictions. Apa Mene told her that it was fine for her to sound "brave," that if trouble arrived she would simply flee. She responded by saying, of course, she could sound brave, then 'die to the bone' (*mate wuku*) when the time came to be afraid. You worry, she told him, because when you are threatened, you feel compelled to fight. We women don't. She said she feels not the slightest urge to stay and fight. It's you men who want to fight. Thus she can sound brave and later "we women" won't be ashamed to flee. Men, she observed, are ashamed to do so. Another woman told me that women were cowardly on account of their children. When danger comes they want to protect them. True enough, as in the Ilongot case, when men get drunk and begin to quarrel, Wana women hide the knives and scurry out of the house with their children.

Physical violence is phrased as a gender-marked characteristic. Although I have in fact recorded cases of spouse-beating by both sexes, men's potential for violence is characterized as greater. I was told of a number of men who won or kept their wives by threats of violence. One loving couple described to me how when he had committed adultery and she had wanted a divorce to marry a more successful man, he had threatened to kill her. An old woman of my acquaintance had permitted her nephew to marry her niece in violation of Wana marriage rules because he threatened her physically. She demanded and received a legal payment entitled "the chill of the body" for the fright she felt. In another case, a woman divorced a man who then ambushed her on a trail, tore out her pubic hair, and threatened to kill her. The legal experts directed

her to return to him, saying simply, "If you don't, he'll kill you." The expectation that male violence must be reckoned with serves to enforce men's will without actual demonstration of its force.[11]

But whereas bravery has its place in sexual politics, ethnicity overrides gender in other contexts. Although some individuals are regarded as brave, Wana characterize themselves as a cowardly people. Flight from danger—especially danger from a non-Wana source, either spirit or human—in most situations is not deemed unmanly. Men as well as women freely admit to fear. When Apa ngGoru heard a strange noise in the forest and returned to have a shaman treat him for a spirit attack, no one found that fact amusing. When he returned to the forest to check his bird traps in the company of his wife and child, *that* was a source of humor—not only did it suggest that he relied on his wife and baby son for protection, but the cries of the child, people laughed, were sure to frighten away the birds.

Rosaldo's (1980) analysis of Ilongot gender suggests that women and men are felt to be fundamentally the same, but men, through acts epitomized by headhunting, are somehow "more so." Wana portray women and men as identical in respect to procreation and similarly engaged in respect to labor. But men, ostensibly because their sphere of activity includes realms at a distance from settlement life, have an "edge" in terms of power and knowledge. This "edge" is not as clearly defined as it is in the Ilongot case, where headhunting was an exclusively male activity that until recently marked men as people who had reached the limits of cultural fulfilment. "Transcendence" in the Wana case is not so explicitly gender-marked. It is phrased as an individual rather than a categorically male achievement (cf. Tsing, this volume).

Complicating the picture is the fact that although men may have the corner on bravery, courage is not the only route to spiritual assistance in Wana theory. Spirits reward not only the brave, but also the weak, the unloved, and the pathetic. A strong theme in the culture is the unexpected reward of a poor and lowly person by spirit benefactors. No doubt this scenario has special meaning for a people like the Wana, whose ethnic self-identity is constructed around marginality, poverty, and exploitation by more powerful peoples. Stories abound of poor, ugly little men who are

sallied away by spirits touched by their misery. Balancing such accounts are stories like that of Ndei nTanajang, who had just borne a child when the enemy attacked. She rose from her mat, seized a sword, and fought off the enemy as the blood from childbirth dripped "thick as rats' tails" down her legs. With the help of spirits, she defeated her enemies, and she and her neighbors were transported to a more pleasant existence by her spirit friends. (One might note that she did not return to become the political leader of an ordinary Wana community. Likewise, the men in stories who win help from spirits solely on account of their wretchedness are generally transported to a happier place, rather than recognized as leaders in their own communities.) As these examples show, male bravery is not the only grounds for attaining the prized values of Wana society. In fact, some brave individuals fail to obtain spirit assistance although they scour the forests for it. Others gain powerful knowledge through study with other people. Still others manage to encounter spirits without venturing far from their settlements. Thus the association of men's travels, their bravery, and the prized values of Wana society is not automatic or inflexible.

But at this point, the fluidity of the Wana gender-system constructs has a limit. In fact, there are many people of both sexes who possess what is supposedly the prerequisite for social influence, namely special knowledge and spirit contacts. But not all of these people are accorded a measure of authority on this account. Women, in particular, shy away from making the social claims that their knowledge would seemingly warrant. When asked why so-and-so did not perform publicly as a shaman or come to the fore in public debate, the excuse often given is that the person is shy or ashamed (mea). Although this is said of both men and women, it is particularly true of women and demonstrates that—ideology aside—Wana society is highly "homosocial," to use Geddes's term ([1957] 1961:58), especially when it comes to fraternizing cliques of influential people. For example, women with the qualifications to perform as shamans often do so only for their immediate households, not in the context of large-scale gatherings. Thus the basis for social influence is cast in terms of personal access to distant realms, but its practice is limited by another set of tacit and more gender-bound expectations about the appropriate conduct of

women and men. Whereas the social goods of Wana society are external to it, and externality is associated with distance, and distance is an aspect of men's experience, not women's, because men are braver than women—nevertheless the attainment of special knowledge and spiritual aid is phrased a fluke of personal fortune irrespective of gender. The fact that men and not women more commonly and more publicly attempt to translate such fortune into political capital is a function not of a categorical rule, but of a tacit assumption that the exercise of authority in Wana life is a male prerogative.[12] That statement is itself modulated by the fact that authority in Wana society is neither monolithic nor generalizable beyond very specific contexts, and it consists primarily of the right in certain situations to deliver commentary on matters of general concern (Atkinson 1984). How much more influential an individual can be depends upon his or her skills of persuasion.

To complete the comparison that has been woven through this essay—in contrast to Ilongot society, where men once established themselves as peers through the act of headhunting, Wana society has no single, all-male route to equality, power, and influence. In fact, Wana society possesses a more differentiated set of specializations to which individuals can aspire than does Ilongot society, and Wana seem more openly accepting of social differences and hierarchy. What is more, the grounds for one's preeminence are not explicitly gender-bound. "Anyone" can become a shaman, a rice specialist, or a legal expert. That those "anyones" are predominantly male is treated as a fluke of fortune, rather than a categorical process of inclusion and exclusion. In this sense, Wana women represent the "everyman," the majority, who because of lack of bravery, fortune, good memory, or inclination never come to excel at what it takes to be a political leader in a Wana community.

A Postscript on Gender Shifting

The gender constructions analyzed here possess a loophole that illuminates their contours in a special way. The loophole is a mixed-gender status called *bante*.[13] This status is hardly an oddity in the Indonesian archipelago. Indeed, as a fieldworker interested in

shamanic practice, I was intensely interested to see if Wana followed a pattern familiar in other parts of island Southeast Asia whereby shamans were either women or male transvestites (see Adriani and Kruyt 1950; Hamonic 1975; Hart 1968; Blanc-Szanton, this volume; Van der Kroef 1954–56; Yengoyan 1983). In fact, they did not. The overwhelming majority of Wana shamans are men, and although some occasionally call upon spirit familiars described as *bante mwe'a*, or 'impersonating women,' Wana shamanship remains a rather unremittingly male domain. Then too, I was told of headhunting rituals of times past in which a woman, dressed as a man, would go forth to challenge warriors returning from a successful raid. Neither memory or exegesis went further than that. But I did obtain reports of individuals who were bante in their daily existence. Admittedly, my "sample" is quite small, but my concern here is not with the individuals and any personal aberrations involved, but rather with the general interpretations people placed upon them. These accounts deserve attention both in light of my reading of Wana gender and in light of Whitehead's (1981) important piece on homosexuality and the American Indian berdache.

Whitehead, eschewing the notion that cultural constructions of sexuality and gender are reflections of sexual physiology or erotic orientation, examines standard theories of homosexuality in light of a widespread Amerindian institution of transvestism. Her argument is that cultural notions of sexuality are a function of the gender system of which they are a part, and gender systems themselves are shaped by the prestige structures of a given society. Her speculation has bearing on what follows.

My acquaintances categorically denied knowledge of homosexuality. They speculated, when questioned, that a person who had sex with another individual of the same sex would be entered by a demon and would probably grow weak and sickly as a result of a violation of social order. Indo Lina, a characteristically more liberal individual, dwelt on the positive rather than the negative side. To the notion of a homosexual couple, she responded, "That would be good; there would not be children, so they could be companions." I was told of one teenage girl who enjoyed rubbing up against another woman, behavior that seemed quite peculiar to

my companions, but did not fit into a cultural category of "homo-sexuality." Although the notion of homosexuality was alien, people told me of several women who had "become men" and married women. Seemingly, the switch in their gender status exempted them from the debilitating dangers of sex with other women.

The best case I have of this concerns Paintobo, the aunt, or as she preferred, the "uncle" of one of the elders of the settle-ment in which I worked. I never met Paintobo. She'd been dead for many years before my arrival. But a number of my older neighbors knew her. According to the clearest accounts, Paintobo had been married and had borne a child. The child died, and in her grief, Paintobo cut off a breast, divorced her husband, and assumed the life of a man. She donned a loincloth and a man's shirt, cut her hair, and bound her head with a scarf in male style. She did male farm work, set traps for game, and worked like a man. My companions dwelt on her physical characteristics. She was short, heavyset, and like a man in appearance, but she lacked a beard. She menstruated, said one woman, and when she peed, her urine sprayed instead of streaming straight like a man's. Whether or not she had a penis was a source of much perplexed discussion. After she died, some said, it was discovered that she wore a wooden top in her loincloth to simulate male genitals. One report had it that her fake genitals were constructed of a bamboo tube and a piece of wood that rattled, when she wrote pants, like the wooden bells hung on carabao necks. According to most reports, she mar-ried a woman. One person claimed that for sexual intercourse she used a pointed implement like a deer horn that hurt her partner. Another claimed that she had a small penis that only emerged when she had sexual relations. This woman noted that it was probably her clitoris. (In other contexts, people likened the clitoris to a penis.) Despite the fact she married, however, she and her wife had no children, I was told. Was she mocked for her peculiarities? I asked. At first, yes, it seems. But after awhile, no, said her nephew, she'd chase you with a knife if you did so. No, said another old man, her spirit familiars were powerful. He could recall the foods she requested for her spirits when she performed as a shaman. He could also recall a poem that she had composed in a poetic style characteristic of influential Wana men (Atkinson 1984), but he, a

fine composer himself, found it short and stupid, and would not repeat it for me. Someone else reported that she repeated her words many times when she spoke. In general, the memory of her was of a generous, hard-working man.

Besides Paintobo, I was told, without elaboration, of two other women who "became" men and married. When I asked if men might "become women," one old couple denied that possibility categorically, saying a man lacked a "hole" and would have to cut off his genitals to become a woman. But in other contexts I was told of men who wore their hair in the female style and preferred women's work. I recorded no case of a man having sex with or marrying another man. Instead, their bante status was based on either dress or work.[14] Tangkonde, for example, was described as an old man with a white beard who was married, but had no children. He did not wear women's clothes, but performed women's work like planting, sewing, and making mats and baskets. He was not strong at doing men's work. He was a shaman who danced in the style of a woman (many male shamans do so on occasion, when inspired by a spirit that 'impersonates a woman,' *bante mwe'a*). Whereas Paintobo would attack anyone who called her "aunt," Tangkonde answered with equinamity to aunt or uncle.

Paintobo, Tangkonde, and others like them are regarded as bante. This term can be applied in relative degrees. Tangkonde was said to be somewhat bante, whereas Paintobo was extremely so (*bante kojo*). Whitehead (1981:93) found that Native American concepts of gender-changing included both physical and social dimensions of gender—sexual orientation, work, and appearance were all factors in the definition of gender and gender intermediacy. So, too, the Wana notion of bante involves several aspects of personhood. For Tangkonde, the emphasis was upon his activities and, to a lesser degree, his appearance, expressed by his choice of hairstyle. In the case of Paintobo, my neighbors' concern—and Paintobo's, as well, it would seem—was with the physiological dimensions of her switch. Her female physiology per se was not the principal problem in affecting her change (although she did hack off a breast in a rejection of maternalism). The real stickler was her lack of male genitals. To live as a man without a penis is the puzzle. With her adaptation of a masculine way of life, people

wondered whether she had in fact grown a penis. A penis, it would seem, is a prerequisite for her chosen mode of being. In contrast to the Native American cases in which—by Whitehead's (1981) reading—women's menstruation and childbearing capacities apparently hampered their efforts to achieve male status, Paintobo's female anatomy and reproductive processes were not her limitation. For a male bante, genitals apparently are not an issue. As my companions put it, no man would "become a woman." To do so, he would have to sacrifice his penis, and that seemed too impossible to imagine. Instead, in becoming bante, a man keeps a foot in both camps. Possessing male genitals, he can adopt aspects of female appearance, most typically by wearing his hair in a bun, and concentrate on feminine tasks like planting, and mat and basket weaving.

Why might someone be provoked to become bante? Revealingly, my neighbors explained Paintobo's behavior as a rejection of childbearing and Tangkonde's as a preference for female work over more strenuous male labor. Paintobo took on male tasks, but Tangkonde did not seek to replicate female sexuality or reproductive functions. But for a woman, simply undertaking male activities is not enough. Nor is establishing her bravery, the critical character difference said to differentiate men from women. A brave woman, I was told, is simply brave, not bante. To approach male status, some "anatomical flummery" (Whitehead 1981:90) is in order as well.

Further speculation from the data I have is, of course, risky and quite skewed by the two cases I know best. But my hunch is the following. Gender-shifting is a rather casual, though not commonly used, option in Wana social life. It is open to both women and men. But given certain cultural assumptions, the nature of gender-shifting is not symmetrical for women and men. This derives from the fact that Wana define women and men as fundamentally the same, but expect that men, by and large, and not women, will be the ones to engage in a quest for the most highly valued resources in Wana culture. While not explicitly defined as excluding women, the central political institutions of Wana society are presumed to be male-controlled, although not all Wana men are expected to control them. Maleness, for the Wana, ap-

pears to encompass both the basic humanity of women and men, and men's extra edge as well. A man who is bante simply shifts to a status intermediate to womanhood and manhood. For a woman, gender-shifting is another matter. Women may be complete in their rib count, but they lack a phallus (in the Lacanian sense), whose significance derives not from its purely sexual or reproductive applications, but from its service as a badge that empowers its owner to exceed the limits of Wana communities to confront the dangers and to obtain the advantages that lie in realms beyond. For Tangkonde, occupying an intermediate gender category meant emphasizing the complement to his maleness. For Paintobo, it meant becoming a man, something that mere changes in dress and activities could not adequately effect. As a consequence, she strove further to attain both a wife and a penis, possessions that Rubin (1975) notes are typically beyond the reach of women. In Wana terms, this seemed necessary since men are like women, and something more.

Gender and Performance in Meratus Dispute Settlement

Anna Lowenhaupt Tsing

Arguing that "the study of objectified images of women cannot be a transcultural feminist methodology," Tsing poses a redirection for anthropological studies of gender. She criticizes the preoccupation of cross-cultural analysts with differences they find in representations of gender across cultures. She builds a case against the "one culture / one gender system" approach that has tended to attribute homogeneity and uniformity to constructions of gender in a single society—a point that can be supported by a number of analyses in this volume. She shows that, although gender symmetry is an important theme in Meratus life, it is not "pervasive" across contexts and domains. She makes a case for comparing not simply gender imagery, but the practices that produce and sustain that imagery. Those practices in Tsing's analyses (1987 and forthcoming) include regional, national, and transnational ones, as well as local ones. In this paper she suggests how facets of Meratus political practice derive not only from the common cultural fund of the region but also from the nation state that asserts control over that region.

Tsing's emphasis on gender as process, not product, is instructive not only for feminist scholarship but for area studies as well. Her analysis here addresses a central topic in Indonesian and Malaysian studies, namely a local system of adat or customary law. As Tsing notes, the rhetoric of Meratus adat features gender symmetry. And like the Wana,

Meratus do not explicitly frame the conditions for community authority in gendered terms. But by analyzing a dispute settlement as a social drama, Tsing is able to show how men are systematically privileged in adat practice. With her focus on oratorical performance, Tsing anticipates the contributions by Keeler and Kuipers, which also examine differential access by women and men to certain prized forms of cultural speech.

Tsing's paper contributes to our understanding of the significance of dramatic performance in island Southeast Asian politics. From the courtly displays of the theater-states of Bali (C. Geertz 1980) to the shamanic performances in local communities (Kessler 1977, Freeman 1967, Atkinson 1987), it is striking how important attracting and holding an audience is for establishing and maintaining a reputation as a powerful social person in these island societies. O. W. Wolters (1982) has recently sketched a model for understanding the evolution of political systems in Southeast Asia from small isolated communities of cognatic kinspeople to the mandala pattern of vying independent kingdoms, each claiming itself to be the center of the universe. In all cases the political system is built around "men of prowess" who seek to prove their spiritual potency—and thus attract followings—through repeated meritorious acts. Readers will note a contrast in these essays between populations who practice a politics of the center and those whose politics are constituted through exchange and alliance, the contrast Errington has characterized as the differences between the Centrist Archipelago and the Exchange Archipelago. How gender may be differently configured through these contrastive practices is a central concern in this volume.

In investigating the construction of gender in particular cultures, anthropologists pay special attention to the imagery with which local people describe men and women.[1] Too often, however, we neglect contrasts in the practices through which gender imagery is created and conveyed. Our interests in cross-cultural comparison homogenize practices of gender production to show similarities and contrasts in the imagery. Following approaches that compare the logic of cultures to that of literary texts, we pick out symbolic contrasts of male and female as if we were reading a novel, and thus we obscure variation in kinds of messages about gender. In this essay, I argue for the importance of analyzing gender imagery together with the gendered practices in which such

imagery is developed. Attention to practices moves us from a model of culture as singular and homogeneous; it allows us to place the study of literate gender imagery—so important to feminist scholarship on gender in Western culture—within the history of our own writing practices.

In Kalimantan studies, issues of gender in political imagery and political practice coalesce around a particular question: What is the relationship between customary law and tradition, on the one hand, and the political process involved in dispute settlement, on the other? I believe this question is key to understanding the existence of gender symmetrical legal rules and aesthetics within a gender asymmetrical political practice among the Meratus, Dayak hill farmers of South Kalimantan. A "textual" analysis of Meratus *adat* or customary law and its gender imagery would show complementarity and balance between male and female; but attention to the dramatic requirements of politics reveals men's advantage in becoming community spokespersons who can articulate and press their rights.

The paradoxes of a particular dispute case illuminate my argument: In the summer of 1981, in the Rajang neighborhood[2] of the Meratus Mountains of South Kalimantan, a man saw his wife waving surreptitiously to another man and surmised that she was signalling a meeting place for a love affair. The husband went to get his spear, vowing to kill his rival, but he was stopped by his wife's intervention. Instead of pursuing this tactic, he took his story to the Neighborhood Head of Rajang, who agreed to take on the case. The next day the Neighborhood Head visited the alleged adulterous man, fined both adulterous parties, and gave compensation to cheated spouses on both sides. He ended the case, at least for the moment, by vigorously threatening to fine anyone who as much as mentioned it ever again.

As I have presented it here, this story suggests the hegemony of adat and community authority. Yet in fuller exposition, the same story shows the transience of adat authority in the Meratus setting, and its dependence on a particular medium—public performance. Furthermore, the story depicts a gender-egalitarian adat settlement: both the man and the woman accused of adultery were equally fined, and both male and female spouses were equally

compensated. Yet a closer acquaintance with the case reveals an-
other gender dynamic. Not only was the Neighborhood Head a
man, but only the men involved in the case were successful in ini-
tiating and guiding both the dispute and its settlement. Indeed, the
case can be used to show the systematic advantages of men as po-
litical participants in the dispute settlement process.

Dutch anthropologists began a long and productive practice of
characterizing the diversity of Indonesian cultures by their sys-
tems of adat law and tradition; and symmetrical gender duality
has been a common theme within descriptions of adat.[3] Yet the
Meratus case suggests that adat rules and values may hide as
much as they reveal: adat remains silent about the conditions
of its own production. In the Meratus context, adat authority is
generated by dramatic public performances that bring together a
political community around a particular set of leaders. The affir-
mation of adat values that include gender symmetry (as well as
gender neutrality) thus depends upon the conditions of perfor-
mance, and these conditions of performance, I argue, privilege
men over women.

The gender asymmetry of Meratus leadership—community
leaders are almost always men—is barely remarked upon by Mera-
tus themselves. Meratus discussions of leadership focus on issues
other than gender, such as the difficulties in organizing local con-
sensus and political action, the fearful yet awesome power of the
state, and Meratus ethnic disadvantage in relation to their Muslim
neighbors. Within this discourse on community politics, leaders
appear as exceptional individuals, able to move beyond familiar
Meratus vulnerabilities. Gender seems irrelevant.

I never heard Meratus use gender stereotypes to exclude women
from political activity. Meratus have no "male" or "female" spaces,
and women participated in every political forum I attended. A few
women are community leaders, but there are not many. How are
women disadvantaged? The performance standards necessary to
create political centrality in Meratus forums privilege male tal-
ents. Women, and less assertive men, become the audience for
male "stars." Yet male aggrandizement in leadership performances
precipitates no categories of gender *opposition*, because such per-

formances are seen as a dramatization of individual, rather than male, charisma.

While Meratus explicitly articulate the gender complementarity of adat rules, they also recognize that men, and not women, tend to be leaders. Here, two aspects of political process produce contrasting messages about gender. Furthermore, these contrasting messages are conveyed in different ways: gender symmetrical complementarity is the message of "custom," whereas male privilege draws from dramatic performance. Divergent messages about gender within the same cultural setting must be examined in relation to their particular uses.

Meratus are not politically or culturally isolated. My investigation of Meratus leadership as performance also requires attention to the Meratus relation to the Indonesian state, and to the notions of power and political legitimacy Meratus gain from this relationship. A number of scholars have shown the importance of theatrical display as the political basis of precolonial Indonesian kingdoms (esp. C. Geertz 1980); ostentation and the dramatic presentation of symbols of authority have also been described as important in contemporary strategies of the Indonesian state (Anderson 1972; Mulder 1978). Furthermore, even in peripheral rural areas these kinds of ideals of state organization influence local understandings of personal potency and community politics (Atkinson 1987; Kessler 1977; Tsing 1987). This paper extends these studies to ask about the consequences of theatrical state power for local understandings of gender and male dominance. I argue for a particular kind of connection between Meratus leadership style and state drama: Meratus leaders base their styles on local interpretations of state administrative strategies. Meratus political performance and male performance privilege draw from common regional themes but gain their particular shape in relation to Meratus consciousness of their peripheral position in the region and the nation. Attention to the role of the state, even in isolated parts of the Indonesian archipelago, suggests that patterns of gender difference and asymmetry may be linked by more than cultural origins and common ways of thought; ethnic and political status can be key issues in understanding gender.

Gender and Adat in the Meratus Setting

The Meratus Mountains bisect the province of South Kaliman-
tan in a north-south direction. The Meratus Dayaks[4] who live in
and around these mountains make their living by shifting cultiva-
tion, forest foraging, and selling rattan and rubber at markets in
the plains. The central mountain Meratus about whom this paper
is concerned live in dispersed houses on hillside swiddens amidst
secondary and mature tropical forest. The small family-like groups
called *umbun*[5] that each year are constituted or reconstituted to
prepare new swiddens have a great deal of autonomy and freedom
of movement; swidden-making land is plentiful, and mobility is
expected. Neighborhoods, which may include some 5 to 25 um-
bun, coalesce around clusters of close kin; but neighborhood con-
stituencies are flexible as umbun change their social affiliations
and physical locations.

Both women and men see their major work as rice farming.
Within this general task men and women tend to perform separate
chores (e.g., men fell large trees; women weed and harvest), al-
though some tasks can be performed by both sexes (e.g., thresh-
ing). There is also a division of labor by gender outside of farming;
for example, it is men who hunt, fish, climb trees, and carry prod-
ucts to market, whereas only women generally weave mats and
baskets, pound rice, or cure tobacco. Men and women are also dif-
ferentiated as they are brought together as sexual partners and as
husband and wife. A male-female pair, usually a conjugal couple,
forms the necessary basis for the founding of an umbun swidden-
making unit.

What are we to make of Meratus gender differentiation? Here
we do not have the starting line of gendered notions of descent,
which anthropologists took for granted for many years in studying
"matrilineal" and "patrilineal" kin groups. Like other Bornean
ethnic groups, Meratus reckon kinship cognatically.

Moreover, Meratus discussions of folk biology and the body do
not provide a rich resource for studying notions of gender differ-
ence; medical, spiritual, and developmental portrayals of the body
tend to be gender-neutral. Menstruation is largely ignored; child-
bearing isn't the central feature defining female experience. The

sex-specific nature of body fluids and parts receives little cultural elaboration, particularly when compared to spectacular gender-izations such as those described for some Melanesian or Euro-American belief systems.

Viewed next to the pervasive gender dualisms described for Eastern Indonesia, or even those of other parts of Kalimantan (Scharer 1963), Meratus culture does not seem ordered by the transformations of a fundamental underlying code of gender differentiation. Meratus responded to many of my attempts to elicit gendered versions of the natural or supernatural world with be-mused looks and conciliatory replies. Neither the house nor the heavens is portrayed as a gendered domain.

Yet gender differentiation is sometimes strikingly used in an aes-thetic motif of complementary symmetry that seems quite remi-niscent of other examples of Indonesian gender dualism. This motif is invoked by the phrase laki-bini—'male-female' or 'husband-wife.' Laki-bini provides a descriptive device for pointing to pair-ing in a variety of natural contexts, such as symmetrical mountain peaks or sequential spurts of forest flowering. Laki-bini is also used to describe symmetrical pairing in ritual, for example, paired rice grains used in some planting rituals, or the paired 'posts of luck' at the center of certain community festivals. In each case, there may be a conventional assignment of 'female' and 'male'—in the last example, tall, white Alstonia posts are 'female,' while thinner, denser ironwood posts are 'male'—yet the motif high-lights complementary pairing more than male or female qualities in themselves.

The aesthetic image of gender difference as symmetrical pairing also has its application for men and women. In large community gatherings—particularly rice-planting parties and festival prepara-tion—men and women dramatically demonstrate the aesthetic of gender symmetry by forming separate groups with complemen-tary tasks. Lines of men dibble holes in the ground while lines of women follow sowing rice seed. Groups of men fashion wood and bamboo decorations for the ritual hall while women cut leafy streamers and shape ritual cakes.

Adat—customary law and tradition—presents the symmetrical motif of gender difference most clearly in the arena of marriage

rights and rules, the locus of laki-bini as 'husband and wife.' Although particular versions of marriage adat differ from one expert to the next, they tend to endorse symmetrical rights for husband and wife in most aspects of married life, including rights to compensation in cases of spouse abuse and adultery, and rights to divorce and to conjugal property and children in the case of divorce.[6] Many aspects of adat, as formally stated, are gender-neutral (e.g., rights of senior kin marrying a couple, inheritance of trees), but 'husband' and 'wife' are differentiated yet symmetrical.

In appealing to an audience of anthropologists, it would be easy to describe this motif of gender symmetry as a basic principle of Meratus cultural logic: this is a variant on a story heard before. Yet such a description seems not at all satisfactory. First, although gender symmetry is an important Meratus theme, it is not a *pervasive* theme. Second, while gender symmetry is an acceptable principle for the formal order of ritual, law, and tradition—the adat way—Meratus do not expect the formal order of things to describe the diverse unpredictabilities of ordinary life. Finally, gender complementarity is never used to justify the major asymmetries of Meratus social life. Why are the symmetrical expressions of adat and ritual best articulated by *men*? Here no formal ideal of gender differentiation is held up as the relevant template for understanding; men's achievements as community leaders and spokespersons are held to be products of their individual charisma, not their positions in male-female relationships.

In order to understand how men gain control of key political positions, while adat points to the same political status for men and women, we must look at the conditions for the production and enforcement of adat.

Like the Iban of Sarawak's Rajang River, made famous by J. D. Freeman's careful ethnography (1970, 1981), central mountain Meratus can be described as autarkic and egalitarian—particularly in comparison to other Dayak groups with hereditary ranking (e.g., Whittier 1973) or class-stratified peasants elsewhere in Indonesia (e.g., Stoler 1977). For Freeman, the unquestioned rule of Iban adat was the basis of Iban egalitarianism (1981:32). In contrast, however, I found the instability of adat to be the hallmark of the non-hierarchical nature of Meratus social life. Without a clearly recog-

nized authoriy on the subject, the specifics of adat are always a matter of negotiation and opinion.[7] In neighboring Dayak communities, the Adat Head has the final say; but in the central Meratus Mountains, every mature and articulate adult theoretically can be a spokesperson about the rules; his or her success in "creating" adat depends mainly on getting enough people to listen.

Particular men (and it was usually men) gain social centrality within the political communities they help to create from ties of kinship and neighborhood, and these men may be recognized as community leaders. Some leaders hold appointed government positions (Village Head, Neighborhood Head, Sub-neighborhood Head), and these titles—available only to men—help their holders' leadership claims. Shamanic abilities are also an important route to leadership. But leadership is unstable, and people may shift their loyalties or form their own subgroups around a new charismatic center. Without much in the way of political or economic power, a shaman may find that no one comes to his ceremonies; a government title holder may lack the influence to pull together an assembly.

Those who aspire to leadership encourage community-level dispute settlement forums as one means of creating their own political centrality. Meratus do not take the institutionalized settlement of disputes for granted; many disputes, quarrels, and alleged wrongdoings—even the most serious—are never brought to a community settlement forum, and even if formally discussed, they may never be settled. Disputants can merely move away, or stop talking to each other. When dispute settlements are convened, however, they allow both disputants and mediator to display their political skills: to proclaim their knowledge of adat as well as their social centrality. As one woman quipped, only when there are leaders are there disputes that seem to require settlement.

Most anthropological studies of dispute settlement have looked at the proceedings either from the perspective of the authorities (in what Comaroff and Roberts [1981] call the "rule-centered paradigm"), or else from the perspective of the disputants, to discover the strategies involved in winning (the "processual paradigm"). In this case, a third perspective, that of the audience, reveals more about gender and gendered privilege. At least during my fieldwork,

Meratus women rarely became either mediating authorities or litigious disputants; instead, they joined dispute settlements mainly as listeners and watchers. My gender focus thus turns my attention away from the issues debated by the men to the question of how the audience is divided from the "stars." From this perspective, dispute settlements appear as elaborate and sometimes quite exciting performances, simultaneously creating political actors and the muted social field of their action—the audience.

Dispute Settlement and the Construction of Gendered Privilege

Disputes are appropriately settled by reference to adat. The mediating authority at a dispute settlement uses his determination of the relevant adat to determine fines, compromises, and apologies as necessary. Often (but not necessarily) the mediator is a government title holder. A little ritual that requires shamanic knowledge may also be used to end the settlement. In all this, Meratus affirm their commitment to the importance of order, tradition, specialized knowledge, and authority in guaranteeing community harmony.

But pulling together a dispute settlement requires more than a knowledge of adat alone; it requires the skills to build both starring roles—disputant, mediator—and a political community within which the dispute can be settled. In the Meratus context, there exists little basis for a preformed division between potential mediators and potential disputants or wrongdoers. The same person may be mediator in one case, disputant in the next. Furthermore, the possibility of avoiding mediation remains continually visible in the attitudes of both disputants and mediators. Angry antagonists always have the option of merely decreasing their mutual interaction by moving, physically or socially, in different directions. Thus mediators must demonstrate exemplary initiative in pulling together a settlement. Disputants, on the other hand, are taken seriously as political actors only to the extent that they can hold out for the possibility of nonsettlement. The self-presentation of the disputant sustains debate only as long as it

shows him capable of leaving and forming his own political community, with his own determination of order.

Given this state of affairs, political stars are always aware of two connected preconditions for their political activity: a dramatic self-presentation and an audience to listen to it.

Building Performance

Compared to shamanic rituals, Meratus dispute settlements demand few formal staging requirements. A mediator and disputants merely get together with other interested parties and discuss the case. Anyone may attend; anyone may speak.[8] But since Meratus in this mountainous area live dispersed in isolated households and small household clusters, convening a dispute settlement forum is not simple. Sometimes, disputants or mediators make use of an arena in which people are already gathered (a festival, a work party) to bring together a dispute case; otherwise, concerned parties must travel from house to house to drum up enthusiasm for a special gathering. Even after a group is assembled, the leading figures must make sure people don't lose interest; otherwise, the discussion may break up or turn to other topics without anything being resolved. To keep the assembled group as audience, starring figures must continually re-create a sense of social networks that suggest their own social centrality. A speaker can mention ties of neighborhood and kinship, situating him or herself as a forger of such ties. In fact, any invocation of past or present audience can be used to suggest that a speaker is an authentic political actor, because he or she has someone who listens. Even to invoke one's focality in an umbun family group—with a spouse and children for "listeners"—can add to a speaker's self-presentation as someone with a base of authority.

Another key strategy for holding public attention is the creation of a threatening reputation. A reputation for violence or anger can intimidate competing disputants and draw bystanders with expectations for drama. By publicly attacking or threatening an opponent, a disputant can force a settlement forum to be convened, since people crowd around to break up the struggle, and an audience is thus assembled.[9] After the discussion begins, threats

and angry words continue to establish a dramatic presence. Stories of past aggression, often irrelevant to the case at hand, can be sprinkled into a disputant's presentation of his case to remind onlookers of his violent potential. Even stories circulated before the settlement forum, including gossip about the course of the dispute itself, can build threatening reputations.

In the egalitarian Meratus context, each aspiring political star must establish himself or herself as singularly threatening, knowledgeable, and persuasive. Government titles and shamanic reputations carry some weight in this, but the most important political talent is the management of performance. Thus, maintaining a starring role can involve concentric layers of dramatic violence: stories of aggression leading up to the settlement forum; fighting, yelling, or threats created on the spot; stories of past aggression that confirm abilities in that direction. Similarly, concentric layers suggesting the appeal to past and present audiences are used to establish a speaker's focality.

Male Privilege and Performance

How do these performance standards privilege men? First, men can use their ordinary tasks in the gender division of labor to build a reputation for initiative and bravery—the material from which dramatic performance is created. Second, male political performances turn this kind of reputation into claims of social centrality—and thus audience appeal—by asymmetrical depictions of marriage, sexuality, kinship, and community.

Men's work in travelling, hunting, climbing and felling trees, and the like is thought to engage them in dangerous situations from which they may become 'brave' (*wani*)—or sometimes even troublesome, aggressive, and foolhardy (all aspects of the use of the term *wani*). In the context of political performance, men draw upon reputations for bravery and aggression in building their dramatic self-presentations.

More important yet, men establish their leadership qualities as the kind of men who have followers (and thus audiences) by claiming that bravery and aggression lead to social centrality. We can see this most clearly, perhaps, in men's attempts to claim leadership

over umbun families. Adult women and men equally gain eco-
nomic and political independence by founding an umbun swidden-
making group, but only men generally try to suggest that they are
leaders of umbun, stimulating umbun foundation through their
initiative in gaining wives by procuring marriage payments.[10] Only
men claim to be capable of physically intimidating their wives,
children, and animals.

The view that male initiative is necessary to form a marriage—
even one that eventually benefits both spouses—echoes with the
portrayal of sexuality as the enactment of male desire. Sexual
jokes and intimations of male sexual prowess enhance men's repu-
tations as political actors through their focus on male initiative in
the sexual act. Sex is also described, particularly by women, in
gender egalitarian terms as 'delicious' pleasure. But in the stories
that enter political dramatics, pleasure as women understand it is
eclipsed by male initiative. In these stories, sex occurs because
men want it, irrelevant of women's wishes. Sexual jokes and stories
suggest a man's ability to put himself in a focal position—in a star-
audience relationship with a real or imaginary female consort.
Sexual stories attract notice as both risky and risqué, and thus
they can be used to build a dramatic self-presentation.

As men claim initiative in sex and marriage, they also claim to
create kinship and community networks. Meratus depict kinship
and community as unstable; mobility and the flexibility of social
networks continually reaffirm the Meratus sense that genealogi-
cally defined "kin" (or neighbors) are really only worth consider-
ing kin (or neighbors) if they actively make something of it. Public
gatherings like dispute settlements are seen as key to community
formation, and men's widespread visiting, which indeed helps to
bring these forums together, politically overshadows women's less
extensive—but also frequent—travel. Furthermore, to the extent
that men claim to speak for the women of their umbun in commu-
nity forums, the forum situation obscures women's contributions
to creating and maintaining social networks.

"Male resources" for claiming social centrality are thus stimu-
lated by the performance context. Because dramatic self-presenta-
tion and audience focusing are necessary for active political partici-

pation, men are inspired to make these kinds of "male" claims in political performance. Rather than arguing that men are leaders of umbun, lording over sex, kinship, and community, I am merely saying that on certain occasions some men are moved to say they are. To what extent anybody believes them outside of those contexts is another question.

Meratus performance politics encourage male self-aggrandizement, yet male claims do not stem from or stimulate a discussion of gender hierarchy. Instead, performance conditions shape a discourse in which each man claims himself to be exceptional, rather than a familiar example of the category "men." Thus "women," rather than taking their place in the discourse as a well-defined "other," become, with all the men who are not currently defining their exception, a taken-for-granted backdrop to the activity of male stars.

The points I have made so far come to life in a particular dispute settlement. A detailed narrative presentation of the adultery case with which I began this essay should clarify what I have been calling "performance" and "privilege," making it possible to specify their wider context later.

The Commotion over a Wave

Adultery and wife-stealing cases were the most common and the most dramatic settlement cases I saw during my fieldwork. In these cases, stories of illicit sex and possible violent retaliation created a public excitement that made prime material for a settlement forum where personal ferocity was woven together with concerns for family leadership and community order. In the case I discuss here, the male adulterer's aggressive reputation as someone who might never submit to settlement prepared the neighborhood for drama. At the same time, both adulterers and injured spouses were so well entrenched in neighborhood kinship networks that it would have been difficult and unlikely for any party to move away. The close kinship connections between the major disputants of the case are shown in the accompanying figure; these connections, as well as multiple ties to the other neighbors who formed the

Major participants in the case. Capitals indicate alleged adulterers; underlining indicates compensated spouses.

"audience" of the dispute, made it possible for the forum to succeed, both as a settlement and as a statement of leadership and its community.

The "dispute settlement" itself began when the injured husband brought his complaint to the young Neighborhood Head. According to one rumor, his wife had been sporadically involved in this affair for years, yet it became a public matter only with this complaint. In order to show how the leading participants worked up their reputations even before a dispute forum was convened, I will begin with the complaint. It was also my first knowledge of the affair; I heard about it together with the household of the Neighborhood Head, with whom I was living.

Ma Busa's story. One evening, Ma Busa visited Ma Salam, Rajang's young Neighborhood Head, with a long story to tell of the events of a few days before. He began the tale with a rambling narrative of his activities that day, situating his message in a familiar nexus of kinship, landscape, and livelihood that could activate his listeners' friendly sensibilities. He had been on a certain route through the forest; he enumerated the neighbors he had met on the trail or passed hunting. He went home. His wife was pounding rice on the

An aspiring disputant establishes his social network

porch. Noticing mouse droppings in the rice bin, he
began work on a bamboo bin cover. As he sat on the
house floor working, he could see his wife pounding
with a tall wooden pestle. What was she waving at?
He called to her; it was nothing, she said, she was just
swinging her arms to the rhythm of the rice pounding. *and tells of the wave*

 Then he decided to go outside to defecate. As he
stepped out onto the porch, he caught a brief glimpse
of his neighbor Ma Bakal ducking into the bushes.
Immediately he guessed the situation: since his wife
had been planning to spend the night at her brother's
house, she must have been waving to Ma Bakal to join
her there! So they were having a love affair. He ran *that signals a
back into the house to get his spear, yelling out to Ma story of sex and
Bakal that he would kill him. violence.*

 But his wife followed him inside, held his arms, and
pleaded with him not to pursue the man. In his fury he
thrashed his wife, tore off her bracelets, beat her with
a vengeance. But he did not go after Ma Bakal. The
next day, husband and wife both lay around the house
quietly, she in pain, he, glad to have reestablished his
conjugal prerogatives, but waiting on his next move.
Finally, he decided to take the case to Ma Salam as
Neighborhood Head.

 Ma Salam's dilemma. In bringing the case to Ma
Salam, Ma Busa had offered Ma Salam the chance to
build his own leadership initiative, and Ma Salam, am-
bitious to prove himself as a leader, was not about to
turn down the opportunity.

 Despite his ambition, Ma Salam was aware of a
number of disadvantages in his self-presentation as au-
thority. Ma Salam was young and a bachelor, without
a wife and children to claim as the bottom-line dem-
onstration of his support. As an umbun co-founder,
with his widowed mother and sisters, and with stores *An aspiring medi-
of a good harvest, he could partly compensate by show- ator's reputation*
ing his rice sufficiency, and even abundance. But he
was gentle and small in build; he was only beginning
to get interested in ritual knowledge and could make
few claims to shamanic talent and its associated spiri-
tual authority. Ma Salam owed his leadership claims to
his appointment, little more than a year before this in-

cident, as Neighborhood Head. (Government appoint-
ments were favoring literate young men over their more
"traditional" seniors.) He drew on this official position
for all it was worth: He mixed the national language
into his speech, sometimes using vocabulary that no
one else understood; he called up his knowledge of the
government and outside affairs; he threatened to call
the police or to take those who refused to comply to
higher regional officials. Such officials in fact had little
interest in local Meratus affairs, and it would have been
difficult indeed for Ma Salam to act on his threats to
call the police. But most Meratus had seen enough of
state power to fear and respect it. Ma Salam used local
awe of the state as the basis for his ability to impress
and to threaten.

Although enthusiastic to take up Ma Busa's case,
Ma Salam was also nervous about his abilities to do
so. Ma Busa had given him authority, but he had little
reason to believe Ma Bakal would do the same. Ma Bakal
had been the Neighborhood Head briefly before Ma
Salam; his title was taken away without his consent
through the arbitrary directives of a distant District
Officer. Furthermore, Ma Bakal was known as tough
and brave, and Ma Salam, in his own words, "had little
with which to answer him."[11] The adultery itself was
being discussed in the neighborhood as additional proof
of Ma Bakal's bravery.

> confronts the
> adulterer's
> reputation.

Furthermore, a story Ma Salam had heard the day
before suddenly clicked into place. Other neighbors
had come visiting with the tale of how Ma Bakal had
beaten his wife with a piece of firewood until she uri-
nated all over the floor. Now it appeared that this inci-
dent had probably occurred on the same day he had
been caught by Ma Busa; where the tale had seemed
senseless violence the day before, it now added signifi-
cantly to the man's reputation as a tough disputant. He
had also, it was said, threatened his son-in-law, and
chased his son out of the house, saying he had already
spilled much foreign blood. Poeple had laughed, ner-
vously, on hearing the story, joking that he had prob-
ably never killed anything more threatening than a pig;
but the threat itself was telling of a reckless bravery.

Ma Salam confided to me that he was afraid.

To refuse to mediate would have been to give up
the leadership opportunity he had been offered, and so
Ma Salam ambivalently determined to visit Ma Bakal The case takes off
the next day. Proper respect for his leadership, he
noted, required the disputants to come to his house,
but there seemed little chance of that. The next morn-
ing he did indeed set off, with me in tow.[12] Normally
the trip involves less than an hour's hike, but this time
we took more than half the day en route; Ma Salam
needed to build support if he would successfully as-
sume a mediator's position, and so we stopped to talk
with everyone he could find on the way.

Each time we stopped, entering the houses of neigh-
bors, even taking advantage of a chance meeting along
the trail, Ma Salam discussed the case. He drew out
his neighbors' opinions and expressed his own worries through building
that Ma Bakal would refuse to settle, all the time urg- support . . .
ing their support for his leadership attempts. He por-
trayed the adultery as a dangerous messiness, capable
of infecting the entire community if not checked; he
implied that the affair was especially shocking because
Ma Bakal's lover was the sister of his second wife, and
he recalled other cases of men sleeping with their sis-
ters-in-law that had disrupted community unity. Then
he suggested that he would bring the case to higher re-
gional authorities, or notify the police, if Ma Bakal re-
fused his settlement plans. The threat both strength-
ened his claims to authority and probably scared his
neighbors, who themselves were kin not only to Ma
Salam but to Ma Bakal and Ma Busa. Their own inter-
est then drew them into supporting a local settlement, and an audience.
Ma Salam's settlement. Ma Salam particularly hoped
to convince a number of his male cousins with braver
reputations than his own to attend the proposed settle-
ment forum. He succeeded in drawing attention to the
case and attracting not only these young men but a
reasonably large audience of concerned kin and neigh-
bors, male and female, who resolved to attend.

Ma Bakal's performance. When we finally arrived
at Ma Bakal's place, we found him harvesting his late
rice crop. He looked up at us with nervousness and

only reluctantly accompanied us to the house. When Ma Salam gingerly referred to the motivation of his visit, Ma Bakal stood up brusquely and strapped on his bush-knife. (It is never appropriate to wear a knife in the house.) There were tears in his eyes and he looked angry and afraid. "If I've committed a wrong, I'll give you my knife and you can kill me," he declared, combining penitence and aggression. "Let there be no more name Ma Bakal any more." It was a lame excuse for wearing his knife, but having seized upon it, he carried on with great emotion about how he wanted Ma Salam to kill him.

The discussion heats up;

Ma Salam began with stock leadership phrases about looking for the good, looking for agreement. But he seemed scared by Ma Bakal's aggressive response, and he quickly moved to threats: he would take Ma Bakal to the Village Head, or to the Police Post if necessary. It would be a weighty matter, he said, but it was up to Ma Bakal to decide if that was what he wanted. Ma Bakal, however, was determined not to be easily cowed into submission. Together he and Ma Salam see-sawed between fear and ferocity, each goading the other to further threats and anxieties.

threats from Ma Salam

"If you want to settle my case, I'll open up a few other good cases," Ma Bakal threatened, bringing up an old accusation that another neighborhood leader had slept with Ma Bakal's wife while he was still Neighborhood Head. "But I'm wrong, I'm still sleeping around, I'm still destroying other people's umbun . . . you might as well finish me off"; he was back to threats of suicidal aggression. To submit to settlement, he implied, would be to lose his name and his identity. By bringing up both repeatedly, even in the context of losing them, he reminded us of his potential. "Go ahead and wipe out the one from Tamiang Layang," he continued, invoking a questionable genealogical link to a spot in Central Kalimantan known as a center of more powerful Dayak culture, his own tentative claim to powerful connections.

are returned with defensive reputation-building,

dramatic penitence, and counter-threats.

Ma Salam switched tactics: "All right, I won't settle your case if you don't want me to, but then I can't guarantee your safety in the future. If anything hap-

pens, I won't be responsible. . . ." The familiar threat
of trouble from the state still lingered behind his
words. Ma Bakal protested and threatened simultane-
ously: "I've no intention of not submitting to settle-
ment. If I wanted to be fierce, I'd be hanging a head
in my doorway [a reference to headhunting], and I
wouldn't do such a thing, although I'm brave enough." More threats are
Gaining confidence, he picked a new theme: "If you exchanged . . .
get rid of me, you'll see what happens to Rajang, young
and old alike, you'll see. . . ."

 "Besides, you're too late," Ma Bakal enlarged; after
all, the incident had occurred several days before, and,
he claimed, everything had already been patched up.
His wife wasn't complaining about anything. Ma Busa
seemed to have resolved things with his wife, and, be-
sides, one couldn't believe much that man said any-
way. There had been no affair. "If it's like that," Ma
Salam agreed nervously, "there'll be no need to settle
anything." But recognizing the hint of future trouble
in Ma Salam's tone, Ma Bakal doubled back and ex-
panded on his earlier counter: "If you punish me,
you'll see what happens to the land of Rajang and all
its children. . . ." Tapping his chest, he added cryp-
tically, "From the heart of the earth," implying his
own deep powers. With his mystic knowledge, his body
was simultaneously the land, and this land would be
in trouble if they went after him.

 They had reached a stalemate in threats of future
retaliation. But as they spoke, people had been filing in and the audience
and arranging themselves around the room to listen. is convened.
Other men began to speak up. They spoke of the his-
tory of kinship and cooperation that tied the commu-
nity together and of the necessity of maintaining good
relations. Ma Bakal calmed down and said he had been
kidding all along. Ma Salam relaxed a little as he saw
that he really had convened a settlement.

 Women's support and resistance. When Ma Busa
finally arrived, Ma Bakal had taken off his bush-knife
but was holding it in his lap, carving the handle. Ma
Busa chose not to take off his bush-knife at all as he
sat down with the group. But for a few moments, the
group's attention turned away from these men to the

women. Ma Bakal's two wives had been present from
the start. It was generally assumed that the second wife,
as the sister of Induan Busa (the female adulterer), knew
and probably approved of the affair all along, and no
one thought to ask her opinion of the proceedings.[13]
Indeed, she sat silently listening and attending to small
chores throughout the meeting. The first wife, how-
ever, was considered an injured spouse, and Ma Salam
would have liked her to make a formal complaint to
him, to augment his claim to authority over the case.
Instead, however, she hesitantly supported her hus-
band. When he stated that there was no quarrel to set-
tle, she agreed that she had not approached Ma Salam
with a complaint. As her husband's dramatic course
changed, she retreated into silence. Ma Salam and
others assumed that her recent brutal beating had muf-
fled any opposition she might have to his affairs. But
they were not about to argue a case *for* her.

> Women's silences, nervous support,

Induan Busa was late to arrive. First she sent a mes-
sage that she was too ill to attend. When fetched again
she reluctantly came, and her sulky demeanor showed
resistance. As she entered, she began mumbling, her
head down, speaking into her chest, her hand on her
face further muffling the words. She was wrong, she
said, to peddle her genitals[14] so easily; she had no in-
tention now of denying it. There was no shortage of
women, even those that didn't play around, and so they
should just divorce her from her husband and get rid of
her. In many ways, her message resembled that earlier
set out by Ma Bakal, but without the knife, the angry
presentation, the reputation for bravery, or the claim
for mystic reprisals. Although she too mixed penitence
and aggression in her resistance, her aggression was
much more easily dismissed by her audience. Ma Salam
curtly dismissed her by saying if she wanted a divorce,
she should approach the marriage official—it was none
of Ma Salam's business—but she had better find Rp.
120,000 to pay the costs. That amount of money, as
everyone recognized, was outrageously far beyond a
woman's means to gather.[15] It was a tactic, and a rude
one at that, to silence her.

> and mumbled words

> fail to make a big effect,

Yet Induan Busa's resistance wasn't quite so easily

hushed, and she continued to mumble softly about her proposed divorce. No one, however, paid her any more attention. Finally she got up and walked out. No one went to fetch her back, and the settlement continued without her. She had shown the power to resist, but not to halt or redirect the settlement process.

I had found the beatings of Induan Busa and Induan Bakal at least as alarming and worthy of community concern as the wave from the porch; I was a little surprised that they were never mentioned in the settlement forum. Yet discussing the incident later with Ma Salam and other friends, I found myself alone in my concern. Women empathized with the pain of the beaten wives, but they, like the men, accepted that this pain (or resistance against it) would disappear in the politically significant version, the tale that created only male initiative against a muted field. If neither wife had the ability to stage a protest, neither wife could invoke adat for her own protection. Only by successfully entering political debate does a person achieve political rights.

reminding me of the case that never emerged.

Negotiating unity. With the appearance of disputants and audience, the most difficult step of dispute settlement had been achieved: the constitution of a "community" formed around the initiative to debate the case. Since authority and political activity were thus already defined, all Ma Salam had to do from there was to suggest an agreeable formal settlement. This was easy enough; following precedent, he asked for fines from the adulterous parties, in this case, Rp. 3000 each.

Once opened, the case can be closed on its own terms

But Ma Bakal was not quite ready to give up his personal drama and accept mediation, and so, protesting that he had no money, he took his knife and stomped out of the house. Unlike Induan Busa's disappearance, this did halt the proceedings. People speculated alternately that he had gone to borrow money or that he was about to kill himself, or someone else. Conversation proceeded in murmured whispers as the audience waited in suspense. In fact, he had gone to borrow money, and he returned with Rp. 5000, laying the money and his knife in front of Ma Busa and telling the injured husband to kill him. Once again, drama

. . . but a little more drama helps all our heroes.

rose, as Ma Busa seemed ready to take up the challenge.
A young woman grabbed their knives (both lying on
the floor) and ran out the door.[16] Ma Bakal and Ma
Busa began a yelling match; Ma Bakal accused Ma
Busa of trying to kill him, in the original incident,
with his spear, while Ma Busa accused him in return.
Ma Salam hastily returned Ma Bakal's money; another
young man muttered protective spells. People crowded
around them to ward off a fight. And Ma Bakal allowed
the drama to break, saying mildly, "I was just joking,
of course."

Having established his self-respect and political ini-
tiative, Ma Bakal allowed the settlement to proceed.
Induan Busa sent over a skirt as her part of the fine;
her son (married to Ma Bakal's daughter) exchanged it
for cash. (This son was also the source of the money
Ma Bakal used as his fine.) Ma Salam took the oppor-
tunity to lecture the crowd about the significance of
the fine. No one would be allowed to as much as men-
tion the affair any more; anyone who told tales of it
would be even more heavily fined. Ma Salam reminded
Ma Busa not to bad-mouth Ma Bakal. And Ma Bakal
took the chance to agree, for a change, by saying he'd
let Ma Salam know right away if anyone was breaking
the rules. This was a good conclusion, from Ma Salam's
point of view. Ma Bakal had pointed to Ma Salam as
authority.

The rule of order
and authority
prevails,

The total fine amounted to Rp. 6000; Ma Salam
gave Rp. 1500 to each of the injured spouses (Ma Busa
and Induan Bakal) and kept the remaining Rp. 3000 for
himself. As soon as the audience had dispersed, how-
ever, he returned his part of the fine, except for a token
Rp. 500, split between himself and a cousin who had
come to support him as 'militia.' As he explained to
me, it was important to collect the money to impress
people, but after the settlement was achieved, and the
listeners had gone home, he might as well give it back,
since relations had returned to normal. Authority, his
actions reaffirmed, is a matter of show, not of economic
advantage or ongoing political leverage. It is created for
the moment, but then disperses as the more egalitar-
ian relations of everyday life reassert themselves.

but disperses with
the audience.

Gender and the Meratus
Political Subject

The case shows a number of contrasting examples of male po-
litical style. First there was Ma Salam, with his threats to call the
police, and his appeals to order, kinship, and harmony. In contrast,
Ma Bakal was much more the tough loner, mixing physical, spiri-
tual, and emotional threats. (On other occasions, however, he also
saw himself as a source of adat authority.) Ma Busa was quiet, but
jumped to his own defense when necessary. The three men used
different mixtures of appeal to adat authority, spiritual power, vio-
lent potential, and kinship support, and the differences had to do
with their varied positions in the argument; but all recognized the
need to join drama and audience-building to the authority of knowl-
edge and order.

The women involved were no less cognizant of adat ideals and
political conditions, yet they were consistently unable to focus
the audience around their performances. Ma Bakal's wife sug-
gested that there should be no case at all, since she hadn't com-
plained; but her words had no success in stopping the dispute pro-
cess. Induan Busa, the female adulterer, left the settlement before
the case had been resolved, but her action had no effect in prolong-
ing the dispute or holding back its settlement. Only the men were
able to make their voices heard.

Men's advantage here is connected with their ability to tap both
political and spiritual resources. Along with the ability to claim
personal bravery, men's travel and trading activities also give them
privileged access to money, government titles and connections,
and widespread social ties.[17] Men are also privileged in the appren-
ticeship system through which shamanic knowledge is commonly
gained. Yet men's clear advantages are not acknowledged as gender
hierarchy. To understand this, we must consider Meratus inter-
pretations of leadership and political activity.

Central mountain Meratus communities are rather egalitarian;
no umbun swidden-making group can boast of much economic or
political advantage over others. Political discourse has not elabo-
rated on power differences within the community, instead point-

ing to power *outside* of the community, in both political and supernatural centers outside of familiar territory. Meratus depict themselves as weak in relation to outsiders, including the Muslims of the surrounding plains, government officials, and various kinds of spiritual beings. In terms of their political situation, this is an assessment that makes sense: since precolonial times, Meratus have held a disadvantaged position in economic and political interactions within the region, and contemporary pressures, such as the migration of Muslims into the Meratus area and government resettlement programs, make this disadvantage particularly evident. Military intimidation and bureaucratic ritual have been major features of Meratus interactions with distant authorities since the era of precolonial kingdoms; Meratus descriptions of state power as based on ferocity, display, and an obsession with order thus elaborate on their political experience. Supernatural realms are described with the same model.[18]

Meratus leaders attempt to draw their own authority from links with these greater outside powers; if they themselves can display the same ferocity and obsession with order as the state, they can show themselves to have moved beyond ethnic vulnerabilities into the realm of power. But these links to power are not the exclusive preserve of an elite: Meratus suggest that it is individual bravery, charisma, and articulateness that create links to power, not community status prerogatives. Leadership in the Meratus context does not depend on prerequisites of wealth, inheritance, or ranking. And an egalitarian mysticism provides the sense that everyone has the potential to develop into a focus of power, knowledge, and authority. There is thus a double sense in which Meratus leaders must become "political subjects": they draw their power from their acknowledged subjection to the state and powerful outside authority, yet as individuals they transcend this vulnerability by becoming the subject of political discourse and performance.[19] A leader can never be a representative of a community category, because he must always be an exception. In maintaining this continuing reminder of both community vulnerability and the possibilities of its charismatic transcendence, political discourse obscures oppositions within the community, making everyone appear a potential "subject" of authority in both senses.

It is within this context that gender oppositions in the political arena remain muted. Men do not claim leadership positions as *men*, but as exceptional individuals—who happen to be drawing on resources more available to men than women. Women, together with men who are not performing, become the background audience upon which charisma can be projected, and over which order and authority may rule with their images of symmetry and balance. But Meratus subjects of political performance identify no "objects."

I was particularly struck by an absence of objectification of women in the stories of sex and violence men use for building leadership reputations. When neighbors told the story of the beating Ma Bakal gave his wife, it sounded as if he was a self-automated whirlwind, and she just happened to get too close. No one suggested that the beating had anything to do with their conjugal relationship; he was a fierce fellow, and it seemed he would beat anyone within arm's length. As related in the adultery case, this was a key piece of gossip in establishing Ma Bakal's dramatic potential.

Similarly, stories of male sexual prowess neglect to mention female participation or lack thereof in the sexual encounter. Unlike Western erotic conventions, in which the male identity of the subject is established by depicting or describing a woman's body as object, Meratus stories of male sexual heroism describe only the activity of the man. Women participants appear in the stories only as the field of male activity; they are the "audience" for male sexual actors. Women listeners are thus doubly reminded of their inability to act (once in the action of the story, once in having to listen to it); but as long as their vulnerable condition remains the ordinary, unmarked expectation—in contrast to the exceptional ability for political drama—they are unlikely to object to the situation *as women*.

Because women are never excluded from political participation by the "rules," ambitious women can, and do, try to enter the action. I saw women use violence, innuendos of sexual prowess, and spiritual inspiration to attempt to be heard; but women rarely get as far with these tactics as men because they are tactics biased for male play. The most successful strategy that I knew of during my fieldwork was instead to circumvent the requirements of male-

privileged political drama, by endorsing an adat codification that superseded conventional performance requirements. In two papers that can be read as companion pieces to this essay (Tsing 1987 and forthcoming), I describe two women leaders who proclaimed that formal knowledge was more important than performance. In one case in particular, the woman pressed a much more rigid gender separation than I observed elsewhere, as part of her adat codification project; by calling for a more clearly articulated gender opposition, she advocated an adat model of gender symmetry and of separate but equal status. In contrast to our expectations that rebellious women are those who fight for the right to break the rules or change them, these women endorsed "rules" as the key to overcoming their gender disadvantages. The "rules" offered an image of gender equality that they could manipulate to overcome their disabilities in the political process.

The distinctiveness of the Meratus system can be seen clearly in a brief comparison with their Muslim neighbors, the Banjar, the majority population of South Kalimantan. Women's inclusion in the unmarked "audience," in the Meratus setting, depends on the fact that in Meratus houses and communities, there are no "male" or "female" spaces, and men and women socialize easily together. There is no clear separation between "women's talk" and "men's talk." In contrast, in Banjar villages and towns there is a clearly demarcated gendered geography, separating women's intimate talk in bedrooms and kitchens, and men's formality or banter in front rooms, offices, mosques, and markets. Male leaders and spokesmen draw primarily on an audience of other men; women have their own separate, female "gossip."

Banjar use stereotypes of men and women to discuss both gender opposition and gender asymmetry. Thus, for example, women are held less able than men to control their bodily needs and desires (cf. Ong, Keeler, this volume); this explains why women are more often sick, why women need male protection and guidance, and why women pray at home rather than in prayer houses or mosques like men. This use of gender imagery is much more familiar in the anthropological literature on gender than what I have described for the Meratus: Meratus do not use images of male and female as a justification for male privilege. Although gender con-

trasts are discussed, particularly in the "adat model," advantages in leadership are not related to gender opposition. Instead, men are advantaged through performances that build on male abilities without acknowledging their gendered source.

In their discussion of the state and local politics, Banjar much more than Meratus are moved by mainstream Indonesian concerns about corruption, bureaucracy and law, Islamic principles, competing foreign influences, and regional prestige within the nation. In comparison, the Meratus interpretation of state power—as merely the display of military force and administrative ritual—seems almost parodic in its abstractness. The Meratus political situation, in which power means little more than the ability to convene an audience, has perhaps allowed local leadership to become a caricature of the state. Yet despite—and through—its caricature, the state has established significant control over Meratus local politics.

Conclusion

This essay has argued for the importance of looking at performance for understanding male privilege in Meratus politics. The notions of male and female embodied in Meratus adat tradition influence the political status of men and women only as one part of the process in which adat is activated and enforced. In this process, men's abilities to present themselves as dramatic actors and centers of audience attention allow them to predominate in key political roles, including both disputant and adat authority. Women are disadvantaged by their comparative inability to become a focus of political action. My analysis illustrates the importance of studying gender roles and categories together with the political practices of which they form a part.

In describing a situation in which men become political subjects without objectifying women, I have implicitly contrasted my material with more familiar kinds of scholarship on gender that focus either on objectified images of women or on a system of gender contrasts. A few more comments on each of these two foci can clarify my position.

The discussion of objectified images of women has been an extremely productive direction for feminist scholarship, especially in considering the cultural construction of the female in Western art and literature. Feminist critics of the Western tradition, from pioneers like Simone de Beauvoir (1952) to poststructuralists like Teresa de Lauretis (1984), have shown how objectified images of women are used to create male subjectivity and the transcendent male gaze. Women's bodies, for example, become natural objects under the scrutiny of a controlling male knowledge. This useful approach only becomes problematic when it is divorced from an appreciation of a particular history of textualizing practices. The contrasts between this textual tradition and performance-oriented Meratus gender politics remind us that the study of objectified images of women cannot be a transcultural feminist method.

Feminist anthropologists studying non-European cultures since the 1970's have looked not for female objectifications but for local notions of both male and female as a semiotic system of gender contrasts.[20] In showing important differences in the cross-cultural content of gender imagery, this anthropological approach has been an important antidote to ethnocentric overgeneralizations about gender in Euro-American scholarship. In describing each culture as having particular "notions" of male and female, however, we may offer too little information about the contexts in which these notions are expressed, the historical specificity of their dominance, and the counterdiscourses that oppose them. In presenting a "culture's" ideas about gender as an abstract body of coherent and undifferentiated thought, we lose sight of both cross-cultural and intracultural contrasts in the practices in which the hegemony of particular ideas about gender is produced and maintained.[21]

My approach here is influenced by misunderstandings that grew from my own initial formulations of ideas about gender in Meratus culture. When I first began to speak and write about Meratus ideas about gender, I wanted to share with my U.S. audience the striking experience of the lack of discussion of gender in so many contexts in which I expected it. I was particularly struck by Meratus discourse on power in which gender was unmarked (Tsing 1982); in contrast, so much of feminist anthropology seemed based on examples of sharply defined gender differentiation and segrega-

tion. Yet, when I began to hear other anthropologists characterize "Meratus culture"—based on my descriptions of gender-unmarked discourses—as an example of a culture lacking in gender differentiation, I was disturbed. This was much too simple. Even within the small sphere of Meratus adat law, for example, gender-unmarked adat works together with gender-complementary adat and gender-asymmetrical political practices. Gender-unmarked discourses on power help Meratus make sense of gender-asymmetrical political practices; an analysis of either separately would be unnecessarily incomplete. This essay argues that feminist anthropologists can afford to move beyond the search for a single set of notions of male and female linked with each culture to explore the production and use of these notions in political process.

My analysis of Meratus gender politics also points in a particular direction for understanding both contrasts and connections among gender systems in island Southeast Asia. I suggest that characterizations of local understandings of gender—as "complementary," "unmarked," "relatively egalitarian," etc.—are only the beginning of an analysis, which must also attend to how these understandings form a part of variously gendered practices. These practices are the activities through which a set of ideas enters public discourse (not, as "practice" is sometimes used, the messy details of life that keep people from realizing their ideals, nor the precultural self-interested strategies that ideals mask). Cultural contrasts within the region involve not only transformations in ideas about gender, but also differences in the social dynamics through which anyone can make a meaningful statement about men and women. Regional connections in understandings of the relationship between gender and power relate not only to cultural ties but also to histories of precolonial, colonial, and postcolonial political relations as these shape regional identities, ethnic antagonisms, or political status vis-à-vis the state.

To address the issue of regional connections I have wound a number of common Indonesian cultural themes through my discussion of Meratus gender and leadership: the importance of adat order, the aesthetic of gender symmetry, the attention to drama as the heart of politics, and the evocation of the state in local performance. In showing the particular ways these themes emerge in

Meratus politics, I have discussed the context of Meratus leadership style within local interpretations of state power as well as Meratus ethnic and political status. My goal here is to suggest possibilities for exploring variation and links among Indonesian systems of gender and male dominance that relate to regional and local political dynamics as well as symbolic continuities and contrasts.

Speaking of Gender in Java

Ward Keeler

In contrast to the relatively egalitarian Wana and Meratus, Javanese so-
ciety is predicated on hierarchical distinctions. Yet in all three societies,
gender differences at the level of the "person" are underplayed. Whereas
an emphasis on human "sameness" deflects attention from differences
between men and women in practice among the Wana and Meratus,
Keeler suggests that Javanese preoccupation with differences among indi-
viduals along the dimension of prestige/potency overshadows gender as a
highly salient distinction in Javanese social life.

Like the preceding paper by Tsing and the subsequent paper by Kui-
pers, the focus of Keeler's paper is language use. Whereas Tsing explored
how individual Meratus sought to create audiences for their political
claims, Keeler considers how Javanese read social interaction for subtle
signs of culturally prized potency. Tsing focused on Meratus men's greater
ease at establishing themselves as political subjects. Keeler, by contrast,
points out the restrictions that status, potency, and elevated speech styles
place on Javanese men and explores the greater social latitude afforded to
women who serve as behind-the-scenes managers of information and
relationships.

Keeler explores how Javanese women can manage economic resources
and social relations yet achieve less prestige than men. The Javanese
case thereby helps to clarify a distinction often muddled in feminist an-
thropological literature between culturally prized prestige and economic/

*practical clout. Cultural valuations of prestige simply do not reflect eco-
nomic relations. Likewise, it would be incorrect to mistake women's
relative lack of prestige in cultural terms for a general statement about
women's inferiority or ineffectiveness in Javanese society.*

*Keeler's account of women who achieve high bureaucratic rank is
similar to Atkinson's account of Wana women who happen to succeed in
a domain like shamanism—"they haven't broken the rules, but beaten
the odds." Both Keeler and Atkinson also each present cases of trans-
vestites in their respective communities. Although homosexuality is de-
nied in both cases, gender-switching is easily tolerated in these fluid gen-
der systems in which "prestige structures" (Ortner and Whitehead 1981b)
are not explicitly framed in gendered terms.*

In a closely reasoned and insightful essay, Marilyn Strathern
has noted disparities between the ways that Hageners in Papua
New Guinea describe the characteristic traits of males and fe-
males on the one hand, and the ways that men and women there
actually interact on the other (Strathern 1981). The fact of gender
difference generates metaphors among Hageners for differences in
social attitudes observed in men and women alike. To participate
in the cooperative pursuit of socially valued goals is "like a man,"
whereas to opt instead to pursue one's own ends is "like a woman."
Conventionally ascribed traits of males and females—Strathern
uses these terms to refer to cultural constructs, in contrast to ac-
tual individuals—enable Hageners to characterize the behavior of
men and women, but people are not really constrained to enact
those stereotypical roles. Just the opposite: women are exhorted,
like men, to overcome inclinations to behave in the denigrated,
consumption-oriented manner "typical" of females.

I would like to examine a similar disparity between the ways
Javanese speak about males and females on the one hand, and the
ways men and women in Java act on the other. My emphasis dif-
fers from Strathern's in two respects, however. First, while specific
traits are indeed attributed to each sex, and gender roles are indeed
differentiated in Java, such distinctions appear less central to Ja-
vanese representations of social life than does the idiom of gender
for Hageners. As with Hageners, Javanese tie different social atti-
tudes to gender, but they tie such attitudes to social status as well.

Gender difference fits into a number of ways to distinguish among individuals in Java, distinctions based on style and status as much as or even more than gender.

A second respect in which my emphasis diverges from Strathern's stems from the particular importance of speaking style as constitutive of both gender and status in Java. That the gender of speakers represents an important constraint upon language use is well documented in sociolinguistic work, particularly of the last fifteen years or so. (See Smith 1985; Thorne and Henley 1975; and Thorne, Kamarae, and Henley 1983 for bibliographies.) Yet Java affords an opportunity to observe the interplay of gender and status constraints upon language use particularly closely, due to the existence of elaborate speech levels in the Javanese language. I will therefore treat Javanese stereotypes of male and female character and behavior in tandem with Javanese ideas about the links between status and speaking styles.

Although gender entails many·distinctions in domestic responsibilities and public activities in Java, it seems to preclude relatively little. For one thing, it certainly doesn't prevent women from exercising great control within the household, since with the exception of some bourgeois families, Javanese wives usually manage their husbands' income, as well as any money they may themselves earn through trade or other business dealings. They also participate fully in discussions with their husbands about the family's plans, such as business, or children's education or marriage arrangements. By the same token, within the family, men are not unwilling to tend children at times, and to wash their own clothes, though they are unlikely to wash their wives' or children's clothes, or to shop at the market for foodstuffs. In a village, both men and women take part in farming, and in town, both men and women participate in business dealings, though in both cases, again, certain differences in what kinds of tasks men and women perform do arise. More remarkably, many Javanese women enjoy positions of considerable prestige and respect in public life, taking on coveted roles in the civil service, as heads of schools, chairs of university departments, and chiefs of government offices. (One of my favorite stories from the transvestite melodrama [ludrug] repertoire is entitled "Susie, Inspektor Polisi.") The percentage of women in high

office is not great. Still, no one finds it astonishing that women should have such influential posts, and that they should thereby enjoy positions of authority superior to lower-ranking male employees. On balance, then, Javanese seem to draw few distinctions between men's and women's roles so rigidly that they cannot be breached at least occasionally.

Despite the fair degree of fluidity in gender roles in Javanese society, however, in conversation Javanese often make sweeping generalizations about the natures of men and women. These tend to derogate women, who are described—particularly but by no means exclusively by men—as lacking in all those qualities Javanese deem worthy of respect.[1] Judiciousness, patience, self-control, deliberate speech, spiritual potency, a refined sensibility, insight, and mystical capacity—in sum, all the traits by which humans are believed to win, and for which they are believed to deserve, prestige—Javanese informants routinely denied to females. Women, in fact, tend to be described, whether individually or globally, as emotional, crude, uncontrolled, uncontrollable, and likely to be somewhat ill-bred. While not endowed with any particularly malevolent powers inaccessible to men, women in Java nevertheless are subject to, and even subject themselves to, negative stereotypes that would appear to preclude the possibility of their enjoying any measure of respect.

This paradox—that females are so easily categorized as inferior, yet women may well attain high rank—is highlighted by the way Javanese performing arts represent women, whether in the prestigious shadow play (wayang) and dance drama (wayang wong) traditions, the less formal folk drama (kethoprak), or the decidedly funky transvestite melodrama (the above-mentioned ludrug). In each of these art forms, some female characters live up to the reputations Javanese commentary ascribes to them: they appear talkative, emotional, and disruptive. Other female characters, however, conform to the ideals of self-restraint and concomitant refinement in language, sentiment, and behavior that Javanese culture prizes in both men and women. These refined women cast their eyes demurely to the ground, move with elegantly flowing gestures, and speak in the most floridly beautiful reaches of high Javanese. On occasion, they even prove models of wisdom and

courage, such as the wayang heroines Kunthi, Sembadra, and Sri-
kandhi. Actually, one need not look to the stage to find such vir-
tuous exemplars of Javanese womanhood. Aristocratic and other
wealthy women in Java often evince enormous dignity and grace
when they appear in public, and many village women show simi-
lar poise. If Javanese women can be represented as possessing, and
can themselves often demonstrate possession of, the self-restraint
that Javanese culture values so highly, why do they seem to garner,
as a category, so little respect?

The most immediate response a Javanese would be likely to
give to such a question would be to say that "women are not
strong," meaning that they are neither physically nor spiritually
powerful. This apparently simple statement implicates Javanese
understandings of the links between power, status, and speech,
and it requires some explanation.

Power, Status, and Speech

Power in Java is understood to encompass both a coercive au-
thority, which is disvalued, and a more subtle, immaterial au-
thority, one that, following Shelly Errington's gloss of a similar
Buginese notion, I will label "potency" (S. Errington 1983). (Ander-
son 1972 provides a general description of this concept in Java.)
Possessors of potency are able to control their own impulses and
desires, most pointedly in ascetic practices, and they thereby main-
tain and foster that store of potency. Possessing potency enables
them to exert a compelling influence over people and events with-
out resort to instrumental means, least of all force. People can be
observed to possess great potency both by their own demeanor,
which is poised and "smooth," and by the effect they induce upon
others, who fear and respect them, and who register those feelings
in their deferential behavior.

High status, whether achieved or ascribed, implies that a per-
son possesses considerable potency (though some will say that po-
tent advisors have been induced to abet an undeserving person's
rise to success). Aristocratic lineage, worldly success, and/or other
grounds for prestige and fame are taken as evidence that a person

has obtained potency. This is particularly true if a person not only enjoys outward manifestations of good fortune, but also evinces the behavioral style associated with potency: the restraint and calm indicative of disinterestedness and self-control. (See J. Errington 1984 on the tenor of Javanese encounter.)

Potency at an ultimate level, and worldly power and wealth at a more immediate level, bring about the differences in status that mark all Javanese social relations. Birth, wealth, education, occupation, and age, all enter into determinations of people's status. That status is fairly stable in a general sense but relative in the specific context of any particular encounter. A peasant is never likely to enjoy much respect from an urban professional, because the status of peasants is low. Yet there are gradations in status among peasants, and even among siblings (as determined by birth order), and these gradations shape the encounter between any two individuals.

Every encounter requires that the relative status of all participants be established and registered in their language, their body stance, and the content of their remarks. Most specifically, speech levels in the Javanese language oblige speakers to choose among a great range of variant lexical items and styles of speaking, all of which suggest diverse estimations of their status relative to that of their interlocutors. Speaking styles implicate estimations of the tenor of people's relations, as well: how familiar and intimate, or formal and distant, their relations are or should be.

People who lay claim to high status pay very close attention to speech. They try to make it clear that they have command of the full range of honorific terms that are the sign of good breeding, and that they are therefore capable of demonstrating the respect for their superiors that sensitivity to status and potency imply. At the same time, they wish to make sure that others validate their claims to status by addressing them with respectful speech. If their interlocutors are of inferior status, then those speakers are expected to proffer more respectful speech than they receive. Failure to elicit respectful speech can discredit a person's claims to status, just as failure to use it can.

The smooth flow of appropriate speech—mutually acceptable sentiments, phrased at the suitable moment, in an appropriate

speech style, in the proper setting—is critical to Javanese feelings of well-being, feelings that depend in great measure upon the mutual validation by two speakers of their relative status and the affective tone suitable to their relationship. In fact, an interlocutor's inappropriate formality, as well as an "indecent" familiarity, might prove upsetting to someone if the particular context—their previous relations and present circumstances—suggested to him or her that a different mode was in order. Nevertheless, the conflation of potency, status, and speech is clearest at the upper end of the range that each of those labels represents. High-status people lay claim to the greatest degree of potency; they evince the greatest restraint and dignity in their manner; and they are expected to be capable of both giving and eliciting the most beautiful and perfect high Javanese when either giving or eliciting such speech is appropriate.

It is precisely because conceptions of potency, status, and speech draw closer together at the positive extreme that Javanese are inclined to opt for increasingly controlled expression the higher they wish to situate themselves in a status hierarchy. It is for the same reason that in any pair, the person who is situated as an inferior enjoys more of what we in the West might call "freedom." By controlled expression I refer not to a particular speech level, but rather to a studied manner and the avoidance of spontaneous or extreme feelings, as evidenced in speech and gesture. Humor is suitable to high-status people in some settings. But uncontrolled anger or envy, or for that matter hilarity, and great excitement of any sort compromise a person's claims to superior status, and no trace of such feelings should appear in the verbal expression of those high in status.

All of these links among potency, status, and speech affect the status of women. Women's status tends to be tied to that of their husbands. This means that the higher their husbands' and thus their own status, the more guarded women become about their own manner. Yet it also means that they are permitted a range of styles, as "inferiors," that their husbands are more likely to eschew. That range accounts for the somewhat paradoxical nature of women's position in Javanese society, as I will try to show by reference to three kinds of ethnographic material. The first kind, relat-

ing to the negotiation of a marriage, demonstrates the "informal" power a Javanese woman can wield. The second concerns women's hypercorrection in the use of speech levels. The third concerns the relations between gender, ideology, and practice, as epitomized by the figure of a village transvestite. What ties these materials together are the Javanese understandings of potency, status, and style just discussed. What they illustrate is the way that diverse kinds of behavior are fitted into unquestioned categories.

A Proposal of Marriage

When I first lived with Pak Cerma and his family in 1978–79, five sons were living at home. When I returned three years later, two of those sons had married and were still living at home, while a third, still a bachelor, had become a schoolteacher in Kalimantan. I was told that word had reached Pak Cerma's family that, before leaving for Kalimantan, this third son, Jarno, had taken up with a teenage girl who lived in a nearby hamlet. The exact nature of their relations was unclear, but Jarno's mother, Bu Cerma, learned from neighbors that the girl, Marni, had been in correspondence with Jarno, and was reputed, furthermore, to be pining for the distant youth. The situation was uncomfortable. Although premarital and extramarital sexual relations are by no means unheard of in Java, the Cermas did not seem worried that the girl might be pregnant. Rather they worried about the ambiguity of the relationship between their son and the girl, and by extension, between themselves and the girl's parents. The Cermas were neither particularly enthusiastic nor disapproving of a possible union between their son and the girl. They were concerned, however, that all parties should feel that everyone's intentions were clear and everyone's dignity was properly maintained. The trouble lay in the fact that Jarno was so far away, and his intentions were so unclear.

Several months before my return to Karanganom in June of 1983, Jarno had written a letter notifying his parents that he would come home for a visit in June and that his family should "ready themselves" for that event. The phrase suggested much and said little. The Cermas assumed he meant that he wished to marry and

they were being instructed to ready the food and money they would need to hold a wedding. Weddings in Java are often celebrated in two parts. The ceremony at the home of the bride's parents is usually more elaborate than that at the home of the groom's parents: a daughter's wedding is the greatest single display of status a family makes, whereas a son's wedding need not involve such show or cost. Nevertheless, Pak Cerma and his wife would presumably wish to organize some sort of celebration for Jarno's wedding, and they would in any case have to ready money for the gifts a groom's family makes to a prospective bride's family in a series of exchanges prior to and at the time of the wedding itself. For the purposes of preparation both financial and social, therefore, the Cermas needed to know when Jarno intended to marry, whom he intended to marry, and for that matter, whether he really was intending to marry at all.

Some time before June, Bu Cerma asked Marni to come to the house, hoping to find out something more definite about both her son's intentions and the girl's wishes. Bu Cerma felt after that interview that Marni's devotion to Jarno was fairly clear, but Marni claimed that her letters to Jarno had gone unanswered for several months. This fact suggested to the Cermas that their son had lost interest in Marni, and quite possibly that he had taken up with some woman in Kalimantan.

The month of June passed without any sign of, or from, Jarno. Pak Cerma sent a letter asking why Jarno had not come. Finally in July a letter arrived. Jarno reported that he had been sick in the hospital for several weeks and so he had been able neither to come home nor to write to his parents. In response to his father's queries about a marriage, he responded that he did not feel ready to marry, but if they wanted him to do so, he would accede to their wishes.[2] The Cermas were not certain that Jarno had really been so ill. At least, however, he had stated his position on matrimony, permitting his parents to regularize relations with Marni and her family.

This the Cermas did by proposing marriage. Bu Cerma let it be known that the offer would be forthcoming, and one evening Pak Cerma, Pak Marto, who was a fairly well-off farmer living next door, and I went to Marni's parents' home. We went in the evening lest we attract the attention of neighbors and be obliged to field

questions about where we were going. We were received by Marni's
father and sat in the front room of the house, while the girl and her
mother appeared briefly to greet us and to serve us tea and snacks.
We made small talk for about half an hour. Eventually Pak Cerma
broached the subject of a marriage between Jarno and Marni, speak-
ing in a refined style and with a light and even jocular tone that
nevertheless teetered on the officious. Marni's father, Pak Lasiman,
responded that he was certainly very honored by the proposal but
that he would have to talk the matter over with the girl's mother,
and with Marni herself. We continued to speak of a variety of unre-
lated, and rather mild, topics for another hour, and then took our
leave, Pak Lasiman assuring Pak Cerma that he would provide an
answer in a few days' time.

More than a week had gone by when Pak Lasiman appeared one
evening at the Cermas' home. The fact that he had let rather a long
time elapse before coming by already prepared the Cermas for his
reply, but then Bu Cerma had already learned from neighbors that
the answer was to be negative. As a result, no one was startled
when Pak Lasiman reported, after a little small talk, that although
he thought the match would be an excellent one, his daughter ap-
peared unwilling to marry at this time. He made various com-
ments about her schooling (a girl is expected to stop attending
school as soon as she marries) and about the inability of parents
nowadays to determine their children's actions. Pak Cerma ex-
pressed complete understanding and fulsome agreement with Pak
Lasiman's remarks. Soon after drinking a glass of tea, Pak Lasiman
took his leave.

The Cermas seemed somewhat relieved at this outcome. They
surmised that Marni's parents hoped to make a more advanta-
geous match for their daughter, with some young man of greater
wealth and prospects. No doubt, the Cermas said, the Lasimans
hoped to find a suitor already ensconced in the bureaucracy in
Java, not way off on some other island. Bu Cerma scoffed a bit at all
this, saying that her parents always said that you should marry
someone neither above nor below your station but rather someone
who is "just the same." It is possible that Marni had indeed cooled
toward Jarno. It is also possible that her wishes were overruled, or
that both her enthusiasm had waned and her parents had expressed

opposition to the match. No matter: good form had been observed on all sides. Now, as the Cermas said repeatedly, if they encountered Pak Lasiman or any member of Marni's family on the road, there need be no awkwardness.

What struck me as peculiar in all this was that while everything that happened appeared fairly comprehensible, nevertheless the focus of concern always seemed somewhat off-center. The long-term consequences of a son's selection of a spouse seemed to occupy the Cermas' thoughts very little, whereas the fulfillment of good form in the short term appeared of paramount importance. At the same time, the communication of essential information seemed to take place almost incidentally, apart from the elaborate communicative forms—letters and formal visits among men— that were ostensibly designed for that purpose. This skewing of emphasis takes us back to the issues of potency, status, and language discussed earlier.

Information in Java always carries some threat of discord. If contrary to its receivers' wishes, it may startle them, causing disarray to their thoughts and feelings, and so endangering both their health and their self-possession. It may, most dangerously, arouse disappointment or anger, which dissipate potency and threaten the outbreak of hostility. If the conveyors of information are also deeply implicated in that information, then they may put terrible strains on their relations with their listeners, because they are contravening the principles that should govern their encounter. Listeners, if they are of high status and are not intimates of the information-givers, would compromise their own status were they to lose control and express their reactions vehemently. They suffer an affront to their status, however, simply in the act of hearing information contrary to their wishes. Information, therefore, must be processed and monitored. It flows most freely among intimates and to and among people of low status. However, it should be diluted in a warm broth of agreeable sentiments, phrased in appropriate vocabulary, whenever it is to be administered to high-status people, in order to protect the smooth flow of interaction and so the status claims of all participants. The worse the news, for that matter, and/or the higher the status of one's interlocutor, the more elaborate the strategems of approach become. When people must

be informed that a relative has died, they are usually first told that he or she is ill, and only later, when they are properly conditioned for the blow, are they told of the person's demise (see C. Geertz 1973e for an example). Even when the information at issue is relatively innocuous, formal address is likely to begin and end with elaborate requests for the indulgence of one's addressees.

The effort to avoid the demeaning implications of discord or conflicting wills explains why men try to enter into only those negotiations for which, if conclusions are not quite foregone, nevertheless all possible outcomes are within acceptable limits. The higher men's status, the more care they take to avoid the expression of conflict, especially when dealing with other males of anything approaching similar status. Conflict should also be ruled out when addressing someone greatly inferior to oneself: an inferior should simply conform to a high-status person's wishes, no matter how bluntly they are stated. But of course, while an imperious manner may be appropriate, real crudeness or displays of emotion are out of the question. These would reflect poorly on the speaker, the more poorly the higher the speaker's status.

Pak Cerma had several claims to fairly high status in the village where he lived: as an adult male head of household; as a landowner, not of large holdings but still of irrigated rice land; as an older resident of the village; and as a shadow puppeteer reasonably famous in the area. Pak Lasiman was a bit less in the public eye, but he was fairly well-off, as well as an adult male head of household. The two men had known each other for years but were not close friends. Their relations, therefore, had to be formal, correct, and at the same time affable, as Javanese almost always wish their relations to be. Nevertheless, relations between them could easily have become strained: Marni's father could have seen his daughter as abused by Jarno's misleading attentions if they had led to no proposal of marriage; Pak Cerma could have taken umbrage at the rejection of the proposal once proffered. The men's fairly considerable status both obliged a harmonious resolution and increased the possibility of its opposite: touchiness, offense, and conflict. Conflict, of course, would not have been likely to lead to violence. But it would have given rise to awkwardness, a situation for which Javanese have very little tolerance. Their encounters, therefore,

had to be arranged. Marriages in Java are arranged only on occasion, but marriage negotiations are always very carefully arranged.

Only high-status people can take responsibility for important matters, and only they can make weighty pronouncements about them. In families, this means, as mentioned above, that male heads of household must take care of such matters. (If a household lacks an adult male, then a male relative must be named as representative when important business is at hand. For example, when a son in the family I first lived with in Java wished to marry a woman whose father was dead, a maternal uncle received the groom's representatives, while the prospective bride's mother sat watching from the sidelines.) Yet while Pak Cerma's exchanges with Pak Lasiman were the critical ones with respect to the relations between the two families, these exchanges could be made only when enough information had already been communicated to assure that there would be no surprises. Women in Java are in charge, among other things, of staving off surprises.

The most salient fact about these negotiations, actually, is what an important part Bu Cerma played in them, and how little her importance showed. It was Bu Cerma who got wind of her son's earlier dalliance with Marni, of their correspondence, and of the girl's longings. It was Bu Cerma who took measures to find out the exact nature of the young people's ties, who let it be known that a marriage offer would be forthcoming, and who learned that the offer would be politely declined. (Had the marriage proposal been accepted, Bu Cerma would have been the one to work hardest in preparing for the wedding, by raising money, buying foodstuffs and clothes, and orchestrating cooperative efforts with neighbors and kin working in the kitchen. Once again, though, it would have been up to her husband to make formal gestures, both in negotiations with the bride's parents, and at the time of the wedding itself.) One reason Bu Cerma could do all this was precisely because she acted out of public scrutiny. She did the advance work, gathering together important information through neighbors and friends and through the meeting with Marni that she instigated. She then advised her husband what their next move should be. Like Marni and her mother on our visit to Pak Lasiman's home, Bu Cerma spent her time in the kitchen or the inner part of the house,

listening intently to the "important" meetings that took place among men.

Bu Cerma could do the advance work—and that included most of what we would see as the "real" work—on her husband's behalf precisely because her communications were not weighty. Having less dignity to maintain, she could speak more freely, particularly to women who were, like her, of less exalted station than their husbands. In private, she could speak frankly with her own and the Lasimans' neighbors, and she could even approach Marni herself. Just as importantly, having less status to affront, she could also hear people more easily, because they would not need to be so mindful of her status and of the implications of dismaying or crossing her. Of course, most news was conveyed to her circuitously. Women in Java get into fights more frequently and easily than men, but women, too, prefer to avoid encounters in which unpleasant feelings are likely to be aroused. Still, the channels, however circuitous, were open.

Bu Cerma could obtain and convey so much information because her relationship as a woman to speech was relatively free. So too was her relationship to social status, and so were her relations with other people. All were *relatively* free: Bu Cerma, like other Javanese, was much concerned with the range of implications that speaking carries with it, and with the range of implications about status and the tenor of the relations between speakers that every encounter suggests.[3] Yet as a woman, the obligations of her status were less onerous than they were for her husband. This permitted her to loosen the bonds that tie language, status, and the style of encounter so closely together for high-status people, especially males, in Java.

Somewhat paradoxically, Javanese women are effective because they are deemed relatively lacking in potency, and they are crucial to the protection of people's status because they are themselves thought to be of relatively low status. They traffic in money and information, whereas their husbands concern themselves with— to say "traffic in" would demean them—potency and an important style. This contrast is not an absolute one. Nor is it by any means uniquely Javanese. Yet it inclines men and women to situate themselves at different places in a hierarchy of statuses, and thereby

commits them to different relations with potency and style. It is the resultant distribution of responsibilities that enables men to maintain the "smooth" and dignified style they prize.

Since all individuals in Java must be ranked differentially relative to each other, husbands and wives are so ranked, and husbands enjoy higher status than their wives. This has several ramifications: it means that a man can address his wife by some abbreviated form of her first name, whereas she must use some sort of title when addressing him; it means that he can use pure low Javanese to her, whereas she should use honorifics at least some of the time with him; and theoretically at least, it means that he can make final and binding decisions in family matters, decisions to which she should yield. In practice, people observe linguistic etiquette quite strictly and negotiate most decisions quite flexibly, though this varies according to the personalities and inclinations of both spouses. As already mentioned, women usually control the family's finances, which grants them considerable instrumental power, both within the family and in the family's relations with others. Furthermore, in private women are often likely to express their views on things somewhat more vigorously than many men, and husbands are apt to yield a point rather than get into an argument. Men protect their dignity, and so the impression of their potency and their status, by removing themselves from situations, such as disputes with their wives and/or children, in which they risk suffering lèse-majesté in any form. This doesn't mean that men's superior status is a sham, rather that the issue of etiquette is thought crucially important, as important if not more so than money matters.[4]

The abundance of information that Bu Cerma was able to obtain contrasts most pointedly in these events with the dearth of information that Jarno conveyed in his letters. Yet the young man's sparing exploitation of the communicative capacity of letters was quite typical of Javanese approaches to written correspondence, which simply exaggerate the tendencies toward formality and formulaic expressions apparent in important speech. Letters are almost invariably written in an elevated style. Although it is possible to write a letter in low Javanese rather than high, it is not possible to write really informally in either level, and to write in

madya would be unthinkable, even though this is the mode—a minimally refined mix of vocabularies—in which most people in Java communicate with the greatest number of other people. The reason for this stylistic stiffness must stem from the status bias in Javanese access to writing: only high-status people have become accustomed to writing at all. Madya, as Joseph Errington (1981) notes, has traditionally been thought by the *priyayi* elite as beneath their dignity, whether to write or to speak. Yet this stylistic inflexibility is probably due as well to the impossibility of monitoring the responses one's words elicit when they are read rather than heard. Particularly when addressing someone of significantly higher status than oneself, but even with one's near equals, one should attend carefully to the tenor of any encounter as well as to the information that is being exchanged, and so be ready to adjust one's tone when that appears appropriate. Writing precludes such negotiation of tone. Committing one's words to paper is also inherently risky, since one cannot control who will read them. Such open-endedness runs very much against the grain of most Javanese, who believe caution always to be the better part of communicative valor. On the contrary, Javanese inclinations in public usually tend toward the self-contained rather than the self-expressive, let alone the self-assertive. With no certain knowledge of who will peruse the words one commits to paper, Javanese tend therefore to write only the blandest or most cryptic of phrases.

When Jarno wrote his parents about his plans to return home but informed them of so little, he annoyed them somewhat. Nevertheless, he could not be faulted for his enigmatic tone. He prepared them for news to follow, as one should do when one wishes to ready one's superiors for information one is about to convey to them yet should not broach boldly. Jarno also endowed his own statements with a weightiness that profuse explanations would have lacked. His weighty tone was appropriate to his parents' superior status relative to his own, to the gravity of the issue at hand, and to his own status, now increasingly important in view of his position as a teacher and a member of the civil service. His letters may have been somewhat exasperating, but they were impeccably correct.

The two principal kinds of communication that took place in the course of these marriage negotiations could be summarized,

therefore, as important, weighty, official, and carefully controlled on the one hand, and informal, unmarked, private, and little controlled on the other. Overall, the contrast coincided with gender difference: men communicated with men in the first mode, women spoke to women in the second. We must be careful, however, to avoid making impermeable contrasts. Men do certainly gossip, particularly with their wives and other women, mostly in the privacy of their own homes, but also to some extent in more public settings, and with other men. Women also occasionally make formal pronouncements, for example, when exchanging gifts in the course of ritual celebrations, or when attending meetings of women's organizations. At such times, they may speak in a very formal style. It is important to bear in mind that speaking styles in Java constitute a range of possibilities within which, aside from the intricacies of some aristocratic usages, most speakers operate fairly well, and which they manipulate according to particular context.

What distinguishes women's from men's speaking styles is not that women take a consistently freer, more casual tone, but rather that they run a wider gamut of styles than men. They can do so, once again, because their speech is deemed less important than men's, and less is on the line when they speak. Relieved of some measure of concern for their status, they are free to introduce a greater range of variation into their speech. They are free to play upon the range of vocabulary, intonation patterns, and sentiments that Javanese puts at their disposal.

That Javanese women shift among degrees of formality in speech more quickly than men often means that they speak in a more familiar and informal style than men, particularly when speaking with other women. Two high-status men may continue to speak some quite refined mix of Javanese when their wives are already speaking something much closer to complete low Javanese to each other. The same women, however, may choose at times to speak to people in extraordinarily florid phrases, and women are much more apt at all times to launch into the long, drawn-out intonation patterns of very polite Javanese. It is women, more than men, who teach their children to mimic themselves saying polite formulas of greeting in an extremely stylized, slow, flat style. Yet it is also their mothers rather than their fathers from whom children

are likely to learn expletives such as *Goblog!* ('Idiot!') or *Tai!*
('Shit!').

Women's relations with speech might be termed playful, in the
sense that women speakers are often less heavily invested in status
concerns, which are intrinsically serious. Status marks the thresh-
old between the serious and the playful in Javanese culture: equiv-
ocations upon people's status can go only so far, whereupon they
shift from jokes to attacks. Males can play with children only un-
til the children and/or they themselves are too old to ignore the
status implications of their interaction. Women can say things "in
jest" that their husbands would be loath to say: a woman who
lived next door in Purwosari, the first Javanese village in which I
lived, asked, laughing merrily, what I was going to send her son
from America, while her husband, sitting next to her, frowned and
shushed her.

Playfulness is also a mode useful to men. Pak Cerma spoke, as I
have mentioned, in a rather jocular tone when we visited Pak
Lasiman. He did so precisely in order to diffuse any impression of
tension in the meeting. The exaggerations in his tone, the bland
jokes, and the deferential asides were all designed to keep every-
one from pondering the potential for disruption in our dealings.
Yet to the extent that women need not maintain complete self-
control and need not therefore appear completely serious, they are
freer to indulge in the mode of playfulness than most men. As al-
ways, it is context and relative status that matter here: high-status
women are likely to opt for a more even, dignified demeanor in
more situations than are lower-status women. But relative to their
husbands, even aristocratic women are of lower status, and so they
are relatively freer when they speak to assume either an exagge-
rated deference or an unexpected familiarity.

Women can disaggregate status and style more than men can in
part because, as I have said, women's status is defined in consider-
able measure by that of their husbands. A woman who marries a
man employed in the civil service or in a firm enjoys people's re-
spect, no matter what her background. (In practice, actually, she is
likely to come from a social and economic background roughly
similar to that of her husband, just as Bu Cerma's parents said
things should be.) Her style, as long as it isn't really outrageous,
will not be thought to undermine the family's status. A man's

status is of course also defined by wealth and means of livelihood, not just style. But he is expected to present himself to the world fairly carefully, the more carefully the higher his status. A man in Karanganom who spoke roughly in public settings was found amusing, but his behavior lowered his status in others' eyes, and he received little deference. People tended to speak of him as being "a bit touched."

Women and Hypercorrection in Javanese

There is a particularly clear instance of women's inclinations to play the range of styles to the hilt in Java: in their use of "false" high Javanese versions of place names.[5] Place names in Javanese are invariant: even if they consist in morphemes that have corresponding high Javanese forms when used in other contexts, place names are not tied to the speech level of the utterance in which they occur. For example, Kaliurang, a hill station on the slopes of Gunung Merapi near Jogjakarta, is invariant even though the first two syllables form a word, *kali,* meaning 'river,' which has a high Javanese equivalent, *lèpèn*. Some Javanese, however, do indeed substitute such made-up or "hyper-krama" forms: some speakers would substitute *Lèpènuwis* for Kaliurang. Javanese men mock the practice, as do high-status women, particularly highly educated and/or aristocratic ones, who do not, I believe, ever use such terms except in jest. Nonetheless, many peasant women do use them in an effort to give their speech a particularly deferential, even obsequious, tone. To many Javanese speakers, such women categorize themselves as bumpkins. The remarkable fact is, though, that many women use such terms even though their husbands never would.

Javanese term this pattern of hypercorrection "village krama," thereby accounting for it with reference to territory and class—the rural peasantry—rather than gender. It is true that both men and women who live far from the etiquette-defining court centers in Java have less secure command of refined speaking styles than do people living near Jogja and Solo, and I have heard men as well as women use hyper-krama forms in the highlands of East Java. Never-

theless, where I did my fieldwork, in the heartland of the Prin-
cipalities, I noticed only fairly low-status peasant women using
these forms. Women in this area seemed oblivious to the fact that
the usage is stigmatized, and in their efforts to make their speech
particularly refined, they compromised themselves.

The phenomenon is worth comparing to Trudgill's summary of
research on gender differences in English pronunciation. Trudgill
(1974:93–94) writes:

Sociological studies have demonstrated that women in our society are,
generally speaking, more status-conscious than men. For this reason, they
will be more sensitive to the social significance of social-class-related lin-
guistic variables such as multiple negation. . . . Given that there are lin-
guistic variables which are involved, in a speech community, in co-variation
with social class (higher-class forms being more statusful or "correct" than
lower-class forms), then there are social pressures on speakers to acquire
prestige or to appear "correct" by employing the higher-class forms. Other
things being equal, however, these pressures [among English speakers] will
be stronger among women, because of their greater status consciousness.

I am uneasy about broad statements to the effect that women are
more status-conscious than men in the United States and England. I
think that is probably only true if status is defined in rather selec-
tive ways. However, the English material does correspond to the
Javanese insofar as Javanese women appear to seek prestige, and hy-
percorrect in order to do so. Yet I don't think one could say that
women in Java are more "status-conscious" than men: men and
women seem about equally preoccupied with status in Java, and as
I have suggested above, men's status is liable to be treated with
particular seriousness. I believe women can use hyper-krama when
their husbands avoid the practice because in so doing, women ex-
tend the rules, inflate the possibilities for deferential speech, and
thereby heighten the stylization of the whole exchange, all in a
manner thought appropriate to women's generally more elastic re-
lations to speaking styles. Women may seek to appear especially
refined, and so to increase the impression of their good breeding
and status, even as they proffer an almost obsequious deference.
Yet that inclination fits into the same pattern by which, at other
times, they speak in a *less* refined fashion than men. As women in
speaking English draw on a greater range of intonation patterns

than men do (see McConnell-Ginet 1983), so Javanese women
draw on a greater range of speaking styles and intonation patterns
than Javanese men.

Once again a cautionary note is in order: difference in gender
does not coincide in any precise fashion with differences in speak-
ing styles in Java. Instead, such stylistic differences correspond
more closely to status differences, and status differences are rela-
tive rather than absolute. As a result, all speakers find occasion to
use all ranges of speaking styles, though higher status restricts the
range of appropriate styles somewhat. It is really for this reason—
that higher status means more deliberate speech—that men tend
to exploit a narrower range of possible styles than women in their
speech. It is not that men speak high Javanese more often, only
that they speak with greater deliberateness, and with less stylistic
variation, than many women.

It is also because higher status implies more deliberate speech, I
believe, that Javanese women can be represented in performance
as speaking and behaving in extreme refinement, and do indeed
speak and behave in that way at times, and yet can be dismissed as
intemperate and even crude. Such categorical statements really
stem not from women's use of a particular style, but rather from
the great range of styles that women are ready to take on. Such
lability in itself, even though it may include great refinement and
formality in some contexts, is out of keeping with the idealized
model of high-status, self-controlled, potent individuals. What
women who speak "in extremes" do is to loosen the bonds be-
tween claims to high status, the impression of one's dignity, and
the ideology of potency. They don't really abjure interest in status.
Indeed, the higher their status, the more restrained women appear.
Yet their relatively lower status vis-à-vis their fathers and hus-
bands does suggest their greater freedom from what, after Goff-
man, one might call "status management."

Gender Categories and Behavioral Variation

Women's denigrators, whether they are themselves men or
women, choose to treat women's contextual variability as the sign

of an essential weakness. They treat lability in style as itself damn-
ing, indicative of an innate lack of self-control. In so doing, they
ignore the flexibility that is actually built into the Javanese lan-
guage and Javanese social organization, in the form of contextual
constraints that make status and speech levels always to some de-
gree relative, variable, and negotiable. Women's detractors fail to
note that Javanese women, and for that matter, some low-status
Javanese men, simply respond to those constraints especially fully.

Blanket characterizations of females do not constrain individu-
als' actions completely. Yet by the same token, no individual can
really undercut these categorical statements, which constitute a
system of gender constructs. That such stereotypes do not prevent
women from attaining fairly high rank in the bureaucracy follows
from the very flexibility of the system; that such women do not
challenge anyone's impressions of females follows from the re-
silience of its categories. If women achieve success, then they are
seen to possess those qualities usually thought lacking in women.
No one need wonder at that, nor reconsider their stereotypes. At
the same time, such women of course take on the style that befits
their station: they speak more deliberately, imperiously, and self-
importantly than do other women, or low-status men. They thereby
reassemble the components of status, style, and even potency, in
observance of the system's principles. The system is flexible only
insofar as people are willing to adhere to its principal associations
between status and style. Some men remarked that while few
women were capable of ascetic practices, those that were became
particularly potent. Men can make this remark because it leaves
the crucial links among categories—potency, asceticism, status,
and gender—intact, despite the occasional anomaly of a potent
woman.

Another incident during my stay with the Cermas demon-
strates how variants in the style of behavior and categorical state-
ments are coordinated in such a way as to leave assumptions in-
violate. One evening at dinner, Pak Cerma spoke to me of the
practice of taking boy lovers, which was common among aristo-
crats in the "old days." Bu Cerma, sitting nearby, heard this infor-
mation with astonishment. Males have sex with males? How? she
asked incredulously. It was inconceivable. She had never heard of

such a thing, had never heard the word for "boy lover," and professed, to her husband's amusement, some outrage at the whole topic. She was in no way mollified when Pak Cerma went on to speak of lesbian affairs among women vocalists who accompany the Javanese orchestra. Yet when Pak Cerma started telling stories about Si Min, a man in the village of decidedly ambiguous sexual identity, Bu Cerma simply joined in the fun.

Si Min was a man the same age, about sixty, as Pak Cerma. Both men had known each other since childhood: if Si Min appeared younger than Pak Cerma, it was because he dyed his white hair black. When they were both young and slept, as young Javanese males often sleep, strewn about on mats in various neighbors' houses, Pak Cerma—though of course at that time he still went by his child's name, not his married name—sometimes woke up to find Si Min fondling his genitals, and even kissing him. Pak Cerma laughed as he recounted these awkward awakenings, and the hasty escapes he would then make. But he expressed amusement, not outrage, at the recollection, and Bu Cerma, who had clearly heard these stories before, laughed too.

Si Min's sexual irregularities were not limited to his youth. He often worked as a middleperson in diamond trading at a market in a nearby town, and at such times he dressed as a woman. He crossdressed as well, in full formal Javanese attire, when he went to attend large-scale celebrations. Bu Cerma related, with delight, that when she and other women were helping neighbors prepare for a large-scale ritual celebration, they would hail Si Min when they saw him entering the kitchen, gesturing to him to come join them at whatever task they were performing. "We all sit crowded up together with him and nobody minds at all," she exclaimed, smiling. In fact, Si Min was a famous cook in the village, and evenings he manned a food stall.

Although Si Min acted and was accepted as a woman at the market and at ritual celebrations, otherwise he dressed as a man and was an accepted head of household in the village. He attended evening gatherings in the village as a man, and was received among males without overt prejudice. He and his wife had four children, and although these were rumored to have been sired by another man, they were still recognized as Si Min's own. His social status

did certainly suffer in light of his ambiguities. Pak Cerma and other older men addressed and referred to him with the very familiar title *Si* rather than the deferential *Kang, Mas,* or *Pak* that a man of his age and position would otherwise receive. Nevertheless, he did not sustain acute social disgrace for his transvestite proclivities: he seemed to be tolerated with fairly good grace by his neighbors.[6]

Yet the fact remains that Bu Cerma knew all about Si Min, both his sexual interests and his transvestite habits, and still professed ignorance of such categories as homosexual preference, for which there exists, to my knowledge, no word in Javanese, or "boy lover," for which there does exist, unlike in English, a single term. To have "known" such categories would have been conceptually disturbing, whereas the information about Si Min was simply experiential fact. By knowing the facts but ignoring the categories, Bu Cerma could assimilate the former without pondering any of their implications. She could tolerate Si Min, without having to countenance the idea of a category of people like him. She was able thereby to maintain with complete complacency the gender distinctions that she assumed.

Bu Cerma was encouraged in that complacency by Si Min's willingness to conform to each of the categories she held. Even if his oscillations were physically, or at least anatomically, flawed, they were stylistically quite successful, and so easily assimilable to standard models. He could be tolerated because he was able to modulate his style according to circumstances. Dressed to the nines when he went, as a woman, to a ritual celebration, he also spoke and gestured at such times in a way people found effeminate. At other times, when among men, he dressed rather frumpily in an old *sarung* and a shirt. The soft plumpness of his body contrasted with the compact but firm physiques of most male Javanese peasants, but his voice was only somewhat softer and his speech only slightly more stylized than other men's. So he was able to adjust his manner to the moment, as women in Java are particularly practiced at doing. He simply did so in a range so extreme that he was able to assume not just a variety of tones, but also a variety—or rather, a pair—of alternative genders.

Conclusion

Javanese tend to characterize contrasts in absolute terms, even when the terms involved are actually only relative, and they tend to link one set of contrasts to other such sets. The contrast between refined and familiar behavior is often linked to that between good and bad: behavior of course includes language use, and many people speak of high Javanese not only as refined but also as "good" language, and low Javanese as "ordinary" or even "bad" language. No such simple evaluations are applied to the sexes, but the fact remains that since there is a contrast in genders, and there is a contrast between high and low status, one term from each pair is apt to be linked to one from the other, and in the absence of other differences, men enjoy higher status than women.

Because men are particularly concerned to define themselves in terms of their prestige, men and women play on the range of refined and familiar speaking styles differently. Men tend to adopt a weightier, more even tone than women, who instead exploit the full range of stylistic possibilities available. By giving up some degree of seriousness, women gain some freedom of action, whether to speak with florid refinement or frankness, to gather and communicate information, or to get into fights. Their volatility gives them room to maneuver, which is what enables them to get a job done. But because lability contravenes the even temper of the potent and important, it also compromises their status.

Yet the option to maintain the style of a high-status person is available to anyone, male or female, possessed of some reasonably justifiable claim to its exercise and the ability to master its forms. Therein lies the flexibility in the system and the possibility for women as well as men to enjoy great respect: despite people's essentialist inclinations when describing males and females, in practice gender roles turn out to be fairly fluid.

The catch is simply that there is an unavoidable trade-off. High status, or claims thereto, implies a certain constriction in style, whereas foreswearing such claims allows greater freedom of expression. To the extent that women choose, as some lower-status men choose, and even an occasional transvestite chooses, to make

less constant or fulsome claims to high status, they can play upon the contextual dimensions of style, and they can speak in the upper and lower reaches of the Javanese language more freely, dramatically, and mercurially than higher-status men, or for that matter, higher-status women.

One last example epitomizes how giving up the forms of high status can afford a certain measure of liberty. One afternoon in Karanganom, the annual village meeting took place at the village headman's house. The meeting, a long dreary recitation by the headman of unverified financial statements and supposed achievements and goals, permitted villagers no meaningful participation. Village men, facing the headman, other village officials, and the subdistrict officer, sat in rows in the large front room, nodding off in the heat and boredom of it all. Women, given their lesser status, sat in another room, beyond the first one. But once a meal had been served and the talk continued to drag on, the women became impatient. So at first one or two, and soon a whole stream of women started walking through the front room to reach the door to the outside, stooping deferentially of course but by necessity passing directly in front of all the officials. The headman urged them to stay just a few more minutes, if only out of respect for the visiting subdistrict officer, to which they replied in the low, flat high Javanese form of "Yesssssss"—as they kept right on going out the door. The village men, though probably no less bored, were more impressed with their responsibility to observe proper form and remained seated, while their wives, outside in the fresh air at last, enjoyed the freedom they had obtained at the expense of their status.

Talking About Troubles

Gender Differences in Weyéwa Ritual Speech Use

Joel C. Kuipers

In her overview of this volume, Shelly Errington notes that within the island Southeast Asian archipelago there exist in fact two cultural archipelagos—the "Centrist" and the "Exchange." The cultures of Eastern Indonesia and some of Sumatra (represented by essays on Weyéwa, Huaulu, Kodi, and Batak in this volume) assume a shape of their own. Instead of exhibiting the "politics of the center" characteristic of other areas of the archipelago, Eastern Indonesian systems are organized into hierarchical chiefdoms in which alliance and exchange involve the transfer of women and valuables between allied Houses whose core members are men. Nevertheless, despite the existence of Houses in Eastern Indonesia, these societies, like those of the Centrist Archipelago, share a belief in their descent from a unitary, originally whole and unbroken ancestral source.

In contrast to what we have seen so far in other parts of the archipelago, gender dualisms figure more prominently in Eastern Indonesian cultures. The experience of women and men in Eastern Indonesia may also be more sharply delineated by the marriage systems there, which typically keep kinsmen together and move women from their natal Houses to those of their husbands. Yet many of the dimensions Joel Kuipers finds in Weyéwa gender resonate with what we have seen in the cases examined so far. Like Tsing and Keeler, Kuipers concerns himself with women's and men's differential access to prized speech forms. Like Tsing, who ar-

*gued for examining gender not as text but as process, Kuipers suggests
that examining speech performance will reveal aspects of gender that a
look at traditional cultural categories might obscure. Kuipers's finely
honed analysis of ritual speech reveals significant differences not only in
the "texts" used by women and men, but also in their delivery.*

*As in the case of Javanese women, who possess more latitude than
men in their use of varied speech styles, the women of Weyéwa where
Kuipers worked are less constrained than men by the limits of ritual
speech. They enjoy greater spontaneity and freedom to express emotions,
but they attain lesser heights of cultural prestige. Like the Javanese women
who do the behind-the-scenes political work, Weyéwa women in their rit-
ual speech are the ones involved with getting a particular job done.*

*As we find elsewhere, the ritual differences between women and men
are more pronounced than the differences in everyday life. As elsewhere,
men have an edge in terms of access to spiritual potency. But in contrast
to many of the societies in the Centrist Archipelago, especially the most
"level" ones, in which spiritual potency is likely to be framed in cultural
terms as an individual achievement rather than a prerogative of gender,
ritual roles in Eastern Indonesia are to some degree a gendered pre-
rogative. As resident representatives of their Houses, men express conti-
nuity between the sources of ancestral authority and Weyéwa commu-
nities. This pattern is illustrated also in essays by Hoskins and Valeri
(this volume).*

Indonesian societies have been depicted by several writers as
nearly genderless. In his well-known essay, "Deep Play: Notes on
the Balinese Cockfight," Clifford Geertz has commented that "sex-
ual differentiation is culturally extremely played down in Bali and
most activities, formal and informal, involve the participation of
men and women on equal ground, commonly as linked couples.
From religion, to politics, to economics, to kinship, to dress, Bali
is a rather 'unisex' society, a fact both its customs and its sym-
bolism clearly express" (C. Geertz 1973a: 417 n. 4). More recently,
Errington (n.d.a) has gone further, suggesting that for much of is-
land Southeast Asia, not just Bali, gender is "not the difference
that makes a difference." Even in those parts of Indonesia where
gender symbolism does figure prominently, such as in Eastern In-
donesia (see Fox 1980b), it emerges as part of pervasive schemes of
symbolic dualism, in which males and females are represented as

complementary but not antagonistic symbolic attributes. Asymmetry, separation, and opposition do not appear to be major symbolic themes in relations between the sexes in this area of the world.

At first glance, then, a study of gender differences among the Weyéwa of the eastern Indonesian island of Sumba would hardly appear to be a promising enterprise. Clear gender asymmetries emerge, however, if one looks beyond traditional ethnographic categories such as religion, economics, or agriculture to the locally valued cultural practice of ritual speaking. While Weyéwa men and women participate on a relatively equal basis in most major subsistence tasks and economic decisions, and Weyéwa religious symbolism stresses the complementarity of male and female principles (see Needham 1984:41), gender differences in the use of speech are striking and pronounced in certain culturally defined situations. In the context of ritual performances concerned with 'calamities' (pódda), such as crop failures, sudden death, or devastating fires, the distribution of verbal resources is markedly different for men and women. Among Weyéwa, such misfortunes provoke male and female specialist practitioners of a lively, poetic, and parallelistic style of "ritual speech" to perform elaborate and prolonged ritualized verbal displays by which these unfortunate events are explained, atoned for, and resolved (cf. Fox 1988). In these circumstances, men are exclusively responsible for the ritual speech performances, which are obligatory and constitutive features of rites of divination, placation, and atonement, whereas women engage in evocative but supplementary performances of high-pitched trilling ululations (pakállaka), and, in the case of deaths, evocative laments (nggéloka).

Although much has been written about the syntactic, phonological, and lexical differences in men's and women's speech, and about the different ways men and women are referred to and indexed through speech (see Key 1975; Philips 1980), there is now a growing literature focused on the differential control of men and women over verbal resources, such as key speech genres (see, e.g., Philips, Steele, and Tanz 1987). Adopting an economic image of speech as a "commodity" or "resource" (Hymes 1974a) underscores the relations between language and other systems of social

value, such as work and exchange goods. This is important since, as Dell Hymes has repeatedly emphasized, language is not an abstract and transcendent system of relational values "parallel" or homologous with sociocultural order (e.g., Lévi-Strauss 1945), but is a set of verbal means by which speakers accomplish that order (Hymes 1970, 1974a; Irvine 1989).

A first step in examining gender differences in speech use among men and women in Weyéwa is thus an exploration of speech's differential distribution. Put simply, men are allocated the task of speaking to the ancestors; women are not. Men's speech is directed toward the ancestors and concerns the continuity of the agnatic lineage; women's speech expresses and evokes personal feelings and is aimed at a human audience.

Since for Weyéwa, the 'ancestors' (*marápu*) are the 'source' (*máta*) of all valued things, such as land, cattle, and well-being, the reproduction of these gender differences in ceremonial events can be seen in broadly political terms. Despite the fact that the speech genres themselves do not directly concern the coercion of other individuals, as Brenneis and Myers (following Bloch [1975]) have recently remarked, "where *who* can speak is the primary concern, political discourse may better be analyzed as the reproduction of relations of dominance rather than as the exercise of 'power'" (1984:4). Among Weyéwa, the political nature of gender relations appears most clearly in the context of misfortune, when the perpetuation of the patrilineal society is most seriously challenged.

The different speaking tasks of men and women correspond to relatively stable, labelled categories of verbal activity, which may be called "speech genres," each characterized by distinctive patterns of style, thematic content, and compositional and interactional structure (Bakhtin 1986; Ben-Amos 1976). Among Weyéwa, men's speech genres—divination, placation, and celebration speeches—strive to achieve narrative form, indirectness, and a generous display of rigidly parallelistic, poetic couplets. Women's speech genres, on the other hand, consist of relatively spontaneous evocative laments, high-pitched trilling, and a deeply affecting style of wailing. Constraints on couplet structure, narrative form, and intonational patterning are relatively loose.

As I will demonstrate below, many of the distinctive linguistic particulars of these genres can be systematically related to Weyéya ideologies of gender and descent. To reduce the differences in men's and women's speech forms and the sharp division of verbal tasks to an "absolute horizon" of political interests (Jameson 1981), or to consider only the ways in which these genres "harbor structures of domination," however, is to overlook the systems of cultural action by which subjects interpret and use those structures (Ortner and Whitehead 1981b: 4–5). As a system of cultural action, speech is not merely a "reflection" of some underlying system of political or economic relations, but is itself constitutive of it.

The Weyéwa and Misfortune

In order to understand the particular preoccupation of Weyéwa with misfortune, and why this is an important context in which men's and women's ritual speech performances are differentiated, it is first necessary to consider briefly environmental, historical, and mythical meanings of misfortune in the lives of the Weyéwa in wider perspective. The 74,449[1] Weyéwa inhabit the hot, dry, drought-prone island of Sumba, located approximately 250 miles east of Bali. On Sumba's chalky soil, they struggle daily to cultivate rice, corn, and a variety of root crops. In those places where underground streams surface, bringing with them water and topsoil, Weyéwa farmers have created an ingenious network of flooded, continuously irrigated wet rice fields. If all goes well, once or even twice a year the pond fields yield their most precious foodstuff. But even in a good year—a year in which the earth receives an average rainfall that would be considered a drought in many regions further west of Sumba—the bulk of their agricultural production is necessarily devoted to less prestigious, but hardy, drought-resistant varieties of corn, taro, and cassava. Despite all best efforts, however, the months of November, December, January, and February, in which farmers and their families must wait for their crops to ripen, are still known as *wúlla karémba* 'the months of hunger.'

Weyéwa spend most of the agricultural year in small isolated

hamlets consisting typically of three to four thatch-roofed bamboo houses. Cool during the day and warm at night, the large, high-peaked, grass-thatched roofs of Weyéwa houses have no chimneys or windows. During the parched, hot, rainless months from May to September, they are extremely susceptible to fire. When a house is devastated by fire, it is a matter with grave and far-reaching economic and symbolic implications. The Weyéwa 'house' (*úmma*) is a shelter, a granary, and a reliquary, as well as a unit of social organization.

Traditionally, Weyéwa built their houses in larger, fortified hill-top villages organized around megalithic ancestral sarcophagi. Driven partly by growing land pressure, Weyéwa are bringing more and more land under cultivation, and as a result they have increasingly been settling in temporary dwellings near their newly opened fields, often in isolated areas, far from other hamlets. Thus more and more families are exposed to the risks of theft, robbery, and arson for which Sumba was famous during the late nineteenth and early twentieth centuries (see Needham 1983). Although police statistics show that the danger posed by these hazards appears to be declining, the fear of 'thieves' (*áta kédu*) and 'robbers' (*áta ka-rébbo*) still motivates much village discourse.

External threats are not the only dangers to life in Weyéwa. Although the fertility of the Weyéwa population is among the highest in the area, life expectancy is generally low, and fatalities from disease and trauma remain a constant source of concern. Fever, dysentery, malaria, influenza, cholera, and other infectious diseases are remarkably common,[2] and the Weyéwa possess few herbal remedies. When an illness is sufficiently serious, and death appears to threaten, a specialist may be called who applies a poultice, or gives a massage; typically, however, he will focus on finding the spiritual cause of the malady.

Misfortune and the Ideology of the "Word"

According to a Weyéwa myth, misfortune (podda) originated when one man failed to heed the "voice" or "word" of the an-

cestors. In the story, ever since Mbora Pyaku neglected to fulfill the "word" of obligation engendered by his forebears, people began to fall from trees, die in fires, and experience all kinds of calamities. Although people tried to prolong their lives by making promises to sacrifice animals to the ancestors, since these "words" of promise to the ancestors are often left unfulfilled, and are "spotted" with imperfection, misfortunes continue to the present day.

In Weyéwa ritual life, *li'i* ('word, voice') is a central trope organizing the relations of obligation and exchange between the spirits and their living descendants. The myth illustrates its moral force: since personal well-being and social stability are ceremonial gifts bestowed by the ancestors in exchange for ritual sacrifice, maintenance of harmonious reciprocity is ensured only through careful fulfillment of one's "word." Failure to keep one's promise or heed the ancestral voice results in misfortune. Neglect of one's ritual duties can lead to disharmony with the spirits, who can cause sudden death, famine, and serious illness. Such discord represents a breach of the "word," a sin ultimately traceable in mythical contexts to the crime of Mbora Pyaku, who transgressed the "word" of his forebears.

For Weyéwa, communication with the 'ancestral spirits' (*marapu*) is the basis of customary religious practices and social stability. Weyéwa have withstood attempts to convert them to Christianity for over 100 years, and for at least 300 years they have resisted Moslem religious influence. Until recent years, Sumba has been the only large Indonesian island on which the majority of the inhabitants were not followers of any major world religion. As of this writing, most Weyéwa remain proudly devoted to their vibrant and elaborate form of indigenous religious practice and belief.

Small exchanges with ancestral spirits are very much a part of everyday life. As women go about their daily tasks in the house, above them are small baskets containing offerings of rice, betel, and areca nut for the ancestors, placed near the roof in special corners and raised shelves. When they serve meals to their family, they first set aside two dishes of rice for the husband-wife ancestral spirits inhabiting the house, food that is later eaten by children. When men journey to their garden fields, clear new forests,

or carry on negotiations, they give small offerings to the personal spirits who are said to ride on their shoulders. In their shoulder bags, men may also bring with them some small heirloom, such as a knife, a lime case, or a piece of cloth, that reminds them of the continued intervention and participation of ancestral spirits in their lives.

In both formal and everyday contexts, Weyéwa often describe the major patterns in the seasons and the life cycle as profoundly dependent on ancestral support. These supporting spirits, and the various minor deities under their guidance, are said to control the germination, growth, and abundance of crops, the flow of water and rain, the fertility of livestock, and the health and well-being of the community. Favorable outcomes of risky transactions, such as marriage alliances, legal disputes, and forest clearings, also require ancestral backing. In one of their many vivid images of this relationship, Weyéwa liken these deities to the cord that a woman holds to brace herself as she squats in the throes of labor (*kambala pakadyatu*). Although these spirits carry the potential for harm, they can also be a mainstay in times of crisis.

Ancestral spirits do not freely provide such goods and services, but require their descendants to reciprocate. Weyéwa must pray to the spirits with their request, and describe the compensation offered. Typically, they simply request an end to misfortune and express their wish for well-being and prosperity, and offer a small animal sacrifice as immediate compensation for future service. A more specific, but quite common sort of deal involves designating a buffalo or pig to a particular spirit as a reward for some desired outcome—e.g., a pest-free rice crop, or recovery of a family member from a serious illness. If the request is fulfilled, the animal will be sacrificed. Depending on the request, the reward may also be a celebrative feast or house temple built in the spirit's honor. Thus, according to Weyéwa religious ideology, the routine patterns of everyday existence—the production and growth of one's crops, health and well-being, the flow of water—come about through negotiation and agreement with ancestral spirits; to fail to strike a deal beforehand is to leave oneself dangerously open to misfortune.

The process of exchange between descendants and ancestors is a matter of obligation and perpetually deferred fulfillment via

promises—the giving of the "word." The lexeme li'i, glossed as
'word, voice,' exhibits a lively tension between two related senses,
one emphasizing prolonged moral obligation and the other focused
on immediate performance. In the first sense, li'i refers to a mes-
sage, a mandate, a promise, and a duty, a temporally structured
network of obligations. For example, li'i inna, li'i ama 'voice of
the Mother, words of the Father' refers to a set of (verbal) instruc-
tions handed down from generation to generation. More generally,
li'i refers to "Weyéwa tradition": all the customary, changeless,
and ancient obligations and responsibilities that those words en-
gender. In this sense, li'i is associated with a fixity that endures
over time, as expressed in the couplet referring to traditional cus-
tom: 'words of the Mother that do not move, words of the Father
that do not change' (li'i inna nda ndiki, li'i ama nda ngero). A
common way of describing a promise is katukku li'i 'to plant the
word' (cf. Renard-Clamagirand 1988).

Li'i also refers to the "voice" as a feature of oral performance.
This "voice" often assumes an audience, and the highlighting of
aspects of delivery: it may be described with adjectives such as
"hoarse," "thin," "powerful," "broken," "flowing," "soft," and
"deep." In this sense, the "voice" is individualizing and particu-
larizing, and reflects a distinct speaking personality. For instance,
when a ritual spokesman presents his point of view in a ceremony,
he 'puts forth the voice' (tauna li'i). "Voice" also has to do with
the features of performance organization, such as rhythm, melody,
and harmony. The verses of a song, for instance, are called "steps
of the voice." If ritual actors fail to coordinate their performances
properly, in either rhythms or meaning, the offense is represented
as a vocal problem: "their voices were out of step," or "their voices
were like untuned gongs."

The dual senses of li'i—as promise and performance—fuse in a
specialized style of poetic 'ritual speech' (panewe tenda), consist-
ing of conventional couplets in which the first line is paralleled by
a second in rhythm and meaning (cf. Fox 1988). The paired struc-
ture of the couplets embodies a fundamental and extraordinarily
productive aesthetic principle of Weyéwa ritual ideology that ap-
plies well beyond the verbal channel, by which social arrange-
ments, objects, and events of all kinds are symbolically consti-

tuted as pairs in a pervasive scheme of dual classification. When the "word" is neglected and misfortune ensues, specialist performers of this ritual speech are hired to recover it through divination, then to restate the neglected promises or "words" in placation rites, and finally to fulfill these promises in celebration and housebuilding feasts. As both the privileged medium for describing the *li'i marapu* 'words of the ancestors,' and the vocal instantiation of it, ritual speech represents an enactment of what is held to be a changeless and ancestrally established order.

When misfortune occurs, the roles of men and women in the ritual process of recuperating and atoning for the neglected "word" are strikingly different. For male performers, the process of ritual atonement consists of an ordered sequence of speaking genres, unfolding over time, devoted to the identification, reaffirmation, and fulfillment of the li'i as ancestral promise. 'Divination' (*úrrata*) is the first ritual step towards restoring the true word of the ancestors. In this genre, the diviner is preoccupied with the problem of indexically establishing the distinctive authorship of the ancestral "word" that was neglected. He enacts in performance the spirits' replies to his questions as individual turns at talk—bracketed in quotes—in an antagonistic dialogue, whose authority is verified with physical manipulations of technical media. In the subsequent all-night-long 'placation rites' (*záizo*) constituting the second stage of atonement, the "word" emerges in a dialogue between the gong- and drum-accompanied song (záizo) of a singer and the orations (*táuna li'i*) of invited speakers, who invoke the alienated ancestral spirits to return to the lineage house. In the final phase, in which the participants finally fulfill their neglected promises through sacrificial slaughter of water buffalo and pigs, a singer recites the tale of the founding of the agnatic clan, and emphasizes how the current feasting is in fulfillment of the "word" of obligation engendered by those original ancestors. These genres are known collectively as *kanúngga* 'migration narratives,' and may take the form of 'blessing songs' (*wé'e maríngi*) or 'chants' (*óka*).

When a young man becomes old enough to assume responsibility for the land, temples, cattle, and heirlooms of his agnatic forebears, he must also take on the responsibility of communicating

with his ancestral spirits. To do this he must use ritual speech. If
he himself is not able to perform effectively, he may hire a proxy
who can. Proxies are described as those who speak "beneath the
lips, beneath the mouth" (i.e., under the auspices) of someone else.
They usually charge a fee for their services, or demand a special
share of the slaughter in a feast. Failure to communicate properly
with the spirits can result in a fine by the human sponsor, and the
wrath of the ancestral deities.

Some women specialize in the knowledge of certain kinds of
ritual speech, and some are regularly invited to perform. Unlike
men, they are not paid for what they do, nor are their perfor-
mances ever proxied by anyone else. Although I was sometimes
told that there are no gender restrictions on any ritual speech per-
formances associated with misfortune, it is generally older women
with good voices who sing funeral laments (nggéloka) to make
people cry, sing work songs to make people work harder during rit-
ual preparations, and perform trilling ululations (pakállaka) to in-
vigorate and energize the all-night ritual speech performances by
the men. In short, these forms of women's ritual communication
are focused on evoking immediate, emotional responses in the
audience, often with practical results, e.g., getting a particular
job done.

The genres of ritual speech performance associated with mis-
fortune can be summarized as follows:

Men's genres

úrrata	'divination'
záizo	'placation song'
táuna li'i	'oration'
wé'e maríngi	'blessing song'
óka	'chant'

Women's genres

nggéloka	'funeral lament'[3]
pakállaka	'ululations'
nggéle	'worksong'

The division between men's and women's speech genres is neither
explicit nor particularly rigid. Indeed, there are some cases of
crossover. In general, however, it is cause for hilarity when a man

performs one of the women's genres, and cause for curiosity and wonder when a woman performs in one of the predominantly male genres of speaking.

Men's Speech

Although both men and women draw from a stock of 1,500 or so conventional couplets, it is only the men who, if they are caught improperly pairing the first line with the second line, may be fined anything from a single chicken to a cloth, a pig, and a knife, to be offered to the client's ancestors and received by the client. One of my informants recalls a time when one man used the couplet:

bóngga ndénde kíku	'dog with a standing tail
ndára métte lómma.	horse with a black tongue.'

The speaker and his audience immediately recognized that he had mixed up the "horse" and "dog" metaphors, and though he kept on speaking, as he spoke, he took off the shoulder cloth he was wearing and put it on the shoulders of the client. Often, however, fines for errors are paid quietly, in a less dramatic fashion, after the infraction. This is usually done in a brief ceremony in which the offender offers a quiet prayer to the ancestors of the client, and hands over the retribution to the ancestor's descendants present at the event. Although this may be done immediately after the performance of the event, it often happens that the spokesman's error is only recalled some time after a ritual event, the efficacy of which is under question. In such cases, it is much harder to extract payment, but Weyéwa say there is often supernatural retribution (see also Onvlee 1973:180).

Another characteristic feature of most men's ritual speech events is a narrative, or historical form of discourse organization, which they call 'the path that was travelled, the tracks that were followed' (*lára li palína, énu lipamáne*; see Kuipers 1984). This name suggests a narrative form, or "chronotope" in Bakhtin's ([1930] 1981) terms, consisting of a spatiotemporally arranged list of place names, like beads on a string, which describe a journey through

the moral space of neglect to misfortune and then finally to re-affirmation. In divinations, for instance, the goal is to find the narrative "story" that accounts for a particular misfortune, e.g., how a crop failure or the death of a child was the culmination of a series of neglected opportunities (dreams, portentous signs, and omens) to recognize ancestral signs of wrath.

Such stories can have a significant political and economic impact. When a diviner determines the spiritual source of the misfortune, his findings may be used to suit the interests of particular parties. After a divination ceremony, lengthy discussions follow, concerning who exactly is guilty of, or at least responsible for, the neglect of the offended spirits. Once blame has been assigned, the economic burden of atonement, through the staging of expensive feasts and temple-building ceremonies, lies largely with the guilty individual.

Another key feature of men's speech is its indirectness, a characteristic similar to that described by Elinor Ochs Keenan in her analysis of men's and women's speech in Madagascar (Keenan 1974). Indirectness is an elusive notion, but I wish to examine two specific aspects: the use of proxies, and the use of reported speech. The use of paid ritual spokesmen, necessary in almost all ritual speech events, not only helps to remove the client from direct confrontation with an interlocutor, as it does in Madagascar, but also makes available linguistic proficiency for those who are not up to the daunting verbal task of delivering fluent, ritual speech orations, which sometimes can last all night. The frequent use of reported speech, phrases such as "you say," "they say," and "he says," not only shifts the responsibility of an utterance away from the speaker, but also heightens the textual authority of the speech as part of a dialogue with the ancestral spirits. By employing a variety of technical and verbal devices that suggest communicative engagement, the diviner creates a rhetoric of responsibility for the 'word' (li'i) of the ancestors.

As an illustration of these characteristics, consider the following transcript taken from a divination ceremony in which a male diviner attempts to account for why his client, a father of six children, was injured in an accident. The divination method employed by the diviner is known as *rópakapúdda*. This phrase consists of

two words, *rópa* 'to fathom, to span' and *kapúda* 'spear shaft,' a more or less accurate depiction of the diviner's actions. In this form of divination, the practitioner is seated cross-legged on a mat in the middle of the floor near the hearth. In front of him are placed three or more dishes of betel and areca nut offerings, and a coconut half-shell containing uncooked, husked rice. He picks up a handful of rice, tosses it towards the various corners of the house inhabited by spirits, and addresses those spirits. As he jabs the tip of the spear into the sacred house pillar associated with the ancestral spirits, he holds his left hand fast on the shaft so that his right falls about 10 centimeters short of the house post. As he attempts various narrative explanations for the reason for the misfortune, he stretches towards the house pillar. If, while holding his left hand tight on the shaft, his right is able "reach" the house post of the ancestor, this is taken as a confirmation of the veracity of his account. If his hand does not reach, the sign is a negative one.

As can be seen from the first lines of the text, the diviner begins by exhorting the spirit to receive the rice. He constructs a dialogue in which the ancestor is reported as saying that the victims tossed aside the words and promises in which they agreed that in exchange for good luck and pest-free rice fields, the spirits of the Mother and Father would be made "exalted" and "glad as bats in banana trees." When the diviner asks if the ancestor did in fact say that, however, the answer is no.

Ne yáza!	Receive this rice!	1
Iúmmungge:	you say:	
hítti ba na	at that time, when they	
kómbaka patúmbana lí'i	tossed away the voices	
ne ba na	when they	5
lánggura pabétina lómmana	cast away the [words of] tongues	
némme Léle Wúlla	there in Ivory Moon [rice field]	
peinaʔ	how about it?	
wá'ingge lí'ina	there was a promise	
ne ba na	when they were	10
ndári tána mángngu bába	working land in the lap of abundance	
ne ba na	when they were	
kanékka rútta mángngu lólo	weeding the grass with tendrils	

na dádidongge parékka	[when] they were having good luck
na tímbudongge paráwi	[and] their efforts were succeeding 15
ndá'imo a	and if there were no pests
karónggongge ró'ona	that break open the leaf
ndá'imo	and if there were no [lundi worms]
a kambílangge pú'u;	that attack the roots, then
na kéketa tóu ínnanggu	the body of Mother would be exalted 20
na sónggoladona wékki ámanggu	the body of Father would be raised
"málla	[and they would say] "well
na ndéta átenggu	my heart is as glad as
paníkki ró'o kalówo	bats in banana trees
na éngge kókonggu	my throat is joyous as 25
kabálla ró'o katéte"	grasshoppers in potato leaves"
hínnangge lúnggu!	it is said by [the ancestors], I say!
ka nda hínna nya	if this is not what they said,
ka péikona óle	then what, my friend,
lúmmuku!	do you say? 30
hínna tákka!	Is this truly what was said?
hínna tákka!	Is this truly what was said?
índaki!	no!
nda hínnaki!	it is not so!
nda láraki!	that is not the path! 35

The diviner concludes that the victims' presumption that they had broken this promise to the ancestors "is not the path" or the "true" history of the event. Their presumption has been "kicked apart," and they are now like orphans who don't know the true path (or history); but the diviner vows to get to the bottom of it all (the roots and source).

pása kókina	the monkey nest
a kandúkka téwwara	has finally been kicked apart
wángu wáwina	the pig's platform
a mára béndi	was dry and cracked
ba kéko ána lálo	they are orphans 40
nda tánda lára núku	who don't know the covenant path
ba pála ána médo	they are poor waifs
nda pándena lára pápa	who don't the paired ways,

ka ba hínnako	if that's the case, then
pónggoponda wáru ndúkka pú'u	let's cut the tree to its base 45
wéiyaponda wé'e ndúkka máta	let's look for the source of water
lúnggu	it is said by me
ba lúmmungge . . .	that you say . . .

The text clearly exemplifies the main features of men's ritual speech genres. The couplets, for instance, tend to be completed wholes, and except for words used as connective devices, every line has its pair. The speech strives for narrative form, as evidenced by the diviner's references to the "path" he is looking for (or was overlooking) on lines 35, 41, and 43. Although the speech is constructed as a dialogue with the "word" of the ancestors, a distanced indirectness is achieved with the use of quotatives, which differentiate and frame the discourse of distinct speaking parties. When the diviner wishes to confirm the accuracy of his speech, he constructs a sentence frame and then asks if he can attribute that frame to the ancestors.

After such a performance, the client, the diviner, and concerned members of the family gather to evaluate the "words" of the ancestors as they emerged from the divination. Was it the true "voice" of the ancestors that they heard through the diviner? How should they fulfill their obligations to those voices? Who should pay for it? After discussing these matters they provide an animal offering to the spirits, the entrails of which are inspected for signs of confirmation of the previous findings.

Women's Speech

The ritualized responses of women to sudden misfortune contrast sharply with those of the men. Among Weyéwa, the most vocal expressions by females appear in placation and mourning rites. Whereas women typically remain silent during rites of divination, observing the proceedings from inside the hearth area, in the záizo (rites of placation) a chorus of women, still in the hearth area, accompany the male *a záizo* ('singer') with periodic, high-pitched 'ululations' (pakállaka). These piercing nonverbal cries are said to "encourage" the men as the latter narrate the all-night-long *lí'i*

marápu 'words of the ancestors.' As dawn approaches, any flagging of enthusiasm on the part of the women is noted by the male participants and members of the audience. The final pages of a number of my transcribed texts of záizo performances are sprinkled with harsh, barked imprecations and insults to women lax in their duties.

In rites of mourning, women give a more articulate voice to the complex feelings and emotions associated with grief. The following nonnarrative, emotive lament (nggéloka) for a dead woman was delivered in spontaneous and uninterrupted form by the dead woman's niece, as she arrived to pay last respects.

Funeral Lament

Tyoo ínna, tyoo ínna	Oh mother, oh mother	1
tyoo ínna, tyoo ínna	oh mother, oh mother	
nda ku éta kala ínnanggu	I don't see you, my mother	
hídda zóba tána kólo.	they dug a big hole.	

By "big hole" she was referring to an earthen burial, a pauper's grave, which evokes pity to Weyéwa. In fact the woman was to be buried in an elaborate stone sarcophagus.

Tyoo ínna, tyoo ínna	Oh mother, oh mother	5
nda ku éta kála ínna	I don't see you	
ku pazódo ránde lálo	I nose around like a lonely duck	
ku ndénde kála ndénde	I'm just standing around	
ku ndénde kála ndénde	I'm just standing around	
ne marédda yómba la.	in a silent, empty field.	10

A common Weyéwa image of happiness is noise and movement inside a house full of people. To be outdoors, and furthermore to be alone, is a devastating image of loss and isolation.

ku wáina wéiyo mátangu	I use my tears	
wé'e máta nda mára	tears that won't dry	
ku óta kála óta	I just stand about	
ku óta kála óta	I just stand about	
ne tílu tána ndála.	in the middle of the road of	
	misery.	15

To Weyéwa, the image of the path, trail, or road is associated with motion, the passing of time, action, and vigor. To be stopped in

one's path is seen not only as a sign of danger, but also as a sign of misfortune and the loss of one's aims.

ku wáina wéiya wíranggu	My nose fills with mucus [from weeping]
wé'e wíra nda mandóri	mucus that won't dry
nda na tímbungge tóro	no eggplants will grow here
ne máta wái pawáli	the spring from which [I] came
inna lángu léiro	my dearest mother 20
nda na wékabangge wáwi	no pigs will squeal anymore
nda na dádibangge nggóle	no vegetables will grow anymore
oo ínna	oh mother
nda na kúkubangge mánu.	the cock does not crow anymore.

Eggplants, pigs, and chickens are seen as domestic products that the mother tends because they typically inhabit the village.

péiyamuni ínnanggu	How could you, my mother. 25
a rúduka pandókungga	who suddenly abandoned me?
péiyamuni ínnanggu	How could you, my mother?
kuwápukowe tí'anggu	I embrace my own belly
kumáta nggíla nggílani	I look and look for her.
péiyamuni!	How could you? 30
péiyamuni!	How could you?
ku ánggumongge kókonggu	I embrace my own neck
ku máta kála éta.	I just stare about.

In Weyéwa, to hug one's own belly is a sign of extreme emotional duress.

kundyárrukoangga úmma	I go up into the house
kundyárrukoangga úmma	I go up into the house 35
kumáta nggíla nggílani	I look and look for her
ku wáina wé'e mátanggu	I use my tears
ku púttukoangga cána.	I go back down into the yard.

In Weyéwa, one expects to find a woman inside the house, but she is not there.

ku kandáwu ndúla kóko	I hope for help
ku kandáwu ndúla kóko	I hope for help 40
na ínna nda panéwe	[from the] mother who doesn't speak

ba lénga tóma dúkki né'e	because I have come to you here
ku lémbu áre áte	I hope for your open heart
ku kalémbu árekuni	I have hope, by coming before
kóro nda panéwe	the wall that does not speak
ku ndúlla kóko wáikona.	with which I hope for love.

45

At this point in the lament, the singer seems to be more resigned; she begins to acknowledge her "mother" as a spirit (e.g., "the wall that does not speak"), and asks for help from her.

After such a performance, I have heard both men and women discuss whether the song "pulled at their liver" or if it "eats at you." After this one, people said things like, "my heart [liver] was really pulled, tears really came out"; "I really cried when she sang." What is interesting is how the audience explicitly evaluates the performance in terms of its effect on them, its ability to articulate their individual feelings of pain and grief with a collective set of symbols for death and mourning, shared by the community as a whole. A really powerful lament provokes spontaneous expressions of grief in the audience and promotes more direct involvement in the ceremony.

This song contrasts with the man's speech in some striking ways. Although the lament was a clear example of panéwe ténda (ritual speech), one of the most marked techniques in this text is the systematic violation of the expectations of couplet formation. For instance, on line 19, *máta wái pawáli* 'the spring from which [I] came' the pair should be completed by *póla púnge ndára* 'the source of the horse.' Also consider line 26, *rúduka pandóku* 'abandoned suddenly,' where the pair should be completed by *bóndala pandénga* 'set down wrong.' This technique gives a sense of breathless spontaneity and total involvement. Other affective devices in this text include repetition (e.g., the repetition of "oh mother" in the first lines of the song) and interjections (e.g., *péiyamuni* 'how could you?' inserted between lines of a couplet). The lack of quotations and the use of the first-person singular contribute further to the spontaneous, immediate, and uncontrived character of the lament. Finally, the singer herself further marks her speech from male discourse on line 15. Rather than guide her speech with the narrative "path that was travelled" type of discourse, she repre-

sents herself as "standing about in the middle of the road"—
refusing narrativity.

Division of Labor and Descent

So men use couplets in a narrative idiom, and quotatives and
proxies to enhance their distanced indirectness. Their speech is
constructed and evaluated in relation to the ancestral "word" (li'i).
They receive payments for their work. Women's invited perfor-
mances, on the other hand, are primarily expressive, like "re-
sponse cries" (Goffman 1981:78–122), and are evaluated accord-
ing to whether they are effective in evoking emotions, which they
do in some cases by systematically violating norms for what one
should expect in ritual speech (panéwe ténda). What accounts for
these differences in the linguistic efforts of men and women?
Why do women seem concerned only to influence those around
them, and not with producing repeatable narrative histories, like
the men?

One possible interpretation is that women are somehow more
expressive emotionally than men. Since Mead's pioneering work
on sex and temperament (1935), few researchers would accept this
as generally true of all societies (see, e.g., Hochschild 1983). Al-
though I have heard Weyéwa men and women both say that women
are "better" at singing laments, and that "women's feelings are
gentler," such Weyéwa commentary tends to beg the question:
Why are women considered to have gentler feelings when it comes
to singing laments?

Another possibility is to view the elaboration of specialized lin-
guistic styles and tasks as a function of the socioeconomic divi-
sion of labor. It is a commonplace observation in sociolinguistic
literature that many occupational categories (e.g., shamans, doc-
tors, lawyers, etc.) develop their own specialized styles of speak-
ing, which relate to the technical particulars of their ways of
making a living. Perhaps, then, the different ways men and women
have of expressing themselves in Weyéwa could be traced to differ-
ent socioeconomic roles: for example, women are concerned with
the more emotional task of rearing children, while men are out-

side the home "making a living." But if one tries thus to view the division of labor in speech (or lack thereof) as a simple reflection of, or facilitator of, the division of labor in subsistence tasks (e.g., Bloomfield 1933; cf. Irvine 1989), one runs into serious problems. One difficulty in the Weyéwa case is that the majority of heavy agricultural tasks are *shared* by men and women (e.g., planting, weeding, and harvesting), and not even child-rearing is regarded as an exclusively female task. Furthermore, such an approach would still not explain why women do not actively participate in divination and placation narratives, why women are not fined for couplet violations, and why women do not use the narrative form in such ritual contexts.[4]

A more promising line of interpretation concerns the different cultural conceptions of men and women in the Weyéwa social and symbolic order. When Weyéwa discuss the totality of their traditional customs, they represent it as the "words of mother, words of the father." Relations between senior and junior agnatic lineages are likewise depicted as speaking roles: as 'givers of the word' (*a ngíndi lí'i*) and 'receivers of the word' (*a dímba lí'i*). Unlike men, who are the mainstays of continuity in this system of agnatic descent, women are socially moveable and exchangeable and thus not reliable keepers of the "word." When the time comes for Weyéwa to marry, the phrase used to describe the event is 'move the woman' *pandíkki mínne*, with the assumption that the man stays put. After her move, the woman has no legal rights to the cattle, land, or golden heirlooms of her natal clan. Although she is subsequently incorporated into her husband's clan, this process takes time, and it is many years before she is a fully competent participant in the key informal decision-making processes of the clan.

Full participation in any Weyéwa clan activity requires a mastery of its history, a history expressed in narrative form. In many contexts, for many purposes, a Weyéwa woman is an ahistorical being, detached from her own history; and indeed, residues of her natal clan history brought to her new home can be cause for anxiety—Weyéwa fear the *marápu padéku*, or 'following spirit.' Since women are "denied" this temporal continuity, they nonetheless

can and do act as "agents" (Giddens 1979), affecting their present social environment in immediate but powerful ways, through active verbal participation in important tasks such as planting, weeding, and harvesting, and funeral laments. A woman's audience here is not the sacred spirits, to whom she is denied access; and so botching a couplet does not result in a fine.

From the perspective of the agnatic clan, calamity is both an opportunity and a threat. It provides the opportunity, in the context of divination, placation, and celebration rites, for an interpretation of the cause of ancestral displeasure that allocates moral blame and economic responsibility for atonement to suit political interests. The ensuing feasts of atonement offer the context for settling disputes and can enhance the prestige of certain individuals. On the other hand, competing interpretations of the cause of calamity can challenge the existing order, and people with external political affiliations can threaten its very continuity. Since wives are associated with outside interests, it is not surprising that no one I talked to could ever recall a time when a woman narrated the lí'i marápu (words of the ancestors) in an úrrata (divination) or záizo (placation rite). The task of articulating the past in rites of divination and placation so that it meets the needs of the present is an exclusively male province of activity.

Yet women's speech is influential. Unlike men's speech, it has a direct, often observable effect on the emotional environment, and on the behavior of co-participants. In one case I observed, the host of a mortuary feast was so moved after hearing a lengthy lament that he spontaneously decided to slaughter an extra pig for his guests. Men's speech in Weyéwa is not seen as powerful in and of itself; it is only authoritative, legitimate, and binding on others insofar as it conforms to, evokes, and is validated by an ancestral 'word' (li'i). Divination or placation rite speeches, for instance, strive for "true" or "real" versions of the ancestral voices, and thus contradictions of the assertions in these performances is not taken lightly. Women's speech is not authoritative in this way, but might be regarded as powerful, or "influential," in Parsons's (1963) sense of bringing about a change in someone's behavior for positive reasons, not because he or she fears sanctions.[5]

Conclusions

When we look at how speech is used by men and women in the special, vulnerable contexts of misfortune, striking gender differences emerge. A consideration of the distribution and rights of access to speech resources in Weyéwa society reveals a reproduction of the structure of power, in which male spokesmen alone are accorded the rights to rearticulate their relationship to the ancestral sources of wealth, prosperity, and value. When we examine the text of women's laments, however, it is clear that women's speech reflects a strategy of influence: through systematic violation of couplets, repetitions, and evocative interjections, women's speech evokes instant and powerful responses in their immediate social environment.

Theatrical Imagery and Gender Ideology in Java

Barbara Hatley

The last three papers have considered performance in legal, conversational, and ritual contexts. Here Barbara Hatley examines performance in its theatrical sense. She focuses on kethoprak, *a twentieth-century form of popular drama with wide appeal for lower-class audiences in Central Java. Hatley contends that* kethoprak *serves as a vehicle for expressing ambivalence over gender roles in Java today. Hatley's paper considers not only the content of dramatic performance, but significantly its import for largely female Javanese audiences.*

All the contributors to this point have dealt in one way or another with women's and men's differential access to spiritual and political resources in their communities. In the case of the Wana and the Meratus, women's relative exclusion from the prestigious arenas of shamanic performance and legal debate is brought about by implicit assumptions and practices rather than explicit categorical rules.

Together, Hatley's and Keeler's papers lend special insight into Javanese gender relations. The kethoprak characterization of Anjasmara, the heroine of the Damar Wulan *story, like the Javanese women described by Keeler, enjoys a wider register of emotion and speech style than Javanese men. Yet her behavior exhibits a lack of the self-control, the mystical insight, and the refinement so valued in Javanese culture. What she gains in instrumentality she sacrifices in prestige. Both Hatley and Keeler underscore the relative freedom women enjoy from the constraints on men's*

status-sensitive behavior. Both treat as well the disjuncture between women's social and economic autonomy and their relative devaluation in prestige terms. Hatley suggests that kethoprak presents Javanese audiences with the breach between women's practical self-sufficiency and their awareness of an ideological diminution of their autonomy. But Hatley also modifies our understanding of Javanese women's autonomy by pointing out that although women may manage household economies and trade in local markets, their prestige and sexual reputation depend on their husbands and adult sons. Thus despite economic self-sufficiency, divorce can deliver a tremendous blow to a woman's social standing. Ong (this volume) and Kessler (1980) make a similar point for village women in Malaysia.

Hatley's paper introduces several important themes that will figure elsewhere in this volume. One concerns the intersection of distinctions of gender, prestige, and class in the context of an island Southeast Asian nation-state, in which new images and ideas about what it is to be a man or a woman are being introduced and promoted, and new arenas of performance and economic interest help to effect socially and sometimes reify those newer images. Throughout her analysis we are aware that Hatley is treating popular enactments of traditional epics about Javanese nobility performed for contemporary proletarian audiences. She also addresses how stereotypes of women serve as vehicles for contemporary ambivalence about social change and fundamental realignments of family and marriage. Ong, Rodgers, and Blanc-Szanton will offer other illustrations of this point. Finally, Hatley stresses not only stereotypes of women, but women's responses to those stereotypes, an emphasis that Blanz-Szanton and Ong in particular will develop.

This paper focuses on images of women and of male-female relations in dramatic performances in contemporary Java. Such images are explored for the insights they offer into current understandings of gender in Javanese society, and into the process of reproduction of gender concepts. The long-recognized role of Javanese theater in displaying and inculcating social values helps endorse and justify such an approach. Commentators, both indigenous and Western, have discussed the celebration in traditional dramatic forms, particularly *wayang kulit* (shadow-puppet theater), of quintessential Javanese notions of social order, of political power, of psychospiritual harmony, of relationship between self and world.[1] Recently developed popular theater, meanwhile, has

been described as an agent for change in these traditional values, and in associated social practices.[2] My own analysis, concentrating attention on links between theater and gender ideology, makes reference to the formative patterns of traditional theater, while it centers primarily on popular forms of twentieth-century origin.

Especially among poor people with little schooling, minimal reading skills, and limited exposure to modern mass media, who predominate among its audiences, popular theater retains a vital communicative, educative role. Its imagery provides for the observer evidence of the attitudes of people whose thought world is not given expression through other channels. Moreover, as different dramatic genres are performed by troupes of varying constitution in diverse social circumstances, the imagery reproduced is not fixed and invariant but fluid and shifting, expressive of the perspectives of different social groups. In the sphere of gender ideology one might look for the suggestion of distinctive male and female perspectives, and for reflection of behavioral expectations associated with different social classes. Another important phenomenon to consider is the interaction of established traditional values with new, Western-influenced ideological concepts.

A specific focus on representation of women arises in response to the apparent complexity and ambiguity of female experience in Java. Viewed from different perspectives, a woman's position vis-à-vis that of men may be interpreted as either dominant or subordinate: ideological prescription and actual social practice are seemingly frequently at odds. Although direct theatrical reference to this situation is perhaps unlikely, there may be identifiable influence on dramatic imagery. Of particular interest is the way women represent female characters on stage, and the picture thereby conveyed of the general condition of women.

Social and Economic Roles of Women

The household "dominance" of Javanese women and their "strong position" in social life generally are frequently commented upon by observers of Javanese society, and of women's status cross-culturally. (See, for example, H. Geertz 1961: esp. 46; Tanner 1974: 134–37). The nuclear family constitutes the basic productive unit

of Javanese society, within which men and women are understood
to cooperate in the earning of a living and raising of a family. Rules
of kinship and property ownership imply gender equality—descent
is reckoned bilaterally, and women may hold and administer prop-
erty in their own right. In large areas of activity, women's roles
appear not merely equal to those of men but indeed dominant.
Within the home women are seen to control household finances,
make all day-to-day decisions, and take major responsibility for
raising the children. At lower socioeconomic levels they partici-
pate actively in economic activities outside the home. Certain
areas of agricultural production have traditionally been regarded
as exclusively female concerns: women predominate in petty mar-
ket trade. And in the social world of village and *kampung* (urban
lower-class neighborhood) women largely determine the social re-
lations of their family with the surrounding community through
their participation in neighborhood networks of exchange. (See J.
Sullivan 1980:15–30; N. Sullivan 1982.)

Women of more privileged position in society, of the aristocracy
of old and of the bureaucratic/professional *priyayi*[3] class that is its
contemporary successor, have traditionally been more circum-
scribed in their social roles and activities. Work outside the home
was considered demeaning to family prestige; young girls were
kept in seclusion until marriage, and after marriage were regarded
as properly dependent on their husbands. Once the secluded young
maidens became wives, however, raising children and overseeing
large contingents of servants, they often developed formidable ad-
ministrative skills, exerting effective authority in the household
and participating independently in social activities outside the
home. Today, in an environment where advanced Western-style
education holds great prestige and practical advantage, young
women of privileged background lead social lives that are far from
secluded, participating in higher education at universities and
colleges.

Traditional Ideological Conceptions

Yet these actual social roles coexist with ideological images of
women that picture them as neither equal nor "dominant." Women

are ascribed characteristics judged as essentially inferior to those of men and are thus assigned subordinate status. Such images of women take several different forms. The traditionally dominant ideal of womanhood, cultivated in the noble courts and seen as characteristic of the social elite, is one of grace, modesty, and refinement, but also of fragility and dependence. Like men of their class, priyayi women were/are associated with dignity of manner, refinement of speech, and skill in courtly artistic pursuits. But lacking the spiritual power and learning characteristic of men, they are rendered dependent on their husbands for protection and guidance. In return a wife should care for her husband's emotional and domestic needs, submissive to his wishes and supportive of his endeavors. As an expression of her virtue and modesty, a woman is understood to be shy and reticent at first in matters of love, but once married she is expected to serve her husband with wholehearted devotion. He returns her affection, while also enjoying the license to express his male power in relationships with other women, which a wife should accept without complaint as part of the natural order.

This "aristocratic" image of women and male-female relations constitutes a cultural ideal in Java, celebrated in dominant cultural forms,[4] and is thus influential at all levels of society. Village people, too, endorse it, when speaking in formal contexts, on the plane of behavioral ideals (Jay 1969:89). Yet in everyday social practice, among the mass of ordinary Javanese, a more down-to-earth appreciation of women's characteristics and of male-female relationships holds sway. Women's and men's activities—in the home, in agriculture, in social life—are viewed as separate and complementary. In rice cultivation, for example, men properly plow the fields and plant seed while women tend the seedlings and carry out the harvest. In accordance with the central economic importance of the nuclear family unit, marriage is viewed pragmatically, as primarily an economic and social partnership rather than a deep personal bond of affection and dependence. The suitability of the two partners to one another becomes evident only over time, as their economic and domestic affairs prosper or fail. If things go wrong, if economic activities fail to thrive and friction sours the relationship, divorce takes place. Divorce incurs little

stigma, and is seen to be relatively easily sustained by women, be-
cause of their economic independence.[5]

Such practically based, apparently egalitarian conceptions of
gender relations in fact embody assumptions that are far from
egalitarian in nature. For men's and women's separate spheres,
though complementary, are by no means *equal* in terms of social
prestige and importance. Men in Javanese village society are iden-
tified both with the sphere of formal gatherings, political and rit-
ual activities, and with the highly valued cultural pursuits of as-
cetic exercise, spiritual learning, and refined, cultivated speech.
These attributes may represent an historical overlay of aristocratic
culture on Javanese village society, assimilated by men rather than
women because of a preexisting male predominance in political
and ritual life. Women, however, remain constrained to the less
prestigious domains of child-raising, food preparation, and house-
hold management.

Though women *may* perform ascetic exercise, it is not consid-
ered usual for them to do so. Thus they are seen as incapable of
refined, controlled speech and of the emotional control that is the
outward reflection of accumulated spiritual strength. Women's
speech is blunt and informal, their behavior often embarrassingly
unrestrained. Their own particular skills in managing the house-
hold and controlling finances, while complementing those of men,
are deemed secondary. Such a perception is based upon the domi-
nant understanding of human reproduction. Woman is seen as a
mere 'container,' a *wadah*, for man's seed, nurturing the life that
he provides. The male role is generative, the female one "merely"
conservative. In the social sphere also, women's tasks are regarded
as conservative rather than generative, and therefore are deemed
secondary to those of men. Women tend the seeds that men have
planted, cook the resulting food, and distribute money—also puta-
tively provided by men—in household expenditure and exchange
relations with other families.[6] Women's economic activities out-
side the home, in market trade particularly, are seen as an exten-
sion of the natural female household concern with money matters.
The association of women with money brings more disparage-
ment than esteem, as men complain of their wives' tightfistedness
and rather contemptuously attribute to women a *jiwa dagang*,
'soul of a trader.'[7]

New Ideological Influences

A new stream of ideological influence has come into Indonesian society in recent years—that associated with notions of "modernity," progress, and Western cultural influence. This gives rise to a new image of woman alongside that of the delicate aristocratic lady and the penny-wise village wife—the educated and accomplished modern woman. Here would seem to be opportunity for greater public esteem and social power.

The concept of independent, socially active woman, first espoused in late colonial times by a tiny modernizing elite, seems to have been quite widely promoted in the "progressive" political atmosphere of the 1950's and 1960's. Through the networks of women's organizations, encouraging women's participation in social and political affairs, the concept achieved currency at village level as well as in towns (Jay 1969:93). In the 1970's and 1980's, however, a shift towards greater conservatism and authoritarianism in the political sphere has been paralleled by similar trends in ideology concerning women.[8] The only large-scale, mass organizations for women, controlled by the government, emphasize women's contribution to society through their roles as wives and mothers. In the state family welfare program, directed specifically at women, promoted through an organizational network encompassing every village and kampung, the five major tasks of women in social and economic development are specified in the following way:[9] (1) loyal backstop and supporter of her husband, (2) caretaker of the household, (3) producer of the nation's future generations, (4) mother and educator of her children, and (5) Indonesian citizen.

Contemporary mass media, meanwhile, promote an image of women that, for all its surface attributes of "modernity" (fashionable Western-style clothes, jet-setting lifestyle, educational achievement), is basically conservative in implication. Esteemed female characters place marriage and family before career and self-advancement. Studies of recent films, for example, describe plots in which characters who do not conform to the image of women as gentle and supportive wives and mothers are portrayed in an exaggerated and unsympathetic fashion. Unmarried, career-oriented professional women, tomboyish teenagers, and the like either come to change their behavior and conform, or meet an unhappy

end (Sen 1982, 1983).[10] In today's conservative political climate the ideology of modernization as it applies to women seems to involve a fusion of the traditional wifely ideal with a Western-derived, bourgeois, women's-magazine conceptualization of a woman's role.

Experiential Consequences for Women

What are the practical consequences for women of the existence of these ideological images? One important effect is that lower-class women especially, in their exclusion from the male domains of formal ceremony and refined speech, are in fact freed of the restriction and inhibition that characterizes much of male social interaction. Whereas men must be constantly mindful of questions of status, careful to display towards others the proper level of deference, on guard against slights to their own dignity, women's conversation is blunt, uninhibited, straightforward. Though often raucous, fulfilling the standard stereotype of female vulgarity, it also allows for more open communication among women than among men, and thus for closer, warmer social ties.[11] Less constraint by rules of social etiquette has also been observed to give women greater confidence and assertiveness in new social situations (Jay 1969:44).

Yet this exclusion from the process of status display also implies exclusion from the possession of status itself. A woman's household control and agricultural or trading activities outside the home do not provide her with standing in the community. Her standing is determined by the occupation and personal reputation of her husband. It is her husband, or in his absence a grown son, who represents her as head of the household at public gatherings and ritual occasions. A woman is dependent on a man, then, for full social representation. She also requires a husband for sexual protection, since a woman on her own is open to both sexual predation and scandal-mongering gossip. All this serves to tie women into marriage, whatever their degree of economic self-sufficiency. Such pressures make married women anxious to hang on to their husbands, and divorcées eager to marry again. Against this background there arises an attitude towards male infidelity that I observed to be far less sanguine and tolerant than that prescribed in

ideology and often reported in academic studies of Javanese society.[12] Married women go to great lengths to ensure that their husbands do not develop outside liaisons threatening to the marriage. Awareness of social encouragement for their men to "stray" makes them all the more vigilant in guarding against this possibility.

Women internalize the notion that their own concerns are of secondary importance compared to those of men. Among lower-class women there seems to be little sense of pride in their activities, little sense of "autonomy" or "dominance." Hildred Geertz quotes remarks by Javanese women that all they know about, day in and day out, is *lombok* ('chili pepper') and *tempe* ('soybean cake'). Geertz brushes these aside as mere levity, since women are in fact involved in so many economic and social activities (H. Geertz 1961:122). She does not explore the possible significance of these remarks as ideological belief, illustrative of women's conditioning to think of their own concerns as trivial. Valerie Hull points out that poor rural Javanese women, working outside the home out of dire necessity, struggling to fit in household chores and child-raising along with earning a living, express no positive affect toward their work life. (It is interesting to note in passing studies of the number of hours spent in productive and domestic labor by men and women of a household. Women are shown to work on average almost 30 percent longer per day than men; White 1981:136–37.) Instead, these women concur with the view of the more socially privileged, that women in circumstances such as theirs are incapable of raising their children properly (Hull 1976:9).

Yet are Javanese women wholly constrained by the framework of dominant, male-created ideology? Or do they feel the ambivalence of their situation, shouldering responsibility for so much day-to-day activity, yet ideologically subordinate and dependent? Does a wife sense contradiction in the situation of dependence for status and social "place" on a man who in so many practical respects is dependent on her? How does a husband, in turn, interpret the contrast between the cultural ideal of wifely submissiveness and supportiveness and his experience of his own plain-speaking, managing spouse? How do these perceptions shape the overall experience of Javanese marriage, so important as a social and eco-

nomic institution, yet individually very fragile, as evidenced by the high divorce rate? And what is the impact, in the areas of love, marriage, and male-female relations, of the new models promoted through modern media and Western cultural influence?

Occasional references to evidence of strain in male-female relations occur in anthropological studies of Java. Hildred Geertz, for example, in *The Javanese Family*, reports on the somewhat begrudging, ambivalent attitude of her chief informant toward her husband, and on the tensions caused by suspicion of infidelity between partners (1961:128–30). Robert Jay speculates on the possibility that disappointment at the discrepancy between idealized expectations of marriage[13] and the unsatisfactory reality of the married state may constitute an important influence on the high divorce rate (1969:67). And James Peacock, in his study of the popular dramatic form *ludrug*, draws intriguing parallels between the perceptions of males in female-dominated Javanese households and the characterizations of women presented by ludrug's all-male casts of actors (1968:74–78). Without wholly endorsing Peacock's enthusiastic equation of theater with life, there seems an obvious connection between the stereotypical ludrug figure of the domineering, nagging wife and male antagonism towards dominant women; likewise the soft and sexy transvestite singer represents a willful male fantasy of womankind. Peacock's comment on these issues is a passing one, in the context of his general preoccupation with the "modernizing" impact of ludrug performances. But my own observation suggests that representation of male attitudes towards women constitutes a crucial aspect of ludrug's significance as a dramatic form, and of its appeal to its audiences.

Gender Imagery in Traditional Javanese Theater

Javanese theatrical tradition has long contributed to the perpetuation of dominant gender ideology. In the characterization of traditional theater one finds embodied the two stereotypes of women described earlier—the "aristocratic" ideal and the unromantic "village" concept of actual female behavior. "Heroines" of

this theater—wives and sweethearts of the noble heroes—are defined in terms of their delicate beauty, refinement, modesty, and total devotion to their men.[14] Other types of female activity, such as household management and care of children, are not depicted: no children appear in the cast of characters. For the most part, women participate in only a minor way in dramatic plots played out in a man's world of spiritual learning and military adventure. In keeping with a general system of counterpoint in Javanese theater between idealized noble characters and humorously flawed low-life figures, these ladies are attended by coarse-spoken, ungainly, and amusingly indelicate maidservants. A related low-status comic figure is the loud, nagging village wife.

These contrasting characterizations of women suggest very strongly projection of the attitudes of the *male* performers who produce them. In wayang kulit (the shadow-puppet theater), the most prestigious of Javanese art forms and a highly influential dramatic model, the puppeteer, musicians, and almost all the audience members are men. Likewise, until recently, men took all the roles in the wayang-based dance dramas *wayang wong* and *wayang topeng*; in village *topeng* performances they continue to do so today. One probable reason for such exclusivity is the fact that performances are traditionally held as part of the public celebration of socioreligious ritual events, a male sphere of activity. Wayang kulit, in particular, is seen to contain erudite spiritual reference and elevated, complex language that place it beyond the ken of women. In the "heroine" figures of traditional theater, men seem to celebrate an image of women as they would wish them to be: comic maidservants and village wives provide a vehicle for mocking reference to perceived female faults and areas of male-female friction.

Male and Female in Contemporary Popular Theater

Alongside such long-established "traditional" forms of Javanese theater, there have developed since the early twentieth century a number of new popular dramas. Their growth appears in part to be

a response to social changes such as urbanization, monetization, and the impact of cultural influence from the West. Such dramas are performed as public entertainment, acting out on a stage, in the manner of a Western play, stories from Javanese history and legend, foreign literature, even contemporary films. Audiences are made up of villagers and urban kampung-dwellers, the lower-class social group among which such theater first developed and continues to have its main support. Interestingly, a large number of women participate, both as performers and audience members. Ludrug, with its all-male casts, is an exception here.[15] In other popular dramas, such as *kethoprak* in Central Java, West Javanese *sandiwara*, the *lenong* of Jakarta, men and women perform on stage together. And women make up a large proportion of the audience at any show.

Performances are created "on the spot," without a script, by a process of adjustment between the details of a particular story and a standard framework of scenes, passages of dialogue, and character types. This framework continues to be strongly influenced by the dramatic structure and rules of characterization of traditional Javanese theater, most highly elaborated in wayang kulit and its associated forms. But the conventional "building blocks" of twentieth-century popular theater have clearly been influenced by other forces also—new theatrical models, and other ideological attitudes. Part of the inheritance from Javanese theatrical tradition are the standard gender stereotypes—gentle, demure "heroine" figures and humorously crass low-life females. In kethoprak performances the sweet, shy princess is a familiar figure, along with sharp-tongued village women; ludrug has its glamorous but submissive sweethearts and mistresses and exaggeratedly overbearing wives. But popular theater forms also contain new character types.

In kethoprak, the type of gentle, devoted heroine classified as *luruh* ('refined') appears alongside a different style of female lead, glamorous and flirtatious, spirited and vivacious, direct and assertive of speech. This type, by contrast, is defined as both *branyak* ('strong') and *kenès* ('coquettish, charming'). Some actors also explictly label such characteristics as *moderén* ('modern') and typical of "foreign" women, while the luruh model is both less up-to-date and identified with the traditional Javanese ideal of feminity.

A stock female role in kethoprak, often played out by the lead actress in the course of her stage adventures, is that of the beleaguered damsel, attempting to escape the unwelcome sexual attentions of predatory men. Such characters, recalling the traditional theatrical motif of the princess abducted by ogre king, appear particularly frequently and prominently in kethoprak. They are far more vocal than their traditional counterparts in protesting at the behavior of their would-be seducers, claiming the right to respect for their own wishes.

Such positively portrayed, assertive female characters are absent from the stage of male-controlled ludrug. Here the major roles as outlined by James Peacock include, alongside the earlier-mentioned nagging wife and soft, sweet mistress, the hero's long-suffering, self-sacrificing mother and "the thirtyish villainess wife." Peacock describes the hostility directed at this last figure, a caricature of the flashy, go-getting modern woman in her ponytail, mini-skirt or tight slacks, and slavish aping of foreign (Dutch or English) speech (Peacock 1968:77). In the 1970's when I watched ludrug in Java, a decade after Peacock's study, in an ideological climate far more open to Western influence, the wearing of Western fashions was by no means limited to evil characters. Gentle, loving sweethearts sported short skirts, bobbed hairdos, etc., in keeping with current styles. Yet outrageously bold and overly sophisticated "modern" behavior continued to be satirized through female characters—for example, in this boom-time for nightclubs and massage parlors, by the title figure of the play *Nenek Berbahaya*, "The Dangerous Grandmother." This middle-aged, pant-suited femme fatale first steals her own daughter's husband, then opens a sophisticated nightclub/brothel, where working as chief "hostess" she unwittingly seduces her own grandson. Whereas kethoprak appears to celebrate a positive association between women figures and notions of modernity, ludrug caricatures decadently "modern" behavior among women.

Such implications arise through the interaction of performers, who work within the standard character stereotypes to produce a play. The improvised format of the performance provides scope for the players to interpret and develop their own roles. Where women appear together with men, actresses may take initiatives in dia-

logue and action, assured of enthusiastic attention from female audience members, while necessarily working with their male counterparts under the direction of a male stage manager/producer. Where all performers and organizers are men, male attitudes and characterizations necessarily hold sway.

Expression of Women's Views

Explicit, public articulation of female gender attitudes would normally be very rare in an environment where men shape dominant ideology and monopolize public discourse. Even if directly asked, many lower-class women, unused to abstract, generalizing modes of expression, their speech confined by ideology and experience to practical matters, might be reticent in voicing their views. For this reason, precisely because of its *lack* of articulation elsewhere, this female representation of gender imagery on stage seems worthy of attention. Hence in the following pages I will focus especially on portrayal of female characters and their relationships with men, in a form of popular theater well known for its romantic themes and appeal to women, kethoprak. In such imagery one might hope to find reflection both of women's conceptualization of these topics and of male responses.

Kethoprak's varied repertoire of historical and legendary tales, Javanese and foreign, provides an abundance of examples from which to develop generalizations about female characterization. Rather than pursuing this course, however, I have chosen to focus on a specific *lakon* ('plot, story') as a particularly clear illustration of general themes. The following outline of the lakon *Damar Wulan* follows the general pattern of contemporary production of this story, while referring in particular to two specific performances. These presentations, to be designated henceforth as performances "A" and "B," were staged as routine commercial shows by two large, successful professional troupes. Though very similar in overall format, the presentations differed in certain ways that will be pointed out in the course of discussion. These variations in dramatic representation are paralleled by differences, to be described later, in gender relations within the two troupes.

The Lakon *Damar Wulan*

Set in the time of the ancient kingdom of Majapahit, the *Damar Wulan* story describes the conflict between the Majapahit court and the region of Blambangan, at the eastern tip of Java, which is resolved when the fearsome Blambangan leader, Menak Jingga, is slain by a young emissary of Majapahit, Damar Wulan. Damar Wulan runs into trouble on his return journey to Majapahit with his trophy, the head of Menak Jingga, but is eventually welcomed as victor, installed as king by becoming consort of the queen of Majapahit, and united in marriage to three other women also—his erstwhile sweetheart, who is the daughter of the Majapahit *patih* ('prime minister'), and the two ex-wives of Menak Jingga. In literary versions the various events of the story consume many chapters; in puppet-play performances they are played out over many nights. But kethoprak presentations focus on one specific part of the story, dealt with relatively briefly in other versions. This concerns Damar Wulan's arrival at the Majapahit court and his subsequent dealings with the family of the patih, his own uncle, including the patih's beautiful and spirited daughter, Anjasmara.

When Damar Wulan first arrives in Majapahit at his uncle's residence, Anjasmara is right there to receive him. She sits talking with her father as a young man enters the stage and sits silently at the back, head bowed until finally he is called forward to introduce himself. Asked his intent he replies deferentially that he has come to serve, in any capacity. Anjasmara, however, shows no such restraint and respect. She immediately sidles across the stage from her previous position to sit next to her handsome cousin, and starts talking warmly and animatedly to him as if they were alone. There follow frantic, funny, and quite futile attempts by the patih to control his daughter's behavior. He may send her offstage to make drinks. But she then rushes back with news of some fabricated disaster that prompts her father to go off to investigate, leaving her free to make even more intimate advances to Damar Wulan. When the patih asserts that there are no openings for the young man, Anjasmara insists that a close relative such as he *must* be found work. So he is given a job as palace guard.

In the next scene Damar Wulan gets into trouble with the patih's two rather loutish sons, who demand the dismissal of "this

stupid village boy." (Damar Wulan, although the son of the previous patih, older brother of the present one, has been brought up in a mountain hermitage, far from the sophistication of the court.) Anjasmara, eyes flashing with anger, strongly attacks their attitude—if Damar Wulan, because of his rural upbringing, is not aware of the ways of the court, he should be assisted and instructed, not punished. The patih shakes his head bemusedly, and remarks on the contrast between Anjasmara and her mother. His wife was not quarrelsome like this but just accepted things (*nrima wae*) and said *inggih* ('yes') to his every word. Eventually it is decided, in spite of Anjasmara's protests, that Damar Wulan should be demoted from the position of guard to that of stable boy and grass-cutter.

Anjasmara is a key figure in both these scenes, the very epitome of the branyak/kenès female type. In traditional presentations of the *Damar Wulan* tale, in performances of the puppet-theater form *wayang klitik* and the court dance drama *langendriyan*, as well as in texts of the literary romance *Serat Damar Wulan*, Anjasmara is already portrayed as a rather strong-minded young lady. She is described as loquacious and outgoing, unintimidated by men; she takes the initiative in the relationship with Damar Wulan by inviting him to her apartments by night.[16] Yet in these older accounts she reveals her "assertiveness" privately, secretly, to Damar Wulan alone. On the kethoprak stage, however, she displays a strong public presence, stating her opinions very vocally, and significantly influencing dramatic action. Her behavior is explicitly contrasted with the submissiveness and decorum traditionally expected of a Javanese woman. Father and brothers express shock at both her bold assertion of opinion and her excessively free behavior with a member of the opposite sex.

In a following scene, this issue of proper standards of behavior for women, and for young people generally in mixing with one another, receives more explicit comment still. Anjasmara decides to go to visit Damar Wulan in the stables. Finding her cousin deep in mystical meditation, she ignores the protests of his servants and immediately shakes him to consciousness. Then there is great hilarity as Anjasmara feeds her cousin with the food she has specially cooked for him. The audience shrieks with excitement at

the sight of this symbolic gesture of connubial intimacy played out on stage, and chuckles as the clown/servants dodge about stealing food from her raised spoon as she gazes obliviously into her lover's eyes. Then Anjasmara shifts to a serious attitude and a solemn tone as she launches into a discussion of weighty matters. She may straightforwardly declare her love for Damar Wulan, or speak more circuitously of "unusual feelings" she can no longer restrain. When Damar Wulan says he knows what she feels, she asks sharply why he has not spoken earlier; for it is considered appropriate for a man to speak first in these matters, whereas women are constrained to silence by rules of feminine modesty and decorum. He argues of the great social distance between them, himself a mere servant in her household. But she asserts the irrelevancy of rank or station in matters of love. "Marriage is not just a matter of social position. The important thing is that your heart and mine are as one."

Finally Damar Wulan smiles, takes her hands, and declares that he loves her too. The pair start singing a love song to one another, in traditional verse form, moving about the stage, then coming together to embrace briefly, to whoops of delight from the audience. Suddenly into this idyll of true love breaks a hostile force—Anjasmara's brothers, followed by her father. They are outraged to find Anjasmara alone with a man, in intimate circumstances, in the lowly environment of the stables. The patih demands an explanation. Anjasmara declares her wholehearted love for Damar Wulan, and the young man likewise states, when questioned by the patih, that he and Anjasmara wish to marry. But the patih refuses to give permission for the match. Anjasmara's protests at this decision prompt equally heated responses from her father and brothers. Soon all three are engaged in intense debate, with much glaring and finger-wagging, while the cause of all the trouble, Damar Wulan, stands silently and uninvolved on the sidelines.

At issue are Anjasmara's daring in coming of her own volition to visit Damar Wulan in the stables, the couple's forwardness in simply getting together and declaring and displaying their affection without their parents' blessing or knowledge, and Damar Wulan's humble social rank. Explicit parallels are drawn between what is happening on stage and patterns of behavior in contemporary so-

ciety. Anjasmara declares that it is quite accepted these days for young people to mix more freely than in the past. It is the patih who is at fault, for behaving in an inappropriate repressive fashion. Father and brothers concede that Anjasmara has a right to find her own sweetheart. But it is the *way* she has done this that is criticized. Even if the social rules are changed, and young people are permitted to select their own partners, they should never *ngliwati bapak/ibu* 'bypass their father and mother.' Anjasmara and Damar Wulan should have come before the patih and asked permission to marry instead of just getting together on their own.

When father and brothers assert that family prestige will be damaged by her marriage to Damar Wulan as a result of the latter's low status,[17] Anjasmara declares with great force, to claps and shouts of agreement from the crowd, the familiar words, that marriage is not a question of rank but of true love. In Anjasmara's eyes, this very opposition to her marriage undermines her father's prestige and authority as patih. As a trusted official, "protector of all the subjects of Majapahit," he has an obligation to deal with all his people fairly and humanely. Yet here he thwarts the wishes and suppresses the rights of two loyal, devoted subjects, Damar Wulan and Anjasmara. When, unmoved by her arguments, her father decides to imprison Damar Wulan, she criticizes his biased attitude, favoring his own family and dealing harshly with others. Since she is quite as guilty as Damar Wulan, she should be punished also. So the patih jails both young people, a prospect not too disquietening for Anjasmara since it will allow her unlimited time with her beloved Damar Wulan.

Though there is no explicit representation of the event on stage, from this point on Damar Wulan and Anjasmara are regarded as being married, and in the course of the action various references are made to the institution of marriage. In performance A, Anjasmara expresses great dismay when the patih comes to the prison to summon Damar Wulan to the court on the orders of the Majapahit queen. The young man is to be sent to Blambangan to fight the enemy leader, Menak Jingga. There are so many beautiful women at court that he will surely find a new love and forget his Anjasmara. She describes very graphically the agonies of jealousy a wife goes through when her husband is out of sight: *Ning jenengé*

*bojo ki ya mesti was sumelang terus. Engko nèk nèng dalan—
ee—engko nèk nèng kono, ee—engko nèk ngené—ngono. . . .
hono?* ('To be married means that you're anxious all the time.
What if in the street . . . ooh . . . or in that place . . . agh . . . or here
and there . . . [your partner meets up with a new lover]. What
then?') But Damar Wulan vows that he loves only her, and even-
tually she concedes that he should go to take up this opportunity.
So she bids him a reluctant farewell, adding a final request to
her father to make sure Damar Wulan keeps his eyes constantly
downcast at court—in keeping with palace etiquette, and more
importantly, to stop him from noticing the glamorous attractions.

In performance B, the scene of farewell between Anjasmara and
Damar Wulan takes place after the audience at court. Anjasmara
is depicted waiting with great agitation and anxiety for Damar
Wulan to return from the palace, an anxiety that Damar Wulan's
clown servants gleefully exacerbate with tales of their master's
dalliances at the court. (Their motivation for so doing may be con-
nected with developments earlier in the scene. The curtain opens
on the servants complaining about their difficulties in dealing
with Anjasmara, who, like women bosses generally, is harsh and
quick to take offense. Moreover, their wages are long overdue.)
One servant tells of meeting Damar Wulan riding in a pedicab (in
fourteenth-century Java!) with a beautiful woman. Reminded of
his commitment to Anjasmara, his master had said, "Oh well,
what's Anjasmara anyway? *Rupané élèk irungé pésèk."* ('She's
ugly, with a pug nose.')

Anjasmara shrieks with outrage at this insult. When Damar
Wulan enters shortly afterwards she bursts into a stream of accusa-
tions in the harsh, strident tones typical of the comic theatrical
figure of nagging village wife. Unable to break into her tirade, nor to
compete with the roars of laughter from the crowd, Damar Wulan
calmly waits for Anjasmara to draw breath before attempting to sort
out the problem. The servant eventually reveals that the whole
story had been a *dream*, which he reported to Anjasmara to test the
strength of her love for her husband. Anjasmara apologizes for fail-
ing to trust her husband, and he adopts a serious, faintly "preachy"
tone in reminding her of her responsibility to be patient and toler-
ant, unmoved by idle rumors. Later, in relation to his mission to

Blambangan, he adopts the same tone again in rejecting her pleas that he should avoid such danger. He reminds her of his sacred duty as a citizen of the realm to carry out the will of his lord. When she remains inconsolable, however, he pretends to agree to stay behind, and they go to bed. In the dead of night, while she is sleeping, he sets off.

In performances of the story staged in a single night, this is the last appearance of Anjasmara—the next scene depicts the triumphal slaying of Menak Jingga by Damar Wulan, then the performance ends. In two- or three-night serial presentations she appears again, assisting Damar Wulan to gain his proper reward after he has been attacked, robbed of his trophy (the Blambangan leader's head), and left for dead by her brothers. The lakon ends as Damar Wulan proves his superiority to the patih's sons by defeating them in combat, and is thereafter crowned king.

Significantly, no mention is made of marriage with the queen of Majapahit as the means by which Damar Wulan comes to ascend the throne—he is simply made king. Nor is there depiction of his marriage to the wives of Menak Jingga, or even mention of the fact of his multiple marriages. Indeed, no production of the lakon I have seen depicts the four wives of Damar Wulan meeting up together. Whereas in traditional literary and dramatic works the several wives of the hero are expressly depicted living in happy harmony together, here the whole notion of Damar Wulan's polygamous unions is a problematic one. For the lakon as performed depicts love as a fusion of two hearts and marriage as an unbreakable bond of love between two people, and lays great stress on sexual fidelity. The rather abrupt ending of the lakon, the failure to round off the picture by portraying Damar Wulan harmoniously united with his four wives, may indicate the difficulty of resolving such contradictions. For how could one possibly depict a woman of Anjasmara's temperament and attitudes happily accepting her place as just one of her true love's four wives? Yet audience members know the story well from other sources, and are clearly aware of what is omitted. It may be that knowledge of Damar Wulan's multiple marriages, conflicting with his vows of faithfulness to Anjasmara, runs as an undercurrent through the performance, giving a special poignance and irony to Anjasmara's concern.

Interpreting the Lakon—Anjasmara as "Modern Woman"

In the kethoprak rendition, this classic legend of ancient Java is interpreted so as to reflect on some very modern ideological values—romantic love, freedom of young people to mix socially and choose their own marriage partners, irrelevance of class barriers to marriage, marital fidelity, and "progressive," assertive behavior in women. The following discussion focuses on the image of woman as exemplified in the characterization of Anjasmara, reflecting on the other values as they impinge upon this central theme.

Anjasmara is clearly the "heroine" of this lakon, the dominant female character, sweetheart of the male lead, focus of audience sympathies. She is far more dramatically prominent, for example, than the Majapahit queen. Their contrasting personalities and behavioral styles exemplify the standard opposition of luruh and branyak/kenès female types. Standard, too, is the relationship between them—the upstaging of the rather shadowy figure of the queen by the vibrant, lively, emphatically flesh-and-blood Anjasmara. Kenès-style female characterizations appear to constitute the dominant model in kethoprak at present, the type to which the most popular and successful actresses conform. (Actresses who take leading parts always specialize in one style or the other.) In the case of Anjasmara, preexisting textual suggestions of character provide a basis for a particularly full flowering of the model, whereas the figure of the queen is correspondingly reduced in dramatic importance.

The popularity of such stage characterization of women can perhaps be explained in terms of its multifaceted appeal. For male audience members it affords glamour, flirtatiousness, and sexual daring; for women, dynamic assertion of a woman's perspective; for the modern-minded, suggestion of potential progressiveness. Meanwhile, for village and kampung audiences as a whole, the presence of such female figures stimulates more lively fun and entertainment than that occasioned by a traditional-style heroine, delicate, refined, and essentially passive.

Anjasmara's stance in the lakon, as "heroine" of the story alongside Damar Wulan as "hero," is naturally depicted in favor-

able terms. When she argues with her father, standing up for her opinions and rights and raising issues of justice, audience members frequently clap and call out in agreement. The fact that criticism of her comes from the "baddies" of the lakon, the patih and his sons, who themselves behave so reprehensibly, serves to boost rather than undermine her image. Yet included in the overall picture are some rather ambiguous features. What is the impact, for example, of the farcical exaggeration of Anjasmara's attention to Damar Wulan on his arrival at her father's court, her absorption in her handsome cousin so total as to block out her father's enraged remonstrances? Much of the humor revolves around the discomfiture of the pompous patih, flapping about ineffectually in his attempts to control his daughter, his dignity severely undermined. But Anjasmara, through this outrageous behavior, can also appear faintly ridiculous. A standard kethoprak scene of comparable type is that of disruption of a stately court audience by the arrival of bumptious villagers who exuberantly disobey every rule of palace etiquette. The humor is double-edged—laughter is invited both by the pompous formality of the court conventions and the consternation their flaunting causes, and by the ignorant misunderstanding of these rules displayed by the villagers. By disregarding the rules not only of feminine modesty, but also of normal social interaction, in disrupting Damar Wulan's audience with the patih, is Anjasmara here making a fool of herself as well as the patih?

Significantly, Damar Wulan, the object of Anjasmara's desires, does not reciprocate her excessive eagerness—he accepts her attentions gracefully but maintains his own controlled and dignified demeanor. In later scenes, too, Anjasmara is several times shown to be less patient and restrained, more volatile and emotional than her sweetheart—when she abruptly wakens him from his meditation in the stables in order to speak with him; as she wrangles with her father and brothers while he stands impassively watching. In performance B, the patih's daughter is shown to lose control even more completely, in her jealous rage over Damar Wulan's supposed infidelity. Like the well-known comic stereotype of the quarrelsome village wife, she rails uncontrollably at her quite innocent husband. The incident provides much fun, but once the laughter has died down, Anjasmara's behavior is explicitly and se-

riously labelled as erroneous. Damar Wulan, cool and controlled as ever, points out the need for patience and reasoned investigation in such matters, and Anjasmara meekly apologizes. Later she is shown to be in need of a further lesson in restraint of personal emotion over the issue of Damar Wulan's mission to Blambangan. Earlier in the scene the clown servants have faulted Anjasmara in regard to another behavioral trait often attributed to village wives, on stage and off—tight-fistedness with money.

To include such features of the stereotype of comic village woman in the characterization of the "heroine" Anjasmara surely undermines her standing, detracts from her seriousness as a dramatic figure. Such stage portrayal of women endorses the conventional Javanese belief, propounded by men and acquiesced to, it seems, by women, that women lack the spiritual strength of men, and are thus less able to control their outward behavior— their emotions and their speech. Given the explicit labelling of Anjasmara's behavior as "modern," is there also an additional derogatory slur, directed specifically at the image of modern woman? Is there an intimation of linkage between so-called "progressive" characteristics in women—public confidence, willingness to express an opinion—and their longstanding and much-derogated traits of direct unsubtle speech and lack of emotional restraint? By contrast, male definition of that other type of female character in kethoprak, the gentle luruh lady, as both "old-fashioned" and "traditionally Javanese" may suggest a certain chauvinist nostalgia. As evidence of real-life ambivalence over this issue, I might cite the comment of a young actor, in the course of a casual backstage chat, that he hadn't yet married, although in his mid-twenties, because he just wasn't attracted to girls these days. They were too forward and "free," not gentle and demure like the young women of his father's generation. One recalls also the glamorously sexy, yet clinging and dependent "heroines" of performances by the all-male casts of ludrug, and their contrastingly negative portrayal of pushy "modern" women.

It is significant that it should be performance B that includes the scene of Anjasmara's jealous wrath. In performance A, by contrast, the issue of suspicion and jealousy within marriage is dealt with much more seriously. Anjasmara's description of the suffer-

ings of a jealous wife, prompted by Damar Wulan's summons to appear at court before the Majapahit queen, is greeted with sympathetic understanding by her husband. These contrasting references to the question of marital fidelity accord with differences in gender attitudes and relations between the two troupes.

Performance B was presented by a troupe that displays in all its activities the dominance of its dynamic and energetic male founder and leader. After 25 years of nurturing and instructing his players, the troupe head no longer needs to exert his authority directly—his values and attitudes, as embodied in his methods of direction and organization, his acting and speech style, have been internalized by other performers. So it is that this man's highly appreciative but not overly respectful attitude towards women comes to characterize the ambience of the troupe as a whole. Troupe actresses, selected for their exceptional prettiness, are constrained simply to follow male direction. Male performers feel free to make comic quips and serious criticisms at women's expense. Women are not subordinate to men in the troupe, each person contributes in an equally necessary way, yet the shaping authority of the troupe leader imparts a distinctively male perspective.

The presenters of performance A, on the other hand, belong to a troupe in which the vivacious and enormously popular female star sets the paces for the group. Because of her fame and audience appeal, troupe activities are tailored to accommodate her: the director feels pressure to assign to her all starring parts. In performance it is she who largely determines how the part of Anjasmara, and that of other female leads, is presented: other performers respond to her interpretation. Here her comments on the plight of the jealous wife may well represent a conscious assertion of the seriousness of this issue, a deliberate assault on the standard theatrical treatment of the issue of marital infidelity as an occasion for joking at the expense of women. She instead asserts the women's viewpoint sympathetically and forcefully, in the context of the characterization of a "serious" dramatic figure. In conversation, this actress admits to a conscious sense while performing of "speaking up" for her fellow women. Here, perhaps, is a good example of such activity.

Direct comment on male-female relations, indeed explicit criticism of male behavior, is another standard aspect of the characterization of the branyak/kenès woman. Examples from the *Damar Wulan* lakon include, in addition to these comments on infidelity, Anjasmara's denunciation of her father as a repressive parent and unjust official, as well as her admonition of Damar Wulan for not speaking first of his affection for her. In stories of the East Javanese prince and culture hero Panji, the joyous reconciliation of Panji and his beloved Candra Kirana after their long and arduous separation must wait while Candra Kirana speaks her piece. She soundly chastises her sweetheart for the reprehensible behavior on his part—unreasonable jealousy, neglect of her needs—that had caused their separation.

Male reaction to such attack, and to the general assertiveness of branyak/kenès ladies, is ambivalent. The esteemed quality of "progressiveness" associated with such figures must be respected, and their declarations paid proper attention. Male characters never argue back when criticized, justifying their own actions or defending the position of men in general. Refined kings and princes, husbands and sweethearts of these women, are at first taken aback, then express some degree of contrition for their fault. Lecherous would-be seducers pay no heed.

When an appropriate opportunity arises, however, actors delight in teasing these spirited branyak/kenès figures, adding a titillating dimension of sexual tension to the show. Humorous expression of antagonism towards women also occurs in off-hand derogatory remarks of the kind quoted earlier from performance B of *Damar Wulan*, and in hostile encounters between village husband and wife, likewise recalled by Anjasmara's wrath in the same performance.

The Social Reference of Gender Imagery

The prevalence of the branyak/kenès style of female characterization in kethoprak, and these male responses to it, presumably bear reference to actual gender tensions in Javanese society, as well as to the impact of new ideological influences.

Explicit description of such female figures as "modern," and reference to their deviation from the traditional Javanese ideal of womanhood, suggest influence from new models from outside the Javanese world in shaping this character type. There seems to be an obvious ideological reference to the Western-derived concept of the capable and active "modern woman." Earlier, in a brief outline of the history of this concept in twentieth-century Indonesia, reference was made to its weakened status in contemporary times, in the prevailing conservative, authoritarian political climate. One might wonder what relevance the model of independent, achieving modern woman might ever have had for village and kampung women in kethoprak audiences, leading lives of bare social and economic survival. Yet however unattainable the image, the understanding that somewhere, out there, women are being encouraged to act in alternate new ways may be influential in a general sense for women's thinking about themselves.

Apart from a few specific lakon, branyak/kenès heroines do not indulge in the kind of action (getting an education, participating independently in battles and political activity) suggestive of feminine "advancement." Nor do they seem much influenced, except in regard to a general highlighting of sexual allure, by the images of women in modern media such as films. Instead, as such characters tease a tardy suitor or chastise a neglectful husband, the strongest dramatic association is a traditional Javanese one, to the stereotypical figure of the plain-speaking village wife. Qualities of frankness and assertiveness negatively esteemed in women, portrayed typically in derogatory fashion on stage, are here asserted as positive, up-to-date. Here is no plain-faced, harsh-voiced, drably dressed village wife railing wildly at her spouse, but a glamorously alluring, finely attired lady, crisply delivering some well-chosen words to put her man in his place. And audience members, particularly women, often clap enthusiastically in endorsement of her words. Issues of womanly concern such as male infidelity, previously treated on stage only with humorous reference, are here asserted seriously. Ancient stories are reinterpreted to highlight such perspectives. It is not the issues and attitudes in themselves that are new, but the seriousness with which they are asserted and received.

Modernizing ideology of whatever complexion, whether nationalist, socialist, or capitalist, involves a conscious focus on women's roles. Women are seen as a distinct social category, contributing in their own way to the social whole. This focus contrasts with traditional religiopolitical thought in Java, which, as a male domain, makes no provision for women. According to the ideology of the contemporary Indonesian state, economic and social "progress" are to be achieved through the combined efforts of various "functional groups" in society, such as workers, army personnel, intellectuals. Women form such a functional group, entrusted, in accordance with their traditional roles as child-rearers, with the task of inculcating modern values in their children, producing enlightened generations of the future. Though the suggested role is dependent and supportive rather than independent and active, it nevertheless has a separate existence and importance.

Such a climate of thought may influence actresses in their stage characterizations, encouraging them in serious presentation of a woman's viewpoint. Their performances, responded to enthusiastically by women audience members, in turn help to reinforce this new social attitude. A figure such as the star actress of troupe A plays a key mediating role in this regard, familiar with and no doubt influenced by elite-directed ideology, while performing nightly for kampung and village audiences. Yet her characterizations and those of other actresses involve no slavish reproduction of dominant ideology or imitation of the models of modern media. Instead, certain qualities associated with the concept of modern woman—independence, assertiveness—are assimilated to traditional Javanese stereotypes of female behavior. This concept thus takes on meaning at all social levels, for humble villagers as well as the elite. The esteemed value of "modernity," broadly applied, endorses a glamorized, positive rendering of the traits of ordinary women, and serious discussion of their concerns.

For male performers and audience members, by contrast, suggestion of a parallel between the concept of modern woman and long-standing stereotypes of female behavior has negative connotations. The connection implies discredit to the image of modern woman rather than increased prestige for familiar female traits. The kethoprak figure of the branyak/kenès lady, like

the traditional theatrical image of the bossy village wife, seems to give humorous expression to actual male resentment of women's household assertiveness and dominance. A humorous trivializing of the branyak/kenès lady's assertive style conveys an underlying antagonism and sense of threat. All-male ludrug, meanwhile, projects an explicit hostility to women in its vilification of the modern, go-getting female. Along with their established faults, women become associated with the perceived evils of the modern age. A similar though milder implication arises in the *Damar Wulan* lakon, as Anjasmara's forwardness with her sweetheart occasions a general attack from her father and brother on the shameless freedom of behavior by young people these days.

A possible implication of this stage interaction is that long-existing tensions in Javanese domestic relations, deriving from the contradiction between theoretical male authority and de facto female control, are today more keenly felt. Men find women particularly threatening in an ideological context that, even in a conservative way, gives recognition and status to the female domains of home and family.

Yet if there is suggestion in the imagery of popular theater of a strengthened sense of female identity, and of resulting male disquiet, there is also very clear reference to the ongoing limitations of ideology concerning women, and to the restrictions and frustrations of womanly experience. The world of women's work and sociality receives virtually no representation on stage. Female figures are not seen gossiping together, cooking, trading in the market. Young children, such an important source of female domestic power in real life, are not depicted. Instead the great majority of women figures in popular drama, like their counterparts in traditional theater, are dramatically important only in their relationships with key male characters.

Even lively, forceful branyak/kenès heroines are constrained by the preestablished framework of the stories in which they appear to their parts as wives, sweethearts, and daughters. Their self-assertion occurs always in regard to relations with men. They criticize husbands, sweethearts, or fathers for failing to properly fulfill their roles, in the manner of Anjasmara's critique of her father the patih in the *Damar Wulan* performance. Like Anjasmara,

these heroines comment explicitly on the rights of and restrictions upon women in their dealing with men. (Recall Anjasmara's complaint about Damar Wulan's failure to speak of his love for her, forcing her into the unseemly position for a woman of having to make the first advances.) And, similarly, they defend a woman's perspective on the issue of marital infidelity. The fiery force with which these women characters put their case conveys a sense of determined conviction. But it also suggests feelings of intense frustration and resentment at the shortcomings of men and at the constrictions of their own position.

Contemporary, "modern" ideology in the realm of gender relations contains different strands that, when combined, indeed seem likely to heighten women's sensitivity to the ambiguity of their situation, by encouraging confidence and autonomy in some areas while thwarting it in others. On the one hand, the enhanced prestige of female concerns encourages a strengthening of women's self-image. On the other, the highlighting of woman's role as wife and homemaker prescribes an increased focus on the husband/wife bond, which implies greater female dependence on men. Promoting this latter tendency is the value of romantic love as the basis of marriage.

First introduced into Indonesian society through cultural influence from the West, celebrated in prewar novels about young love in conflict with traditional social custom, the concept of romantic love now flourishes not only in modern media such as films but also in the local-level, vernacular-language dramas of village and kampung people. The typical theme of ludrug plots has been described as conflict between generations over issues of love and marriage, championing the cause of the young lovers (C. Geertz 1960:294–95). Kethoprak performances, highlighting the "love interest" of traditional stories, contain frequent reiteration of the value of true love, tresna, along with visual representation of such emotion in love scenes that constitute a major attraction of the show.

Stage representation of love themes is, however, marked by certain peculiarities. Sweethearts declare their love for one another in fixed, formulaic statements, lofty of sentiment and rhetorical of tone. Such assertion of tresna as an exclusive bond of affection be-

tween two individuals is immediately followed by talk of founding
a new household and having children, suggestive of older commu-
nity-oriented notions of marriage. The overtones of dignity and
propriety conveyed by these verbal statements contrast oddly with
the intimate physical gestures of kethoprak love scenes, notorious
for their daring. Conventional gestures of affection may in them-
selves impart a sense of coy reticence. In the *Damar Wulan* lakon,
for example, the full sexual lovemaking in Anjasmara's bedchamber
of traditional literature and theater (naturally omitted from stage
representation, but frankly described by the narrator) is "toned
down" to hand-holding and singing of love songs, justified as in
keeping with contemporary social mores.

All this suggests some ambivalence towards the new concepts
of romantic love and freedom of choice of marriage partner,[18] an
uneven social acceptance. Important here may be a holdover of the
traditional Javanese mistrust of sexual passion as a dangerous con-
dition close to madness, unsuitable as a basis for marriage.[19] Hence
the necessity for highly proper verbal statements, compensatory
in function, accompanying physical gestures of attraction and
affection. The formulaic nature of these pronouncements, sug-
gestive of word-for-word translation from other sources, may re-
flect the remoteness of the sentiments expressed, their status as
admirable ideals rather than the stuff of actual practice and discus-
sion. This would concur with sociological evidence that marriages
among poorer, less-educated Javanese, especially in rural areas,
continue to be largely parentally arranged, involving very slight
prior acquaintance.[20] Yet the enthusiastic applause evoked by these
assertions of tresna, especially from young men in the crowd, indi-
cates the felt importance of the concept for some sections, at least,
of kethoprak audiences. Similar statements in ludrug performances
are likewise warmly received. James Peacock reports upon the ex-
pressed interest in and desire for romantic affection (he uses the
Indonesian word *cinta*, 'love') of many young male ludrug-goers.
Yet the context in which such sentiments are voiced is often one
of complaint about the absence of love in their own marriages, to
wives chosen for them by their parents (Peacock 1968:44).

For these young men, discontent arises from the discrepancy
between expectations of a marriage based on love, and the reality

of unions established on different grounds. Propagation of the value of romantic love conceivably widens the gap between ideal and real in Javanese marriage, exacerbating the resulting tensions. For women, problem areas of marriage may be thrown into sharper relief by the intense emotional focus on one's spouse that romantic love prescribes. A key example is the issue of sexual infidelity. Emphasis on romantic love as an exclusive bond of affection between two partners gives support to long-standing female disapproval of male dalliance. On stage, accordingly, the spirited heroines of kethoprak make frequent, abrasively critical comment on such behavior by their men. At the same time, increased emotional dependence on one's husband intensifies the pain of suspicion and jealousy when he nevertheless continues to "stray." For new values have surely not eradicated old ways. In kethoprak, in the performance of *Damar Wulan* described above, the character Anjasmara gives a graphic description of such wifely suffering. Her stage husband responds with sympathy and concern. Audience members are all aware, however, that in spite of his protestations of devotion and the omission from the performance of problematic incidents, our hero goes on to marry three more wives—a fitting final example, perhaps, of the process of reference through popular theater to the ambiguities and tensions of contemporary Javanese gender experience.

Balinese Twins Times Two

Gender, Birth Order, and "Household" in Indonesia/Indo-Europe

James A. Boon

Hatley's paper considered a traditional epic about the Javanese elite as it has been reworked in contemporary popular drama. James Boon's paper speculates about the place of gender in another aristocratic form— namely, the competitive ancestral Houses of the neighboring island of Bali. Grandly comparative in scope, Boon's essay has crucial implications for the construction of kinship and gender in the archipelago and beyond.

Kinship in the Centrist Archipelago has posed thorny questions for anthropological analysis. In his monumental volume The Elementary Structures of Kinship *([1949] 1969), Lévi-Strauss focused primarily on "unilineal descent systems" (like those of the Exchange Archipelago) constructed through exchange. Cognatic systems (of the sort found in the Centrist Archipelago) he treated as a minor aberration in world ethnography despite their prevalence not only in the Pacific but in Europe as well. Lévi-Strauss's recent discussion of "house societies" (1979, 1983a), although not specifically addressing the problem of cognatic kinship, may very well—if Boon's ideas prevail—direct us to new ways of thinking about social structure in island Southeast Asia. In particular, it may help us to bridge what has been an analytical gap between the Centrist Archipelago and the alliance systems of Eastern Indonesia. Anthropological preoccupation with descent rules—unilineal in the Exchange Archipelago and nonunilineal elsewhere in most of island Southeast Asia—*

has perhaps obscured an understanding of social and ritual complexes that may be shared by these areas. In this essay, Boon suggests that the competing, optionally endogamous ancestral houses of Bali may well be a transformation of the exogamous ancestral houses of Eastern Indonesia. Recognizing the salience of male-female difference in both instances lends clarity to the comparison Boon is making. Eastern Indonesian systems operate with an ideal of men marrying their matrilateral cross-cousin. Ancestral houses rank higher than those which give them wives and lower than those which take their women as wives. Boon points out that in such a system everything—in principle—comes around again. House A may be superior to House B, but similarly House X will be superior again to House A. In other words, the system negates a "total, centralized hierarchy" of the kind that Western Indonesian kingdoms such as those found in Bali strive to achieve. In other words, systems of indirect exchange are incompatible with "politics of the center." The solution of high-minded houses in Bali is to eschew exogamy and keep some daughters "at home," by suppressing the gender difference that makes cross-cousin marriage between social units possible and making birth order within the house the sole marker of hierarchy. As Boon puts it, by marrying daughters within the ancestral houses, "rivals compete to become primary centers rather than mutual exchangers." Carried to its logical extreme, incestuous twinship—which suppresses both gender and birth order—becomes the most prestigious union in the system.

Boon's paper holds fascinating possibilities for interpreting the emphasis on gender symbolism in Eastern Indonesian house societies and the upstaging of gender by age in other parts of the archipelago. Boon gives us new insight into the relations between hierarchical sociétés à maisons in island Southeast Asia, and extends our comparative possibilities to Indo-Europe as well. It remains to sort out how the "level" societies of the archipelago (such as the Wana and Meratus treated in this volume) might represent permutations on the themes outlined by Boon.

Only a comparative study can explain.

—A. M. Hocart

The history of Balinese culture has been shaped in part by rivalrous ancestor groups whose leaders may favor endogamous unions for their members, among other varieties of marriage. In islands east of Bali, corresponding social units have been, ideally, exogamous. I hope to illuminate this empirical, historical, and

cultural difference by examining aspects of gender both within
and beyond the realm of social organization. Balinese evidence—
particularly the prevalence of optionally endogamous, quasicorpo-
rate ancestral houses—throws into relief other Indonesian social
and ritual complexes: this is our first frame of comparison. Simul-
taneously, Balinese ideas and activities adapted from India open
toward that other massive cultural and historical sphere: Indo-
Europe, our second frame of comparison. Because Balinese institu-
tions and texts have straddled Indonesian and Indo-European sys-
tems of values, so Balinese studies should straddle Indonesian and
Indo-European studies.

These pages address two types of social tie, taking a cue from
Balinese myth and marriage: (1) collaterals distinguished as either
parallel (same sex) or cross (opposite sex), especially in the realm
of cousin marriage; and (2) siblings distinguished as either same
sex or opposite sex, especially in the realms of twin births and leg-
endary incestuous unions. I use "gender" here to refer to a cultur-
ally construed difference: male/female. In anthropology's tech-
nical parlance, a "cross" link includes this difference, a "parallel"
link does not. Thus, "cross" indicates the presence of gender (this
difference), while "parallel" indicates the absence of gender. By op-
posing gender codes in twinship to gender codes in collaterality,
we can pass from Bali's logic and ethic of optional endogamy to
neighboring Indonesian systems of exogamy at comparable levels
of cultural constructions.[1]

Gender codes do not align with actual sex roles or with rela-
tions between men and women. They often multiply vantages and
reverse hierarchies rather than consolidate a singular "man's"
or "woman's" viewpoint. Nor can gender be isolated from other
codes of difference: birth order, location, etc. This fact makes the
politics of gender in places such as Bali complicated. For example,
long-documented qualms expressed by Balinese brides about viri-
locality cannot be taken as the female view. Opinions of mar-
riageable daughters differ depending on the variety of marriage,
and opinions of daughters do not necessarily represent the opin-
ions of mothers. Moreover, conventional formulas against viri-
locality may be repeated even when residence is taken up at the
familiar hearth of a patriparallel cousin. Issues of division of labor

and ritual work (*karya*) along male/female lines are enmeshed in hierarchical aspirations of successful houses to release their members—daughters foremost of all—from unrefined tasks.

Balinese images of women and men do not simply complement a stratified rank of male over female. Stereotypes of demonesses from folktales and ritual coexist with those of female deities; whereas Balinese exorcisms celebrate demonic Durga, rice rituals are devoted to divine Dewi Sri. Many ills, particularly in the realm of marriage, are attributed to male Rakshasas and other goblins. Most germane for present purposes, Tantric-Siwaic values of purity/pollution reversals abound: for example, there is a divine-regeneration side to menstruation and a menstrual-like pollution attributed to smallpox victims, kings in particular. Such reversals pervade not just esoteric courtly circles but ongoing vernacular rituals of cure (see Boon forthcoming: chs. 5–7 for discussion of recent sources). And these complexities connect Bali's Indic components to Indo-European variations on gender-inflected symbols and systems. Finally, in the institutions and rituals that concern us here, the category "female" will be shown to remain symbolically double, even where wives do not necessarily link opposable social units. Wives in their various resonances and valences represent an encompassing mediator not just in exogamous kinship systems but in what we might call endogamous "twinship systems" too. Here the accent falls not only on wives or wives-become-mothers, but also on sister-wives-become-ancestresses, and superior ancestresses at that.

Preliminaries

Bilateral or cognatic values characterize most, if not all, Southeast Asian societies, even where certain rights, obligations, or statuses may be transmitted unilineally. Nevertheless, to designate Southeast Asia "nonunilineal" retains, by default, unilineality as the touchstone order. Moreover, the labels "bilateral" and "cognatic" seem too diluted to evoke the social, ritual, political, and symbolic forces that animate the region, Indonesia in particular. It is, I think, advisable to gear comparative typologies not to a

lowest common denominator of social organization but to evidence of cultural extremes and their transformations.

Bali as a "Société à Maisons"

In 1979 Lévi-Strauss published a brief article winkingly titled "Nobles sauvages" devoted to rethinking F. Boas's and A. L. Kroeber's long efforts to understand anomalies in Kwakiutl and Yurok societies respectively. Lévi-Strauss delineates a structural type found in Northwest Coast, Californian, and other Amerindian groups; perhaps Africa and Japan; certainly medieval Europe and Melanesia; and most expansively and notably Polynesia and Indonesia (1983a:170). A recent English translation renders this sociopolitical complex "house societies"; but I shall retain the original "sociétés à maisons" for its important plural form. With convincing brio Lévi-Strauss proposes a unit missing in the ethnology of Boas's and Kroeber's day, "whose institutional arsenal did not offer the concept of house in addition to that of tribe, village, clan, and lineage" (ibid.: 174).

A *maison* reveals features familiar to Indonesianists; they include:

a corporate body holding an estate made up of both material and immaterial wealth [land, heirlooms, relics, stories, names, etc.], which perpetuates itself through the transmission of its name, its goods, and its titles down a real or imaginary line considered legitimate as long as this continuity can express itself in the language of kinship or of affinity and, most often, of both. (Ibid.; brackets added)

House "wealth," then, is both material and immaterial. House continuity is sometimes thought to pulse either irregularly or cyclically (Lévi-Strauss cites Tsimshian notions of reincarnation of grandfathers as grandsons; one thinks immediately of similar Balinese ideas about transmigration of souls within a house coded in naming devices, views of same-sex twins, etc.). Principles of exogamy in *sociétés à maisons* are not necessarily exclusive. Characteristic functions of exogamy-plus-endogamy can be illustrated by the Kwakiutl, who used exogamous marriage to capture titles and endogamous marriage "to prevent [the titles] leaving the house once they have been acquired" (ibid.: 183). Although spe-

cific practices and institutional arrangements vary across cases, the possibility of nonexclusive exogamy-plus-endogamy remains central.

Any "société à maisons," hardly static, accentuates tensions in social processes, such as "the dialectic of filiation and residence":

In the Philippines, as well as in some regions of Indonesia, and also in several parts of Melanesia and Polynesia, observers have for a long time now indicated the conflicting obligations that result from a dual membership in a group with bilateral descent and in a residential unit: village, hamlet, or what in our administrative terminology we would call ward or neighborhood. (Ibid.: 180)

Such dialectics intensify in Bali, which manifests (1) "bilateral" descent groups (inflected, however, by agnatic emphases and by efforts to retain their own women as spouses and eventual ancestresses); and (2) simultaneous village-area (*desa*) and hamlet (*banjar*) residence (neither of these social frames coincides with rice-production cooperatives). Here, then, filiation and residence is indeed bifurcated; but there is an additional bifurcation of "residence" itself. This fact underscores the importance of relating modes of residence to ritual space and locality.

As Lévi-Strauss notes, the role of "houses" can seem transitory; hence Boas's suspicion that the Kwakiutl were evolving toward more matrilineal (less "housy") arrangements found among the Haida and Tlingit. Other examples, however, including medieval European ones, suggest that the type can endure for centuries. Lévi-Strauss offers "possible combinatorials" of *sociétés à maisons*, an "institutional creation that permits compounding forces which everywhere else seem only destined to mutual exclusion because of their contradictory bends"; he continues:

Patrilineal descent and matrilineal descent, filiation and residence, hypergamy and hypogamy, close marriage and distant marriage, heredity and election: all these notions, which usually allow anthropologists to distinguish the various known types of society, are reunited in the house, as if, in the last analysis, the spirit (in the eighteenth-century sense) of this institution expressed an effort to transcend, in all spheres of collective life, theoretically incompatible principles. By putting, so to speak, "two in one," the house accomplishes a sort of inside-out topological reversal, it

replaces an internal duality with an external unity. Even women, who are the sensitive point of the whole system, are defined by integrating two parameters: their social status and their physical attraction, one always being capable of counterbalancing the other. (Lévi-Strauss 1983:185)[2]

Lévi-Strauss locates the *maison* in general "at the intersection of antithetical perspectives of wife-taker and wife-giver." It is this point which may help us compare Balinese ancestor groups to strictly exogamous houses elsewhere. Possible viewpoints from which to conceptualize any *maison* from the inside can be permuted as follows: "The father, as wife-taker, sees in his son a privileged member of his lineage, just as the maternal grandfather, as wife-giver, sees in his grandson a full member of his own" (Lévi-Strauss 1983:186). This complementary conceptualization from the two sides may help explain why so-called nonunilineal systems equate the daughter's son and either the son or the uterine nephew. Regardless, the paramount point for our purposes is this: whether strictly exogamous or partly endogamous (as in Bali), houses are ranked both internally and externally by birth order, by anisogamy, and by other indices of differential transmissions of estates, heirlooms, titles, prerogatives, and renown.[3]

Finally, Lévi-Strauss's comments on early European houses (before intensified agrarian capitalism and centralized power over territories) apply equally well to Bali and many other societies and polities of Indonesia and Indo-Europe.

When the basic units of the social structure are strictly hierarchic, and when this hierarchy further distinguishes the individual members of each unit according to both the order of birth and the proximity to the common ancestor, it is clear that matrimonial alliances contracted internally or externally can only be made between spouses of unequal status. In such societies, marriage is therefore unavoidably anisogamic. Their only choice being between hypogamy and hypergamy, in this respect, too, these societies must compound two principles. (Ibid.: 181)

To facilitate later discussions it may be worth mentioning here a near-antithesis of "unavoidable anisogamy": incestuous siblings, real or imagined. *Sociétés à maisons*, moreover, often accentuate female-mediated bonds; houses remain "female" in key categorical ways. Below we sample Siwaic and Tantric schemes of value

in Bali that preclude our glossing "centers" (whether of power or of productivity) as "male."[4]

Balinese Ancestor Groups Incline Toward "Househood"

In previous publications based on fieldwork in 1971, 1972, and 1981, and on the history of Balinese studies, I emphasize Bali's optional ancestor groupings and the ideology and ritual surrounding them, beyond the royal courts (*puri*) and Brahmana compounds (*griya*). Nonnoble "houses" were underestimated in much Dutch colonial ethnography; their importance could be better appreciated after Jane Belo's (1936) study of Balinese endogamy and subsequent fieldwork (1957–58) by Hildred and Clifford Geertz in a village area dominated by competitive metalsmith houses (see H. and C. Geertz 1975). Over the history of Balinese studies, pertinent social and political principles came to light only gradually. By correcting an overemphasis on warna schemes, divine kingship (presumably permanent), priestly texts and ceremonies, Java-derived arts, or local cooperatives in irrigation and civil codes, we discover in Bali a basic unit of social and cultural process: the optional ancestor group. Many contemporary developments in title-caste mobility, marriage alliances, political allegiances, economic entrepreneurship, and interlocal temple networks, including recent success stories of Balinese who capitalize on the expanding tourist industry, are harnessed to these forces (Boon 1977, 1982a, 1985).

Rival houseyards have competed for prominence throughout the precolonial, colonial, and postcolonial eras of Balinese history (C. Geertz 1980). Characteristically a house or cluster of houseyards begins to outstrip other members sharing hamlet and/or village-area duties and obligations (H. and C. Geertz 1975). Rising houses in a given locality "activate wider kinship and marriage networks and concomitant temple affiliations," often producing internal factions as ambitious members gain superior jobs or temple custodianships; disputes, often muted, arise concerning succession to leadership, marriage strategies, political maneuvers, and temple affiliations. Balinese ancestor groups recall Oceanic

"status lineages" (including, if we reverse the status associated with endogamy, Maori *hapu*); their legendary narratives of perpetuators' worthy achievements conform to a general pattern of Malayo-Polynesian historiography (Fox 1971a).

Ascendant Balinese houses, regardless of title-caste, aspire to (1) ancestor temples that direct ritual concerns of supporters away from village-area temples; (2) gifted founders and legendary forebears whose special virtues (compare Machiavelli's *virtù*) reappear in select descendants; (3) varied marriages (endogamous unions between patrilateral parallel-cousins, favorable alliances with other houses, and individual unions, sometimes upgraded to an active alliance); (4) grades of descendants, based on mother's rank and, arguably, talent and achievement; and (5) exclusive occupations in the temple system, courtly arts, local administration, and various tasks with ritual overtones (Boon 1977: esp. 95). Marriage policies, including possibilities of both dowering and title adjustments, and death rituals enable a house to extend relations regionally while still declaring itself a self-contained ritual and social universe.

Lévi-Strauss made explicit reference to Balinese houses in his Collège de France lectures recently collected in *Paroles données*, which briefly reviewed the older Dutch works and more recent observations of Belo, Bateson, Mead, H. and C. Geertz, and Boon:

> Particularly revealing was the quandary of H. and C. Geertz [1975] when confronted by the institutions called *dadia* in Bali. When they observe it in a noble context, the word "house" occurs spontaneously and rightly in their account; but in the village context they do not know what definition to choose, and hesitate without deciding among lineage, caste, cultural association, and faction. "A little of all those, and sometimes even a political party," nicely observes Boon [1977]. Isn't the distinctive quality (*le propre*) of the house—as historians of ancient Europe describe it—to bring together all these aspects? And do not houses emerge and are they not extinguished? (Lévi-Strauss 1984:198; my translation)

Such indeed has been the case in Bali, where houses rising and falling over the course of time have displayed their relative standings through many devices: (1) estates comprised of house land, ancestor temple land, and rice lands owned by members who stock

their rice bins directly; (2) ranked titles that differentiate status both internally and externally; (3) heirlooms (including the famous *pusaka* of weapons, clothstuffs, and texts); sumptuary privileges or their recent commercial equivalents; (4) copious ritual, architectural, and narrative adornments; (5) spouses drawn from both inside and outside (the latter including brides from prearranged marriages, mock-captured wives, and borrowed sons); and (6) fluctuating networks with other houses, manifest in mutual temple attendance. We thus see before us living, breathing *maisons* in action, a social form that is negotiable, flexible at both the center and the margins, more effective in its potentiality than its actuality, more "cultural" than corporate.[5]

Excursus I: Between Bali and Outer Indonesia

> Even if . . . the search for the atom of kinship may encounter obstacles, it facilitates analysis in depth of rules of conduct. It establishes correlations among rules and demonstrates that they acquire significance only as integrated in a greater ensemble, including attitudes, kinship nomenclatures and marriage rules, plus the dialectic relations that together unite all these components (les relations dialectiques qui unissent entre eux tous ces éléments).
>
> —Lévi-Strauss 1983b: 104; my translation

In famous exchange systems east of Bali, exogamous units engage in the transfer of spouses. The most auspicious legitimate sexual intercourse occurs between social categories (the cross relation): economic, political, and religious activities, both cooperative and competitive, beat to the rhythm of ideal mother's brother's daughter (MBD) marriage, called "circulating connubium" by Dutch ethnographers. In the classic hypogamous configuration, relative rank is intransitive: if unit A provides brides to unit B, B to C, and C to A, then A is superior to B, B to C, and, yes, C to A. Rank, coded at the level of each exchange relation, does not project into a total, centralized hierarchy. Eastern Lesser Sunda examples of such exchanges between "houses" include the *uma* in

Sumba, the *luma* in Seram, the *amu* in Savu, the *ume* in Atoni, and the *fada* in Mambai (Fox 1980a: 10–12).

Sharp contrast to this configuration appears in cases where auspicious coitus may occur within the ancestral "house." Bali, for example, shares features of ritual, myth, and spatial and temporal codes (including some components of "house" ideology) with societies that range from Sumbawa and Sumba to Seram. Yet Balinese endogamy and hypergamy (bride-providers are inferior) seem designed to transfer both wives and status to a center, or to one among rival centers. Such endogamy-hypergamy formulations are often associated with hierarchic "states," so unlike decentralized exchange systems articulated by MBD marriage. We should recall that exogamous exchanges constitute social divisions in and as a gender distinction: gender plus generation (mother's brother-sister's son) mark the locus of social division; they "operate" the affective charge of "social division" itself. Ideals of MBD marriage simultaneously divide and repair society; that is, the values constitute "society" as reparably divided. From this vantage a society that even optionally allows house endogamy appears bizarre, indeed nonsensical, in social organizational terms.

To help Bali and exchange societies seem less bizarre, each to each, why not accentuate the gender codes implicit in basic cross/parallel formulations? Again, any parallel tie (female-female or male-male) indicates the absence of gender difference; any cross bond indicates its presence. Thus, cross/parallel can be formulated as presence/absence of gender. This fact helps explain Lévi-Strauss's (1969) dialectical view: to activate a parallel valence is to suppress a cross valence, and vice versa.[6]

Recall these succinct definitions in Robert Lowie's classic *Primitive Society*:

The children of siblings of the same sex are parallel cousins and are usually themselves called siblings in primitive languages; the children of siblings of unlike sex are cross-cousins and are generally designated by a term expressing greater remoteness of kinship. Cross-cousin marriage may theoretically be of two types: a man may marry either the daughter of a mother's brother or of a father's sister. Practically these two forms may coincide through the fact that the mother's brother by tribal custom usually espouses the father's sister. So far as this is not the case, marriage of a

man with the maternal uncle's daughter is decidedly the more common
variety. (Lowie [1920] 1961: 26–27)

Lowie wished to demonstrate "diverse motives" behind cross-
cousin marriage; he accordingly reviewed (1) Tylor's elaboration
of Fison's idea that rules favoring cross-cousin marriages and
prohibiting parallel-cousin marriages stemmed from exogamous
moieties; and (2) Rivers's evidence of preferred *first* cross-cousin
marriage where dual organization is lacking. Lowie then queried:
"Why does one tribe permit cross-cousin marriage, while the in-
stitution is anathema to its next-door neighbors? Why do some
communities under no conditions allow the other variety of cross-
cousin marriage?" (ibid.: 29). Lowie cautiously inclined toward
suggestions that such rules help preserve ownership and rank:
"The cross-cousins would thus remain as the next of kin whose
marriage, being permissible by customary law, could at the same
time preserve the property and the social prestige within the
family" (ibid.: 31).

Lévi-Strauss's *Elementary Structures of Kinship* was in part a
monumental salute to Lowie's *Primitive Society*. Yet, building on
Durkheim and Mauss, Lévi-Strauss advanced as axiomatic the fact
that base social units forbid self-provisioning of spouses; society's
reciprocal nature revolves around exchange and "communication"
of spouses. Still, Lévi-Strauss echoed Lowie's central formula-
tions: "In an exogamous system [cross-cousins] are the first collat-
erals with whom marriage is possible" (Lévi-Strauss 1969:98).
Rather than explaining associated rules exclusively "functionally,"
he proceeded to plot the variational logic and ethic of marrying the
nearest "other" that prohibitions permit or positive rules enjoin.
Lévi-Strauss thus converted Lowie's caveats and hesitations to the
ground or foundation of comparative dialectics.

In an influential "domestication" of Lévi-Strauss's more dia-
lectical formulations, J. P. B. de Josselin de Jong ([1952] 1977) em-
phasized the matrilateral variant of "that fundamental exchange
mechanism resulting in the dichotomy of cousins"; he summa-
rized his own tilt toward matrilateral cross-cousin marriage sys-
tems (informed by Indonesian evidence) as follows:

Cross-cousin marriage is not simply one of many types of preferential
marriages, as most anthropologists are inclined to consider it. For it is the

only type which, normally and exclusively, enables every man to find a spouse whenever kinship terminology divides all individuals of the same generation into (real and classificatory) cross-cousins and (real and classificatory) siblings (real siblings and parallel-cousins). Other types, such as levirate, sororate, avuncular marriage, are never exclusive or primary, being always based on and added to pre-existing other types. They should not be called "preferential" but "prerogative" marriages ("unions privilégiées"). (Ibid.: 286, 265)

For Lévi-Strauss, he argued, "not the nuclear family, but a group of at least two men and their women, allied by rules of exchange, is the really primary unit" (ibid.: 287). Josselin de Jong thus pared down Lévi-Strauss's "atom of kinship" to an irreducible complex of consanguinity *cum* affinity, minus descent.

The famous "atom of kinship" formulation proposed, revisited, and revised by Lévi-Strauss (1963c; 1973; 1983b) has a major drawback: despite the author's warnings, it allows readers to infer substantive social relations rather than dialectical fields of structural differences. (Readers led around Lévi-Strauss by Josselin de Jong's commentary sometimes mistook the "atom of kinship" for an "elementary structure," whereas the "atom" is the minimal set of contrasts for generating the range of elementary structures). Moreover, in Josselin de Jong, and in parts of Lévi-Strauss's original *Elementary Structures* as well, the locus of social organization was made to appear constant across cultures. Josselin de Jong thus reinforced a residue of functionalism in Lévi-Strauss's own formulations of bilateral, matrilateral, and patrilateral cross-cousin variants; this functionalism eliminates from the outset meaningful comparisons with patriparallel cousin marriage systems, even neighboring ones, and with so-called complex systems (see Boon and Schneider 1974; Boon 1982c; 1983:94, 98).

Today the importance of escaping a strictly social organizational framework is clear from evidence of variations even within a particular elementary type, such as hypogamous mother's brother's daughter marriage. Consider, for example, the contrasting indigenous models of MBD marriage in Sumba and Seram. Following Adams (1980), in Sumba wife-givers are classified as female and givers of textiles. In Seram, however, wife-givers are classified as male and superior, because, if I understand Valeri (1980), indirect marriage exchange is seen from the vantage of brother-sister

rather than husband-wife. This cultural shift in conceptualizing the exchange system reverses indicators of gender and status, thereby dislocating so-called hypogamy. Culture thus separates two cases that look equivalent from the perspective of social organization. Might such play in the combinations of gender and status symbols open comparisons to ancestor groups that allow or accentuate endogamy?

First Transitional Thought-experiment

To attain a cultural fulcrum for comparing *sociétés à maisons*, we should look beyond features that some cases lack—such as systematic exogamy—to features that all cases have—such as sets of siblings distinguished by gender and birth-order categories. James Fox's characterization of MBD marriage in Indonesia's Lesser Sundas helps set the stage: "If relative age distinctions . . . between siblings of the same sex form the categorical basis for differentiating groups of the same kind, then relationships between siblings of the opposite sex serve to categorize their alliance" (Fox 1980a:13). Citing Valeri's evidence from Seram, Fox suggests that in cross-cousin exchange ideologies, the transmission of blood in the female line may relate to "the idea of a return of reunions of life: the 'life' that a brother and a sister share can be restored only by the marriage of their children or the descendants of their children" (ibid.: 12–13). (Below I address emphatic versions of "the idea of a return"—the reunion of children of a brother and sister.)

Fox's partial treatment of this issue still isolates somewhat societies that practice "circulating connubium." Nevertheless, his "categorical bases" can smooth this essay's transition into Balinese variations, provided we revise his relative age distinction (elder/younger) to one of relative birth order (see also Berthe 1972). Toward this end, I hazard a thought-experiment.

Imagine a social classification comprised exclusively of gender and birth order. Heuristically, forget collaterality (and therefore "descent"); ignore siblingship. Restrict our imagination to combinations of the gender difference (M/F) plus birth order as categorical bases. The logical possibilities are few: M-M-F, M-F-F, F-M-

M, F-F-M, F-M-F, M-F-M. Next, constrict the categorical field a bit more: the "parallel" component becomes male-male, resulting in concentrated categories of M-M-F, F-M-M, M-F-M. At this level, then, that is all the "difference" there is.

Now, imagine that similar thought-experiments underlie certain narratives and ritualized ideals of Indonesian societies. Permutations of male-female/male-male plus relative birth order may be manifest in diverse cultural projections: *genealogically* as three siblings, even triplets; *narratively* as brother-sister and brother-brother protagonists; *cosmologically* as pairs of deities, such as Siwa/Buddha construed as elder/younger brother in the *Bubuk-shah* traditions of sectarian relations (see Rassers 1960:65–91). I suggest that such projections imply a basic gender/birth order "grammar," also figured in and as two sets of twins (male/female, male/male): twins times two.

Back to reality. As Fox states, in societies ordered by marriage exchange, differentiation *within* a social unit is marked by positional contrast in the parallel bond (birth order); differentiation *across* social units is marked by the cross-bond, or rather *is* the cross-bond. The dialectical point underlying my comparison may be phrased dramatically: in Bali this within/across distinction is ablated whenever the "house" portrays itself as coterminous with "society." In these circumstances, values attached both to the parallel relationship and to twinship become salient. In twinship, a birth order and perhaps also a gender difference *occur where none was anticipated*. Out of what might have been a single birth position can emerge both birth order and gender. Twinship "itself" is an empirical event suggestive of the categorical bases outlined above. In Balinese house ideology, an irregularity of nature is selectively converted to a model of and for culture, and rituals are enacted accordingly.

Some Elementary Structures of Twinship

Notions of divine, perhaps incestuous, twins occur worldwide, including Indonesia, Indo-Europe, and Oceania. However isolable they might appear, neither "twinship" nor "incest" are things in

themselves, even symbolically (see Schneider 1976; Boon 1982b).
Eschewing the dubious topic of what twinship and/or incest might
mean substantively and generally, we can still pursue diverse do-
mains that their conjunction interrelates. What, variably, might
twinship-plus-incest signify?[7]

In a survey of Indo-European twinship imagery, Donald Ward
emphasizes twins of parallel sex, usually brothers: "The myth-
ologies of peoples who speak languages related to Indo-Euro-
pean include traditions of both cross twins and parallel twins.
The tradition of cross twins, however, is not nearly so complete
and well-defined as that of parallel twins, and as a result, does
not lend itself readily to comparative investigation" (D. Ward
1968:3). Parallel twins, of course, may code differences (ibid.: 4):
for example, aggressive/docile, hunter/shepherd, hunter/agricul-
turalist, foolish/clever, fair/dark, or, it should be stressed,
male/female (again, I distinguish the gender difference from sex-
ual dimorphism). Cross-twins may loom larger in covert Indo-
European traditions than Ward acknowledges, as ideas of their
power possibly have been suppressed by historical forces of ortho-
doxy: note European undercurrents of Gnostic heresies and Osiris
cults; and Tantric and Sivaic mythologies reasserted during India's
"Hindu renaissance" over and against ethical-reformist move-
ments of Buddhism. Cross-sex twins possibly clustered at the
margins of Indo-European orthodoxies. Construed broadly, such
margins can include both Europe's hermeticisms and Bali's Hindu-
Buddhism, replete with Tantric tonalities.

Practices prompted by incestuous images of twinship are a clas-
sic topic in Balinese ethnology (Zwaan 1919; Belo 1935; Bhadra
1969; H. Geertz 1959:31). Ambivalent cultural values link pa-
rallel-cousin marriage, legendary sibling marriage, and incestlike
unions; actual practices of father's brother's daughter (FBD)
marriage are likened to stepped-back incest, less dangerous or
"hot," but still highly charged. Influential narratives and reworked
"histories" resolve fretful love matches into reunions of forgot-
ten twins separated at birth into rival kingdoms. A sister-spouse
protagonist may simultaneously attract an ostensibly unrelated
suitor, effect an alliance of "houses," and achieve incestuous mar-
riage when her partner is revealed as her brother, perhaps her twin.

The rituals, texts, and contexts associated with these themes comprise less a "socio-logic" than a socio-poetics, an imagined perfectibility unavailable in any combination of actualities. It is even possible, although difficult conclusively to prove, that past widow immolations were meant to redefine wives, and perhaps concubines, as sisters, with the cremated husband's unions ritually reconstrued as "incestuous," the nearest endogamy. Despite such sensational extremes, the associated values cannot be dismissed as a "mystification" imposed by an elite. Rather, ideas of twins and incest inform different impulses of marriage. These include sensual allure and the magical arts of attraction/repulsion in courtship, battle, and cure; strategic alliance producing political advantage; and ancestral interests cultivated by ascendant houses who favor endogamy.[8]

The ideology of an ascendant Balinese "house" accentuates the ancestors' viewpoint in social values. Ancestors are imagined to envision a world of descendants, divided by gender, birth order, and generations alone. House rituals even manage to treat outsider spouses (married-in women or borrowed sons) as if they were insiders. In this ancestor-centered outlook (one position in a panoply of ideological vantages implied in full ritual cycles), endogamy is an encompassing value. Parallel collateral bonds thus become more or less "functional equivalents" of cross bonds in exogamous exchange societies (Boon 1978; 1982c). In Bali's houses, opposite-sex parallel-cousins (children of brothers) may be favored spouses, although "hot." Together with opposite-sex twins and opposite-sex siblings, such cousins (whatever the degree) are the main opposite-sex relations germane to ancestral interests. Upon occasion, then, Balinese imagine that their ancestors imagine their "house" as a self-sufficient social and ritual entity.

We turn now to narratives that complement unions between opposite-sex twins, siblings, or parallel-cousins in a striking way: they add another brother. Episodes joining a brother-sister (perhaps twins, perhaps incestuous) to a second brother protagonist include: (1) *Malat* tales (called *Panji* in Java); (2) Tantrism-tinged accounts of excessive sexuality and wayward intercourse; and (3) above all, the *Ramayana*, a dominant sourcebook for Balinese ritual and performance. How might one "read" this bifurcated

brother-function coupled with a doubled sister-spouse? Do such texts—central to Bali's emphatic ancestral ideology among both nobles and commoners—preserve a sense of their radical departure from values of social exchange?

Second Transitional Thought-experiment

Alert to Balinese endogamy, which contracts the "elementary function" into the parallel bond, recall again Lévi-Strauss's "atom of kinship." This analytic model makes an affinal tie generic. "Society" irreducibly entails both a sibling link and a spouse link: cross-sex siblings with a spouse parallel-sex to one of them. Again assuming that the parallel bond is male, we next reduce the atom to its relational core by cancelling any "descent" projection; that is, by collapsing the temporal dimension whereby categories reproduce themselves. Thus "synchronized," the atom contains two male valences and one female valence. One "male" stands to the female as "brother" (they are *like*); the other male stands to the female as "spouse" (they are *other*). Tales filled out by "another brother" seem almost to personify this slightly expanded field of distinctions: a model of social totality constricted into a bundle of cross/parallel-sex possibilities. This reading must resist construing the narratives "genealogically," much less "historically." Rather, we provisionally consider the two male positions as parallel-sex pure and simple: on the cross-sex axis one male valence is *like* the female (routinely glossed in our genealogical conventions as "sibling"); the second male valence is *other than* the female (conventionally glossed as "spouse"). This rarified categorical reading may be called "mythic," to distinguish it from fuller narrative dimensions simultaneously at work in any actual tale.

In actual narratives additional contrasts may accrue. The two male valences, portrayed as born protagonists, must also contrast by birth order. In genealogical projections the male valences become "men" and the female "woman." At this level paradox comes into play. Such narrative dimensions may be construed as interwoven riddles (Lévi-Strauss 1963c; Boon 1985, 1989). How, for ex-

ample, can a woman's brother and her "not-brother" (her spouse) themselves be brothers? A "genealogical" answer to the riddle is "incest." At the rarified mythic level abstracted above, however, where categories are restricted to gender/birth order, "incest" properly speaking cannot enter in. Its relevant valences do not obtain.

Mention of incest helps underscore the advantage of carefully distinguishing *mythic* (in this case, gender/birth order) from *narrative* dimensions (here implying more genealogical projections). Again, sibling incest is a *valued* transgression in Balinese ancestral ideology. Here incest, I suspect, is analogous to twinship *as twinship pertains to the sphere of birth order* (and *not* genealogy). Twinship is a valued infraction of birth order: a godlike instance of two births where one was expected. In twinship, what should normally remain separated in time—birth positions—nearly coincide (a situation sometimes deemed auspicious for the high-born, but catastrophic for commoners). Analogously, sibling incest is a valued infraction of coital order, a godlike coupling of what normally remains separated. Both twinship and incest represent transgressions against proper distance, one of birth-order positions, the other of sexual relations. In Hindu-Balinese terms, both thus connote deity-rivaling status, a risky affair for all but the worthiest humans. Previous commentators have stressed the standard just-so stories linking twinship to incest because twins share the same womb; this native construction is itself based on a metonymic association. I recommend instead a fuller metaphoric (and analogical) interpretation of the link between incest and twinship more pertinent to the ideology of Balinese houses: *twinship is the incest of birth order.*

In images of incestuous brother-sister twins, his side may be bifurcated into another brother, her side remains duple: the sister-spouse. Certain narratives echoed in marriage practices also envision retained daughter-sister components balanced by a male side split into brother/husband. The sole female is pivotal; her ideal disequilibrium sustains paradoxes of shifting power and authority, in episodic motives of renewal and lapse, deflective of centralized standards.

Excursus II: Toward Inner Indo-Europe

> Rama and Laksmana depart to enter meditation (ke pertapaan). . . .
> Afterwards Rama is ordered to Mitila kingdom, because Raja Jan-
> aka is conducting a marriage contest (sayembara) for his child
> named Dewi Sita. Rama wins that sayembara and marries Dewi
> Sita. Rama, Sita, and Laksmana are sent away into the forest (di-
> asingkan kehutan).
>
> —Lilaracana-Ramayana, from Santoso 1973; my translation

To recapitulate: Balinese mythic twins condense gender/birth
order categorical distinctions into a single birth slot. We may con-
strue even the apparent "triplets" of many narratives as twins
times two: cross-twins and parallel-twins. This reading opens
paths from Balinese twinship motifs to gender and marriage ideol-
ogies associated with Indo-Europe.

One path of speculation returns us to those Indo-European
codes surveyed by Donald Ward (1968). Parallel-sex twins appear
in both the *Vedas* and the *Mahabharata*; in the *Rig Veda* the
twins' sister is Surya, the pervasive female component comple-
mentary to male Soma. The *Mahabharata* proclaims its Asvin-
like twins Sudras from birth, perhaps implying an intervention of
divinity in the lower social orders (on such counter*varna* themes,
see Boon 1977:196). Matters are more explicit in some versions of
the *Ramayana*. Ward reviews dioscuric aspects of the abduction
and liberation of Sita, the contrasting characteristics of Rama/
Laksmana (handsome/plain, errant/faithful, etc.), the banishment
of Rama, and the exile of all three. He adds: "In some of the popu-
lar oral tales that treat this theme, Sita is reported to be the sister
of the heroic brothers . . . ; one can assume that a mythological
incestuous element is involved . . . parallel to the Vedic tradition"
(D. Ward 1968:63).

We can speculate further. Sita is sister-spouse to Rama and
Laksmana's distilled parallel-sex. The *Ramayana*, moreover, seems
to accentuate marriage and collaterality (the combined forces of
Rama, Sita, and Laksmana). This basic "alliance" orientation con-
trasts to the *Mahabharata*'s emphasis on dynasty and "descent."
The *Ramayana* patently questions all direct evidence of legiti-

mate dynasty when Rama manages, through Sita, to regain his chariot (in some versions).

Balinese performances of episodes from the *Ramayana* amplify implications of twinship codes. Echoes of dioscuric features in the monkey realm imply additional valued transgressions that pose rules and boundaries through images of their infraction. The complex of Rama/Laksmana/Sita in the heroic world is repeated by Sugriwa/Subali/Hanuman in the animal world. Indeed, Sita and Hanuman (her theriomorphic counterpart) both suggest trickster-style symbols: Hanuman in the realm of battle, Sita in the realm of marriage, two intimately related spheres of courtly values. Moreover, the conjunction of marriage, ordeal by fire, and twin-ship embodied in Sita resonates with multiple attributes of alliance and endogamy in Balinese houses. Here rival valences of displaced exchange, exclusivistic hierarchy, and even asceticism meet. Ancestor-pleasing endogamy is nuanced vis-à-vis incest (Sita-Rama as twins) *and* asceticism (the trio of Sita-Rama-Laksmana removed in contemplation or *tapas*). Incest and asceticism alike represent variants of the antisocial (incest marginally less so, because it at least requires two). Such negative forces are harnessed in Bali's ancestral houses, where retained brides may become heirlooms, along with weapons and preserved texts. This constellation of values perhaps implies, at one level, the eclipse of exchange conceptualized in categories of social divisions.[9]

Another path leads, tantalizingly, to still more distant Indo-European variations. Ward notes a "significant difference" between Indic and Germanic dioscuric myths: "In the Indo-European tradition the liberators are the brothers and joint husbands of the maiden in distress. In the German epic one of the liberators is the fiancé, while the other is her brother. Such a change is not only possible, but necessary" (D. Ward 1968:68). Contrary to Ward's suggestion, Balinese evidence reveals a "brother-fiancé" component in Indic-style variants. Moreover, the brother-fiancé is tucked into the combined cross (brother-sister) and parallel (brother-brother) protagonists; and *the fiancé is incestuous*. This point helps tie Indic legendary transgressions to Germanic themes of domestic incest, such as Siegmund/Sieglinde (note also the many scholars who have paralleled *Lohengrin* and the *Rama-*

yana). Might such legends characterize diverse "house" ideologies, including medieval and Renaissance European ones, both during their prime and in subsequent nostalgic revitalizations (Boon forthcoming)?

These possible ramifications of the *Ramayana*, inadequately sketched here, point beyond previous readings of Balinese and Javanese marriage factions as polarized contests between right/left and good/evil, as in W. H. Rassers's classic effort:

In Guru, with his quickly inflammable heart and with his train of divine gods, one . . . recognize[s] the representative of the right phratry; he falls passionately in love with the beautiful Lady from the other half of the tribe, who is engaged in initiating herself in world-shattering asceticism. Dewi Tenaga is indeed destined to be his wife, but the exogamous division and the fact that her initiation test must first be completed oblige her to refuse his offer of marriage, and to fly from his pursuit. But this does not prevent Guru's passionate desire from having any result: from his "evil seed" [*kama salah* = spilled sperm] a son is born to him with the appearance of a monstrous giant, who is given the name of Batara Kala. (Rassers 1960:49)

Sita's significance in Bali would seem to lie in bridging opposable spheres that Rassers felt compelled to construe as archaic, polar phratries. Sita herself (situated within twins-times-two) suggests rather a condition of generic ambiguities, doubled valences, and nonstop paradoxes of reversal. As she professes to Rama, before she is obliged to enter the Oblation-eater: "Tiger among men, by giving way to anger like a trivial man, you have made womankind preferable" (O'Flaherty 1975:201).

Conclusions

Cross-twins concentrate not just gender but birth order into a single birth slot. They seem to symbolize a veritable "atom" of house ideology, which allows marriage within a sphere imagined to be society's equivalent: the fictively autonomous house. Just as different symbolics of exchange shift the frames for conceptualizing wife-giver/wife-taker formulations, so in-marrying ancestral units imply a cultural shift in the function of cross/parallel dis-

tinctions. This kind of ideological transformation manifest in Balinese culture helps explain why Bali appears ambiguous, indeed anomalous, when viewed through typologies based on social organization.

Methodological conclusion. If Balinese "twinship" ties valences of cross/parallel (gender-present/gender-absent) to birth order, then investigators err when they restrict the referent of twin tales to actual birth. (It seems especially unwise to infer from images of triplets a history of polyandrous incest!) Although actual births may trigger reflections upon twinship, myths of twins do not simply gloss natural facts of multiple births (however "awed" they, we, or anyone else might be by them). Rather, myths enmesh such facts in cultural paradoxes that biological actualities alone (even rare ones) cannot comprehend. Whether or not multiple births happened, they could be imagined. My argument against reductionist naturalist fallacies can be phrased in a Lévi-Straussian chiasmus: that twins in fact *do* happen implies not that cultural images mimic nature but that nature "herself," particularly in her exceptional cases, has an imagination.

Interpretive conclusion. Incestuous twinship conveys a doubled transgression: against routine birth (properly separated), and against routine coitus (sufficiently distant). The ambivalent desirability of the transgression characterizes aspects of the ideology of Balinese houses. Perhaps significantly, this ambivalence straddles an historical and cultural intersection of contrasting social orders conventionally abstracted in comparative kinship studies: exchange/hierarchy. In classic examples of exchange systems, the gender difference coincides with social difference (e.g., clan to clan); hence wives, or more accurately spouse relationships, are "signs" that constitute opposable parties through their mediation. In contrast, hierarchical "house societies" gear social difference more exclusively to birth order: rivals compete to become primary centers rather than mutual exchangers. Spouses, then, are not inevitably "signs" mediating social divisions (per Lévi-Strauss's "elementary structures"). Nor, however, are spouses (wives in particular) therefore inevitably "property" (per scholarly convictions that history has proceeded as an utterly expropriating patriarchy). Wives may also be, or become, *pusaka*: valuables originating from

exchange, subsequently conserved and cultivated to restore to descendants loyalties that might otherwise be forgotten. Daughters—like the weapons and regalia received from metalsmiths by courts, and then preserved—may be retained as wives by the house, which ritually converts even outsiders into insiders in order to counteract forgetfulness. Here "history" of a different sort enters in, to be championed.

House hierarchies may also celebrate *épreuves*, or love tests, familiar from *Swayamvara* episodes of Indic epics, from manifold Indonesian tales with plots like that of *Jayaprana* (Boon 1977 : 193), and from parallel European traditions. These love tests eventually legitimate an ostensible *mésalliance*; to celebrate them is to qualify certain marriage values. The arch bride is neither exchanged nor simply retained; rather, she is superficially lost, although profoundly restored: the female-pusaka is renewed by an outsider champion. How do the exogamous/endogamous transformations evidenced across *sociétés à maisons* compare to such "histories"? Does a promise of incest remain, even where *Swayamvara* (or *sayembara*) marriage (suggestive of individualized unions) is ritually indicated? Such questions would return us, with qualifications, to the concluding chapters of Lévi-Strauss's *Elementary Structures*—pages devoted, as were those of Mauss and Durkheim, to the philosophy of social forms and processes, and their dialectical contraries.

Concluding conclusion. The present essay has tried to cultivate Lévi-Strauss's sweepingly comparative sense of *sociétés à maisons*:

> The whole function of noble houses, be they European or exotic, implies a fusion of categories which elsewhere are held to be in correlation with and opposition to each other, but here are henceforth treated as interchangeable: descent can substitute for affinity and affinity for descent. From then on, exchange ceases to be the origin of a cleft whose edges only culture can mend. It too finds its principle of continuity in the natural order, and nothing prevents the substitution of affinity for blood ties whenever the need arises. (Lévi-Strauss 1983a : 187)

What more vivid ablation of distinctions between descent and affinity could be imagined than intensely incestuous twins?

Such symbols, moreover, transfer the burden of descent/affinity distinctions to cross/parallel gender. They seem almost deliberately to convey a palpable sense of difference from systems of balanced regulations that interrelate descent through affinity, such as the circulating connubium (MBD marriage) of Indonesia, the Dravidian terminologies of south South Asia, and so forth. Balinese culture displays an aura of transgressivity. Bali's historical situation between analytically separable complexes of value illuminates excesses of both exchange systems and hierarchies in touch with Indo-European ideology: the latter include Bali's odd variant of Hindu-Buddhism, Hinduism proper(!), and European heterodoxies. Perhaps any culture tacitly recognizes that "it" commits what various other cultures are obliged to prohibit. Without this subliminal dialectical awareness across cultures, there could be no comparison and consequently—recalling our opening epigraph from Hocart—no explanation.

Both Nature and Culture

Reflections on Menstrual and Parturitional Taboos in Huaulu (Seram)

Valerio Valeri

*Valeri's essay on the Huaulu of Seram in Eastern Indonesia is an impor-
tant contribution to the substantial literature on menstrual pollution, a
topic of long-standing interest in symbolic analysis and more recently a
concern in the anthropology of gender (see Buckley and Gottlieb 1988).
He addresses the question of how to read a cultural incompatibility be-
tween men's shedding of blood in hunting and war and women's shed-
ding of blood in menstruation and childbirth (cf. Ortner 1974; Rosaldo
and Atkinson 1985). Dismissing attempts to derive notions of female im-
purity from an analysis of women's social standing in Huaulu society,
Valeri explores Huaulu valuations of gender, focusing in particular on
cultural concepts of "warm" and "cool" as they organize Huaulu ideas
about male and female activities. Finding a fundamental contrast be-
tween men's assertion of agency over key social processes and women's
procreative functions, which lie beyond the control of human agency,
Valeri argues for the usefulness of a nature/culture dichotomy.
 Since the pioneering work of Ortner and Ardener, critics have ques-
tioned the appropriateness of this dichotomy for analysis of gender sym-
bolism. Valeri takes issue with Strathern's (1980) critique of the nature/
culture dichotomy on the grounds that it reduces the opposition to its
contemporary Western connotations and hence renders it inapplicable
beyond a Euro-American context. Valeri asserts that it is possible to de-
fine the contrast in such a way as to illuminate the underlying logics of*

non-Western cultural systems. To do so, however, it is necessary to exclude many of the modern Western associations of the contrast, especially the notion of a systematically regulated natural order. Valeri recasts the dichotomy in order to highlight why women's reproductive processes should represent a challenge to male authority and control.

Huaulu men, through ritual activity, seek to contain and control the dangers posed to social and cosmic order by menstrual and parturitional blood. The contrasts to other parts of island Southeast Asia are striking. Ethnographers in Centrist parts of the archipelago commonly find menstruation to be an unremarkable category, or in the case of the Rungus of Borneo, an "unmarked category" of thought and experience (Appell 1988). In the Wana case, where it does receive emphasis, the question is why such efforts should be made to equate the sexes symbolically in terms of their ritual and procreative powers. Huaulu culture invites the opposite question, Why should the sexes be so sharply opposed in these areas? Significantly, Valeri points out that in their ordinary work and lives, Huaulu men and women are nowhere near as differentiated as they are in relation to political and ritual authority, a pattern evident elsewhere in the archipelago. But in the dualistic systems of Eastern Indonesia such differentiation, related as it is to the political and ritual authority of exogamous ancestral houses, invokes gender in distinctive ways (see Boon, this volume). Valeri shows how Huaulu notions of pollution express the "mutual dependency" of men and women, and at the same time enforce their hierarchical separation. Marriage alliance, conceived as "a transaction among men that has the reproductive powers of women as an instrument and object," is, according to Valeri, the main factor of inequality between Huaulu men and women. Elsewhere in Eastern Indonesia (including areas where we find exogamous ancestral houses but no system of asymmetrical marriage alliance), gender also operates along with other dualisms as a key metaphor for social and cosmic relations. For example, Hoskins's paper in this volume explores how key forms of spiritual potency in Kodinese culture represent a conjunction of male and female principles, a symbolic operation that would be abhorrent to Huaulu culture. Whether strictly segregated or conjoined, however, gender oppositions serve as prominent social and cosmological markers in this part of the archipelago.

Menstrual and parturitional pollution is a puzzle for which at least three different groups of explanations have been proposed. The first group states that such pollution is an ideology that re-

flects in distorted and masked form ecological or political and more generally social-structural facts. Thus some say that in a number of New Guinea societies, "fear of pollution [from menstrual blood] is a form of ideological birth control" (Lindenbaum 1972:248). Others claim that it is the consequence of an "equation of femininity, sexuality and peril," itself due to the fact that wives and mothers are drawn from hostile groups (Meggitt 1964: 218–19). Still others feel that this ideology reinforces male solidarity, which is necessary in warlike societies (Langness 1974: 208–9). These interpretations may point out important sociological correlates or functional results of the belief in menstrual pollution, but they beg the fundamental question of why these should be focused on menstrual blood in the first place. In fact, it seems to me that at best they account for the idea that women are dangerous to men and socially devalued, not for the fact that menstrual blood is dangerous and symbolic of inferior social value.

In the second group of explanations, the polluting character of menstrual blood is explained in terms of a general theory of pollution and taboo. A favorite theory connects pollution with intermediate areas between categories. Douglas (1966), for instance, claims that body dirt and body fluids are a focus of pollution beliefs because they are transitional between inside and outside the body (or they are "both me and not me," as Leach 1964 puts it), and because, as such, they become identified with the dangerous areas of ambiguity in the cosmological and social system with which the body tends to be metaphorically identified. Thus they do not so much pollute in themselves as in carrying some social and cosmological weight. However, as Meigs (1978:312) notes, this makes short shrift of the fact that body emissions are the primary focus of pollution beliefs, at the same time that not all social and cosmological anomalies or ambivalent and transitional states are associated with pollution. Notwithstanding its narrower focus on the body, Meigs's theory is not much better able than Douglas's and Leach's to account in general terms either for the very special status of menstrual blood among polluting substances or for its special dangerousness for men. Even less able to provide such an account is the claim, based on a very loose notion of anomaly, that women are seen as polluting because, being between friend and

foe, or insider and outsider, they are "socially anomalous" (e.g., M. Z. Rosaldo 1974:31).

The third and last type of explanation claims that menstrual and parturitional bleedings are viewed as polluting because they connect culture with the devalued domain of nature (e.g., Beauvoir [1949] 1984; Ortner 1974; Ardener 1975a, 1975b). This type of account often suffers from the use of a notion of "nature" that remains extremely vague and thus open to all kinds of misunderstandings (cf. MacCormack and Strathern 1980). Furthermore, the exclusive equation of "polluting" with "what is natural in humans" cannot explain why certain highly valued cultural activities or objects of men are themselves polluting for the natural phenomena of female physiology (see below).

When refined, completed, and corrected, though, this third type of account has something important to contribute to the solution of the problem of menstrual pollution. At least this is the case in the context of Huaulu culture, which is my main concern in this paper.

The Huaulu of Central Seram

The mountains of Northern Central Seram are inhabited by a complex of small societies that speak closely related dialects of the same language, called "Manusela" after the name of one of the most important villages of the area (cf. Collins 1983:20). These societies share many cultural features and are interconnected by a complex network of political alliances, some of which are conceived in terms of siblingships, others in terms of affinity. Traditionally, matrilateral cross-cousin marriage was the ideal, and it remains fully so in Huaulu (Valeri 1975–76). Most of the Manusela peoples are now converted to Protestantism; only the Huaulu have remained entirely faithful to traditional beliefs and practices.

The Huaulu people (numbering about 140 during my first visit in 1971–73 and 168 during my last in 1988) live today in one single mountain village and in a few settlements on the coast.[1] They subsist on arboriculture (exploitation of the pith of the sagu palm and of fruit trees), hunting, fishing (particularly in the rivers),

and gathering. Horticulture is much less important, to the point
that many households do not bother to have gardens or have only
very small ones, since the exploitation of wild or semi-wild re-
sources is sufficient to insure plenty of food (cf. Ellen 1975). Some
cash is obtained by selling forest products (such as parrots and deer
antlers) to peddlers from the outside and—on the coast—by sell-
ing foodstuffs to non-Huaulu. In recent years, the production of
copra, cloves, and coffee has developed somewhat. There is little or
no economic inequality among lineages in subsistence resources;
but there are some inequalities in the ownership of mobile prop-
erty, which consists of ancient porcelain, imported cloth, arm-
shells, and other prestige goods used in ceremonial exchanges.
Some of these heirlooms do not circulate, however, as they em-
body the special powers and prerogatives of the lineages that own
them (cf. Weiner 1985).

Although there are few outer signs of social inequality, every-
thing and everybody is ranked. The main criteria of ranking are
age, gender, and membership in groups that are themselves ranked.
The most encompassing descent groups (*ipa*) are ranked according
to the order of their arrival in the Huaulu territory. Their segments
(also called *ina*) are ranked by genealogical seniority. Furthermore,
the asymmetrical relationship between wife-givers (*hahamana*)
and wife-takers (*hahapina*) combines in complex ways with the
other two criteria of ranking, reinforcing them in certain cases,
countering them in others. Also, this asymmetrical relationship
combines with symmetric exchanges of affinal gifts, which should
ideally be balanced (Valeri 1980) but which, in practice, have a va-
riety of outcomes ultimately reflecting on the status of the parties
involved. The coexistence of these principles produces ambigu-
ities in hierarchical status; nevertheless, the principle that every-
body is ranked, and that certain lineages have an immutable posi-
tion, remains important. In particular, everybody attributes the
status of *Latu* ('Ruler') to the dominant descent group (Huaulu)
that gives its name to the society as a whole. This group thus ex-
emplifies the classical hierarchical formula that identifies the
dominant part with the whole.

The principle of hierarchy coexists, however, with a principle of
balance, which expresses itself in dualistic formulas (cf. Valeri

1989). Ultimately, then, the most striking features of Huaulu so-
ciety, as of similar societies in the Moluccas and Lesser Sunda is-
lands, are the tensions between asymmetry and symmetry, and
complementarity and subordination. This explains, perhaps, why
the male/female opposition, which manifests the same tensions,
is the master symbol in these societies, where it has acquired the
status of a generalized symbolic currency into which most social re-
lations can be converted for purposes of evaluation and comparison.

Equality and Inequality

It is usually said that Southeast Asia is "an area where women
enjoy enviable power and status" (Esterik 1982a:2). Some even
speak, with obvious exaggeration, of "the absence of male domi-
nance in Southeast Asian societies" (ibid., 12). Certainly, gender
asymmetry seems less pronounced in Southeast Asia than in
South or East Asia (cf. Winzeler 1982), but our conclusions on this
matter depend on the criteria used, and the choice of criteria raises
problems that are not usually considered by those who make the
claims just quoted. Quite apart from the fact that many criteria of
comparison are not equally applicable to all societies examined,
there is the fact that the areas of social life that they concern have
different values in each culture. Thus I would be hard put if I had
to decide, on the basis of the criteria used by many current com-
parative efforts (see Esterik 1982b for instances), whether the rela-
tionships between men and women are more egalitarian or less
egalitarian in Huaulu than in other Southeast Asian societies. For
instance, if we take the amount of work done by men and women
as a criterion of their relative status, the Huaulu would appear to
be remarkably egalitarian. Care of children is also fairly equally
shared between man and wife (cf. R. Valeri 1977). Adolescent boys
and girls are allowed equal amounts of sexual freedom before mar-
riage, and spouses are treated as equals with regard to adultery
compensation and divorce.

Inequalities appear, however, with regard to property and the
marriage alliance. The two areas of inequality are related. Because
women are "in between," because they shift their allegiance from

their own lineage of birth to that of their husband, and may even marry into several lineages serially, they are not allowed a share in the control of lineage property (land and heirlooms). This asymmetry is not due to any inherent incapacity attributed to women, but is simply a function of the fact that lineage property is collective and inalienable. Thus all property (household implements, cloth, and some heirlooms) that belongs to a couple as such is divided equally between husband and wife in a divorce. Moreover, a woman's personal property (including some jewelry) is never alienated from her.

Alliance in Huaulu is viewed as a transaction among men that has the reproductive powers of women as an instrument and an object: women are explicitly said to be given by one lineage to another in order to insure its reproduction. Thus women's status depends to a large extent on the number of children they are able to give to their husbands. Although they may be vocal in asserting their individual interests and wishes (whenever they are compatible with the rather restrictive marriage rules), women remain defined by an alliance ideology that presupposes and ultimately requires their "docility," if not outright passivity (embodied by the heroines of many narratives), vis-à-vis men's transactions and projects. Both because this passivity is one of its fundamental conditions of existence and because it makes of women perennial outsiders to the descent groups among which they circulate, alliance is the main factor of inequality between the sexes in Huaulu. Moreover, it legitimizes other inequalities, such as the privilege of polygyny. Men rarely take advantage of this privilege, however, not only because it presupposes a wealth and prestige that are rarely achieved, but also because their wives strongly resist it.

Women do not hold office and are not allowed a voice in the deliberative or judiciary meetings of the community, except when they are directly concerned, as in a divorce or adultery case. Nevertheless, they usually listen from the kitchen to the proceedings, which take place on the veranda, and are often able to influence their menfolk's opinions and decisions.

Women are also excluded from all priestly roles, although their presence (in a subordinate position) is indispensable in the shamanic rites, where they are considered to be the hostesses and

even "wives" of their husband's spirit familiars. Although women are often very knowledgeable in matters of tradition, they are not usually allowed to display or use their knowledge in public, official occasions, nor to formally bestow knowledge that is lineage property. They have a free hand only with various forms of individually owned magic, such as love magic, or with magical-empirical lore that has to do with purely female activities or processes, such as childbirth. Even in these domains, however, some of the most powerful remedies are administered and owned by males.

Thus several important social activities and contexts in which women are involved reveal their subordination to men, or at any rate, a clear inequality between the sexes. The inequality would seem to be even stronger in the domains that plainly exclude women because women are considered incompatible with and even inimical to them. These domains are war, with most of its accompanying rituals, and to a lesser extent, hunting. Women are considered incompatible with such domains primarily because of their generative powers: they menstruate and give birth by losing blood and other polluting liquids.

There is a problem, however, with viewing the exclusion of women from war and hunting as an indication of "inequality" pure and simple. For the incompatibility is here reciprocal: not only are women, because they bleed and thus particularly when they bleed, inimical to men who are engaged in the most "manly" activities—war and hunting—but also men who are engaged in those activities are dangerous for what is most womanly in women—their generative processes.

Men and women reciprocally exclude one another from their most defining activities, then. Given this reciprocity, is it legitimate to say that here exclusion is an index of inferiority? Is it not simply an index of *difference*—a difference so radical that it excludes the very idea of comparing and grading? In other words: Are these activities marked by reciprocal dangers and exclusions precisely because they involve an ultimate reciprocity and complementarity between men and women? Is this a case of women's abysmal inequality with men in war being compensated by men's abysmal inequality with women in generation, or is it a case of

differences that are incomparable, because they consist in two ontologically heterogeneous domains?

As I shall attempt to show in this paper, it is true that the reciprocal taboos between men's war and women's parturition indicate an ultimate ontological difference that emphasizes mutual dependency as part of the dialectics of life and death (although there is no space for treating this dialectics here). But it is also clear that mutuality is not incompatible with hierarchy. Indeed, the existence of a hierarchical component is suggested by two fundamental facts: bleeding women are more dangerous to warring men than the latter are to women; and bleeding women are more dangerous to society as a whole than are warring men. It seems, in other words, that women in those states are superior to men in terms of destructive power, and this is why they are considered inferior to them in terms of positive value.

Symmetrical and Asymmetrical Pollution

As soon as a woman begins to menstruate, she is required to leave the village and to enter one of the menstrual huts (*liliposu*) that are situated just outside the village, usually at a lower level. Even a temporary house in the forest or a garden house will have a menstrual hut annexed to it. There a woman must stay until the bleeding stops, which is supposed to happen after four nights. Although she cannot under any condition enter the village, she may, if she so desires, walk in the forest during that period, provided that she avoids men and their hunting dogs, or at least does not walk before them. Indeed, it is feared that men or dogs may be "polluted" by stepping on drops of menstrual blood that have fallen on the ground. A pregnant woman must also leave the village and enter the menstrual hut as soon as labor begins. After delivery, she remains there until any vaginal flow ceases—at the very least for ten nights.

After leaving the menstrual hut, a woman must bathe and wash all her clothes in a stream outside the village; then she can return

to her house. However, the women who live in the *luma potoa* 'big house,' which is the social and ritual center of the village, or in the house in which the village's sacred heirlooms are preserved, cannot immediately set foot on the veranda (the male part), but must remain confined in the kitchen (the female part) until the following day.

The menstrual huts must be built by the women themselves, using woods different from those used for the ordinary houses and following many other rules too involved to discuss here. According to my informants, "in the past" the huts were built very far from the village and deep in the forest (as was still the case in Western Seram not long ago, cf. Jensen 1948:139). As a result, women frequently fell victims to prowling headhunters (*timatem*), and this finally persuaded men to let women build the huts close to the village. I was also told that the women of one Huaulu lineage, Peinisa, had to build their menstrual hut at a site that, at my pace, is at an hour and a half walking from the site of the village they inhabited at that time.

Babies or small children of both sexes may accompany their mothers to the menstrual hut. Only after boys have become independent of their mothers, and especially after they have formally received the ceremonial bark loincloth marking manhood, must they avoid menstruating women and everything that has been in contact with them. They must be particularly careful not to step on menstrual blood that may have dropped, and even not to spit their betel quid on it. Some even say that they should not lay eyes on women who menstruate or give birth, and should avoid talking to them. There is not much chance for this to happen, anyhow, since women are required to shut themselves in the windowless menstrual huts apart from the village and thus make themselves almost invisible and inaudible to the other sex.

Because women are the agents of pollution, most of the burden of taboo is on them. Not only are they required to leave their husband's or father's house and the village and not to walk before the men; they must also, during the period that they spend in the menstrual hut, avoid cooking for men, using men's clothes or other personal objects, eating the meat of deer, wild pig, and cas-

sowary (which are hunted by men and their dogs), and even laughing and making noise.

Postmenopausal women and prepuberal girls are not dangerous to men, but the first menstruation seems to be particularly dangerous, since it requires staying in the liliposu for a period as long as ten days (and sometimes twelve). Interestingly, the duration of the taboo varies with birth order—it is longest for the eldest girl, probably because she stands, to some extent, for all her sisters.

The violation of the taboos that separate bleeding women from men and village has a variety of negative consequences. If men or dogs have contact with menstrual blood (mokopina), they become "soft" and "their 'livers' (hali) are like water" (i.e., fearful, indecisive). As a consequence, they are unable to hunt or go to war, and are even afflicted by sneezing, colds, coughing, and a general weakness that impedes their activity. Dogs are treated with 'antimenstrual medicine' (aytotumokopina) before the hunt, but no such medicine exists for men as far as I know. Hunting implements and traps are also negatively affected by contact with menstrual blood, menstruating women, or the clothes they wear during their periods.

Contact through food has the same disastrous effect. If menstruating women or women in childbirth eat the big game killed with bow and arrows, spears and traps, it becomes impossible for the men who have made the kill to hunt successfully again,[2] at least until a purification rite is performed. Accordingly, several women informants told me that when they reside in the liliposu, they do not eat that meat "because they have pity on their men." This taboo fits the strong identification existing between hunter and kill: by polluting one, menstruating women pollute the other. But it may also indicate an incompatibility due to the excessive similarity of bleeding women and bleeding animals. I shall return to this point.

Menstruating women have their most dangerous effects on warriors, their weapons, ritual vestments, and charms: a man affected by menstrual blood, albeit indirectly, is likely to die in war, or at least be wounded. As a result, men who believe themselves polluted do not join war parties. Only the most fearless and powerful warriors are said not to fear menstrual blood: some were even re-

ported to have spent the last night before leaving for war in a menstrual hut, making love to all the women there, in order to prove their invulnerability.

Even in the absence of direct contact, the husband of a woman menstruating or giving birth is considered sufficiently polluted to be disqualified from ritual activity, or even political activities. Thus a shaman never performs while his wife is in either of those conditions. The taboo cannot be explained merely by the fact that he needs a hostess to receive the spirits ("to offer them betel nut," as the Huaulu put it), since a shaman could use the services of another woman, as is the case with unmarried shamans.

The negative effects of menstruating women on individual men and their activities are nothing in comparison with the effects they may have on the houses and on the village as a whole. For the women's presence would utterly pollute them, would threaten the powers of the various sacred objects on which Huaulu ritual life depends, and would cause a devastating ancestral wrath. As an informant put it: "The presence of menstruating women in the houses is an extremely serious offense against the ancestors. Once a woman, in order to avoid going to the menstrual hut, used some rags instead. A terrible storm fell on the house, with wind, thunder, and lightning, until her husband implored the ancestors' forgiveness. If a menstruating woman enters the house where the village's ancestral heirlooms are preserved, many in the village will die."

Ancestors are enraged (a bit like the men themselves, I must add) even when the menstruating women's laughter reaches the village. Indeed, this was one of the reasons given for the traditional custom of building the menstrual huts far from the village. The seriousness of the menstrual taboos is indicated by the fact that a woman's failure to follow them is one of three reasons that entitle her husband to ask for divorce. The others are adultery and refusal to cook.

If contact with bleeding women has serious negative effects on men, and particularly on the activities and objects that are considered to be most "male," some of these objects and activities are dangerous for women. In fact, the standard justification for

keeping women away from them is that "otherwise, they will bleed endlessly, they will never be able to leave the menstrual hut."

The activities and accompanying paraphernalia that have such an effect on women are war and headhunting. Since they involve the spilling of human blood, we may ask ourselves if this fact does not provide the explanation for their incompatibility with female bleeding and, at the same time, for their power to accentuate such bleeding in the women who unlawfully enter in contact with them. According to this hypothesis, contact with bleeding women stunts the power of warriors by turning them from bleeders of humans into humans bleeding (just like menstruating women). Reciprocally, if women had contact with these objects, they would be assimilated to victims of headhunting, in that the contact would make them bleed excessively.

These Huaulu beliefs and practices are obviously relevant to the two theories of taboo that exist in anthropology. According to one (going back to Durkheim 1912:431, and reworked by Leach 1964 and Douglas 1966), taboo avoids a loss of difference by keeping apart terms that are already different;[3] according to the other (ultimately going back to Durkheim 1898, but recently reformulated and generalized by Héritier 1979 and Testart 1985), taboo avoids an accumulation of similarity, by separating—indeed, by making incompatible[4]—terms that are similar. The two theories need not be viewed as mutually exclusive. In fact, there would be no need to keep distinct things separate if they did not have something profoundly similar that risks coming to the forefront and thus cancelling their distinctiveness; analogously, why would similar things be incompatible if they did not strive to preserve some preexisting difference between them?

It is true that some taboos are better explained by the incompatibility of things that are too similar while other taboos are better explained by the incompatibility of things that are too different; but the mechanism of taboo always implies in some measure the coexistence of similarity and difference. It is because the profound difference between female reproductive powers and male destructive powers is threatened by a point of similarity, the shedding of

blood, that the two terms must be kept rigorously distinct by a ta-
boo. Moreover, that similarity is used as a sanction precisely to
show that it is the negative, destructive aspect to be suppressed.

In sum, the phenomenon of taboo indicates that the active re-
pression of points of similarity between two terms is necessary to
sustain their contrast. Any transgression of the taboo takes the
form of a return of the repressed: the similarity returns, with de-
structive force, to the forefront. But this does not mean, as in Tes-
tart's view, that difference is not presupposed by taboo but is only
created by it. On the contrary, a difference such as the one between
male destruction and female generation exists on grounds other
than those of taboo alone. Similarity always presupposes differ-
ence, indeed incompatibility, to become something to be avoided.[5]

An account of male and female pollution as a device for preserv-
ing or creating a mere difference is clearly insufficient, however. It
does not explain why the polluting power of the two opposed
terms is far from being perfectly symmetric, why women are more
dangerous to men than men to women. Take, for instance, the rule
that proscribes the eating of cassowary, wild pig, and deer by men-
struating women. As a measure for preserving a difference, this ta-
boo would seem equivalent to the one enjoining menstruating
women not to touch the male paraphernalia of war. Moreover, the
two taboos are concerned with the same substance—flowing blood.
Yet the results are rather different: in one case there is reciprocal
pollution, in the other—the food taboo—there is pollution of men
by women, but not of women by men. Indeed, menstruating women
do not have unstoppable hemmorhages as a result of eating the
meat of game hunted by men. Accordingly, they avoid eating it not
out of fear but, as I have mentioned, out of "compassion" for men.

Analogously, menstruating women are terribly polluting for the
village, the houses, and men in most situations, but are not pol-
luted in return. The only area in which they are polluted in return
by what they pollute is that of war. It is almost only as killers of
humans that men can be dangerous to women as generators of hu-
mans. Yet even here a true reciprocity is lacking: for the damage
inflicted by female pollution is superior to the damage inflicted by
male pollution. What women attack and threaten are the supreme
powers of the society as a whole: the sacred objects that allow men

to successfully defend it, that make it—the Huaulu believe—invulnerable and fearsome in the eyes of their enemies. Male pollution of women, in contrast, threatens the generation of replaceable individuals, not the continuity of society as a whole.

We face here something that is more than mere difference: a hierarchy of values in contradictory relation with a hierarchy of powers. What is most despised, least valued in the official scale of values, appears to be more powerful, ultimately, than what is most valued: the activities of men as warriors, hunters, and performers of rituals. What is the secret source of the irresistible power of the impure over the pure? This is a problem that every hierarchical system seems to face at some level (cf. Dumont 1959), but that we must firmly situate in a Huaulu context.

Before attempting to find an answer to this problem, we must settle a number of issues. Is menstrual blood really a most despised thing in Huaulu? Do men and women differ in their evaluation of it? Are menstruating women really considered impure? Is it legitimate to identify their destructiveness with "pollution"? If certain male activities and objects are themselves polluting to women, why is it that they are not to be viewed as impure? Let us briefly answer these questions in turn.

One of the insults that Huaulu hurl most frequently at one another, and at animals or objects, is *mokopina* 'menstrual blood.' When someone or something has to be defined as bad, unreliable, and even somewhat malicious, it is called mokopina. Disgust, revulsion, scorn, are also frequently expressed by this word. Its force is made stronger by the fact that its use is somewhat transgressive: being a disgusting thing, menstruation is not usually discussed or directly mentioned. Hence its mention in obloquy often triggers the embarrassed laughter that accompanies bad or obscene words.

There is no difference between men and women in the derogatory use of mokopina. If anything, my (admittedly unsystematic) attempts at counting suggest that the word is proffered more often by women than by men. But then this is probably insignificant, since the women tend to be more filthy-mouthed than the men anyhow. That women use the word for menstruation in the same insulting way as men, however, need not indicate that they share men's disgust for menstruation. After all, they are simply follow-

ing a communicative convention. Yet they must also be aware that this convention is one way in which the negative identification of menstruation is reproduced and that using it concedes a point to men, so to speak.

Although I have never done participant observation in a menstrual hut, all in all my impression is that women share with men the negative view of menstruation that is prescribed to both sexes by Huaulu culture. Yet they relate differently to the phenomenon. This is due to the fact that for men the negativity of genital blood is avoidable, since it does not come from their own bodies, whereas for women it is unavoidable and is always present, potentially when not actually. A correlate of this is that men have more to lose than women by coming into contact with that blood, and thus with what it signifies and induces: weakness, sickness, lack of courage, a lowered level of activity, etc. Hence men fear the pollution of menstrual blood much more than women do. Psychologically, this asymmetry translates into women's evident lack of concern for menstrual bleeding (parturitional bleeding is another matter) and into men's equally evident resentment of this lack of concern.

This resentment is not simply due to the feeling that women do not take seriously enough the threat that their condition constitutes for men. They are also accused of taking advantage of the rule of menstrual segregation by faking their menses or pretending that they last longer than they actually do. In this way they are able to escape their obligations toward their husbands and family. Undoubtedly women enjoy their vacation in the menstrual hut. Observing this, and the rage of many a man when hearing the laughter that occasionally comes from the happy women in the menstrual huts, one is even tempted to speculate that the custom of menstrual segregation is a particularly sly female invention. But even if this were true, one would still have to presuppose the male fears that put menstruating women so effectively beyond men's reach, and thus a male contribution to the custom.

Thus this custom, like all others, bears the mark of the different forces that produced and perpetuate it. Women have as much of a vested interest in it as men: they have not simply been forced into it by a male phobia. Furthermore, they clearly enjoy a sense of

power, not powerlessness, in being segregated. They say, with evi-
dent pleasure and some malice: "Men are afraid to die if they
touch us." There is no contradiction between sharing with men
the view that menstruation has a negative power on men and male
things on the one hand, and living the phenomenon in ways differ-
ent from and even opposite to men's on the other. For it is ob-
viously part of the ideology of menstruation that men and women
must relate to it differently, since they are differently affected by
it. It would be completely wrong, then, to interpret the differences
in male and female attitudes as ideological differences. In fact,
there is an extraordinary degree of consensus between men and
women on these matters.

Are menstruating women considered impure? "Impurity" is of
course a metaphoric expression: it refers to the identification of a
phenomenon, moral or physical, with "dirt," with something that
evokes revulsion. Menstrual blood and menstruating women may
be considered impure in this sense. Although in the Huaulu lan-
guage neither the word that signifies 'bodily dirt' (hoy) nor the
word for 'excrement' (tay) has been metaphorically extended to
menstruation and other phenomena to express a generalized no-
tion of "impurity," there is a clear identification of menstrual
blood with disgusting putrefaction and bodily dirt. One indication
is the alleged malodorousness of women, which is most intense
during menstruation or childbirth, but which continues in some
measure to be perceived by the sensitive noses of men even be-
yond those conditions.[6] Furthermore the expression *fauhihina* 'fe-
male odor' is frequently used to refer to any offensive effluvium,
particularly those originating from rotting organic matter or wild
animals. Here again women's usage does not differ from men's, in-
dicating some degree of agreement with what the linguistic con-
vention implies about the odoriferousness of women. Perhaps
more indicative of women's introjection of their image as dirty and
stinking is their frequent bathing, especially since in this they dif-
fer from men (particularly the mature and old ones), who think
they can dispense with baths most of the time, because they fancy
themselves free of odor.

It seems to me that if menstruation is not subsumed in Huaulu
into a generalized concept of "dirt," it is not because it is not

"dirty," but because "dirt" would be a very weak metaphor for the very special impurity that is attributed to it. Indeed, neither body dirt nor excrement partakes of the extreme dangerousness of menstrual blood. But is it legitimate to identify this dangerousness with pollution?

Here again, we are faced with the relationship between our metaphors and Huaulu metaphors. Insofar as different metaphors cover the same conceptual ground, it seems to me that it is possible to translate one with another. "Pollution" evokes both the idea of making dirty and that of doing so simply by contact, automatically. The "dirt" induced by a polluting agent is, moreover, the intrusion of an alien substance that, being incompatible with the body into which it enters, makes it diseased (cf. Meigs 1978). Although the Huaulu do not unify all these notions in one single linguistic metaphor, we find both linguistic and nonlinguistic equivalents to them. The ideas of contamination, of disease, of diminution of life, and even of death induced by mere contact with an incompatible substance are very clearly present. These ideas are conveyed by various representations and associations, the most important and relatively generalized being that of "making cold," which covers some of the same ground as our metaphor of "pollution" and much else in addition. I shall return to it in a moment. First let me address the last of the questions raised above: If certain male activities and objects are themselves polluting to women, why is it that they are not viewed as "impure" in the sense defined above?

The answer to this question is simple: pollution is not always due to the contact of a pure thing with an impure one, but may be induced by the incompatibility of terms, neither of which themselves need be "impure." The point is illustrated by most of the Huaulu food taboos, which are unfortunately too complicated to be discussed here. Suffice it to say that in most cases pollution (in the sense of sickness or loss of vitality through contagion) strikes when two or more categorically incompatible foods (for instance, fish and bird) are eaten together. Interestingly enough, the "pollution" produced by a good deal of these transgressions is believed to be leprosy (*koloputi*), that is, a loss of bodily differentiation that is the metaphor of a loss of cosmological differentiation (in the above

example, the difference between sky—the habitat of birds—and water—the habitat of fish). We can thus understand that males engaged in war and all the main correlates of war may be polluting to women without ever being related to the idea of "dirt," "rottenness," "stink," etc.

Hot and Cold

The above discussion should have made it clear that my use of the terms "pollution" and "impurity" is not grounded in the translation of comparable words of the Huaulu language, but in the description of comparable notions. The actual choice of metaphors, however, and in certain cases the absence of unifying metaphors, must be considered part of the evidence for purposes of interpretation. As I mentioned above, a metaphor often used by the Huaulu to signify the noxious effects of menstruation is that of "making cold." Let us examine it more closely. It will put us on the right track for resolving our central problem: Why is menstrual blood so despised, so low in the scale of social values—and yet so powerfully dangerous for what stands above it in that scale?

I have often heard it said that menstrual blood and blood lost in childbirth are dangerous to men because, being "cold," they make men "cold." Indeed, the symptoms of menstrual pollution are usually similar to those of excessive "cooling." Coughing and sneezing and even the common cold in men (but not in women) are often attributed to direct or indirect contact with menstrual blood. Furthermore, apathy and sleepiness, and a general lack of vitality, may also be attributed to the "cooling" effect of menstrual blood. What does it mean that menstrual blood is "cold"? And why is this "cold" dangerous for men? These questions can only be answered by considering the Huaulu ideology of "hot" and "cold."

The contrast of *naasana* (adjectival form: *naasaa*)—'hot' or 'warm'—and *morina* (adjectival form: *moría*)—'cold' or 'cool'—is often used, explicitly or implicitly, to classify beings and states.

Warm things are supposed to be more potent and usually more beneficial than "cool" things, although it is ultimately the hierarchical conjunction or alternation of the two that sustains life at the social and cosmic levels. This is demonstrated by the charac-

terization of many processes in the natural and human world. It is believed, for instance, that germination, blossoming, and female fertility in both animals and humans require "coolness." But either these processes need also to be combined with a warm counterpart to come to fruition, or they do so spontaneously by producing something warm.

An example of the latter case is offered by the tree that is an object of most intense interest in Huaulu: the durian (*tulinoam*). It is believed that its flowering (more than that of any other fruit tree) is characterized by a "cool" so intense that it affects humans and gives them colds. These afflictions are gladly suffered by the Huaulu, however, as the cool induced by the durian contains the premise and the promise of its contrary: intense warmth in its fruits. Indeed, there seems to be a principle of balance and compensation at work here over time: the greater the cool of the flowering, the greater the warmth of the fruits.

An example of a cool process requiring a warm complement to be actualized in the first place is offered by human reproduction. Although a woman's fertility depends on her possession of the necessary degree of coolness, it also requires an appropriate degree of warmth in her husband. It is said that if the husband is not warm enough or is too warm, his wife cannot generate. The husband's "warmth" does not simply refer to sexual potency: it also indicates mystical attributes that are considered excessively "hot" because extremely active. Thus it is said that great warriors and shamans are often condemned to childlessness because the intense "heat" induced in their body by the possession of medicines and other magical objects destroys their wives' "cool" fertility.

The hierarchy and complementarity of "cool" and "warm" also defines one of the most important oppositions in Huaulu cosmology: that of forest (*kaitahu*) and village (*niniani*). The forest—damp, perennially immersed in the dark shadows of the gigantic trees—is considered "cool," whereas the village, being cleared of all spontaneous vegetation (even the ground is obsessively kept free of grass) and thus exposed to sunlight, is considered "warm." But this literal contrast is accompanied by a metaphoric one that is much more important.

The village is "warm" because it is the greatest result of human

effort and the seat of the most intense social activities, both of which are characterized by "heat." The spontaneous life-producing processes of the forest are viewed as "cool" by contrast. Being uncontrolled or ultimately uncontrollable by society, these processes are seen as antithetical to it, and as such are devalued. Yet, as sources of the raw materials that human labor must transform to create the village and the social life that takes place in it, the forest's processes are also viewed as indispensable conditions of human life. These contradictory evaluations give the forest an ambiguous status: both life-giving and death-giving. Thus it is in the forest that one encounters the greatest powers on which human life depends and at the same time the most dangerous spirits or ghosts who threaten it. This ambiguity has its temporal expression in the very course of human life, since it is in the forest that children are usually conceived (sexual intercourse rarely takes place in the village), and it is in the forest that corpses are buried or put in hollow trees or cliffs' holes. The human life associated with the village is thus spatially and temporally encompassed by the eternally victorious wilderness.

This cosmological contrast of "warm" and "cool," with many of the above-mentioned connotations, is also applied to male and female activities.[7] The most typical male activities are hunting, warring, felling trees for gardening or other purposes, building houses, speaking in public, and performing rituals. Hunting and warring are characterized by sudden bursts of energy and produce violent and dramatic effects: it is thus not surprising that they evoke heat. Felling trees and building houses are also fairly intensive and complex activities. Shamanic rituals, and those which were formerly connected with war and are still performed in festive occasions, involve violent dancing. More generally, ritual is supposed to be "warm" because of its potency and effects, particularly when these involve the mobilization of the entire community. Furthermore, in the activities just enumerated, the element of control is prominent: by hunting animals or enemies or evil spirits, by placating ancestral spirits, etc., men bend the world to their will in the most impressive ways known to the Huaulu. Thus heat evokes transformation, control, and the increase of societal intensity and potency.

In contrast, the "cool" activities of women are less transformative and have a slower pace. Where a man's life is characterized by bursts of intense activity between periods of inactivity, women are usually concerned with daily routines and thus remain in a "steady state." Furthermore, what really qualifies women in Huaulu eyes is that they bear children, and this evokes passivity, since it involves letting the body do its own work. Women's reproductive processes thus introduce an element of "cool" spontaneity, analogous to that characterizing the forest, inside the society.

Although male and female activities or states are globally opposed as "warm" and "cool" respectively, a distinction must be drawn between those activities or states which are sufficiently close in "temperature" (we may say) to make them compatible, and those which are too far apart to be compatible. Thus a man going to war must make himself "hot." Accordingly, he must avoid sexual intercourse: otherwise he would be "cooled off" by his wife. But reciprocally, men in a "hot" state are dangerous to women because they threaten the "coolness" on which motherhood depends. Women of reproductive age (and a fortiori women who are pregnant or breastfeed a baby) avoid even the male dance ground (*usalihaliniam*), at least in the first few, more intense days of war dancing (*usali*) in connection with the *kahua* (a feast held to celebrate important events in the life of a community; see Valeri forthcoming). This is because the ground is made very hot by the dance, and this excessive heat could make a woman infertile, hurting the fetus if she is pregnant, or making her suckling "yellow" (a color associated with death). These beliefs seem to suggest that women and their babies are too "weak" to sustain the intense energy produced by the dancing men; but they also confirm that the "weakness" indicated by their "coolness" is also their "strength," since it allows them to produce children.

Men and women are also incompatible when women have become "too cool" (a state henceforth described as "cold") as a result of the loss of blood involved in menstruation and childbirth. In sum, it is sufficient for the balance of "warmth" and "coolness" to be upset by the increase either of heat in men or of cold in women, to make the two sexes incompatible. The crucial question is thus:

What causes excessive heat in men and excessive coolness in women?

The "hotness" of men engaged in war and related activities is due to the mobilization of extraordinary energy, necessary to neutralize and control the enemies and other threatening forces beyond society. The ultimate sources of this energy are the *sacra* that are at the center of the society, although they have their origin outside it, often in originally hostile forces. As such, the sacra display the male ability to transform what is beyond society into its very substance, to turn the originally uncontrollable into something controlled and contributing to controlling activities. This point is often made in the origin myths of these sacra. It is no coincidence that most of these objects either are obtained from cannibal monsters that have been "tamed" or are relics and other trophies from the enemies killed.

If male "hotness" signifies intensified control, female "coldness" seems to signify just the opposite: loss of control of one's body (indexed by an uncontrollable loss of vital substance—blood), presumed loss of vitality due to the hemmorhage, etc. But these also characterize all other forms of bleeding (particularly from accidentally self-inflicted wounds), and indeed most sicknesses and soul-loss (all indexed by "cold"), without making these other forms polluting for the men and the village. What makes the hemmorhages of menses and parturitions so particularly dangerous? Our answer can only be hypothetical, since the phenomenon that we are investigating is rooted in unconscious ideas and evaluations. But it seems likely that the special dangerousness of female genital bleeding is due to the convergence of two facts.

The first fact is that these bleedings are the internal becoming external, the normally hidden and therefore mysterious generative power of women made visible. They thus signify that power more than any other phenomenon of the female body, and take on the importance attributed to women's fertility as the fundamental precondition for the continuity of Huaulu society. This importance is strongly emphasized by the Huaulu, who often pointed out to me that women are logically prior to men, since "without them we men would not exist," and who constantly bemoan the fact that

the insufficient fertility of their women weakens their society demographically. "Let women give birth well" is perhaps the most frequently heard invocation in Huaulu prayers: it describes what is also a goal of many rituals. There is no doubt, in sum, that in the cult of life and strength that is Huaulu religion, the fertile power of women has an important, if passive, part. This overevaluation, however, like any overevaluation, implies a profound ambivalence. For if women do not deliver the life that they alone are capable of giving, they threaten the existence of society and of men. But the actualization of the life-giving potential of women appears to the Huaulu to be extraordinarily unpredictable, and thus to be fundamentally uncontrollable.

We have moved on to the second fact that, in combination with the first, probably explains the polluting power of women. Vaginal bleeding is not just the mysterious internal power of women's belly made visible: it is also a loss of that precious power. Moreover, in a menstruating woman it is a sign of failed actualization: the Huaulu ideal woman is constantly pregnant or nursing; she rarely menstruates. The "weakness" that menstruation indicates is also society's weakness: it has failed to be strengthened by another child. But more generally and more profoundly, vaginal bleeding, a phenomenon of incontrollable loss, is the clearest and sometimes (as in parturition) the most debilitating manifestation of women's helplessness vis-à-vis a process of their bodies. This helplessness, however, is not theirs only: it is even more men's helplessness. Loss of blood in menstruation and childbirth (but also simply childbirth) is perceived as threatening to men precisely because it evokes their inability to control, through the control of women's generative processes, the basic condition of their own physical existence. Bleeding women reveal to men that ultimately they do not control their own being, that their existence is contingent (cf. Beauvoir [1949]1984:200). The revelation is all the more intolerable because men incarnate the ideal of control and are the more manly the more they approximate it. This explains why all the symptoms of pollution from vaginal blood evoke loss of manhood.

As we have seen, men become "cold," "weak," "cowardly," unable to hunt, to wage war successfully, or to perform ritual, etc. A

further confirmation of bleeding women's power to "feminize"
men is offered by the belief that the ghosts of women whose gen-
erative powers have gone completely wrong—who have died in
childbirth together with their children—threaten the very sign of
men's maleness: their genitals. Such female ghosts (*muluakina*)
are said to attack men in the forest, severing their genitals and giv-
ing them to their babies as playthings. In milder cases, they make
men fall from trees or cut themselves, thus often inducing death
by bleeding (a female-like state).

Since other muluakina originate from women who never had a
child and thus always menstruated, these ghosts seem to symbol-
ize in extreme form the danger that bleeding females constitute
for men's very identity. They signify, quite simply, the loss of
men's maleness through the loss of its most distinctive sign—the
phallus. In this connection I should mention that the supreme pal-
ladium of Huaulu society, the greatest source of its strength and
the symbol of its alleged superiority over all neighboring societies,
is a "living" phallus descended from Lahatala, "Father Heaven."
This object (referred to as "a human being," and named Leautuam
'the sun's life principle') is preserved in the most sacred house in
the village, and it is to it, as *luma upuam* 'lord of the house,' that
men consecrated (and perhaps still occasionally consecrate) the
fruits of their manly exploits—the heads of their enemies. I was
told that when this happened, the always-erect phallus vibrated in
triumph, its strength renewed. There could not be a more telling
proof of the identification of maleness, as strength and power of
subjugation, with society's identity and sacredness.

In the past, the practice of head-hunting was connected with
that of the incision of the penis at the time of initiation. Only a
man "who had seen blood" (i.e., who had killed in a headhunt)
could incise the boys. Today, when head-hunting has apparently
come to an end, male initiation has ceased to include the incision
of the penis (called *pasunate*).[8] This lack of a sign on their penises
is one of the signs, for the Huaulu, that nowadays they are less
manly, and thus less different from women, than their ancestors
were.

Why was the incision of the penis able to transform boys, still
somewhat ambiguous creatures from the point of view of gender,

into full men? Why did the bleeding of their penises, so similar to the bleeding of vaginas, allow men to cease to be like women and indeed to become their opposite, inasmuch as they bled people in the headhunt, instead of themselves losing blood? I would argue that incision had this transformative effect precisely because the bleeding that resulted from it was similar to menstruation *in appearance only*: in reality, it was profoundly different from it in that it was voluntary and artificial.

Pasunate could thus mark a boy's passage from a state in which he was still powerless like females to a state in which he assumed male powers. The "fake menstruation" of boys was effective precisely because it was both a menstruation and a "fake." In producing the bleeding voluntarily and artificially, and thus in a manner that demonstrated male control, pasunate negated menstruation, and thus femaleness, by the very act of *representing* it.[9] Boys were made men in the extreme act by which the epitome of undergoing was transformed—significantly by a headhunter's knife—into the epitome of acting and controlling. That pasunate was this dialectical reversal is confirmed by the complete inversion of the value of bleeding it effected: although abundant bleeding is highly negative in menstruation, it was highly positive in pasunate, where it was believed to have announced luck, wealth, and a completely developed maleness.

Thus by bleeding once and for all as women, men became forever different from women. Nowadays, the same effect continues to be produced with reduced intensity by the ritual binding of a barkcloth around the boy's loins. The first loincloth, as a symbol of containment and control of the now-active genitals, indexes man as social being, that is, as controller of what is natural in himself and around him. Appropriately, then, the rite makes it lawful, for the first time, for the boy to approach women as sexual objects, that is, as sources of natural reproduction to be harnessed to the male projects of social reproduction.

But precisely because this harnessing is never complete, and because ultimately the existence bestowed by women is beyond men's control, the rite that fully identifies a male with an autonomous and controlling agent must also mark the moment when bleeding women truly become polluting to him. As I hope to have

shown, they pollute him in the sense that they confront him with the evidence of a weakness that he refuses to acknowledge, that he cannot acknowledge without losing his identity. The segregation of bleeding women avoids the "contamination" of men: that is to say, men's realization that they participate in the weakness of women, that this weakness is their weakness too. A system has been set up in which men can avoid confronting a fact in contradiction with their categorical definition; and yet the existence of the system is sufficient evidence that they recognize the fact. The system, then, is a sign that the limiting fact is neither negated through the fantasy of male control of fertility (as in certain New Guinea rites; see Langness 1974), nor accepted with all its consequences. It is in a sense recognized, but not accepted. Huaulu men could say, like Clemenceau of France's defeat in 1870, "n'en parlons jamais, pensons-y toujours."

Nature and Culture

The features of female generative processes that I have isolated above are not viewed in isolation. They are enmeshed in a complex web of associations. I have already mentioned, for instance, that their "cool" spontaneity has its counterparts in similar processes of the vegetal and animal worlds observed in the forest that surrounds the village. Some other associations must be mentioned because they are significant for the hypothesis that I have just formulated. Menstruation is connected with the lunar cycle: the transition from the old to the new moon allegedly triggers it. When I pointed out to my informants that women seemed to go to the menstrual huts at any time of month, I was answered that there is a greater concentration of menstruating women at about the time of the new moon and that, anyhow, this was always so "in the past."

The connection of the menstrual cycle with the lunar cycle reinforces my hypothesis that the phenomena of female fertility, just like the motions of the celestial bodies, are viewed as incontrollable, as functioning beyond the power of human will and action. Moreover, the connection with the lunar cycle reveals another feature of the life-giving power in women's wombs: that it is

inextricably connected with death.[10] I believe that this is the sense of the dogma that menstruation is associated with both the death and the rebirth of the moon. The periodicity of menstruation signifies the dialectics of waning and waxing, of decomposition and recomposition, and ultimately of death and life.

For the Huaulu, being born of woman means being destined to die. It was a female monster, Hahunusa, who introduced death in the world by outwitting a male cultural hero, Olenusa—the epitome of the powerful warrior. Olenusa's "system" guaranteed immortality and eternal youth to humans by providing them with a nonsexual mode of replacement. Once old, they would not die and be replaced by their children, but would be transformed into stone. The stone, put in the kitchen, would break after three days, and the old person would come out of it, transformed into his or her youthful self. This system, in which man's continuity would be modelled after that of the durable stone, was opposed by Hahunusa, who propounded a "system" modelled after the banana tree. The tree is soft and does not last long, but is replaced by the 'children' (*ananiem*) that sprout at its base. Individual immortality is thus contrasted in this myth with individual mortality as a logical correlate of species immortality through sexual reproduction. And since in the latter woman is viewed as preponderant, she becomes identified with a life that implies death. She has been associated ever since with all the loathing felt for Hahunusa—but also with the idea of necessity that is personified by this mythological character. In fact, the Huaulu say that the victory of Hahunusa was necessary: if humans did not die, the world would be too full of them, "we would have not enough to eat, we would have to eat one another." This statement shows that the original state is not so much one in which sexual reproduction is unknown as one in which it does not offer the only possible immortality—that of the species. Thus proliferation was originally possible, but it was not logically related to individual mortality. Hahunusa's victory meant that the two phenomena became linked, and that they had to be linked in order to make it possible for human life to exist at all. Life thus must imply death in order to continue: the paradox is recognized, but men still cannot quite accept it, as they cannot quite accept its signs in women's bodies.

That life given by woman implies death as its logical correlate is also implied by woman's connection with Earth. The Huaulu anthropomorphize Heaven and Earth, respectively called Lahatala and Puhum. Lahatala is the primordial Father, Puhum the primordial Mother. The bodies of humans, which come from their mothers, were originally made of earth, and are thus said to be corruptible like all earthly things. In contrast, the breath of life, which is "like a wind," comes from the heavenly Father. When the body dies, the breath leaves it and disperses in the air. We thus find in Huaulu the familiar dualism of heavenly male and earthly female, of "spirit" (in its etymological sense) and mud.

The male is as "abstract" as the uniform and transparent sky and as "spiritually" powerful as the invisible winds that contain the animating breath of past generations; the female is as multiformly concrete as the thick earth and what grows from it. One is associated with heat, light, and day and thus with the uniformly round and resplendent sun (remember that the "archpenis" worshipped by Huaulu men descended from heaven and is connected with the sun); the other is associated with coolness, darkness, and night and thus with the moon, which changes in shape and luminosity.[11] Humans participate in both principles, the immortal one of sun and sky and the mortal one of moon and earth, because they are all born of man and woman. But like men of many other cultures, the Huaulu man, feeling closer to heaven, views woman as what "imprisons him in the mud of earth" (Beauvoir [1949] 1984:196).

Another form taken by the contrast male heaven/female earth emphasizes its equivalence to the contrast of freedom and necessity. The Huaulu distinguish two forms of death: necessary, "natural" death in old age, and premature, violent death. The latter is ultimately attributed to an arbitrary decision of Lahatala, and includes, notably, death in childbirth for women and death by falling for men. Because the premature dead are "called by the father" (Lahatala), their shades reside in heaven. In contrast, the ordinary dead are "called by the mother" (Puhum), and their shades reside on earth. The female principle is thus again connected with inescapable, "natural" limitations, whereas the male principle is connected with willed, arbitrary occurrences. Women are the passive

bearers of a force that gives a life implying death; men willingly and artificially give death.

A little story was told to me that illustrates the point that we drink vulnerability with our mother's milk: "One of our ancestors, at the time when humans first began dying, killed four of his seven sons hoping that they would return from the land of the dead and tell him how things were there. They did not return, however. When this cruel man died and went to the land of the dead, they attempted to punish him with various tortures. But the man's shade still retained invulnerability to pain: fire did not burn him, etc. Then one of the children whom he had killed suggested: 'Go to the land of the living, fetch some milk from the breast of a woman, and let him drink it.' As soon as he drank the milk, he became vulnerable to all tortures."

The facts that I have adduced seem to me to confirm the general thesis about menstrual and parturitional pollution put forward in the preceding section of this paper. They show that women's generative power has many traits in common with processes that happen without the agency of man, and that this agency cannot hope, ultimately, to control. At the same time, woman's fertile processes are different from all other natural processes because human existence is directly dependent on them. Hence this existence is marked by a contingence all the more intolerable for men because they incarnate more than women the ideal of culture as control, as active or even constitutive relationship with existence. Moreover, this sense of contingency is increased by a second trait indicated by some of the facts just adduced: like all generative processes in nature, the generative processes of women are marked by the paradoxical connection of life and death.

I am, in sum, claiming that something like the contrast of "nature and culture" is correlated with the contrast of male activity and female generativity. No doubt, this claim will strike anthropologically up-to-date ears as an ugly dissonance, and I had better argue my case a little further, lest I be immediately consigned to the pit of the damned. The present anthropological wisdom on the nature/culture opposition can be found in the influential volume edited by MacCormack and Strathern (1980). This volume, and

particularly the long and interesting essay by Marilyn Strathern included in it, seem to suggest, if not always to argue, that the above-mentioned opposition is of doubtful applicability outside our modern Western culture, which is said to be its veritable creator. Should we believe their claim and ban the terms "nature" and "culture," together with their opposition, from our analytic lexicon?

Different answers given to this question depend to a large extent on different definitions of the terms "nature" and "culture," and, more importantly, on different anthropological strategies that justify the use of such definitions. What I mean is that these terms may be treated as notions of a particular culture (modern Western culture) and compared to notions of another particular culture (Huaulu culture, for instance), or treated as terms of a metalanguage that we create (and revise when necessary) in order to adequately describe comparable—that is to say both different and similar—notions in different cultures. As terms of such a metalanguage, "nature" and "culture" need not have any other meaning besides those we decide to give them on the basis of what we know about the cultural notions that we want to compare, explicitly or implicitly. Analogously, a physicist may use a term (for instance, "force") with meanings quite different from, or much narrower than, those it has in ordinary English.

It may be objected that some of the ordinary meanings of the words that we use in a special sense unconsciously force themselves upon us. This objection, however, applies with equal force to the first strategy mentioned above, that is, to the comparison of another culture's notions with the notions of our culture. Indeed, this comparison is made in our language and thus involves the danger that the whole range of meanings that words have in our language will force itself upon us when we use our language's words to translate and define the meanings of another language's words. And more importantly, does not the "indeterminacy of translation" thesis imply that it is impossible to decide which, of the several translations that are compatible with the information, is the true one? (cf. Quine 1964; Hookway 1978; Roth 1986). Clearly, the difficulties involved in both strategies are substantially the same.

But also substantially the same is the remedy available: the critical self-consciousness that is made possible by the very activity of comparison, whatever form it takes.

Strathern herself seems to deny that the notions of "nature" and "culture" can be given critically controlled meanings for comparative purposes; only the first comparative strategy seems acceptable to her. Accordingly, she takes the notions of "culture" and "nature" in all their meanings (as she views them) in modern Western culture. To give only one example: Strathern points out that in modern Western culture, "Nature is not merely acted upon but a system of laws of its own, and it is these laws that limit the possible" (Strathern 1980:196). It would be surprising indeed if the Hageners or the Huaulu or any other people without a scientific culture had the notion of natural law. The point has been repeatedly made ever since de Brosses and Hume. Durkheim (1899, in Pickering 1975:78) reiterated it and Lévy-Bruhl (1931:xxii, xxviii–xxix, xxxviii) used it to deny that the opposition natural/supernatural applied to "pre-logical mentality."

That the Huaulu do not have the notion of natural law, and even less a notion of nature as "a system of laws of its own," does not mean, however, that they do not take for granted a number of regularities in processes "that limit the possible." As we have seen, and as we could see even better if we could discuss their very complex cosmogonic myths, the Huaulu even reflect on them in certain cases. Therefore it does not seem inappropriate to invoke in the analysis of some of their beliefs a contrast between natural and cultural processes predicated on *one* of the two notions of "nature" that are classically distinguished in Western thought. As Mill puts it, nature "in one sense . . . means all the powers existing in either the outer or inner world and everything which takes place by means of these powers. In another sense, it means, not everything which happens, but only what happens without the agency, or without the voluntary and intentional agency, of man" (Mill 1874:8, cf. 12).

As a host of commentators have pointed out, both notions go back to Greek thought, but the first is much later than the second, and presupposes the development of a philosophical and scientific

monism that came to full fruition only in the modern period (and which, in strict logic, excludes the possibility of contrasting nature and culture). Collingwood, for instance, after having noted that the meaning "sum total or aggregate of natural things" for *physis* (the Greek equivalent of Latin *natura*) is secondary and late (Collingwood 1945:44), explains that "when a Greek writer contrasts [*physis*] with [*technē*] (i.e., what things are when left to themselves with what human skill can make of them), or [*physis*] with [*bia*] (how things are when left to themselves with how they behave when interfered with), he implies that things have a principle of growth, organization, and movement, in their own right and that this is what he means by their nature; and when he calls things natural he means that they have such principle in them" (ibid.: 81–82). In his commentary on Aristotle's idea of *physis*, Heidegger (1968) also concludes that the original meaning of the word *physis* was what has its *archē* 'principle of being' in itself and is opposed to what is made, which has its *archē* outside of itself, in the *technē*, that is, in human agency. These interpretations agree with the etymology of *physis*, which is "growth," and with that of *natura*, which is "birth" (Frisk 1970, 2:1052; Ernout and Meillet 1979:430).

It seems to me that the original, and still primary, notion of *physis* is not so far from the implicit notion of nature that we must presuppose to make sense of a number of Huaulu beliefs, evaluations, and metaphors. At any rate, my use of "nature" in the Huaulu context excludes the linkage of the two senses of this term, which Strathern (1980:195–96) takes to be the hallmark of the Western notion of nature and which she implicitly attributes to such users of the nature/culture contrast as Beauvoir, Lévi-Strauss, Ortner (1974), and Ardener (1975a, 1975b). Therefore when I say that menstruating women or women in childbed are associated in Huaulu thought with "nature," I am not implying that they are associated with Collingwood's "sum total or aggregate of natural things," or (even less) with Strathern's definition of "nature" as "a system with laws of its own": I am only pointing at an association with those spontaneous generative processes in the wilderness (and some other phenomena, such as the moon cycle,

supposed to be linked with them) that are both necessary and lim-
iting for human existence and human agency, and that are there-
fore viewed with ambivalence.

This also implies that I do not view the *analytic* (and yet real)
contrast nature/culture, especially when applied to the contrast
between certain male and female phenomena, as having the same
logical *extension* of the contrast wild/tame. Indeed, it is well
known that the "savage mind" uses phenomena of the wild to sig-
nify phenomena of culture. Not only do the Huaulu have "totemic"
animals, for instance, but animal imagery permeates shamanic be-
liefs and rites, as it permeated head-hunting practices. Animals,
vegetals, and other nonhuman phenomena, as practical and intel-
lectual correlates of human action or aspects thereof, may symbol-
ize them (cf. Valeri 1985). But it would be wrong to argue (as many
who attack the validity of the nature/culture opposition do) from
these correlations between phenomena in the wild and actions as-
sociated especially with males that no privileged association exists
between men and culture, and thus none exists between women
and nature. For this argument would confuse "nature" and "cul-
ture" as I have defined them here with "all things wild" and "all
things tame" respectively—a regrettable confusion that people
like Ardener and Ortner seem to share with their critics, and in
particular with some of the contributors to MacCormack and
Strathern's volume.

Analogously, one cannot claim that all things and events situ-
ated in the village evoke men alone, because there is an associa-
tion between certain fundamental qualities associated with the
village (controlling, transforming, willing) and masculinity. Of
course, it is recognized that women also transform, control, and
will, and that men also display passivity, lack of control, etc. After
all, both men and women die and both men and women work. But
this is not the point. The point is that there are here no equations
but significations. Specifically, there is a division of symbolic
tasks between men and women in certain contexts. Because men
and women seem to display in different proportions the two terms
of a duality present in every human, each becomes the signifier of
the term that he or she displays better. Indeed, we may say with
Durkheim that symbolic (he said "religious") thought "ne connaît

pas la mesure et les nuances . . . cherche les extrêmes" (1912 : 342). It looks for extremes to make its order as evident, and as unquestionable, as possible.

Conclusion

We have started from the problem: does the belief in female pollution imply inequality between men and women? We first discussed phenomena that seemed to indicate that it does not, since they are characterized by a certain degree of reciprocity between men and women in the matter of pollution. This seemed to suggest that gender pollution is similar to the pollution connected with the wrong association of food categories: it should be explained as a device for keeping categories of equal value distinct. It soon appeared, though, that in all other cases pollution between men and women is far from reciprocal.

This indicated that the ideology of gender pollution is not based on a logic of separation pure and simple, but on a hierarchy of states, processes, and activities. This hierarchy appeared to be reducible to one basic opposition of values: that between the superior value of intentional activity, control—symbolically associated with men—and the inferior value of passive undergoing, lack of control—symbolically associated with women. Normally the superior value is associated with superior power, but this association is contradicted by female generative processes, which are extraordinarily powerful but basically uncontrollable. A further contradiction is that men, as embodiments of intentional control, are conceived as autonomous; yet they are dependent on women's generative powers for their existence, which is thereby made contingent.

In sum, what is highest because most autonomous and most capable of asserting control is revealed by the phenomena of female fertility as ultimately heteronomous and passive. The powerful must avoid confronting its powerlessness: thus when women most evidently manifest their fertile power, together with its contingent and uncontrollable character, as in menstruation and childbirth, and especially in the bleeding that is their common de-

nominator, they must be removed from men and the village, which embody the power of control and autonomous self-determination. It is, then, the contradiction between power and value that creates pollution in this case. The term that is inferior is threatening to the superior because it undermines its claims to superiority; it contradicts its categorical definition.

In effect, the dangerousness of female fertility for men and society is the other face of its enormous importance. Society depends on it, and yet it includes features that are among the most devalued in the hierarchy of social values. Like the Hegelian slave, woman as generator is both the base and the bottom, so to speak. And as Rameau's nephew speaks the language of disintegration, woman's body speaks the language of pollution. Sometimes her implicit challenge even rises to her mouth and she laughs at men's pretentions, to which she normally bows (cf. R. Valeri 1977). She knows that she must be accepted, even if she will not be approved of.

Yet the very ambivalence and paradoxical status of female generative power at its most evident (in menstruation and childbirth) forbids considering its separation from men and village simply as a device for avoiding dangerous consequences for them. Precisely because men cannot do anything to transform and control this power, they must let it follow its course undisturbed. Although they may provide women with medicines to facilitate parturition, the basic idea seems to be that any exaggerated attempt by men to intervene in a natural process over which they have no true control is destined to be disastrous. The point is beautifully illustrated by a myth that I often heard not only in Huaulu but also, in somewhat different versions, in many other parts of Central Seram. Its popularity testifies to its importance, and the amusement that it always produces shows that it strikes a sensitive spot. I can give it here only in abbreviated form and without taking into consideration its variants.

A strong wind blows Ayafu away from Makwalaina, his native area east of Huaulu, and lets him fall near Besi.[12] The people of Besi have no knowledge of fire and must therefore eat their food raw or, when they attempt to "cook" it by exposing it to the sun, rotten. Ayafu teaches them how to make fire and how to cook food with it. In gratitude they give him in mar-

riage the two girls who had originally found him. The two become pregnant at the same time. When they are about to give birth, Ayafu sees his male in-laws sharpen their knives. He asks what they plan to do with them and they tell him that they will cut open the bellies of the two women in order to extract the babies. Ayafu thus realizes that the people among whom he lives do not know that birth takes place by a natural (i.e. spontaneous) process and substitute an artificial one for it. The result of this is that men, in order to have children, lose their women. Ayafu teaches them to let nature follow its course instead, thereby making women and men compatible.

In very Lévi-Straussian fashion, the myth associates the precultural state with the raw and the cultural state with the cooked. Fire, as the instrument of the fundamental transformation of nature by culture, stands for the transforming power of culture as a whole, a power that anyhow is characterized by "heat," as we have seen. Furthermore, since this "heat" is quintessentially "male," it is represented by a male fire-giver.

But the most interesting aspect of the myth is that it does not identify culture with transformative power pure and simple. In fact, the precultural men of Besi are not characterized only by their inability to transform what should be transformed—food; they are also depicted as transforming what should not be transformed—the spontaneous process of childbirth. The myth's message, then, is that the state of culture implies not only attempting mastery over nature by transforming it, but also recognizing the limits of transformative action. Profoundly, the myth connects an excessive male obsession with subjugating nature with the impossibility of the coexistence of men and women. Women are literally destroyed by men's mad attempt to substitute their artificiality for female "naturalness," which amounts to attempting to be, as much as it is possible, fathers without wives.[13]

The myth's point, then, is very much like the point of the whole ideology of warm and cool when applied to gender. Sometimes warm and cool, male and female, must be separated in order to preserve their distinctiveness, but they always imply each other. Women's generative processes do evoke the limitations of the controlling power of their male counterparts, but these limitations,

however threatening, cannot be transcended: men cannot do without women, without the contingent life that they bring to the world. In the end, men put aside the knife of action and bow to existence as it befalls them, as we all—women and men—must undergo it.

Doubling Deities, Descent, and Personhood

An Exploration of Kodi Gender Categories

Janet Hoskins

Janet Hoskins's paper concerns an Eastern Indonesian population for whom male-female difference is a socially and cosmologically important category. Gender dualism in Kodi is based on a presumption of unity. The gender differences that obtain in everyday life and receive special emphasis in life-cycle rituals are conjoined in the images of deities whose transcendence of mortal life is represented by their double-genderedness. Hoskins stresses the utility of gender for expressing a variety of relationships, including parallels, polarities, analogies, and asymmetries. One reason gender often operates as a metaphor for other relationships in Kodinese society, she suggests, is that it is not "the clearly dominant structure of inequality." Thus it can serve to express mutuality as well as asymmetry.

To demonstrate this point, Hoskins explores a topic of central importance in the region, namely, the cultural construction of potency. Her analysis reveals how power operates differently at particular levels of cosmic and social order. What is united at the highest spiritual planes must be kept distinct in the construction of society and personhood. Indeed, male and female, united at the level of deities, must be distinguished to generate the forms of exchange and alliance on which these systems are based (cf. Boon, this volume). The potency of uniting gender is tied to the regeneration of society and the cosmos and hence is subject to scrupulous ritual control.

Placed in the framework of a spiritual hierarchy in which gender is united at the highest levels and dichotomized at lower levels, the gender-crossing of Kodinese ritual specialists can be seen as a particularly potent manipulation of cosmic powers. Hoskins's account of ritual gender-switching for community-wide ritual should be compared not only to similar practices in Eastern Indonesia, but also to gender-switching in rice ritual elsewhere in the archipelago where dual gender classification is less pronounced, such as Tana Toraja (Coville 1988).

Hoskins's paper depicts the thoroughgoing gender dualism of Kodi culture that constructs the person as well as society and cosmos. Socially and cosmically the person contains male and female aspects—ranging from membership in both a patriclan and matriclan, to possession of a male soul and a female soul, each located at a different point on the head. The Kodi model of personhood differs dramatically from models of personhood found in areas of the archipelago where unitary centers rather than dualistic principles hold sway. Yet Hoskins's comparison of gendered agency in Kodi and Huaulu, where male agency is conceived as "active, mobile, and transformative" and female agency as "stable, unmoving, and substantive," identifies a major theme with local variations across the region.

Hoskins, like a number of other contributors to this volume, depicts a society in which men and women have different access to sources of spiritual potency. In Eastern Indonesian societies in which marriage is organized as exogamous exchanges between ancestral Houses, resident male members of each House exercise special ritual authority. Kuipers, Valeri, and Hoskins show us several forms such ritual authority can take. In the Centrist Archipelago, it would seem that ritual and spiritual authority is conceived to be more an individual achievement than a categorical prerogative; but in Eastern Indonesia, as Boon implies, the categorical separation of men and women and male and female principles seems inevitable when the politics of exchange, on which these societies are predicated, requires it.

The use of gender categories as a pervasive mode of social classification is familiar to us from many regions of Eastern Indonesia. They often appear to be simple "principles of difference" that are used to express any number of relations of contrast and complementarity in terms of the conceptual opposition of male and female. But it should also be obvious that the evocation of male and female principles in the building of a house, construction of an ir-

rigation system, and recitation of a myth has more far-reaching consequences than the simple quest for modes of classifying the universe into two parallel orders. Gender is a distinctive mode of classification because it can incorporate differences into schemes worked out in terms of polarities and analogies rather than hierarchy or one-sided domination. Yet, although at times male and female are only a sort of language for expressing relations, at other times they embody values with a more fixed weight and signification. The "value" of male and female is potentially asymmetrical and is linked to complex ideologies of the composition of the person.

It will be my argument in this paper that specific modes of gender classification in Kodi, West Sumba, are linked to a theory about the nature of power. In general terms, the pervasive Eastern Indonesian theme of sexual complementarity can be seen as part of a system of complementary dualism that makes the participation of both male and female elements a requirement for all creative production and a characteristic of overarching power. In its particular Kodi articulation, the regulation of this power is worked out differently in the spirit world (where gender attributes are joined in the names of the higher deities), in the ritual roles assigned to human functionaries (who are often called upon to cross gender boundaries), and in conceptions of descent and personhood (where an original blending of attributes passed along male and female lines is then socially processed to create separate men and women).

In effect, the argument will be that although the Kodinese maintain that we are born with both male and female elements (which make up both our souls and our bodies), we must learn socially to distinguish these elements and to control them. In specific periods of liminality or transition, a few human beings may cross over gender boundaries in order to create a concentration of various powers necessary for the shifting of the new year, reincarnation of the rice crop, or the journey of the dead soul. But the overall sense of the life-crisis rites themselves is to effect a separation in the human world between male and female roles, and to erect a boundary within the person between softer, vulnerable female parts (identified with "blood" and nature) and the harder, more durable male

parts (identified with fate and a role in patrilineal worship). The cultural divisions between inside and outside intersect with a gender division between powerful deities who fuse male and female aspects, intermediate spirits who bring these attributes together in communication, and lower-ranking spirits who are gender-ambiguous and rather inert.

We shall therefore explore Kodi notions of gender and power in four specific domains: the hierarchy of the spirit world, the gender-crossing of ritual performances, ideologies of descent and inheritance, and the social construction of the person through life-crisis rites. In each of these, the balance between gender fusion and gender separation is worked out a bit differently, and we can observe how the combination of male and female elements is linked to the invocation of power, but also to its distancing and control.

The Spirit World: Union at the Top

The 45,000 people of the Kodi district of the western tip of Sumba cling jealously to the worship of traditional spirits or *marapu*. At the time of my first fieldwork in 1979–81, eighty percent had not converted to any world religion. They lived in scattered hamlets inland from their ancestral villages, subsisting on dry rice and corn while participating in a prestige economy based on the circulation of pigs, cloth, horses, and buffalo at collective feasts and as bridewealth payments.

The Kodi spirit world has a complex chain of communication in which messages sent between people and deities are mediated through a network of intermediate spirits. These mediators are known as the 'lips told to pronounce, the mouths told to speak' (*wiwi canggu tene, ghoba tanggu naggulo*), who carry human entreaties phrased in humble language to the upper world. There is a series of gradations between the inside deities of the enclosed lofts of the high-peaked cult houses, the deities of the clan altar and ancestral village, and those of outlying hamlets and cultivated land. Those spirits which lie outside all these cultural boundaries are the wild inhabitants of the forests and fields, the seashore and the

ocean, who are associated with witchcraft, fertility, and the matriclans. Their power is contrasted with the order, control, and hierarchical organization of the localized patrilineages and their clan altars. Within each enclosure there is also an internal ranking built up around a stationary deity resident in the rock and tree altar (or sacred house pillar) and a number of intermediate spirits arranged around the periphery.

This spatial organization of the cosmology in terms of the degrees of "insideness" and "outsideness" intersects with a hierarchical arrangement of the spirit world that is coded in terms of gender (see the cosmology on page 278). All of the highest-ranking deities are double-gendered, addressed as mothers and fathers who together extend the blessings of prosperity, fertility, and personal concern to their charges. The house-pillar deity, for instance, who is directly addressed in divinations and seen to control human childbearing and health, is the Great Mother/Great Father (*Inya Bokolo, Bapa Bokolo*). The clan deity that lives in the large banyan tree planted in the center of each ancestral village is the Elder Mother/Ancient Father (*Inya Matuyo, Bapa Maheha*), who enforces ancestral law and presides over ceremonial feasts. Their deputy in the garden hamlet is the lower-ranking Mother of earth/Father of rivers (*Inya mangu tana, Bapa mangu loko*), who watches over those who work in the fertile inland valleys. Each of these deities is seen as a sympathetic divine parent, who can be called upon to come to the aid of human beings. 'Oh, Great Mother,' people call out in prayers, 'stretch out your breasts of cucumber milk to us! Oh, Great Father, open up your lap of wide thighs to us!' (*O, Inya Bokolo, pa malambe a huhu wei karere! O, Bapa Bokolo, pa ndilyako a baba kalu kenga!*)

Although Sumbanese double deities are not represented as either hermaphroditic or androgynous, their combination of male and female characteristics expresses a dynamic tension between the qualities associated with each sex, and the tense, electric balance between the two aspects of their being creates an image of power that has pan-Indonesian overtones (Anderson 1972). While their praise-names flatter the deities, who are described as all-powerful and generous, there is no iconic depiction of their double-bodied anatomy. The metaphorical parenthood is meant to suggest

DOUBLE-GENDERED DEITIES

The Creator:
Mother Binder of the Forelock, Father Smelter of the Crown (*Inya wolo hungga, Bapa rawi lindu*)

Guardian deities
of the clan altar:
Elder Mother, Ancient Father (*Inya Matuyo, Bapa Maheha*)
of the house pillar:
Great Mother, Great Father (*Inya Bokolo, Bapa Bokolo*)
of the hamlet:
Mother of earth, Father of rivers (*Inya mangu tana, Bapa mangu loko*)

FEMALE AND MALE SPIRIT INTERMEDIARIES

Female	*Male*
the female upright drum (*bendu*)	the male divination spear (*nambu*)
woman at the ceiling's edge (*Kahi rou kawendo*)	man on top of the house (*Ndelo toko uma*)
old woman at the garden's gate (*Njoki watu kareka*)	male lord of cultivated land (*Ringgi mori cana*)
female digger of graves (*Lyale rate wu palolo*)	male maker of tombstones (*Cogha hondi wu panduku*)

Anthropomorphized objects used to communicate with the spirit world are in this category, as well as peripheral spirits who skirt the margins and boundaries of the house and the upper world, the cultivated garden and wild fields

FEMALE AND MALE ANCESTRAL FIGURES

Female	*Male*
Mbiri Kyoni—the rice goddess	Ra Hupu—lord of lightning
Inya Nale—sea worm creator	Lete Watu—trickster who acquired rainfall in exchange for fire
Warico Lolo Kapadu—old medicine woman	Pala Kawata—python of fertile fields
Mbila Tamaro—the bride of a crocodile	Rato Bokokoro—gatekeeper of the waters of the heavens

Female ancestral figures maintain links with the earth and sea, while male ones travel to the sky

GENDER-AMBIGUOUS SPIRITS OF WEALTH OBJECTS

The souls of rice and corn, livestock and cloth, as well as named heirlooms (gold, weapons, porcelain urns), and the altars used for hunting, planting, and domestic offerings

These lower-ranked souls are made up of an undifferentiated and unpersonified spirit substance

an abiding concern to protect and punish, nurture and control their human charges like so many children.

This metaphor is extended all the way up to the distant, rather otiose Creator figure, who is referred to as the Mother Binder of the Forelock, Father Smelter of the Crown (*Inya wolo hungga, Bapa rawi lindu*). The female activity of binding the hairs at the forelock (much as in everyday life women bind the threads of *ikat* cloth before dyeing it) is paired with the male activity of smelting metal to form the harder skull at the crown. The female weaver and male metalworker also combine to create the individual soul, which for the Kodinese has a two-fold aspect. The softer, vulnerable female soul or *hamaghu* ('life force' or 'vital energy') is anchored at the soft spot on the head or fontanel and falls over the forelock.[1] The more durable, hard male soul is located at the back of the crown or *ura ndewa* ('spirit swirls'), where the swirls of hair may be read to determine one's fate or destiny. It is the female soul that may be attacked by witches or displaced during illness, whereas the male soul remains stubbornly attached to the head and provides signs of an unalterable life pathway. We shall return to the implications of the two-fold creation of each human being later on.

Below the highest-ranking spirits with double names (which I have called "deities"), we find a middle rank of anthropomorphized objects used in communication with the spirit world (such as the divination spear, the singing drum, and other musical instruments) and peripheral spirits. These mediators are not addressed as respected mothers and fathers, but as peers and equals who are given female and male names in couplets that designate their common function. Thus, the spirits who sit on the top of the roof to "catch" flying souls that come down after a bad death or other misfortune are called 'Kahi [a woman's name] at the thatched eaves, Ndelo [a man's name] on top of the house' (*Kahi rou kawendo, Ndelo toko uma*). The spirits who watch over the large megalithic tombstones in the center of the ancestral villages are called 'Lyale [a woman's name] who dug the earth for the graves in a row,' and 'Cogha [a man's name] who lifted the stones for the tombs in a line' (*Lyale woki cana la rate wu palolo, Cogha lengga watu la hondi wu paluku*). The guardians of the garden plots are known as 'Njoki who lives by the stone gate' and 'Ringgi, lord of cultivated land' (*Njoki watu kareka, Ringgi mori cana*). Njoki and

Ringgi skirt the margins and boundaries between the cultivated garden and wild territory, just as Ndelo and Kahi control the line between the house and the upper world, and Lyale and Cogha the line between the living community and the dead.

The drum used in singing ceremonies and the divination spear are each assigned a specific gender identification, but they are ritually paired with contrasting elements in order to allow for communication with the higher powers. Thus, the drum is portrayed as a lovely young woman ('you with the full chest, you with the slendar waist,' *yoyo na tamboro kuru, yoyo na taranda kenda*). Her female cavity must be pierced by the male voice of the singer ('pierced by the cockatow with the long teeth, bored by the parrot with the large beak,' *pa toghi kyaka marou ngandu, ha bola pero manumba ghoba*) before the two can travel together to the upper world to bring human entreaties to the attention of the divinity. In a parallel fashion, the divination spear is addressed as the 'Savunese man, divination man' (*mone haghu, mone urato*) who must be united with bundles of (female) areca nut before he can be sent off to 'bring the voices across the waters, carry the message over the bay' (*tanggu ndoru mbaha, hambewa do menanga*), as an emissary to the higher deities.

Various ancestral figures may also be invoked in male-female pairs. Most of the spirits of the dead are simply referred to as 'dead mothers, dead fathers, dead grandparents, dead forebears' (*inya mate, bapa mate, ambu mate, nuhi mate*). But when a specific personality is called upon—either a mythical ancestor or a recently deceased parent or grandparent—his or her name will conventionally be paired with that of the spouse. When the person is unmarried, often a brother or sister will be substituted. Thus, the ancestral figure who controls lightning, Ra Hupu, is called down along with his sister Tila, who supposedly held his magic nets when he roamed along the coast casting for human and animal victims (*Ra Hupu watu, Tila danga dala*, 'Ra at the end of the stones, Tila stringing out the nets'). Male figures control the sky powers of thunder, lightning, and rainfall, but female figures are associated with rice, the sea worms (harbingers of a successful harvest), and garden magic.

At a lower level, the spirits that live in heirloom objects (gold,

weapons, sacred urns, or cloth) and various smaller altars used for hunting or planting are gender-ambiguous, since they are made of a more inert and undifferentiated "spirit substance." Of course, many of these objects can themselves take on a male or female aspect through their use in complementary exchanges (especially marriage payments), but questions to informants about the gender of the spirits themselves will only elicit uncertain giggles. Gender characteristics themselves are part of the process of anthropomorphism that grants human-like powers to some inanimate objects, and shows them to be part of a wider power system that ultimately leads back to the parental authority of the Creator and major deities.[2]

Gender-Crossing and Ritual Specialists

The double-gendered deities of the upper world are addressed and placated by human ritual specialists who often cross gender boundaries in specific behavior patterns during liminal phases. Kodi has no permanently liminal figures, such as the transvestite priests known in some other areas, but there are many persons who may assume a gender-ambiguous role for a short period when it is necessary to concentrate power on a certain important undertaking.

The most famous of these persons is the highest-ranking priest in the whole area, the Rato Nale or Priest of the Sea Worms. The holder of this hereditary office, usually an older man, remains strictly confined within his cult house for a period of over a month during the preparations for the festivities held to welcome the swarming of the sea worms along the western beaches in February. He is forbidden to eat corn, is generally silent and restricted in his movements, and is forced to "brood" over the coming of the new year as if the year itself were his own offspring.

As in the metaphorical English extension of the term, the Rato Nale's "brooding" is held to concern weighty matters, and if he should fail to follow the prescribed rules of conduct, the whole region would be swept by whirlwinds and ravaged by lightning. Traditional ritual language describes him as the 'hen who broods over her eggs, the sow who calls out to her young' (*a bei myanu na ka-*

bukutngo taluna, a bei wyawi na karekongo anana), using the couplet that also designates a woman at childbed or a widow mourning the death of her husband. The woman who conducts the planting ceremonies within each household at the beginning of the "bitter months" of ritual silence in October is similarly constrained to follow the rules of conduct. This peculiar combination of power and immobility, passive authority and constrained action, is obviously a lietmotif in Kodi mediations of rites of transition. The Rato Nale's paradoxical position can only be understood in terms of the wider system of complementary dualism and diarchy of which it is a part.

The Rato Nale's confinement is specifically counterposed to the mood of license and permissiveness that pervades the other preparations for the collection of the *nale* 'sea worms.' The month of February is marked by unusual conviviality and festiveness, as several thousand inhabitants of the inland garden hamlets throng back to their ancestral villages. They come bringing with them fine textiles and ornaments, fresh betel peppers and areca nut, chickens dangling by their feet and sacks full of rice to be cooked and offered to the deities of their ancestral houses. For four months, they have been forbidden to sing, dance, beat the gongs, or kill large livestock at feasts because of the intense labor required to start the new crop. Now, a month or so before the young rice sprouts will be golden and ready to harvest, they are holding these festivities in anticipation of the delights to come. Groups of young boys and girls roam along the beaches at night, teasing each other with exchanges of lewd songs and occasionally disappearing into the dunes. Their very gaiety and abandon is said to breathe new life into the young rice still in the fields, and the abundant swarming of the sea worms the next morning will not only predict but actually *depict* the later size of the rice harvest.

The restrictions placed on the Rato Nale, therefore, serve to safeguard the rice harvest to come, and protect the whole region from the ravages of weather and the irregularities of the agricultural calendar. The swarming of the multicolored sea worms is seen as a harbinger of a successful harvest and the renewal of the earth's fertility for the coming year, so the Sea Worm Priest is placed in the Frazerian position of representing the mythic death

of the rice goddess in human form.[3] As the guardian of the community and the main actor in the offerings to come, he controls a source of life and prosperity for the whole region. When there has not been enough rainfall the sea worms do not swarm in sufficient quantities, and people know that the harvest in April will be a poor one.

The dangers that stalk the whole region in the months before are most dramatically portrayed in a competitive horseback battle called *pahola*, which is carried out between the clans of either side of the river on the morning that the sea worms arrive. Close to five hundred horses and riders may participate in the spectacle, dashing into the center of the playing field to hurl wooden lances at their opponents in order to knock them off, much as in medieval jousting. Although mainly an occasion for an entertaining and exciting display of speed and horsemanship, these battles can also cause injuries, blindness, and even death. A fatality on the pahola field, such as the one that occurred during my own fieldwork in 1980, is inevitably interpreted as expressing the displeasure of the ancestral spirits that not all the proper restrictions were observed.

The sea worms themselves are addressed as a female deity, Inya Nale, who created them from the transformed locks of her long flowing hair, which floated to the surface after she was sacrificed to end a long famine. With the collection of the sea worms, eaten as a condiment by the local people, came the promise of increased rainfall and the first abundant rice crop in many years. Through this myth, Inya Nale's story parallels that of the Kodi rice goddess, Mbiri Kyoni, who was also sacrificed and transformed in order to feed a starving populace. The ritual confinements of the Sea Worm Priest before the arrival of the sea worms and of a woman in each household after the planting ceremonies thus appear as a form of mourning and as the concentration of reproductive energies before the reincarnation of the goddess concerned in the form of either sea worms or young rice sprouts.

The day that the sea worms will swarm is counted out by the Sea Worm Priest in conjunction with his ritual partner, the Rato Padu or 'bitter priest.' Whereas the Rato Nale inaugurates a period of permissiveness and plenty, his counterpart "brings down the prohibitions" in October that will shroud the region in silence for

the four 'bitter months' (*wulla padu*) that are required for the young rice crop to reach maturity.

Several weeks after the nale festivities, when the new crop is golden on the stalk and ready to be harvested, a parallel series of rites must be conducted to offer the first fruits to the appropriate ancestors and make them 'bland' (*kaba*) and edible. The ritual transition from bitter to bland is also effected by a ritual specialist who is symbolically identified as female, or rather by a peculiar oscillation of behaviors defined as both male and female. The harvest priest dresses up in full battle dress to carry the first paddy sheaves out to the rock altar in the fields, donning his barkcloth headpiece, sword, and spear. But then the offerings of cooked rice are prepared by the men and carried on their heads, in a fashion that in everyday life is identified as womanly.

Most interesting for our purposes is the fact that the office of Rato Nale or Sea Worm Priest has not always been male, but was for a long time held by a famous priestess with the highly suggestive name of the original rice goddess, Mbiri Kyoni. "Old Woman Kyoni," as the Kodinese still refer to her, was a widow who served as the high priestess of the region's calendrical festivities from the turn of the century to the period of the Japanese occupation. Her long illness and eventual death are associated in the popular imagination with the hardships and privations of that era, fusing myth and history in the metaphor of the diminishing fertile force of the region that accompanied her diminishing health. Although at the time of my own work the Rato Nale in each of the three regions that celebrate the rites was male, the office is open to persons of both sexes, selected by divination from the descendants of the sea worm cult house. Mbiri Kyoni herself seems to have learned the necessary prayers and invocations from an apprenticeship to her husband that lasted for several years, and she did not assume the office until after his death and her own passage through the rites of seclusion and confinement prescribed for widows. Perhaps her advanced age and ritual expertise qualified her for this prestigious but gender-ambiguous role in a way that has not been duplicated by contemporary women.

The position of the Sea Worm Priest is, however, the only instance I know of anywhere on the island where a woman has held

a position of such importance in the patrilineally organized fes-
tivities of the ancestral cult. In other parts of Sumba, the promi-
nence of this famous priestess was often remarked upon, and even
attributed to the also exceptional existence of matriclans on Kodi—
a notable anomaly on an island otherwise characterized by patri-
lineal descent and frequent asymmetric alliance. Concerning other
important ritual offices and types of knowledge in Kodi, we find a
more familiar pattern of women being not so much excluded from
as culturally discouraged from assuming the most central and
prestigious roles.

Thus, during the period of my fieldwork I met many women
who were gifted storytellers, singers, and even famous chanters of
the dancing music used at night-long buffalo feasts. But there were
no women diviners, since the question-and-answer format requires
a more direct dialogue with the ancestral spirits. Women also did
not join the more politically charged arena of ritual oratory. Their
roles as singers and storytellers placed them in a cultural category
of good stylists rather than innovators or creators of a text. They
took the words given to them by a male orator and arranged them
to fit the melodic line and rhythms of the gong, performing them
in a manner that was pleasing to the ear and faithful to traditional
canons. Male ritual speakers, on the other hand, used occasions
for political oratory to make rivalrous claims to land, office, or
local leadership—thus supporting a cultural image of their sex as
the more adventurous and ambitious one.

Women are always the key ritual actors, however, in the plant-
ing and harvesting rites held in each individual household, and a
single woman—usually the mother or widow—must assume the
most stringent mourning taboos for a period of four days after bur-
ial. In Kodi mythology, the female spirit guardian of the rice crop
is represented as the grandmother of Mbiri Kyoni, the sacrificed
rice goddess. Each year she rejoices when the new sprouts appear
above the ground because they contain the soul of her lost grand-
child. She continues to protect and nourish the young rice souls as
if they were children throughout the cycle. The nurturant bonds
between mother and infant are repeated symbolically in the en-
closing, encircling movements of the women in agricultural rites.
At planting, a married woman in full ceremonial dress must circle

the fields clockwise, gradually spiraling toward the center as she repeats a charm to keep away the birds, insects, snakes, and mice that might damage the rice seedlings. At the harvest, she circles in the opposite direction, coming out from the seed platform in the center and "trapping" the rice souls with her small knife to keep them from escaping into a neighbor's fields.

The techniques of "stealing" the souls of rice by coaxing them away into another field are associated with specific magic rice baskets usually passed on from mother to daughters, along with the teachings and spells used in conjunction with them. Some of these baskets (*kanehgu pangape*) are said to "beckon" to the rice souls in a seductive fashion, and the rice-stealing may be accompanied by dancing and singing in an alluring fashion. For this reason, the months when the young rice crop is growing are shrouded in a strict silence by the prohibitions of the bitter months. Rice-stealing magic is one of the secret techniques learned from the spirits of the outside, forces of the wild that are fundamentally at odds with the order of the ancestral centers. These techniques form part of the rather small domain of specialized female knowledge, a domain that includes the secrets of weaving and dyeing cloth, massage to ease childbirth or treat barrenness, and some medicinal practices linked to contraception and abortion.

The importance of women in household rites of planting and harvesting is restricted to the domestic sphere, however, and we have already noted that male ritual specialists are used at clan-wide harvest offerings (*kahale*) and the ceremonies to begin the "bitter months" of the planting prohibitions. The reason that women are the ritual actors in smaller-scale rites whereas "symbolically female" men are the actors in region-wide ones is presumably related to the intersection of gender systems and prestige systems. When the health and prosperity of only a single family is at stake, onerous periods of confinement and restriction are best borne by the women of the household. In earlier times, the periods of "mourning" for a broken grave stone or a burned-down lineage house were observed by the seclusion of a female slave, who was forced because of her lowly position to bear the heaviest ritual burdens. Nowadays, sometimes even a symbolically female inanimate object—such as the cotton spindle and rolling board (*kinje*

mono kabirio)—can be substituted for a woman and kept in a secret place while preparations for a ritual transition are made.

But when the safety and fertility of the whole region is in danger, the task of bearing that burden is generally entrusted to a man. In return for observing a month-long confinement and various food taboos, he receives a tremendous amount of respect and many ritual gifts of chicken and rice. But the Rato Nale is powerful not only because he is a man, but because he has crossed the normal gender boundaries and demonstrated his ability to unite both male and female values in a single whole. The pervasive principle of double-gendered power is represented in his behavior and his control over two opposing sexual energies, a passive control that is necessary to "anchor" the region soundly in the season of strong winds, and to embody the dynamic, regenerative potential of the rice crop, the rains of the coming year, and regional rites of renewal. The male ritual specialist who consents to adopt behaviors of confinement, immobility, and a body posture associated with women is marginal to normal social categories and able to rise above them. Likewise—although it is a much rarer phenomenon—the female priestess who "crosses over" into the male arena of patrilineal ancestor cults transforms her own sexual identity into a more complex and powerful combination of male and female aspects.

In terms of the indigenous division of political and ritual powers, diarchic principles emerge in the opposition of the passive, silent authority of the Sea Worm Priest and the more active, worldly power of the lineage house delegated to enforce these edicts. Mythological accounts that explain the coming of the sea worms to Kodi recount a division of powers among two brothers. Rato Mangilo, the elder brother, was given the "immoveable urn" of calendrical authority and told to sit firmly among his valuable objects so as to guard them from outside intervention. His task was elaborated in ritual language as the anchor of traditional authority and the controller of the passage of the seasons:

Yo dikya na kandi a ngguhi nja pa dadango	You are the one who guards the urn that cannot be moved
Yo dikya na dagha a pengga nja pa keketo	You are the one who watches the plate that cannot be lifted

Na ghipo ndoyo la tana nale	Who counts out the year in the land of sea worm festivities
Na baghe a wulla la tana padu	Who measures out the months in the land of planting prohibitions
Na ketengo a rabba rica	Who holds (the right to) the rica [wooden] trough
Na ketango a keko nalo	Who grasps (the power of) the wooden sea worm trap

Rato Pokilo, the younger brother, received a roaming horse (*ndara halato*) and was given the task of policing the region to guard against theft or trespassing into another man's land. The passive, unmoving authority of the great urn was contrasted with the active, mobile role of the mounted rider, and Rato Pokilo's task was further elaborated as follows:

Yo dikya a ndara ndende kiku	You are the horse with the erect tail
Yo dikya a bangga mete lama	You are the dog with the black tongue
Na halato kataku loda	Who roams over the posts in the region
Na halato kataku pada	Who roams past the posts in the area
Na doda marada	Who crosses the fields
Na pepe kapumbu	Who travels through the elephant grass
Na haranga manumbu likye	Who sees the crossed boundaries
Na haranga mangora mango	Who sees the garden that bypasses its limits

The two brothers settled in the ritual center of Tossi, with Rato Mangilo in the Sea Worm House at the head of the central square, and Rato Pokilo in the house of discussions and debates (Uma Kandi Pulungo) at the base of the square.

Appropriately enough, when the Dutch first gained control of the area in 1909, they asked the people of Kodi to gather together to select a *raja* who would represent them to the colonial government and serve as district administrator. Since there had been no centralized ruler of the domain in earlier times, the prominence of Tossi in the sea worm festivities made it the logical place to meet.

A descendant of Rato Pokilo, the younger brother, was chosen as the first head of government and expected to continue the active, enforcing role of his ancestor. The descendants of Rato Mangilo, the passive, symbolically female elder brother, did not object, but continued to enjoy a certain spiritual authority and superiority because of their preeminent ritual role. As in all dualistic systems, the silent residual powers of the female term were not completely eclipsed by the more visible and mobile male term, but rather were transformed in their functions and brought more clearly into line with our own notions of the separation of sacred and secular, church and state.[4]

Ideologies of Descent and Inheritance

Ideas of the double nature of the person and of power are also played out in Kodi social organization. The region has long attracted the attention of Dutch structuralist scholars because of its unusual system of double descent. In fact, it was in Kodi that van Wouden hoped to find the most intact version of what he believed to be the original proto-Austronesian form of dual organization (van Wouden 1935). Alas, since the Kodinese differ from many other Sumbanese peoples in their failure to practice asymmetric marriage, they did not fully bear out the famous "Leiden hypothesis." But van Wouden's own disappointment allowed him to understand more fully how dualistic principles expressed in systems of descent could be part of a system of structural variations throughout the eastern archipelago, not necessarily derived from any single model created out of historical conjecture (van Wouden 1977).

Double descent[5] still provides a convenient locus from which to explore the linkages between gender constructs and types of political power, since it presents the contrast between localized patriclans and dispersed matriclans in terms of male and female transmission of qualities. Rights to land, ritual office, livestock, and lineage houses are all passed along the patriline, but certain types of magical knowledge, food taboos, and personality traits are passed along the matriline. Only patriclans or *parona* are formal corporate groups that convene at marriages, funerals, and prestige

feasts to discuss transfers of women, livestock, and objects within their sacred patrimony. But matriclans (*walla*) are linked to the transmission of witchcraft, magical skills, and secret arts of weaving and dyeing cloth.

Although both patriclans and matriclans are supposedly exogamous, the patriclan concern with exogamy seems to focus mainly on the direction of marriage payments, while the matriclans are concerned with violations of incest taboos. This is because the matriclan defines a relationship through ties of blood (*ruto*), whereas the patriclan is a socially created corporation united through the worship of a specific group of ancestors. The patriclans have political, ritual, and jural authority, so membership can be transferred by legal fictions and ritual mediation. One can be adopted into a parona or patriclan, but not into a walla.

The matriclans are based on a unity of blood, symbolized by the substance formed within the mother's womb, presenting a physical reality that is inalienable. If sexual relations should occur between members of the same walla, the very blood of the two partners concerned is said to "rise up in protest," producing high fevers and hemorrhaging. It is impossible to mediate the problem in any way, and childbirth difficulties, illness, and even death could result.

The patriclans are, in contrast, social groups united in the worship of common ancestors.[6] Incest within the patriclan, although discouraged, is acknowledged to exist, and if it becomes desirable to turn an informal liaison into a marriage, the girl can be "adopted" into another clan with a small sacrifice and the transfer of the brideprice payment. Although new wives are formally incorporated into the patriclan of their husbands and join them in their ancestral rites, when sexual relations occur between a man and the wife of a fellow clansman, they are classified as adultery rather than incest. Only when there is a previous tie of "blood" (that is, a common walla affiliation) are supernatural sanctions involved in addition to the payment of livestock compensation (*kanale*).

In essence, incest that fails to respect the boundaries of patrilineal groups is interpreted as a violation of a cultural and social law, and so is subject to ritual mediation, whereas incest that fails to respect the boundaries of matrilineal groups is interpreted as a

more serious violation of natural physiological processes. The association is also found in the relation of the two different ways of reckoning descent to ritual: There are no marapu, or named ancestral deities, associated with the wallas, and the founding ancestresses of these groups are not named or propitiated in public ceremonies. Instead, the first walla women are said to have been part of the autochthonous population, which had extensive knowledge of witchcraft, herbal medicines, and poisons, but did not yet know about agriculture or the use of fire. Their cult, to the extent that it is formalized at all, lies outside the boundaries of the clan villages in relations contracted with wild spirits—powers resident in forests and streams, coral reefs, and the depths of the sea. The patrilineal ancestors, founders of the political-religious apparatus of Kodi society, can be publicly worshipped, but the walla ancestresses, as part of the still enduring powers of "the wild," cannot.

Gender concepts in Kodi are articulated in a botanical idiom, which forms an ironically appropriate "root metaphor" (Ortner 1973) for the whole descent system. Female descendants are described as the flowers (walla) that bloom along the bough of a given ancestral branch, while the male descendants are the fruit (wuyo). Both spring from the same trunk (punge ghai), but only the males will pass on the seed to future generations. The female descendants of each patriclan go on to "bloom" in other villages, and it is the path of these successive "bloomings" that is traced by the matriclan, whose name also means 'flower' or 'blossom.'

Individual matriclans are given the personal names of their founders, while individual patriclans are named after the sites of their ancestral villages or parona. Thus a person might be a member of the matriclan Walla Loghe, supposedly descended from an early woman named Loghe, and of the patriclan Bondo Kawango ('great banyan tree'). A few less socially respectable matriclans bear the names of neighboring districts from which wives or slave women may have been obtained, or of an animal that was said to have cohabited with the original ancestress. This is the case of Walla Kolongo ('the sparrow clan,' whose members do not eat sparrow meat) and Walla Huhu Wawi ('the pig suckling clan,' whose members will not hunt the wild boar, since one was supposedly raised by an ancestress as her own child). Other walla tales reflect

the "pervasive spirit of slander," which van Wouden noted in his original investigations (van Wouden 1977), by associating these original ancestresses with incest violations, antisocial acts of defamation, and copulation with wild animals.

Since walla membership often contains clues to descent from an outside population, generally suspected of being slaves or witches, people are reluctant to discuss their walla affiliations, and will usually only refer to the wallas of others in the course of malicious gossip. Young courting couples may discuss the matter in a few nervous giggles before their relationship progresses far enough to endanger their own health and well-being, but one's matriclan is never as publicly known as the patriclan. It can therefore be the subject of rumor and speculation even for very prominent families, who may have had an ancestor who was duped into marriage with a woman from a lowly walla.

The danger is particularly great concerning women who are members of Walla Kyula or Walla Ngedo, the two matriclans most strongly associated with the hereditary transmission of witchcraft. Although often very beautiful and seductive, witch women are known as *tou marango, tou hamoro,* 'evil-doers and eaters of men.' They are reputed to engage in secret, nocturnal cannibalism, when their souls leave their bodies and fly through air to devour the inner organs of their enemies. They can be seen as flashes of light, or in the form of wild cats, snakes, lizards, mice, or birds. The *kyula* itself is a small blackbird whose song, heard during the early hours of the dawn, is a sign that someone in the house will soon die. Some people trace the origin of Walla Kyula to a secret pact negotiated with this bird by a woman who sought the power to harm her fellows. Ever since this relationship was established, her descendants have been very touchy and quick to feel insulted, so that people must always give them anything that they desire. Their power to fly comes from the anus, which produces a 'flower of fire' (*walla api*) that projects them like rockets when they wander about for nefarious purposes. They often seek to seduce and marry important men or priests (*rato marapu*), so that they can sap their husbands' power with nocturnal feedings until they are thin, sickly, and unable to resist their desires.

The locus of witchcraft is in the realm of the wild, deep in the 'forest full of wild spirits, the fields full of disease and epidemics' (la kandaghu danga yora, la marada danga pungo). Women of witch-related wallas may try to infiltrate the sacred centers of the ancestral villages in order to wreak havoc on the prevailing social order. The Kodinese see the cult houses of the sea worm and harvest rites as the locus of fertility and prosperity, which is threatened by the divisive sexuality and wanton ambition of the witch. Although there is rarely much consensus about who really is a witch (and those accused by others will usually deny it), the uncertain and concealed nature of walla descent makes it a convenient mode of explanation for evil elements within the central cult houses. Within the idiom of the hereditary transmission of traits, female-linked powers are seen as coming from the outside and the periphery, while male ones remain securely on the inside.

Because of the structure of the descent system, the ties established through men and women operate very differently in Kodi society. Patrilineal clan ceremonies establish and legitimate principles of rank, inheritance, and succession, while the matriclans are associated with the diffuse, controlled vitality of the wild spirits. Prayers addressed to the ancestral "spirits of the inside" stress hierarchical and collective relations with the human community traced through male descent. Pacts with the "spirits of the outside" are often sources of female magic and illicit knowledge, and cut across social boundaries horizontally to provide the possibility for individual achievement in a more direct and worldly sense.

Relationships through men serve to order society *vertically* in three senses. (1) They link people *back through time* by delimiting lines of descent that organize the transmission of ritual prerogatives through the generations. (2) They relate the human order to divinity and to ancestral origins, providing a cosmological justification for the contemporary division of land and powers. (3) They dramatize hierarchical relations in both human and spirit worlds at large-scale ceremonies and feasts.

Relationships traced through women, on the other hand, order Kodi society in a *lateral* sense in three ways. (1) They link people of different patriclans *across through space* because of common

matriclan membership, affinal ties (to the wife's village of origin), and sibling ties (to the sister's village of marriage). (2) They form personal networks of walla members who share physical substance (blood) but no social or ritual corporate functions. These informal networks are often said to form the basis for individual power manipulations and status-climbing. (3) Relationships traced through women work against notions of rank and lineage opposition by providing a cross-cutting system of kin ties that are essentially egalitarian.

The overall effect of this aspect of complementary functions is a sort of "perpendicular" intersection, with vertical, patrilineal relations organizing some domains and lateral, woman-defined (although only sometimes matrilineal) relations organizing others. The Janus-faced genealogies of Kodi informants are oriented in very different directions, since male ties trace transmission of land, office, and privilege, whereas female ties relate to sex, marriage, and personal characteristics that are believed to be transmitted by blood.

The inalienable, substance-sharing component of walla membership may seem to be at odds with its description as a "flowering" of the line that does not produce descendants. In fact, however, the descendants who are produced for the parona or patriclan are social descendants. Their membership in the clan is socially constructed through the ritual cycle that brings the newborn infant into the cult of his patrilineal ancestors. Children are biologically created within the mother's body, but they must then be socially re-created outside her womb so that they can take part in ordered social relations. The rites of the life cycle are concerned with establishing the child's membership in its paternal descent line and protecting it from various wild, outside influences that may come from its maternal descent line. As such, they mediate between the parona and the walla to create a boundary within the person, constructing the child "socially" in order to protect it from the dangers of its biological "nature." It is to this process that we shall turn now, to see how gender and power are finally separated in the individual human being after being united at the higher levels of the cosmos.

The Life Cycle and the Social Construction of Male and Female

The rites of the life cycle can be divided into two separate complexes. The first, which includes the rites of childbirth, cutting the first hairs, and naming, is concerned with socializing the newborn child and bringing it into the human community from a previously wild, animal-like existence. These rites incorporate the magical use of certain oppositions, such as hot and cold, "cooling" coconuts and "warming" baskets, which serve to capture these qualities and communicate them to the infant. The second complex, including later sex-differentiated hairstyles, tattooing, and circumcision, serves to mark gender identity and marital status. The Kodinese say that the birth and naming rites allow the child to join its ancestors in the afterworld, since it has been culturally identified, whereas the later rites of puberty and maturity construct social notions of male and female that fill out this cultural identity within the balanced relations of sexual complementarity.

As soon as a woman begins to feel labor pains, her husband must assume the normally female tasks of fetching water and firewood, as well as plaiting a small basket of raffia leaves in which to store the placenta. Two midwives use traditional massage techniques to press the child out, severing the umbilical cord with a sharpened piece of bamboo as its name is pronounced. If the child is not named promptly enough, it can be "saddled with a spirit name, a name from the forests and the long grass." A wild spirit could creep in at this initial, unprotected stage, recruiting the unwitting child to the forces of witchcraft and the wild.

The child is not really considered to have joined the human community until it has been formally incorporated into the clan in a ceremony where a chicken is offered to the deities to announce the child's arrival. If it should die before this day, the child is buried beneath the house like a miscarriage rather than given a separate grave. The understanding is that its soul will remain inside the house and come into the mother's womb again for a later reincarnation. The naming rite also gives the child a place within the world of the ancestors, and extends their protection over the

child to ward off illness and hardship as long as ancestral law is respected within the house.

Parallel to the human ceremony, which involves the exchange of a cloth brought by the mother's brother with a bit of gold provided by the host, there is another, invisible spirit ceremony where the marapu together decide on the child's fate. It is here that the seat of destiny is established at the swirls of hair (*ura ndewa* or *ura kataku*), the "male soul" of each child. And it is also here that the child's vulnerability and life force are anchored at the fontanel, the "soft spot" over the brow (*hungga*) where the *hamaghu* or 'female soul' is located.

At the naming ceremony, the child's first hairs are cut off and carefully stored with the severed navel cord in a coconut shell. These hairs are referred to as the *wulu kataku* or 'head fur,' and sometimes also as the *wulu wali la kambu dalo* or 'fur from inside the womb.' The term used is the same as the one used for animal fur, and different from the word used to designate human hair (*longge*). The removal of these hairs thus removes the animal character of the child and allows it to be integrated into the human world. Once they regrow, these hairs will be allowed to cover the soft area where the hamaghu resides, as well as the firmer seat of the ura ndewa. Rather than being associated with the powers of the wild, these hairs are now among the attributes of a being with a soul.

The coconut shell containing the navel cord and first hairs is placed in a cool place in the house (usually on the pillar ring of the right front pillar, the *mata marapu*) until the child is a few years old. Then, it is brought back to the ancestral clan village and placed beside the sacred source. The clan village is referred to in ritual discourse as the "site of the first rings of hair, the site of the severed navel cord." Placing the coconut-shell container there legitimates the child's membership in his or her father's clan, and establishes inheritance rights. If a child is ever adopted into another clan (or a bride is shifted into another clan to permit marriage with a fellow clan brother), this is described as "moving the bundle of hairs and navel cord" from one site to another. As long as the bundle remains beside the ancestral shrine, however, it is "protected from the rays of the sun and shielded from the falling

rain." Its destiny is merged with that of the wider group and brought into the shade of the large banyan tree that forms the clan altar. Through both the ancestral name and various nicknames that link this name to others, a person is tied to specific dead forebears and living relatives who are supposed to be solicitous of that person's welfare and eager to help in times of hardship. The person may be reminded of the ancestors by the name relationships in ritual invocations, where the descendant is referred to as the 'young goat come to replace the name, the young rooster come to stand for the namesake' (*ana pakode helu ngara, ana maghailo ndende tamo*). Use of such names further stresses the familiar theme that later generations are those which "replace the breath of those who go before, giving birth to those who will take up their place." The continuity and unity of the community is reasserted through its naming practices.

Gender Differentiation Through Markers of Maturity

The hair of a newborn infant is allowed to grow back so that it covers the forelock (hungga) and protects the female soul (hamaghu) or life force that resides there. The rest of the hairs continue to be shaved off until the child is old enough to crawl around on its own. Just as the first hair-cutting ceremony marked socialization into the human community and acquisition of an ancestral soul, later hairstyles come to mark sexual identity and marital status. Unmarried girls wear small cheek curls over each ear and a single longer lock at the forehead (*longge hungga*). The rest of their hair is kept short around the face and unparted. Unmarried boys do not wear either the cheek curls or the forelock curls, but they do keep the hair around the face short, while the hair at the back of the head is allowed to grow long and loose until they reach maturity.

Other cosmetic measures may be used to enhance attractiveness as puberty approaches: traditionally, the ears of both boys and girls were pierced so that they could wear the pandanus-leaf ornaments of the sea worm ceremonies (*habu heghu*, described in Riekirk 1940) and the heavy gold ear pendants given as brideprice.

Nowadays, only girls continue to pierce their ears, and many older women still have greatly distended earlobes from wearing heavy gold pendants during dancing.

Tooth-filing begins at about the age of nine or ten, usually with the front teeth filed first with a long cutting knife. The goal is to even out the teeth so that they appear more "human," as the Kodi describe them, rather than sharp and jagged like the teeth of a wild animal. The most desirable women have smooth, rounded, and rather short front teeth, like the trimmed hoofs of a horse. The teeth may also be blackened with the ash from a coconut shell or smashed candlenut. The pulp is ground into a kind of paste and rubbed onto the rough edges of the filed teeth to decrease the pain and give them a deep, shiny luster, "as black as thunder and lightning at night."

Darker teeth are a sign not only of sexual maturity and attractiveness, but also of age and wisdom in general. Almost all older Kodi people have teeth that have been stained red or black from chewing a combination of betel and tobacco. When an inexperienced young man is called upon to speak in a ritual context, he will protest that his "teeth are still too white, his hair is still too blue-black." He argues that his pale teeth show that he cannot have acquired enough knowledge for the task at hand. Similarly, girls who do not yet feel ready for marriage will refuse the offer of betel nut. Chewing a betel quid is a sign of sexual maturity, and the exchange of betel pouches is the necessary first stage in courtship. A girl's parents may try to excuse her shyness or unwillingness with the explanation that she "does not yet know how to chew betel" and therefore should not be pushed into any decisions.

Youths and maidens who follow traditional styles continue to wear their hair trimmed close around the face until marriage. Once a girl is formally betrothed, she will begin to let the hair grow out so that it can be parted. When she moves into her husband's house, the hair is parted down the center and wound into a bun. The first husband is referred to as 'the one who bound my hair on the head, the one who parted the opening in the center' (*na woti a longge nggu, na pepe a lirya nggu*), in a couplet that at once refers sexual initiation and the restriction of access to others. The shift in hairstyles marks the girl's transition from maiden (*lakare*)

to young married woman (*bondi*). In earlier times, married men also bound their long hair into a bun, which they loosened only for dancing and head-hunting expeditions. Nowadays, most men and boys cut their hair to a conventionally short length, but priests and traditional elders may keep the older style as a sign of office.

Even before marriage, girls may begin to have their forearms tattooed, starting just above the wrist where ivory bracelets and beads are worn. Geometric designs are used, the same on both arms, duplicating the diamond and omega motifs used in weaving women's sarongs. Boys may also receive some tattoos higher on the arm, usually at the biceps, or at the knee. But only married women who have already borne a child might get the more elaborate series of tattoos that begin at the calf and go all the way up the leg to the upper thigh. The tattoos on women's legs are a subject of much erotic speculation, and are often described in courtship verses that recount adulterous liaisons. One of the worst insults a man can yell at another translates as "your mother doesn't have any tattoos on her thighs," since it implies such intimate knowledge of her anatomy, and further mocks its unsocialized character.

The tattoos that a mature woman has placed on her legs are part of a ritual ordeal that parallels that of male circumcision. Although thigh tattooing is now rarer, women of rank in their forties and fifties still have elaborate designs all the way up the leg, applied in several painful sessions where citrus thorns are crushed into the flesh and rubbed with soot. Recently tattooed women were restricted to their home during the period of convalescence, but were not as secluded as the boys were after circumcision rites.

Circumcision has not been performed for a generation in Kodi, although it is still common in neighboring areas, where it is associated with a period of ritual stealing and license. In Kodi, even older men agreed that the rite had always been a secret one. It was referred to euphemistically as the 'removing of the earth leaf' (*halingo a rou tana*), and paired with tattooing in the ritual couplets that referred to rites of transitions (*a ta kamandu, a hali a rou tana*, 'putting on the tattoos, removing the earth leaf'). In everyday speech, it was more often referred to as the 'trimming' (*topolo*) or 'cutting' (*teba*) of young boys, who were thus made into full men and 'finished' (*ngenda*). Phrases that refer to the rite in terms of its

period of seclusion usually call it the "going out to the fields" or the "traveling down to the water."

The "earth leaf" or foreskin must be removed in a wild setting, where no other people (and specifically no women) may see the boys after the operation. The circumciser goes off with a group of five or ten adolescent boys and lives with them for several weeks in a simple shelter near the river. When his turn has come, each boy brings with him an egg, a bit of betel nut, a small metal ring, and a chicken, while the circumciser brings a specially constructed knife, a wooden base, and a clear coconut shell. Travelling off to the east, they come to rest in the shade of a particular pandanus tree near the coast, and the circumciser asks the boy privately if he has any sexual experiences to confess. Without such confessions, the operation would be a very dangerous one and could even cause death. A chicken is killed, and a bit of its flesh is offered to the east and west to purify the boy (to expel all evil in him or *paloho*, 'put it outside'). Then the boy's foreskin is trimmed off and placed inside the coconut shell, where it is stored at the trunk of the pandanus tree, "to keep it cool and safe in the shade." The cooked egg and a bit of betel nut are also left at the tree trunk so that the wild spirits will not disturb it. The boy goes back to the shelter with the circumciser to live there until his wound has healed.

After the operation, the boy must seek out a woman to take the first 'water from the knife' (*wei keyeto*), which can be dangerous to her fertility. Usually, an older woman (perhaps a slave in earlier times) past childbearing age is chosen, since the first semen expelled is supposedly capable of "searing the womb" of a younger woman and making her unable to give birth. Once this "water" has been safely deposited and it is clear that the boy has recovered, he pays the circumciser with the gift of a long cutting knife (*katopo*), one live chicken and one dead one, and a meal of pork or dog meat. The rite has served as a marker of his social maturity by severing him from the last sign of his animal self and discarding that sign at a site in the middle of the wild. The excessive "heat" of untamed masculinity has been reduced to a safer level, where it is compatible with balanced, human fertility and can combine fruitfully with female blood in conception.

Person and Gender Through
the Life Cycle

Male life-cycle rites stress a more complete separation of the merged gender elements of childhood, and they dramatize the construction of a male identity in ways that anticipate, rather than confirm, these changes. Although a woman's pain at the tattooing of her legs is said to parallel the pain of male circumcision, there is no specific part of her anatomy that is severed and cast off in a similar fashion. The tattoos are also applied only *after* she has already shed blood in childbirth and menstruation, and are thus markers of a status that she had already achieved, rather than points of transition in themselves. The woman's personhood is more closely linked to her reproductive functions, and rightly so in Kodi eyes, whereas the man's personhood must be more deliberately constructed in social terms in order to form a complete adult identity.

These differences reflect Kodi theories of the person. We have noted that each person is said to have two parts to his or her soul, designated by the couplet *ura ndewa, hamaghu dadi* ('the swirls of the spirit, the vital energy of birth'). The softer, vulnerable soul or hamaghu was created by the Mother Binder and is subject to various kinds of supernatural attack. At times of serious illness it can be separated from the individual and sent on wanderings of its own. The harder skull at the crown is the seat of the firmer component of Kodi personhood, the ura ndewa or male soul, which was created by Father Smelter who formed the unshakeable destiny seen in the pattern of hair swirls. Thus creation occurs as the result of a conjunction of male and female activities, and the parts created by female efforts are softer and more easily attacked than the firm, enduring parts created by the male ones.

The theory of a double soul provides a sort of "ethnopsychology" that is not too far removed from similar theories of male and female components of the personality proposed by Western scholars such as Freud and Jung. It admits that each person has elements of both sexes in a residual pattern, but that with adequate social conditioning he or she can make a successful adjustment to

the appropriate gender identity. In Kodi terms, we are all born with
a human potential that mixes male and female attributes, but we
must learn to become individual men or women.

Kodi theories of conception do not distinguish between the
male and female contributions in terms of the familiar opposition
of blood versus bone (Traube 1980b:98; Lévi-Strauss 1969:374),
but they do make a similar distinction at the level of the spiritual
conception of mankind by the double-gendered Creator. The fe-
male life principle has supplied the part of a human person that is
delicate and changeable, while the male principle supplies the
hard, unalterable destiny. It is the *ndewa toyo*, or personal destiny,
that lives on after death and is worshipped in the ancestor cult, but
it is the hamaghu that must be protected and sustained through-
out the life cycle, by the ritual complex that we have just dis-
cussed. Thus the rites that socialize the male child and construct
his public persona are concerned with bringing his female identity
"inside" and protecting it from the dangers of the outside. They
are also concerned with impressing upon the child the duties and
obligations of patriclan membership, in contrast to the more indi-
vidualistic talents and abilities that may be among the traits in-
herited along the matriline.

The myths and oral traditions that we have discussed concern-
ing the matriclans are all linked to wild animals and original pow-
ers that seem to have been lost over the generations. The mythol-
ogy of the patriclans is, in contrast, a story of the gradual accretion
of powers, which grow in importance with their age. In similar
fashion, a young boy can be said to acquire various kinds of knowl-
edge that help him to grow into a man and an important person. A
woman is usually restricted to performing her most important
functions (those of providing descendants) early in her life, and be-
comes less useful later on. Although some women do become well
known for their skills in dyeing cloth, singing songs, performing
garden magic, or serving as midwives and folk healers (see Hoskins
1987a, 1988b, 1989a), they do not need to separate themselves so
thoroughly from the world of the wild, outside spirits in order to
do so. Their relation to the wild remains a metonymic one, one of
touching realities, while the male relation is more metaphoric: it

involves parallel powers that are transmitted among equals, not shared powers that are communicated by likeness.

Conclusions: The Union and Separation of Gender Attributes

The paradox that has emerged in the course of this analysis is that gender attributes that are united at the cosmological level (in the names of double-gendered deities) and sporadically combined in various ritual practices (where gender-crossing serves to mark a liminal period of transition) are rigorously separated by the rites of the life cycle that serve to define individual identity in cultural terms. The fusion of male and female attributes among deities symbolizes their concentration of power, whereas in human beings a parallel fusion of gender characteristics is inappropriate and even dangerous. Except for a few ritual specialists whose behavior is heavily shrouded with prohibitions and restrictions, members of the human community are encouraged to separate their own female-linked "natural" characteristics from male-linked "social" ones.

Kodi theories of the nature of the person create a dualism within the individual, represented by male and female "souls" attached to different parts of the head. All persons, men as well as women, are the products of this dualism, and are composed of attributes passed on to them along maternal and paternal lines. The closeness of women to certain "powers of the wild" is not due to an essential difference in their make-up, but to the greater strategic advantages of seeking out such powers as an alternative to the official ancestral cult of the patriclan villages.

Women do not play an important role in patrilineal ancestor worship for social reasons. They are perennial outsiders, marrying into the clan and incorporated into its cult by a sacrifice following the initial brideprice payment. Keeping women ritually inside involves procedures of confinement and immobility at times of transition—rites that are occasionally performed with male actors in female roles. Gender-crossing is asymmetric: men may "become women" in these contexts, but it is much rarer for women to "be-

come men." Yet the very fact that women can operate on both the
inside and the outside, in the world of the wild spirits and the
world of the ancestral powers, suggests that they remain a kind of
agency that is different from, but complementary to, the kind of
power retained by men. Women are seen as the "source of life" and
are honored for their contributions, but they are linked to frag-
mentary, particularistic concerns and individual ambition, rather
than to the shared interests of the corporate group.[7]

The progression from a childhood state of gender ambiguity to a
socially constructed state of clear maleness or femaleness is fol-
lowed by all persons as they mature. Some of the metaphors used
in Kodi gender imagery suggest that women might be conceived as
an earlier stage in this process—the "flower" that has not yet be-
come the "fruit," the ritual actor in smaller rites who is not yet
ready to take central stage. But my informants were adamant in
explaining that this was not the case. Gender differences are seen
as in some way incommensurable. They cannot be reduced to any
criterion of similarity and comparability that would allow them to
be ranked according to the same principle. Women are not there-
fore "less complete" men, but are wholly different creatures, whose
capacities are not diminished by being distinguished from those of
their male counterparts.

Kodi notions of descent defined through the inalienable, physi-
cal characteristics of the walla and the social, culturally formed
characteristics of the parona seem to recall Ortner's famous (1974)
essay on the relation between the symbolic oppositions of nature
and culture, woman and man. Her formulation has recently been
criticized (MacCormack and Strathern 1980), but much of this
criticism either fails to grasp the nature of the opposition (see Va-
leri, this volume), or is insensitive to the possible dynamic within
this contrast. Both Ortner and Strathern link associations between
women and "natural" characteristics to justifications for "univer-
sal female subordination" (Ortner 1974:67) and the "colonizing"
mode of cultural domination (Strathern 1980:210). Kodi gender
ideology, however, stresses themes of mutuality and interdepen-
dence that are not necessarily hierarchically valued. Male and fe-
male powers are seen as qualitatively, rather than quantitatively,
different, and men and women can change their relationships to

male and female elements within themselves over the course of the life cycle, and in relation to their roles in social groups. I think it is wrong to argue, as Ortner does, that an association between women and certain "wild" powers necessarily results in a devaluation of female powers.

On the contrary, the importance that the symbolic opposition of male and female assumes in Eastern Indonesia as a conceptual tool allows gender concepts to serve as a "way of thinking" about a variety of relationships that are not directly structured by gender. Gender can operate as a metaphor precisely because it is not the clearly dominant structure of inequality, and the idealized interdependence of male and female can be diffused over a number of contexts where images of mutuality are needed.

The key distinction could be phrased in relation to types of agency. This distinction seems to hold fast even in such differing societies as Kodi and Huaulu: male and female, as abstract categories, provide a language for talking about ways of acting in the world. Male agency is active, mobile, and transformative; female agency is stable, unmoving, and substantive. In Kodi social organization, male-formed groups are the result of public negotiations and exchanges; female-linked groups are bound by ties of unchanging substance. Society is reproduced through a conjunction of dissimilar forces: women offer life in its generalized, undifferentiated form, while men divide up this life in public transactions and exchanges into clearly established social categories. Both descent ideology and ritual performance allude to an original unity of male and female as an all-encompassing generative principle, but stress the social necessity of effecting a separation of gender elements in individuals. This separation is not necessarily a devaluation; the stress on difference is not always a rationale for domination.

The separation of male and female elements in the human community allows for the possibility of exchange. But exchange is also founded on the division of what was once unified: the cosmic fusion of double-gendered deities. Thus complementarity is justified by an original fusion of both genders and by periodic returns to that fusion in ritual contexts. In the lives of individual men and women, gender idioms are used to stress a utopian vision of mutuality and

interdependence that recalls the original unity. It is the irreducible principle of sexual difference that creates the possibility of exchange, and also that of transcendence.

Valeri (this volume) has noted that cosmological divisions between male and female are not always directly connected to sociological imbalances and asymmetries. The symbolic elaboration of gender symbolism and gender difference can be compatible with both the Huaulu emphasis on the occasional compartmentalization of male and female and the Kodi emphasis on their combination. In Kodi, the conjunction of male and female elements is made into an image of the overarching totality that transcends not only the lives of individual men and women, but also the social necessity to demarcate differences through the rites of the life cycle. Deities defy social convention by combining both gender attributes, but in so doing they display the electric tension that lifts them above the world of mere mortals. The "values" given to men and women operate in different ways and define different spheres of action. But their complementarity is the dynamic at the heart of Eastern Indonesian sexual dualism, and combinations and variations in their relations form the key metaphors of the Kodi spirit world.

The Symbolic Representation of Women in a Changing Batak Culture

Susan Rodgers

The Angkola Batak of Sumatra at the western end of the archipelago share some features in common with many Eastern Indonesian societies. A traditionally noncentralized population, the Angkola Batak have a system of asymmetrical marriage alliance that organizes political and kinship hierarchies. As in the case of Eastern Indonesia, the symbolism that surrounds prestations between wife-givers and wife-takers is highly dualistic. Susan Rodgers provides a lucid review of Indonesian systems of asymmetrical marriage alliance to frame her account of Angkola marriage. Her review may be profitably compared to Boon's account of optionally endogamous marriages by aristocratic houses in Bali to bring out the salient differences between house societies featuring mandatory exogamous exchange and those with endogamous possibilities.

Rodgers focuses her analysis here on imagery of Angkola Batak brides. Like other contributors to the volume, she emphasizes that cultural images of gender in Angkola society are not reducible to the economic division of labor. It is Rodgers's thesis that images of the young bride provide a vehicle for expressing the tensions within Angkola marriage and clanship. Talk about marriage similarly serves as a way of delivering commentary on the rapidly changing conditions of modernizing Angkola life. In this way Rodgers's paper intersects with Hatley's, Ong's, and Blanc-Szanton's, which underscore how representations of women in theater,

media, and political rhetoric respectively express social ambivalence about changing conditions of social life.

Rodgers treats the symbolic depiction of the bride as the mediator or "bridge" between her own natal descent group and her husband's. Rodgers's rich account of symbolic imagery here suggests intriguing comparisons to Eastern Indonesian societies. Her description of the in-marrying woman's relation to her own and to her husband's natal group and ancestral ritual can be compared to Kuipers's, Valeri's and Hoskins's papers in this volume.

Arguing that the dynamics of gender construction in the Angkola case must be understood in the context of a multiethnic, modern nation state, Rodgers explores how marriage is used by Angkola Batak as a means of managing relations with other ethnic groups. Just as women serve as intermediaries between Angkola natal groups, so they, through marriage, serve to establish and regularize ties with non-Angkola. Rodgers speculates that as ethnic go-betweens, women may come to be stereotyped in ways that express tensions not only between Angkola clans, but between Indonesian ethnic groups as well.

Ideas about gender are woven through virtually the entire social fabric of Angkola Batak life in South Tapanuli rice-farming villages, in this society's ethnic homeland in North Sumatra, Indonesia. Concepts about the feminine and the masculine aspects of persons, houses, villages, fields, crops, rituals, speech, foods, textiles, weapons, and ornaments are conceptualized in Angkola villages in relation to local ideas about clan descent, noble houses, and asymmetrical marriage alliance between "holy" wife-giving lineages and "mundane" wife-receiving lineages. Angkola gender ideas, however, extend beyond the homeland village: gender concepts, particularly those relating to womanhood, are crucial to the present-day Angkola understanding of their ethnic identity, and to Angkola ideas about the social position of the Batak societies in the multiethnic national state of Indonesia. This paper examines some of the ways that gender is used in Angkola to help structure this wide range of human social experience, reaching from concepts about relationships among villagers to ideas about interethnic relations in the Indonesian nation. Importantly, just as village-based kin-related concepts influence Angkola conceptualizations of other ethnic groups, that ethnic interaction itself works

back on Angkola kinship concepts to give them new meaning and applicability. Angkola gender ideas form a crucial part of this kinship/ethnicity interaction. Such an interactive view is a familiar anthropological approach to this type of society. Much of Leach's book *Political Systems of Highland Burma* (1954), in fact, went to demonstrate that the kinship and political system of the Kachin was a changeable creation of ethnic interaction with the Shan. This paper simply extends that familiar insight to the study of Batak gender in modernizing Indonesia.

The socially complex character of contemporary Angkola Batak culture calls for a style of analysis that involves attention both to structural and symbolic features of gender and to processes of social action, through which meaning is defined and redefined in actual social contexts. Studies of gender in a changing culture like Angkola must be set into an appropriate political context, reaching in this case to interethnic relations between Angkola and other Batak peoples and between Angkola and other groups, such as Javanese. In the homeland town and village where I did my fieldwork from July 1974 to January 1977, and in November-December 1980, Angkola culture was both rural and open to urban-based influences.[1] Angkola has patrilineal clans called *marga*, asymmetrical marriage alliance with MBD (mother's brother's daughter) marriage, and an extensive folk imagery of politics that asserts that villages are led by chiefs who live in "ancestral" noble houses. These chiefs, or *raja*, solidify their power through marriage alliances with wife-givers (who provide them with spiritual blessings and luck) and wife-receivers (who afford the raja financial support and physical protection). Angkola village political thought at this level is filled with complementary oppositions (right and left, highness and lowness, cloth and metal, and so on). These oppositions are related in systematic ways to local ideas of marriage alliance. Such schemes of thought recall the dualistic cultures of Eastern Indonesia, which have similar asymmetrical marriage alliance systems (van Wouden 1968; Fox 1980a).

Angkola *adat* ('customary law,' or better, ceremonial life and village norms) would have its adherents believe that these categories of kinship and traditional political relationship account fully for Angkola life, but the actual situation is more complex. Ang-

kola Batak culture stretches from the largely agricultural home-land to migrant communities in Jakarta, Medan, Pekan Baru, and other large cities in Sumatra and Java. Many Angkola hold salaried jobs there, stress educational degrees as the key to "escaping" the rice villages, and consider the city their permanent home. Interaction with members of other Indonesian ethnic societies (Acehnese, Minangkabau, Javanese, etc.) is frequent for children and employed people. In addition, many Angkola are also committed nationalists; many today are high government officials, particularly in the military, educational, and judicial bureaucracies. In urban areas, younger Angkola Batak especially have access to the growing national mass media of Indonesian-language newspapers, books, radio programs, cassette-tape songs and song dramas, television shows, and domestic and imported movies.

Social change of this sort, bringing homeland villages into vigorous interaction with the national culture and with other Indonesian ethnic groups, is reshaping southern Batak kinship and political thought in far-reaching ways (Rodgers 1979a, 1979b, 1981a, 1983, 1984).[2] A number of anthropologists have recently suggested that the organization of gender in preindustrial societies is often related in systematic ways to local political hierarchy and to the local construction of kin relationship (Collier and Rosaldo 1981; Ortner and Whitehead 1981a; Ortner 1981). Angkola concepts of gender confirm this argument in several ways, at both the village level and at more national, interethnic levels.

Since the Angkola employ a language of wife-giving and wife-receiving to structure both village kinship and traditional chiefdom-level politics, gender concepts partake of both domains in village thought. In the rural areas, gender must be studied in the context of what might be called bride-bound lineages. Beyond this, though, because the uses and social references of Angkola political and kinship symbols are expanding today with the rural region's increasing integration into the Indonesian nation, gender ideas are also changing. Gender thus gains a new, larger political dimension at the level of interethnic relations in Indonesia. Methodologically, this situation calls for a two-step plan of study, based on the fact that Angkola is both a culture with prominent and pervasive dualistic symbol systems like those in Eastern Indonesia,

and also a rapidly modernizing Indonesian society. At one level, Batak village kinship (and particularly its intricate dualistic imagery of marriage alliance) provides a productive framework within which to analyze Angkola gender concepts. A symbolic approach similar to that set out in several essays in *The Flow of Life* (Fox 1980a) is undeniably a useful perspective on the cultural construction of gender in relation to Angkola alliance and descent ideas. Indeed, the first part of this paper attempts just such an interpretation. However, since village-level alliance and descent is not all there is to Angkola gender concepts, the anthropological framework must be expanded beyond the village, and in fact beyond the ethnic culture itself, to include the many ethnic and national cultures that influence Angkola thought today. The second part of this paper investigates some of the ways in which Angkola gender concepts help to organize Angkola concepts about other ethnic societies in Indonesia.

I will focus on the variety of symbolic representations of women in Angkola culture, partly for reasons of economy (the essay can cover only a small portion of Angkola gender concepts) and partly because the symbolization of women has historically provided the Angkola Batak with a crucial symbolic language for talking about human social relationship in general. The Angkola conceptualization of women—their essentially good nature, their beauty, their "bounteousness," their cajoling nature, their need to *be* cajoled, their unpredictability at certain times of their lives—has given voice to a range of Angkola thoughts about the workings of their system of patrilineal clan descent and marriage alliance. In fact, in important ways the characterization of women has allowed Angkola culture to say the unsayable about some of the internal logical inconsistencies and perceived inequities of their marriage alliance system and clan system. The Angkola sense that wife-receiver men are "girl children" to their wives' fathers is a pivotal part of this inherently ambiguous, paradoxical system of ideas. Beyond this, however, symbols of women are also important in that they are serving the Angkola today as an idiom for talking about modernization in Indonesia. In an essay on folk drama in Java, Barbara Hatley (1981) noted that the Javanese often deal with the dislocations of rapid modernization by talking in their literature and

drama about marriage choice and family squabbles.[3] Angkola make
similar use of talk about marriage, concentrating particularly on
arranged marriages as a way to discuss social change in general
(Rodgers Siregar 1981c: 154–61). Angkola employ some aspects of
their conceptualization of women in the same way, condemning
certain types of women as a way to condemn what they see as the
failings of modernity and life in Indonesia. This relates particu-
larly to interethnic situations.

My major texts for the first part of the paper are ritual speeches
transcribed from tape recordings I collected in my 1974–77 field-
work. I also use a few commercially printed written sources on
Angkola adat. Working largely from oratory will of course limit
the range of gender symbols at hand to highly conventionalized
ones. Ritual portrayals of gender are by no means direct represen-
tations of the social world. In fact, today Angkola adat oratory is
set at an unusual distance from the social world of institutional
arrangements. This is so for two reasons. First, much adat speech
concentrates on patrilineal inheritance and ties between men, al-
though (as we shall see) women and concepts of the feminine are
the very linchpin of the whole system. This emphasis might lead
outsiders to think that women had somehow been left out of Ang-
kola adat, which is certainly not the case on closer inspection.
Second, folk models do not fit Batak social reality in any easy way
in this century of social change (Rodgers Siregar 1979a; R. S. Kipp
1979), if indeed they ever did (Bruner 1979).[4] The oratory of adat
ceremonies deals in a language of convention and custom. Women
are the pivot around which kin relationships and politics turn in
Angkola, and the ritual oratory is largely an extended paean to this
idea. Consequently, ritual oratory provides an apt text on gender at
this level of stereotyped concepts.

The first part of this paper focuses on Angkola concepts of ado-
lescent girlhood and new brides. These receive especially heavy
play in the oratory. The main texts in the second part of the paper
are fieldnotes on family histories and tape recordings of adat wed-
dings in which non-Batak are incorporated in various ways into
the Batak social world via women. In this section we will see that
bride adoption of foreigner non-Batak women is a major entree
into Batak ethnic identity. Balinese or Javanese women, for ex-

ample, are ritually converted from outsiders into their husbands' ideal marriage partners, their mother's brother's daughters, in special parts of wedding ceremonies.

The Larger Indonesian Context

Before considering these points of Angkola ethnography it would be useful to discuss the gender systems typically found in Indonesian cultures that have asymmetrical marriage alliance,[5] and to note the Angkola ethnic homeland's current-day political position within the Indonesian nation.

Indonesian cultures with asymmetrical marriage alliance have patrilineal clans divided into lineages that are often focused on ancestral houses, heirlooms, and inherited farmlands. These lineages sometimes have mythical genealogies, which are often about founders who first cleared the forest for the village. Family heirloom treasures (*pusaka*, in Indonesian), thought to be "full of powers," are passed down the patriline in many of these cultures, and sometimes serve as a sort of altar for contacting the ancestor spirits. Localized lineages (and among the nobles, the Great Houses) are allied to each other through the exchange of one house's marriageable sisters and daughters for the other house's labor services and bridewealth gifts. House A gives its nubile women as brides to House B and, through this exchange, A establishes itself as the superior, ritually "higher," holier beneficent giver-partner to its more mundane, lower, eternally indebted receiver-partner, B. For aristocratic families the system is often portrayed in ideal terms as an asymmetrical arrangement, with B forbidden to give back its own women as brides to A. Rather, women from B are given to a third house, C. This house in turn has its own set of wife-takers and wife-takers of wife-takers. In practice, each focal exchange unit will have a number of wife-giving groups and a number of wife-taking groups. Aristocratic houses have highly traditionalized exchange relationships, which supposedly go back many generations, whereas commoners often have more ad hoc marriage alliance ties, of shorter duration (it may be that they simply do not control the myth-making resources of the culture to the extent that the aristocrats do).

A structurally similar system among the Kachin was described by Edmund Leach in *Political Systems of Highland Burma* (1954). As Leach pointed out, these marriage systems often provide a language for structuring political relationship as well. Chiefs can ally themselves with lesser chiefs through beneficent gifts of women (or myths of such relationships). Descent from a common clan ancestor can also be used to tie villages together. And, as Leach noted, these marriage systems contain contradictory tendencies: on the one hand, they allow for egalitarian relationships between settlements, based on the relativistic notion that "superior" wife-givers will also inevitably at some time find themselves playing the inferior wife-taker role to a third marriage-exchange partner; on the other hand, such systems hold tendencies toward political hierarchy, based on an association of wife-givers with superiority. This last tendency can foster a class system. The various oscillations of this type of Southeast Asian culture have been examined by many theorists, from Lévi-Strauss (1969) to Dutch structuralists (van Wouden 1968; see also Fox 1980b and P. E. Josselin de Jong 1980) to Marxists (Friedman 1975).

The specific symbols connected to alliance and descent often vary in these cultures. In general, however, there is a common and in fact almost obsessive reliance on binary, or rather complementary, oppositions. For example, Angkola Batak associate wife-givers with the right side, the heavens, physical height, spiritual nurturance, blessings, and luck; they associate the beholden wife-takers with the left side, the earthly world, lowness and crouching positions, the physical protection of wife-givers (in a sort of bodyguard fashion), and the attitudes of solicitation and receptivity to the "blessing gifts" and "blessing words" from the wife-givers. The creative forces of the fields and of human wombs do not come simply from women but rather flow from the temporary, powerful union of complementary opposites, such as wife-givers and their wife-takers and this pair's many associated activities and objects.

Gift exchange enters at this point: the two sides "complete" each other and in a sense keep the universe going by exchanging a prescribed set of gifts and countergifts. In the Batak cultures, in a pattern found in many of these societies, wife-givers give their wife-receivers fertile brides, cloth gifts (woven by women, often for use by men or babies),[6] "blessing words" for firming the wife-

takers' souls against dangers, and a variety of cooked and un-cooked foods. Wife-takers give back bridewealth payments (consisting today of livestock and paper cash, but associated in the adat oratory with gold), physical-labor services, and foods. Both sorts of exchanges must be completed for the bridal couple to prosper and produce children for the lineage. Note that women are the chief vehicles through which the blessings, luck, and life force of the wife-givers flow to their wife-takers. In the folk theories of human conception found in some of these cultures, the soft, fleshy parts of babies are thought to derive from the wife-givers, via the child's mother, while the hard, bony skeleton of the child is the contribution of the father (Leach 1961b). It should be noted that no such pattern was mentioned by Angkola Batak in my fieldwork, nor was much attention paid at all to the bodily composition of babies.

The interaction of cloth and metal gifts captures another crucial point of these philosophical systems: soft, pliable, open-weave cloth, associated with femininity, is a prime wife-giver prestation, while hard, sharp-edged, dense metal crafted by men is a masculine, prototypical wife-taker gift. The two sorts of prestige objects are often united in ritual displays (cloths wrapped around swords and so on) to symbolize—and in fact to liberate—the powers of the entire alliance system. Given this, it is probably best to see cloth as a wife-giver prestation, rather than simply as a "female good" or a "feminine prestation." The wife-givers themselves are certainly not a "feminine" unit counterposed to some "masculine" wife-taker group. In Angkola symbolism, as we shall see, the wife-takers, as well as the young women of a wife-giver group that they marry, are conceptualized as "daughter-people," as it were, of the young women's fathers and their lineage. These lineagemates, in turn, are the "holy" wife-givers and seem to be seen more as fatherlike and brotherlike (vis-à-vis the young women they give as brides and those women's husbands) than as simple feminine-gift providers.

The Political Context

What is the larger social context of these sets of symbols? It is possible to study the symbols within the confines of a single local

culture, but for the Angkola Batak today this seems to be a limited perspective. In Angkola, symbols such as those just discussed exist within a small minority culture that is to an important degree an open society influenced and in fact defined by many surrounding cultures. Angkola is not a free-standing, pristinely isolated group. Rather, it is best seen as a dependent-part society within Indonesia. This is a concept Nelson Graburn developed for dealing with the arts of indigenous peoples located within modernizing Third World nations (Graburn 1979). The art systems of these peoples, Graburn finds, are social creations of the interaction between rather defensive small ethnic societies and expanding nation-states. In this view, local cultures define themselves in interaction with larger, outside polities. Even the very notion of art, and in fact ethnic culture, is often a product of this sort of interaction.

Angkola today has this particular sort of dependence and "incompleteness." The major symbolic complexes in Angkola culture are not simply generated and maintained from within that ethnic group but are constructed in interaction with other Indonesian ethnic cultures, the national culture, and even an international, Western-oriented culture centered in the cities and the literate and electronic mass media. Jane Atkinson (1983) has suggested that local ethnic religions in Indonesia are created in counterpoint to and sometimes in competition with the monotheistic religions promoted by the national state; Anna Tsing (1987) has noted that local adat systems, and in fact local cultures as such (Minangkabau culture, Lio culture, and so on), are creations of ethnic interaction between more- and less-centralized politics. A similar perspective is useful in understanding Batak gender concepts. At least in part, Angkola concepts of men and women and the relationship between them are products of Angkola's particular social situation in Indonesia today.

Angkola is a politically composite culture. There are six major Batak societies occupying largely agricultural homelands around Lake Toba: the Karo, Pakpak-Dairi, Toba, Simelungun, Angkola, and Mandailing. In the homelands, villagers and townspeople often identify themselves as members of an adat chieftaincy, leaving the broad-gauged ethnic designations mentioned above (or even the

idea of Batakness per se) to city Batak, outsiders, and the national mass media. The homelands and the adat chieftaincies within them are thought locally to vary in ritual practice, in adherence to Islam or Protestant Christianity or an ethnically distinct mix of the two, in Batak dialect, in speech-delivery style, in ceremonial dress, and in "character" (arrayed according to how *kasar* ['rough-mannered'] or *halus* ['smooth'] a group is).

Adat chieftancy ideas of social and spiritual hierarchy (phrased in terms of noble houses and their superior wife-giver houses and subordinate wife-taker houses) are important in the conceptualization of village space and village objects. Angkola villages generally have rows of Malay-style houses facing each other across an unpaved wide path; some villages are irregular jumbles of houses. Roof shape is sometimes a modification of the jutting-eaves style associated with adat houses in Sumatra and Eastern Indonesia. Each complete village has a Malay-style raja's house, a *bale* or adat meeting pavilion, a graveyard, an ancestral bamboo tree, a protective stone effigy called a *pangulubalang*, and separate women's and men's bathing pools. Some self-consciously old-fashioned villages also have a Tapian Raya Bangunan, a special bathing pool for the sons-of-raja and the daughters-of-raja. This is used by both sons and daughters of the noble houses for ceremonial baths. This pool was once thought to be in especially close contact with the spirit world, and some representation of the Tapian is still crucial today in rituals to "firm up the wandering souls" of new brides, new mothers, and infants. These persons are thought to be in especial danger of "soul fracture," where the fragmented souls escape to the fields through the soft spot on the top of the head.

Clan descent and asymmetrical marriage alliance between "superior," "holier" wife-givers and their subordinate, subservient, mundane wife-takers are the primary organizing categories in village social thought. Angkola oratory describes village origins and village organization as follows. Each village has a founder (usually a man or a set of brothers or a father and sons) who first claimed the land from the forest, laid down rice paddies, and "opened the adat there." The founders and their patrilineal descendants "own the village" and "own the adat" there. The men of this line become the village raja. They are linked to other important village

founders in Angkola, and sometimes even in Toba and Mandailing, through clan descent. As noted, Angkola has named patrilineal clans, which are called *marga*. These were supposedly founded about 25 generations ago by semi-mythical male clan ancestors who lived two to four generations after Si Raja Batak, the ancestor of all humans. About 12 generations ago, descendants of several long-established Toba clans migrated southward to open Angkola-area villages. Thus a major clan like Siregar or Harahap will have numerous Siregar villages and Harahap villages scattered throughout the area, and is also likely to have related villages back in Toba.

Relations among households in a village, and between ruling lines of different villages, are also seen as structured according to marriage alliance. Ideally, the village founders will bring along two indispensable partners to open their village: a *mora* (or wife-provider) household to supply them with brides and good luck; and an *anakboru* (wife-receiver, or daughter-group) household to receive women as brides and act as the chiefs' physical protectors, military forces, and adat spokesmen (*juru bicara*, in Indonesian). The clan descendants of the original mora household become "traditional mora" for the village raja, and the descendants of the original anakboru become *anakboru pusako*, or inherited anakboru wife-receivers. An *Orangkayo* ('Man of Eminence') is drawn from this anakboru pusako in each generation. He is the raja's chief spokesman in rituals and serves as the main protector of the village. The raja himself is known as *raja parhutaon* ('village raja'), and he is aided in governing the village by a Council of Village Elders (*hatobangon*) and a Raja's Council (*harajaon bona bulu parhutaon*). The Village Elders include older, married male representatives from each clan living in the village, whereas the Raja's Council is made up of the lineagemates of the raja and his inherited wife-givers and wife-receivers.

The raja's control of the village is a matter of cosmology as well as social position. Good, peaceable social relations among humans (endlessly eulogized in the adat oratory) is thought to be set into the structure of the universe. In addition, village mora assure a flow of luck and prosperity to the villagers via the raja.

Marriage alliance is also used to form intervillage ties. Any *ka-hanggi* (a patrilineage that ideally acts as the wife-taking or wife-

giving unit) will have several mora and several anakboru. More-over, Angkola adat assigns important exchange functions to the anakboru of anakboru (called *pisang raut*), and to the mora of mora. Alliance ties thus proliferate throughout the village and among villages. Any important raja lineage will probably have in-herited wife-givers and wife-takers in its home village, and then a number of established mora and anakboru throughout the adat chieftaincy.

Gift-giving and gift-receiving put Angkola's clan descent and marriage alliance ideas into action. Over the life cycle of a house-hold, the adat demands that a huge flow of exchange goods be passed between anakboru and mora and their auxiliary alliance partners. The household is the unit that forms the immediate focus for any exchange. As noted, this exchange is largely a matter of mora and anakboru interaction, not male goods being exchanged for female goods, as some of the literature on Indonesian exchange systems of this type might imply.

In the widest sense, taking intangibles with tangible goods as Angkola do, mora provides its anakboru with blessing, good luck, fertility, and the living brides that convey these good things. Mora also showers its anakboru with magic words and magically protec-tive textiles, along with special cooked foods and the practical goods used to set a new bride up in housekeeping (cookware, china dishes, a bed, mats, yardgoods). Anakboru gives back the agricul-tural labor of its young men to help their mother's brother, cash brideprice payments, livestock for ritual sacrifice, physical protec-tion, labor services at adat rituals, and cooked and uncooked foods. Anakboru men also cook the meat at mora's adat rituals.

Ulos cloths are mora's blessing gift to anakboru: the bride's par-ents present the large *abit godang* cloak to the new bridegroom; the young wife's parents (or sometimes her older brother) give the small *parompa sadun* baby sling to their daughter to protect the health and *tondi* ('soul') of a newborn. In a more general sense, be-yond ritual, it is mora's obligation to keep anakboru in good cloth-ing (see Rodgers Siregar 1981a for more discussion of Angkola textiles).

This is not the entirety of Angkola political thought today, though, since the culture is an ethnic minority within the Indone-

sian nation. Angkola has a double political order. On the one side
is the ceremonial polity of village raja and councils and intra-
village raja leagues, maintained through gift exchanges of the sort
just described. The raja control rites of passage, some points of in-
heritance law, aspects of land tenure, and aspects of everyday vil-
lage social life. The raja also provide a sort of shadow government
of moral suasion, through their advice and blessing speeches.
However, a second government for the area, and a more powerful
one, consists of the bureaucracy and military of the national gov-
ernment. Each village has its appointed Headman, each town its
mayor, and each subprovince its *bupati,* or chief administrator.
All of these officials are employees of the national government and
see themselves as administering political units of the nation,
rather than parts of "Batakland." The two polities exist today in
uneasy alliance in the southern Batak areas, with the power of the
state increasing. At the level of the village and town families,
Batak schoolchildren grow up knowing they are citizens of the In-
donesian nation as well as residents of an Angkola village; their
parents know very well that the domain of the old chieftaincy
leagues is shrinking. The police force and court system of the na-
tional government now controls much of the domain of criminal
and civil law. The cash-based economy and the agricultural devel-
opment projects are also under the control of the Indonesian nation.

Angkola Gender Concepts in an
Alliance and Descent Framework

We can turn now to gender ideas as they relate to alliance and
descent, as shown in the ambiguous nature of the young bride.
This form of analysis, focused on village thought, offers useful in-
sights but remains limited, unless one places the ethnographic
material within a larger interethnic framework (the subject of the
last section of the essay).

An examination of Angkola gender concepts as a total system is
beyond the scope of this paper and my field research. Any small
subsystem of Angkola gender symbols would warrant a lengthy
treatment in any full account. For instance, in just the one area of

defining the female person, Angkola posits several cultural constructs. There are baby girls called Butet (a general term of reference and address for the youngest daughter in a family), preadolescent girls, marriageable teenagers, new brides, young wives with no children yet, Mother-of-(First Child), Grandparent-of-(First Grandchild), Daughter-of-Clan-A, Daughter-of-Raja (aristocrats), and on through Angkola's elaborate range of kin relationships (MBD of Clan B; woman of wife-giver of wife-giver speaking to man from wife-taker of wife-taker; and so on). Because of the fragmentation into various facets of social relationship, womanhood or "woman" does not seem to be constituted as a unitary category either conceptually or sociologically. The use of gender imagery to categorize space, material culture, ritual activities, and so on makes the topic wider still.

In lieu of a full account of the Angkola construction of womanhood, I focus instead on one small but crucial area of local thought about gender: the Angkola understanding of what they call *bujing-bujing* (adolescent, unmarried girls) and *boru* (new brides, just arrived in their husband's father's house). Adolescent girls are seen as flighty, blithe, sharp-tongued, coy creatures who spend a great deal of their time joking with boys. New brides, in one of the sharpest contrasts in the culture, are seen as demure, restrained, sad, quiet people who have to be coaxed into talking. The startling transformation from cheerful bujing-bujing to doleful boru is accomplished and put on public display in the several ceremonies of the adat wedding. (In fact, after the wedding, the bride begins to emerge as a more forthright and forceful person again, a tendency that increases as she moves further into her marriage.)

The sad new bride is a highly conventionalized character that exists beyond the feelings of individual brides. Many brides today in fact arrange to marry a man of their choice and in other contexts seem quite happy about the marriage. The characterization of the bride as a sad, uncertain person exists at the level of conventionalized expectations, in the ritual setting of the several adat wedding ceremonies.

These are not just stereotyped social roles that individuals fulfill. Rather, bujing-bujing are thought to be innately joyful and brides innately sad. This seems to be seen not simply as adat

(which Angkola occasionally view with remarkable dispassion as a set of social customs they consciously adopt), but as part of the inevitable nature of women as they grow older. Angkola seem to view marriage as a natural step, much as an increase in body size accompanies an increase in age for children. As noted, Angkola Batak seem to have little interest in "woman" as an abstract category. Rather, women are represented through the series of highly elaborated "types" mentioned above. All of these types are shaped by alliance and descent concepts to an important degree, but the bujing-bujing and the boru, and the transformation of one into the other, are especially strong representations, as it were, of the larger kinship system. This is how I shall interpret them here.

To provide some ethnographic background, let me first define certain indispensable terms: *boru*, *anakboru*, *dadaboru*, *kahanggi*, *mora*, and *marga*. After this, we can look to the oratory for the folk portrayal of bujing-bujing and brides. Then, with the aid of the folk portrayal of the relationship between wife-takers (anakboru) and their wife-givers (mora), we can see how these conventionalized types of women make sense against a larger marriage-alliance context. Many of the features of brides, particularly, can be explained by looking at the ambiguous position of women as mediators between wife-givers and wife-takers.

Some Definitions

Although a dictionary-like list of terms and definitions gives a rather dessicated view of Angkola culture, a primer on words related to gender and alliance and descent would be helpful as background to the analysis that follows. Some of the terms have already been mentioned: *marga* (patrilineal clan), *kahanggi* (a small lineage of that clan, engaged in bride exchange with other comparable kahanggi), *anakboru* (wife-receivers), and *mora* (wife-givers). However, the definitions given to this point have been cursory and in some ways misleading. There are particular problems with tagging anakboru simply as wife-receivers and mora as wife-givers. One of the main problems in rendering these terms into English is the position of women within these groups.

Marga needs little more explanation; these are the patrilineal

clans founded about ten to thirty generations ago by heroic figures often thought to come from Toba (some few prominent Angkola clans are said to have Minangkabau founders). Marga clans have origin myths (called *tarombo*) and ancestral home villages. Entire clans are not linked to each other by marriage alliance (for instance, some Clan A lineages may be wife-givers to some Clan B lineages, but other B lineages give brides to other A lineages), although in Sipirok it is often said that Siregar clan daughters marry Harahap men (there are several other pairings of this sort in different areas).

Kahanggi is a contraction of *angkang-anggi* (older lineage sibling-younger lineage sibling, the same word used by *pareban*, marriageable matrilateral cross-cousins). A kahanggi is usually traced back to an ancestor five to six generations in the past. A man's kahanggi consists of all males in his lineage segment, their male descendants, and their wives. The man's daughters are his anakboru, as are their husbands and children. All female offspring of the kahanggi, and their husbands and children, are anakboru.

Women only 'carry kahanggi' (*maroban kahanggi*) once they are married. Their kahanggi are the members of their husband's kahanggi. Both before and after marriage, however, a woman will employ the terms *angkang* and *anggi* toward her male matrilateral cross-cousins. As noted, these cousins are called *pareban* (in Angkola terms, marriageable men and women "call pareban" to each other). The word *pareban* is also used to refer to any two anakboru that share the same relationship to a common mora (these two lineage units would be *kahanggi pareban* to each other).

The difficult term *anakboru* can be taken next. In Angkola, *anak* means 'son' and occasionally 'descendant of' in a looser sense (children in general are *daganak*). *Boru* alternatively means 'wife-takers' (a rare usage), 'new bride,' 'daughter,' or 'girl' (another occasional usage); *boru-boru* can be used to mean a female animal. When a man or a woman is asked how many children they have, they generally answer in the form, "four anak and three boru," four sons and three daughters.

The bride meaning of *boru* is evident in the terms for several major wedding rituals: *Pabuat boru* ('Sending Off the Bride,' from

her parents' household); *Ro boru* ('Arrival of the Bride,' in her father's sister's and father's sister's husband's house); and *Mangupa boru* ('Major Celebration of the Bride').

Now, *anakboru*. One fairly unusual use of the word employs it to simply mean 'girl.' The main use of *anakboru*, however, goes beyond individuals to talk of the kahanggi lineage that receives brides and other blessings from a mora, a provider lineage. *Anakboru* can also mean any member of that receiver lineage. Additionally, a woman is anakboru to her parents and their kahanggi. Thus the term translates most exactly as 'daughter-people.' An example might clarify this. The anakboru of the Siregar clansmen and their wives of Bungabondar village are the Harahap clansmen of Hanopan village *and* the Siregar Bungabondar clan daughters whom those Harahap men marry. These women are called "boru Regar." In signing her name, a Siregar woman named Torkis will write "Torkis boru Regar," while her brother Horas will write "Horas Siregar." (Some women today, however, are using the Indonesian "Nyonya" form, which is used similarly to the English "Mrs.," as in "Ny. Parlindungan Harahap" used by a woman married to Parlindungan Harahap.)

Sherman (1987) has noted a similar conceptual complexity for the Toba Batak category of boru. He urges anthropologists to avoid such terms as "wife-takers," which obscure local ideas of respect and indebtedness between alliance partners. He prefers the term "wife-receivers," noting that the Toba "boru" category includes a strong sense of "the men called women who receive wives" from another lineage. Sherman's comments are also entirely appropriate for Angkola.

Mora also has several meanings. At one level, it means rich or wealthy, with some connotation of nobility. In adat, however, *mora* means the people and place that give brides to one's own kahanggi. A man's mora are all of his kahanggi lineage's established wife-giving lineages. His mother's brother is mora; his mother's brother's father is mora; his mother's brother's son is mora. If he marries a woman whose father's family has never before provided brides, her father, brother, and so on through that lineage are forthwith made into the "correct" mora partners in the adat. Thus

a man addresses his wife's father as *tulang* (mother's brother) no matter what her family origins. A new marriage like this is said to *pabidang tutur*, 'widen the range of kinship talk.' A woman "calls mora" to her own clan (a translation of the Angkola phrase), so a boru Regar would have Siregar as mora.

The entire unit of kahanggi, anakboru, and mora is often called the *dalihan na tolu*, the three stones on the hearth for balancing a cookpot. A cookpot would of course tip over, Angkola are fond of saying, if one stone (one kinship partner) were out of place and failed to support its partners.

Conversational speech and certainly ritual speech usually demand that individuals be called by their kin term, by their teknonym, by a clan term such as "boru Pane" or "boru Regar" for women, or by one of the several honorific titles for men such as "Sutan Doli." Occasionally, however, Angkola speakers will say something akin to the English "the woman . . ." or "the man" *Dadaboru* means 'woman' in this sense (*dada*, 'breast') and *halak-lahi* means 'man' (*halak*, 'person, human'; *lahi*, similar to the Indonesian *laki*, 'male'). (The Angkola *jolma* is similar to the Indonesian *manusia*, 'humankind.') Sometimes the word *bayo* is also used to mean 'man,' although this is a much more informal usage. We can now go on to look much more closely at two prime types of dadaboru and anakboru—the adolescent unmarried girl and the new bride.

Representations of Women: Bujing-bujing and Boru

The images of both the blooming bujing-bujing teenager and the restrained new bride are foci of considerable comment and affection in Angkola. In fact, much of Angkola thought about women, and femininity, is phrased in terms of these two types of women.

A girl starts to be called a bujing-bujing at the onset of physical puberty and becomes an *ina-ina* (*inang*, Indonesian *ibu*: 'mother, mother of') upon her marriage. At the birth of her first child she becomes an *ina*. Bujing-bujing implies virginity; Angkola often translate the word into Indonesian as *gadis*. A new clothing style is used to mark the state in conservative villages: bujing-bujing

must always wear sarongs covering their legs. *Kebaya* jackets are for married women, and the first time village girls should wear them is at their wedding ceremonies.

Prime bujing-bujing behavior consists of giggly conversations with girl friends, a general boisterousness and air of fun, and a seeming inability to act or talk seriously for more than a moment. Bujing-bujing change their minds a lot; their parents can never predict what they are going to do. Bujing-bujing are harder to raise, and manage, than *doli-doli*, unmarried adolescent males. Doli-doli swagger about, court girls, and fall in love with one bujing-bujing after another.

Bujing-bujing are not to walk out alone or with boys their age or men unless in a large group. Bujing-bujing travel in groups, with four or five of them walking abreast down the very center of the village, arm in arm. Any marriageable doli-doli they meet will hail them with a teasing remark and try to get them to talk. Such talk is *tabo*, 'delicious.'

Bujing-bujing are *berani*, an Indonesian word used more frequently than the Angkola word *puluk*. That is, they are brave, adventuresome, fearless, and a bit reckless. They confront marriageable boys their age with great social aplomb and give as good as they get in spirited *martandang* talk. This rhymed courtship poetry for pareban cousins demonstrates the bujing-bujing's boldness and verbal facility. Young unmarried men stereotypically have a similar forthrightness and cleverness in speech. Few adolescents use formal martandang speech today, but the old genre displays the character of Angkola women quite well. Numerous elderly Angkola I talked to insisted that young people in villages once actually employed this form of banter, although I could only record it in the mid-1970's from adat experts.

bujing-bujing	
Ois da poltak bulan tula	Ois da, there's the full moon
Anggi ni si maniholom	Little brother of the new moon
Muda ho parjolo lupa	Should you be the one who forgets first
Didoit lipan laho modom	May you be bitten by centipedes in your sleep!

doli-doli

Muda dung langkup ni tagan	Once the lime-case is sealed up
Ulang di paungkap-ungkap	Watch it not be broken open
Muda au parjolo muba dipandan	If I'm the first to change in oath
Au mada parjolo hona sumpa	I'll be the one the curse befalls.[7]

Bujing-bujing (in ritual speech at least) are also adept at using clan identification queries and riddled answers, in order to best young men in speech. In this, the girls are seen as acting for their clans as a whole.

Au maol do hurasa manjagit on	Well, I find it difficult to accept all this
Dialaman silangseutang	In Great-House-Yard-Obligation-Setting
Tai dison anso tangkas hamu mamboto	But now so that with exactness you might know
Anso syah kita na maranak namboru	So we validly have you-as-sons-of-father's-sister
Hamunu na marboru tulang	And you have-us-as-daughters-of-mother's-brother
Siramba dia rambamunu	Young forest, which forest is yours?
Riorio ramba na poso!	Young forest where light gleams through—
Marga dia margamumu!	Clan, which clan is yours?
Anso tangkas au mamboto	So with exactness I might know.[8]

This is a standard clan identification query, to which the boy answers in circuitous fashion that he is from the Harahap clan, the "Wind Clan":

Anggo da sirambanami	Well, as for our young forest
Andulpak balik-balik angin	It grows with *andulpak* and *balik-balik angin* trees
Anggo da simarganami	Well, as for our clan
Tepat ma on Si Bayo Angin	It's exactly that of Man-of-the-Wind
Bayo Angin Haba-haba	Man-of-the-Wind blowing strong
Habang so tarida-ida	Flying not seen
Songgop so tarboto-boto	Alighting not known

Lungun ni bujing na	Sweetheart of girls all out a-
mardalanan . . .	walking . . .

Girls have clan identification riddles of their own. Once assured that they are talking to a father's sister's son, the girls will some-times assert that they like him after all. Note here what may be veiled sexual symbolism:

O ale laklak ni singkoru	O, friend, bark of the herb plant
Rege-rege ni ampang	Edge of the rattan basket
Layang-layang hadungdung	Kite swoops down
Gumba-gumba ni poldang	Bean-casing long and round
O ale sianak ni namboru	O friend son-of-father's-sister
Babere ni damang	Beloved sister's-son-of-father
Ayam-ayam malungun	Plaything that makes me long
Siangkup lumba magodang.	My companion racing me to
	grow up.

Another quality of bujing-bujing is that they are beautiful. They have long shiny hair, a *mokmok* ('plump') figure, and eyes that look at you as they speak. Their beauty is unaffectedly praised in oratory and conversational speech, and seems to be considered a danger only to men who stand in strong deference and avoidance relationships to them (who should not touch them, or speak di-rectly to them).

It is also important to note that bujing-bujing are thought to be especially subject to certain soul illnesses and soul losses. Doli-doli sometimes visit *datu* spellcasters to put love spells on girls who refuse their courtship; sometimes spellcasters are hired to prevent such a girl from ever having children. This condition, and the "climbing disease" in which bujing-bujing run about the house in great agitation and try to climb up the walls, are thought to be caused by disgruntled suitors.

When a bujing-bujing arrives in the house of her groom's father, to "seek her *namboru*" (father's sister) and marry her father's sis-ter's son, many aspects of her adolescence are replaced by their opposites: severity, restraint, deference, shyness, uncertainty, sad-ness, and an inability to speak very fluently. Such things are imag-ined to be part of the nature of the boru or bride.

First, her sadness. Perhaps the most affecting presentation of

this is the bride's *andung*, her wailed mourning song delivered as she leaves her parents for the last time. After the wedding, she should not see them until after the birth of her first child. The bride can andung her parents, her little brothers and sisters, and all the physical places of her childhood (her bed, her father's doorsill, the bathing pool she used as a playground). The following andung was from a staged performance by a raja adat, as real andung is almost impossible to tape-record:

> *Uba he inang na lambok marlidung,*
> *Songon simarpangpang ditonga dapur ma da*
> *Sinuan boyumu mangoloi lidung ni siadosatku*
> *Lumapat tu jae tu julu*
> *Songon bulu tolang ditonga padang*
> *Manyambut manyaluangi*
> *Lidung ni siadosanku*
> *Na jaor manghalamotan i*
> *Anso mardabu ni pangarohai da damang dainang*
> *Na manjagit omas sigumorsing*
> *Na marlindak marlobi-lobi i*
> *Umanan ma au dainang*
> *Sumikot tali siudiran*
> *Humombar kayu sinahitan jong-jong marangin sipurpuron*
> *Anso mardabu ni pangarohai do ma i damang dainang.*

(O alas, Mother, Soft-spoken One,
Like meow-meowing Cat in the kitchen was I
Your loving daughter yes'ing all the sayings of my intimate
 one [the little child—a father's brother's child or such—
 that she has been caring for during her late girlhood; she
 must now leave the child to get married]
Bounding here and there when ordered,
Bending like the big bamboo in mid-grassland
Answering, following,
All the sayings of my intimate one
Who was left lost orphaned as a tiny child
And yet your hearts are made up, *damang dainang* [my
 father, my mother]
To accept my brideprice, yellow yellowest gleaming gold
Gold that overflows its container
Better that I yank tight the suicide-rope, my mother

Hang my body parallel to my hanging tree
Hang upright in the blowing wind [an andung phrase for
 "to die"]
So your heart's wish is had, my father, my mother.)

Note the bride's stated resentment of her mother for valuing
brideprice gold over her. This is a sore point in marriage oratory.
Mora speakers will often protest that "we have eyes only for hu-
mans, not for brideprice gold" in negotiating their lineage daugh-
ter's brideprice with their anakboru. Proverbs and written com-
mentary in proverb handbooks carry out similar themes of the
bride's sadness (Marpaung and Sohuturon 1962:74).

During the wedding rituals, the bride sits on special rattan mats
in the spot of honor in the house, sometimes accompanied by her
husband (one of the few times in the culture that a married pair
appears in public as an obvious pair; in the large-scale *horja* wed-
dings they dance facing each other in one grand slow dance).
Throughout the wedding, of whatever level of extravagance, the
bride is to keep her eyes downcast, her hands folded in her lap, and
her feet tucked under her. She is to stay immobile, and never
smile. She has little appetite and has to be coaxed to eat.

The bride's soul is in danger of fragmentation. Speeches, special
foods, and trips out to the Tapian Raya Bangunan (Bathing Pool of
the Raja) are used to make her soul *pir* ('hard, firmly held to-
gether'). In the many advice-to-the-newlyweds speeches delivered
throughout the wedding, the bride is encouraged to give up the un-
certain, fickle ways of youth and take on adult responsibilities and
steadfastness of purpose. The advice speeches are specifically
called "Advice for the Boru," and the bride is told over and over
again to become a peaceable partner for her husband, "to honor
and worship her mora, to be good to her kahanggi, and to be solici-
tous of anakboru" (*somba marmora, denggan markahanggi, elek
marboru*). And she is urged to have "seventeen sons and sixteen
daughters," all as quickly as possible. These magical blessing ad-
vice speeches are thought to effect the hoped-for condition through
the very saying of the words (Rodgers Siregar 1979a).

Beyond all this, however, perhaps the most telling sort of speech
about the boru consists in the many short phrases used to refer to

her throughout the wedding. The bride is called *Siparoban tua* ('Bringer-of-Luck'), *Siparoban dame* ('Bringer-of-Peace'), *Siparoban hatatorkis* ('Bringer-of-Health'), *Silua na godang* ('the Greatest Gift'), and *lahanlahanan ni pardomuanta* ('the Vehicle-for-Our-Common-Meeting'). She is,

> *sulu panorang manjadi silua na godang*
> *pangisi ni bagas na godang*
> *simangumpal simangumbalo*

> A torch for lighting the way,
> The Greatest Gift
> The Occupant to fill up the Great House
> The Firmer-Up of souls

The "Greatest Gift" means the mora's greatest, supreme blessing presented to its anakboru.

The bride is also celebrated as a "fierce defender" of her kahanggi, fending off dangers (*jaga juang ketimbang balik*). In line with this, in large-scale weddings she is outfitted with daggers as part of the wedding costume. Her gold-spangled headdress hangs down over her eyes at the left and right. This is a message to her, the orators tell her, to keep her eyes straight ahead and downward, not letting her loyalties stray from her husband and kahanggi lineagemates.

The bride is the cane to help her father's sister over the slippery spots: she becomes that older woman's *tungkot di na landit sulu-sulu di na golap*, 'cane over the slippery spots, torch in the darkness.' She resembles *ombun manyorop tu rura maroban aek panowari*, 'clouds that drift into the valleys, bringing cooling waters,' to cool hot quarrels among her husband's kahanggi. She is *dalan ni api martimus*, 'the reason the ceremonial fires are smoking.' Finally, she is praised as someone whose head "will soon sprout with leaf crowns" and whose shoulder "will soon sprout with branches": that is, sons and daughters will soon be born to her, and she will wear the headdresses in the shape of trees announcing this and tie the ulos (baby-holder textile) in a big knot on her shoulder.

At one level, some of this characterization of new brides can be

explained by a familiar social structural pattern found in many strongly patrilineal societies with patrilocal residence. Conflict between the bride and her husband's mother, the woman she will eventually replace as woman of the household, is expected by all parties. The bride will also have conflicting ties to her father, mother, and siblings back home. However, much more than what this institutional perspective would indicate is occurring in Angkola culture.

Consider the conventional way the anakboru's relationship to mora is presented in the adat oratory. In the phrases used by orators to praise anakboru's correct relationship to mora, anakboru are said to be "*Anakboru*-the-Strong-at-Balancing-*Mora*-on-their-Heads, the-Ones-Who-Stride-to-the-Fore, Who-Brace-Themselves-to-the-Rear, the-Cane-Over-the-Slippery-Spots, the Torch-in-the-Darkness, Augmenter-of-What-Lacks, Remover-of-Excess, a-Terror-When-Angered, Untouchable-Thornbush, Hardwood-Bar-Crossing-Sealing-the-Gate, Central-Support-Beam-Holding-Up-the-Roof"[9] of mora's house. Anakboru "suffers rain and mosquitoes," protecting mora and furthering its aims. Anakboru fights for mora in its battles, raises money for mora's rituals, cooks its food at those rituals, and praises mora through ritual speech. Moreover, anakboru is the designated peacemaker for mora if mora quarrels among itself. Mora brings *tua* ('luck'), blessings, and fertility to anakboru; anakboru in its turn preserves mora from external threat and internal dissension.

It is evident already that the new bride is a mediating figure—in fact, the chief mediating figure—between mora and anakboru. She combines characteristics of both sides. She is fierce, but also a Carrier of Peace. Like anakboru, she is said to be a supporting cane, yet she supports her father's sister, not her parents. She is a "bridge" between mora and anakboru, to use an exact local term. The bride is "the Greatest Gift" mora can bestow on anakboru, yet she herself is also anakboru to that same mora. As someone whose structural position falls between two well-defined social and cosmological categories, the newly arrived bride is worrisomely ambiguous. As E. R. Leach and Mary Douglas have pointed out in their studies of mythic and ritual symbolism (Leach 1964; Douglas 1966), intermediary figures of this sort do not fit cleanly into

any single category but partake of two at once. As a consequence, such figures are often the focus of fear, taboo, and considerable emotional ambivalence. Bujing-bujing are daughters who will surely leave home to go live with the anakboru, or 'daughter people.' Consequently, they have a double character.

The bride shares with mora the qualities of luckiness, wealth, and the promise of fertility. She shares with anakboru the ability to bring peace to mora. Like anakboru too, she has a certain military bearing (the daggers in the bridal dress), an essential unpredictability, and a capacity to inflict great damage. The "Untouchable Thornbush" phrase in the eulogistic speech on anakboru refers to anakboru's ability to inflict "thorn wounds" in a mora that does not behave in the proper indulgent, beneficent way. Brides can wreak havoc themselves. When a bride has just arrived in her new house, for instance, there is an undercurrent of fear about the firmness of her intentions to stay there. Some new boru simply sneak out of their husband's father's houses and run home to their parents and younger brothers and sisters. This is an event that causes much embarrassment and conflict between the lineages involved. The bride's affection for her younger siblings she has left behind, and whom she now must not see for many months, is also a conventionalized focus of suspicion among her kahanggi. Much of the wedding advice commands her to cut all her ties to her natal family.

Recall also that a lineage should cajole (marelek-elek) its anakboru into doing its bidding. By contrast, lineage members may simply order lineagemates to do something without resort to flattery or wheedling. As well, anakboru as a unit generally try to cajole their mora into doing something rather than requesting it directly. This is an instance in which the characterization of women as presented in the bride overlaps with the character imputed to anakboru as a larger unit. Fathers treat their sons and daughters differently, despite such proverbs as the locally famous 'you bend over to hand-feed masticated rice to sons the same way you do to daughters' (tungkap marmama anak, tungkap marmama boru). The inheritance rule governing the allocation of riceland states that each son shall have a share of his father's property, with slightly larger parcels going to the eldest and youngest sons. Then,

all the daughters together share one additional portion, equal to that of one son. Angkola men and women expect women to complain about the "inequity" of this, and they expect daughters in a family to try to rectify the situation before their fathers die. Two stereotyped scenarios go as follows. When a girl is about to be sent to an arranged marriage, she will tell her father that she flatly refuses to get married, to anyone, unless he outfits her with a complete set of twenty-four-carat jewelry (earrings, bracelets, necklace). This type of jewelry the bride may carry to her marriage and sell for the good of her new household. Even if she succeeds in this ploy, upon the birth of her first child she may take the newborn on its first visit to her father and announce that "your grandchild must eat and so we need a present of more riceland." The father then agrees to give the land, which in turn angers his sons. In sum, both brides and anakboru as a whole approach men of their mora through "unofficial channels" such as assertive cajolery and flattery.

The abrupt transformation from happy bujing-bujing to sad, uncommunicative boru may be a ritual inversion marking a transition of great danger. The advice-to-the-newlyweds speeches attempt to align the bride completely with her kahanggi, but she is still pulled toward her natal household. Many features of her adolescent life, perhaps overly identified with her father's clan, are reversed in her wedding ceremony. This may represent a ritual attempt to transfer the bride from one category to the other.

A fuller analysis would show that the bujing-bujing and the bride occupy only two parts of the longer idealized life cycle of Angkola women. Once firmly established in her new household (thanks to the birth of a son or, to a lesser extent, a daughter), the Angkola wife is expected to regain much of her talkativeness and outgoing nature. In fact, in the later period of her marriage the Angkola woman is expected to return to the assertiveness associated with her adolescence. Fuller analysis would also reveal that later adat rituals in a woman's life (those marking the births of children, and her own funeral) also display many of the tensions of the wife-giver and wife-taker relationship, and women's place within this tension, as anakboru clan daughters to their father's lineage. At the more elaborate sort of funeral for an old woman, the corpse is outfitted in splendid textiles and serves as the focus of oratory

by wife-givers and wife-takers that is quite similar to the ritual speeches at the wedding. An old woman's funeral is explicitly recognized in Angkola adat as the "completion" of her wedding, and the gifts exchanged at a grandmother's funeral are seen to complement the bridewealth gifts exchanged years before.[10]

Clearly, Angkola see women as go-betweens uniting mora and anakboru, but today they also use that symbolism of indebtedness, of cagey, powerful subordination, and of somewhat vulnerable beneficence to structure relations between other, more encompassing social categories. Women are seen today as go-betweens uniting entire ethnic groups, and an analysis of gender symbols would not be complete without some mention of the Angkola logic of bride adoption and clan adoption in dealing with foreigner peoples.

Angkola Gender Concepts and Ethnicity

Ethnicity concepts in Angkola have much of the fluidity and sensitivity to social context noted in other small-scale societies in Southeast Asia (Leach 1954; Moermann 1965).[11] That is, ethnic membership is not fixed but may change if individuals move into new social locales; individuals may switch up and down a large range of ethnic categories, from the adat chieftaincy level through "Angkola" to Batak to Indonesian; and individuals may consciously drop out of an ethnic category that puts them in an unfavorable social situation. To these common features, however, Angkola add peculiarly Batak elements. People can drop out of Batak society by dropping off the clan genealogies, and foreigners can enter Batak society by adopting Batak clans. Batak of one subgroup, such as the Angkola, can switch their natal clan for its "equivalent" in another Batak sub-society if they move there for any length of time. Foreigner families from other Indonesian societies can become Batak by using the local symbolism of marriage alliance and clan descent, and foreigner brides from Bali, Java, and so on can be transformed into proper mother's brother's daughters by convenient bride-adoption rituals, performed at their adat weddings. Furthermore, Angkola often talk of interacting

with other ethnic groups in terms of *marrying* other ethnic groups. One of the great fears of conservative homelanders, in fact, is that their sons who have migrated to cities will *mambuat boru Jawa* ('take a Javanese woman as a bride') or *boru Bali* or *boru Sunda* or, in a vaguer sense, *mambuat boru Doli*, 'take a Deli girl as a bride.' Deli refers to the east coast plantation belt of Sumatra where some Angkola families migrated in the 1920's and 1930's. In a larger sense, Deli is the Indonesian world outside the Tapanuli homeland. Brides are the bridge to this world, much as they are the bridge between anakboru and mora, and foreigner brides are the focus of particular distrust because of it. In fact, they act as symbolic representations of the larger foreign ethnic groups that have "given" them to the Batak.

Before examining several actual cases involving Angkola families interacting through women with other ethnic groups, let me briefly summarize some of the major points of Angkola thought about ethnicity.

Firstly, Angkola postulate clan relationships between all members of the several Batak societies. As noted, Angkola say that almost all Batak are ultimately descended from a single male ancestor, Si Raja Batak. Si Raja Batak's sons, grandsons, and great-grandsons fathered the major clan groups and clans. The members of these supposedly spread out gradually from the ancestral homeland on the shore of Lake Toba to open the outlying Batak homelands such as Angkola and Karo.

Intermarriage between these societies is discouraged. Each Batak society has a different "innate character," a different dialect, and a different traditional ceremonial system. Importantly, these differences are said to adhere in part in the different clan composition of each area.

In mixed marriages involving partners from two Batak societies, the children automatically inherit the ethnic identity of their father, much as they inherit their clan identity. This is "only natural"—children always *ikut bapak*, or 'follow fathers.' Because of this, the marriage of a daughter to an outsider is cause for greater alarm than the marriage of a son to a non-Angkola.

This pattern is also true in cases of marriage between an Angkola Batak and a member of a non-Batak Indonesian society. The

children of sons can be retained for the clan. Further, the outsider bride can be ritually adopted into the clan of the groom's mother, often into the exact household of the groom's mother's brother, making her an exact mother's brother's daughter (a *boru tulang kontan*, in the slang: a "cash-variety" mother's brother's daughter). This provides the sons of the new marriage with marriageable matrilateral cross-cousins. When a daughter of an Angkola family marries out, however, her children will follow their fathers in matters of clan identity and ethnicity. Daughters are the sort of children who grow up and marry away from the household, and sons are the sort of children who stay. Ethnic affiliation follows the same logic.

Angkola also use their symbolism of marriage alliance to shape ethnic thinking. This affects their dealings with non-Batak societies in Indonesia. For instance, for the occasional Javanese or Minangkabau family living in the Batak homelands, full entry into local Batak society, as Angkola Batak (something the Angkola assume every foreign Indonesian will aspire to), can only come through the turnstile of Batak kinship. The outsiders must be ritually adopted into local clans, but they also must give daughters and receive brides according to local rules of marriage exchange. Importantly, no matter how adept the outsiders may be at playing the role of an Angkola Batak and looking, according to local physiological standards, quite Batak, if they have not been literally adopted into the full Angkola kinship system, they remain outsiders.

One aspect of Angkola ethnicity is immediately obvious. With the institution of clan adoption and the possibility of entering into Angkola bride exchanges, the society becomes a remarkably permeable ethnic group. The Angkola hospitably, or perhaps imperialistically, accept breakaway families from neighboring societies on Sumatra or even Java and have the cultural apparatus to pronounce them full-fledged Angkola Batak. Much as Angkola take new brides from lineages never before affiliated with a household and kahanggi, and call them mother's brother's daughters with classificatory panache, they pull foreigners into their ethnic unit by extending the *turtur*, the 'range of kinship talk.'

It should be pointed out that the system can work in the other direction too. That is, if clanship and marriage exchange is a main

way into Batak ethnic identity, it is also a way out. "Born Batak" themselves can rather easily leave their ethnic groups by the simple expedient of dropping their diagnostically Batak clan names. Many Indonesian societies do not have clans, and the 300 or so Batak clan names are widely recognizable throughout Sumatra and Java as distinctively Batak.

Dropping out of Batak society has become more uncommon in the national period since 1945 as the Batak have succeeded in establishing themselves in the Indonesian national imagination as a generally admirable, go-getting, education-minded people active in the political, military, and literary life of the country. This increasingly benign regard for the Batak is, however, quite new. In the late Dutch colonial period, for instance, the Muslim Malay peoples of Sumatra's east coast plantation belt regarded the Batak with disdain if not outright horror as a loutish, unpredictable, pig-eating, uniformly *Christian* tribe of backwoodsmen ("upriver-people" in the exact Malay phrase). Dutch and German Protestant missionaries had begun converting some of the Batak in Angkola and Toba in the 1850's and 1860's, but the majority of Sipirok and Angkola and all of Mandailing to the south remained firmly Muslim, a legacy of Minangkabau-led conversion efforts begun in the 1820's. Muslim Batak men from these southern areas were anxious to separate themselves from this image of the violent, infidel Batak in their efforts to secure clerking jobs in the east coast plantations. They sometimes dropped their stigmatically Batak names and melted into the general Muslim Malay population.

Villagers and townspeople in the Sipirok region see varying ranges of ethnic groups peopling the world. Though I did no systematic survey research on the topic, those villagers with whom I spoke apparently see only eleven peoples arranged about them in Indonesia: *halak Angkola* (*halak* again means 'people'); *halak Padang Bolak; halak Mandailing; halak Toba;* a very broad-gauged Malay group; *halak Aceh; halak Daret* or *halak Minang* (the Minangkabau in West Sumatra); *halak Nias; halak Jawa* (the Javanese); *halak Cino* (the overseas Chinese in Indonesia). They also see several scruffy, unnamed bands of primitive pagan peoples on faraway islands. Their perceptions of societies beyond Indonesia are even sketchier: villagers have an all-too-clear memory of

the Japanese, but whites are often all *halak Bolanda*: Dutchmen. Highly educated townspeople, especially those who have retired to the homeland after careers in cities, sometimes make finer category distinctions, or see more societies.

Beyond the simple classification of outside groups, full stereotypes of "Javaneseness," "Minangness," and so on vary too, from isolated village to market town to cosmopolitan city. An untravelled Sipirok villager's image of the Javanese, for instance, is often something put together from tales brought back from the east coast estate lands first developed by the Dutch. Impoverished Javanese were brought to this lowland plantation belt as coolie laborers in the early years of this century. The image of the Javanese as shiftless plantation laborers has stuck in Batak village consciousness. The villager's relatives living in the multiethnic North Sumatran provincial capital of Medan, though, have another picture of the Javanese altogether. Medan, though largely a Batak town, is an administrative and economic center and a magnet for migrants from all over Sumatra. The city has many well-educated Javanese civil servants and army men, not to mention a Javacentric mass communications network and public school system, to temper the Batak villager's notion that the Javanese are a crew of plantation coolies, street sweepers, houseboys, and maids. These city people cannot avoid information about the ancient court culture of Java, much touted in the national media and in the schools. The Batak villager's conviction that the Javanese are a somewhat culturally deprived and adat-less people of uncertain religious convictions meets daily disconfirmation in a cosmopolitan city like Medan.

In the Sipirok neighborhood where I lived (to cite some popular stereotypes), unmarried young men were counseled not to marry Javanese women because they were not very firm in the adat and tended to divorce often. The men were also advised to stay away from Toba women because they did not know how to cook vegetables. Nias women were too primitive. Sundanese women were very beautiful, but again, like the Javanese, they did not have much adat. Angkola women were defined, in contrast to all this, in glowing terms.

The social incorporation of individual Indonesian foreigners

and foreigner families as local Batak calls for attention to marriage alliance, local clanship, village residence, language use, and adherence to ceremonial customs. The following cases (taken from my fieldnotes) illustrate this, and demonstrate the importance of women in fixing ethnic identity.

Toba Batak Migrants in an Angkola Village

Some 60 years ago, a young Toba Batak of the Hutagaol clan was working as a salt merchant, carrying loads of sea salt from the sea beds of coastal Sibolga through Sipirok north into Toba. On one trip, according to the story his sons tell, he simply decided that he had had enough of the salt carrier's trade, and he settled down in an Angkola farming village along his usual route. The raja of the village, happy to get new settlers, presented the man with a clan daughter as a wife. After living in the village for several years, the newcomer switched his clan from Hutagaol to Pane, a locally prominent clan and one deeply connected through alliance to the area's dominant Siregar clan. Taking on this new Angkola clan when he already had a Toba Batak clan was because he "had no Hutagaol clansmen to befriend him and look out for his interests in Sipirok." He later became a Muslim like most of his village neighbors and raised a family of Angkola Batak children who have, apparently, no interest in or knowledge of Toba Batak ways. This man serves as the village's *Orang-kayo* (spokesman for the raja and main anakboru) in rituals today, and his new clan name is fully accepted in village kin-term usage.

The Pane clan was chosen, the sons say, because it was "the Sipirok equivalent" of the Toba clan Hutagaol. This is based on the logic of Batak clan separation and migration: some clans that split and sent branches into several homeland areas took different clan names in the new regions.

A second case delves further into alliance.

A Bride Adoption

Marriages between Batak societies demand no clan adoption ceremonies, but those involving Batak men and women from other Indonesian societies leave the ritual and social status of any future children dangerously ambiguous. The children of such marriages are Batak in the sense of having clans, but the adoption of their mother into the father's mother's clan goes beyond this to give the children a firm spot in local marriage alliance networks. With the clan adoption of a foreigner mother, the sons gain the magical protection of mother's brothers, and full claim on their all-important mother's brothers' daughters as future brides. Adoption of

foreign men into Batak clans is much more difficult and expensive than the adoption of outsider brides.

In the case here, a Muslim man in his mid-twenties from a Sipirok village brought home a Javanese woman to marry in a village adat ceremony. They had met at a state police academy, where they were both students; after their wedding, they planned to return to Jakarta to live. A large-scale wedding and clan adoption ceremony for the bride was held, and she was made a "boru Pane," a daughter of the Pane clan (the clan of the groom's mother and his correct marriage choice "had things gone as they should" and he had married a local girl).

I tape-recorded this adoption ceremony, and was able to catch an illuminating off-stage exchange between the groom's father and the presiding ceremonial raja just before the raja conferred clan membership on the bride:

Father of the groom: Yes then, forgive me for saying this but, lots of folks say, to marry a *boru Java* [a Javanese girl], that's a girl added on from the outside, they say!

Presiding Raja: Yes, don't they!

Father of the groom: Well, then, let's just correct it; words are the good thing anyway. [*Jadi, tapadenggan; hata do na denggan;* from the Angkola Batak]

Like many Sipirok people, the father here has a fine sense for the social efficacy of language. He as much as says that the match is an unorthodox situation that can be set aright with the clan adoption of the bride and the consistent use of Batak kin terms toward her and her children in the future. These children will have full ritual status as local Batak, full claim on their mother's brothers' daughters as brides, and full claim on their Pane mothers' brothers for benedictions and good luck. This is all independent of any social identity as Batak the new couple may cultivate in their new lives as civil servants in Jakarta; ominously, this bride did not plan to study the Angkola Batak dialect.

A third case shows a more complete integration into local society.

A Javanese Family That Became Batak

This case involves the clan adoption of a whole family whose father and mother were Javanese plantation laborers from Sumatra's east coast.

Ten years or so after the clan adoption, a granddaughter of the settlers was given in marriage to a local Batak family, and the family acquired anak-boru, wife-receivers. In 1975, a grandson of the settlers got a bride from a village family, and the family acquired mora, wife-givers. In the adat cere-mony held to celebrate the marriage, village orators made a great point of the fact that the newcomer family was now "complete": they had clan-mates, anakboru, and mora. They are, in addition, firmly established in village kin-term usage as Batak, and they have not consciously held on to any Javanese speech or custom. The settlers' son still speaks broken Batak, but the grandchildren—the ones who made the marriages—speak the local dialect without an accent. They seem to be successfully estab-lished as Angkola Batak both because they fulfill all the kinship and vil-lage residence requirements, and because they make a conscious effort to shuck off their ancestors' culture and take on Angkola Batak ways.

This family, importantly, first got their toehold in their Sipirok village along traditional political lines: the raja who first invited them there, as laborers for his small-scale rubber farm, provided them with rice paddy and garden land. After this raja died and the rubber plantation failed, his sons gave the settlers still more rice paddy and adopted the settlers into their own lineage.

The last case illustrates how a negatively stereotyped culture, that of the Indonesian Chinese, is perceived by Angkola Batak through imagery of "immoral" Chinese women.

A Chinese Attempt to Become Batak

While the once-Javanese family is accepted matter-of-factly as Ang-kola, the children of a Chinese father and Angkola mother living in the town of Sipirok are accorded a mongrel status and find themselves the fre-quent target of gossip and witchcraft accusations. The mother and 38-year-old daughter of the family have been singled out in the town for par-ticular dislike. This family has three strikes against it in its efforts to gain acceptance as Angkola Batak: it was their father, not their mother, who was the outsider; he was Chinese, not a member of another Indonesian society; and the mother was a descendant of one of Sipirok's old *hatoban* or slave families. The last hatoban were freed under the Dutch, but their descendants remain ritual and social castaways in the midst of regular Angkola society. Some original hatoban were war captives, often from other Batak societies. Their descendants in Angkola today are accepted as local Batak, but are still largely segregated from the rest of the population in terms of residence, adat ceremonial, and marriage. The Chinese married his hatoban woman, people say today, because no one else would have him, and she found in him her only possible nonhatoban marriage choice.

Though some of the children of this pair have married local Batak, the father was never adopted into a clan. As his children tell it, he long insisted that his Chinese surname was "a raja's clan back in Hongkong," his hometown. This has left the family with a half-breed status that no amount of social climbing, local language use, participation in the adat, and behavior as local Batak can overcome. The fact that the Batak see the Chinese in Sumatra as a rapacious merchant class has also damaged this family's chances of attaining full Angkola Batak identity.

Kin-term usage toward the children of this Chinese man demonstrates their social insecurity in miniature. Though the grown daughter still living in town has taken on a local clan name for everyday use, without going through an adoption, everybody calls her by her father's Chinese surname—behind her back. With her clan status so shaky, she has not had any great success in converting the town to the kin-term usage she prefers.

This woman is the subject of unusually vitriolic gossip by the Angkola of nonslave, Angkola descent.

In all these cases, individual outsider men, and entire families, enter Angkola through women. Angkola relate to societies such as Java via "boru Java," in the double sense of Javanese brides and daughters-of-the-Javanese. So as not to stay in the uncomfortable position of subservient anakboru to another ethnic group, Angkola try to adopt the brides into appropriate Angkola clans. In the last case, Angkola distrust and in fact outright hatred of the Indonesian Chinese is phrased in terms of "immoral Chinese women." Angkola women define themselves, in positive terms, in contrast to these Chinese women. It is interesting to note that there is relatively little discussion in Angkola of womanhood per se; different kinship types are much elaborated, and women are divided according to clan, but the notion of women as a larger unit seems not of vital concern. It may be that with increasing interethnic contact and competition in Indonesia, Angkola will develop ideas of the Batak woman and womanhood in comparison to similarly blunt ethnic and gender symbols for other societies. This is an instance of national-level ethnic interaction working back on Angkola gender ideas, while the bride-adoption strategy and clan name changes for men are cases of Angkola employing their alliance and descent ideas to come to grips with ethnic diversity.

In these ways Angkola gender symbols go beyond village-based alliance and descent to encompass interethnic relations. As such, these gender ideas illustrate the changing political context of all

Angkola homeland thought today. Women are conceptualized as intermediaries, this time between entire ethnic groups, and symbolize the groups from which they came. Thus the negative images of non-Batak women who marry Batak and come from "bad" ethnic groups. This process may spur the further development of new concepts of Angkola women that go beyond village kinship categories, and may eventually result in an interest in some supposed panethnic character of women.

Using a two-step analysis of Angkola concepts of woman in their alliance and descent and larger political contexts, this paper has presented an example of a style of anthropological analysis that combines attention to symbolic features with attention to changing political contexts—an approach dictated by the Angkola Bataks' sociologically transitional character today, as they become more fully integrated into the multiethnic Indonesian nation. The Batak peoples are relatively more involved in national Indonesian life than are many ethnic groups in eastern Indonesia with similar systems of asymmetrical marriage alliance. It may be that as these other cultures are drawn into the national orbit, their systems of gender symbolism, like that of the Angkola Batak, will come to be used to shape ethnic concepts, and ethnicity symbols themselves in turn will reshape gender ideas.

Collision of Cultures

Historical Reformulations of Gender in the Lowland Visayas, Philippines

Cristina Blanc-Szanton

The Ilonggo of the Visayas (Philippines), the subject of Cristina Blanc-Szanton's paper, are decidedly members of the "Centrist Archipelago." In contrast to the Angkola, the Kodinese, the Huaulu, and the Weyéwa, the Ilonggo bring us back to a cultural world in which gender differences are not put to service as major social and cosmic markers. Instead, the dichotomous possibilities of gender are relatively undeveloped, as is the case in a number of the western Indonesian examples discussed in this volume.

Blanc-Szanton's paper adds two important dimensions to our consideration of gender. The first one is historical. Like a number of papers in this volume, Blanc-Szanton's treats the construction of gender not as a text to be read but as a process to be understood. Her analysis spans some three centuries of Philippine history. As such it makes us aware of the ongoing "invention of tradition" (Hobsbawn and Ranger 1983) as Filipinos engage in political bricolage, citing elements of the past to challenge or uphold social realities of the present.

Second, Blanc-Szanton's is the only paper in this volume to address systematically the effects of European colonialism upon the construction of gender in the archipelago. As an Italian reared with Mediterranean Catholic notions of gender, Blanc-Szanton registers her amazement at local Visayan variations on Spanish themes of sexuality and gender. Far from passively absorbing European stereotypes, Ilonggo have made selec-

tive use of Spanish efforts to inculcate their values in the Visayan population. Indeed, Blanc-Szanton's analysis stresses Ilonggo agency in the colonial encounter. Her point is that although Spanish, Americans, and now the Philippine national government have introduced new elements to the Ilonggo gender system, they have never been able to countermand the means by which that system is produced. Hence local Visayans have selectively integrated Spanish notions while continuing to formulate and reformulate notions of gender in patterns that stress comparable rather than contrastive qualities of femaleness and maleness.

Blanc-Szanton's account of the Visayan datu or political leaders bears special consideration as it illuminates some differences between Eastern Indonesian societies and those found elsewhere in the archipelago. Marriage occupies a very different place in political hierarchy in the Visayas than it does in the dualistic alliance systems where marriage exchanges between Houses serve as instruments and expressions of political hierarchy. The traditional Ilonggo political system here is more of the "center" sort—powerful leaders are individuals who attract followings by developing reputations for bravery and special potency. Like the Meratus political subject depicted by Tsing, the traditional Ilonggo datu was someone who could attract and hold an audience. In contrast to influential individuals in Meratus and Wana societies, however, the traditional Visayan datu had practical resources like land, labor, and tribute to bolster his reputation. (In that respect, Visayan chiefdoms possessed the ingredients, including social stratification, that could have led to incipient state formation.) He seems also to have been surrounded by aspiring "men of prowess" seeking to marry his kinswomen. One might speculate that the Visayan datu, in contrast to his exchange-minded Eastern Indonesian counterpart, sought the center for himself by defining his kindred in optatively endogamous rather than mandatorily exogamous terms.

Gender systems, like other cultural constructions, are neither static nor impervious to social, political, and economic change. The lowland Philippines offer a particularly interesting theoretical example of historical collisions between gender systems under colonial and postcolonial rule. It allows one to analyze the outcome of historical encounters during which a gender system common, with variations, to most of Southeast Asia, and constructed on ideas of human sameness and complementarity, was dominated and influenced during three successive time periods by other very different gender systems.

Until the late sixteenth century, the Ilonggo lived in small rural communities, largely populated by swidden cultivators and scattered along the coastline of the island of Panay. Together with the rest of the Philippines, they were then conquered and dominated for over 300 years by a Spanish Mediterranean culture in which images of gender and sexuality powerfully shaped both the ideological world (i.e., fear of women's sexuality) and, though often in contrasting ways, the world of daily action and behavior. In this context, a man's honor and prestige is tied to the defense of house, land, and family, which constitute the base of his social standing in the community, and he is thus directly threatened by the personal and/or sexual (mis)conduct of "his" women. Prestige and gender systems are closely connected (Pitt-Rivers 1971; Brandes 1980, 1981; Ortner 1981).

Then, starting at the turn of the century and lasting for nearly 50 years, the lowland Philippines became subject to a North American culture with its ideologies of personal equality, democracy, and individualism; by the mid-twentieth century, the Philippines had become a modern Third World nation with nationalistic requirements of growth and state control. Each period had its own varied, discontinuous, at times overlapping, and often conflicting or ambiguous symbolic formulations and reformulations of gender and sexuality.

This Ilonggo case study allows us to analyze the often disparate and fragmentary gender images and views of sexuality operating at different time periods (early Spanish, late Spanish, early twentieth- and late twentieth-century North American), and to view gender construction as an ongoing product of social action, i.e., as a process, as well as to analyze the effects of this interaction over time.

These interactions were also affected by the different times and contexts of power and inequality, that is, as they took place in pre-state ranked societies, in two kinds of colonial systems with different economic, social, and political settings, and in the midst of deep social and ideological transformations resulting from increasing commercialization and industrialization in the twentieth century.

In these changing contexts of power, more fully articulated systems of symbols were made explicit by formal colonial/govern-

mental institutions and by local elites. These systems reached particular segments of the populations in different ways over time. Through formal pronouncements and colonial and postcolonial legislation, governments and elites promulgated different historically specific symbolic idioms (local and foreign), with different degrees of conscious objectivization. In other words, ideas, words, metaphors, increasingly became political "material," elements of discourse, and there occurred an increasingly conscious utilization and manipulation of concepts of "culture," "tradition," and "sexuality" (Taussig 1980; Foucault 1980, 1984a, 1984b; Williams 1983). In the Philippines, one can monitor these changes, as well as some surprising continuities in both the terms of the discourse on gender and the techniques of symbolic construction. These continuities represent the limitations on change imposed by the historically determined structures in which the changes emerged and in which they were lived.

Ordinary Visayans[1] responded to attempts to mold them, their gender systems, and their potential social relationships by becoming selective and adapting old and new cultural images and formulations, giving the images new meanings, or meshing the images in syncretic combinations. These reformulations did not appear as formal statements, but were revealed in unobtrusive daily interactions in the language of everyday things, in personal strategies, bricolage, and subtle tactical combinations.

The Visayans insinuated their own language and countless differences into the dominant text offered to them (de Certeau 1984: Introduction). They responded to successive attempts to problematize sexuality and restructure their sense of self. Some restructuring took place, and long-term historical reformulations were eventually delineated. In that process the colonized behaved as "active agents and subjects in their own history" (Ortner 1984:143) confronting and exercising agency, within the context of power and the "implacable dependency" (Memmi 1965:90–118) that was being imposed on them. Both colonizers and colonized rooted the reformulations in their own experiences. Determining what they selected, stressed, refashioned, and developed over time and what they did not select is essential to understanding the Visayans of today.

In other words, this paper emphasizes that it is not sufficient to outline colonial and neocolonial policies and practices of power, or to list the political, economic, and social processes that accompanied them. Rather, one needs to focus, particularly as an anthropologist, on the implications of these dialectical interactions between colonizers and colonized and on the effects that such dialectics have on the cultural configurations of both, particularly the colonized.

This paper begins with an outline of some of the main features of gender among contemporary Ilonggo based on personal fieldwork over a period of fifteen years in Estancia, Iloilo, a lowland fishing and farming municipality on the island of Panay in the Western Visayas, and on published research on other Visayan communities (Jocano 1976; Ledesma 1982; Rutten 1982; Yu and Liu 1980). Next, it explores historical sources—in particular, the detailed seventeenth-century descriptions of comparable Visayan communities and the late nineteenth- and early twentieth-century British and American accounts of gender construction written when Spanish colonists were being replaced by Americans. The contrasts and continuities that emerge will then lead us to re-examine very briefly the contemporary case material and bring us to some wider theoretical considerations. Before proceeding, however, three methodological points need to be made.

1. The historical and ethnographic observations to which we will refer were mostly made by travelers and foreign residents writing about what struck them as noteworthy or significant. They wrote, as to some extent we all must, from the perspectives of their own cultures and with the burdens of their prejudices about Philippine society in general and about gender relationships in particular. They often no doubt misunderstood what they saw, or misconstrued what it meant to the Visayans. But through their fundamentally contrastive and comparative approach, they also made many sharp observations, and we shall try to build on these strengths.[2]

2. These observations were regionally specific. The Visayan region apparently did not experience the missionizing Christian and Spanish presence, for example, quite to the same degree than the

Tagalog area, with their larger friar estates and the proximity
to Manila as an entrepôt and colonial capital. Historians of the
Philippines are still trying to unravel the implications of these dif-
ferent regional histories for a fuller understanding of contempo-
rary Filipino society (McCoy 1982). And recent studies on Spanish
colonialism in the Philippines have cautiously focused on a spe-
cific region rather than automatically generalizing from it to the
whole country (for the Tagalog region: Ileto 1979; Rafael 1988).

3. These ethnographic and historical observations were made
largely in rural communities and their hinterlands, not in the
more modern urban or industrial areas. The gender constructions
and symbolism they manifest are thus characteristic of an exten-
sive and quite rural Visayan countryside. As a result, they only
partially reflect some of the more revolutionary changes occurring
through the twentieth century in other parts of the country, as in
Manila and in the free trade and industrial zones.

Lowland Ilonggo Constructions of Gender—Initial Observations

As an Italian raised on the variations and continuities of sexual
ideologies found in the Circum-Mediterranean region (described
by Pitt-Rivers 1971, 1977; Mernissi 1975; Dwyer 1978; Brandes
1980, 1981), I was struck and puzzled when I first reached Iloilo
province by similarities and differences with Ilonggo gender sym-
bolism and ideologies. I recognized many familiar features, but the
total impression was quite different from my own experience and
my readings on the Mediterranean. Local concepts of maleness
and femaleness appeared to be constructed of many of the same
symbols and metaphors, but organized, combined, and empha-
sized in different ways. What is more, they were not as clearly tied
to concepts of male prestige. For example, Ilonggo men in both
rural and smaller urban settings manifested many elements of
Latin "machismo," e.g., aggressiveness against other males, espe-
cially during drinking sprees, or when their personal honor was at
stake; demonstrations of manhood with threats or violence, appar-
ent fearlessness, and the carrying of arms; and, particularly among
young bachelors (*soltero*), bragging and joking about sexual ex-

ploits. By contrast, Ilonggo women were much less often viewed according to the Latin stereotypes: the evil temptress, the whore (*la mala mujer*, i.e., 'bad woman'), the virgin (*birhen*), or suffering mother (*la madre abnegada*). The Ilonggo symbols do not portray women as inferior because of a treacherous sexuality or tricky "nature."[3] Instead, women are largely defined positively, as more reliable and responsible than men, as less prone to temptation, vices, or self-display, and as providers for the continuity and security of the family. Indeed, women are charged with worrying about and controlling the gambling, drinking, and philandering of their fathers, husbands, brothers, and sons. Contrary to my Latin expectations, a preference for male offspring was not marked, and both lower class *and* elite clearly preferred daughters as a first child, arguing that daughters would assist the parents in raising younger siblings and in general would be more helpful and reliable (D. L. Szanton 1970:182; Yu and Liu 1980:102ff., 110).

Though women are not viewed as naturally sexually aggressive, the ideal norm encourages chastity and the preservation of virginity among unmarried girls (*dalaga*). This attitude is particularly strong among middle-class families for whom the known loss of virginity or loose sexual morals are generally seen as a negative mark for the family and a possible source of problems in arranging a good marriage (Yu and Liu 1980:59–64; Jocano 1969:61–62). Dalaga are thus encouraged to be cautious and responsible in this area and to avoid being seen alone with a boy publicly without an appropriate companion. On the other hand, it is considered "natural" for a soltero (unmarried young man) to pursue sexual adventures when the opportunity arises, and the responsibility for resisting sexual intimacy rests largely with the girl (Yu and Liu 1980:55–57; Jocano 1969:61–62).

Nevertheless, breaking the ideal norm of premarital virginity is quite frequent (28.6 percent in Cebu, up to 63.2 percent in Manila: Yu and Liu 1980:66–68).[4] More importantly, it meets with remarkably little public condemnation. It is considered a "natural" and expectable human response and provokes none of the dark tales or dramatic shadows on the honor of fathers and brothers that are common in Mediterranean societies. In other words, it does not seem to implicate quite as directly the personal honor and prestige of the male members of the family. It only more gen-

erally hinders the socioeconomic strategies of the family group. Thus, while it is generally better for a woman to remain a virgin before marriage, discreet premarital sexual intercourse is readily condoned in Ilonggo communities, particularly with a potential future husband. It is not viewed as inherently bad, and chastity is not stringently enforced (Pinard 1975).[5]

After marriage the Ilonggo woman does not conform to the image of la madre abnegada, which is patterned on the Virgin Mother—the self-sacrificing mother submerging her own identity and absorbing her husband's abuse for the good of the children—a woman lost in motherhood. Nor does she cultivate the manipulative martyr image rooted in her own goodness, and other women's badness, characteristic of her Mexican counterparts (Romanucci Ross 1973:58). Though children are very important to both husband and wife, and the wife might use them as go-betweens during crises to remind her husband of their former love and of the rights and duties with respect to children that bind them all together, children are not primarily viewed as extensions of the mother and fulfillments of her identity. Thus, despite 300 years of Spanish colonial pressure on questions of sexual morality and Catholic gender symbology, the patterns have been only selectively absorbed and are more often transformed into something else.

A life-cycle approach may clarify this assertion. For example, where concerns for chastity and accompanying symbols partially control the dalaga (young unmarried girl), a middle-aged married woman, unencumbered by stereotypes of being tempting, tricky, and weak because of uncontrollable sexuality, may achieve a remarkable measure of social, economic, and political power and control in rural and small-town settings (Blanc-Szanton 1981:135–37; Nakpil 1963:16–17). Likewise, a young dalaga may become a mistress (*kerida*), but this does not entail the condemnation it provokes in rural Spain or Greece. Though a kerida might be subject to some ostracism for choosing an unconventional path, she is less often viewed as an evil temptress than as a cunning woman (often lower-class) taking advantage of the economic support provided by a married lover. After an initial somewhat negative reaction by friends and relatives, she can be accepted back into the community, if her family welcomes her.[6]

Prostitution per se did not exist in rural Ilonggo communities in the 1960's and early 1970's, but men could go to the city with friends or alone to find "women for rent," or "women for the asking or for a few pesos" (Yu and Liu 1980:185). Though these women might regret their lost virginity, they sometimes work as prostitutes or massage-parlor attendants before and even after marriage for the good income, economic considerations overcoming the loss of status (Evangelista 1977:107; Yu and Liu 1980:193–96). Married women do consider kerida and prostitutes as potential threats, but they are usually much more indignant about the male double standard that these infractions represent. Kerida and prostitutes are not viewed as inherently bad people.

Furthermore, there is a belief that men have sexual urges that for health reasons must be released with greater regularity than those of women. When a man's sexual needs are not fulfilled by his wife (because of pregnancy, misunderstandings, etc.), he can, will, and should seek outlets with other women. This belief is institutionalized in the legal difference between adultery by women (considered by the 1950 new Civil Code and reemphasized in the 1966 revised Penal Code), which is "an instantaneous crime that is consummated and exhausted or completed at the moment of carnal union" and thus is proven by evidence of a single intercourse (Yu and Liu 1980:182), and concubinage by men, which needs to have occurred under scandalous circumstances or with proven cohabitation in order to be punishable (San Diego 1975:31).

A local event may highlight the general point. A reputable middle-class professional, the most "eligible bachelor" in town, married—after a long search by his socially prominent family—the daughter of a nouveau riche entrepreneur. The bride had been the fiesta queen several years before. The new husband was very proud of his pretty and industrious new wife, just back from an overseas education, until it was discovered that she had had a child in the United States now being raised by her mother. Despite the gossip about her promiscuity and deviousness, no drama or family feud ensued and the couple remained together. They behaved only a little less flamboyantly than in the past. The husband was consoled in his public embarrassment by his friends, who pointed to his wife's redeeming qualities.

Given all my preceding comments, it should thus not be sur-
prising that two-thirds of the elite weddings during my eighteen
months of fieldwork had pregnant brides, and that this was not a
dark secret but the occasion for light jokes among the guests. In-
deed, premarital pregnancy is common in the Visayas, and the girl
often allows premarital sexual intimacy to secure a marriage to
which families may be opposed (Yu and Liu 1980:69). The norm is
thus some machismo in men and chastity for women, but almost
always in a lighthearted fashion, in part counteracted by other cri-
teria for evaluating manhood and womanhood.

Of course, aspects of the imagery imported from Spain or the
Catholic tradition emphasizing women as virgins, and men as
having a monopoly on sexual needs, were present and were used
by people to explain, fight for, or justify their present conditions.
These images were also pressed by the state's legal apparatus and
reappear, as we will see, in aspects of recent (also Judeo-Christian)
Westernization. At the same time, they have been modified over
the centuries by local populations that reinterpreted and incorpo-
rated them in their own ways. These images had been subjected
over time to the daily creativity and tactics of everyday practice in
the Ilonggo colonial and postcolonial context (de Certeau 1984: In-
troduction). They were thus quite different from the Mediterra-
nean originals with which I was familiar.

Let us now go back to trace the history of this dialectical pro-
cess of interaction, partial incorporation, and transformation of
the Mediterranean/Judeo-Christian concepts of maleness and fe-
maleness, to describe how they were pressed over the centuries
on the Philippine population, and to detail some of the local re-
sponses to them.[7]

The Importation and Local Trans-
formation of Colonial Symbols
and Metaphors

The Seventeenth Century and the Pre-Spanish Visayans

The inhabitants of the Western Visayas first visited by Spanish
colonizers in the 1560's lived mostly in communities (*hapon*) of

30 to 100 family groups, the largest being Cebu with some 2,000 people, comparable to Manila and Vigan in the north.[8] (In the Eastern Visayas, Alzina describes fortified hilltop settlements where the population retired for protection against raiding for booty and slaves or intracommunity conflict.) Other Visayans were scattered in the countryside. Each settlement was composed of one or more extended kin groups, and included three general categories of people (largely hereditary but with some possibility of mobility): (1) nobles or elites, (2) a large number of variously dependent commoners, and (3) a large number of even more dependent persons often classified as *oripun* (or slaves), but in some cases difficult to distinguish from dependent commoners. The Visayans had an elaborate set of ranked terms for different kinds of people within each of these categories, defined by their relationships to each other. The settlements were led by many leaders, or *datu*, at times organized under a main datu, who controlled more slaves and dependents (50 to 100 armed men) and had some control over the rest of the population. The different datu provided protection to the community, led sea and land raids, organized public works, and adjudicated disputes (Alzina 1668: 103; Scott 1982: 114–16). Though usually born of a noble man or woman, a datu acquired his position through valor and charisma, reinforced by redistributive feasting and generosity, made possible by controlling land and exacting tribute and labor. Brothers of datu often split away with followers to create new settlements.

Datu and potential datu tried very consistently to marry upward, often going great distances to find daughters of even more powerful datu. These elite women, who were highly praised and powerful, and who might command as many dependents and slaves as their husbands, were carried by slaves in closed palanquins, and their marriageable daughters were often kept in seclusion (*binokot*, lit. 'wrapped up') (Loarca 1582 in BR 5: 119). Such elite women (and indeed most others as well) generally went unpunished for sexual transgressions, though any man caught with an elite woman might suffer severely (Alzina 1668: 62–84). At one level this was a means of controlling offspring and marriages since the position of datu was not automatically inherited, and the marriage of a slave to a woman of datu rank could produce a datu. Control over elite

women thus appears to have been an essential part of initial efforts to consolidate rank.

Under the datu, rather than clear-cut categories of nobles and freemen (Scott 1982:118–24), there were ranked categories of people in various degrees of subservience and with different kinds of obligations. There were second- and third-order nobles (*fumao* and *tumao*) from among whom the datu usually selected his counselors, and there were the *timawa* or *timagua* mentioned by Loarca (BR 5:147) and others, who were the datu's comrades-in-arms and personal bodyguards who tasted his drink for poison before he or other datu drank it, acted as emissaries, and generally functioned as loyal armed supporters. They could be the datu's own relatives or natural sons, or children of ex-slaves (Scott 1982:112–18). Such individuals apparently constituted an economically unproductive retinue (Scott 1983:68; Alzina 1668:62–84). Most of the population, however, consisted of even more variously dependent oripun, ranging from hereditary soldiers (*horo-han*) to captives and slaves (*bihag*) in the lower levels of this dependent order. Most of these commoners had become dependents through debt, purchase, or heredity, but only *ayuey* (domestic dependents) lived full-time with their masters (Scott 1982:118–26; 1983:138–55). The early Spanish observers Loarca (1582–87), Chirino (1604–8), and Alzina (1668) described a reasonably fluid system of ranking in the Visayas. Some mobility throughout the system and just the beginnings of consolidation of positions at the top through control of marriage, land, and labor were noted by Scott (1978:22–25).[9]

Non-noble Visayan men owed goods and services to their datu, worked part-time on the datu's land, or brought the datu tribute from their dry-rice swiddens, the forest, or the sea. From an early age, their women planted, weeded, and harvested as well as spun and wove for their families and masters, making skirts, holiday clothes, or heavy blankets (*habul*) for tribute, for their own use, or for sale in friendly neighboring communities.

The early Spanish observers also were struck by the generally autonomous behavior and customs and by the egalitarian views of Visayans concerning the sexes, which were in implicit contrast with their own traditions. In Visayan daily imagery, according

to these Spaniards' impressions, Visayan women were generally praised for their industriousness, beauty, and fertility, while men were admired for valor and generosity. More significantly, the *bay-lanes* (dancing mediums), usually female or male transvestites (*asog*), were held in great respect and acted as mediators between the community and local animistic spirits and gods. Ceremonies, which included spirit possession and the sacrificial spearing of wild boars at midnight, were held in times of sickness, planting, or war, and were similar in method and appearance to the lengthy rituals of today. The Visayans also had a very powerful but gentle female earth god and a male god who distributed justice.

The Spanish were struck by the marked differences between Ilonggo customary law, as it was practiced, and Spanish law, with respect to women. Ilonggo women inherited equally, had equal rights to their children after a divorce, and could independently decide whether they wanted to stay married or not. Women could own property, occasionally could be chieftains, and could travel some distance from home with other females (Blanc-Szanton 1982; Infante 1975; Racusa-Gomez and Tubangui 1978), rather than being restricted to the domestic realm as in the Mediterranean. When disagreement arose with their husbands, Ilonggo wives did not hesitate to appeal to their fathers for help. According to Spanish sources, such controversies were often resolved in the women's favor (Chirino 1601–4 in BR 12:295). Husbands could also ally themselves with their wives' in-laws, against their own brothers and fathers.

The Spanish consistently denounced as primitive, barbarian, un-Christian, and uncivilized the easy dissolubility of local marriages, especially the frequent divorces where "on the slightest occasion" wives abandoned "husbands who displeased them" (ibid.: 285–86). They also denounced: (1) the Ilonggo belief whereby a woman's soul—whether she was married or single—could not be saved without "having a lover to help her in the perilous trip to her last repose" (ibid.: 251–54); (2) the lack of concern by men whether their wives were virgins or not ("virginity was not recognised or esteemed among them; rather they considered it a misfortune and humiliation" [Loarca 1582–87 in BR 5:117–19]); (3) the

fact that adultery was often practiced by women with little or no punishment; (4) the fact that Ilonggo mothers encouraged their daughters to lead a life of "unchastity" before marriage (Chirino 1601–4 in BR 12:251–54; Loarca 1582–87 in BR 5:117–19); and (5) penis pins, elaborate brass wheels and ornaments pinned to the male penis—also known in other parts of Southeast Asia (Reid n.d.)—which were frequently used by Ilonggo husbands (despite the discomfort they produced) at the insistence of their wives, to whom they gave greater sexual gratification (Alzina 1668: bk. 3, pt. 1, 345ff.).[10] In effect, the Spanish writers were underscoring a more autonomous and egalitarian evaluation of Ilonggo women than they were familiar with in their own culture, and the lack of negative associations to femaleness in general and female sexuality in particular.

In contrast, there are very few Spanish commentaries on Ilonggo maleness, possibly because men's feasting, drinking sprees, raiding, and warfare concerns were more easily comprehended by the Spaniards. The latter often marveled, however, at the Ilonggo men's love of, attentions to, and attachment to their wives and children (Loarca 1587 in BR 5:119), possibly in contrast to the more sternly authoritarian behavioral expectations of Spanish husbands and fathers. Clearly, images of male and female and their relationships were constructed in very different ways among the Ilonggo and the seventeenth-century Spanish.

Finally, for the Ilonggo, sexuality was not yet a subject of unitary discourse as it was in the European Middle Ages. It had not yet been fragmented and objectified to the degree it had in the West by the eighteenth century (Foucault 1980:24–35). Alzina insightfully commented on the lack of blatant practice of either fornication or homosexuality among the rural Visayans (1668:353ff.), in contrast to their frequency among Chinese and Spaniards in the Philippine cities and in the West generally. Also, transvestism and lesbianism were held in esteem and not condemned by the Ilonggo. All this suggests that the negative identification of sexuality and its objectification through insistent discourse were introduced by the Spanish during their missionary efforts beginning in the seventeenth century.

Policies and Consequences of the
Spanish Colonial Presence

Catholicism and missionaries. "One of the major goals of the missionary enterprise was to make the Filipinos adhere more strictly to standards of premarital chastity and marital fidelity" (Phelan 1959:39). Conversion to Catholicism was seen as a way to save the personally modest and well-cared-for, but essentially hedonistic, native women by teaching them the significance of purity and virginity. The fact that women occasionally asked the Catholics to fend off an unwanted suitor (Loarca 1587 in BR 5:119ff.; Chirino 1604 in BR 12:285–95) helped to justify the Spanish priests' efforts. At the same time, local women suffered many de facto sexual excesses by the priests themselves, still personally enmeshed in Spanish machismo (Phelan 1959:36–40; Chirino 1604 in BR 12:285–95).

Although the Spanish priests consistently branded Visayan women as sinful (except Alzina, who was much more sensitive to cultural differences; see note 8), and tried to reform them in good Mediterranean fashion, they still placed their greatest emphasis on teaching religion to young boys and adult men so that they could better control their women. Males, especially those among the local elites through which they ruled, were the prime political and religious targets. Children of such elites, particularly young boys, might enter a local *convento* for years of service and training in the Doctrina Christiana, or might be taught reading, writing, and religion in religious schools or by a local Spanish maestro. (It was not until 1861 that the religious schools were even partially replaced by state schools [Abella 1971:953–56].) Since adult men were instructed to attend mass and catechism up to two or three time per week (Chirino 1604 in BR 12:257), it was assumed that their changed vision would affect their relationships with their wives and daughters, making them less permissive as heads of households and better guardians of their transformed womenfolk's purity. The strategy was inspired by Spanish assumptions about gender hierarchy and the Spanish close connection between gender systems, female sexuality, and male family honor. This strategy had a profound overall impact locally on both men and women

because it tightly tied notions of Christian morality and personal good and evil to ideas of colonial superiority and gave a moral edge to the colonialists, thus reinforcing their power and authority. It also gave a moral edge to men over women, transforming their relationship almost to one between colonizer and colonized.

But the new concepts of gender were only partially adopted, and with substantial transformations, as we have seen. Furthermore, the gender symbolism brought by the Spanish monks and friars was also changing over time, in close connection to changes occurring in Spanish and European Catholicism, as well as in response to local circumstances. Since sublimated sexual imagery was central to the religious language of the Judeo-Christian tradition, gender symbolism remained closely related to sexuality. This was evident at first with the focus on Eve as the seductive temptress and source of sin from the fourth century A.D. onward; then with the rise of Mariology, which focused on Mary's virginity, by the eleventh century; and finally with the double image of Mary the Virgin and Mary the (suffering) Mother introduced by nineteenth-century Marianism (Bird 1974:49ff.; Prusak 1974; Ruether 1974:178−79).

In the Philippines, the Spanish religious leaders initially implanted images of saints and madonnas as protectors of communities and as intermediaries with a feared God (the earlier interpretation of sainthood in rural Spain). During the seventeenth and eighteenth centuries they brought a growing interest in Christ and his *Pasyon*, and in the mid-nineteenth century they imported a new emphasis on images of Mary as both Virgin and Mother (Christian 1981:55ff., 190−207).[11] These images were selectively received by the Filipinos. Though some remain very popular today (e.g., the Pasyon, the Vigil), others waxed and waned in popularity (e.g., San Roque, San Sebastian as protector against the plague, San Gregory, San Jose), and still others never took root in the next context. Among those that did not take hold are the images of Eve and of the Virgin Mary as the Immaculate Conception, whose accompanying emphasis on virginity and on sexuality as sin clashed with local definitions of femaleness. Nor did the image of Mary as the suffering, unselfish, self-sacrificing mother fare too well. In contrast, the Christ Child as protector and curer, the Santo Niño, was enthusiastically worshiped from the sixteenth century on-

wards. The Santo Niño's symbolic significance in terms of power relations in the Philippine colonial setting needs to be better understood.

The Spanish political, economic, and social presence. The factors that led to the particularly mixed and syncretic mode of importing Spanish/Christian symbolism and culture into the Philippines were quite different from those in Mexico and Latin America, where the Spanish colonialists had a much more immediate revolutionizing impact on local structures. During the first century of high missionary zeal in the Philippines, the Spanish attempted to operate an *encomienda* system similar to that in Mexico, apportioning land and its resident populations to local Spaniards and to the Spanish Crown. (In return for the payment of an annual tribute, the Spanish *encomendero* was obligated to protect his wards and to indoctrinate them in the rudiments of the Christian doctrine [Phelan 1959:10].) But this reorganization of agricultural production with its new emphasis on ranches (*rancherias*) and animal husbandry, which had deeply disrupted Mexican Indian maize cultivation, did not prove very successful in the case of the largely swidden Philippine rice-farming agriculture and was soon discontinued. The Spanish colonial economy developed instead around overseas trade between Asia (Chinese silks and Southeast Asian precious goods and spices) and the Spanish colonies in the New World (Mexican gold) via Spanish galleons using Manila as an entrepôt (Phelan 1959:95–96). This had two long-term consequences for the Philippines. First, the Spanish shifted to indirect rule through indigenous elites authorized to collect the often heavy colonial taxes. Second, relatively few Spanish settled physically in the Philippines and, as a result, there were few Spanish mestizos. There was also much less decimation of indigenous populations by imported Western illness than in Latin America (ibid.: 107, 158).

Population statistics make the contrast between the two colonial areas even more striking. By the eighteenth century, Latin America was 47 percent Spanish or Spanish mestizo (20 percent and 27 percent, respectively), 45 percent Indio, and 8 percent black. Yet all through the 300 years of colonial rule in the Philippines, Spanish and Spanish mestizos never amounted to more than 1 percent of the total population (Abella 1971:9–10; Phelan 1959:24–

25). The Spaniards in the Philippines represented a small oligarchy of religious men, ruling over a local population but not mixing much.[12] Spain and local-born Spaniards, as well as Spanish mestizos, were closely allied in the Philippines, not competitors as in Mexico. The significant demarcation line in the Philippines was with the much larger number of natives (of whom the Spanish were contemptuous and who considered anyone with Spanish blood in some sense Spaniards [Abella 1971: 30]).

Indirect rule by colonial Spain was administered by the local *principalia*, who regulated local law and justice and collected *polo* (draft labor), *vandala* (compulsory sale of products to the government), and regular tributes by region, as well as *cajas de comunidad* (community funds, often diverted from emergency or educational needs to lavish fiesta expenditures) (Cushner 1971: 16–32; Phelan 1959: 127–28). These local elites had great powers of manipulation and control while personally guaranteeing to the colonial government the required payments in kind and in services. It was with the official representatives of the colonial state that the local population interacted most extensively. But, though more exposed to and prone to imitate Spanish ways, these local elites were culturally still fellow Visayans, or at most Chinese-Visayan mestizos, and thus less effective models of Spanish gender and family relations.

Colonial strategies and the redefinition of authority. These circumstances produced varied effects. The Spanish colonial government progressively carved out a public domain defined by politics and religion and drew men into it, while attempting to fashion a domestic domain in the image of Mediterranean Spain. Furthermore, the presence of only a few, predominantly male Spaniards made direct Spanish social interaction and personal models of behavior relatively scarce and available primarily to local men. The Spanish thus constructed aspects of gendered privilege in those two spheres. At the same time, because of their strategy of indirect rule, they contributed to the construction of a two-tiered society where local elites, Chinese mestizo or pure Ilonggo, were more directly affected by their influence, socially and otherwise, than the larger population and were more inclined to use them as models in order to enter their good graces and share some of their power.

More generally, the Philippine economy was diverted towards the colonial extraction of luxury goods for elite-controlled use and trade, rather than agricultural, productive extraction. And, because of its limitations, the colony was never a very successful enterprise (Bauzon 1977:1037–40). Furthermore, colonial authority was couched in religious terms and was manifest mostly through priests and religious personnel. This encouraged a view of the Indios, particularly of the women, as needing moral redress. The Spaniards attempted in two ways to transform the natives' customs, physical appearance, morality, and religious beliefs into morally fit and socially controllable Christian models. They tried to restructure the Indios' sense of self by denigrating their customs and practices and establishing them as inferior, and they tried to endow local men with Spanish symbols of authority while indirectly legislating the behavior of women.

The symbols of authority, more than an elaborate military (there were no more than 5,000 soldiers for 7,000 islands until the early nineteenth century [Comyn in BR 51:121ff.]), were the stone churches and houses, a sharp contrast to the indigenous wooden forts and bamboo houses. By the mid-seventeenth century, over 500 massive cut-stone constructions stood in the Spanish walled *Intramuros* in Manila (BR 19:286–87), and there were between ten and twenty in the three provincial bishoprics (Francisco San Antonio in BR 28:148). Churches in rural parishes (569 by 1750) and in sub-parishes were built first of bamboo and logs, and only by the nineteenth century of cut stone or brick (Phelan 1977:1253; Patanne 1977:1814–20). The colonialists attempted to concentrate the rural population around those churches but met with particularly limited success in the Visayas (Phelan 1959:47). The Spanish writers expressed continuing admiration for their own imposing houses, galleons, heavy furniture, plates, cutlery, and other household objects in contrast to the "flimsy," "light," and thus somehow "primitive" bamboo architecture and daily objects of the natives.

The presence of churches was accompanied by a new pageantry of fiestas and patron saints, religious imagery, and massive religious celebrations. These were easily grafted upon a population in which large parties and ritual drinking were a major mode of

entertainment, status enhancement, and redistribution (Alzina 1668:245ff.). Urban Jaro and Molo in Iloilo were known for their fiestas and celebrations, but until the end of the seventeenth century, comparable activities went on in at least 200 other churches around the country during Holy Week, Corpus Christi, and the patron saint's day (BR 19:286–87). These celebrations occasionally included women playing the Virgin Mary in the Pasyon or Queen Isabella or Queen Helen in the Santacruzan (possibly the origin of the elaborate "fiesta" and "fiesta queen" complex of the nineteenth and twentieth centuries [Santos 1982:35–36]). Of the 13 most important religious fiestas in the Philippines in the 1960's, however, only three had some official female participants, whereas most others had entirely male participants, such as male flagellants or dancers (Martires 1968).

Finally, the Spanish attempted to encourage a more appropriate personal appearance and presentation of self. Though favorably impressed by the Indio neatness and cleanliness, they pressed the Indios to dress in more formal clothing. The distinction between Spanish and native dress reinforced the lines of demarcation between principalia and nonelite, and by the nineteenth century, with the rise of the Chinese mestizo, a mestizo elite style of dress intermediate between the Spanish and the Indio became the appropriate model for the common Filipino. It also created greater gender differences. Clothing of men and women, be they commoners or elite, was relatively undifferentiated in the sixteenth century: both wore loose tunics or wrapped cloth. Dress became more clearly differentiated on the basis of sexual differences over time—in the Western mode—with skirts for women and pants for men.[13] And Spanish legislation concerning dress remained particularly stringent for women due to the Spanish colonialists' obsession with female morality and prudery.

Generally, the Spanish considered the traditional types of physical decoration that the Visayans valued—such as tattoos,[14] tooth filing and coloring, head shaping, and the wearing of amulets—to be manifestations of their primitive and uncivilized nature, and as such were to be eliminated as quickly as possible. The Visayans, however, considered personal ornamentation symbolic of personhood and human control. Thus tooth filing and darkening differ-

entiated humans from white-toothed forest beasts, and tattoos and amulets added power as well as beauty, since by touching the body they "meant" power (McCoy 1982:340; Reid 1988:77). Tattooing disappeared in the Visayas by the mid-eighteenth century, but amulets are still worn today, often a mix of native charms and Christian medallions.

The Visayans also considered head dress, which covers a key part of the body, as more important than body dress. The Spaniards, by contrast, were more concerned about naked bosoms and visible limbs as sexual attributes of the body, thus exporting in the process the progressive problematization of sexuality that was occurring in Europe at the time. During the seventeenth century, a special attempt was made to secure female decency by encouraging full skirts and blouses, instead of the loose and "immodest" clothing worn daily, or the soft tunics Visayans wore on special occasions. The Spaniards also regularly discouraged Indios from wearing the heavier and more elaborate Western-style clothing, regarding it as cumbersome and ridiculous on all but an occasional principalia mixing socially with Spaniards. This was not official state policy, but resulted from the colonialists' personal efforts and inclinations. At the same time, the Spanish emphasized their distinctiveness through their own clothing. Spanish religious who wore native dress were severely disapproved of by their peers and superiors.

In the late seventeenth and early eighteenth centuries, Visayan women wore *tapiz* skirts, usually checkered, and short *baro* blouses of local weave or cotton. Men wore cotton or linen breeches and shirt-coats appropriate to the weather. On festive occasions, village and town principalia, especially those closer to Spanish settlements, changed into full Spanish attire for men (coat, trousers, stockings, and shoes), and native silk skirts and light blouses or white Spanish petticoats for women (Francisco San Antonio in BR 40:esp. 329–331; Alzina 1668:213).

By the nineteenth century, the mestizas in particular had developed a different costume that was neither native nor Spanish. This included an elaborate long silk skirt, embroidered *piña* (pineapple fiber) cloth blouse and kerchieves covering but not concealing "a bosom that has never been emprisoned in stays" (Gironière 1855:124–27), slippers or shoes, and stockings. Spanish mestizas

sometimes also wore Spanish Victorian clothes. But it was the elite mestiza's clothes and jewelry, not the Spanish costume, that the wealthy native women imitated when dressing for special occasions. Normally, they wore regular skirts (*saya*) and short overhanging semitransparent blouses adorned with numerous native and Christian amulets. That same mestiza costume, modified and reformulated, with large butterfly sleeves, has since become the basis for the current formal national dress, the "traditional" Philippine costume for women.[15] The Philippine costume for men remained simpler—an embroidered shirt-coat in piña cloth over regular trousers—but still quite different from their original tunics. A newly elaborated collective conception of the past was created in the process (Hobsbawn and Ranger 1983:1–14), glorifying an earlier mestizo elite and, in effect, reinventing "tradition" for the larger population.

In these several ways, Spanish metaphorical messages of authority to noncentralized Visayan society from the seventeenth to nineteenth centuries were predominantly couched in a religious idiom and expressed a special concern for women's morality as the cornerstone of family morality. To the Spanish, the effort seemed essential in order to achieve a strong social fabric and effective colonial control. Architectural forms, ceremonies, customs, dress, and daily objects of use were some of the spheres in which colonial strategies and Visayan practices met, meshed, and were transformed. Their effects on men and women, the messages of power and control that they projected, were part of the partial restructuring of the Filipino self and of concepts of personhood that was taking place. The colonialists were continually generating or contributing to the transformation of symbolic forms that were to become the "traditions" of the future.

The degree of success of these Spanish policies was uneven, however. Until the latter part of the seventeenth century, and particularly during the eighteenth century, missionaries referred frequently to the shallowness of conversions and the limited implantation of Catholicism in the spiritual life of the Visayans (Ortiz 1731). Nor were the Visayan men as successful in controlling themselves, or their women, as the Spanish wished. There are still frequent references in the eighteenth century to local ceremonies

performed by female *baylanes*, or spirit mediums. Women were still sometimes sent by their men to discuss community business with Spanish officials (BR 40:248). Similarly, the Spanish repeatedly objected to joint bathing by extended families or groups of families in bamboo-shaded bathing areas in the rivers. According to the Spanish (who rarely bathed themselves), men, women, and children bathed together in revealing and immodest camisoles and breeches (BR 51:176ff.). Historical contingencies and unexpected consequences, which shaped the form colonialism took in the Philippines, as well as the independent desires of local populations with their own momentum, practices, and priorities, produced a much more dialectically syncretic cultural situation than the Spaniards had initially anticipated.

The Twentieth Century

The American political, economic, and social presence. By the late nineteenth and early twentieth centuries, there are many detailed accounts and impressions of the Philippines by Spanish-mestizo intellectuals such as Jose Rizal, by non-Spanish businessmen and adventurers in the Visayas like Robert MacMicking (1848), Sir John Bowring (1858), and Nicholas Loney (1852–66; British Consul and commercial firm manager in Iloilo City), and by travelers from France, Germany, Austria, and North America. They describe various types of elite and nonelite women, but together demonstrate the only partial, and often differential, penetration of Catholic, and later American, values.

1. The Spanish and Philippine-born Spanish women are seen as soft, pleasing, and flirtatious, but extremely frivolous and totally uneducated despite the secondary schools for elite women established in Manila by the late nineteenth century (Robles 1969:221). They are depicted as spending their days on hammocks or lounge chairs with their maids around them, sleeping, lolling, and combing their hair (Wilkes, MacMicking), or endlessly dressing for *pasejos* (their daily promenades). Despite their physical attractiveness, their "minds are like weedy gardens" (Loney 1964:79), and they seem to represent extreme models of colonial "Victorian" ideals.

2. Spanish and Chinese mestizas appear more lively and active. They are described as pure, virginal, and grand ladies by some (e.g., Jose Rizal's portrait of Maria Clara),[16] but by others as "industrious," "persevering," "economical," "generally prosperous," and better at managing business affairs than men. (They were certainly very supportive of their men in the fight against colonialism.) In the Visayas they seem to have been caught between a status-enhancing desire to be more Spanish, and an urge to remain native and be active, at least economically. Their Spanish tendencies were manifested in their extreme religiosity (especially among women educated in women's colleges like S. Potenciana), in their dress (black veils and Spanish garb), in their active participation in cofradias (religious sisterhoods) and religious activities, and in a vocal concern for chastity—in other words, in all the entrapments of the Spanish upper classes. Their native background, on the other hand, particularly in the case of the Chinese mestiza, brought them to chew betel and become active in business. They were a new Victorian bourgeoisie, intermediate in position between Spaniards and natives, and struggling to raise their status (Tiongson 1977:1784–85; MacMicking 1967; Bowring 1858).

3. In contrast, the native Indias mostly used common-law marriages ("they could not even afford morality" [Tiongson 1977: 1785]), were engaged in practical endeavors, and often worked hard. At home and in factories they embroidered and wove the piña cloth that clothed the Spanish, the mestizas, and even, at times, Queen Victoria and her entourage. The Indias rolled imperial cigars for Europeans and rich mestizos, traded their goods in markets, tended the fields, and served their señoras so that the latter could lie in bed or kneel in church all morning. European observers admired the native women for their energy and entrepreneurship,[17] though they often viewed them through colonial Spanish eyes as "ugly."

Insights on concepts of maleness and femaleness in the writings of some of the early American teachers observe the same contrasts with the Judeo-Christian gender symbolism that struck me much later in Estancia. During the first decade of the century, Mary H. Fee, one of the 160 women among 500 "Thomasite" teachers,[18] was assigned to the provincial town of Capiz, with a population of

ca. 25,000, together with ten to twelve male teachers. She graphically describes the "great, square, white painted, red-tiled houses lining both banks of the river" with wooden and bamboo houses behind them, "quiet and restful." She also comments on the devout and conservative Catholic elite.[19] She characterizes the young elite girls of Capiz, mostly Chinese mestizas or Indias, as very "attractive," "slender," with "swan-like necks," not flirtatious but natural and unaffected, loving dress, jokes, and mimicry. They appeared to be closely guarded, virtually imprisoned in the conventions of Catholic morality, but also not too severely stigmatized for their sexual adventures. After reaching the age of 14 or 15, they were closely supervised by their family and friends, who escorted them everywhere. They met young men in groups and were courted in the company of others. They married around 17 or 18, and by 22 or 23, if unmarried, retired from the competition in favor of younger sisters. But even in this situation of tight social control,

> forced marriages occur in spite of the restrictions put around young girls. They cause a ten days hub-hub, winks, nods, and much giggling behind fans. But *no social punishment and ostracism of the girl follows as in our own country* [emphasis mine]. So long as the marriage is accomplished, the Filipinos seem to feel that the fact of it being a little late disturb no one. But if, as sometimes happens, a girl is led astray by a married man, then disgrace and punishment are her lot. And she may leave her native town never to appear again. Her seducer however may be an honored guest at her brother's house less than three months later [with little public condemnation]. (Fee 1912: 119, 125)

In other words, marriage as a monogamous institution was protected, but not female purity as a basis for family honor, as in Spain. Fee also highlights some of the differences between more Catholic elites, for whom marriage is an important cornerstone of their way of life, and

> the common people (of Capiz) [who] seldom marry except as we would term it, by common-law marriage. When they do marry in church, it is quite as much for the *éclat* of the function as for conscientious reasons. Marriage in church costs usually eight pesos (four dollars gold), though cheaper on Sundays, and to achieve it is quite a mark of financial prosperity. (Fee 1912: 118)

At the same time, lower-class native girls

are watched like prisoners, and are never allowed to stray out of the sight of some old woman. It is almost impossible for an American woman to obtain a young girl to train as a servant, because, as they say, we do not watch them properly. This jealous watching of a child's virtue is not, however, always inspired by love of purity. Too frequently the motive is that the girl may bring a higher price when she reaches a marriageable age, or when she enters into one of those unsanctified alliances with some one who will support her. [Keridas are frequently selected by elite men among pretty lower-class women.] (Fee 1912:127)

Fee's insights for early twentieth-century Capiz confirm my observations of the last decade in an Ilonggo municipality only 65 kilometers away.

Other sources offer statements about the excessively bashful manner of unmarried native girls at the turn of the century, contrasted with the enterprising aggressiveness they demonstrate after marriage, in both elite and lower-class families. We also read of "their evident superiority over the males in business capacity," and their key role in upward family mobility. One hears about womanhood being respected, and about women independently owning and managing substantial lands even under the more constraining Roman law introduced by Spain (Mendoza-Guazon 1928:25–27, 41). In contrast to Spanish gender symbology that views the male gender positively, young girls were told that men were devils or that they were "just like the *balete* tree that entwines and smothers the tree to which it clings. Men can be compared to the boa constrictor which jumps on its prey. Beware of them" (ibid.:20).

At the same time, Western education, an American presence in the rural areas (including American women), the introduction of Protestantism, as well as the American economic and political colonization, all helped release former constraints and had real effects on gender in the countryside.[20] The strength and independence of Filipino women in general was recognized and valued by the new colonialists. The effects were particularly evident for elite women who had been under the heaviest Spanish social constraints and now had access to the best new opportunities. West-

ern education and industrialization had a more negative impact on poor rural women, who were less in need of such liberation and more generally threatened by twentieth-century Third World-type development (Blanc-Szanton 1982).

The new Filipino elite woman described by Philippine and American writers was no longer "the timid and bashful woman of former days, who was afraid to shake hands with men and who answered in monosyllables when addressed"; "under the new regime, the sphere of action of the new woman, who is better equipped in every respect to-day, has expanded a hundredfold. . . . Prudery is no longer considered a necessary ingredient for virtuosity" (Mendoza-Guazon 1928:44–45). The Filipino woman now demanded respect as a human being rather than being looked upon as a doll of muscles and bone (an American idea viewed positively by Filipinos) (Fee 1912:128) and was not tied down by old devices of courtship. She met young friends more freely, was becoming educated, and owned and administered important business interests. All of this happened very fast (Fee 1912:127–29; Mendoza-Guazon 1928:44–47).

Other contemporary accounts show the elation of elite Philippine women at their rapid progress and feminist/nationalistic hopes for the future, along with strong condemnations of the Spanish period. For example, one account states, "[The Filipino woman] is tearing the Spanish colonial shroud that enveloped her and the real native soul of the race will be reborn in its women with new energy, ambition and faith, ready to assume an important role in the affairs of their country" (Mendoza-Guazon 1928:48).

Not all of these hopes were realized, though the position of elite women improved even faster than that of elite men through the American period in terms of education and professional employment, in contrast with their exclusion from such spheres in Spanish times (Blanc-Szanton 1982:142–46). There were also successes on legal issues and female suffrage (Aquino 1984:14–15).[21]

At the same time, the accelerated transformation of the economy into a modern colonial, and after World War II, neocolonial, capitalistic system initiated the restructuring of men's and women's roles in production, distribution, and consumption, and

created a more complex, multitiered, objective class structure with different trajectories for women. It modified the socioeconomic and political context for the two sexes, introduced new hierarchical differentiations, and had far-reaching consequences for each sex's sense of self. It also introduced new forms of gender imagery and new manipulations of the same by power-holders.

Socioeconomically less advantaged rural and urban women in the Visayas, for example, lost potentials for self-employment and economic entrepreneurship when British textiles replaced farmers' homeweaving and Western and Chinese firms successfully competed for expanding local businesses and trade. These women were pushed, together with their male counterparts but in even greater numbers, into an informal urban/rural sector whose growth potentials are limited (Blanc-Szanton 1982: 147), while being exposed to new manipulations of gender symbolism. The advantages of education, new jobs, and elected (or appointed) positions were reaped primarily by elite men and women (Owen 1971; Blanc-Szanton 1982: 145–47; Neher 1980: 116). Nevertheless, educated middle-class female professionals, managers, and government employees faced discriminatory inequalities in pay scales, benefits, career potentials, etc., that reflected gender ideologies and related practices that were often Western-patterned. Thus, capitalist development (both colonial and neocolonial) and incipient industrialization, as well as exposure to European and American forms of gender symbolism and practice, influenced how local women and men saw themselves and each other.

Post-World War II imagery: reinventing womanhood and sexuality in the neocolonial state. After the long World War II guerrilla warfare against the Japanese, the Filipino people emerged as an independent nation in a very nationalistic mood. They looked back more critically than ever on the preceding period of American occupation and on its social effects. The liberating changes undergone by middle-class (and other) women and their families were a major component of that reassessment. At the same time, the Filipino people were searching for a noncolonial identity on which to construct a sense of self.

Certain Filipino conservatives strongly felt that "Democracy,

Fraternity, and Equality carry with them the elimination and sup-
pression of those elemental courtesies, necessary for the proper
functioning of civilized life" (Londres 1958:58). This older Fili-
pino elite felt that the Americans had introduced destructive fads,
such as divorce, which destroyed the sanctity of the home, a mad-
ness for the mighty dollar, lawless music such as jazz, dances like
the rumba and the Charleston that replaced the native songs and
dances, shorter women's clothes, bobbed hair, painted faces, and in
general a more "sensual" woman, who displayed her anatomy in
transparent stockings and led to the "degeneration of woman-
hood" (ibid.:59, 92). They also complained that young people no
longer obeyed or showed appropriate courtesy to their elders and
lacked respect for chastity, morals, and good manners. Young
women were becoming educated and defiant (ibid.:58–65). These
authors appealed for a return to Philippine "womanhood, her
ideals, customs, traditions, and aspirations." They called for what
makes Philippine womanhood the "embodiment of virtue and of
strength of character" and "the epitome of Filipinism" (ibid.:101,
34). The Philippine woman was seen as the cornerstone of the
family, but, according to President Roxas (1946:17), "the family,
once the bedrock of our society, is loosed from its moorings . . . we
are losing the urge to retain our culture patterns, the stern and
virile virtues of our fathers which are the essential elements giving
it cohesion and form." What he and others meant was that reli-
gion, moral precepts, sobriety, chastity, obedience, truth, and ar-
duous toil were losing force and meaning in Filipino lives. But
what they defined as Philippine womanhood was not really pre-
Hispanic in origin; it was largely the woman inspired by Christi-
anity, and endowed with feminine modesty, personal dignity, and
reserve.

At the same time, the pre- and post-World War II Philippine
feminists, as we outlined earlier, appealed for a general and legal
recognition of the more egalitarian pre-Hispanic gender relations
as a model and base for improving the present conditions of women
(Mendoza-Guazon 1928; Pura Villanueva Kalaw 1920's, Alzona
1933; Aquino 1984). In contrast, the frequently Spanish or Chi-
nese mestizo national leadership was asking in the name of Chris-

tianity for a return of the pliant Philippine women to replace today's defiant women influenced by pervasive concepts of individual equality.

Since the 1950's, there has developed an image of Filipino women freed from earlier constraints by the liberating effects of modernity. Presented both by government spokesmen and by academics, and anchored in the then-fashionable theories of modernization, this view emphasizes the liberating effects, for women, of better education, progressive laws, and new employment opportunities. It sounds true because it reflects in part the experiences of middle-class and elite women all through the century.

Ironically, the authoritarian regime of the past two decades used all these arguments to project an image of achieved equality and strength for contemporary Filipino women, to praise their achievements, and to encourage them to pursue further contributions (Marcos 1980: 1–5). The emphasis was on the existing strengths of Filipino women in all areas of social life. Both the National Commission on the Role of Filipino Women, established in 1975 in recognition of the International Year of Women, and *Balikatan sa Kaunlaran* (Shoulder-to-Shoulder for Progress), an organization within it led by Imelda Marcos, aimed at "raising the consciousness of Filipino women" about their important role and channelling their group activities. These organizations, however, also consistently focused on "female-oriented," unthreatening projects such as beautification, nutrition, cottage industries, youth development, arts, and culture, rather than on women's economic and political participation, thus demonstrating the existence of internal contradictions between message and action.

Furthermore, both the earlier statements on the achieved equality of Philippine women and these more recent voices about the inequalities of Western-inspired legal codes and of the employment structure disregard socioeconomically different historical experiences, ongoing social processes, and the contemporary realities of those women's lives as revealed by recent social studies and surveys (Gonzalez and Hollnsteiner 1976; Montiel and Hollnsteiner 1976; Villariba 1982; Porio, Lynch, and Hollnsteiner 1978). More particularly, they do not acknowledge that during the post-World War II period, Philippine women of all socioeconomic levels were

being assailed anew, on both the practical and symbolic levels, by new Western encroachments, their own severe economic deterioration, the conservative tendencies of the religious hierarchy, and government policies and pronouncements, as well as by the qualitative transformations of sense of self and society resulting from the very particular development of capitalism in the country.

New contradictory images of women have been projected in the 1970's and 1980's. On the one hand, the image of strong contemporary Filipino women who have resisted colonial encroachments and are being further freed by modernity compares favorably with its counterparts in most developed countries and stands in parity to the image of men. These women embody metaphorically the whole of Philippine history and the soul of nationalism.

On the other hand, there have been new emphases on images of women as primarily subordinated wives and mothers, and/or as male sex objects. The qualities of the Filipina wife were emphasized with pride in speeches by Imelda Marcos and her blue ladies and again by Cory Aquino. Both images are projected in the media, experienced in the population's daily interactions with resident Westerners and tourists, and encouraged by government institutions. Again, transforming sexuality appears to be a major tool in these renewed attacks on Philippine and, more specifically, Visayan gender construction.

The gender imagery found in the media exemplifies a popular aspect of these ongoing struggles of meanings and their relationships to practices. The emphasis is on a promiscuous seductress female, a far-from-innocent tempter of men. She is increasingly associated with modernity and maturity by her presentation as a Philippine version of the modern, sexually liberated Western woman. The temptress imagery appeared first in the very popular porno-like *bomba* films of the early 1970's. After a few years of transition due to censorship during the early years of martial law, these films have reappeared in a somewhat different format in the "bold" look of the 1980's. The bold look emphasizes the lifestyles of "high-class" high-school-graduate hookers, bored rich housewives, beauty queens, and fashion models, and often contrasts them to those of provincianas—sweet, innocent, pure, and noble provincial girls, also portrayed as gullible, foolish, and immature.

The lesson is: be like the "modern" oversexed temptresses and with this newly acquired maturity avoid the provincianas' problems. The theme of martyrdom, abused women or willing partners, has also been explored at some length. (A recent example would be *Himala* (Miracle), directed by Ishmael Bernal in 1982.) Similarly, portraits of the lives of Manila prostitutes and live sex performers, such as *Playgirl*, directed by Mel Chionlo in 1985, remain focused on somewhat naive and melodramatic sacrifice rather than presenting in-depth analyses of the new problems faced by women and their connections to international tourism and the economy. Attempts to develop more serious female roles and a more realistic depiction of Philippine women continue to be hindered by the tendency of the mostly male Philippine scriptwriters and film directors to continue to play out male fantasies on the screen, and their wish to always append a moral lesson that will purify the sinful viewers (Lanot 1982:18–22). This is achieved by objectifying sexuality, continuing to emphasize an elitist Judeo-Christian vision of womanhood, and depicting women as mindless dolls or puppets.

The only exceptions have been the works of a handful of controversial, mostly female, film directors (Guillen, Diaz-Abaya, Brocka) that have focused on women as real individuals, on their capacity for honor, human dignity, and resistance in the face of adversities, on the real choices they face in contemporary Philippine life. Films like *Brutal*, *Salome*, or *Moral* do not hesitate to show the easy acceptance of premarital pregnancy, the middle-class woman's conflicts between child-raising and self-realization through work, intergenerational conflicts, sexual brutality, and the new issue of political activism for women. In general, however, a more honest, straightforward portrayal of contemporary Philippine social realities, sexual or otherwise, is actively discouraged by the National Film, Theater and Television Review Boards, because it supposedly projects a negative image of the country—in other words, on nationalistic grounds.[22] Images of women thus continue to be strategically manipulated and used as key metaphors for the country as a whole.[23]

The power of mass media in the creation and perpetuation of images relating to gender or politics was well understood by post-

World War II Philippine power-holders and masterfully utilized by Ferdinand Marcos during martial law. Magazines and newspapers, television and movie industries, are centralized in Manila and operate exclusively in Tagalog rather than in the many provincial languages of the country. During martial law, they were under close government supervision. And under President Aquino they are penetrating ever more deeply in the rural countryside thanks to a continued government emphasis on Tagalog, increased rural electrification, and the need for rural entertainment.

At the same time, the more openly competitive advertising world, while attempting to influence Philippine consumption patterns, also projects life-size images of *sexy* women selling cigarettes or beer, strewn over the tops and sides of urban buildings.

Finally, tourism is increasingly advertising Philippine women as sex objects. In the 1960's, the large U.S. bases in the Philippines were surrounded by growing communities providing services and commercializing entertainment for the numerous U.S. servicemen, including bars, massage parlors, and prostitution. Servicemen often married Filipinas, former prostitutes or not, and racially mixed couples became the subject of heavy joking and stereotyping in public places. By the 1970's, world-wide tourist appeal by a country increasingly in need of foreign exchange and eager for remittances openly focused on the "attractions" of Filipina prostitutes, while young Filipinas were recruited, often illegally, in rural and urban areas to fill prostitution houses in western Europe or in Japan.

These renewed attacks on Philippine gender construction and this extreme commercialization of sexuality were accompanied by other processes. In particular, there was the progressive drawing of men into the public sphere, realized in different ways during the Spanish and American colonial as well as the Nationalistic periods, and the accompanying progressive attempts at relegating women to the domestic sphere, while redefining the meaning of these two spheres of activity altogether. A detailed analysis of these processes will be the subject of a subsequent paper.

By the late 1970's, the Visayan provinces, and particularly the municipality of Estancia, in the Ilonggo-speaking province of Iloilo, island of Panay, presented a good example of contemporary varie-

ties and discontinuities of symbolic content, as well as a consider-
able degree of parity with respect to gender. In fact, they mani-
fested a remarkable mixture of symbolic references to machismo
and virginity of both Spanish and Judeo-Christian origin, an aware-
ness of the new sexuality, but also an emphasis on the sameness
and comparability of the sexes.

A person was seen as constituted both physically and character-
wise during the parents' intercourse and then during pregnancy by
the joint influences of both mother and father. There was very
little differential treatment of children until the age of seven or be-
yond. After puberty, on the other hand, one observed some differ-
entiation between males and females, with some conventional re-
strictions on the freedom of movement of unaccompanied young
unmarried girls (considered improper), but also a heavy reliance
and admiration for women's greater responsiveness and responsi-
bility towards the family when compared to their male counter-
parts. After marriage, both men and women had complete freedom
of movement, and women often engaged in very public occupa-
tions, such as long-distance trade. In most daily productive tasks,
both within and outside the household, there was a considerable
mutuality of labor: men cared for children, prepared meals, or
tended animals when required; women regularly worked in the
fields or as laborers and engaged in large-scale marketing of pro-
duce. Also, women often assumed preeminent and respected roles
in the household and beyond, becoming the managers of the house-
hold's economic resources and of the family businesses, with ex-
tensive business contacts.

Gender differences were commonly characterized on the basis
of temperament and sociopsychological propensities, with males
seen as easygoing, generous, and fun-loving but easily offended,
and females as more reliable, more skilled in economic interac-
tions, and more inclined towards verbal rather than physical abuse.
Each gender combined positive and negative characteristics, and if
anything there was a more positive view of femaleness than of
maleness. The two sexes were not juxtaposed in hierarchical fash-
ion, but were viewed as complementary and comparable, with an
emphasis on symmetry and parity.

In conjunction with those locally generated images of gender,

already the result of admixture, the educated elite in Estancia were also very aware of Central Government metaphors regarding strong womanhood, and occasionally reflected on their own understandings of current Christian and American debates on gender and sexuality. Because they frequently resided in urban areas or overseas, they were more heavily exposed to new concepts, which they then introduced in daily town discussions. By 1982, a prominent male member of the local elite had also set up a bar and bordello in the center of town, and Estancia was occasionally visited by Western tourists from a neighboring island's tourist center. All members in the community also were exposed to national media, such as Tagalog movies, magazines, and increasingly television, especially after the rural electrification program reached the municipality in the late 1970's.

The Estancia case study emphasizes the coexistence, in an analysis of Visayan constructions of gender, of many different images and symbolic contents, presenting an often ambiguous and overlapping pool of potential arguments or metaphors to be utilized by different agents for different purposes at different times. These images of gender, with their disparate and sometimes contradictory elements (and their more recent reformulations) cannot be properly understood without a contextualized awareness of history, since every single interaction relating or not to gender contains in embryo its entire history, which is both refashioned and reconfirmed in each encounter. What we find in the Visayan countryside is the product of the dialectical interaction between colonial/neocolonial structures of power—which selected gender, in particular female gender, as a major focus of attention—and Visayan elites and populations, who responded to them in their own terms, though not always consistently or uniformly.

A Reassessment of Visayan Gender Construction

We have seen reasonably egalitarian gender relations and images of gender in the pre-Spanish Visayas, then 300 years of a weak colonial state and religious institutions trying to reshape the sym-

bolic content of both maleness and femaleness into something closer to that of their motherland.[24] The Spanish focused primarily on the "unchaste" native women since the males they met appeared closer to their own ideals. Whenever possible, the native woman was baptized, dressed, and given Christian notions of good and evil. As a young girl, she was trained to obey her father and the local religious, to cast her eyes down, to be pure, and to pray the rosary. As an elite girl, she was watched over by *duennas* and locked up in *colegios*, learning enough to read the missal and write her name, but not enough to communicate with her sweetheart. She could take the veil (though very few did), become a spinster, or get married after an extremely circumspect courtship to a young man not objectionable to her parents. Legally, she was classed with children, needing parents' or husband's consent to enter contracts or leave her home. And yet she remained industrious, resourceful, and strong, and used daily images of femaleness that did not quite match the Spanish versions.

The God-inspired American colonialists came as Pygmalions of another kind. They educated the Visayan women, encouraged them to reject Spanish influences and speak their native mind. They tempted them with American ideals of equality and freedom. The response, from elite women in particular, was overwhelming. At the same time, young short-haired and Western-dressed urban Visayan "go-getters" challenged the established male power structure, obtained the vote, and behaved in quasi-Western fashion. In the countryside, too, many Spanish constraints were lifted, and there was an apparent resurgence of native female independence, entrepreneurship, and ingenuity.

With nationalism and neocolonialism, Filipinos felt an even stronger need to reclaim a precolonial identity by reinventing "traditions," i.e., by transforming nineteenth-century patterns into long-lost traditions and adapting old customs for contemporary use. Once again, images of women played a major role in these reconstruction efforts.

At the same time, an evolving Third World economy, the changing needs of an authoritarian regime, together with built-in Western Judeo-Christian preconceptions about women grafted onto previous Mediterranean ones, were limiting the Filipina's full par-

ticipation at all levels in the new polity and economy. And she was being introduced, first with the military and then with tourism and overseas migration, to a twentieth-century capitalistic version of sexuality and large-scale prostitution, in both cases harshly judged by the larger society.

To these symbolic bombardments by power-holders, these repeated attempts to remold them, rural and elite Visayans responded each in their own way, incorporating some things, rejecting others. They were surrounded by symbolic messages and metaphors about gender, understood but filtered selectively. These penetrating messages were absorbed somewhat more completely by the more Catholicized, Hispanicized, and later Americanized urban elites, and less completely by those in more remote interior areas. The end result has been a modern composite gender symbolism and imagery, with aspects of pre-Hispanic egalitarianism, Spanish Catholicism, and some American individualism, but with a continually strong and autonomous presence for women. At the same time, womanhood, selected by Spaniards, Americans, and Nationalists alike as a major focal point, has remained a central metaphor in the country's history.

What explains this surprising mixture of continuities and fragmentations? Nakpil (1963) advanced a hypothesis about Filipino gender relations in an insightful paper called *Myth of Reality*. The woman is the schemer who goes through the steps of the conventional requirements (shyness, virtue, religion), but in fact, because she is more "energetic, efficient and unscrupulous than her self-effacing husband," she quietly holds all the power and behind the throne controls men's involvements. This is an almost complete reversal of Brandes's (1981:218, 234–36) observation for rural Spain, in which men fear women symbolically, but oppress them in reality. Ilonggo men praise women symbolically and neither oppress nor are oppressed by them in reality, since Ilonggo women are still far from holding all power and control.

Furthermore, who ultimately has the power, a largely Western concern, is not what is being discussed in Ilonggo gender relations. There is not the clear dichotomy between a "real" and "not real" (i.e., symbolic) power set up by Brandes. There are ongoing and often contradictory processes of inclusion or exclusion from cer-

tain spheres of activity, historically determined, which are repre-
sented by symbols as much as by anything else.

The reason for these considerable inconsistencies in Ilonggo
and Visayan gender construction is, I believe, quite complex. The
Spanish, Americans, and neocolonialists indeed introduced many
new components in the Visayan "symbolic content" that relate to
gender. But they have been unable to reconstruct and influence the
"technique of construction" itself (Strathern 1982:678–88), for it
is too closely tied to other aspects of culture, personality, and fea-
tures of social organization, such as bridewealth, brideservice, and
bilateral kinship.[25]

The major difference in gender construction between Visayan
and Western societies is not so much in the symbolic content, but
in the way the two packages of symbols and images relate to each
other and to other social orders and systems of social relations
(male/female domains of action, hierarchical institutions, prestige
systems). In contemporary Ilonggo rural society, gender is con-
structed not on the basis of a contrast in preexisting substances, of
a moral dichotomy between good and evil confronting each other
in constant opposition, as in Southern Europe, but on nonhier-
archical complementarity. There is a male and a female tempera-
ment, equally sexed (and objectivized sexuality in this context is
not bad), including some good and bad characteristics in a dy-
namic mixture. Brothers and sons in Estancia, for example, suffer
no shame or discomfort in recognizing the power and control of
elder sisters over them, nor in the fact that they may all owe their
positions to an elder sister (Blanc-Szanton 1981:129, 131). The
husbands of strong rural elite women, or the lower-income men
whose wives shifted common-law husbands, do not feel particu-
larly diminished or distressed. The relational packaging of gender
is not based on contrast but on comparability and equivalence. It
talks about attributes of persons but does not expand maleness
and femaleness to represent icons of good and evil in the world. It
implies neither hierarchy nor interdependence with other symbol
systems.

Virginity remains thus a positive convention, but not the quali-
tative essence of Ilonggo womanhood. Indeed, if Mediterranean

women must carry a heavy weight as descendants of Eve, that weight was never quite successfully transferred onto the Visayans.

The Visayans are but one of hundreds of world populations that have been colonized. This paper is an attempt to better understand the dialectics and practices of power that are involved in the processes of colonization. But also—and foremost—it starts charting the important effects that these processes had—or did not have— on cultural formations and starts identifying areas of cultural resistance or give, given the different cultural bases, patterns of development, and historical backgrounds of these populations. Colonialism and neocolonialism attempt to fashion new subjectivities over time while establishing new hierarchies. People respond with the cultural tools they have at hand. The end result of these ongoing struggles involving the appropriations and reappropriations of meanings and practices is the contemporary Visayans of the Central Philippines countryside.

Japanese Factories, Malay Workers

Class and Sexual Metaphors in West Malaysia

Aihwa Ong

In the previous paper, Blanc-Szanton explored the interaction of local and colonial gender systems in the historical past. In her treatment of the the sexual imaging of Malay factory women, Aihwa Ong examines the dynamic interaction of Malay village culture, Japanese electronics firms, Malaysian politics, the government-controlled media, and revivalist Islam. Rejecting the notion that gender symbolism in rapidly industrializing contemporary Malaysia could be reduced to a single, static cultural code, Ong explores the processes whereby multiple, competing, and unstable assertions about sexuality and gender are generated through the interaction of conflicting sectors of society.

Ong begins with an examination of relations between women and men in rural village life in West Malaysia. Her account can be compared to Hatley's and Keeler's accounts of gender relations in Java. In both areas women possess a high degree of economic and social autonomy, yet in both areas women are defined as weaker than men in terms of self-control and spiritual potency. And in both areas divorce poses a serious threat to women's security and social viability.

Ong then explains the massive shift of young unmarried Malay women into the manufacturing industry over the last fifteen years. In the electronics industry, Malaysian government policies, foreign culture and management policies, and kampung (village) culture meet. Ong's paper

offers important insights into the industrial culture of Japan and its influence in Southeast Asia today.

Several contributors to this volume (Rodgers, Hatley, and Blanc-Szanton) have suggested that depictions and expressions of gender and sexuality serve as vehicles for social and political commentary. Ong analyzes how Malay factory women have become a focus for the expression of ambivalence about economic development and social changes in contemporary Malaysia by a number of powerful sectors of Malaysian society. Of particular note in a region of the world in which Islam predominates is Ong's exploration of Islamic revivalist responses to young women's participation in the industrial sector of the Malaysian economy.

Just as Ong argues for an analysis of symbolism not as text but as process, so too she is acutely aware of the agency of the people being imaged by different contingents of Malaysian society. Instead of leaving us with a picture of passive Malay factory women as depicted by others, she presents an extraordinary account of these women "in their own voices" as they struggle with their rights as workers and their obligations as family members.

In Malaysian free-trade zones (FTZs), young Malay women working the "graveyard" shift are sometimes visited by demons. A bloodcurdling scream suddenly shatters the silence, followed by wailing and sobbing on the shop floor. The spirits of ancestors and aborigines, many claim, will not be appeased until corporate managements hire *bomoh* ('spirit-healers') to ritually cleanse factory premises with the blood of sacrificed animals. Such incidents of affliction, generally labelled "mass hysteria" by the local media and commentators, raise questions about the lived experiences of young Malay women who are being made into an industrial labor force. This paper will consider how the diverse images of docile female workers, "loose women," and spirit visitations in modern factories confound local and scholarly thinking about control, morality, and sexuality in the process of cultural change.

Recent studies about the cultural construction of gender tend to presume that sexual meanings are produced from core symbols derived from a cultural system (see some examples in Ortner and Whitehead 1981a). Feminist scholars have taken at least two different perspectives to account for perduring sexual meanings in particular societies. Sherry Ortner (1974) maintains that western

European cultures have fundamental philosophical principles for thinking about and ordering gender relations that persist over long historical periods. In another approach, scholars attempt to account for opposing views of gender in a single culture by discussing contrastive male and female perspectives of "the other" (e.g., Dwyer 1978; Brandes 1980). What has been overlooked is how sexual symbolism becomes reinterpreted and transformed in the dynamic interplay of power conflicts rooted in class and nationalism, which have often, but not inevitably, been culturally constructed as a gender dichotomy.

My inquiry into the diversity of sexual images that has blossomed in the wake of female proletarianization emphasizes the construction of gender in situations of conflict among groups identified other than by gender difference. I argue first that cultural notions of sexuality depend on an interplay between norms, practices, and the lived experiences of women and men in a material world. Contradictory, discontinuous, and overlapping images of gender are produced from conflicting interests, choices, and struggles among different social groups. Second, old cultural forms and gestures of female-male relations may acquire new meanings and serve new purposes in changed arenas of power and boundary definition. Meaning is not static but dynamic, ambiguous, and provisional, especially in a multicultural society undergoing industrial development and open to the onslaught of divergent foreign influences.

Drawing largely on my field research in West Malaysia (1978–80), I maintain that the multiple and contradictory images of Malay factory women are modes for thinking through control and morality by dominant groups that are profoundly ambivalent about the social effects of industrialization. As a counterpoint to these public commentaries, the changing views of factory women, largely ignored by the censuring public, are introduced as an alternating theme of daily contradictions and private anguish experienced by the first generation of Malay industrial women.

The inquiry begins with a discussion of *kampung* (Malay village) perceptions of young unmarried women as vulnerable and controllable by men. This rural notion of gender difference becomes reconstituted by corporate practices in the local Japanese

factories that employ rural Malay women on a large scale. Next, I will discuss how the sexuality of neophyte factory women becomes a matter for public discourse and surveillance by the media, politicians, and Islamic revivalist groups competing for control over cultural production. Caught in a moral dilemma produced by family claims, factory coercion, and public criticisms, Malay factory women in daily acts of resistance attempt to construct alternative identities in their own terms.

Male and Female in Rural Malay Society

Male Reason, Female Passion

In the following sketch of customary norms governing male-female conduct in contemporary rural Malay society, I argue that Malay notions of gender-specific prerogatives, obligations, and cultural justifications of ideals are historically produced categories. The ideal of male prerogatives in religious ceremonies, inheritance, marriage, and divorce, which developed primarily out of the interactions between Malay *adat* (customary sayings and practices) and Islamic tenets, has nevertheless left village women with a remarkable degree of autonomy in everyday life (Djamour 1959; Swift 1963; Rosemary Firth 1966). I argue, however, that Malay notions of male prerogatives and the related values of male responsibility toward women can be easily translated, given the institutional arrangements, into norms for the systematic domination of women by men. This is particularly the case when Malay male authority, most fully realized in the control of young female virgins, becomes the basis for ideological justification of male supremacy over all women in modern bureaucratic and industrial institutions.

In kampung life, two sets of beliefs underpin and legitimatize male claims to prerogatives: (1) according to derived Islamic ideas, men are more endowed with *akal* (reason and self-control) than are women, who are overly influenced by *hawa nafsu* (disruptive emotions/animalistic passion); and (2) men are therefore obligated to protect women's honor and socioeconomic security. Women are perceived to be more susceptible to imbalances in the four hu-

moral elements, which result in a state of weakened spirituality (*lemah semangat*). In such a spiritually vulnerable condition, women become susceptible to irrational and disruptive behavior. Such conduct includes *latah*,[1] during which the victim breaks into obscene language and compulsively imitative behavior. Alternately, the spiritually weakened woman invites spirit possession (*kena hantu*) and may explode into raging fits. Subsequent ritual intervention by male healers is considered necessary to restore the victim's spiritual balance so that self-control and self-knowledge (akal) once again regulate human passion (cf. Siegel 1969:98–133; Kessler 1977:320–21).

Village Malays consider the higher incidence of spirit possession and latah episodes among women as evidence of women's weaker spiritual strength and limited ability to consistently exercise reason and self-control in the conduct of their daily affairs. Anthropologists, however, associate spirit possession and latah episodes with the particular stresses Malay women experience as daughters, wives, and divorcées, i.e., in relation to men in the domestic sphere. For young unmarried women in particular, the threat of spirit possession operates as a powerful sanction to keep them emotionally and physically close to home (Ackerman 1979). Malay girls, unlike boys, are brought up to be shy (*malu*), especially obedient to their parents (*ikut parentah bapamak*), and timid/fearful (*takut*) of strangers and unfamiliar surroundings. They are discouraged from venturing out unless accompanied by at least a younger sibling. Young single women who go out alone at dusk run the risk of attracting wayside spirits that will attack them.

Such cultural mechanisms for controlling daughters are not applied to married women, especially those who have had many children or are past menopause. Married women move freely from house to house, go marketing, and travel alone to their garden plots. They gather in groups to prepare feasts, gossip, and cackle loudly, making sexual innuendos even in the presence of kinsmen. In their own houses, married women are not constrained by sexual modesty and may go about their housework with only a sarong tied around the waist. However, Malay women who try to resist their assigned roles as mothers and wives are said to become vulnerable to spirit attacks and/or be transformed into demons (see Laderman 1982). In commonsensical Malay idiom, the weak spiri-

tuality of the female sex is also the source of their physical-social weakness in the material world. Since men are blessed with more akal, they are given the responsibility of protecting kinswomen and morally correcting local women who step out of line.

Insecurity of Women, Responsibility of Men

Although they agree that Malay women enjoy relative social and economic autonomy in everyday life, scholars observe that women in both rural and urban communities do suffer from great insecurity because of the impermanence of the marital relationship, mainly the consequence of male prerogatives to pronounce divorce and to practice polygamy (Djamour 1959:42–43; Swift 1963:260; Firth 1966). Clive Kessler notes that the situation of women in Kelantanese villages is not as favorable as commonly believed; only the low status and impoverishment of the fisherfolk, which make conjugal cooperation and the wife's earnings critical to the household budget, "militate against any marked subordination of women to men" (1977:303–4). He stresses that women's individually acquired income should also be seen as a strategy to avoid subjugation by husbands and as the realization of enforced independence, especially following divorce. In Sungai Jawa, rural Selangor, where I conducted fieldwork,[2] women retain private wealth in land, jewelry, and cash; they resist pooling it in the household budget unless the husband, as required by Islamic law, contributes the bulk of family maintenance (bagi nafkah). Over the past decade, most of the divorces in the district of Kuala Langat have been motivated by the failure of the husband to provide maintenance.[3] Divorced women have to fall back on personal savings and the support of their immediate kin. Thus, women's "relative autonomy" is to a large extent the opposite side of their socioeconomic insecurity in relationship to men, and to male prerogatives in forming and breaking marital relations.

Malay notions that buttress such male prerogatives over wives are strengthened by male obligations to protect their kinswomen. Fathers and brothers are morally responsible for the chastity of their daughters/sisters; by extension, all men in the village guard against the violation of young unmarried women by outside men. In matters of property and economic security, Malay men are ex-

pected to look out for their daughters and sisters. Even after marriage, parents consider their daughters less able than sons to fend for themselves. Women are given portable inheritance (clothing, jewelry, household items) upon marriage; only rarely do they inherit land. Divorced or widowed women are expected to move back into the natal home or be supported (at least partially) by an older brother. Thus David Banks argues that Malays justify unequal devolution of land along sex lines on the grounds of men's greater sense of responsibility and the laws that enable kinsmen to thwart attempts by other men to appropriate women's property (1976:577–78). While Banks overstates "Malay fraternalism," his observation reflects the Malay recognition that women are less able to protect their bodies and property from exploitation by non-kinsmen (e.g., husbands), and the special responsibility of fathers and brothers for ensuring the moral and economic security of their kinswomen.

This tension in differentiated male responsibility toward their womenfolk is reflected in the male perception of daughter/sister as vulnerable and controllable, and of wife/divorcée as petty and manipulative. I suggest that the view of female untrustworthiness is linked to the inadequacy of actual attempts by kinsmen to safeguard the socioeconomic interest of women. Wives often have to resort to private strategies to secure their interests, and those of their children, even at the expense of husbands and kinsmen. Thus a married woman's control of her private resources and maintenance of close relations with her natal family may be construed by the husband as manipulation of the marital relationship. Alternately, a woman may use her independent source of wealth or sympathy generated by spirit affliction to hold together a faltering marriage (Kessler 1977). A divorcée may use her charms to forge a new marital relationship in order to ensure her socioeconomic security and that of her children, sometimes from different previous marriages.[4] Such practical management of their affairs no doubt earns divorcées and widows (janda—single, previously married women) the image of the sexually experienced flirt, not attached to or protected by any man, luring youths into illicit liaisons.

This most critical image of the Malay women is symbolically linked to the beautiful and dangerous *langsuir*, the demon of a

woman who dies in childbirth, and the *pontianak*, her stillborn
child. The former has a gaping hole, concealed by long tresses, in
the nape of her neck, through which she sucks the blood of infants
at childbirth (Skeat [1905] 1965:320–28). Both langsuir and pon-
tianak thus represent women in transitional states (existing be-
tween birth and death, both giving and taking life) who pose a
threat to human social order (cf. Endicott 1970:61–63, 82). The
pontianak, for instance, is also believed to materialize before men
and attempt to seduce them into marriage. Like the pontianak,
who is transformed into a human woman only when a man inserts
a nail into the hole in her neck, the janda is considered a socially
respectable woman only when she remarries.

In rural Malay society, then, the form and content of gender re-
lations are shaped by norms and attitudes that uphold male superi-
ority and guard against women attempting to gain male preroga-
tives. The sexually fertile woman not legally tied to a man threatens
family interest. In daily life, male authority is most easily en-
forced over young unmarried women, referred to as *budak budak*
(children/virgins), whereas single, previously married women are
most able to challenge male authority. Janda are not answerable to
any kinsman; their sexual misconduct can only be punished by
the Islamic judge (*kathi*) or members of the Religious Department.

The following sections of this paper will deal with the changes
in and increasing complexity of sexual imagery when budak budak
enter factory employment in large numbers and come to experi-
ence some of the social freedom hitherto enjoyed and managed
only by janda. To sort out the divergent meanings embodied in the
symbolic representations of Malay factory women, we will need to
consider the different interests of social groups and institutions
other than those in rural Malay society.

Japanese Factories, Malay Women: Manufacturing Gender Hierarchy

Japanese Factories in Kuala Langat

Export-oriented industrialization introduced since 1970 has
brought about the reorganization of the sexual division of labor

among Malays, and in the process it has reshaped local ideas about male-female relations. Industrial production has been undertaken mainly by inviting transnational companies to base labor-intensive factories in FTZs; the bulk of the semi-skilled labor force is drawn from the pool of young rural Malay women (see Ong 1987). It is estimated that in 1970, no more than 1,000 Malay migrant women worked in manufacturing industries; by the end of the decade, over 80,000 of these women were industrial workers, most of them concentrated in the electronics, textile, and food-processing industries (Jamilah Ariffin 1981). The great majority of Malay women workers are employed in the electronics industry. There are over 140 electronics firms in Malaysia, mainly the subsidiaries of Japanese and American corporations, which together employ over 47,000 women workers, the majority of them Malays (ibid.). The most common image of the new working-class Malay woman is in fact "Minah *letrik*" (the local equivalent of "hot stuff").

Field experience in Japanese and American firms in rural Selangor and urban Penang (1978–80), however, uncovered significant differences in corporate ideologies and in the impact of these policies on Malay notions of gender relations and sexuality. Other scholars have briefly observed that American companies encourage individualistic practices, whereas Japanese factories emphasize group cooperation and subordination to male authority (Grossman 1979). Cosmetic shows and beauty contests in Western firms, together with images of passive sexuality in advertising, have induced city-based factory women to spend more on market items than on food (Gay 1983). The new subjectivity, including the adoption of Western forms of social intercourse, is the source of factory women's *bebas* ('loose') reputation, and the secret envy of their sisters in staid Japanese factories.

Significantly, the Malaysian prime minister recently proclaimed his "Look East" policy of emulating the Japanese model of industrial development. Japan is not only the biggest investor in Malaysia, he argued, but it presents the particular combination of policies that ensures efficient systems of production without sacrificing "Malaysian values." He elaborated: "[I]t is true that they [the Japanese] are not very religious, but their cultural values are akin to the kinds of morals and ethics that we have in this country

or would like to have in this country . . . profit is not everything"
(*Far Eastern Economic Review*, June 11, 1982). The prime minis-
ter pinpointed the Japanese company's concern for the "welfare"
of its workers, who are said to show great loyalty to their company
as "their family." Furthermore, he observed, Japanese house unions
promote the workers' feeling of belonging (ibid.: 38–39).

This picture of the Japanese company[5] is part of the general
Japanese corporate strategy of using the idiom of the family to
disguise relations of production that systematically subordinate
women to men. Here I will focus on the Japanese factories in
Kuala Langat district, Selangor, where I conducted fieldwork in
Malay villages and in the local free trade zone. In the early 1970's,
three Japanese factories, which I will call Electronics Japan Incor-
porated (EJI), Electronic Nippon Incorporated (ENI), and MUZ, a
micro-machine plant (manufacturing musical movement compo-
nents), were set up in the FTZ. They have a constant labor force of
over 2,000, the vast majority being young Malay women from the
surrounding villages. The forms and gestures of male power in
these factories, I argue, are informed by Confucian principles
that sustain a corporate ideology rooted in non-Malay patriarchal
values.

Mukim Telok is an agricultural subdistrict lying just south of
the Klang Valley industrial belt. The FTZ has been inserted into a
local economy of plantations and Malay villages. The five villages
are settled primarily by Javanese immigrants, who produce coffee,
coconut, rubber, and palm oil in their smallholdings. The planta-
tions (which employ large Tamil labor forces) specialize in rubber,
palm oil, and cocoa. In the wake of the establishment of the FTZ
in 1971, state agencies, large private enterprises, and political par-
ties have penetrated Malay village society, bringing about the
emergence of new social groups.

In the local Malay society, "traditional authority" in the We-
berian sense is vested mainly in Islamic scholars, locally elected
hamlet leaders, and, less firmly, government employees like the
penghulu (administrator of the mukim), teachers, and party func-
tionaries, who all command, in varying degrees, the loyalty of the
commonfolk. In day-to-day life, men enjoy moral authority over

women, and adults over children, although such deference to men and elders is not inevitable and unproblematic in a situation where most adult women and men enjoy some measure of autonomy in work and access to some independent form of wealth (in land or savings). Malay values of male prerogatives are asserted and enforced in attempts to control and protect young unmarried daughters within individual households. Male authority is *never* realized in a systematic male domination of all women, who enjoy a moral authority of their own as elder kinswomen and in interhousehold relations.

Social differentiation, however, engendered by population growth and competition for village land by outside capital, has attenuated the ability of many households in general and of women in particular to retain their autonomy and resist the realization of inegalitarian values in male-female and interhousehold relationships. A 1979 survey of 242 Malay households in Kampong Sungai Jawa (a pseudonym) indicates that about 24 percent of them have access to less than .5 acre of land, if any, while land-poor households (with holdings of .6 to 2 acres) account for 37 percent of the survey population. Another 27 percent of the households operate plots of 2.1 to 5 acres, while middle peasants (with holdings of 5.1 to 10 acres) comprise only 5 percent of all households. Wealthy households, with access to land ranging in size from 10.1 to 70 acres, constitute 6.6 percent of the sample. Thus, differentiation in command of village resources compels more village men and women to seek wage earnings not only to supplement farm incomes but increasingly for subsistence and social reproduction. Most of the male wage workers seek employment in the Klang industrial belt, whereas the majority of young women are employed in the local Japanese factories.

Since the early 1970's, then, Malay village women in *mukim* Telok have been exposed to new modes of control in capitalist industries that they have never before encountered in peasant society. In locally based Japanese factories, the management reconstitutes Malay norms of male-female relations and transforms them into a corporate ideology rooted in Confucian values. Different but overlapping forms of factory discipline generate ideologi-

cal and social acceptance of systematic female subjection to male control, thereby producing a new system of gender hierarchy along with microcomponents.

Nimble Fingers, Slow Wit

Asian women employed by transnational industries have often been characterized in industrial brochures as biologically suited for the painstaking and fine handiwork required in labor-intensive processes. A Malaysian investment brochure notes "the manual dexterity of the oriental female" and queries: "Who, therefore, could be better qualified *by nature and inheritance* to contribute to the efficiency of a bench-assembly production line than the oriental girl" (emphasis added; Federal Industrial Development Authority 1975). This dubious explanation of women's biological "qualification" for low-paying, semi-skilled work is further elaborated by the corporate policies of multinational subsidiaries. In ENI, the Japanese manager asserts that "females [are] better able to concentrate on routine work [which may be] compared to knitting, generally speaking."[6] He admits further that "young girls [are] preferable to do the fine job [of assembling microcomponents] than older persons, that is because of eyesight." At EJI, the Malay personnel manager states candidly: "[The] assembly of components is a tedious job . . . [with] miniaturized components we feel that females are more dexterous and more patient than males." Thus nimble fingers, fine eyesight, and, by implication, the passivity to withstand low-skill, unstimulating work are said to be biological attributes unique to women. Perhaps not unexpectedly, the Japanese financial manager of MUZ links these imputed female attributes to cost considerations: "Each initial work is very simple . . . if we employ female workers [it is] enough. . . . Also cost of female labor [is] cheaper than male labor in Malaysia, not so in Japan.[7] . . . If we have male assembly workers, they cannot survive. . . . Fresh female labor, after some training, is highly efficient." A Chinese assistant engineer in the same factory elaborates further these patriarchal beliefs in female passivity: "You cannot expect a man to do very fine work for eight hours [at a stretch]. Our work is designed for females . . . if we employ men,

within one or two months they would have run away. . . . Girls [sic] below thirty are easier to train and easier to adapt to the job function."

Given the continual supply of cheap female labor from the surrounding kampung, the three Japanese factories can be selective about the type of female workers they wish to employ: between the ages of sixteen and twenty-four, with at least primary education (which is free in Malaysia), and unmarried. Young women are preferred because of their diligence, and their eyes can withstand the heavy use of microscopes employed in many of the basic production processes (wiring, bonding, and mounting of components). Married women are discouraged from applying because they do not represent fresh labor and yet cost more than young single women, who can be employed for a short span of their life cycle.[8] In addition, secondary school graduates are not actively sought because, the ENI engineer feels, "the highly educated person is very difficult to control."

Such corporate notions of sexual differences in adaptation to work find a faint echo in Malay views on male and female differences in work patterns. Malays tend to stress that men should perform tasks involving heavy expenditure of energy, like carrying loads, digging, and construction work. Women, being of smaller build, should engage in activities that require fewer bursts of strength and force. Thus the saying that men can carry two loads on a pole whereas women can balance only one load on their heads (laki tanggong, perumpuan junjong). Other attributes associated with women, like patience (sabar), are considered to be the result of training, and fine qualities to be cultivated by all Muslims. When I asked the village women why they were concentrated in operator ranks, they replied that they have more patience than men to stick to the complex handiwork; men should operate heavy machines. However, they also said that women will accept low wages, whereas men, who have more expenditures, will refuse such poorly paid work.

Thus, although Malay women may accept the fact that they have been better trained to engage in fine detail work, they are not blind to the connection between their position in the industrial system and the lowest wages. Since they have been socialized

from early childhood to be hardworking, to have modest expectations of reward, and to be more responsible towards their families than men as a measure of their worth as women (daughters, wives, and mothers), Malay women are not dissuaded from low-paying jobs so long as their families depend on those earnings. One cannot simply argue, as Linda Lim has done, however, that the "traditional patriarchy" of Third World families is "at the bottom of women's subjection to imperialist exploitation" by multinational industries (Lim 1983:79, 86). I maintain that beyond preexisting ideas of innate sexual differences and incipient ideas of male domination, the corporations have to intervene to produce and reproduce, in daily conditions, the ideological and social mechanisms whereby concepts of male domination and female subordination are infused into and become the "common sense" of power relations in the industrial system.

The Family Way: Managing Maidens and Morality

Within the factories, production processes are organized for maximum efficiency and surplus extraction, not only capturing in the structure of work relations the existing uneven distribution of expertise between ethnic groups (Japanese, Chinese, Indian, and Malay), but also exaggerating power differences between men and women. The organizational pyramid and wage structure of EJI provide a vivid example (see the accompanying table). There are six major occupational strata: managing director, departmental manager, production manager, supervisor, foreman/technician, and production operator. The last category, which is almost totally filled by women, is further stratified into four categories: chargehand, lineleader, ordinary operator (the majority), and temporary (six-month) operator. As expected, women workers are also concentrated in the secretarial and typing pool, but most of these women are from outside the district.

The massing of women at the lowest levels of the occupational hierarchy ensures that the majority of them will not work for more than a few years because of the occupational boundary. Women workers are not given the training, provided to men, that would qualify them for jobs as technicians and supervisors. The highest positions operators can aspire to are those of chargehand

Distribution of EII Employees by Ethnicity, Gender, and Earnings, 1979

Occupational rank	Ethnicity[a]				Gender		Total workers	Salary scale
	J	M	C	I	Men	Women		
Management								
Professional	10	0	0	0	10	0	10	$1,500–4,000
Nonprofessional	0	2	2	1	5	0	5	$800–1,080
Supervisory								
Engineer, foreman, supervisor	0	14	32	6	50	2	52	$785–895
Clerical staff								
Clerk, typist	0	17	19	7	11	32	43	$345–480
Service workers								
Phone operator, driver, guard, gardener	0	15	0	3	16	2	18	$225–290
Factory workers								
Skilled—technician, chargehand	0	56	21	19	71	25	96	$275–400
Unskilled—operator (daily rate)	0	460	48	74	5	577	582	$3.75–4.80 male $3.50–4.00 female
Temporary operator (daily rate)	0	135	37	52	0	224	224	$3.10
TOTAL	10	699	159	162	168	862	1,030	—

[a]J, Japanese; M, Malay; C, Chinese; I, Indian.

and clerk. There are only 25 positions for chargehands for the 800 operators in EJI. The most vulnerable workers are undoubtedly the temporary operators who comprise one-quarter of the semi-skilled work force, and who are taken on and laid off according to market conditions. Thus the structure of the industrial system itself rigidly defines and institutionalizes the extreme male-dominated hierarchy wherein all women, concentrated in the lowest job ranks, take orders from and are supervised by male workers in daily activities on the shop floor.

The gender hierarchy embedded in the production system is paralleled by paternalistic management policies toward the female operators in general. Japanese corporate policies are finely tuned to local cultural values, taking into consideration the network of social relationships factory women maintain with their families in the Malay kampung. Cognizant of the particularly junior status of young unmarried Malay women as daughters and as nubile females, and the moral obligation of Malay men to protect them, Japanese firms project an image of "one big happy family." The companies deliberately emphasize the "welfare" and moral custody of the operators, thereby winning not only the social acceptance of kampung elders but also the active cooperation of parents in supporting corporate mechanisms directed at controlling the factory women.

Thus the symbolic expressions of authority and domination over the female labor force depend on values that reverberate within the Malay moral universe. In MUZ, large factory posters proclaim the "company philosophy":

> To create one big family
> To train workers
> To increase loyalty to company, country, and fellow workers

At EJI, factory supervisors refer to the operators as "one happy family" working together, guided by rules and regulations printed in a little book referred to, rather inappropriately, as the "Bible." Couched in the idioms of family, religion, and patriotism, corporate policies acquire moral resonance with such key kampung values as cooperation, loyalty, and sacrifice. Such ideological synchrony of corporate policies and Malay mores help to disguise the extent of factory control over local women.

At ENI, the Malay personnel manager, an ex-army man with the air of an enlightened bureaucrat, explains that his company is "more Eastern in nature" than the other firms. There are no social gatherings or parties held on factory premises, which might encourage the mixing of male and female workers. He points out that the factory is located in "a *kampung* where the outlook of the people [is] too religious, old-fashioned," and that the informal segregation of young unmarried men and women is the norm. He admits that the factory has no time for social functions. Citing criticisms in the press about factory women being "too free" and the few cases of prostitution reported among FTZ workers elsewhere in the country, he spells out his company policy:

We do not want to go against Malay culture, *and* Japanese culture too. . . . We are entrusted by the parents to give the girls good employment, not otherwise. This is a family system; we are responsible for the girls inside and outside the factory. If the girls get sick, for example, we send them home by private cars. . . . Of course they complain. But we say the big "Yes" here. Parents are very happy and we never receive any phone call or letter from parents calling for their daughters' resignation—like other companies [do]. (Emphasis in the original)

Indeed, social control is so effective that the monthly turnover at ENI is no more than two percent, compared to four percent at MUZ and six percent at EJI.

The corporate attempts to adhere closely to Malay attitudes toward young women not only reassure parents and promote social conformity "to make everyone happy," but also distract workers from work-related problems. Although unions are legal in Malaysia, the government registrar has thus far delayed recognizing unions in the electronics plants established by multinational corporations. In 1979, following a strike, MUZ established an in-house union that has the purpose of working with the management. The Malay personnel manager remarks candidly: "We recognize the union in order to make them [the workers] happy . . . [we] increase efforts on welfare, benefits. We bring them to a point away from the wage focus—otherwise heaven will be the only limit to wage demands . . . we create a happy family environment."

There are no unions at the other two electronics factories, but alternative systems based on paternalistic relations help the man-

agement to confine workers' grievances to manageable channels. At EJI, each work section sends a leader to the "employees' monthly meetings" to meet with the personnel manager. It operates as a "grievance procedure system" to pass all complaints to the top; group leaders are required to poll their workers for reactions to decisions and report back to the management.[9] Operator representatives requesting second sets of factory shoes and overalls for workers are told to increase production output in their lines first. This procedure represents the informal bargaining relationship between fathers and children.

At ENI, corporate policies stress the social obligations that the first-time women workers still have to their village families, thereby enhancing the discipline of the workers and also preserving the conditions in which parents send their daughters to seek wages at the factories. In monthly meetings with workers' parents (not with workers themselves), the personnel manager presents himself as the 'foster father' (*bapa angkat*) of all the female workers, whom he also calls 'children' (budak-budak). At the meeting, he acquaints the parents with the work schedules of the workers because parents are particularly concerned about the night shift and "overtime," which may be used as a cover for nonwork activities. Company bus drivers are given strict orders to keep to assigned routes, and parents are provided with "overtime" forms to check their daughters' daily schedules. The manager thus impresses upon the parents his concern for the moral reputation of his "charges," while eliciting parental cooperation in enforcing control over the workers' movements between home and factory (which affect production schedules). At the meeting the personnel manager also asks parents about the complaints of the 'female children' (*budak budak perumpuan*) because they are too "shy" (malu) to tell factory personnel. The kampung parents thus unwittingly play the part of a grievance feedback system, adding their own moral weight to the social control exerted by the management.

Outstation women workers, who pose a threat to the carefully constructed factory-kampung alliance to control operators' movements, are grouped by ENI in the same rooming houses because "they are exposed to dangers [and] we have to look after them." Migrant workers at the other factories also rent rooms, but their

landlords act as self-appointed custodians, mediating between the workers and the kampung society, which looks askance at them. Thus, although the factory management may genuinely be concerned for the safety of the women workers, their paternalistic strategy ultimately contributes to the formation of a disciplined and docile female work force subject to the dual pressures of kampung and corporate control.[10] Domestic male moral authority and the protection of nubile daughters have been transformed into a large-scale alliance between kampung elders/parents and factories for the industrial exploitation of Malay women.

The Foreman-Operator Relationship:
The Daily Production of Female Subordination

Ultimately, Japanese ideals of male domination and female obedience are produced and reproduced in the daily interactions between foremen and operators on the shop floor. The foreman-operator relationship, based on the male-female authority system in Japanese culture, is the mechanism by which women workers become infected with ideas of female inferiority and servility to men, and the process by which high production levels are attained. Because of low labor costs and consistently high production rates, the Malaysian subsidiaries of Japanese corporations are more profitable than parent companies. Nevertheless, Japanese managers feel that in order to compete successfully with American firms, they have to push continually for higher production targets for Malaysian workers. Again, the image of family claims is invoked: "Parents do not say that they are satisfied with their children; every time parents hope for more from their children."

The foreman-operator nexus is pivotal in enforcing such endless expectations. Each foreman is in charge of ten to ninety operators, depending on the particular production process and shift. At ENI, the plant director calls the foreman the "head of . . . family members," leading a pyramidal distribution of female workers, from their immediate assistants (chargehands) to lineleaders of workbenches, to operators at the bottom. To implement production goals, foremen rely heavily on chargehands and lineleaders to deal directly with operators. One lineleader complains: "The foremen,

they give this job, that job, and even before my task is done they say do this, do that, and before that is ready, they say to do some other work. At times I tell the operators and they get angry too because of the repeated orders . . . the endless orders to work fast."

Besides exerting work pressures, foremen also try to control every aspect of operators' behavior within the factory and to influence their outside activities. In daily interactions, male power is demonstrated either in an authoritarian, intimidating manner or in a paternal, benevolent fashion to enforce general compliance and discipline among the women workers. Thus Japanese officials tell me that women cannot make good foremen because they lack the necessary "leadership qualities," such as a "fierce demeanor," the ability to give and stick by decisions, and the capability to command the respect of male technicians.[11] Management thinks that it is necessary to be very strict with Malay operators, even though they are "very obedient and hardworking types." At MUZ, the engineering assistant and head of the in-house union describes the operators whose interests he represents: "Obedience covers all—[it makes them] easier to control. But they are emotional—they cry when errors are pointed out—the threat [is felt] there. Some [however] yell at you." At ENI, operators are instructed not to answer back when reprimanded by foremen, but to be "very polite." Operators are scolded by overvigilant foremen for wanting to go to the prayer room (where as Muslims they have the right to prayer five times a day), the clinic, and the toilet. Some workers are subjected to questioning, conducted in a humiliating manner, about their menstrual problems[12] or nonwork activities, and are even followed to the locker room. Thus, female inferiority is instilled in the operators by such daily surveillance and the need to ask for male permission for the most mundane activities.

Other foremen believe in the paternalistic handling of operators encouraged by Japanese managers. Kindly foremen, who play a role more akin to "father" or "brother," can obtain the women's obedience and loyalty, while fostering a comfortable "family" environment in the midst of actual exploitation. An EJI supervisor explains his approach to me: "Force [is] not so important as understanding of subordination . . . mutual understanding and respect

[are] very important for [the] leader's control." He notes that it is important to encourage the workers daily and to compliment them on their handiwork. This approach is quite successful. A factory woman says, "I consider the foreman as my elder; he takes the place of my father and so I respect him." The gentle treatment of female workers operates within the context of gender hierarchy and as a mechanism for enforcing worker control.

The inequality in the foreman-operator relationship is sometimes enhanced by the emotional gratitude engendered in the women workers by kindly foremen. An EJI supervisor says that he advises his foremen to treat all the operators "equally, but a few fall in love." Other operators are favored with recommendations by their foremen for special cash allowances awarded for reaching high production targets. Favoritism by foremen of a few women workers thus creates division among the operators and reinforces the image of dependency on male authority figures dispensing orders and rewards.

Such factory experiences are in contrast to women's work in the village, where young girls and unmarried women enjoy self-determination in work and are taught complex skills by older women, but are not generally supervised by others. Women set the pace, schedule, and objectives of their activities so long as they see to their family needs. Many women tell me they like to work in the factories mainly for the friends they make there, but they feel that their parents have a better work situation as smallholders because they do not have a "boss" to watch over them, nor can they be threatened with expulsion.

Factory work is performed mechanically and the operators are not taught to understand the production processes.[13] A Malay technician comments: "Operators have never been given training or skills which will be adequate for them to use when they leave [the factory]. They absolutely do not understand [the work operations]. . . . I feel that if they are given more training in operating machines . . . the proper way, maybe they can become technicians. But really, they do not have the opportunity to rise [in the job ranks]." Operators eager to learn more about production operations have to learn from men, not other women. An operator re-

veals that "I feel that if I work closely with men they will tell us whatever we ask, so that for those women who get the most comments, things will be easier [for them]."

In the factory, then, Malay women are shaped, through the cultural reformulation of Malay gender relations and the daily enactment of production roles, into the Japanese ideal of the subservient female who is in every way inferior to men and subjected to their control. Nevertheless, the view that the Malaysian public has formed of industrial Malay women contradicts the actualities of their factory experience. We will next discuss why this is the case.

Sexual Metaphors: Consumer Culture and Social Control

A visitor to the large Malaysian towns will be struck by scenes of factory women not common even ten years ago. Pools of uniformly clad young women can be observed eddying around bus stops, food stands, or factory gates at the FTZs. In the evenings, neophyte factory workers, dressed in more colorful Malay or Western clothes, may be seen on their way home, shopping at marketplaces or wandering around downtown. A running commentary often follows in the wake of these women, many of them recently arrived from the countryside. Shop assistants, passers-by, and street urchins may cheerfully greet them with "Minah *karan*" ('high-voltage Minah,' a variant of "Minah *letrik*"), "*kaki* enjoy" ('pleasure-seekers'), and sometimes "*perumpuan jahat*" ('bad women' or prostitutes). Not only people in the streets but the Malaysian press, politicians, and religious institutions have all raised key moral issues in a cacophony of critical commentaries about these women of the nascent Malay working class.

The various epithets, public warnings, and pronouncements that these factory women have excited among different social groups represent overlapping but divergent perspectives on changing Malay culture. In the context of hegemonic crisis, conflicting dominant interests within Malaysian society—capitalist institutions, state agencies, and the Islamic resurgence movement—

participate in the ideological struggle to redefine the status of the modern Malay woman.

Neophyte Factory Women and the Negative Image

Since 1970, the media (radio and Televeshen Malaysia), which are controlled by the state, have played a role in focusing attention on young Malay factory women and provided the frame of reference for public discussion of their new status. Newspaper articles popularize public familiarity with appellations coined in the streets (*The New Straits Times*, Aug. 31, 1979), describing the apparent proclivities of Malay working women for activities such as *jolli kaki* ('seeking fun') and *jolli duit* ('having fun with money'). Women who seek Western-style recreation in bars and nightclubs are referred to as "*kaki* disco." These terms, which continually play on the words "jolly" and "enjoy," emphasize the image of factory women as pleasure-seekers and spendthrifts participating in Western forms of consumerism. In particular, the emphases on 'feet' (*kaki*) and on "electric" (a triple pun on the women's industrial product, their imputed personality, and the bright city lights that they supposedly seek) imply freedom associated with footloose behavior, the unhampered pursuit of pleasure, and more than a suggestion of "streetwalker." By emphasizing such negative images, the media exaggerates the portrayal of Malay factory women as active participants in a culture of consumption.

Indeed, many factory women, especially in the urban-based FTZs, dress in eye-catching Western outfits and spend their off-work hours shopping and going to the movies. In the village, factory women often go window-shopping after payday. They go into towns in the loose Malay *baju kurong* and return wearing make-up and Western dresses or clothed in T-shirts and jeans, in the "rugged, Wrangler style" affected by Malay youths. In fact, conspicuous consumption and participation in a Western youth culture are most prevalent among young middle-class professionals and university students, but the press has chosen to highlight such activities among working-class Malay women. As one factory woman observes, office workers are also known to be "immoral," but the public "raises itself above those who work in the factories

because they do not have [high academic] qualifications." By riveting public attention on women's consumption, the press trivializes the women's work and helps divert discontent over their weak market position into the manageable channels of a "youth culture."

The mass circulating press also operates as a vehicle whereby public officials and politicians attempt to increase social control over Malay working-class women by amplifying events that tarnish their reputation. From 1976 onwards, newspaper reports intermittently have carried stories about factory women in the Penang Bayan Lepas FTZ who are said to service soldiers and tourists, under such headlines as "Factory Girls in Sex Racket" (*The Star*, May 19, 1978). In early 1979, *The Star* proclaimed on its front page: "It is not fair to associate *all* factory girls with immorality" (Feb. 18, 1979). The factory women featured in the story are from mainland peasant villages working in the FTZ. They rent rooms in kampung homes and are placed under the informal jurisdiction of village leaders so that they will not "fall prey to any city playboy." As the oldest and largest FTZ in the country (with twenty multinational factories on location employing some 18,000 workers), the Bayan Lepas FTZ has developed a reputation for sexually permissive women. Factory workers are dubbed with factory-specific nicknames such as "micro-*syaitan*" ('micro-devils') for operators at Microsystems, and "night-sales" or "*nasi sejok*" ('cold rice,' i.e., leftovers) for workers at National Semiconductors. Malay women in other FTZs are also described as "preyed upon" and "tricked" into prostitution. An Ipoh industrial estate has earned the label of "the Malaysian Haadyai," after the famous Thai red-light border town frequented by Malaysians (*The New Straits Times*, Feb. 16, 1979).

The alarm raised over the perceived threat of Malay factory women asserting social independence, thus casting doubts on official Islamic culture, has prompted state officials to call for greater control of women in the nascent Malay working class. In 1980, the then-deputy prime minister noted that rural women who work in factories are said to become "less religious and have loose morals." As a champion of the export-industrialization program, he advised that the solution to the problem is not to blame the factories but for people to guide the "young girls" to "the right path" (*The Star*,

April 4, 1980). The public association between Malay factory women and "immorality" has become such a national issue, he stated, that further state action is required to quell the fears of Malay parents back in the kampung. In the next year, the Welfare Minister called for orientation programs to be set up by kampung youth associations to prepare village women for urban life so that they would not fall into the "trap" and "discard their traditional values" in the towns (*The New Straits Times*, Oct. 17, 1981).

The problem of "immorality" among Malay women is presented as the outcome of rural-urban migration and the urban Westernized culture, rather than linked to industrial employment. This "sarong-to-jean" movement, the vice chancellor of Universiti Malaya argues, results in problems of urban living that can be alleviated by providing counselling and recreational and education facilities. "Lack of recreation, he says, leads to untoward patterns of behavior" (*The Malay Mail*, June 14, 1982). By thus amplifying the moral corruption of Malay industrial women, the state and mass circulating press suggest a connection between their relative economic freedom and the irresponsible use of that freedom to indulge in commercialized sensualism. This selective focus on the problems of Malay working women provides the excuse for greater public control over their "leisure" time (which in actuality is very limited) while simultaneously diverting attention from the harsh realities of their "working" time.

Islamic Groups and a New Model of Islamic Womanhood

Islam is the religion of all Malays (in the Peninsula), but there are divergent Islamic perspectives on the changing status of Malay women. State religious offices, like other governmental agencies, tend to direct attention toward the perceived misuse of "free time" by factory women, whereas Islamic revivalist groups are more concerned with questions of defining appropriate spiritual and social boundaries.

Since the early 1970's, when the implementation of the New Economic Policy (NEP) brought thousands of young rural Malays into urban educational institutions and factories, state Islamic in-

stitutions and the Islamic revitalist groups (in the missionary or *dakwah* movement) have participated actively in attempts to shape the public image of modern Muslim women. I maintain that the increased vigilance of state Islamic institutions in monitoring the deportment of young Muslims is a deliberate state response, through its ideological mechanisms, to political protests by Islamic resurgence groups over corruption in state bureaucracies and the goals of the development program (see Kessler 1980; *Far Eastern Economic Review*, March 3, 1983).

To the young Malay workers, official Islam, as represented by the state religious offices, is often experienced as a legal system that deals with marriage, divorce, inheritance, and religious offenses. Since the influx of young Malay women to work in the FTZs, there have been more frequent reports of raids by members of the Religious Department in the poor lodgings and cheap hotels inhabited by workers and the semi-employed. Under current official interpretation of Islamic offenses, Muslims may be arrested for *khalwat*, or 'close proximity' between a man and a woman who are neither immediate relatives nor married to each other. Offenders caught in situations suggestive of sexual intimacy (but not *in flagrante delicto*) are fined or jailed for a few months; the sentences vary from state to state. Muslims may also be arrested for *zinah*, i.e., illicit sexual intercourse, which is more severely punished.

Although theoretically there is general surveillance of other sectors of the Malay population, the understaffed religious offices seem to have turned their attention to areas where Malay factory women are concentrated. Malay factory women found walking around at night are sometimes threatened with arrest for khalwat by men who are not members of Islamic offices (*The New Straits Times*, Aug. 30, 1979). Both parties arrested in an incident are punished, but sometimes the female partner is given the heavier sentence. When the culprits are too poor to pay both fines (M$1,000 or more each), the payment is sometimes made jointly by both parties to release the male offender so that he can return to work, while the female offender serves the jail sentence (see Strange 1981:23–26). Thus the state, through Islamic offices, disciplines

the social conduct of working-class Malays, subjecting women to greater religious surveillance and sanctions.

Malays involved in the dakwah movement—"a politically-informed religious resurgence" (Kessler 1980)—are primarily disaffected students and intellectuals more concerned with the inculcation of Islamic-Malay ascetic values than with punishing Muslims who deviate from the principles of moral behavior. For many highly educated Malays, especially members of the dominant dakwah group ABIM (*Angkatan Belia Islam Malaysia*: Malaysian Islamic Youth Movement), which has some 35,000 followers,[14] Islamic revitalization provides a means of affirming kampung values (Kessler 1980) and of "striving (*perjuangan*) for religious truth" (Nagata 1981:414) in the alienating urban environment. Other Islamic sects like Darul Arqam and Jemaat Tabligh[15] also have alternative versions of an Islamic society they would like to see installed in Malaysia (see *Far Eastern Economic Review*, Mar. 3, 1983). The main dakwah groups demand, among other things, a new model of Malay womanhood.[16]

The modern, religiously enlightened Malay woman is defined in opposition to what is considered capitalist and derivative of Western individualist and consumer culture. Through a radical reinterpretation of the Quran and Sunnah, the revivalists call upon Muslims, but especially Muslim women, to abstain from Western forms of behavior like drinking alcohol, driving cars, and watching television and movies (regarded as the major vehicles for transmitting undesirable foreign values). Instead, women are encouraged to veil themselves modestly, observe segregation of the sexes, undertake communal activities, and participate in serious Quranic studies. Although few, if any, of the Malay factory women (as compared to office workers) don Arabic robes in voluntary purdah, the dakwah movement has struck a responsive chord in many young women who wish to be recognized as morally upright Muslims engaged in honest hard work (*kerja halal*). They see in the Islamic resurgence an assertion of pride in Malay-Muslim culture and an affirmation of its fundamental values in opposition to foreign consumer culture.[17] Factory women, humiliated by their public representation, often ask that religious instruction be given on factory

premises so that Islamic guidance will foster harmony among workers, discipline in work, and an ascetic attitude towards life (see below).

To some working-class Malay youths, ABIM is considered the appropriate vehicle for organizing workers in their conflicts with industrial enterprises and attempts to articulate a working-class consciousness. Radical criticisms of multinational corporations by the intellectual leaders of the movement have informed the consciousness of worker-members, providing them with a lens for recognizing their situation as exploitative and a political idiom to articulate this *"exploitasi."* Thus a Malay technician at EJI, who joined ABIM when he was training in a vocational school in Kuala Lumpur, analyzes the management strategy of giving annual dinners to workers as a means to "ease their hearts" and make them "forget" basic issues like worker allowances and work conditions. He claims that as an ABIM member, he is not "blinded," like the kampung folk, by the disguised intentions of the factory management: "I know my own feelings [of being manipulated and exploited]. I know the feelings of other [workers]. Therefore, I am sort of in 'revolt' [against the management] . . . behind their backs." He argues that there is no "one road" to solving the problems faced by factory women who are badly underpaid and "stamped" with a degrading image. A university don has suggested that one solution to the "social problems" of Malay factory women is to provide them with dormitories near the FTZs, but the technician disagrees: "I feel that to tie them up like this . . . is not the 'democratic' road. We cannot tie them up . . . it is not practical." Such statements reflect attempts to link Islamic ideas of chaste honest work and worker rights with democratic notions, perhaps within the context of an emerging proletarian consciousness.

The conflicting images of Malay factory women, linked to public agencies, official religious authorities, and the dakwah movement, are symbolic expressions of different mechanisms of social and class manipulation. The mass-media portrayal of the Malay factory woman as a pleasure-seeking creature is connected with increasing social surveillance of her "free time," whereas her in-factory presentation as a child requiring male custody is expressive of the industrial control of her working time. These images of

wantonness and childlike dependency are ultimately significant as the cultural legitimization of state and industrial control, while revealing general anxiety over young Malay women gaining control over their own lives. Their assertion of social autonomy would begin a process of undermining public assumptions about the "common sense" of gender inequality in power relations. We will see how, by mediating the reconstruction of their subjectivities, factory women develop a gender consciousness based on social responsibility to family, class, and race.

Malay Factory Women: In Their Own Voices

We now turn to the off-stage voices of factory women themselves, their own self-perceptions, which have emerged partly in reaction to external caricatures of their status, but mainly out of their own felt experiences as wage workers in changing rural Malay society. I have argued that in a society undergoing capitalist transformation, it is necessary not only to decipher the dominant gender motifs that are the symbols of relations of domination and subordination, but also to discover in everyday choices and practices how ordinary women and men remake their own identities and culture. Class is taken as a cultural formation (Thompson 1967), but one that is constantly remade in definite contexts structured by the state. Disparate statements, new gestures, and untypical episodes will be used to demonstrate how Malay notions of gender become transmuted through the new experiences and emergent consciousness of women workers.

Self-Images: Young Women Between Self-Esteem and Social Emancipation

In rural Selangor, Malay women employed in the Telok FTZ, together with their parents, reject the commoditized image of factory women as illegitimate and an affront to Muslim womanhood. The media portrayal of industrial workers spending so much of their time and money on individual gratification assails kampung communal norms and expectations of female loyalty to family in-

terests. The emerging self-image of factory women in the kampung is conditioned by simultaneous efforts to be true to family expectations on the one hand, and to claim new rights as workers on the other. Such conflicting claims are *not* resolved in favor of individualism as a crucial part of their new identity.

As previously discussed, kampung Malays consider the moral purity of young unmarried women to be the responsibility of kinsmen, and these women, more than any other social category, are most subjected to male authority and control. Closely connected to these customary expectations are the moral obligations daughters owe their families. Wage employment at the factories enables young women to contribute to their household budgets, thus helping to conserve family relations in circumstances of declining agricultural economy. This increased ability to fulfill family obligations enhances the women's self-esteem.

Social emancipation, however, especially in the form of rampant consumer behavior, is viewed as destructive of the very kampung social relations that the women's wages help to sustain. Thus, though kampung women understand the yearnings for social freedom betrayed by urban-based and migrant workers, they severely censure any such individualistic orientation. In their view, the pursuit of consumer behavior is associated with the "unnatural" inversion of noncapitalist ideas about sexual difference: "It is not nice the way [factory women] attempt to imitate male 'style.' Like, they want to be 'rugged.' For instance, men wear 'Wrangler,' the women want to follow suit. . . . Some of them straight away behave like men, in their clothing. They forget their sex. If they are already very *bebas* ['unrestrained,' 'loose'], they forget that they themselves are women." The term "social" has entered Malay parlance to describe young single women who freely associate with men in the Western manner, quite contrary to kampung adat, which expects an informal segregation between unmarried members of both sexes. Factory women who are "social," and thus bebas (untied by convention), are believed to reverse noncapitalist values in other ways: they are said to be less hardworking, to be careless about their work, to seek self-gratification, and to not be restrained by parental guidance. One factory worker comments on the bebas women: "Our values and theirs are en-

tirely different . . . they want *bebas* values, do not want to be tied down. They do not want to be shackled so that they can go out and be *bebaslah*. . . . It would be better if their earnings are for their families, that way, they will not bring disaster to their families, do something that will bring them shame."

Kampung women who work in the nearby FTZ define their own self-images in opposition to the cultural alienation exhibited by urban-based workers. Informal social mechanisms such as moralistic platitudes, gossip, and the idealization of chastity (*kesuchian*) by kampung women regulate intrafactory interactions between male and female workers. "Dating," a Western practice in which a man selects out a woman to spend time with alone, seems to reflect unequal market relations and generates competition within the ranks of women workers. In cases of interethnic dating (where the male technicians/foreman are almost all non-Muslims), a "*krisis*" situation develops as co-workers intervene to protest this added violation of Islamic injunctions against liaison with non-Muslims. Incessant gossip, moral outrage, and sometimes physical violence usually put an end to such assaults on kampung ideals of sexual and ethnic solidarity.

Village women's censuring statements are fraught with the effort of upholding noncapitalist values of reciprocity, and yet are poisoned with secretly nurtured envy of the "free women." Women who use their earnings to satisfy newly acquired needs are said to be "so free that they have no thought for their families." "In following what their hearts desire" (i.e., extramarital sex), such women can only end up "damaging themselves" (i.e., pregnant and abandoned). Malay women who seek Western individualistic behavior and capitalist values are not only accused of having no regard for family interests, but also are charged with being 'not Malay' (*bukan Melayu*) and 'un-Islamic' (*bukan orang Islam*). As one kampung operator assures me, "Most of us do not want to be *bebas*; we are truly Malays who have been properly brought up by our parents."

Not surprisingly, positive attempts at self-construction of a new female identity depend on a cult of purity and self-sacrifice. The neophyte factory women identify with an intensified Islamic asceticism (advocated by dakwah members), which not only incor-

porates kampung emphasis on a daughter's loyalty and moral virtue, but also a new kind of sexual repression (not inherent in rural Malay society). Since the women's new self-esteem is based on their wage contributions as unmarried daughters, many postpone marriage to fulfill such familial expectations, thus prolonging their junior status to their parents and to male authority. In Sungai Jawa, the average age at first marriage for women increased from 19 to 21 years between 1976 and 1980, when many village women began working in the FTZ.

Postponement of marriage introduces new problems of controlling adult daughters and guarding their virtue. Malays acknowledge sexual drives and provide cultural means for their adequate satisfaction in daily life. Until recently, parents arranged early marriages for sons and daughters for the legitimate management of sexual needs (among other reasons) (see Banks 1983 : 88–90). When marriage is delayed for women, their sexuality becomes more susceptible to individual control; therefore greater social discipline is considered necessary to reduce this threat to male authority. Thus the self-esteem and self-images of rural factory women as honest workers and loyal daughters become inextricably tied to prolonged junior status, increased Islamic chastity, and the rejection of social emancipation promised by wage employment. This reinforcement of noncapitalist norms and rejection of Western values were produced out of the contradictory situation the workers found themselves in. An operator complains:

[Malaysian] society only knows how to criticize [us] but does not know the importance of our work in the factories. . . . What ought to be done is to establish religious classes . . . to give warning to factory workers, and then to set up rules . . . against the unrestrained interactions (*kebebasan*) of workers during work in the factories as well as outside. These rules should be directed at increasing "discipline." Most of us read the newspapers; we should explain our problems in the papers to the general public.

Nevertheless, the fusion of kampung communal norms and intensified Islamic discipline as the basis of their self-identity does not blind some village women to their rights as workers. One factory woman sees a definite connection between the unsavory public image of Malay women and their weak market situation:

The opportunities for employment in this country are still limited. In our country, we Malaysian women need greater security in our livelihood so that there will be no occasion to work . . . like prostitutes. . . . The jobs available [to women] are still very limited compared to the work available to men. Also currently very few women are employed so they tend to give priority to housework because employment with the government [greatly desired by women] is still restricted.

In their lived experiences, cultural evaluations, and difficult choices, factory women thus internalize the contradictions between communal values and customary male authority on the one hand, and claims for better employment conditions vis-à-vis men on the other. It is their claims for worker rights, I argue, that lead them to protest the male domination that is so systematically institutionalized in the factories.

Spirit Possession: Rites of Protest

To what extent can customary values, noncapitalist imagery, and new experiences of industrial work promote the beginnings of an articulated awareness of female subordination as members of a nascent working class? On the shop floor, factory women daily engage in covert boundary-setting rituals to limit management control. Operators complain continually that production targets are often intolerable; sometimes, they believe, the management forgets that "we too are human beings." In their resistance to being treated like things, mounting work pressure (*tekanan*), and harsh (*keras*) treatment by foremen, operators often deliberately cultivate an uncomprehending and unconcerned (*tidak apa*) attitude toward orders and the technical details of production. A common strategy is to make excuses to leave the shop floor by citing religious reasons and "female problems." Day-to-day struggle against management pressure takes the form of female resistance to male power. A residual space is contested and held for the preservation of human dignity, but the boundary-maintenance ritual does not articulate the problems of felt female oppression.

I wish here to discover, in the vocabulary and imagery of spirit possession, the unconscious beginnings of an idiom of protest against male control in the industrial situation. E. P. Thompson notes that an examination of the untypical ritual, especially of

female subordination, may yield as yet unspoken values (1977).
The phenomenon of hysteria outbursts, formerly associated with
middle-aged Malay women afflicted by latah (see Murphy 1972;
Kessler 1977),[18] has in the past decade become associated with
spirit-possession episodes among young Malay women who have
flocked by the thousands to urban institutions and industries. Re-
cent studies of the sudden spate of possession incidents reported
among young Malay women in boarding schools and factories in-
terpret the bizarre phenomenon as an "oblique strategy" (I. M.
Lewis's term) of protest against male authority in these modern
institutions without directly challenging official male control
(Ackerman 1979).

Possession episodes, which have plagued both foreign and local
factories with sizeable numbers of young Malay female workers,
produce epithets and spirit images that dramatically reveal the
contradictions between Malay and capitalist ways of apprehending
the human condition.[19] In late 1978, a major American electronics
firm in the Bayan Lepaz FTZ was disrupted for three consecutive
days by dozens of women participating in spirit-possession inci-
dents. The victims screamed in fury and put up a terrific struggle
against restraining male supervisors, shouting "Go away!" (Sun-
day Echo, Nov. 27, 1978). In 1980, a possession incident involving
21 women broke out in a Japanese factory in Pontian, Kelantan. As
they were being held down (to prevent the spirit seizure from
spreading to other workers), the victims threatened, "I will kill
you, let me go!" (The New Straits Times, Sept. 26, 1980). In the
Telok FTZ, spirit-possession incidents usually occur on a smaller
scale, but with some regularity. Some victims merely sob con-
tinually, others laugh in a demonic manner, while still others fero-
ciously abuse and fight male technicians attempting to carry them
off the factory floor. In one case the possessed victim screamed, "I
am not to be blamed, not I!" (Aku ta'salah, bukanku!). The targets
of the victims' abuse are always male staff members; female co-
workers, if not kept apart, are easily swept into a fury of uncon-
scious sympathy with their afflicted sisters.

Factory women are usually startled into possession episodes
by visions of frightful spirits that suddenly materialize in their
microscopes, or loom over their shoulders as they attend to their

business in the locker room or prayer room. Most of the spirits are described as having the form of an ancient man (sometimes headless), clothed in black, pressing down on or gesturing angrily at the women. On one level, this vision is a feverish projection of the awesome male authority figure, like the supervisor, as a local psychiatrist suggests (*Asiaweek*, Aug. 4, 1978). In other cases of hysteria incidents, the victims refer to an ancestral spirit (*dato*) whose wrath has been incurred because the factory operations have made "dirty" (*kotor*) his sacred abode (*kramat*) (*Sunday Echo*, Nov. 27, 1978).[20] In the American factory disrupted by spirit invasion, workers claimed that soiled sanitary pads[21] in the toilets polluted the sacred ground of the dato, who would not be appeased unless the management held a ritual feast (*kenduri*). Similarly, hysteria episodes in Telok have been interpreted by the women workers as the consequence of erecting the FTZ on the sacred burial grounds of aboriginal groups; disturbed earth and graveyard spirits swarm through the factory premises, threatening the women and demanding to be placated. One victim claims to have seen a weretiger, the familiar of ancestral spirits, roaming the factory floor. Another victim has the gruesome vision of a spirit sucking menstrual blood from a sanitary pad—a complex image of danger, loss of corporeal control, and profound social dislocation.[22] These nightmarish visions, and the screaming protests of possession victims, thus give vivid form to their male oppressors; they are also symbolic configuration of the violation, chaos, and barrenness encountered on the shop floor. The noncapitalist imagination thus speaks to the women's alienated experience of capitalist relations. We therefore have the weird juxtaposition of the gleaming, sanitized world of multinational firms with the performance of cleansing rites by hired bomoh who chant incantations, sprinkle holy water, and drench the factory grounds with the blood of chickens slaughtered in sacrifice to the unleashed, avenging spirits of a world torn asunder.

The threat of female fury, momentarily unveiled in spirit affliction episodes, is efficiently controlled; victims are given Valium and sent home on medical leave. In kampung households, however, male power to induce women to conform to their ideal of the subservient sister/daughter is being undermined as female wage

employment changes the content of customary brother-sister, parent-child relations. Female factory earnings, in a situation of under- or unemployment of Malay youths, have provided sisters/daughters with the relative economic autonomy to realign domestic power relations. As sons are kept longer in school (training for potential bureaucratic careers) or out of the labor market by poor opportunities, parents feel that they can rely less on their sons. One working daughter remarks: "The males often do not want to listen to their parents' advice, and so the parents do not have much hope in them. . . . Boys only know how to eat." As regards village male views of factory women, another operator notes, with irony:

Some of their talk is mocking, because in their view perhaps, our work here gives us too much freedom, as for instance, always going out at night, always "dating" with "boyfriend." . . . Ah, maybe they like [factory women]. They only talk, but they pick factory women too. . . . For instance, in my family, my brother himself has never talked badly about me [as a factory worker]. Now, he is marrying a woman who works at the factory too.

In the kampung then, factory women are more able to define their new self-image in the context of the family. Working daughters, often with the implicit backing of mothers and the expected but weak disapproval of fathers, demonstrate their resistance to male authority in their consumer behavior, use of savings for planning alternative careers, resistance to undesired marriage matches, more daring enjoyment of premarital sex, and refusal of money to parents who remarry. Nevertheless, the self-image of these neophyte factory women continues to uphold family loyalty, Islamic asceticism, and male authority as central values.

In maintaining the official view of male responsibility, kampung women manipulate their formal subordination to kinsmen by playing factory men (largely from outside the district) against kampung men. Male honor/prestige depends on men's ability to protect their sisters/kampung women against nonkinsmen/outside men, especially in the contemporary situation in which kampung men have the economic ground cut out from under their feet. Thus individual factory foremen who are overly zealous in

enforcing production targets or in harassing women workers are talked about in the workers' families. Gossip, complaints, and tears goad village men to undertake acts of retaliation against the black-listed culprits. In Telok, there have been at least three incidents of attacks by village youth gangs on factory personnel as they leave the FTZ gates in the evening. The victims include one Indian, one Chinese, and two Malays, none of whom is of local origin. Such incidents reveal that within the kampung matrix of enforcing rough justice and settling scores, especially where female honor is concerned, village men and women are forging a new kind of solidarity. Rural youths not only empathize with the women's harassment in the workplace, but also wish to register their vengeance against outside men who not only hold relatively well-paid jobs in the FTZ (from which most kampung men are disqualified), but are placed in daily situations of control and competition over nubile village women. This renewed form of kampung male protection of women workers, which compensates for the reduced sense of male honor, is purchased by their women's earnings, which help sustain the rural standard of living.

The values and choices that inform the gender consciousness of young Malay kampung women are thus interconnected with family strategy and dependence upon their wage earnings at this phase of their life cycle. This helps account for the actions of many village women who reject individual emancipation as wage workers in towns in favor of fulfilling family obligations by working in the local FTZ. In leaving kampung society, young Malay women may realize the social emancipatory promise of wage employment in the urban milieu, but at the expense of male protection and of preserving family relations in the deteriorating rural economy. To remain means that in meeting family needs, the women postpone self-gratification (marriage and retention of their own earnings) and prolong their formal subordination to parental and male authority. It remains in doubt whether female sustenance of rural relations would foster a new solidarity with men as members of the nascent proletarian class.

Women's self-evaluations and value choices have not been achieved without internal conflict, doubts, and distress. The commoditized image of urban factory women holds up to view the

negative consequences of extreme individuation, while their own possession episodes give vent to the pain and protest engendered by the dehumanizing effects of capitalist production. The gender consciousness of Malay factory women in rural Selangor has, I suggest, this fundamental, dynamic ambivalence: adherence to kampung communal values, asceticism, and male authority on the one hand, and different forms of incipient claims as wage workers and resistance to male control (in home and in factory) on the other. The subjectivities of these women are thus reconstituted in the local context of changing family strategy, customary norms, and social relations; they are both gender- and class-specific.

This analysis of the effects of industrialization on social relations in Malay society has focused on the cultural construction and reconstruction of gender as an aspect of divergent consciousness and interests associated with different social groups. I have argued that the key metaphor of Malay factory women as victims of consumer culture is a symbolic expression of the struggle for cultural hegemony by dominant groups in Malaysian society. Below but inseparable from this system of social control, Malay men and women in the local contexts of factories, peasant villages, and worker communities are engaged in their own struggles and reformulation of sexual symbolism.[23] Gender was taken as a potentially contradictory configuration of meaning that codes alternative structures of morality, control, and power. By redefining their self-identities and interests, neophyte factory women have begun to wrest control of their lives in opposition to the dominant forms of cultural production.

Reference Matter

Notes

Errington: Recasting Sex

I was fortunate to have as readers of various drafts and partial drafts a variety of people with well-formulated and quite often opposing views on sex and gender. They will be relieved that the usual dissociations apply—I am responsible for the piece, they are not—but all were careful, thoughtful, and very frank, and I was the beneficiary. Thanks to (arranged alphabetically, not by camps): Jane Collier, Evelyn Fox Keller, David Schneider, Bradd Shore, Judith Shapiro, Candace West, and Adrienne Zihlman. Jane Atkinson read several early drafts, and Anna Tsing read drafts and partial drafts up to the last moment; both have been extraordinarily helpful and generous with their time, knowledge, and sensible comments. I also much appreciate help from Lorraine Daston, Don Donham, Vera John-Steiner, and Kathleen Much. And many thanks to Liza and Michael Dalby, the most gracious hosts one could have.

1. Collections that do study women in Southeast Asia include Barbara Ward's (1963b) edited collection on women in both South and Southeast Asia, a truly vast area of the world with stunning cultural and governmental diversity; Esterik's (1982b) collection, which covers both mainland and island Southeast Asia; Manderson's (1983) volume on women and work in parts of island Southeast Asia; Chandler, Sullivan, and Branson's (1988) collection on women and development; and volume 13 (1977) of the journal *Archipel*.

2. The term "prestige system," a useful one, and its salience for gender studies, was suggested by Ortner and Whitehead (1981b).

3. Collier and Yanagisako (1987) are in the center of the debate about whether and to what extent the concept of gender should be dissociated from the concept of sex.

4. For a scathing short piece on empty universals, see Roland Barthes's "The Great Family of Man," in *Mythologies* (1972).

5. The bibliography on this topic is enormous, but a useful start, with an extensive list of references, can be made with Scheper-Hughes and Lock's "The Mindful Body" (1983).

6. Classic accounts of Javanese etiquette can be found in C. Geertz 1960 and Keeler 1987; see also Errington 1989:ch. 4.

7. In *The Death of Nature* (1980), for instance, Carolyn Merchant links women with the organic, with community, with nonhierarchy, and with the ecology movement, while implicitly or explicitly linking the mechanical, competition, hierarchy, and the exploitation of nature to men. Carolyn Gilligan (1982) suggests that women tend to speak ethically "in a different voice," favoring the context-specific, the concrete, the nurturant moral decision over the abstract, logical way of making ethical decisions allegedly more characteristic of men.

8. The logic of siblingship explicated in this paragraph is fairly general in the area of island Southeast Asia that I call the "Centrist Archipelago," where people tend to think they are related equally to their mothers and fathers and to their two parents' siblings of both sexes; hence they tend to classify all types of cousins, that is, the children of the people we call "aunts" and "uncles," together, and to view them as more distant siblings. The socially and symbolically dualistic societies of the "Exchange Archipelago," by contrast, tend to have a much more complex system of categorizing the people we call "cousins," differentiating between the children of one's father's same- and opposite-sex siblings, and one's mother's same- and opposite-sex siblings, for a total of four categories. Thus the logic of siblingship I outline here, while present in the Exchange Archipelago, is far more complex. See James Boon's paper (this volume) for more on this topic.

Atkinson: Wana Society

This paper is based on research conducted in Indonesia from July 1974 until December 1976 under the auspices of the Lembaga Ilmu Pengetahuan Indonesia with support from Gertrude Slaughter Award from Bryn Mawr College, and an NIGMS training grant through the Stanford Anthropology Department. For assistance with this paper I am very grateful to the participants and discussants at the SSRC conference. I also owe special thanks to Greg Acciaioli, Jane Collier, Shelly Errington, Susan Millar, Renato Rosaldo, and Anna Tsing, and an anonymous reader for Stanford University Press. Anna Tsing's editorial suggestions for the final version were well taken and much appreciated.

1. One might speculate that gender relations could have been more dichotomized before pacification because of men's involvement in warfare (cf. Valeri, this volume).

2. The practice of donning white was not being widely observed at the

time of my fieldwork. Whether this had anything to do with the cessation of vengeance killing, I do not know.

3. In this section, I treat production as though it involves only husbands and wives. Indeed it does not. The labor that goes into a swidden, or a house, or a hunting or fishing expedition is nearly always cooperative labor involving others besides the conjugal pair. But conceptually it is the conjugal couple that shares the responsibility and control over the productive process. Their joint endeavor involves carrying out complementary tasks phrased in gendered terms. In fact, adults of both sexes are familiar with both women's and men's work. Whether or not they perform such work depends on circumstance.

4. That men's access to coastal goods gives them a distinct economic advantage over women is acknowledged by Wana in the case of widows, who often lack an able-bodied man to carry their rice to market. Such women may be "cheated" by non-family members who take a cut of whatever the women's produce earns.

5. There was a marked change in Ilongot hunting between 1967–69 and 1974, brought about by settlers, depletion of game, and martial law.

6. Young boys are also enjoined not to smoke, lest their foreskins become too tough for the knife. I know of no parallel prohibition for girls.

7. One old crippled man told me that he's never been sorcerized because he does not travel to faraway places.

8. Perhaps there is an allusion here to women's childbearing. Coconut, like other foods, is supposed to be the transformation of a young child, and the pocket formed by the fold in a sarong is likened in other contexts to a womb (see above).

9. But instead of the eight/nine count of mortuary ritual, a boy baby is thought to gestate for nine months and a girl for ten.

10. As indicated in note 4, women's economic disadvantage in relation to coastal markets is clearly recognized. In a number of contexts I was told that young men were free to visit distant settlements because they could obtain the wealth needed to pay off legal fines they might incur by sleeping with married women. Young women, however, were advised to stay at home, lest they incur a fine they had no means to pay.

11. In fact, there are instances of legal experts being stymied as much by women's intransigence as by men's violence. For example, in a case of a man repeatedly siring children by his wife's sister, the legal authorities attempted at one point to marry the man to both women. The resistance of the first wife forced the elders to attempt another solution.

12. To take one example, interpreting bird omens is a male prerogative in Wana society. Women must never *topo oni*, that is, claim to know what

a particular bird call implies. If they do, the implied negative outcome will undoubtedly be realized. Omen birds are said to be the possessions of a great warrior named Palaauale. At his death, his headcloth, sheath, knife, betel bag, and other accoutrements turned into omen birds. Omens are important portents of danger, such as imminent raids and other threats to human life. The notion that women should not interpret omens implies that women should not assume leadership roles that presume the right to comment on such weighty matters, a right associated with men's adventures in distant realms.

13. In his book on the Native American berdache, Walter Williams (1986:79–80) criticizes Whitehead's use of the term "gender-crossing," which presumes two discrete and opposed gender categories with no intermediate options. As will be seen, Wana have the option of shifting along a continuum of maleness and femaleness. What evidence there is suggests that for men such shifts tend to be by degree, whereas for women the shifts may be more categorical.

14. The father of one man I knew was called bante solely, it would seem, because he wore his hair knotted like a woman's. There seemed to be no aspersion cast by this label.

Tsing: Meratus Dispute Settlement

This paper is based on research conducted in South Kalimantan between 1979 and 1981 under the sponsorship of the Lembaga Ilmu Pengetahuan Indonesia and Dr. Masri Singarimbun. The research was supported by grants from the National Institute of Mental Health, the Social Science Research Council, and the Center for Research on Women at Stanford University. I am grateful to Shelly Errington and the participants of the SSRC Conference on Gender in Insular Southeast Asia for their helpful comments on an earlier draft of this paper. Kathi George, Dennis McGilvray, Jeremy Narby, Renato Rosaldo, and Sylvia Yanagisako also offered much valuable advice. My particular thanks go to Jane Atkinson for the many conversations that made this paper possible.

1. MacCormack and Strathern (1981) and the first half of Ortner and Whitehead's *Sexual Meanings* (1981a) focus on the cultural logic of gender systems and illustrate recent scholarship on the cultural construction of gender. Tsing and Yanagisako (1983) also discuss the cultural analysis of gender systems.

2. A *neighborhood* in this area is a dispersed hamlet: a localized grouping of households that, to a greater or lesser extent, forms a maximal unit of sharing and cooperation, holds major festivals together, and respects a

local bureaucrat, the Neighborhood Head (*Pangerak* or *RT*). Neighborhood and personal names have been changed in the interest of privacy.

3. Koentjaraningrat (1975:ch. 5) reviews the study of adat law in Indonesia. For southern Kalimantan, Mallincrodt's work (1928) is seminal; adat has also figured prominently in the work of more recent authors, such as Hudson (1967) and Garang (1974). Van der Kroef's essay on "Dualism and Symbolic Antithesis in Indonesian Society" (1954) reviews some of the evidence for gender dualism in Indonesian thought; for southern Kalimantan, Scharer (1963) is the key source.

4. The Meratus are called "Bukit" by their Muslim neighbors. This term has precedence in some written records, but it is considered pejorative by Meratus. I created the ethnic label "Meratus" together with Bingan Sabda, a Meratus scholar, who, like myself, preferred a nonderogatory term. Most Meratus tend to use local place names or the wider term "Dayak" as labels of identity. "Dayak" refers to non-Muslim indigenous inhabitants of Borneo; Meratus are thus a Dayak subgroup.

5. *Umbun* are swidden-making groups. Most umbun are composed of a conjugal couple and their dependents, including children as well as single, disabled, and newly married adults. Even those umbun without a conjugal couple generally include a responsible male-female pair, such as a widow and her bachelor son or grandson. A number of umbun may form a household together, but rice stores are kept separately.

6. The major exception to the expectation of adat-based gender symmetry in marriage revolves around the inception of a marriage: men are expected to court women, more than the other way around; men are expected to provide a marriage payment for the kin of the bride; and men may initiate more than one marriage relationship simultaneously, while women generally do not. Courtship was sometimes regarded as counter to adat rather than a part of adat itself, since courting bachelors were often led to acts of which elders might not approve (e.g., premarital sex); marriage payments were sometimes explained as fines for courtship transgressions. Yet the gender symmetry of marriage adat is ambivalently contradicted by marriage beginnings.

7. Within this negotiation, there are, however, some common understandings about what kinds of statements make sense as adat. The negotiation of adat is discussed in greater depth in Tsing 1984, pt. 3.

8. I saw no evidence of a polished and indirect oratory like that reported for the Ilongot of Luzon (M. Rosaldo 1973) and the Wana of Sulawesi (Atkinson 1984).

9. I saw several public attacks in which it appeared that the attacker had no intention of hurting the other person, even though a weapon was

used; instead, it seemed, he or she merely hoped to draw attention to the struggle. Bystanders quickly restrained attackers, and I never saw anyone hurt in a public scuffle.

It would never occur to me to characterize Meratus social life as "violent," yet fights and threats hold a special place in Meratus political action because they lend themselves so nicely to the production of dramatic scenes. The importance of violence in social settings where property and the control of labor are not major coercive forces is discussed in Collier and Rosaldo (1981). They suggest that threats of violence may be a key feature of conflict even when the culture strikes us as "gentle."

10. As mentioned in note 6, men are expected to provide marriage payments, which are divided among the senior kin of the bride. Marriage payments during my fieldwork generally consisted of cash and plates bought at market. The payment almost always came from the marketing activities of the groom himself. If the relationship between the groom and his affines was good, most of the payment might be returned to the groom after the marriage ceremony.

11. *Kada ada untuk manyangga'i.*

12. My presence indeed helped Ma Salam build his authority. At one point during the settlement—much to my embarrassment—Ma Salam drew attention to my notetaking, threatening Ma Bakal: "Look at Anna; she's writing down everything. If you don't go along with this, she'll report you to the police." Despite the fact that everyone knew me as something other than a police agent, nothing I could have thought of to say at that moment could have erased my connections to power.

13. Sisters who enjoy each other's company, I was told, are less likely to raise issues of sexual exclusivity. Sororal polygyny is not uncommon.

14. *Puki didagangakan.* Women sometimes receive presents or money in sexual and romantic relations (including marriage), and Induan Busa was probably referring to this cultural expectation in her use of this phrase.

15. In 1981, Rp. 120,000 was a little less than US $200. Most cash in Rajang was obtained through selling rattan strips. A load of strips, gathered and prepared sporadically over a period from several weeks to several months, sold for Rp. 15,000–30,000. Men, who carried the strips to market, appropriated the cash from their sale. Women rarely had cash, and never in large quantities.

16. As Jane Atkinson pointed out in hearing of this incident, the woman's role in hiding the knives illustrates the importance of women's audience activity. Although not the focus of attention, audiences are not passive.

17. Collier and Rosaldo (1981) have argued for the importance of men's

wider ties (compared to women's) for their ability to claim to control so-
cial reproduction. In the cases they discuss, these wider ties are created in
distributing meat and arguing about rights over women. Their model
seems generally relevant to the Meratus, although hunting has little im-
portance in Meratus political discourse. Meratus men's marketing activi-
ties and ties to state officials take on some of the same significance in both
creating wider ties and creating a gender imbalance in the meaning of
marriages.

18. The theme of the power of "centers" has been much remarked
upon in studies of Indonesian cultures. Meratus also make use of motifs of
"centers" and "centering." First, they point to physically distant (pe-
ripheral?) "centers" of political and spiritual authority—Banjar market/
administrative towns in the plains surrounding the mountains, and moun-
tain peaks where the spirits have their "cities." Second, the work of
shamans and community leaders is often spoken of using idioms of gath-
ering and centering. Rather than referring to constant "centers," these idi-
oms refer to travelling and bringing together. Thus, a great shaman is
called a *panggalung*, a 'coiler' (*galung* = a woman's hair knot, a coil of
rattan); he 'ties' (*mambabat*) the community and 'corrals' (*bakurung*,
bakandang) its luck and livelihood.

Local leaders self-consciously juggle the connotations of these two
contexts of centering. But the *differences* between respect for stable, but
distant, centers of power, and local efforts to tie people together, remind
us of the importance of attention to political practice in investigating cul-
tural motifs.

19. The double meaning of "subject" here was suggested by Foucault's
use of the term in describing a rather different cultural history (1982).

20. A key moment in turning the feminist critic's agenda ("objectifica-
tion") in this anthropological direction ("gender contrasts") can be seen
in Sherry Ortner's article, "Is Female to Male as Nature Is to Culture?"
(1974). Ortner draws from Simone de Beauvoir's argument (1952) that wo-
men are objectified as closer to nature so that men may see themselves as
transcendent cultural subjects. But in Ortner's article the argument be-
comes a matter of images of men as well as women; Ortner sees men's
advantage in the kinds of symbolic associations for "male" rather than in
asymmetric assignments of cultural subjectivity (e.g., the male gaze). Dis-
cussion of Ortner's article has left the de Beauvoirian issues behind en-
tirely to focus on whether indeed every culture has the particular images
of male and female Ortner suggests (e.g., MacCormack and Strathern
1981). I would argue that the unself-consciousness of this transformation,
and of the new agenda in feminist anthropology to which it helped give

birth (looking for gender imagery contrasts), reflects an unfortunate lack of attention in feminist theory to the practices through which gender images become socially and politically relevant.

21. Two rather different gender studies illustrate my point. In her book *Images and Self-Images: Male and Female in Morocco*, Daisy Dwyer (1978) uses folk tales to explore Moroccan gender contrasts. Because she believes that folk tales tell us more about *langue* than about *parole*, she offers little information about particular uses of folk tales, why people enjoy them, how they interpret them in relation to their own behavior, and the like. This confuses her attempt to compare Moroccan gender imagery to that of "the West," for it is not clear what aspects of Western thought would be most comparable. How are we to think about differences between getting one's insights on gender from folk tales versus other kinds of sources?

In a book that, like my paper, focuses on the significance of performance (in this case, Sinhalese demon exorcism), Bruce Kapferer (1983) devotes a chapter to the question of why Sinhalese women are more given to possession than men. His answer posits that Sinhalese view women as mediators between nature and culture, and that this is the most vulnerable position for demon attack. In pointing to cultural imagery of gender contrast, he loses sight of the fact that demon possession involves activity as well as interpretation; at least in the cases he describes, women actively promoted their diagnosis as possessed. Women who dramatize their possession are surely negotiating cultural standards rather than passively letting standards inscribe their actions. As Kapferer himself demonstrates nicely in regard to other aspects of possession ceremony, performance is not reduceable to a flattened "text."

Keeler: Gender in Java

This article is based on research conducted during three periods of fieldwork in Java, in 1971–74, 1978–79, and 1983, all made possible by the Indonesian Institute of Sciences. I received support for my research in the form of dissertation grants from the Office of Education (Fulbright-Hays) and the National Institute of Mental Health, and a postdoctoral grant from the Anthropology Section of the National Science Foundation. I am grateful to Leslie Morris and Elizabeth Traube for comments on earlier drafts of this essay.

1. As a single male, my research brought me into contact with more male than female informants, introducing inevitable biases into my data. Nevertheless, female members of the families with whom I lived, and of a

few neighboring families, and the wives of some of the puppet masters I visited in the course of my fieldwork, often spoke fairly freely with me. As a result, while my remarks reflect some degree of androcentric emphasis in my impressions, I don't think I have an exclusively androcentric vision of Javanese society.

2. Meanwhile, Jarno asked that his parents ship him a considerable amount of cloth so he could sell it in Kalimantan, presumably for his pupils to make school uniforms from. Such trafficking in items required at school, while generally thought undignified and even corrupt, is a widespread way in which teachers try to augment their often meagre incomes. But Bu Cerma, who exercised primary authority in such money matters, was not inclined to agree to Jarno's financial demands. She reported that at one point Jarno had written home to ask for money to buy a motorbike, claiming that he lived a very long way from the school where he taught. Unfortunately for him, though, while the Cermas were thinking the matter over, a person from their area who had also gone to Kalimantan happened to come to Karanganom and mentioned that Jarno lived just a few yards from school. So Jarno got neither a motorbike nor cloth.

3. Bu Cerma often waxed highly indignant at an incident that had taken place fourteen years before my fieldwork. In 1966, her husband was imprisoned for political reasons, and it was all she could do to make ends meet without selling off the family's rice lands. One day a local scout troop leader met her in front of the Cermas' house and asked rudely about her husband. That was of course upsetting. But to make things worse, a neighbor of much lower status, a poor farmer, happened to be passing by, and he stopped to watch. That he did so, and that he didn't even squat respectfully but rather "stood there insolently," as Bu Cerma put it, still rankled in her memory.

4. For further discussion of this point, see Keeler 1987.

5. For further discussion of these forms, see Soepomo Poedjosoedarmo 1968.

6. Lest I appear to suggest that Javanese are tolerant about people's sexual preferences, I should add that it is unlikely that Si Min was able to satisfy any homosexual desires he might have had. I doubt that any homosexual activity, if discovered, would be tolerated in a Javanese village.

Kuipers: Weyéwa Ritual Speech Use

The research on which this paper was based was carried out with the permission and support of the Biro Penelitian, Universitas Nusa Cendana, Kupang, Timor, and the Indonesian Institute of Sciences (LIPI). Financial support came from the Yale University Concilium on International and Area Studies, the Social Science Research Council, Sigma Xi, and the Na-

tional Endowment for the Humanities. This assistance is hereby grate-
fully acknowledged. I would also like to thank Jane Atkinson, Judith Ir-
vine, Teresa A. Murphy, and anonymous reviewers for helpful comments
and suggestions.

1. This figure comes from the 1984 census conducted by the Badan
Pusat Statistik, Cabang Perwakilan Waikabubak (Central Statistics Agency,
Waikabubak Branch).

2. This information comes from the Indonesian Bureau of Statistics
Report for the Province of Nusa Tenggara Timur in 1980.

3. In a previous version of this paper (Kuipers 1986), I referred to these
same women's genres as *matekula*. On subsequent visits to the island I
learned that there are dialect differences in Weyéwa region with respect to
the use of this term, and that the label *nggéloka* is more widespread for
this category of women's lament.

4. This does not imply that women *never* use the narrative form. They
certainly do, and some women are well-known raconteurs. However, they
tend not to employ a narrative idiom in ritual responses to misfortune.

5. A number of writers on societies in Eastern Indonesia describe a "di-
archy" in which silent, passive, and stationary political attributes are as-
sociated with females and "authority," while active, mobile, and verbal
attributes are associated with males and "power" (Cunningham 1965;
Francillon 1980:261). What this apparent reversal in the Weyéwa case sug-
gests to me is that (1) gender is an extremely flexible opposition, which is
invoked in many contexts, and that (2) since "power" and "authority" are
Western concepts, we must be careful to define them in each case. In some
circumstances, women behave toward others in ways that correspond to
our concepts of "authority"; in other contexts, they behave in "powerful"
ways. This is not a problem as long as the meanings of the terms are de-
fined clearly in each case.

Hatley: Imagery and Ideology in Java

1. In relation to wayang kulit, see, for example, C. Geertz (1960) for
discussion of Javanese understandings of the psychological meanings of
wayang, Anderson (1972:39–40) for examples of political imagery, and
Keeler (1982, 1987) for an analysis of wayang performances in terms of
their expression of deep-seated Javanese notions of relationship between
self and other, self and world.

2. James Peacock's study (1968) of the east Javanese popular theater
form *ludrug* argues that ludrug has a transforming, modernizing social
impact.

3. The term *priyayi*, said to derive from the expression *para yayi* 'younger brother (of the king),' referred traditionally to members of the Javanese aristocracy and to commoners appointed to positions of high administrative office. Today the social prestige of the priyayi elite is inherited by government officials, professionals, and holders of other "white collar" positions. The priyayi have long shared with the bulk of the peasantry of Java, sometimes termed *abangan*, a syncretic culture consisting of a blend of indigenous, Indic, and Islamic elements. Art forms, including theatrical performances, constitute an important medium of expression of this culture. The connections between theater and ideology discussed in this paper are relevant to the priyayi-abangan majority social group. Among adherents of the third, orthodox Islamic cultural stream in Javanese society, on the other hand, theater plays no such social role. Very few committed Muslims attend performances of the theater forms to be described. Such factors help explain the absence of reference in the discussion to identifiable Islamic values.

4. In classical literature and theater, for example, and in the ritual of the traditional Javanese wedding ceremony.

5. Divorce is seen to be relatively easy for village and kampung women because of their economic independence and the general acceptance of divorce in their social group. At higher social levels it causes more difficulty, because of the social stigma incurred and the greater dependence of elite women on their husbands, and is therefore less common. For the general population the divorce rate is very high—around 50 percent. This is the figure quoted by both H. Geertz (1961:69) and Manning and Singarimbun (1974:73).

6. Keeler (1983) describes the workings of Javanese perceptions of analogy between the biological sphere and other areas of life as they affect house structure and language patterns, as well as agriculture and domestic interaction.

7. The negative connotations of female concern with money are graphically illustrated in an account by the Indonesian anthropologist Raharjo, given in a lecture in Melbourne in 1983, of the social teachings of an East Javanese mystic, mbah Wali. In mbah Wali's view of Indonesian history, the Dutch colonialists, in their grasping greed and obsession with money, are said to have embodied *jiwa wadon*, 'the spirit of women.' Indonesian patriots, on the other hand, in their bravery and strength, exemplify the male spirit, *jiwa lanang*.

8. The "shift" referred to here occurred with the crushing of socialist forces and the deposition of President Sukarno in the mid-sixties, and the installation of the present military regime.

9. This list of roles is quoted from N. Sullivan (1983:148).

10. Film audiences consist largely of urban, middle-class people, especially young people. This is the main social group being exposed to the movie image of women described here. Television, which reaches a much wider cross-section of the population, displays both images of "modern woman" and more conservative female roles. The imagery of popular theater such as *ludrug* and *kethoprak*, meanwhile, is influential among the lower-class people who constitute the social base for these forms.

11. Solidarity of social groupings and direct openness of communication are well-recognized characteristics of interaction among peasant women cross-culturally. See, for example, the references to communities of peasant women in Europe, the Middle East, and Taiwan in Rogers 1975. Rogers argues that their strong social networks and positions of informal control within the household constitute social power for these women—the supposed "dominance" of their men is merely a convenient myth. I do not support Rogers's argument here—the example of Javanese village women suggests that control without formal authority does *not* constitute power.

12. Male scholars report women's tolerant acceptance of their husbands' dalliances. (See, for example, Jay 1969:94 and Keeler 1982:94.) Hildred Geertz, while to a certain degree endorsing this viewpoint, also provides vivid illustrations of wifely jealousy (H. Geertz 1961:128–33). My own experience suggests that anxiety over their husbands' potential infidelity causes great concern to many Javanese women. Could this discrepancy between the perceptions of male and female observers perhaps reflect the greater reliance of the former on the accounts of male informants, passing on the "official line" about their wives' attitude? And the probability that village women are reluctant to speak frankly, revealing problematic attitudes, to an esteemed foreign male?

13. Jay (1969:91) reports that a number of his young informants spoke enthusiastically about marriage as a close, companionable relationship between a man and a woman. This expectation seemed to grow out of indigenous Javanese ideas about marriage, shaped presumably by the ideal gender stereotypes mentioned earlier, and strengthened by Western images of romantic love.

14. There are, of course, exceptions to this stereotype. In particular, Srikandhi, second wife to Arjuna in stories based on the Mahabharata epic, who is independent and skilled at fighting, is often quoted as an alternate model of female character to the gentle submissive one. But Srikandhi seems to represent instead a counterpoint to the standard ideal, as embodied by the vast majority of theatrical heroines. Pausacker (1988) has made an interesting study of the way the *written* wayang texts charac-

terize Srikandhi and Sumbadra, Arjuna's first wife, who is understood to epitomize feminine gentleness and refinement. Pausacker finds greater complexity and commonality between the two figures than this standard understanding would allow. But in my own experience, in wayang as *performed* by men for men, stereotypical depiction of female character and idealization of the passive, submissive woman prevail.

15. There is a well-established tradition in Indonesian theater of cross-sexual performance—men taking the parts of women or, on occasion, in court dance and dance drama, women playing male roles. Actors give the explanation that this practice was followed in accordance with moral attitudes of the time—the perceived impropriety of men and women appearing together on stage. Before long, however, perhaps in part through the influence of European cultural models, forms such as kethoprak incorporated women players along with men. Ludrug's maintenance, by contrast, of all-male casts seems to have had little to do with moral propriety. Instead, there is much illicit sexual allure in the performance by men of women's roles. The raunchy, broadly comic style of ludrug, expressive of the rough-and-ready male culture of the port city of Surabaya where it developed, is probably less than conducive to participation by women. Actors frankly admit that the absence of women is one of the appeals of troupe life, although very occasionally, in performances by consciously "modern" troupes, women may take part. Ludrug's explicit suggestion of hostility to women probably reflects the opportunity under such conditions, in this admittedly *kasar* ('rough, uncouth') theater form, for direct expression of male sentiment, rather than the existence in its performing area of special gender tensions.

16. Such suggestion is clear, for example, in the text of the *Serat Damar Wulan* commissioned and published by Hinloopen-Labberton (1905:9).

17. Argument over Damar Wulan's lowly social rank may seem out-of-place, since the young man is in fact a close relative of Anjasmara, her own cousin, cast only temporarily in the role of stable boy. The anomaly perhaps arises as this legend of ancient Java is reproduced on stage through a process of highlighting connections with contemporary social experience. In present-day Indonesia, differences of social status, especially as they affect marriage, have an immediacy that encourages presentation of this incident from the *Damar Wulan* lakon as an occasion for comment on status discrimination. The legacy of democratic and populist ideology promoted in the 1950's and 1960's, and the ongoing popularity of the ideal of love-based marriage, unaffected by considerations of status, clearly shape the way the issue is handled.

18. Romantic attraction between the sexes is by no means unknown in

Javanese cultural tradition. In literary works and theatrical performances, royal princes and princesses, lovers predestined for one another by the gods, on first meeting fall immediately and abidingly in love. The rarefied perfection of these matches, however, places them beyond the ken of ordinary folk: no links are drawn with contemporary social practice, nor are expectations aroused that such love should form the basis for the general institution of marriage.

19. Ward Keeler (1982:93) explicates this attitude concerning sexual passion. Against such a background, the term *tresna* as used in kethoprak performance may assume a discomfiting ambiguity. For tresna is generally understood as an affection without passion, characteristic of parents and children as well as spouses. In kethoprak, however, in the context of a titillating love scene, a rather different suggestion is conveyed.

20. In their study of Javanese village marriage, Manning and Singarimbun report that arranged matches predominate at all social levels, and are especially frequent among people with little schooling (Manning and Singarimbun 1974:68–70).

Boon: Balinese Twins

I thank Jane Atkinson, Shelly Errington, David Schneider, and other participants in the SSRC conference that yielded this volume for helpful comments. Parts of this study appeared in rough form in an earlier paper called "The Other-Woman" presented in 1982 at the Wenner-Gren Conference on "Feminism and Kinship Theory." That study has been revised in Boon forthcoming (chs. 5–7); there I expand comparisons here confined to Indonesian cases plus suggestions about Indo-European constructions that have been in historical contact with Indonesia. I wish to dedicate these pages—especially their refusal to assume genealogy to be the constant foundation of kinship and marriage—to David Schneider, an incomparable teacher. His insistence on the cultural constitution of various systems of social solidarity and difference, including unbounded units and open-ended transformations, has motivated much of my research on Balinese kinship and marriage. See particularly Schneider [1968] 1980, 1976, 1984.

1. For a parallel study of South Asia that contrasts North and South Indian images of brides, wedding observations, and marriage practices, see Kolenda 1984. For further sources and a demonstration of what we lose when alliance theory is mistakenly assumed to treat women as commodities rather than spouses as socially embedded "gifts" in Mauss's sense, see Boon forthcoming (chs. 5–6).

2. On the social and hierarchical value of Balinese spouses enhanced by make-up—particularly costumed brides on the verge of wifehood and

outfitted corpses on the verge of ancestressness—see Boon forthcoming.

3. Lévi-Strauss's formulation abandons, or nearly, his earlier models, more social organizational in character, that assumed societies are ideally bounded and, directly or indirectly, cohesive (Boon and Schneider 1974). Following Schneider, I question classifications of kinship and marriage that assume social coherence to be what they are "all about" and make Balinese houses, among others, appear anomalous. Thus, I employ the *maisons* notion not to produce another reified category of societal type but to question typologies that let houses "slip through" or go unnoticed. The term *maisons*, moreover, does not simply reintroduce the distinction between kin-based and contract-based societies and polities. Rather, houses muddle conventional analytic distinctions of clan, lineage, guild, *warna, jati,* party, etc. Nor do criteria of birth versus voluntarism get us very far into the meanings, hierarchies, exchanges, and various options of houses. Paramount is the fact that "house" can relate to "house," even across presumed boundaries of society, nation, or other construction. One might, then, want to think of "houses" and any construction of boundable "society" in some kind of dialectical tension, neither actualizable. This possibility is developed below.

For another case that contests the isolability of cross-cousin systems, see Carter's summary of evidence from Maharashtrian Brahmans who "do not distinguish parallel cousins from cross cousins. . . . What is involved are not rules enjoining or forbidding cross-cousin marriage, but a series of considerations revolving around ritual status. Wife-givers are inferior in ritual status to wife-takers, and younger persons are inferior to their elders" (1984:93–94).

4. Compare Traube (1980b) on the categorical femininity of the Mambai (Timor) house. Similarly, the entrenched Balinese house (ritually Siwaic) contrasts to more active "masculine" (Wisnuvaic) challengers moving in and up from the peripheries (Boon 1977:203–5).

On aspects of *maison*-like attributes fundamental to Balinese statecraft, see C. Geertz (1980). Another advantage of "house societies" as a guiding category of comparative interpretation is its avoidance of rigid distinctions between court and commoner, accentuating instead many dimensions of rank, economy, historical narrative, ritual performance, etc. This advantage helps explain the notion's appeal in recent historical work on medieval and early modern Europe (see Boon forthcoming: ch. 6); and it should facilitate cross-*cultural* analyses of Bali, Java, Bugis, Dyak, Battak, Toraja, and so forth, thus advancing H. Geertz's (1963) seminal article on comparative Indonesian social structures (see Errington's introduction to this volume).

5. Some more practical aspects of houses, marriages, and weddings are discussed in Boon 1977 (chs. 4–8), with information about high-titled com-

moner houses engaged in social mobility (e.g., Pasek). Options of dowering daughters, meticulous adjustments of titles of spouses and offspring ("immaterial wealth"), and strategies of prearranged alliances remain important today; colonial Dutch scholarship on these dimensions was summarized in Korn 1932. C. Geertz (1980) outlines the marriage alliance system (*wargi*) from the court's vantage. H. and C. Geertz (1975) review dowry negotiations when "gentry" houses are tied to noble ones. For additional details and interesting case studies, see Hobart 1980; Gerdin 1982; Guermonprez 1984; and recent studies being edited by H. Geertz (n.d.).

6. For an analysis employing a notion of "valence" rather than "social relation" that refines Lévi-Strauss's approach to marriage structures, see Héritier 1979. I thank Stephen Headley for suggestions on this point.

7. I have deleted a more general survey of twinship values included in my original conference paper. I hope the discussion of incest images that remains conveys the importance of seeing the woman not just as wife to her husband but as sister to her brother; indeed, the sister-spouse constitutes both but accentuates her tie brotherward. Much more is made of the relation between twins and incest in Boon 1977, 1983, and forthcoming. I am less inclined than Errington (see Introduction) to see incest (even of twins) as symbols of unity or of reunification of opposites (in the early Romantic tradition). Rather, something inherently contradictory trails through narrative and ritual constructions characterized by this device; and I follow L. Dumont and A. M. Hocart in stressing what is countercentrist in hierarchical rites and images: hierarchies cannot add up to a singular stratification or a taxonomy of ranks. My work in progress continues to scrutinize the relation of incest (and twins) to signs of the most extreme social and political difference—irreconcilable, although transposable, difference. See Boon 1986.

8. For more on some of the themes touched on in this paragraph, see Boon 1977:136–41, 199–204, 234–39; 1983:esp. ch. 6; 1985; and forthcoming.

9. Themes of fertility, plus renunciation and eclipses between exchange and hierarchy in realms of religion and discourse, are treated more fully in Boon 1983 (part 3). Upon mention of exchange, I might note that the tripartite conclusions to this paper (see below) allude to the same device in M. Mauss's *The Gift* ([1925] 1967). Only now Mauss's three varieties of conclusion can be folded back over the work of Lévi-Strauss that succeeded his and was inspired by it; see also Boon 1989, 1986.

Valeri: Taboos in Huaulu (Seram)

The present paper is based on the data collected during my first fieldwork in 1971–73, although corrections and additions have been moti-

vated by subsequent research in 1985, 1986, and 1988. Thirty-six months in all were spent in the field. Research and/or writing time was financed by the Wenner-Gren Foundation (twice), the Social Science Research Council, the Institute for Intercultural Studies, the Lichtstern Fund of the Department of Anthropology of the University of Chicago, the Guggenheim Fellowships Program, the Dutch Department of Education, and the Centre National de la Recherche Scientifique (Paris). Fieldwork in 1971–73 was conducted in cooperation with Renée Valeri, who was funded by the Association franco-suédoise pour la recherche. My research in Seram was sponsored by the Universitas Pattimura of Ambon and by L.I.P.I. in Jakarta.

In its successive forms, the paper was given at the SSRC Conference on Gender in Insular Southeast Asia (Princeton 1983), at the seminar of the Department of Anthropology, Research School of Pacific Studies, A.N.U. (Canberra 1985), and at the anthropology seminar of New York University (1986). I wish to thank the organizers and participants of these scholarly meetings, particularly Jane Atkinson, Shelly Errington, James Fox, and Annette Weiner. I am also indebted to Carol Delaney, Marianne Gullestad, Patsy Spyer, and Margaret Wiener, who commented on the first draft of the paper, and to Janet Hoskins, who was the critic of successive versions. Finally, I must say that I owe a great debt to Renée Valeri for her contribution to my ethnographic research in 1971–73 and for her own paper on Huaulu gender (R. Valeri 1977).

1. The reader is cautioned against confusing the Huaulu people of Northern Seram with the Nuaulu people of Southern Seram, studied by Roy Ellen of the University of Kent. Although they consider each other to be "brothers," Huaulu and Nuaulu speak very different languages and have notable cultural differences.

2. A similar belief exists among the Enga of the New Guinea Highlands (Meggit 1964:208).

3. This implies suppressing ambiguities and overlappings between terms and thus making their contrasts more clear-cut (cf. Leach 1976).

4. "Le tabou, de façon générale, sépare le même d'avec le même" (Testart 1985:401; cf. 355, 364–65, 423). Héritier's position is in principle more nuanced than Testart's, since she admits that the "cumul de l'identique" (1979:233) may be desirable, rather than polluting, under certain conditions.

5. Thus it is not necessary to separate menstruating women from one another, a fact that cannot be explained in terms of Testart's theory that taboo avoids the accumulation of similarity.

6. The Hua of New Guinea have a similar view that woman "suffers from a disturbing and unattractive moistness and smelliness of her body" (Meigs 1984:27).

7. On the sexual division of labor in Huaulu, see R. Valeri 1977.

8. This word obviously derives, via the Indonesian language, from the Arabic *sunat*, but in contrast to it, it refers to incision, not to circumcision (cf. Riedel 1886:139).

9. This affirmation through a negation that takes the form of a fictitious representation of what is negated is a common procedure in ritual (cf. Valeri forthcoming).

10. The idea that menstruation indexes the paradoxical relation of life and death is often found in the ethnographic literature. See, for instance, Buchbinder and Rappaport 1975:26; Meigs 1978:314; Ahern 1975:198.

11. A similar contrast is found among the Paiela of New Guinea (Biersack 1987).

12. At the time of the story this village was still located on Seram's south coast. Later it was moved to the north, in the Huaulu domain. I do not discuss the evident political implications of this myth.

13. In this respect Huaulu is far from providing unambiguous confirmation for Strathern's (1980) mechanical linkage of the contrast nature/culture with ideas of domination, mastery, and colonizing. Strathern seems to think that this linkage is inevitable, which for her is an argument for asserting the fundamentally modern Western character of the nature/culture opposition. Even in the West, however, the linkage is far from being axiomatic. As Keith Thomas's (1983) recent study demonstrates, the ideal of total domination and exploitation of nature by culture is more early modern than modern proper. Modern thought from the seventeenth to eighteenth centuries onward, by radically separating nature and culture, undermined the ideal more than it gave a new basis to it, contrary to what Strathern and some of her associates imply (MacCormack and Strathern 1980). In effect, the scientific notion of nature as an order radically distinct from the cultural order justifies the belief that nature should not be subordinated to human ends at least as much as it justifies the opposite belief that nature is a mere object of appropriation for man. If anthropologists really wish to compare the West and the Rest they should learn something more about the West, and especially about ideological ambiguity.

Hoskins: Kodi Gender Categories

1. The term *hamaghu* is a cognate of the Indonesian *semangat*, and related to the Malay *sumangat*, discussed by Skeat ([1900] 1965), Wilkinson (1906), Endicott (1970), and others. In a recent examination of the related Bugis concept of *sumange'*, Errington notes that in Luwu, *sumange'* is attached to the torso at the navel, in sharp contrast to its location in Kodi at the front of the head (Errington 1983:559). I cannot help speculat-

ing whether the point of attachment in Luwu is linked to the "rhetoric of centers" favored in former Indic states, while the Kodi treatment of the same vital energy is worked out in terms of a "rhetoric of polarities" and dual oppositions more familiar to the societies of the eastern archipelago.

2. Although the double names of deities are related to the more general use of couplets in ritual language, gender in the spirit world is not merely a function of ritual parallelism. All spirits discussed in this paper are addressed in the formal style of paired images (the prescribed form for prayers to spirits inside the clan villages), but only a few have full double names. Souls of rice, corn, and wealth objects are not as thoroughly personified as the higher deities, and lack the power represented by the combination of male and female characteristics. Spirit hierarchies are stratified not only by gender combination, division, and ambiguity, but also by rules of address and mediation discussed in Hoskins (1988a, 1988c).

3. The ritually specific bisexuality of the Rato Nale stems from both his adoption of female attitudes of mourning and confinement (the *kabukutongo* 'brooding') and his impersonation of Mbiri Kyoni, the rice goddess who is sacrificed to create food. Male holders of this office may lead normal family lives during the rest of the year, but are forced to adopt female behavior patterns and observe a kind of celibacy during the month preceding the arrival of the sea worms. When the office was held by a woman, informants told me that she was also ritually bisexual for this period, because she "sat in a man's place" and ordered the clan elders to observe calendrical restrictions. They told me that only an older woman, past reproductive age, could assume the office, because the prohibitions could "burn the womb" of a younger woman and damage her fertility.

4. It is possible that the basis of Kodi diarchy and hence the weighting of gender symbolism has shifted and been reinterpreted by historical transformations (Hoskins 1987b, 1987c, 1988b, 1989b). The opposition of a conceptually female mode of passive control versus the active, virile display of male power is clear in couplets describing the ancestral mandate, but the association with the temporal power of the government versus the spiritual authority of religion is probably more recent. These reinterpretations are often politically charged: opponents of the Sea Worm House stress the passivity of the female term as a sign of political inferiority, while its descendants use the fact that the "mother priest" is the elder to argue for spiritual superiority and ultimate authority.

Debates about the modern meanings of these diarchic differences have tended to favor active, male government administrators over the ritually important, and symbolically female, priests, so that some female ritual houses no longer perform their calendrical duties. The emergence of a

more clearly defined "public sphere" from which women are largely excluded shifts the emphasis from traditional notions of complementarity and balance toward a more one-sided domination by male-identified government forces.

5. The definition of double descent has been the object of much dispute in anthropological writing, which I do not care to rehearse here. Suffice it to say that Kodi *walla* are named, exogamous descent groups that have no corporate functions and recruit their members by birth alone. As such, they would not fit the narrow definition of double descent proposed by Goody (1961), but they do correspond to his more minimal definition of unilineal descent groups, and are clearly distinguished from Fortes's notion of filiation. My usage of the term is consistent with that favored by Leach (1961a) and Keesing (1975), and serves to identify a social formation with some analogues in other areas.

6. Since parona affiliation is dependent upon the completion of marriage payments and ritual incorporation into an ancestral cult, some commentators have also questioned the status of the parona as a descent group. The parona is clearly defined as a category whose members trace descent from named apical ancestors, and cases of matrilateral affiliation or adoption are both rare and socially stigmatized. The manipulable nature of patriclan ties stems from their heavy involvement in the politics of exchange, and introduces the legal fictions common to most corporate groups. Whereas "descent" is always a social construct that must be defined within each cultural context, Kodi ideologies of descent are clearly formulated in relation to ancestors and the cult of their descendants. In spite of the importance of marriage relations in determining rank and social prestige, affinity cannot substitute for descent, nor descent for affinity. The complex bundle of names, titles, heirloom objects, and ritual prerogatives that are held by Kodi houses may qualify them to be described as in some ways similar to Lévi-Strauss's type of "house societies" (1983a: 187)—but the house itself is formed around a patrilineage (the *mori uma* or 'masters of the house') that is further united in a patriclan (made up of all the patrilineages in an ancestral village, or parona). Kodi "houses" do not stand independently, but are suspended within a complex political hierarchy defined by descent, segmentary opposition, and territoriality.

7. Kodi ambivalence toward female powers and the matriclan is certainly related to the preservation of patriclan cult solidarity and the presence of in-marrying women, but it cannot be reduced to social tensions concerning group membership. Men as well as women are members of matriclans, and men who share a common walla are often suspected of plotting together to subvert patriclan unity. Kodi feasting and ceremonial life is torn by rivalries (Hoskins 1985, 1986), which may be explained as resi-

dues of walla blood that "refuses to flow along," or is incompletely incorporated into the ancestral village. But such suspicions do not necessarily affect women more than men, since both are believed to harbor a passive, inalienable substance that is recalcitrant to wider social forces. Boys' lifecycle rites appear more elaborate than girls' because of the greater importance of consolidating clan ties among men, but the tension exists for all persons. Kodi women may, however, regret the transfer from their clan of birth to that of their husband at marriage, and their sense of loss at this detachment from their natal home is expressed in mourning dirges, discussed in Hoskins 1987a. Female involvement in textile production, and particularly indigo dyeing, is also a form of "female initiation" that establishes an identification with the cloth that circulates in traditional exchange prestations (Hoskins 1988d, 1989a, 1989b).

Rodgers: Women in Batak Culture

1. See Rodgers 1978 for basic ethnographic information on this Batak society. I have chosen to call the society "Angkola Batak" here, although some Western accounts term the area around Sipirok the "Sipirok Batak" region. Sipirok people themselves are divided on the issue, with some calling themselves Sipirok Batak, some using the phrase Angkola Batak, and some omitting reference to Batak identity altogether. Siagian 1966 provides excellent bibliographical material on the different Batak cultures. Vergouwen [1933] 1964 is a classic work on Toba; Singarimbun 1975 discusses Karo culture; Kipp and Kipp 1983 and Charle 1987 are anthologies of recent anthropological articles on several Batak cultures; Richard Kipp 1983 discusses Karo ethnic identity. Rodgers 1978 includes ethnographic data on clan descent and ethnicity. Siregar 1977 is a brief dictionary of Angkola Batak, whereas Eggink 1936 is a Dutch-Angkola/Mandailing dictionary. The word list in Nasution 1957 is an excellent source of *adat* phrases, with definitions in Angkola.

2. See Bruner 1973a and 1973b for discussions of Toba Batak urbanization; Harahap 1987 includes a discussion of Angkola migrant communities in cities.

3. See also Peacock 1968 for another discussion of the ways in which Javanese popular drama on family conflict themes is used to publicly "talk about" the tensions of rapid Indonesian modernization and national consolidation. Rodgers 1986 deals with the use of commercially produced cassette-tape "soap operas" in similar ways in southern Batak cultures.

4. See Ortner and Whitehead 1981a for a helpful discussion of various anthropological approaches to conceptualizing the relationship between folk models and social institutional relationships involving gender. My

perspective here relies on Clifford Geertz's insight (1973a) that Indonesian societies create symbolic forms such as drama, games, and rituals that they use as devices to "think through" and comment upon local social structure. In this view, ritual and aesthetic forms are not some sort of Durkheimian "reflection" of the social institutional level but are critically important folk commentaries on it. Thought about women and femininity seems to serve Angkola Batak in much this way.

5. Indonesian cultures that have asymmetrical marriage alliance include: in Sumatra, the Batak cultures; in Eastern Indonesia, numerous peoples in Flores, Sumba, Timor, Seram, Tanimbar, and many of the smaller islands of Nusa Tenggara Timor and Maluku. See Forth 1981; Adams 1969; Schulte-Nordholt 1971; Onvlee 1980; Forman 1980; Barnes 1974; and MacKinnon 1983 for detailed ethnographies of several of these groups.

6. There is an extensive anthropological literature on the symbolic position of woven textiles in Indonesian cultures with asymmetrical marriage alliance (Gittinger 1979, 1980; Adams 1969, 1980; MacKinnon 1983 includes an excellent discussion of gender ideas in relation to weaving and metalworking in a Tanimbar culture).

7. This passage is excerpted from a dictated story-poem by Ompu Raja Doli Siregar, 1975. See Rodgers Siregar 1981c: 143–45 for more courtship speech of this sort.

8. This passage and the two following were taken from standardized speeches. The first one is from a taped *osong-osong* session arranged for my research on February 13, 1975. *Osong-osong* is a verbal duel between anakboru and mora.

9. The Angkola phrases for this go as follows: *Anakboru na gogo man-jujung, na juljul tu jolo, na torjak tu pudi, tungkot di na landit, sulu-sulu di na golap, stitambai na hurang, sikorus na lobi, piri-piri manyaon-ging, dapdap so dahopon, goruk-goruk hapinis, bungkulan tonga-tonga.* There are more of these praise words, and another large range of eulogistic phrases for wife-givers.

10. See Forman 1980 for useful comparative information from a Timorese culture, the Makassae.

11. See Richard Kipp 1983 for discussions of ways in which Bataks' ethnic identity changes in different contexts.

Blanc-Szanton: The Lowland Visayas

This paper greatly profited from the intensive and focused discussions generated during the SSRC conference in Princeton in October 1983, as well as a subsequent presentation at a panel of the Northeastern Asian meeting in October 1984. I would furthermore like to particularly thank

the following people who generously provided insightful comments along the way and helped me clarify and document my argument: Marilyn Strathern, Jane Atkinson, Scott Gugenheim, Aihwa Ong, William Henry Scott, David Szanton, Owen Lynch, David Schneider, and Donna Harraway. Jane Atkinson, Shelly Errington, and an anonymous reader for Stanford University Press provided extensive and thorough editing of an earlier version. Any remaining faults should be considered my responsibility.

1. The Visayan people live in the Central Philippine islands of Panay, Negros, Cebu, Samar, Leyte, and Bohol. Sometimes Masbate is included as well. They speak three major languages, Ilonggo, Cebuano, and Waray, which belong to the largest language family in the country and are often spoken on alternative sides of the same waterway between two islands rather than by individual islands.

2. I am referring here primarily to the historical writings of Spanish priests, travelers, and American teachers and missionaries extensively cited in this paper. The issue of their existing biases and selectivity is now being addressed by historiographers and postmodern social scientists. The implications of this selectivity for the reconstruction of those societies' cultures have not yet, however, been fully explored by anthropologists— and are suggested here.

These earlier writers were unself-consciously classifying native practices on the basis of their Spanish or American categories (Scott 1982: 196–276; Reid 1988: 120), placing them in Spanish (Rafael 1988) or American perspectives and/or reporting very personal impressions shaped by their own world views.

Contemporary American or European anthropologists (such as the author) are undoubtedly subject to comparably selective interests and perspectives that limit them but also—when self-consciously comparative— may highlight facets of local social systems that might otherwise have been taken for granted or gone unnoticed.

3. Gender definitions (much as race definitions) are presented in many cultures as "natural" and biologically based. This has the effect of making the way men and women are born, the way they "are," and by extension what they end up doing, undebatable and inevitable. A major task of anthropology has been to reveal the cultural layering that endows "nature" as defined in each culture.

4. We focus here on Visayan populations, and particularly Ilonggo, because of my personal knowledge of those areas and the greater availability of detailed historical data. Many of these processes relating to gender were occurring in other parts of the Philippines, with somewhat different regional histories and local developmental experiences.

5. This is qualitatively different from saying that, despite the morality

rules of the times, married Victorian women had a much more active sex life than has been acknowledged (Cannadine 1984: 19–22). The actual total number of women involved in Victorian times is unclear, and social condemnation and the stigma to women were more serious in the Victorian context of Western bourgeois morality.

6. This statement is based on observations in Iloilo province. In Cebu, Yu and Liu (1980: 199–200) found greater social stigma attached to a kerida by her disappointed blood relatives; her support usually came from understanding neighbors. Married men maintaining a separate household for a kerida are not uncommon in Visayan cities, and among the middle class it often establishes a long-term relationship. For the lower class it usually involves brief encounters (ibid.: 188). Many lower-class couples live in fragile common-law marriages, with frequent exchanges of sexual partners.

7. This paper was "imagined" and written before I became familiar with the important works and insights of Rafael (1988) and Ileto (1979) on the effects of Spanish colonialism on the Tagalog population in the sixteenth to eighteenth centuries and in the nineteenth to twentieth centuries. It is interesting to note how, as an anthropologist, I was moving in directions comparable to those of these two historians. And it was my interest in feminist theory and gender that provided me with a point of entry into the analysis of Ilonggo culture and its transformations.

8. Major sources for this section are the historical works of Miguel de Loarca (*Relacion de las Islas Filipinas* 1582–87), Pedro Chirino (*Relacion de las Islas Filipinas* 1601–4), and an unpublished partially translated manuscript by Francisco Alzina (*Historia de las Islas bisayas y sus indios* 1668), as well as analyses by the Philippine historian William Henry Scott. Loarca was for ten years an encomendero in Arevalo, Panay, and manager of a shipyard in nearby Oton, Iloilo. He includes in his account more economic data than any of the others. Chirino, a Jesuit, lived in Tigbauan, Iloilo, as a parish priest during the 1590's. His work contains data on social structure, largely relating to the story of the Jesuits' early evangelical efforts. Alzina, also a Jesuit, though 60 years later than Loarca, spent 35 years as a parish priest on Samar Island in the Eastern Visayas before writing his monumental work on Visayan ethnography and natural science. He twice visited Iloilo and gained a knowledge of the daily and poetic forms of Samareno, which is very close to Ilonggo. He was one of the very few Spanish writers of the time who appreciated the native culture and literature. His thirteen chapters on the Visayan spirit world, beliefs about life and death, burial practices, and Visayan character, his five chapters on marriage practices, and his nine chapters on preconquest gov-

ernment, warfare, and slavery remain the most penetrating cultural study of Philippine society in the Spanish period. (English translations of the works by Loarca and Chirino can be found in Blair and Robertson 1903–9, hereafter cited as BR.)

9. Rafael (1988:136–46), on the basis of a brilliant essay on Filipino class structure written by William Henry Scott (1982:96–126), points out the inadequacy of the rigid definitions of Filipino social hierarchy utilized by the Spaniards (rooted in Roman law and European feudalism) in comprehending and describing the fluidity and complexity of Tagalog social structure. He emphasizes the implications that they carried for moral control and the legitimation of the colonial presence. There were similar misapplications of terms and concepts with regard to gender and sexuality, and responses to them by native Visayans, which are analyzed in different portions of this paper and developed, with some of their implications, in the conclusions.

10. "The males, large and small, have their penis pierced from one side to the other near the head with a gold or tin bolt as large as a goose quill. In both ends of the same bolt some have what resembles a spur, with points upon the ends; others are like the head of a cart nail. I very often asked many, both old and young, to see their penis, because I could not credit it. In the middle of the bolt is a hole, through which they urinate. They say their women wish it so, and that if they did otherwise they would not have communication with them. When the men wish to have communication with their women, the latter themselves take the penis not in the regular way and commence very gently to introduce it, with the spur on top first, and then the other part. When it is inside it takes its regular position; and thus the penis always stays inside until it gets soft, for otherwise they could not pull it out" (Pigafetta 1524:43, quoted in Reid 1988:149). According to Reid, "the same phenomenon is described by many others, in different Visayan islands and in Mindanao (Loarca 1582:116; Pretty 1588:242; Dasmarinas 1590:417–18; Carletti 1606:83–84; Morga 1609:278), who agree that its purpose was always explained as enhancing sexual pleasure, especially for women." Reid does point out that this "most Draconian surgery," i.e., the penis pin, is known for the Central and Southern Philippines (Visayan, Mindanao) and parts of Borneo (contemporary Iban and Kayan in Northwest Borneo in particular). Other countries inserted small balls or bells under the loose skin of the penis (reported by travellers or traders for Siam [1433], Pegu [1525], Java [1524], Central Luzon [1590], Pattani [1591, 1604], Makassar [1607], non-Islamic Toraja [1912–14]; Reid 1988:149–50).

11. Mary was initially incorporated as intermediary with a feared god,

as a patroness for seafarers, defender against invaders (reported for differ-
ent images of Mary in the Philippines at different dates: la Naval [1593],
Nuestra Senora del Pilar [1500's], La Soledad [1611], Carmel [1617], Paz y
Buen Viaje [1626], Rosary in San Jose, Iloilo, etc.), or as one who could cure
illnesses (for example, Nuestra Senora de Guia [1575], del Pronto Socorro
[1588], de los Remedios [1598], del Dolores [1600's], de Calambao [1600's],
del Loreto [1613], del Buon Sucesso [1625], de los Desemparados [1719],
etc.) (Tiongson 1977:1733–36). There was an early use of the Virgin as La
Purissima, as patron of the first three cathedrals in the Philippines (Ma-
nila, Cagayan, and Camarines—all built in the 1590's), and for celebra-
tions on papal pronouncements on the Immaculate Conception or its an-
niversary (1619, 1765, 1854, 1879, 1884). During the nineteenth century, a
new emphasis was placed on the Virgin and Mother with Nuestra Senora
de Lourdes, and Nuestra Senora de Guadalupe was proclaimed patroness
of the Philippines by Pio XI. Despite some initial enthusiasm, however,
these never became major cults (Santos 1982:89), comparable, for ex-
ample, to the national cult of the Guadeloupe in Mexico (Wolf 1960). This
is particularly true in the Visayas. Instead, old and new images of Mary as
protector of the sick and poor are now most popular (Santos 1982:38ff.).
Their celebrations are still mostly officiated by men, with only rare offi-
cial female participation, except for the *zagalas* and *hijas de Maria* of the
Flores de Mayo pageants. And although Our Lady of the Candle, patroness
of the Western Visayas, is celebrated in Jaro, Iloilo, the attendant fiesta
with cockfighting and games has more the flavor of a postharvest thanks-
giving feast than of a religious celebration of Mary's purity (ibid.:9–10).

12. During the seventeenth century the total number of Spanish reli-
gious leaders in the Philippines fluctuated between 254 and 400, as against
ca. 600,000 Indios. The shortage of religious leaders was often emphasized
in contrast to the overpopulated Mexican monasteries (Phelan 1959:41ff.).
Even in the mid-nineteenth century there were only 307 Spanish-born
Spaniards outside of Manila, ca. 1,000 in Manila itself, only around 1,000
Philippine-born Spaniards (called *Filipinos*), and still fewer than 2,000
Spanish mestizos (ibid.:12, 24), in a population of some 3,000,000 Indios,
Chinese, and Chinese mestizos.

13. Reid (1988:86–87) points to the general lack of "sewn garments
with sleeves or legs" in ancient Southeast Asia. Short-hair conformity was
also apparently imposed on Filipino and Chinese males who converted to
Christianity after the seventeenth century, whereas earlier "there was
little distinction between men and women in hairstyles" and "both sexes
encouraged the hair to grow as long and abundantly as possible" (ibid.:
79–82). Both quotes refer to the Filipinos as well as to other Southeast
Asian countries.

14. The Visayans were called *Pintados* by the Spanish writers because the men decorated their whole bodies, and the women their arms and hands, with elaborate tattoos.

15. The "traditional" national dress was taken from this nineteenth-century mestiza costume, throwing away shawl and bodice, and adding imported whalebones and Swiss material for the butterfly sleeves. It well symbolized the hybrid character of the new Filipina (Nakpil 1963:18–19).

16. "Maria Clara did not have the small eyes of Capitan Tiago. Like her mother, she had large, dark eyes, shaded by long eyelashes, which sparkled and were smiling when she was playing, but sad, deep and thoughtful when she was quiet. Her nose, which was correctly etched, was neither high nor flat; her mouth was a reminder of her mother's small and gracious lips; she had mercy dimples on her cheeks. Her skin was cotton-white and had the fine texture of onion, according to her adoring relatives who saw a token of Capitan Tiago's paternity in the small but well-formed ears of Maria Clara. . . . Aunt Isabel attributed the child's semi-European features to the conceiving whims of the mother. . . . Maria Clara, idolized by all, grew amidst smiles and love. The friars themselves pampered her when they dressed her in white for the processions, her abundant and curly hair interwoven with *sampaga* flowers and white lilies, with two tiny silver and gold wings attached to the back of her costume, with two white doves in her hand, tied with a blue ribbon" (Rizal [1887] 1956: 42–43). "Maria Clara was stunningly beautiful. . . . The new life was reflected on the whole being of the young lady. . . . Nevertheless, she hid her face behind her fan when she received a beautiful compliment, but then her eyes smiled and a slight trembling ran through her whole being" (ibid.:205).

17. By this period, crafts, and in particular the weaving of piña and abaca cloth as well as embroidery, were well developed among the Ilonggo. The weaving was done on some 50,000 "rude looms," often three to four in a house; engaging practically the entire female population (Loney 1964:62–63).

18. "Thomasite" teachers were American teachers who arrived on the S.S. Thomas to open schools and teach English, one of the first acts of the American government at the end of the Spanish-Philippine war.

19. In the evenings the bells of the Angelus brought a reverent pause, wishes of good evening were shared, and the younger generation respectfully kissed the hands of the oldest family representative. The town's ladies sat in their houses in the evenings "in silken skirts of brilliant hues and in camisas and pañuelos of delicate embroidered or hand-painted piña" that could become quite elaborate long gowns with butterfly sleeves and collared blouses for more formal occasions. They offered a contrast to

the plaid skirts and short blouses worn by the farming population. The town's gentlemen wore light-colored slacks, shirt-jackets, and straw or hard hats, if not full black evening dress in the European style for more formal occasions (Fee 1912:119–29).

20. Social categories like Chinese mestizo or Indio lost their meaning in the early twentieth-century American colony. Democracy, equal rights, and professionalism anchored in education were the main messages conveyed by the American administrators. They nevertheless perpetuated the local hierarchy by continuing to rule largely through the native mestizo elites of the nineteenth century (Owen 1971:109–23).

21. Filipinas were among the first to fight for women's rights in many fields. In 1922, the first Filipina obtained a Ph.D. (from Columbia University). Women's suffrage was sought as early as 1912 by the *Asociacion Feminista Ilonga*, the first regional feminist organization. It was obtained in 1937 after a long debate and stern opposition from the exclusively male Filipino assembly. By 1940 women had a sizeable percentage of the vote.

22. Panel discussion, First Philippine Film Festival, Hunter College, New York, November 1965; panel discussion on "Femme Fatalism," Series on *Cinema and Society: Asian Perspectives*, American Museum of Natural History, November 1988; Caagusan 1982.

23. The most recent example would be the rise of Cory Aquino, who usually emphasizes her "housewife" origins, but whose rise is closely connected with martyrdom and the live "pasyon" of her husband, Benito Aquino. That "pasyon" and Cory as an individual martyred wife have at key moments represented Philippine society as a whole in its fight against oppression brings out echoes of Rizal, the nationalistic martyr of the Spaniards, now a quasi-God in the Philippines (Ileto 1985; Blanc-Szanton 1989).

24. It is ironic that while national economic policies encourage the sexual and industrial exploitation of women, President Marcos's family sponsored a major celebration in honor of virginity, "La Purissima," in Manila in early 1982, with Irene Marcos, the president's daughter, leading the virgins (*zagalas*) in honor of the Virgin Mary (Santos 1982). The Church's stress on virginity and the disparagement of whores as evil has further complicated the lives of many Filipinas forced into prostitution by personal needs and national economic policies.

25. Brideservice, i.e., labor contributions for one year by the groom to his in-laws, was one of the requirements accompanying bridewealth in the legitimation of marriage among pre-Hispanic Visayans (Alzina 1668:pt. 2, ch. 4:182ff., 205–6). Bridewealth remained an important component of sixteenth-century Visayan marriage practices, but was sternly prohibited by the Spanish colonialists on the mistaken notion that it constituted a

form of sale (Phelan 1959:129–33). It is now only infrequently reported in the lowlands, but has survived in less-Hispanicized areas like Apayao and montane Mindanao, running to really impressive fees in slaves and gold and complex levels of gifts (W. H. Scott, personal communication).

Brideservice may take the form of premarital *panghagad*—i.e., if the boy is accepted, he starts serving the girl's family for a period of time, formerly up to seven years, now for a few weeks, at most a month. This is a time when the true character of the husband-to-be can be observed by the future in-laws, according to the inhabitants of interior areas of Panay (Jocano 1976:73). Or brideservice may simply involve residence with wife's parents for one year after marriage, both in interior towns and in more coastal communities (Jocano 1969:80, 1976:74). In small Ilonggo towns there is also the tendency towards uxorilocality after marriage, and children tend to grow up surrounded by their maternal relatives. A bilateral kinship system, with comparable emphasis on ascendants and descendants on both male and female sides, characterizes all lowland Philippine society.

Ong: Metaphors in West Malaysia

Anthropological research on which this study is based was funded by the National Science Foundation (BNS–78769) and the International Development Research Centre (Ottawa) under the Household/Demographic Behavior Project. This paper has benefited from the careful criticisms and editorial pruning by Scott Guggenheim and Joan Vincent. Further searching comments were made by William Roff, Marilyn Strathern, Valerio Valeri, Jane M. Atkinson, and Shelly Errington. Remaining errors of interpretation are my own.

1. H. B. M. Murphy (1972) notes that latah cases seemed to have appeared only with colonial contact; it was an affliction suffered by female servants of Europeans. Others have argued that latah is a culture-specific syndrome that can develop out of teasing games practiced by children and adults in some Southeast Asian societies. Both forms of psychosocial conflict have since become established patterns of emotional disorder in Malay society.

2. Fieldwork from which data is drawn was conducted in two stages. In the latter half of 1978, a brief exploration of labor recruitment and control was carried out in the Bayan Lepas Free Trade Zone, Penang. Between March 1979 and April 1980, I conducted fieldwork in Kuala Langat district, in the state of Selangor, West Malaysia (see Ong 1987).

3. The causes of divorce are extremely difficult to determine, but the

failure of husbands to provide maintenance was cited by the local *kadi* (Islamic judge) as the main reason (i.e., from 1969–79, it accounted for between 30 percent and 45 percent of all divorces each year; see Table 15 in Ong 1987 : 132). Of course, the issue of nonmaintenance can also be interpreted as evidence of husbands withdrawing funds from the family budget in protest against working wives not contributing significantly to the family budget. In 1978, there were 20 percent more working women petitioning for divorce throughout West Malaysia. "The problem centered on the fact that some men expected their working wives to contribute a big chunk of their income towards household expenditure while the wives felt that their contributions ought to be of a supplementary nature" (*The New Straits Times*, Mar. 27, 1979).

4. Malays do not make alimony payments. Partly for security considerations, divorced Malay women frequently remarry, and some may keep children by previous husbands with them. Thus relations among siblings often override their different paternal ties. Such children are referred to as 'milk siblings' (*adek beradek susu*).

5. In Japan, only a few large Japanese companies—e.g., Sony, Hitachi, Toyota, Nissan, Japan Steel—provide extensive welfare coverage for their workers, who are largely male. The vast majority of working women (70 percent) are employed as temporary, part-time, or unpaid family workers in medium-size and small firms, and they seldom, if ever, enjoy lifetime employment (Cook and Hayashi 1980: 5). Besides, in Malaysia, the some 220 Japanese firms in the late 1970's did not expect their workers to become lifetime employees, and many of the companies did not have house unions (see *Far Eastern Economic Review*, Mar. 31, 1983).

6. All interviews with factory managers, engineers, and supervisors (who may have been Japanese, Indian, Chinese, or Malay) were conducted in English. Interviews with Malay technicians, production operators, and villagers, which took place in village settings, were conducted in *Behasa Kebangsaan* (Malay).

7. This point is not quite accurate. In 1975, Japanese women comprised some 50 percent of the total labor force in Japan. Even with the same educational background as men, women by the age of thirty-five earned less than half of men's wages. Moreover, since women cannot be considered part of the permanent labor force, men are the beneficiaries of lifetime employment (Cook and Hayashi 1980: 1–14; Matsumoto 1978: 62).

8. This practice of employing young women for a short span of their life cycle means that multinational industries are generating, not a classic proletariat, but rather a labor reserve among rural Malay women (Ong 1987).

9. This process should not be confused with the *ringi* mechanism for collective decision-making whereby each segment of the Japanese company participates in presenting its opinions and suggestions concerning firm policies and plans. The "grievance procedure" merely collects complaints from the shop floor without involving the lower ranks in decision-making.

10. Celia Mather (1983) discusses a more systematic case of alliances between village headmen ("Islamic patriarchy") and factory managers to control the supply of young peasant women for factories in the Tangerang region, West Java.

11. At EJI, a Malay woman had been trained to be a foreman; but since she was the only female in that rank, she felt uncomfortable and was given a desk job and never worked in a foreman capacity. In her interviews with some Japanese factory women, Sheila Matsumoto reports that they "feel that men are generally superior to women and prefer a man for supervisor. They fear that women are too emotional and will not perform well under pressure" (1978:72).

12. Matsumoto reports that Japanese factory women also have to bear humiliating questioning by their male supervisors about menstrual discomfort. They are sometimes accused of lying about their need for medical leave (1978:68). In the Telok FTZ, young Malay women working in the factory for the first time (usually in production processes using microscopes) are so traumatized that they miss their menstrual cycles for the next few months, and suffer from assorted bodily aches like eye strain, chest pains, and gastric problems.

13. Again we find echoes of the same situation among Japanese counterparts of the Malay operators. Japanese women interviewed by Matsumoto are not taught the functioning of the machines they operate (1978:67).

14. ABIM leaders are graduates of local universities—Universiti Malaya, Universiti Kebangsan, and MARA Institute of Technology—and their recruitment activities have penetrated the civil service, police, military, professional organizations, and schools. Most of the followers are urban-based Malays who have been exposed to secular education. In 1982, the ABIM leader Anwar Ibrahim "defected" to the government by accepting one of the five vice presidencies of UMNO party. Since this political maneuver by its most charismatic leader, the ABIM movement has lost some of its moral fervor and sense of direction as a major political force critical of government policies.

15. The Darul Arqam movement, centered on a communal kampung outside Kuala Lumpur, stresses economic self-sufficiency. The members

participate in many agricultural projects and operate a number of small factories to produce *halal* (religiously pure) food-stuffs. The Jemaat Tabligh, influenced by Indian Muslim missionary activities, is based on a network of congregations for religious lectures and retreats. Both groups are composed of university students, white-collar workers, and professionals who practice communal life, intensive religious study, and sexual segregation, in contrast to the individualist lifestyle pursued by many middle-class Malays. Women in the Darul Arqam work in the factories, operate the school and hostel, and prepare the communal meals while their men travel the lecture circuit. Female members of the Tabligh group are more confined and are excluded from the men's vigorous missionary activities (see Nagata 1981:416–23).

16. Some of the very small sects modelled after foreign groups try to introduce obligatory sexual activity between female converts and the khalifah (Nagata 1981:416; *Far Eastern Economic Review*, Mar. 3, 1983). This association between Islam and female sexual service is extremely repulsive to Malaysian Muslims and has been condemned by all authorities and major dakwah groups.

17. The impact of multinational corporate advertising in West Malaysia has been particularly powerful on young Malays recently arrived in the cities from rural kampung. Many factory women are captivated by the portrayal of white women in the commercials and seek to emulate their Western, glamorous images. Annual beauty contests held in multinational firms also reinforce Western images of feminine passivity (see Grossman 1979).

18. Cases of female spirit possession during the colonial period and up until recently more commonly involved middle-aged Malay women than any other female age group. Such women have a particularly stressful status at this phase of their life cycle, when they become divorced or widowed, and children begin to depart from home. They may also begin to suffer a decline in their standard of living because of these household changes (Kessler 1977).

19. Michael Taussig (1980) argues that the "fetishization of evil" in the form of the devil represents a mode of critique of capitalist relations by Colombian plantation workers and Bolivian tin miners.

20. These images of "filth" and pollution, following Mary Douglas (1966), also reflect the women's sense of having transgressed the boundaries between kampung and public life.

21. Many village women only begin using these market items after they have started working in the factories. They not only have the cash to purchase sanitary napkins, but also need the protection because of the

long hours confined at work. Thus factory employment also introduces kampung women to an urban culture of modern sanitary systems and practices that disrupt their corporeal sense of self.

22. In rural Malay beliefs, Negritos and were-tigers, the associates of spirits, move easily between human and nonhuman domains. The were-tiger is said to prey on human beings and suck their blood (Endicott 1970:82, 85). The women's visions thus suggest their acute consciousness of being bodily and spiritually endangered. See Ong (1988) for a more extended discussion of the contrasting Malay, corporate, and cosmopolitan medical views of spirit possession in factory settings.

23. In a forthcoming article (Ong 1990), I link the sexual symbolisms of working-class and middle-class Malay women to the nationalist struggle over the form and boundary of the changing Malay family. I have suggested elsewhere (1989) that a promising direction for understanding gender difference in Southeast Asia, and the contemporary world in general, is one that incorporates insights from both political economy and symbolic analysis.

References

Abella, Domingo. 1971. "From Indio to Filipino," *Philippine Historical Review*, 4:1–34.

Abu-Lughod, Lila. 1986. *Veiled Sentiments: Honor and Poetry in a Bedouin Society*. Berkeley: University of California Press.

Ackerman, Susan E. 1979. "Industrial Conflict in Malaysia: A Case Study of Rural Malay Female Workers." Paper presented at the Seminar on "Women in Malaysia Today," Kebangsaan University, Bangi, W. Malaysia, Mar. 14–16.

Adams, Marie Jeanne. 1969. *System and Meaning in East Sumba Textile Design: A Study in Traditional Indonesian Art*. Cultural Report 16. New Haven: Yale University Southeast Asia Studies.

———. 1980. "Structural Aspects of East Sumbanese Art," in Fox 1980a, pp. 208–20.

Adriani, N., and A. C. Kruyt. 1950. *De Bare'e-Sprekende Toradjas van Midden-Celebes*. Rev. ed. Amsterdam: Noord-Hollandsche.

Ahern, Emily Martin. 1975. "The Power and Pollution of Chinese Women," in *Women in Chinese Society*, ed. Margery Wolf and Roxane Witke, pp. 193–214. Stanford: Stanford University Press.

Alzina, Francisco. 1668. "Historia de las Islas bisayas y sus indios," parts 1–3. Unpublished ms. Philippine Studies Program. University of Chicago.

Alzona, Encarnacion. 1933. *The Social and Economic Status of Filipino Women 1565–1932*. Manila: Institute of Pacific Relations.

Anderson, Benedict. 1965. *Mythology and the Tolerance of the Javanese*. Monograph no. 37. Ithaca: Cornell Modern Indonesia Project.

———. 1972. "The Idea of Power in Javanese Culture," in *Culture and Politics in Indonesia*, ed. Claire Holt, with Benedict Anderson and James Siegel, pp. 1–69. Ithaca: Cornell University Press.

———. 1983. *Imagined Communities: Reflections on the Origin and Spread of Nationalism*. London: Verso.

Angeles, Leonora C. 1989. "Getting the Right Mix of Feminism and Nationalism: The Politics of the Women's Movement in the Philippines."

Paper presented at the Third International Philippine Studies Conference, PSSC, Diliman Quezon City, July.

Appell, Laura W. R. 1988. "Menstruation Among the Rungus of Borneo: An Unmarked Category," in Buckley and Gottlieb 1988, pp. 94–112.

Aquino, Belinda A. 1984. "Filipino Women: The Colonial Double Bind." Paper presented at the 1984 Meeting of the Association for Asian Studies, Washington, D.C., Mar. 23–25.

Archipel. 1977. Volume 13, special issue, "Regards sur les Indonésiennes."

Ardener, Edwin. 1975a. "Belief and the Problem of Women," in *Perceiving Women,* ed. Shirley Ardener, pp. 1–17. New York: J. Wiley and Sons.

———. 1975b. "The 'Problem' Revisited," in *Perceiving Women,* ed. Shirley Ardener, pp. 19–27. New York: J. Wiley and Sons.

Atkinson, Jane. 1982. "Anthropology: Review Essay," *Signs,* 8, no. 2: 236–58.

———. 1983. "Religions in Dialogue: The Construction of an Indonesian Minority Religion," *American Ethnologist,* 10:684–96.

———. 1984. "Wrapped Words: Poetry and Politics among the Wana of Central Sulawesi, Indonesia," in *Dangerous Words: Politics and Language in the Pacific,* ed. D. Brennis and F. Myers, pp. 33–68. New York: New York University Press.

———. 1987. "The Effectiveness of Shamanism in an Indonesian Ritual," *American Anthropologist,* 89:342–55.

———. 1989. *The Art and Politics of Wana Shamanship.* Berkeley: University of California Press.

Bakhtin, Mikhail M. [1930] 1981. *The Dialogic Imagination,* ed. Michael Holquist, trans. Caryl Emerson and Michael Holquist. Austin: University of Texas Press.

———. 1986. *Speech Genres and Other Late Essays,* ed. Caryl Emerson and Michael Holquist, trans. Vern W. McGee. Austin: University of Texas Press.

Banks, David J. 1976. "Islam and Inheritance in Malaya: Culture Conflict or Islamic Revolution," *American Ethnologist,* 3, no. 4 (Nov. 1976): 573–85.

———. 1983. *Malay Kinship.* Philadelphia: ISHI Publications.

Barnes, R. H. 1974. *Kedang: A Study of the Collective Thought of an Eastern Indonesian People.* Oxford: Clarendon Press.

Barthes, Roland. 1972. *Mythologies.* Selected and translated from the French by Annette Lavers. 1st American ed. New York: Hill and Wang.

Bauzon, Leslie. 1977. "The Mexican Subsidy," in *Filipino Heritage: A Nation in the Making,* vol. 4, pp. 1037–40. Manila: Lahing Pilipino.

Beauvoir, Simone de. [1949] 1984. *Le deuxième sexe,* vol. 1. Paris: Gallimard.

———. 1952. *The Second Sex.* Trans. H. M. Parshley. New York: Alfred Knopf.

Belo, Jane. 1935. "A Study of Customs Pertaining to Twins in Bali," *Tijdschrift voor Indische Taal-, Land-, en Volkenkunde*, 75:483–59.

———. 1936. "A Study of a Balinese Family," *American Anthropologist*, 38, no. 1:12–31.

———. 1949. *Bali: Rangda and Barong.* Monographs of the American Ethnological Society, no. 16. Seattle and London: University of Washington Press.

Ben-Amos, Dan. 1976. "Analytical Categories and Ethnic Genres," in *Folklore Genres*, ed. Dan Ben-Amos, pp. 215–42. Austin: University of Texas Press.

Berthe, Louis. 1972. "Parente, pouvoir et mode de production: Elements pour une typologie des sociétés agricoles de l'Indonesie," in *Echanges et Communications*, ed. Jean Pouillon and Pierre Maranda. The Hague: Mouton.

Bhadra, I. Wayan. 1969. "Nonconformity in Villages of Northern Bali," in *Bali: Further Studies*, ed. J. Swellengrebel. The Hague: W. van Hoeve.

Biersack, Alette. 1987. "Moonlight: Negative Images of Transcendence in Paiela Pollution," *Oceania*, 57:178–94.

Bird, Phyllis. 1974. "Images of Women in the Old Testament," in *Religion and Sexism: Images of Women in the Jewish and Christian Traditions*, ed. Rosemary R. Ruether. New York: Simon and Schuster.

Blair, Emma Helen, and James Alexander Robertson [BR]. 1903–9. *The Philippine Islands, 1493–1898.* 55 vols. Cleveland: A. H. Clark. (Collection of sources on the entire Spanish period translated from ecclesiastical and administrative chronicles.)

Blanc-Szanton, Cristina. 1972. *A Right to Survive: Subsistence Marketing in a Lowland Philippine Town.* Philadelphia: Pennsylvania State University Press.

———. 1981. "'Big Women' and Politics in a Philippine Fishing Town," in *Women and Politics in Twentieth Century Africa and Asia*, ed. V. Sutlive, pp. 123–42. Studies in Third World Societies, no. 16.

———. 1982. "Women and Men in Iloilo, Philippines 1903–1970," in Esterik 1982b, pp. 124–53.

———. 1990. "Nationalism and Transnationalism," in *The Transnationalization of Migration*, ed. Linda Basch, Cristina Blanc-Szanton, and Nina Schiller. London: Gordon and Breach.

Bloch, Maurice. 1975. "Introduction," in *Political Oratory in Traditional Society*, ed. Maurice Bloch. New York: Academic Press.

Bloomfield, Leonard. 1933. *Language.* New York: Holt, Rinehart and Winston.

Boon, James. 1974. "The Progress of the Ancestors in a Balinese Temple-group," *Journal of Asian Studies*, 34:7–25.

———. 1977. *The Anthropological Romance of Bali, 1597–1972: Dynamic Perspectives in Marriage and Caste, Politics and Religion*. New York: Cambridge University Press.

———. 1978. "The Shift to Meaning," *American Ethnologist*, 5 (2): 361–67.

———. 1982a. "Centralization, Sort of, in Balinese Ritual and Society." Paper presented to the Southeast Asia Seminar, Cornell University.

———. 1982b. "Introduction to the English Edition," in *Between Belief and Transgression*, ed. Michel Izard and Pierre Smith. Chicago: University of Chicago Press.

———. 1982c. Review of James J. Fox, ed., *The Flow of Life: Essays on Eastern Indonesia. American Anthropologist*, 84.

———. 1983. *Other Tribes, Other Scribes: Symbolic Anthropology in the Comparative Study of Culture, Histories, Religions, and Texts*. New York: Cambridge University Press.

———. 1984. "Folly, Bali, and Anthropology, or Satire Across Cultures," in *Text, Play, and Story*, ed. Edward Bruner, pp. 156–77. Proceedings of the American Ethnological Society.

———. 1985. "Symbols, Sylphs, and Siwa: Allegorical Machineries in the Text of Balinese Culture," in *The Anthropology of Experience*, ed. Ed Bruner and Victor Turner, pp. 239–60. Champaign: University of Illinois Press.

———. 1986. "Between-the-Wars Bali: Rereading the Relics," in *History of Anthropology*, vol. 4, ed. George Stocking, pp. 218–47. Madison: University of Wisconsin Press.

———. 1989. "Lévi-Strauss, Wagner, Romanticism: A Reading-back," in *History of Anthropology*, vol. 6, ed. George Stocking, pp. 124–68. Madison: University of Wisconsin Press.

———. Forthcoming. *Affinities and Extremes: Crisscrossing the Bittersweet Ethnology of East Indies History, Hindu-Balinese Culture, and Indo-European Allure*. Chicago: University of Chicago Press.

———. N.d. *Why Are Balinese Brides Made Beautiful: Ritual, Gender, Feminine Allure, and Comparative Courtly Love*. Unpublished ms.

Boon, James A., and David M. Schneider. 1974. "Kinship vis-à-vis Myth: Contrasts in Lévi-Strauss's Approaches to Cross-Cultural Comparison," *American Anthropologist*, 76, no. 4:799–817.

Bourdieu, Pierre. 1977. *Outline of a Theory of Practice*. Cambridge: Cambridge University Press.

Brandes, Stanley. 1980. *Metaphors of Masculinity: Sex and Status in Andalusia Folklore*. Philadelphia: University of Pennsylvania Press.

———. 1981. "Like Wounded Stags: Male Sexual Ideology in an Andalusian Town," in Ortner and Whitehead 1981a, pp. 216–39.

Brenneis, Donald Lawrence, and Fred Myers. 1984. "Introduction," in *Dangerous Words: Language and Politics in the Pacific*, ed. Donald Lawrence Brenneis and Fred Myers, pp. 1–29. New York: New York University Press.

Bruner, Edward M. 1973a. "The Expression of Ethnicity in Indonesia," in *Urban Ethnicity*, ed. Abner Cohen, pp. 251–80. ASA Monograph. London: Tavistock.

———. 1973b. "Kin and Non-Kin," in *Urban Anthropology: Cross Cultural Studies of Urbanization*, ed. Aidan Southall, pp. 373–92. New York: Oxford University Press.

———. 1979. "Introduction: Indonesian Models in Social Action," in Bruner and Becker 1979, pp. 1–9.

Bruner, Edward M., and Judith O. Becker, eds. 1979. *Art, Ritual and Society in Indonesia*. Southeast Asia Series, no. 53. Athens, Ohio: Ohio University Center for International Studies.

Buchbinder, Georgeda, and Roy Rappaport. 1975. "Fertility and Death among the Maring," in *Man and Woman in the New Guinea Highlands*, ed. P. Brown and Georgeda Buchbinder, pp. 13–35. Special publication of the American Anthropological Association, no. 8. Washington, D.C.: American Anthropological Association.

Buckley, Thomas, and Alma Gottlieb, eds. 1988. *Blood Magic: The Anthropology of Menstruation*. Berkeley: University of California Press.

Caagusan, Flor. 1982. "Interview," *The Diliman Review*, 30, no. 6 (Nov.–Dec.): 23–28.

Cannadine, John. 1984. "Victorian Women: New Perspectives," *New York Review of Books*, 19–22.

Carletti, Francesco. 1606. *My Voyage Around the World*, trans. Herbert Weinstock. New York: Random House, 1966.

Carter, Anthony T. 1984. "Kintype Classification and Concepts of Relatedness in South Asia," *American Ethnologist*, 11, no. 1:81–97.

Casiño, Eric S. 1982. "The Philippines: Lands and Peoples, A Cultural Geography," in *The Filipino Nation*, ed. Jim Haskins. Grolier International.

Chabot, Hendrik T. [1950] 1960. *Land, Status and Sex in the Southern Celebes*, trans. Richard Downs. New Haven: Human Relations Area Files. (Originally published in 1950 as *Verwantschap, Stand en Sexe in Zuid-Celebes*. Groningen-Djakarta: J. B. Wolters.)

Chandler, Glen, Norman Sullivan, and Jan Branson. 1988. *Development and Displacement: Women in Southeast Asia*. Monash Papers on Southeast Asia, no. 18. Clayton, Victoria, Australia: Monash University Centre of Southeast Asian Studies.

Charle, Rainer, ed. 1987. *Cultures and Societies of North Sumatra*. Berlin and Hamburg: Veröffenlichungen des Seminars fur Indonesische und Sudseesprachen der Universitat Hamburg, Band 19.

Chirino, Pedro. 1604. "Relacion de las Islas Filipinas," in Blair and Robertson 1903–9, vol. 12, pp. 167–324.

Christian, William A. 1981. *Local Religion in 16th Century Spain*. Princeton: Princeton University Press.

Collier, Jane F., and Michelle Z. Rosaldo. 1981. "Politics and Gender in Simple Societies," in Ortner and Whitehead 1981a, pp. 275–329.

Collier, Jane F., and Sylvia J. Yanagisako, eds. 1987. *Gender and Kinship: Essays Toward a Unified Analysis*. Stanford: Stanford University Press.

Collingwood, R. G. 1945. *The Idea of Nature*. Oxford: Oxford University Press.

Collins, James. 1983. *The Historical Relationships of the Languages of Central Maluku*. Pacific Linguistics, series D, no. 47.

Comaroff, John, and Simon Roberts. 1981. *Rules and Processes*. Chicago: University of Chicago Press.

Connell, R. W. 1987. *Gender and Power: Society, the Person, and Sexual Politics*. Oxford: Polity Press.

Cook, Alice H., and Hiroko Hayashi. 1980. *Working Women in Japan: Discrimination, Resistance, and Reform*. Ithaca: New York State School of Labor and Industrial Relations.

Coville, Elizabeth. 1988. "'A Single Word Brings to Life': The Maro Ritual in Tana Toraja (Indonesia)." Ph.D. dissertation, University of Chicago.

Cunningham, Clark. 1964. "Order in the Atoni House." *Bijdragen tot de Taal-, Land- en Volkenkunde*, 120:34–58.

———. 1965. "Order and Change in an Atoni Diarchy," *Southwestern Journal of Anthropology*, 21:359–83.

Curtiss, Susan. 1977. *Genie: A Psycholinguistic Study of a Modern-day "Wild Child."* New York: Academic Press.

Cushner, Nicholas P. 1971. *Spain in the Philippines: From Conquest to Revolution*. Institute of Philippine Culture Monograph, no. 1. Quezon City: Ateneo de Manila University.

Daeng Mangemba, Hamzah. 1975. "Les statut des femmes Bugis et Makasar vu par leur propres sociétés," *Archipel*, 10:153–57.

Dasmariñas, Goméz Peréz. 1590. "The Manners, Customs, and Beliefs of the Philippine Inhabitants of Long ago, Being Chapters of 'A Late Sixteenth Century Manila Manuscript,'" trans. Carlos Quirino and Mauro Garcia, *Philippine Journal of Science*, 87 no. 4 (1958):389–445.

De Certeau, Michel. 1984. *The Practice of Everyday Life*. Berkeley: University of California Press.

Djamour, Judith. 1959. *Malay Kinship and Marriage in Singapore*. London: Athlone Press.

Douglas, Mary. 1966. *Purity and Danger: An Analysis of the Concepts of Pollution and Taboo*. London: Routledge and Kegan Paul.

———. 1973. *Natural Symbols: Explorations in Cosmology*. New York: Vintage.

Dumont, Louis. 1959. "Pure and Impure," *Contributions to Indian Sociology*, 3:9–39.

Durkheim, Émile. 1898. "La prohibition de l'inceste et ses origines," *L'année sociologique*, 1:1–70.

———. 1912. *Les formes élémentaires de la vie religieuse*. Paris: Alcan.

Dwyer, Daisy H. 1978. *Images and Self-Images: Male and Female in Morocco*. New York: Columbia University Press.

Eggink, H. J. 1936. *Angkola-en Mandailing-Bataksch/Nederlandsch Woordenboek*. Bandung, Indonesia: A. C. Nix and Co.

Ellen, Roy. 1975. "Non-Domesticated Resources in Nuaulu Ecological Relations," *Social Science Information*, 14:127–50.

Endicott, Kirk M. 1970. *An Analysis of Malay Magic*. Oxford: Clarendon Press.

Ernout, Alfred, and Antoine Meillet. 1979. *Dictionnaire étymologique de la langue latine*. Paris: Klincksieck.

Errington, James Joseph. 1981. "Changing Speech Levels Among a Traditional Javanese Elite Group." Ph.D. thesis, University of Chicago.

———. 1984. "Self and Self-Conduct Among the Javanese Priyayi," *American Ethnologist*, 11, no. 2:275–90.

Errington, Shelly. 1983. "Embodied Sumange' in Luwu," *Journal of Asian Studies*, 43, no. 3:545–70.

———. 1987. "Incestuous Twins and the House Societies of Island Southeast Asia," *Cultural Anthropology*, 2, no. 4:403–44.

———. 1989. *Meaning and Power in a Southeast Asian Realm*. Princeton: Princeton University Press.

———. N.d., a. "The Construction of Gender in Southeast Asia: A Call for Papers." Unpublished ms.

———. N.d., b. "The Power of Meditation in Luwu." Unpublished ms.

Ervin-Tripp, Susan. 1972. "On Sociolinguistic Rules: Alternation and Co-occurence," in *Directions in Sociolinguistics*, ed. John Gumperz and Dell Hymes. New York: Holt, Rinehart and Winston.

Esterik, Penny van. 1982a. "Introduction," in Esterik 1982b.

———, ed. 1982b. *Women of Southeast Asia*. Northern Illinois University Series on Southeast Asia, Occasional Paper, no. 9. De Kalb: Northern Illinois University.

Evangelista, Alfredo E. 1972. *The Functions of the Nipa Palm Beverage*

Tuba in a Philippine Community. Data paper no. 2. Quezon City: University of the Philippines.

———. "An Analysis of Massage Parlors Attendants," *Philippine Sociological Review,* 25, no. 1:122–34.

Fast, Jonathan, and Jim Richardson. 1979. *Roots of Dependency: Political and Economic Revolution in 19th Century Philippines.* Quezon City.

Federal Industrial Development Authority (FIDA), Malaysia. 1975. *Malaysia: The Solid State for Electronics.* Kuala Lumpur.

Fee, Mary H. 1912. *A Woman's Impressions of the Philippines.* Chicago: McClurg.

Firth, Raymond. 1959. *Social Change in Tikopia.* New York: Macmillan.

Firth, Rosemary. 1966. *Housekeeping Among the Malay Peasants.* 2nd ed. London: Athlone Press.

Forman, Shepard. 1980. "Descent, Alliance, and Exchange Ideology among the Makassae of East Timor," in Fox 1980a, pp. 152–77.

Forth, Gregory L. 1981. *Rindi: An Ethnographic Study of a Traditional Domain in Eastern Sumba.* The Hague: Martinus Nijhoff.

Foucault, Michel. 1975. *The Birth of the Clinic: An Archaeology of Medical Perception.* Translated from the French by A. M. Sheridan Smith. New York: Vintage.

———. 1979. *Discipline and Punish: The Birth of the Prison.* Translated from the French by Alan Sheridan. New York: Vintage.

———. 1980. *The History of Sexuality,* vol. 1, *An Introduction.* New York: Vintage.

———. 1982. "The Subject and Power," in *Michel Foucault: Beyond Structuralism and Hermeneutics,* ed. Hubert Dreyfus and Paul Rabinow, pp. 208–26. Chicago: University of Chicago Press.

———. 1984a. *Histoire de la sexualité,* vol. 2, *L'usage des plaisirs.* Paris: Gallimard.

———. 1984b. *Histoire de la sexualité,* vol. 3, *Le souci de soi.* Paris: Gallimard.

Fox, James J. 1971. "Semantic Parallelism in Rotinese Ritual Language," *Bijdragen tot de Taal-, Land- en Volkenkunde,* 127:215–55.

———. 1971a. "A Rotinese Dynastic Genealogy: Structure and Event," in *The Translation of Culture,* ed. T. O. Beidelman, pp. 37–78. London: Tavistock.

———. 1973. "On 'Bad Death' and the Left Hand," in *Left and Right,* ed. Rodney Needham. Chicago: University of Chicago Press.

———. 1974. "Our Ancestors Spoke in Pairs: Rotinese Views of Language, Dialect, and Code," in *Explorations in the Ethnography of Speaking,* ed. Richard Bauman and Joel Sherzer, pp. 65–85. London: Cambridge University Press.

———. 1977. *Harvest of the Palm*. Cambridge, Mass.: Harvard University Press.

———, ed. 1980a. *The Flow of Life: Essays on Eastern Indonesia*. Cambridge: Harvard University Press.

———. 1980b. "Models and Metaphors: Comparative Research in Eastern Indonesia," in Fox 1980a, pp. 327–34.

———, ed. 1988. *To Speak in Pairs: Essays on the Ritual Languages of Eastern Indonesia*. Cambridge: Cambridge University Press.

Francillon, Gérard. 1980. "Incursions upon Wehali: A Modern History of an Ancient Empire," in Fox 1980a, pp. 248–65.

Freeman, J. Derek. 1967. "Shaman and Incubus," *The Psycho-Analytic Study of Society*, 4:314–43.

———. 1970. *Report on the Iban*. New York: Humanities Press.

———. 1981. *Some Reflections on the Nature of Iban Society*. Canberra: Occasional Paper of the Department of Anthropology, Research School of the Pacific Studies, Australian National University.

Fried, Morton. 1967. *The Evolution of Political Society*. New York: Random House.

Friedman, Jonathan. 1975. "Tribes, States, and Transformations," translated by the author, in *Marxist Analysis in Social Anthropology*, ed. M. Bloch, pp. 161–202. ASA Studies no. 2. New York: J. Wiley and Sons.

Friedrich, Paul. 1979. "Poetic Language and the Imagination: A Reformulation of the Sapir Hypothesis," in *Language, Context and the Imagination: Essays by Paul Friedrich*, selected and introduced by Anwar S. Dil, pp. 441–512. Stanford: Stanford University Press.

Frisk, Hjalmar. 1970. *Griechisches etymologisches Worterbuch*. 2 vols. Heidelberg: Winter.

Gallagher, Catherine, and Thomas Laqueur, eds. 1986. *Sexuality and the Social Body in the Nineteenth Century*. *Representations* 14 (special issue).

Garang, Johannes Enos. 1974. *Adat and Gesellschaft*. Weisbadan: Franz Steiner Verlag.

Garfinkel, Harold. 1967. *Studies in Ethnomethodology*. Englewood Cliffs, N.J.: Prentice Hall.

Gay, Jill. 1983. "Sweet Darlings in the Media: How Foreign Corporations Sell Western Images of Women to the Third World," *Multinational Monitor* (Aug.).

Geddes, W. R. [1957] 1961. *Nine Dayak Nights*. London: Oxford University Press.

Geertz, Clifford. 1960. *The Religion of Java*. Chicago: University of Chicago Press.

―――. 1973a. "Deep Play: Notes on the Balinese Cockfight," in C. Geertz 1973c, pp. 459–90.

―――. 1973b. "The Impact of the Concept of Culture on the Concept of Man," in C. Geertz 1973c, pp. 36–54.

―――. 1973c. *The Interpretation of Cultures*. New York: Basic Books.

―――. 1973d. "Person, Time, and Conduct in Bali," in C. Geertz 1973c, pp. 412–53.

―――. 1973e. "Ritual and Social Change: A Javanese Example," in C. Geertz 1973c, pp. 142–69.

―――. 1980. *Negara: The Theatre State in Nineteenth Century Bali*. Princeton: Princeton University Press.

―――. 1984. *Bali: L'interpretation d'une culture*. Paris: Gallimard.

Geertz, Hildred. 1959. "The Balinese Village," in *Local, Ethnic, and National Loyalties in Village Indonesia*, ed. G. W. Skinner, pp. 24–33. New Haven: Yale University Southeast Asian Studies.

―――. 1961. *The Javanese Family: A Study of Kinship and Socialization*. Glencoe, Ill.: Free Press.

―――. 1963. "Indonesian Cultures and Communities," in *Indonesia*, ed. Ruth T. McVey. New Haven: HRAF Press.

―――, ed. N.d. *Balinese State and Society: Essays from the 1984 Conference*. Leiden: KITLV.

Geertz, Hildred, and Clifford Geertz. 1975. *Kinship in Bali*. Chicago: University of Chicago Press.

Gellner, Ernest. 1983. *Nations and Nationalism*. Oxford: Basil Blackwell.

Gerdin, Ingela. 1982. *The Unknown Balinese: Land, Labor, and Inequality in Lombok*. Gothenburg: Studies in Social Anthropology.

Giddens, Anthony. 1979. *Central Problems in Social Theory: Action, Structure, and Contradiction in Social Analysis*. Berkeley: University of California Press.

Gilligan, Carolyn. 1982. *In a Different Voice: Psychological Theory and Women's Development*. Cambridge, Mass.: Harvard University Press.

Gironière, Paul P. de la. 1855. *Adventures d'un Gentilhomme Breton aux Îles Philippines*. Paris: Lacroix-Comon.

Gittinger, Mattiebelle. 1979. *Splendid Symbols: Textiles and Tradition in Indonesia*. Washington, D.C.: Textile Museum.

―――, ed. 1980. *Indonesian Textiles*. Proceedings of the Irene Emery Roundtable on Textiles. Washington, D.C.: Textile Museum.

Go, S., and L. Postrado. 1987. "Filipino Overseas Contract Workers: Their Families and Communities," in *Asian Labor Migration: Pipeline to the Middle East*, ed. Fred Arnold and Nasra M. Shah. Boulder, Colo.: Westview Press.

Goffman, Erving. 1959. *The Presentation of Self in Everyday Life*. New York: Anchor Books.

———. 1981. *Forms of Talk*. Philadelphia: University of Pennsylvania Press.

Gonzalez, Anna Miren, and Mary R. Hollnsteiner. 1976. *Filipino Women as Partners of Men in Progress and Development*. Institute of Philippine Culture. Quezon City: Ateneo de Manila University.

Goody, Jack. 1961. "The Classification of Double Descent Systems," *Current Anthropology*, 2:3–12.

Gould, Stephen Jay. 1981. *The Mismeasure of Man*. New York: W.W. Norton.

Graburn, Nelson. 1979. "Introduction: The Arts of the Fourth World," in *Ethnic and Tourist Arts: Cultural Expressions from the Fourth World*, ed. Nelson Graburn. Berkeley: University of California Press.

Grossman, Rachel. 1979. "Women's Place in the Integrated Circuit," *Southeast Asia Chronicle*, 66:2–17.

Guermonprez, J.-F. 1984. *Les Pande de Bali. Memoire pour le doctorat de troisième cycle*. Paris: École des Hautes Études en Sciences Sociales.

Hamonic, Gilbert. 1975. "Travestissement et bisexualité chez les 'Bissu' du pays Bugis," *Archipel*, 10:121–34.

———. 1987. *Le langage des Dieux: Cultes et pourvoirs pre-Islamiques en pays Bugis, Celebes-Sud, Indonesie*. Paris: Édition du Centre National de la Recherche Scientifique.

Harahap, Basyral. 1987. "Islam and Adat Among South Tapanuli Migrants in Three Indonesian Cities," in Kipp and Rodgers 1987, pp. 221–38.

Hart, Donn V. 1968. "Homosexuality and Transvestitism in the Philippines: The Cebuano Filipino Bayot and Lakin-on," *Behavior Science Notes*, 3:211–48.

Hatley, Barbara. 1981. "The Pleasure of the Stage: Images of Love in Javanese Theatre," in *Five Essays on the Indonesian Arts*, ed. Margaret J. Kartomi, pp. 17–41. Melbourne: Monash University.

Headley, Stephen. 1983. "Le lit-grenier et la déesse de la fécondité à Java: Rites nuptiaux?" *Dialogue*, 82:77–86.

Heidegger, Martin. 1968. "C'est qu'est et comment se détermine la *physis*," trans. François Fédier, in *Questions*, vol. 2, pp. 165–276. Paris: Gallimard.

Heine-Geldern, Robert. 1956. *Conceptions of State and Kingship in Southeast Asia*. Southeast Asia Program Data Paper 18. Ithaca: Cornell Southeast Asian Program.

Henley, Nancy M. 1977. *Body Politics: Power, Sex, and Non-Verbal Communication*. New York: Simon and Schuster.

Herdt, Gilbert. 1987. *The Sambia: Ritual and Gender in New Guinea.* New York: Holt, Rinehart and Winston.

Héritier, Françoise. 1979. "Symbolique de l'inceste et sa prohibition," in *La fonction symbolique,* ed. M. Izard and Pierre Smith, pp. 209–43. Paris: Gallimard.

Hinloopen-Labberton, Dirk van. 1905. *Lajang Damar Wulan.* Batavia: Bataviaasch Genootschaap van Kunsten en Wetenschappen.

Hobart, Mark. 1980. *Ideas of Identity: The Interpretation of Kinship in Bali.* Den Pasar: Universitas Udayana, Jurusan Antropologi Budaya.

Hobsbawn, Eric, and Terence Ranger. 1983. *The Invention of Tradition.* Cambridge: Cambridge University Press.

Hocart, A. M. 1952. *The Life-Giving Myth.* London: Methuen.

Hochschild, Arlie R. 1983. *The Managed Heart: Commercialization of Human Feeling.* Berkeley: University of California Press.

Hodgen, Margaret T. 1964. *Early Anthropology in the Sixteenth and Seventeenth Centuries.* Philadelphia: University of Pennsylvania Press.

Hookway, Christopher. 1978. "Indeterminacy and Interpretation," in *Action and Interpretation,* ed. C. Hookway and Phillip Pettit, pp. 17–41. Cambridge: Cambridge University Press.

Hooykaas, C. 1964. "Agama Tirtha: Five Studies in Balinese Religion," Verhandelingen der Koninklijke Nederlandse Akademie van Wetenschappen, Afd. Letterkunde 70.

Hoskins, Janet Alison. 1985. "A Life History from Both Sides: The Changing Poetics of Personal Experience," *Journal of Anthropological Research,* 41, no. 2:147–69.

———. 1986. "So My Name Shall Live: Stone Dragging and Grave Building in Kodi, West Sumba," *Bijdragen tot de Taal-, Land-, en Volkenkunde,* 142:31–51.

———. 1987a. "Etiquette in Kodi Spirit Communication: The Lips Told to Speak, the Mouth Told to Pronounce," in Fox 1988, pp. 29–63. Cambridge: Cambridge University Press.

———. 1987b. "Complementarity in This World and the Next: Gender and Agency in Kodi Mortuary Ceremonies," in Strathern 1987a, pp. 174–206. Cambridge: Cambridge University Press.

———. 1987c. "Entering the Bitter House: Spirit Worship and Conversion in Sumba," in Kipp and Rodgers 1987, pp. 136–60.

———. 1987d. "The Headhunter as Hero: Local Traditions and Their Reinterpretation in National History," *American Ethnologist,* 14, no. 4:605–22.

———. 1988a. "Matriarchy and Diarchy: Indonesian Variations on the Domestication of the Savage Woman," in *Myths of Matriarchy Recon-*

sidered, ed. Deborah Gewertz, pp. 34–57. Sydney: Oceania Monographs, University of Sydney Press.

———. 1988b. "The Drum Is the Shaman, the Spear Guides His Voice," in *Social Science and Medicine*, special issue on healing in Southeast Asia, vol. 27, no. 2:819–29.

———. 1988c. "Arts and Cultures of Sumba," in *Islands and Ancestors: Styles of Indigenous Southeast Asia*, catalogue for the Metropolitan Museum of New York, ed. Douglas Newton and Jean-Paul Barbier, pp. 120–38. New York and Geneva: Musée Barbier-Mueller/Metropolitan Museum.

———. 1989a. "Why Do Ladies Sing the Blues? Indigo Dyeing, Cloth Production and Gender Symbolism in Kodi," in *Cloth and Human Experience*, ed. Annette Weiner and Jane Schneider, pp. 141–67. Washington, D.C.: Smithsonian Institution Press.

———. 1989b. "On Losing and Getting a Head: Warfare, Exchange and Alliance in a Changing Sumba, 1888–1988," *American Ethnologist*, 16, no. 3:419–40.

Hudson, Alfred. 1967. "Padju Epat: The Ethnography and Social Structure of a Ma'anjan Group in Southeastern Borneo." Ph.D. dissertation, Cornell University.

Hull, Valerie. 1976. *Women in Java's Rural Middle Class—Progress or Regress?* Yogyakarta: Gajah Mada University, Population Institute.

Hymes, Dell H. 1970. "The Linguistic Method of Ethnography," in *Method and Theory in Linguistics*, ed. Paul Garvin. The Hague: Mouton.

———. 1972. "Models of the Interaction of Language and Social Life," in *Directions in Sociolinguistics*, ed. John Gumperz and Dell Hymes. New York: Holt, Rinehart and Winston.

———. 1974a. *Foundations in Sociolinguistics*. Philadelphia: University of Pennsylvania Press.

———. 1974b. "Ways of Speaking," in *Explorations in the Ethnography of Speaking*, ed. Richard Bauman and Joel Sherzer, pp. 433–51. Cambridge: Cambridge University Press.

Ileto, Reynaldo Clemena. 1979. *Pasyon and Revolution: Popular Movements in the Philippines, 1840–1910*. Quezon City: Ateneo de Manila University.

———. 1985. "The Past in the Present Crisis," in *The Philippines After Marcos*, ed. R. J. May and Francisco Nemenzo, pp. 7–16. Sydney: Croom Helm.

Inden, Ronald B., and Ralph W. Nicholas. 1977. *Kinship in Bengali Culture*. Chicago: University of Chicago Press.

Infante, Teresita R. 1975. *The Woman in Early Philippines and Among*

the Cultural Minorities. Manila: Unitas Publications, University of Santo Tomas.

Irvine, Judith T. 1979. "Formality and Informality in Communicative Events," *American Anthropologist*, 81:773–90.

———. 1989. "When Talk Isn't Cheap: Language and Political Economy," *American Ethnologist*, 16, no. 2:248–67.

Jakobson, Roman. 1966. "Parallelism and Its Russian Facet," *Language*, 42:398–429.

Jameson, Frederic. 1981. *The Political Unconscious*. Ithaca: Cornell University Press.

Jamilah Ariffin. 1981. "The Position of Women Workers in the Manufacturing Industries in Malaysia," *Akademika*, 19 (Jan. 1981):63–76.

Jay, Robert. 1969. *Javanese Villagers*. Cambridge, Mass.: MIT Press.

Jenks, Christopher. 1987. Reviews of *Crime and Human Nature* by James Q. Wilson and Richard J. Herrnstein, and *Confronting Crime: An American Challenge* by Elliot Currie. *New York Review of Books*, 24, no. 2 (Feb. 12):33–41.

Jensen, Adolph E. 1948. *Die drei Stroeme*. Leipzig: Harrassowitz.

Jocano, F. Landa. 1969. *Growing up in a Philippine Barrio*. New York: Holt, Rinehart and Winston.

———. 1976. *Tuburan: A Case Study of Adaptation and Peasant Life in a Bisayan Barrio*. UP-NSDB Integrated Research Program, Quezon City: University of Philippines.

Jones, Gavin. 1981. "Labor Force Developments Since 1961," in *The Indonesian Economy During the Soeharto Era*, ed. Anne Booth and Peter McCawley. Kuala Lumpur: Oxford University Press.

Jordanova, Ludmilla. 1980. "Natural Facts: A Historical Perspective on Science and Sexuality," in MacCormack and Strathern 1980, pp. 42–69.

Josselin de Jong, J. P. B. de. [1952] 1977. "Lévi-Strauss's Theory of Kinship," in *Structural Anthropology in the Netherlands*, ed. P. E. de Josselin de Jong, pp. 253–319. The Hague: Martinus Nijhoff.

Josselin de Jong, P. E. 1980. "The Concept of the Field of Ethnological Study," in Fox 1980a, pp. 317–26.

Kahn, Joel S. 1978. "Ideology and Social Structure in Indonesia," in *Comparative Studies in Society and History*, 20, no. 1:103–21.

Kapferer, Bruce. 1983. *A Celebration of Demons*. Bloomington: Indiana University Press.

Kartomi, Margaret J. 1981. "Lovely When Heard from Afar: Mandailing Ideas of Musical Beauty," in *Five Essays on the Indonesian Arts*, ed. Margaret Kartomi, pp. 1–16. Melbourne: Monash University.

Keeler, Ward. 1975. "Musical Encounter in Java and Bali," *Indonesia*, 19:85–125.

———. 1982. "Father Puppeteer." Ph.D. thesis, Committee on Social Thought, University of Chicago.

———. 1983. *Symbolic Dimensions of the Javanese House*. Melbourne: Monash University Centre of Southeast Asian Studies.

———. 1987. *Javanese Shadow Plays, Javanese Selves*. Princeton: Princeton University Press.

Keenan, Elinor Ochs. 1974. "Norm-Breakers and Norm Makers: Uses of Speech by Men and Women in a Malagasy Community," in *Explorations in the Ethnography of Speaking*, ed. Richard Bauman and Joel Sherzer, pp. 125–43. London: Cambridge University Press.

Keesing, Roger. 1975. *Kin Group and Social Structure*. New York: Holt, Rinehart and Winston.

Keller, Evelyn Fox. 1983. *A Feeling for the Organism: The Life and Work of Barbara McClintock*. San Francisco: W. H. Freeman.

Kelly, Raymond. N.d. "Sanctions and Symbolic Dominance: Patterns of Male-Female Relations in New Guinea." Unpublished paper.

Kessler, Clive S. 1977. "Conflict and Sovereignty in Kelantanese Malay Spirit Seances," in *Case Studies in Spirit Possession*, ed. Vincent Crapanzano and Vivian Garrison, pp. 295–331. New York: J. Wiley and Sons.

———. 1980. "Malaysia: Islamic Revivalism and Political Disaffection in a Divided Society," *Southeast Asia Chronicle*, 75:3–11.

Kessler, Suzanne J., and Wendy McKenna. 1978. *Gender: An Ethnomethodological Approach*. Chicago: University of Chicago Press.

Kevles, Daniel J. 1985. *In the Name of Eugenics: Genetics and the Uses of Human Heredity*. New York: Alfred Knopf.

Key, Mary Ritchie. 1975. *Male/Female Language*. Metuchen, N.J.: Scarecrow Press.

Kipp, Richard D. 1983. "Fictive Kinship and Changing Ethnicity Among Karo and Toba Migrants," in Kipp and Kipp, eds. 1983, pp. 147–84.

———. 1985. "Rights and Sentiments in Karo Batak Kinship." Paper read at a session on "Sumatran Structural Transformations" at the 1985 Association for Asian Studies meeting, Philadelphia, Pa.

Kipp, Rita S. 1979. "The Thread of Three Colors: The Ideology of Kinship in Karo Batak Funerals," in Bruner and Becker 1979, pp. 62–95.

———. 1984. "Terms for Kith and Kin," *American Anthropologist*, 86, no. 4:905–26.

———. 1986. "Terms of Endearment: Karo Batak Lovers as Siblings," *American Ethnologist*, 13, no. 4:632–45.

Kipp, Rita S., and Richard D. Kipp, eds. 1983. *Beyond Samosir: Recent Studies of the Batak Peoples of Sumatra*. Southeast Asia Series, no. 62. Athens, Ohio: Ohio University Center for International Studies.

Kipp, Rita S., and Susan Rodgers, eds. 1987. *Indonesian Religions in Transition*. Tucson: University of Arizona Press.

Koentjaraningrat. 1975. *Anthropology in Indonesia: A Bibliographical Review*. The Hague: Martinus Nijhoff.

Kolenda, Pauline. 1984. "Woman as Tribute, Woman as Flower: Images of 'Woman' in Weddings in North and South India," *American Ethnologist*, 11, no. 1:98–117.

Korn, V. E. 1932. *Het Adatrecht van Bali*. 2nd ed. The Hague.

Kuipers, Joel C. 1982. "Weyéwa Ritual Speech: Language and Ceremonial Interaction in Eastern Indonesia." Ph.D. dissertation, Department of Anthropology, Yale University.

———. 1986. "Talking About Troubles: Gender Differences in Weyéwa Speech Use," *American Ethnologist*, 13, no. 3:448–62.

———. N.d. "The Rhetoric of Quotation in Weyéwa."

Laderman, Carol C. 1982. "Putting Malay Women in Their Place," in Esterik 1982b, pp. 79–99.

Lakoff, George, and Mark Johnson. 1980. *Metaphors We Live By*. Chicago: University of Chicago Press.

Langness, L. L. 1974. "Ritual, Power, and Male Dominance in the New Guinea Highlands," *Ethos*, 2:189–212.

Lane, Harlan. 1976. *The Wild Boy of Aveyron*. Cambridge, Mass.: Harvard University Press.

Lanot, Marra Pl. 1982. "The Absentee Woman in Local Cinema," *The Diliman Review*, 30, no. 6 (Nov.–Dec.): 1, 18–22.

Lauretis, Teresa de. 1984. *Alice Doesn't: Feminism, Semiotics, Cinema*. Bloomington: Indiana University Press.

Leach, Edmund R. 1954. *Political Systems of Highland Burma*. Boston: Beacon Press.

———. 1961a. "On Certain Unconsidered Aspects of Double Descent Systems," *Man*, 62:214.

———. 1961b. "Rethinking Anthropology," in *Rethinking Anthropology*. London: Athlone.

———. 1964. "Anthropological Aspects of Language: Animal Categories and Verbal Abuse," in *New Directions in the Study of Language*, ed. Eric H. Lenneberg, pp. 23–63. Cambridge, Mass.: MIT Press.

———. 1976. *Culture and Communication*. Cambridge: Cambridge University Press.

Leacock, Eleanor. 1978. "Women's Status in Egalitarian Society: Implications for Social Evolution," *Current Anthropology*, 19, no. 2:247–75.

Ledesma, Antonio J. 1982. *Landless Workers and Rice Farmers: Peasant Subclasses Under Agrarian Reform in Philippine Villages*. Los Banos, Laguna, Philippines: International Rice Research Institute.

Lévi-Strauss, Claude. 1945. "L'analyse structurale en linguistique et an-thropologie," *Word*, 1:33–53.
———. 1962. *The Savage Mind (La pensée sauvage)*. London: Weidenfeld and Nicholson.
———. 1963. "The Structural Study of Myth," in *Structural Anthropology*, pp. 202–28.
———. 1963a. "Do Dual Organizations Exist?" in *Structural Anthropology*, pp. 132–63.
———. 1963b. *Totemism*. Translated from the French by Rodney Needham. New York: Beacon Press.
———. 1963c. *Structural Anthropology*, trans. Claire Jacobson and Brooke Grundfest Schoepf. New York: Basic Books.
———. 1969. *The Elementary Structures of Kinship*. Rev. ed., ed. Rodney Needham. Boston: Beacon Press.
———. 1973. *L'anthropologie structurale deux*. Paris: Plon.
———. 1979. "Nobles sauvages," in *Culture, science, et developpement*. Toulouse: Privat.
———. 1983a. *The Way of the Masks*. 2nd ed., trans. Sylvia Modelski. London: Jonathan Cape.
———. 1983b. *Le regard eloigné*. Paris: Plon.
———. 1984. *Paroles données*. Paris: Plon.
Lévy-Bruhl, Lucien. 1931. *Le surnaturel et la nature dans la mentalité primitive*. Paris: Alcan.
Lewis, Ioan M. 1971. *Ecstatic Religion: An Anthropological Study of Spirit Possession and Shamanism*. Harmondsworth: Penguin.
Lim, Linda Y. C. 1983. "Capitalism, Imperialism and Patriarchy: The Dilemma of Third World Women Workers in Multinational Factories," in *Women, Men and the International Division of Labor*, ed. June Nash and Patricia Fernandez-Kelly, pp. 70–91. Albany: SUNY Press.
Lindenbaum, Shirley. 1972. "Sorcerers, Ghosts and Polluting Women: An Analysis of Religious Belief and Population Control," *Ethnology*, 11: 241–53.
Loarca, Miguel de. 1582–87. "Relacion de las Islas Filipinas," in Blair and Robertson [BR] 1903–9, vol. 5, pp. 1–187.
Londres, A. 1958. *Thumb Tacks: Defects and Virtues of the Philippine People*. Manila.
Loney, Nicholas. 1964. *A Britisher in the Philippines, or The Letters of Nicholas Loney*. Manila: The National Library.
Lowie, Robert H. [1920] 1961. *Primitive Society*. New York: Harper and Row.
McConnell-Ginet, Sally. 1983. "Intonation in a Man's World," in *Lan-*

guage Gender and Society, ed. Barrie Thorne, Cheris Kamarae, and Nancy Henley, pp. 69–88. Rowley, Mass.: Newbury House.

MacCormack, Carol, and Marilyn Strathern, eds. 1980. *Nature, Culture and Gender*. Cambridge: Cambridge University Press.

McCoy, Alfred W. 1982. "Baylan: Animist Religion and Philippine Peasant Ideology," in *Moral Order and the Question of Change: Essays on Southeast Asian Thought*, ed. David K. Wyatt and Alexander Woodside, pp. 338–413. Yale Southeast Asia Studies Monograph Series, no. 24.

McCoy, Alfred W., and De Jesus Ediberto, eds. 1982. *Global Trade and Local Transformations*. Honolulu: University of Hawaii Press.

McKinnon, Susan M. 1983. "Hierarchy, Alliance and Exchange in the Tanimbar Islands." Ph.D. dissertation, Department of Anthropology, University of Chicago.

MacMicking, Robert. 1967. *Recollections of Manila and the Philippines During 1848, 1849 and 1850*. Manila: Filipiniana Book Guild.

Mallincrodt, J. 1928. *Het Adatrecht van Borneo*. Leiden: Dubbleman.

Manderson, Lenore, ed. 1983. *Women's Work and Women's Roles: Economics and Everyday Life in Indonesia, Malaysia and Singapore*. Development Studies Centre Monograph, no. 32. Canberra: The Australian National University.

Manning, Chris, and Masri Singarimbun. 1974. "Marriage and Divorce in Mojolama," *Indonesia*, 17:67–82.

Marcos, President Ferdinand. 1980. *Philippines National Commission on the Role of Filipino Women. Annual Reports 1977–1980*. Manila.

Marpaung, Baginda Marakub, and B. R. Sohuturon. 1962. *Pundjut-Pundjutan*. Medan: Islamyah.

Martires, Myrna. 1968. *Folk Festivals of the Philippines*. National Media Production Center. Manila: National Museum of the Philippines.

Mather, Celia E. 1983. "Industrialization in the Tangerang Regency of West Java: Women Workers and the Islamic Patriarchy," *Bulletin of Concerned Asian Scholars*, 15, no. 2 (Apr.-June), pp. 2–17.

Matsumoto, Sheila. 1978. "Women in Factories," in *Women in Changing Japan*, ed. Joyce Lebra, Joy Paulson, and Elizabeth Powers, pp. 51–74. Stanford: Stanford University Press.

Mauss, Marcel. [1925] 1967. *The Gift*, trans. Ian Cunnison. New York: Norton.

Mead, Margaret. 1935. *Sex and Temperament in Three Primitive Societies*. New York: New American Library.

Meggitt, Mervyn. 1964. "Male-Female Relationships in the Central Highlands," *New Guinea: The Central Highlands*, ed. James B. Watson, special publication of *American Anthropologist*, pp. 204–24.

Meigs, Anna S. 1978. "A Papuan Perspective on Pollution," *Man*, 13: 304–18.

———. 1984. *Food, Sex and Pollution: A New Guinea Religion*. New Brunswick, N.J.: Rutgers University Press.

Memmi, Albert. 1965. *The Colonizer and the Colonized*. Boston: Beacon Press.

Mendoza-Guazon, Maria Paz. 1928. *The Development and Progress of the Filipino Woman*. Office of Public Welfare Commissioner, Department of the Interior, Government of the Philippine Islands.

Merchant, Carolyn. 1980. *The Death of Nature: Women, Ecology, and the Scientific Revolution*. San Francisco: Harper and Row.

Mernissi, Fatima. 1975. *Beyond the Veil: Male-Female Dynamics in a Modern Muslim Society*. New York: J. Wiley and Sons.

Metcalf, Peter. 1982. *A Borneo Journey into Death*. Philadelphia: University of Pennsylvania Press.

Mill, John Stuart. 1874. *Nature, the Utility of Religion and Theism*. London: Longmans, Green, Reeder and Dyer.

Miralao, Virginia A. 1980. *Women and Men in Development*. Findings from a pilot study. Quezon City: IPC, Ateneo de Manila.

Morga, Antonio de. 1609. *Sucesos de las Islas Filipinas*, trans. J. S. Cummins. Cambridge: Hakluyt Society, 1971.

Moermann, Michael. 1965. "Ethnic Classification in a Complex Civilization: Who Are the Lue?" *American Anthropologist*, 67:1215–30.

Montiel, Cristina, and M. R. Hollnsteiner. 1976. *The Filipino Woman: Her Role and Status in Philippine Society*. Quezon City: IPC, Ateneo de Manila.

Mulder, Neils. 1978. *Mysticism and Everyday Life in Contemporary Java*. Singapore: Singapore University Press.

Murdock, G. P. 1949. *Social Structure*. New York: Macmillan.

Murphy, H. B. M. 1972. "History and the Evolution of Syndromes: The Striking Case of Latah and Amok," in *Psychopathology: Contributions from the Biological, Behavioral and Social Sciences*, ed. Muriel Hammer, Kurt Salzinger, and S. Sutton, pp. 33–55. New York: J. Wiley and Sons.

Nagata, Judith. 1981. "Religious Ideology and Social Change: The Islamic Revival in Malaysia," *Pacific Affairs*, 53 (Fall):405–30.

Nakpil, Carmen Guerero. 1963. *Woman Enough and Other Essays*. Quezon City: Vibal Publishing House.

Nasution, Mangaradja Goenoeng Sorik Marapi. 1957. *Turi-turian ni Radja Gorga di Langit dohot Radja Soeasa di Portibi*. Medan: Mimbar.

Needham, Rodney. 1980. "Principles and Variations in the Structure of Sumbanese Society," in Fox 1980a, pp. 21–47.

————. 1983. *Sumba and the Slave Trade*. Working Paper, no. 31. Melbourne: Department of Anthropology, Monash University.

Neher, Clark D. 1980. "The Political Status and Role of Philippine Women in Cebu Province," *Philippine Quarterly of Culture and Society*, 8:108–24.

————. 1982. "Sex Roles in the Philippines: The Ambiguous Cebuana," in Esterik 1982b, pp. 154–75.

Nurge, Ethel B. *Life in a Leyte Village*. Seattle: University of Washington Press.

O'Flaherty, Wendy. 1975. *Hindu Myths*. Baltimore: Penguin Books.

Ong, Aihwa. 1987. *Spirits of Resistance and Capitalist Discipline: Factory Women in Malaysia*. Albany: SUNY Press.

————. 1988. "The Production of Possession: Spirits and the Multinational Corporation in Malaysia," *American Ethnologist*, 15 (1, Feb.):28–42.

————. 1989. "Center, Periphery, and Hierarchy: Gender in Southeast Asia," in *Gender and Anthropology: Critical Reviews for Research and Teaching*, ed. Sandra Morgen, pp. 294–312. Washington, D.C.: American Anthropological Association.

————. 1990. "State versus Islam: Malay Families, Women's Bodies, and the Body Politic," *American Ethnologist* (forthcoming).

Onvlee, Louis. 1973. "Cultuur als Antwoord," *Verhandeling van het Koninlijk Instituut voor Taal-, Land- end Volkenkunde*, no. 66.

————. 1980. "The Significance of Livestock on Sumba," in Fox 1980a, pp. 195–207.

Ortiz, Fr. 1731. *Practica del Ministerio*. Manila.

Ortner, Sherry B. 1973. "On Key Symbols," *American Anthropologist* 75:1338–46.

————. 1974. "Is Female to Male as Nature Is to Culture?" in Rosaldo and Lamphere 1974, pp. 56–87.

————. 1981. "Gender and Sexuality in Hierarchical Societies: The Case of Polynesia and Some Comparative Implications," in Ortner and Whitehead 1981a, pp. 359–409.

————. 1984. "Theory in Anthropology Since the Sixties," in *Contemporary Studies in Society and History*, 26, no. 1.

Ortner, Sherry B., and Harriet Whitehead, eds. 1981a. *Sexual Meanings: The Cultural Construction of Gender and Sexuality*. Cambridge: Cambridge University Press.

————. 1981b. "Introduction: Accounting for Sexual Meanings," in Ortner and Whitehead 1981a, pp. 1–28.

Owen, Norman G. 1971. "Philippine Economic Development and American Policy: A Reappraisal," in *Compadre Colonialism*, ed. N. Owen, pp. 103–29. University of Michigan Papers, no. 3.

———. 1977. "Textile Displacement and the Status of Women in Southeast Asia," in *The Past in Southeast Asia's Present*, ed. G. Means. Ottawa: Canadian Society for Asian Studies.

Parsons, Talcott. 1963. "On the Concept of Influence," *Public Opinion Quarterly*, 27:38–48.

Patanñe, E. P. 1977. "Iloilo: Old Dock City," in *Filipino Heritage: The Making of a Nation*, vol. 7, *The Spanish Colonial Period*, pp. 1814–20. Manila: Lahing Pilipino.

Pausacker, Helen. 1988. "Srikandhi and Sumbadra: Stereotyped Role Models or Complex Personalities." Thesis, Department of Asian Languages and Anthropology, University of Melbourne.

Peacock, James. 1968. *Rites of Modernization: Symbolic and Social Aspects of Indonesian Proletarian Drama*. Chicago: University of Chicago Press.

Phelan, John Leddy. 1959. *The Hispanization of the Philippines: Spanish Aims and Filipino Responses 1565–1700*. Madison: University of Wisconsin Press.

———. 1977. "Catholicism in Folk Trappings," in *Filipino Heritage: The Making of a Nation*, vol. 5, pp. 1252–57. Manila: Lahing Pilipino.

Philips, Susan U. 1980. "Sex Differences in Language Use," *Annual Review of Anthropology*, 16:522–46.

Philips, Susan U., Susan Steele, and Christine Tanz, eds. 1987. *Language, Gender, and Sex in Comparative Perspective*. Cambridge: Cambridge University Press.

Pickering, W. S. F., ed. 1975. *Durkheim on Religion*. London: Routledge and Kegan Paul.

Pinard, Leo William II. 1975. "Courtship in an Urban Visayan Setting," *Philippine Quarterly of Culture and Society*, 3:98–113.

Pineda-Ofreneo, Rosalinda. 1982. "Philippine Domestic Outwork: Subcontracting for Export-Oriented Industries," *Journal of Contemporary Asia*, 12:281–93.

Pitt-Rivers, Julian. 1963. "Introduction," in *Mediterranean Countrymen: Essays in the Sociology of the Mediterranean*, ed. Julian Pitt-Rivers, pp. 9–25. Paris: Mouton Press.

———. 1971. (1961). *The People of the Sierra*. Chicago: University of Chicago Press.

———. 1977. *The Fate of Shechem, or The Politics of Sex: Essays in the Anthropology of the Mediterranean*. Boston: Cambridge University Press.

Poedjosoedarmo Soepomo. 1968. "Javanese Speech Levels," *Indonesia*, 6:54–81.

Porio, Emma, Frank Lynch, and Mary Hollnsteiner. 1978. *The Filipino*

Family, Community and Nation. Institute of Philippine Culture. Quezon City: Ateneo de Manila University.

Porter Poole, Fitz John. 1981. "Transforming 'Natural' Women: Female Ritual Leaders and Gender Ideology among Bimin-Kuskusmin," in Ortner and Whitehead 1981a, pp. 116–65.

Pratt, Mary Louise. 1977. *Toward a Speech Act Theory of Literary Discourse.* Bloomington: Indiana University Press.

Pretty, Francis. 1588. "The admirable and prosperous voyage of the Worshipfull Master Thomas Candish [Cavendish] . . . round about the whole earth, begun in the yeere of our Lord 1586, and finished 1588," in Hakluyt 1598–1600, vol. 8, pp. 206–55.

Prusak, Bernard P. 1974. "Woman: Seductive Siren and Source of Sin," in *Religion and Sexism: Images of Women in the Jewish and Christian Traditions,* ed. Rosemary R. Ruether, pp. 89–116. New York: Simon and Schuster.

Quine, Willard van Orman. 1964. *Word and Object.* Cambridge, Mass.: MIT Press.

Racusa-Gomez, Lourdes, and Helen R. Tubangui. 1978. "Reflections on the Filipino Woman's Past," in *Philippine Studies,* 26:125–41.

Rafael, Vincente L. 1988. *Contracting Colonialism: Translation and Christian Conversion in Tagalog Society under Early Spanish Rule.* Ithaca: Cornell University Press.

Ramseyer, Urs. 1977. *The Art and Culture of Bali.* Oxford: Oxford University Press.

Rassers, W. H. 1960. *Panji, the Culture Hero: A Structural Study of Religion in Java.* The Hague: Martinus Nijhoff.

Reid, Anthony, ed. 1982. "The Penis Pins Syndrome in Southeast Asia." Unpublished paper.

——, ed. 1983. *Slavery, Bondage, and Dependency in Southeast Asia.* St. Lucia: Queensland University Press.

——. 1988. *Southeast Asia in the Age of Commerce 1450–1680,* vol. 1, *The Lands Below the Winds.* New Haven: Yale University Press.

Reiter, Rayna R. 1975. *Toward an Anthropology of Women.* New York: Monthly Review Press.

Renard-Clamagirand, Brigette. 1988. "Li'i Marapn: Speech and Ritual among the Wewewa of West Sumba," in Fox 1988, pp. 87–103.

Reyes, Socorro L. 1989. "Legislation on Women's Issues in the Philippines: Status, Problems and Prospects." Paper presented at the Third International Philippine Studies Conference, PSSC, Diliman Quezon City, July.

Riedel, Johan Gerrard. 1886. *De sluik–en kroeshaarige rassen tusschen Selebes en Papua.* The Hague: Martinus Nijhoff.

Riekerk, G. 1940. "Haboe Hoegho," *Bijdragen tot de Taal-, Land- en Volkenkunde*, 90:89–92.

Rizal, Jose. [1887] 1956. *Noli Me Tangere*. Translated from the Spanish original by Dr. Jorge Bacobo. Quezon City: R. Martinez and Sons.

Robinson, Kathy. 1988. "What Kind of Freedom Is Cutting Your Hair?" in Chandler, Sullivan, and Branson 1988, pp. 63–77.

Robles, Eliodoro G. 1969. *The Philippines in the Nineteenth Century*. Quezon City: Malaya Books.

Rodgers Siregar, Susan. 1979a. "Advice to the Newlyweds: Sipirok Batak Wedding Speeches—Adat or Art?" in Bruner and Becker 1979.

———. 1979b. "A Modern Batak Horja: Innovation in Sipirok Adat Ceremonial," *Indonesia*, 27:103–28.

———. 1981a. "Blessing Shawls: The Social Meaning of Sipirok Batak Ulos," in *Indonesian Textiles*, ed. Mattiebell Gittinger, pp. 96–114. Washington D.C.: The Textile Museum.

———. 1981b. *Adat, Islam and Christianity in a Batak Homeland*. Southeast Asia Series, no. 62. Athens, Ohio: Ohio University Center for International Studies.

———. 1981c. "A Batak Literature of Modernization," *Indonesia*, 31:137–62.

———. 1983. "Political Oratory in a Modernizing Southern Batak Homeland," in Kipp and Kipp 1983, pp. 21–52.

Rodgers, Susan. 1978. "Angkola Batak Kinship Through Its Oral Literature." Ph.D. dissertation, Department of Anthropology, University of Chicago.

———. 1984. "Orality, Literacy, and Batak Concepts of Marriage Alliance," *Journal of Anthropological Research*, 40, no. 3:433–50.

———. 1986. "Batak Tape Cassette Kinship: Constructing Kinship Through the Indonesian National Mass Media," *American Ethnologist*, 13, no. 1 (Feb.):23–42.

Rodgers, Susan, and Richard McGinn. 1985a. "Interpretive Approaches to Southeast Asian Languages and Cultures—A Symposium," *Journal of Asian Studies*, 44, no. 4:735–42.

Rogers, Susan. 1975. "Female Forms of Power and the Myth of Male Dominance: A Model of Female/Male Interaction in Peasant Society," *American Ethnologist*, 2, no. 4:727–56.

Rosaldo, Michelle Z. 1973. "I Have Nothing to Hide: The Language of Ilongot Oratory," *Language in Society*, 2, no. 2:193–223.

———. 1974. "Woman, Culture and Society: A Theoretical Overview," in Rosaldo and Lamphere 1974, pp. 17–42.

———. 1980. *Knowledge and Passion: Ilongot Notions of Self and Society*. New York: Cambridge University Press.

———. 1980b. "The Use and Abuse of Anthropology," *Signs*, 5, vol. 3:389–417.

Rosaldo, Michelle Z., and Jane M. Atkinson. 1975. "Man the Hunter and Woman: Metaphors for the Sexes in Ilongot Magic Spells," in *The Interpretation of Symbolism*, ed. R. Willis, pp. 43–75. London: Malaby Press.

Rosaldo, Michelle Z., and Louise Lamphere, eds. 1974. *Woman, Culture and Society*. Stanford: Stanford University Press.

Rosaldo, Renato. 1980a. *Ilongot Headhunting 1883–1974*. Stanford: Stanford University Press.

———. 1984. "Grief and a Headhunter's Rage," in *Text, Play and Story: The Construction and Reconstruction of Self and Society*, ed. Edward M. Bruner. Washington, D.C.: Proceedings of the American Ethnological Society.

Roth, Paul A. 1986. "Pseudo-problems in Social Science," *Philosophy and Social Sciences*, 16:59–82.

Roxas, President Manuel. 1946. "Presidential Speech," in Londres 1958.

Rubin, Gayle. 1975. "The Traffic in Women: Notes Toward a Political Economy of Sex," in Reiter 1975, pp. 157–210.

Ruether, Rosemary R. 1974. "Mysogenism and Virginal Feminism in the Fathers of the Church," in *Religion and Sexism: Images of Women in the Jewish and Christian Traditions*, ed. Rosemary R. Ruether. New York: Simon and Schuster.

Rutten, Rosanne. 1982. "Women Workers of Hacienda Milagros: Wage Labor and Household Subsistence on a Philippines Sugarcane Plantation," *Publikatieserie Zuid- en Zuidoost- Azie*, no. 30. Antropologisch-Sociologisch Centrum, Universitet van Amsterdam.

Sacks, Karen. 1979. *Sisters and Wives: The Past and Future of Sexual Equality*. Westport, Conn.: Greenwood Press.

San Diego, Lourdes P. 1975. "Women in Family Law," in *Philippine Law Journal*, 50, no. 1:25–35.

Santos, Luz Mendoza. 1982. *The Philippine Rites of Mary*. Manila.

Santoso, Soewito, ed. 1973. *Lilaracana-Ramayana*. Yogyakarta: Gadjah Mada University Press.

Scharer, Hans. 1963. *Ngaju Religion*, trans. Rodney Needham. The Hague: Martinus Nijhoff.

Scheper-Hughes, Nancy, and Margaret Lock. 1983. "The Mindful Body." *Medical Anthropology Quarterly*, n.s., vol. 1, no. 1:5–41.

Schiebinger, Londa. 1989. *The Mind Has No Sex?: Women in the Origins of Modern Science*. Cambridge: Harvard University Press.

Schneider, David M. 1957. "Typhoons on Yap," *Human Organization*, 16:10–14.

———. [1968]. 1980. *American Kinship: A Cultural Account*. 2d ed. with a new chapter. Chicago: University of Chicago Press.

———. 1972. "What Is Kinship All About?" in *Kinship Studies in the Morgan Centennial Year*, ed. Priscilla Reining. Washington, D.C.

———. 1976. "The Meaning of Incest," *Journal of the Polynesian Society*, 85, no. 2:149–69.

———. 1984. *A Critique of the Study of Kinship*. Ann Arbor: University of Michigan Press.

Schulte-Nordholt, H. G. 1971. *The Political System of the Antoni of Timor*. The Hague: Martinus Nijhoff.

Scott, William Henry. 1978. *Filipino Class Structure in the 16th Century*. Philippines in the Third World Paper Series, no. 13. Third World Studies. Quezon City: University of the Philippines.

———. 1982. *Cracks in the Parchment Curtain and Other Essays in Philippine History*. Quezon City: New Day Publishers.

———. 1983. "Oripun and Alipin in the Sixteenth Century Philippines," in Reid 1983.

Sen, Krishna. 1982. "The Image of Women in Indonesian Films," *Prisma: The Indonesian Indicator*, 24 (Mar.): 17–29.

———. 1983. "The Taming of the Shrew, or Film in the Production of Femininity in Indonesia." Paper presented at the Women in Asia Workshop, July 1983, Monash University, Melbourne.

Shapiro, Judith. 1988. "Gender Totemism," in *The Dialectics of Gender*, ed. Richard Randolph and David M. Schneider, pp. 1–19. Boulder, Colo.: Westview Press.

———. 1989. "The Concept of Gender." Paper presented to the Department of Anthropology, Stanford University, February.

Shattuck, Roger. 1980. *The Forbidden Experiment: The Story of the Wild Boy of Aveyron*. New York: Washington Square Press.

Sherman, George. 1987. "Men Who Are Called 'Women' in Toba Batak: Marriage, Fundamental Sex Role Differences, and the Suitability of the Gloss 'Wife Receiver,'" *American Anthropologist*, 89, no. 4:867–78.

Sherzer, Joel. 1983. *Kuna Ways of Speaking*. Austin: University of Texas Press.

Shore, Bradd. 1976. "Incest Prohibitions and the Logic of Power in Samoa," in *Incest Prohibitions in Polynesia and Micronesia*, ed. Judith Huntsman and Mervyn McLean, pp. 275–96. *Journal of the Polynesian Society*, 85 (special issue).

———. 1981. "Sexuality and Gender in Samoa: Conceptions and Missed Conceptions," in Ortner and Whitehead 1981a, pp. 192–215.

———. 1990. "Totem as Practically Reason: Food for Thought," *Dialectical Anthropology*, 13, no. 3 (forthcoming).

Siagian, Toenggoel P. 1966. "Bibliography on the Batak Peoples," *Indonesia*, 2:161–84.

Siegel, James. 1969. *The Rope of God*. Berkeley: University of California Press.

Singarimbun, Masri. 1975. *Kinship, Descent and Alliance Among the Karo Batak*. Berkeley: University of California Press.

Siregar, Ahmad Samin. 1977. *Kamus Bahasa Angkola/Mandailing-Indonesia*. Jakarta: Pusat Pembinaan dan Pengembangan Bahasa, Department Pendidikan dan Kebudayaan.

Skeat, Walter W. [1900] 1965. *Malay Magic: An Introduction to the Folklore and Popular Religion of the Malay Peninsula*. London: Macmillan.

Smith, Philip M. 1985. *Language, the Sexes and Society*. Oxford: Basil Blackwell.

Snow, Robert T. 1978. "Export-Oriented Industrialization and Its Impact on Women Workers," *Philippine Sociological Review*, 26:3–4.

Soetan, Pangoerabaan. 1930. *Tolbok Haleon*. Sipirok. [Privately published.]

Stepan, Nancy Leys. 1982. *The Idea of Race in Science: Great Britain, 1800–1960*. London: Macmillan.

———. 1986. "Race and Gender: The Role of Analogy in Science," *ISIS*, 77:261–77.

Stoler, Ann. 1977. "Class Structure and Female Autonomy in Rural Java," *Signs*, 3, no. 1:74–89.

Strange, Heather. 1981. *Rural Malay Women in Tradition and Transition*. New York: Praeger.

Strathern, Marilyn. 1972. *Women in Between: Female Roles in a Male World. Mount Hagen, New Guinea*. London: Seminar Press.

———. 1980. "No Nature, No Culture: The Hagen Case," in MacCormack and Strathern 1980, pp. 174–222.

———. 1981. "Self-Interest and the Social Good: Some Implications of Hagen Gender Imagery," in Ortner and Whitehead 1981a, pp. 166–91.

———. 1982. "Culture in a Netbag: The Manufacture of a Sub-Discipline in Anthropology," *Man*, n.s. 16:665–88.

———, ed. 1987a. *Dealing with Inequality: Analysing Gender Relations in Melanesia and Beyond*. Cambridge: Cambridge University Press.

———. 1987b. "Introduction," in Strathern 1987a, pp. 1–32.

Strauss, Erwin. 1966. "Upright Posture," in *Phenomenological Psychology: The Selected Papers of Erwin W. Strauss*, pp. 137–65. New York: Basic Books.

Sullivan, John. 1980. *Back Alley Neighbourhood: Kampung as Urban Community in Yogyakarta*. Working Paper, no. 18. Melbourne: Monash University Centre of Southeast Asian Studies.

Sullivan, Norma. 1982. "Women, Work and Ritual in a Javanese Urban

Community," in *Class, Ideology and Women in Asian Societies*, ed. G. Pearson, pp. 261–76. Hong Kong: Asian Research Service.

———. 1983. "Indonesian Women in Development, State Theory and Urban Kampung Practice," in Manderson 1983, pp. 147–72.

Swift, Michael. 1963. "Men and Women in Malay Society," in B. Ward 1963b, pp. 256–68.

Szanton, David L. 1970. "Entrepreneurship in a Rural Philippine Community." Ph.D. dissertation, Department of Anthropology, University of Chicago.

Tanner, Nancy. 1974. "Matrifocality in Indonesia and Africa and Among Black Americans," in Rosaldo and Lamphere 1974, pp. 129–56.

Tapales, Proserpina D. 1989. "Filipino Women, Migration, and the Mail-Order Bride Phenomenon: Focus on Australia." Paper presented at the Third International Philippine Studies Conference, July.

Taussig, Michael T. 1980. *The Devil and Commodity Fetishism in South America*. Chapel Hill: University of North Carolina Press.

Testart, Alain. 1985. *Le Communisme Primitif*. Paris: Éditions de la Maison des Sciences de l'Homme.

Thomas, Keith. 1983. *Man and the Natural World*. London: Allen Lane.

Thompson, Edward P. 1967. *The Making of the English Working Class*. New York: Vintage.

———. 1977. "Folklore, Anthropology and Social History," *Indian Historical Review*, 3, no. 2:247–66.

Thorne, Barrie, and Nancy Henley, eds. 1975. *Language and Sex: Difference and Domination*. Rowley, Mass.: Newbury House.

Thorne, Barrie, Cheris Kamarae, and Nancy Henley, eds. 1983. *Language, Gender and Society*. Rowley, Mass.: Newbury House.

Tiongson, Nicanor G. 1977. "The Virgin in a Feudal Time," in *Filipino Heritage: A Nation in the Making*, vol. 7, pp. 733–36. Manila: Lahing Pilipino.

Traube, Elizabeth. 1980a. "Mambai Rituals of the Black and White," in Fox 1980a, pp. 290–314.

———. 1980b. "Affines and the Dead: Mambai Rituals of Alliance," *Bijdragen tot de Taal-, Land-, en Volkenkunde*, 136:90–115.

———. 1986. *Cosmology and Social Life*. Chicago: University of Chicago Press.

Trudgill, Peter. 1974. *Sociolinguistics: An Introduction*. Harmondsworth: Penguin.

Tsing, Anna. 1982. "Gender and Leadership in a Meratus Ritual." Paper presented at the 81st annual meeting of the American Anthropological Association, Washington, D.C.

————. 1984. "Politics and Culture in the Meratus Mountains." Ph.D. dissertation, Stanford University.

————. 1987. "A Rhetoric of Centers in a Religion of the Periphery," in Kipp and Rodgers 1987, pp. 187–210.

————. Forthcoming. "Riding the Horse of Gaps: A Meratus Woman's Spiritual Expression," in Creativity and Anthropology, ed. Renato Rosaldo, Smadar Lavie, and Kirin Narayan. Ithaca: Cornell University Press.

Tsing, Anna, and Sylvia Yanagisako. 1983. "Feminism and Kinship Theory," Current Anthropology, 24, no. 4:511–16.

Valeri, Renée. 1977. "La position sociale de la femme dans la société traditionnelle des Moluques Centrales," Archipel, 13:53–78.

Valeri, Valerio. 1975–76. "Alliances et échanges matrimoniaux à Seram Central (Moluques)," L'Homme, 15, nos. 3–4:83–107; 16, no. 1:125–49.

————. 1980. "Notes on the Meaning of Marriage Prestations Among the Huaulu of Seram," in Fox 1980a, pp. 178–92.

————. 1985. Kingship and Sacrifice: Ritual and Society in Ancient Hawaii. Chicago: University of Chicago Press.

————. 1989. "Reciprocal Centers: The Siwa/Lima System in the Central Moluccas," in The Attraction of Opposites: Thought and Society in the Dualistic Mode, ed. D. Maybury-Lewis and Uri Almagor, pp. 117–41. Ann Arbor: University of Michigan Press.

————. Forthcoming. "Culti e credenze," in Enciclopedia delle Scienze Sociali, vol. 2. Rome: Istituto della Enciclopedia Treccani.

————. Forthcoming a. "Autonomy and Heteronomy in the Kahua Ritual: A Short Meditation on Huaulu Society," Bijdragen tot de Taal-, Land-, en Volkenkunde.

Van der Kroef, Justus. 1954. "Dualism and Symbolic Antithesis in Indonesian Society," American Anthropologist, 56:874–82.

————. 1954–56. "Transvestitism and the Religious Hermaphrodite," in Indonesia in the Modern World, vol. 2, pp. 182–97. Bandung: M. Baru.

Van Wouden, F. A. E. 1935. "Sociale Structuurtypen," in De Groote Oost. Leiden: Ginsburg.

————. 1968. "Types of Social Structure in Eastern Indonesia," trans. R. Needham. Koninklijk Instituut voor Taal-, Land- en Volkenkunde Translation Series, vol. 11. The Hague: Martinus Nijhoff.

————. 1977. "Social Groups and Double Descent in Kodi, West Sumba," in Structural Anthropology in the Netherlands, ed. P. E. Josselin de Jong, pp. 183–222. The Hague: Martinus Nijhoff.

Vergouwen, J. C. [1933] 1964. The Social Organization and Customary

Law of the Toba-Batak of Northern Sumatra, trans. J. Scott-Kimball. The Hague: Martinus Nijhoff.

Villariba, Maria C. 1982. *The Philippines: Canvasses of Women in Crisis*. International Reports: Women and Society, pp. 1–15. London: Change.

Wallace, Anthony C. 1956. *Tornado in Worcester: An Exploratory Study of Individual and Community Behavior in an Extreme Situation*. NAS-NRC Disaster Study 3. Washington, D.C.: National Research Council.

Ward, Barbara. 1963a. "Men, Women and Change: An Essay in Understanding Social Roles in South and South-East Asia," in Ward 1963b, pp. 25–99.

———, ed. 1963b. *Women in the New Asia: The Changing Social Roles of Men and Women in South and South-East Asia*. Paris: UNESCO.

Ward, Donald. 1968. *The Divine Twins*. Berkeley: University of California Press.

Weiner, Annette. 1985. "Inalienable Wealth," *American Ethnologist*, 12:210–27.

West, Candace, and Don H. Zimmerman. 1987. "Doing Gender," *Gender and Society*, 1, no. 2:125–51.

White, Benjamin. 1981. "Population, Involution and Employment in Rural Java," in *Agricultural and Rural Development*, ed. G. Hansen, pp. 130–46. Boulder, Colo.: Westview Press.

White, Hayden V. 1973. *Metahistory: The Historical Imagination in Nineteenth-Century Europe*. Baltimore: Johns Hopkins University Press.

Whitehead, Harriet. 1981. "The Bow and the Burden Strap: A New Look at Institutionalized Homosexuality in Native North America," in Ortner and Whitehead 1981a, pp. 80–115.

Whittier, Herbert. 1973. "Social Organization and Symbols of Social Differentiation: An Ethnographic Study of the Kenyah Dayak of East Kalimantan." Ph.D. dissertation, Michigan State University.

Williams, Raymond. 1983. *Culture and Society: 1780–1950*. New York: Columbia University Press.

Williams, Walter. 1986. *The Spirit and the Flesh: Sexual Diversity in American Indian Culture*. Boston: Beacon Press.

Winzeler, Robert. 1982. "Sexual Status in Southeast Asia: Comparative Perspectives on Women, Agriculture and Political Organization," in Esterik 1982b, pp. 176–213.

Wolf, Eric R. 1960. "Society and Symbols in Latin Europe and in the Islamic Near East: Some Comparisons," in *Anthropological Quarterly*, 42, no. 3:287–301.

Wolters, O. W. 1982. *History, Culture, and Region in Southeast Asian Perspectives*. Singapore: Institute of Southeast Asian Studies.

Yengoyan, Aram. 1983. "Transvestism and the Ideology of Gender: Southeast Asia and Beyond," in *Feminist Re-visions: What Has Been and Might Be*, ed. Vivian Patraka and Louise A. Tilly, pp. 135–48. Ann Arbor: Women's Studies Program, University of Michigan.

Index

In this index "f" after a number indicates a separate reference on the next page, and an "ff" indicates separate references on the next two pages. A continuous discussion over two or more pages is indicated by a span of page numbers, e.g., "57–58." *Passim* is used for a cluster of references in close but not consecutive sequence.

Library of Congress Cataloging-in-Publication Data

Power and difference: gender in island Southeast Asia /
 edited by Jane Monnig Atkinson and Shelly Errington.
 p. cm.
 Papers from a conference held Dec. 13, 1983, in Prince-
 ton, N.J. Includes bibliographical references.
 ISBN 0-8047-1781-8 (alk. paper):
 ISBN 0-8047-1779-6 (pbk.):
 1. Sex role—Asia, Southeastern—Congresses.
 2. Power (Social sciences)—Congresses. 3. Asia, South-
 eastern—Social life and customs—Congresses. I. Atkin-
 son, Jane Monnig. II. Errington, Shelly, 1944–
 HQ1075.5.A785P68 1990
 305.3'0954—dc20 89-78330
 CIP

 ∞ This book is printed on acid-free paper